D0899121

Applied Environmental Geochemistry

Academic Press Geology Series

Mineral Deposits and Global Tectonic Settings—A. H. G. Mitchell and M. S. Garson—*1981*

Applied Environmental Geochemistry—I. Thornton (ed.)—*1983*

Applied Environmental Geochemistry

Edited by

IAIN THORNTON

Applied Geochemistry Research Group,
Department of Geology,
Imperial College, London, UK

1983

ACADEMIC PRESS

A Subsidiary of Harcourt Brace Jovanovich, Publishers
London New York Paris
San Diego San Francisco São Paulo
Sydney Tokyo Toronto

ACADEMIC PRESS INC. (LONDON) LTD.
24–28 Oval Road
London NW1 7DX

U.S. Edition published by
ACADEMIC PRESS INC.
111 Fifth Avenue
New York, New York 10003

British Library Cataloguing in Publication Data

Applied environmental geochemistry
 1. Geochemistry 2. Environmental chemistry
 I. Thornton, Iain
 551.9 QE515

 ISBN 0-12-690640-8

 LCCCN 83 71358

Filmset by Mid-County Press, London SW15
Printed in Great Britain by St. Edmundsbury Press, Bury St. Edmunds, Suffolk

List of Contributors

ERNEST E. ANGINO Geology Department, University of Kansas, Lawrence, Kansas 66844, USA

S. H. U. BOWIE, F.R.S. Tanyard Farm, Clapton, Crewkerne, Somerset TA18, 8PS, UK

JOHN T. BRAY Department of Surgery, School of Medicine, East Carolina University, Greenville, North Carolina 27834, USA

ROBERT G. CROUNSE Department of Surgery, School of Medicine, East Carolina University, Greenville, North Carolina 27834, USA

BRIAN E. DAVIES Department of Geography, University College of Wales, Llandinam Building, Penglais, Aberystwyth, Dyfed SY23 3DB, Wales

ULRICH FÖRSTNER Arbeitsbereich Umweltschutztechnik, Technische Universität Hamburg-Harburg, Harburger Schlosstrasse 20, Postfach 90 14 03, 2100 Hamburg 90, West Germany

RICHARD J. HOWARTH Applied Geochemistry Research Group, Department of Geology, Imperial College, Prince Consort Road, London SW7 2BP, UK

BETSY T. KAGEY Downstate Medical Center, Brooklyn, New York 11203, USA

JOE KUBOTA Plant, Soil and Nutrition Laboratory, ARS, USDA, Cornell University, Ithaca, New York 14850, USA

J. LÅG Institutt for jordbunnslaere med Statents Jordundersokelse, Norges landbrukshogskolle, Postadr Boks 27, N-1432 As-NLH, Norway.

S. V. MATTIGOD Department of Soil and Environmental Sciences, University of California, Riverside, California 92521, USA

RICHARD L. MAUGER Department of Geology, East Carolina University, Greenville, North Carolina 27834, USA

BETTY H. OLSON Environmental Analysis, Program in Social Ecology, University of California, Irvine, California 92717, USA

A. L. PAGE Department of Soil and Environmental Sciences, University of California, Riverside, California 92521, USA

JANE PLANT Metalliferous Minerals and Applied Geochemistry Unit, Institute of Geological Sciences, 154 Clerkenwell Road, London EC1R 5DU, UK

WALTER J. PORIES Department of Surgery, School of Medicine, East Carolina University, Greenville, North Carolina 27834, USA

R. RAISWELL Department of Environmental Sciences, University of East Anglia, Norwich, Norfolk NR4 7TT, UK (Present address: Department of Earth Sciences, Leeds University, Leeds LS2 9JT, UK)

GARRISON SPOSITO Department of Soil and Environmental Sciences, University of California, Riverside, California 92521, USA

MICHAEL THOMPSON Applied Geochemistry Research Group, Department of Geology, Imperial College, Prince Consort Road, London SW7 2 BP, UK

IAIN THORNTON Applied Geochemistry Research Group, Department of Geology, Imperial College, Prince Consort Road, London SW7 2BP, UK

BOBBY G. WIXSON Environmental Research Center, Department of Civil Engineering, University of Missouri, Rolla, Missouri 65401, USA

Foreword

JOHN S. WEBB

Emeritus Professor, FEng, DSc, Hon. FIMM

It is now nearly 25 years since the Applied Geochemistry Research Group, Department of Geology at Imperial College commenced research into the applications of geochemical surveys to agriculture (subsequently generously funded by the Natural Environment Research Council and the Agricultural Research Council). Shortly after an article by Dr Allen-Price appeared in *The Lancet* (Allen-Price, 1960), pointing out an unusual incidence of cancer in part of southwest England, an investigation was initiated by geochemists, chemists, soil scientists, water engineers, veterinary scientists and medical practitioners — the first multi-disciplinary team in this field in Britain.

Since then applied environmental geochemistry has grown enormously to encompass the many factors influencing the sources, dispersion and distribution of elements in the environment, their pathways into foodstuffs and water supplies, and possible effects on health and disease in plants, animals and man. The multi-disciplinary and international nature of this work is reflected by the authorship of the contributed chapters in this volume. Progress has been assisted by two major advances. Firstly the development of rapid low-cost instrumental procedures enabling the simultaneous analysis of geochemical samples for a large number of elements fed directly to computer format. Secondly the evolution of geochemical surveys based on stream sediment analysis coupled with automated data plotting procedures to provide regional and national maps of major and trace element distribution. These maps provide the basis for research into geochemical factors influencing the health of man, animals and plants and also assist mineral exploration and land use planning to the benefit of the community. Following a number of preliminary studies funded by the Institute of Geological Sciences and others, and the publication of the experimental prototype geochemical atlas of Northern Ireland, the Imperial College Group compiled the *Wolfson Geochemical Atlas of England and Wales*, the first of its kind. This was followed by more detailed regional atlases by the Institute of Geological Sciences in Britain and by numerous regional geochemical mapping programmes elsewhere.

Much of the early work in applied environmental geochemistry was initiated in Canada, USA and USSR. In particular the pioneering efforts of Helen Cannon and Howard Hopps in the US and Harry Warren in Canada must be acknowledged, together with the foresight of Delbert D. Hemphill in organising the continuing series of Annual Conferences on Trace Substances in Environmental Health at the University of Missouri, Columbia. The 17th Conference in this series took place this year. Commencing in 1972 the US National Academy of Science Subcommittee on the Geochemical Environment in Relation to Health and Disease organised several multi-disciplinary workshops and the Society for Environmental Geochemistry and Health was established.

Following a Discussion Meeting on Environmental Geochemistry and Health organized by Professor Stanley Bowie and myself at the Royal Society in 1978, a Working Party was appointed by the Royal Society in 1980 to review the relative importance, progress and future potential of this subject in the United Kingdom. Their recently published report urgently recommends Government to recognise "the great economic importance of environmental geochemistry, both to plant and animal husbandry and for human welfare".

This volume edited by Iain Thornton is unique in that it is the first to bring together major contributions in nearly all the component parts of environmental geochemistry and pollution, which contribute to the knowledge of the quality of the environment in which we live. Although the main emphasis is placed on applied aspects, it is recognised that recent and future advances depend on a clearer understanding of fundamental principles and processes, the forms and species of elements in the environment and the complex interactions between chemical and biological components.

August, 1983

J.S.W.

Allen-Price, E. D. (1960). *The Lancet*, i, 1235–1238.

Contents

4 Soils and Plants and the Geochemical Environment
Joe Kubota

5 The Chemical Forms of Trace Metals in Soils
Garrison Sposito

6 Geochemistry and Water Quality
Ernest E. Angino

7 Microbial Mediation of Biogeochemical Cycling of Metals
Betty H. Olson

8 Geochemistry Applied to Agriculture
Iain Thornton

9 Geochemistry and Man: Health and Disease.
1. Essential Elements
Robert G. Crounse, Walter J. Pories, John T. Bray and Richard L. Mauger

10 Geochemistry and Man: Health and Disease.
2. Elements Possibly Essential, Those Toxic and Others
Robert G. Crounse, Walter J. Pories, John T. Bray and Richard L Mauger

11 Geomedicine in Scandinavia
J. Låg

12 Assessment of Metal Pollution in Soils
S. V. Mattigod and A. L Page

13 Assessment of Metal Pollution in Rivers and Estuaries
Ulrich Förstner

14 Heavy Metal Contamination from Base Metal Mining and Smelting: Implications for Man and His Environment
Brian E. Davies

15 Health Implications of Coal Development
Betsy T. Kagey and Bobby G. Wixson

16 Radioactivity in the Environment
S. H. U. Bowie and Jane Plant

1

Principles of Environmental Geochemistry

JANE A. PLANT and ROBERT RAISWELL

I. Introduction

The distribution of chemical elements over the earth's surface is not random but is controlled by physicochemical parameters that are increasingly well understood as a result of progress in Geochemistry. Geochemistry, in its broadest sense, is concerned with understanding the distribution of elements and their isotopes in the atmosphere, hydrosphere, crust, mantle and core of the earth. To man, the surface environment has dominant importance, and environmental geochemistry has developed rapidly over the past decade in response to the population "explosion" and economic growth, and to the associated problems of resource development and pollution. Much information on the processes controlling the distribution of elements in rocks and their dispersion and concentration in soil and water during weathering has been obtained, and systematic data on the levels of elements in the surface environment have also been accumulated by regional geochemical mapping. This information provides a basis for interdisciplinary studies in environmental geochemistry and health.

Environmental geochemistry is concerned with complex interactions in the system rock–water–air–life, that give rise to a wide range of chemical characteristics in the surface environment. This chapter is concerned mainly with interactions in the rock–water–soil system in humid temperate climates such as that of Britain; soil–(agricultural)–plant–animal and water–man interactions are considered in later chapters of this volume. Processes controlling the redistribution of chemical elements in the surface environment

APPLIED ENVIRONMENTAL GEOCHEMISTRY
ISBN 0-12-690640-8

are likely to differ significantly in other climatic regimes such as those of the arctic or tropics. Atmospheric geochemistry is beyond the scope of this chapter, although the importance of airborne contamination (Cawse, 1974, 1981; Oliver *et al.*, 1974) on the abundance of such trace elements as Pb and F and on major species such as sulphur dioxide, which may increase acid dissolution of trace elements, may be considerable.

In the first section of this chapter, information on the abundance and distribution of the elements in different types of bedrock is briefly summarized. This is followed by discussion of the redistribution of elements into soil and water systems during weathering of bedrock. Finally, examples are drawn from Britain to illustrate some of the more important variations in regional geochemistry that are of potential importance to health. Three groups of elements are considered. Firstly, the major elements Ca, Mg, Na, K and Fe, which are important not only to the health of crops, agriculture, animals and man, but are also important controls on the primary distribution, and secondary dispersion of trace elements; secondly, the trace elements that are essential to animal life and which, according to Underwood (1977), are the first-row transition elements—Mn, (Fe), Ni, Cu, V, Zn, Co, Cr—together with Mo, Sn, Se, I and F; and thirdly such elements as Pb, Cd, Hg, As that are potentially toxic to plants or animals and may have adverse physiological effects at relatively low levels. The naturally occurring radioelements U, Th and K are considered in Chapter 16 with particular reference to the decay series headed by the ^{238}U isotope which includes ^{226}Ra and ^{222}Ra gas and its short-lived daughters, which are of physiological significance.

Examples of areas in Britain where deficiencies or excesses of potentially toxic elements occur are drawn from the Webb *et al.* (1968) and the Institute of Geological Sciences Regional Geochemical atlas series in the case of Scotland (IGS, 1978a and b, 1979, 1981, 1982). The methods used in compiling the atlases—their development, advantages, limitations and applications—are discussed elsewhere (Webb and Howarth, 1979; Plant and Moore, 1979; Thornton and Plant, 1980; Howarth and Thornton, this volume).

II. The distribution of elements in rocks and some geochemical associations

1. Primary (igneous) rocks

Ninety-nine per cent of the earth's crust is made of eight elements (O, Si, Al, Fe, Ca, Na, K, Mg in order of abundance). These elements form a simple array of low-density minerals of which silicates and aluminosilicates are the dominant compounds (Table 1.1) making up more than 80% of the crust. Silicates formed at the highest temperatures and pressures are generally compounds of Fe, Mg and Ca and occur in basic rocks, whereas those formed at the lowest

Table 1.1 Common igneous rock forming minerals (after Levinson, 1974)

Oxides	SiO_2	Quartz
	Fe_3O_4	Magnetite
Feldspars	$NaAlSi_3O_8$	Albite
	$KAlSi_3O_8$	Orthoclase
	$CaAl_2Si_2O_8$	Anorthite
Pyroxenes	$CaMgSi_2O_6$	Diopside
	$MgSiO_3$	Enstatite
Olivines	Mg_2SiO_4	Forsterite
	Fe_2SiO_4	Fayalite
Micas	$KAl_2AlSi_3O_{10}(OH)_2$	Muscovite
	$KMg_3AlSi_3O_{10}(OH)_2$	Phlogopite
Amphiboles	$Mg_7Si_8O_{22}(OH)_2$	Anthophyllite
	$Ca_2Mg_5Si_8O_{22}(OH)_2$	Actinolite

temperatures and pressures are mostly compounds of Na, K, which with "pure" silica (quartz), form acid rocks such as granites. Incorporation of trace elements into the crystal lattices of silicates is controlled largely by their valency and ionic radii (Fig. 1.1), the similarity of these parameters to those of major ions controlling substitution. However, electronegativity, and, in the case of the first-row transition elements, crystal field stabilization energies are also important. Hence the first-row transition elements are mostly incorporated into Mg and Fe minerals in ultrabasic (Cr, Ni) or basic (Co, V) rocks. Pb^{2+} substitutes mostly for K^+, whereas Mo, F, U, Sn and W tend to be incompatible with sites in major rock-forming minerals and are enriched in highly evolved K granites, in accessory minerals or micas. The average abundancies of trace elements in the most common types of igneous rocks are shown in Table 1.2.

Igneous rock classification is based in part on the content of such major oxides as SiO_2, but calculated average abundance values provide only a general guide to the levels of trace elements in the different rock types. These vary in relation to such factors as chemical heterogeneity of the source region, which is frequently the mantle or lower crust; changes in the temperature, pressure and activity of volatiles in the source region; and fractional crystallization and contamination of the magma in the crust.

In some cases, during emplacement of igneous rocks, such as granite plutons or volcanic lava sequences, near to the surface of the earth, large-scale interaction with sea-, or groundwater occurs and the elements are dissolved out of primary silicate minerals and concentrated into hydrothermal ore deposits sometimes containing tens of thousands of tons of ore. Some

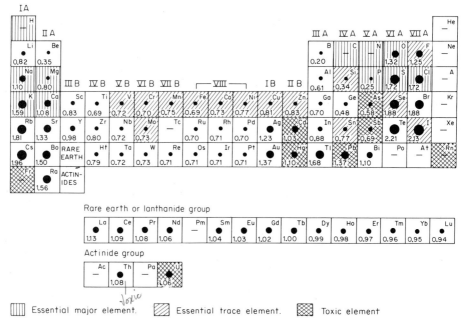

Fig. 1.1 Diagrammatic representation of the ionic radii of the elements (in Ångstrom units). Note (1) coordination numbers for all elements are VI, except for Be, B, Si, Ge and P which are IV; K, Tl, Ba, Sr, Pb and Ra which are VIII; and Rb and Cs which are XII. (2) the following valence states were used where there is a reasonable choice: 1+ for Tl; 2+ for Mn, Fe, Co, Ni, Cu, Hg and Pb; 3+ for V, Cr and B; 4+ for Sn, Mo, W and the platinum group; 5+ for Nb, Ta, P, As and Sb. (3) data for unstable elements, noble gases, H, C and N, not included.

associations of trace elements with granite-related mineralization and hydrothermal sulphide ores are shown in Table 1.2.

2. Sedimentary and metamorphic rocks

Igneous rocks, which are generated at high pressures and temperatures, are not in equilibrium with conditions at the earth's surface and so are eroded and chemically altered (see p. 10). The weathering products are transported and redeposited as sediments variably composed of fragments of the parent material, and/or secondary phases such as clay minerals, and iron and manganese oxides. In addition biochemical and chemical mineral precipitates may be formed such as limestone, dolomite, phosphate and coal. The major element chemistry of the main types of sediment is shown in Table 1.3, and the trace element concentrations of some of the main groups of sediments are

Table 1.2 Average abundance of some minor and trace elements in the earth's crust, rocks and soil (all values in ppm) (after Levinson, 1974)

Element	Earth's crust	Ultra basic	Basalt	Grano-diorite	Granite	Sandstone	Shale	Limestone	Soil
Ag	0.07	0.06	0.1	0.07	0.04	—	0.05	1	0.1
As	1.8	1	2	2	1.5	1	15	2.5	1.50
Au	0.004	0.005	0.004	0.004	0.004	—	0.004	0.005	—
B	10	5	5	20	15	35	100	10	2–10
Ba	425	2	250	500	600	35	700	100	100–3000
Be	2.8	—	0.5	2	5	—	3	1	6
Bi	0.17	0.02	0.15	—	0.1	—	0.18	—	—
Br	2.5	1	3.6	—	2.9	1	4	6.2	—
Cd	0.2	—	0.2	0.2	0.2	—	0.2	0.1	1
Cl	130	85	60	—	165	10	180	150	—
Co	25	150	50	10	1	0.3	20	4	1–40
Cr	100	2000	200	20	4	35	100	10	5–1000
Cs	3	—	1	2	5	—	5	—	6
Cu	55	10	100	30	10	—	50	15	2–100
F	625	100	400	—	735	270	740	330	—
Ga	15	1	12	18	18	12	20	0.06	15
Ge	1.5	1	1.5	1	1.5	0.8	1.5	0.1	1
Hg	0.08	—	0.08	0.08	0.08	0.03	0.5	0.05	0.03
I	0.5	0.5	0.5	—	0.5	1.7	2.2	1.2	—
Li	20	—	10	25	30	15	60	20	5–200
Mn	950	1300	2200	1200	500	—	850	1100	850
Mo	1.5	0.3	1	1	2	0.2	3	1	2
Ni	75	2000	150	20	0.5	2	70	12	5–500
Pb	12.5	0.1	5	15	20	7	20	8	2–200

—continued—

Table 1.2—*continued*

Element	Earth's crust	Ultra basic	Basalt	Grano-diorite	Granite	Sandstone	Shale	Limestone	Soil
Rb	90	—	30	120	150	60	140	5	20–500
Sb	0.2	0.1	0.2	0.2	0.2	—	1	—	5
Se	0.05	—	0.05	—	0.05	0.05	0.6	0.08	0.2
Sn	2	0.5	1	2	3	—	4	4	10
Sr	375	1	465	450	285	20	300	500	50–1000
Te	0.001	0.001	0.001	0.001	0.001	—	0.01	—	—
Th	10	0.003	2.2	10	17	1.7	12	2	13
Ti	5700	3000	9000	8000	2300	1500	4600	400	5000
Tl	0.45	0.05	0.1	0.5	0.75	0.82	0.3	—	0.1
U	2.7	0.001	0.6	3	4.8	0.45	4	2	1
V	135	50	250	100	20	20	130	15	20–500
W	1.5	0.5	1	2	2	1.6	2	0.5	—
Zn	70	50	100	60	40	16	100	25	20

Table 1.3 Major element geochemistry of sedimentary rocks (after Fyfe, 1974)

Rock type	Mineralogy	Chemistry
Sandstone	Quartz, feldspars	Dominated by SiO_2 ($+$ K, Na, Ca, Al)
Shale	Clay minerals, chlorites, carbonates	Al_2O_3–SiO_2–H_2O
Limestone	Calcite, dolomite	$CaCO_3$, $MgCO_3$
Chert	Quartz, haematite	SiO_2 ($+$ minor Fe_2O_3, MnO_2)
Phosphorite	Apatite	Calcium phosphate
Soil	Complex clay minerals, quartz, organic materials	Al_2O_3–SiO_2–H_2O
Laterite	Bauxite, haematite	Al_2O_3–Fe_2O_3–SiO_2
Evaporite	Halite, gypsum	NaCl, $CaSO_4$, $CaCO_3$

shown in Table 1.2. The relatively low levels of trace elements over arenaceous sediments such as unmineralized sandstones and the correspondingly high levels over shales—particularly those associated with organic detritus (black shales)—are of particular significance in environmental geochemistry, whereas the calcium carbonate content of sediments is important in determining pH in the surface weathering regime. Selected geochemical associations of minor and trace elements in volcanic and sedimentary rocks and hydrothermal sulphide ores are given in Table 1.4. Although such information provides general guidance on the levels of trace elements in different sedimentary lithologies, considerable variation may occur as a result of (a) changes in the chemistry of the source region, (b) physical and chemical conditions during weathering, transport and deposition, (c) diagenesis and (d), in the case of sandstones, the movement of groundwater which may produce such high concentrations of U, V, Mo and Se that ore deposits are formed (Table 1.4).

Reconstitution (metamorphism) of volcanic and sedimentary rocks occurs as a result of burial in tectonically active zones of the earth's crust sometimes to depths of 30 km; temperatures may exceed 600°C with pressure greater than 10 000 atmospheres. Most elements are thought not to be redistributed over large distances during metamorphism with the exception of H_2O, Cs, K, U, Th and Rb and possibly B, which are depleted at the highest temperatures and pressures and under conditions of high partial pressure of CO_2. Thus, in general, the chemical composition of metamorphic rocks reflects that of their sedimentary or igneous precursors. The behaviour of trace elements and

Table 1.4 Selected geochemical associations of elements (modified from Andrews-Jones, 1968, and other sources)

Rock type or occurrence	Association
1. Plutonic associations	
Ultrabasic rocks	Cr–Co–Ni–Cu–Fe–Mg–Ca
Basic rocks	Ti–V–Sc–Fe–Mn–Ca
Alkaline rocks	Ti–Nb–Ta–Zr–RE–F–P–U–K–Na
Carbonatites	RE–Ti–Nb–Ta–P–F–U–K–Na
Granite rocks	Ba–Li–W–Mo–Sn–Zr–Hf–U–Th–Ti–F–K–Na
Pegmatites	Li–Rb–Cs–Be–RE–Nb–Ta–U–Th–Zr–Hf–Sc–F–K
2. Granite-related mineralization	
Scheelite–cassiterite deposits	W–Sn–Mo–F
Fluorite–helvite deposits	Be–F–B
3. Hydrothermal sulphide ores	
General associations	Cu–Pb–Zn–Mo–Au–Ag–As–Hg–Sb–Se–Te–Co–Ni–U–V–Bi–Cd
Porphyry copper deposits	Cu–Mo–Re
Complex sulphides	Hg–As–Sb–Se–Ag–Zn–Cd–Pb
Low-temperature sulphides	Bi–Sb–As
Base metal deposits	Pb–Zn–Cd–Ba
Precious metals	Au–Ag–Cu–Co–As
Precious metals	Au–Ag–Te–Hg
Associated with basic rocks	Ni–Cu–Pt–Co
4. Sedimentary associations	
Black shales	U–Cu–Pb–Zn–Cd–Ag–Au–V–Mo–Ni–As–Bi–Sb
Phosphorites	U–V–Mo–Ni–Ag–Pb–F–RE
Evaporites	Li–Rb–Cs–Sr–Br–I–B–K–Na
Laterites	Ni–Cr–V
Manganese oxides	Co–Ni–Mo–Zn–W–As–Ba–V
Placers and sands	Au–Pt–Sn–Nb–Ta–Zr–Hf–Th–RE
Red beds, continental (mineralized)	U–V–Se–As–Mo–Pb–Cu
Red beds, volcanic origin	Cu–Pb–Zn–Ag–V–Se
Proxites	Nb–Ti–Ga–Re
5. Elements with similar geochemistry	K–Rb; Rb–Cs; Al–Ga; Si–Ge; Zr–Hf; Nb–Ta; RE; S–Se; Br–I; Zn–Cd; Rb–Tl; Pt–Pd–Rh–Ru–Os–Ir

constraints on their redistribution during metamorphism are only poorly understood, however; and the average abundance of chemical elements in metamorphic assemblages is not well documented.

III. Redistribution of chemical elements by weathering

The redistribution of elements from bedrock into the surface environment occurs as a result of physical and chemical weathering which transforms rock which is hard, frequently non-porous and of low reactivity, to soil which is soft, porous and chemically active. Physical weathering breaks the rock into smaller particles, thereby increasing the surface area which is exposed to air and water, which are the main agents of chemical weathering.

During chemical weathering, primary minerals, which have been formed at high temperatures and pressures mostly in the absence of air and/or water, are changed into phases that are stable under surface conditions characterized by lower temperatures and pressures and the presence of air and water. The redistribution of elements involves interactions between bedrock and water containing dissolved gases with replacement of bedrock by particulate and colloidal products, having physical properties which are intermediate between bedrock and water, together with fragments of minerals and rocks which are resistant to weathering, and solutions (Fig. 1.2).

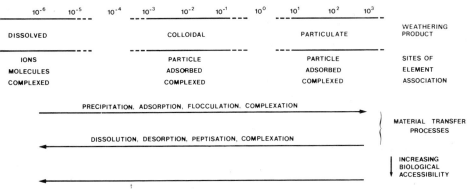

Fig. 1.2 Weathering products, sites of element association, and biological accessibility.

Table 1.5 Mean composition of rainwater and river water (from Garrels and Mackenzie, 1971). TDS = Total dissolved solids

	Rainwater (m mol l^{-1} except TDS)	River water (m mol l^{-1} except TDS)
Cl	0.107	0.22
Na^+	0.086	0.27
Mg^{2+}	0.011	0.17
SO_4^{2-}	0.006	0.12
K^+	0.008	0.06
Ca^{2+}	0.002	0.38
HCO_3^-	0.002	0.96
TDS (in mg l^{-1})	7.13	130
Ionic strength	0.0001	0.002

1. Chemical weathering

The redistribution of elements in the surface environment is initiated by interactions between rainwater and bedrock. Rainwater contains low concentrations of dissolved solids (Table 1.5), which are mainly derived from the evaporation of seawater, together with small amounts of atmospheric gases.

A comparison between the average composition of rainwater and river water (Table 1.5) shows that the latter contains a higher concentration of total dissolved solids (TDS) and different proportions of major elements—changes that result from such chemical weathering processes as dissolution, oxidation, hydrolysis and acid hydrolysis. These processes involve the following types of reactions (Raiswell et al., 1980).

(a) Dissolution

Dissolution is the simplest process and involves the solution of soluble minerals, independently of pH. Water, because of its polar nature, is most effective in dissolving solids with ionic bonding, such as NaCl:

$$NaCl(s) \overset{H_2O}{\rightleftharpoons} Na^+(aq) + Cl^-(aq) \qquad (1.1)$$
$$\text{Halite}$$

(The letters in parentheses that denote the nature of materials involved in the equations are: (s), solid; (l), liquid; (aq), aqueous or dissolved; (g), gas.)

(b) Oxidation

Free oxygen is important in the breakdown of rocks that contain such reduced substances as Fe^{2+}, S and trace elements of the first-row transition series, such

as Mn^{2+}. The oxidation of reduced metals results in the formation of colloidal oxides or hydroxides. For example, the iron silicate mineral fayalite reacts with oxygen and water to give iron hydroxide and silicic acid:

$$Fe_2SiO_4(s) + \tfrac{1}{2}O_2(g) + 5H_2O(l) \rightarrow 2Fe(OH)_3(s) + H_4SiO_4(aq)$$

Fe(II) Fe(III)

Fayalite Iron hydroxide Silicic acid

$$(1.2)$$

The oxidation of sulphides such as pyrite (FeS_2) produces sulphate and hydrogen ions:

$$FeS_2(s) + \tfrac{15}{4}O_2(g) + \tfrac{7}{2}H_2O(l) \rightarrow$$

Fe(II)

Pyrite $Fe(OH)_3(s) + 2SO_4^{2-}(aq) + 4H^+(aq)$ (1.3)

Fe(III)

Iron hydroxide

In areas of metalliferous mineralization and spoil heaps from mineral workings, oxidation of sulphide ore minerals may generate acid waters with a pH <4.

(c) Hydrolysis

Hydrolysis is a similar process to dissolution, except that the water reacts chemically with the dissolved ions. The reaction of the igneous silicate mineral forsterite (Mg_2SiO_4) and the sedimentary carbonate mineral calcite ($CaCO_3$) with water are examples:

$$Mg_2SiO_4(s) + 4H_2O(l) \rightleftharpoons 2Mg^{2+}(aq) + 4OH^-(aq) + H_4SiO_4(aq)$$

Forsterite Silicic acid

$$(1.4)$$

$$CaCO_3(s) + 2H_2O(l) \rightarrow Ca^{2+}(aq) + 2OH^-(aq) + H_2CO_3(aq)$$

Calcite Carbonic acid

$$(1.5)$$

Both reactions produce weak acids (H_4SiO_4 and H_2CO_3) which are only poorly dissociated in most surface environments. Thus, since calcium and magnesium hydroxides are strong, well dissociated alkalis, the solutions produced are alkaline (pH >7), the cations of the mineral being replaced by hydrogen ions ($Mg_2SiO_4 \rightarrow H_4SiO_4$, $CaCO_3 \rightarrow H_2CO_3$) derived from the dissociation of water, which leaves residual OH^- ions in solution:

$$H_2O(l) \rightarrow H^+(aq) + OH^-(aq)$$

Consumed in Residual anion

hydrolysis in solution

Most silicates, oxide/hydroxide and carbonate minerals which are the major constituents of rocks at the earth's surface thus yield a weak acid and a relatively strong alkali on hydrolysis.

(d) *Acid hydrolysis*

Acid hydrolysis is a similar process to hydrolysis, except that the water contains hydrogen ions from dissolved acids which make it more effective in chemical weathering. The most important sources of acidity in the environment are from the dissociation of water (which supplies a maximum of 10^{-7} mol l^{-1} H^+), the dissolution of CO_2, sulphide oxidation and organic acids. Carbon dioxide dissociates in water to bicarbonate and carbonate ions, thereby supplying hydrogen ions for chemical weathering according to Eqn 1.6):

$$CO_2(g) + H_2O(l) \rightleftharpoons H_2CO_3(aq) \rightleftharpoons H^+(aq) + HCO_3^-(aq)$$
$$\rightleftharpoons 2H^+(aq) + CO_3^{2-}(aq) \tag{1.6}$$

Analyses of surface water frequently show that HCO_3^- is the most abundant anion indicating that the reaction of CO_2 with H_2O is the most important source of H^+ consumed in the weathering.

The CO_2 may be derived from the atmosphere or from soils in which organic matter is being oxidized, and in areas of well-drained agricultural soils biogenic sources of CO_2 may be 1 to 2 orders of magnitude greater than those of the atmosphere, thereby producing an accelerated rate of weathering. In areas of mineralization, sulphide oxidation may be the major source of H^+ ions, whereas in areas of poorly drained acid and peaty soils organic acids will be of greater significance. The organic fraction of soil contains a variety of compounds with acidic groups. The high molecular weight fulvic and humic acids are only weakly acidic and may be considered as undissociated, their principal role being to complex metal cations (p. 23). Only the relatively small proportion of carboxylic acids contribute significant numbers of hydrogen ions by dissociating to a hydrogen ion and a residual carboxylate anion:

$$R—COOH(aq) \rightleftharpoons RCOO^-(aq) + H^+(aq)$$

Thus the effect of water–rock weathering reactions is to produce waters with increasingly large concentrations of dissolved solids, with variations in anionic composition determined mostly by the sources of hydrogen ions whilst variations in cationic composition are determined solely by availability in soil and bedrock.

2. Influence of bedrock on weathering

The resistance of minerals to weathering depends partly on their mineralogy and partly on their chemistry. For example, low temperature iron magnesium silicates, such as hornblende, are generally more stable during weathering than high temperature phases, such as olivine. Most minerals are soluble to some degree in surface conditions. Some, such as calcite, dissolve readily, whereas others, including the most abundant aluminosilicates, are only partially soluble and interact with water to produce dissolved and solid phases. For example, potassium feldspar breaks down in water to give a solution containing potassium and silica, and a clay mineral (kaolinite):

$$2KAlSi_3O_8(s) + 9H_2O(l) + 2H^+ \rightleftharpoons Al_2Si_2O_5(OH)_4(s) + 2K^+(aq)$$

Potassium feldspar Kaolinite

$$+ 4H_4SiO_4(aq) \qquad (1.7)$$

Silicic acid

{ K-spar

This acid hydrolysis reaction is the mechanism by which most major elements (Na^+, K^+, Mg^{2+}, Ca^{2+}) are released from silicate minerals.

The incomplete dissolution of aluminosilicates arises from differences in the behaviour of the component ions in water; that is, whether water molecules are more strongly attracted to each other (in which case the ion will be precipitated) or to the ion (when the ion will be hydrated). The strength of the ion–water attractive force varies directly with the electronic charge Z and inversely with the ionic radius r; the parameter Z/r is known as the ionic potential. *{ ionic potential*

A plot of ionic radius against charge is shown in Fig. 1.3, and three main groups of ions can be distinguished: strong cations with an ionic potential <3; strong complex anions with an ionic potential >12; and ions with an ionic potential between 3 and 12, which are precipitated as hydroxides and are relatively immobile in the surface environment. Aluminosilicates contain two elements, Al and Si, which tend to form insoluble hydrolysates, although the behaviour of Si is marginal and it may form the soluble H_4SiO_4 complex. Many aluminosilicates break down to form a dissolved phase (containing mainly cations and some H_4SiO_4), and a clay mineral in which the Al/Si ratio is increased. The dissolved phase contains little Al.

Thus surface waters in areas of calcareous rocks—particularly sediments— contain more dissolved solids and are mainly Ca^{2+}–HCO_3^- waters with a higher pH (partly because of the greater solubility of such rocks and hence the increased H^+ consumption) and are termed hard waters. In contrast, waters on igneous and metamorphic rocks contain lower quantities of dissolved solids, have a lower pH and contain different proportions of cations depending on bedrock chemistry and mineralogy. These waters are termed soft. The main properties of hard and soft waters are given in Table 1.6.

IONIC POTENTIALS

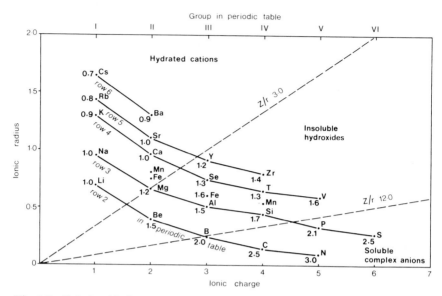

Fig. 1.3 Relationship between ionic charge and ionic radius. Lines connect elements in the same row of the periodic table. Values of the ionic potential Z/r distinguish elements that behave as hydrated cations, insoluble hydroxides and soluble complex ions.

Table 1.6 The chemical properties of hard and soft water (from Raiswell *et al.*, 1980)

Property	Soft waters	Hard waters
TDS	Low	High
pH	6–8	7–9
Cations	Na^+, K^+, Mg^{2+}, etc.	Ca^{2+}, Mg^{2+}
Anions	HCO_3^-, H_4SiO_4	HCO_3^-
Weathered solids	Clay minerals	None

IV. Redistribution of chemical elements in the surface environment

In this section the main types of weathering product (dissolved, colloidal and particulate) and the processes which control the redistribution of elements into sites in these secondary phases are considered. These are summarized in Fig. 1.2. The discussion is simplified by considering the different processes to be predominantly associated with a particular phase. For example, complexing is discussed mainly in the section on colloids and particles, although it is also an important process in solutions.

1. Rock and mineral particles

Elements bound in resistate minerals are not chemically available and are therefore unlikely to be of significance to health in the natural environment. Particles of minerals of fibrous habit such as the asbestiform hornblendes may be associated with a dust-related disease because of their physical properties, however (Elmes, 1980).

2. Solutions

Elements found in solution are present mainly as ions (electrolyte solution) and neutral molecules (non-electrolytes) of organic or inorganic compounds. The extent to which material dissolves in electrolyte form depends on the degree of ionic bonding. The only covalent compounds with a degree of water solubility are those with such functional groups as OH^- and F^- that exert intermolecular forces comparable in strength with those between water molecules. In the case of organic compounds there is also a size effect, and solubility generally decreases as molecular size increases. The percentage ionic character of bonds between several chemical elements and oxygen are given in Table 1.7. The major elements (Na, Mg, K) that have an ionic potential < 3 and the elements with an ionic potential > 12 which form complex anions (e.g., N, P, S), all show a high degree of ionic bonding and thus occur predominantly in solution.

The chemical behaviour of dissolved species is determined by the effective concentration (or activity) of their ions. The activity of an ion is generally less than its total concentration because of interactions that occur between oppositely charged ions. These effects are most pronounced in concentrated solutions and can often be ignored in freshwaters, which are dilute. For example, interactions between ions cause the activity of Ca^{2+} and Mg^{2+} ions to be only 3% less than their total concentrations, in average river water.

Table 1.7 Selected elements and the percentage ionic character of their bonds with oxygen

Element	% Ionic character	Element	% Ionic character
Aluminium (Al)	60	Magnesium (Mg)	71
Barium (Ba)	84	Manganese (Mn)	72
Calcium (Ca)	79	Potassium (K)	87
Carbon (C)	23	Silicon (Si)	48
Iron (Fe^{2+})	54	Sodium (Na)	83
Iron (Fe^{3+})	69	Strontium (Sr)	82

Neutral molecules in solution do not have electrostatic interactions to the same extent and activity can be assumed to be equal to concentration.

The redistribution of elements amongst the different weathering products is to a great extent determined by solution composition, with E_h and pH being of particular importance in mineral dissolution and precipitation.

3. E_h and pH

The E_h or redox potential of a solution is a measure of its oxidizing capacity (ability to accept electrons from a reducing agent) or its reducing capacity (ability to supply electrons to an oxidizing agent). It is particularly important in reactions involving S, and such transition elements as Fe and Mn that exist in different oxidation states in the normal range of surface conditions. In many surface environments E_h is mainly a function of the supply of gaseous or dissolved oxygen in relation to the amount of organic matter to be oxidized, although in any natural system there may be several species that may act as oxidizing (NO_3^-, SO_4^{2-}) or reducing (Fe^{2+}, Mn^{2+}) agents. If the supply of organic matter exceeds that of oxygen then reducing conditions occur, as in the case of poorly drained acid soils and peat bogs. In contrast, in areas underlain by porous sediments oxidizing conditions may persist to considerable depth due to downward percolation of oxygen-bearing groundwaters (Fig. 1.4).

By convention, positive values of E_h indicate oxidizing conditions and negative values reducing conditions.

The reaction:

$$2H^+(aq) + 2e \rightarrow H_2(g)$$

is arbitrarily given a potential of 0 volts at 25°C and 1 atmosphere for a solution containing hydrogen ions at unit activity (approximately 1 molar H^+). The potentials of other electrode reactions measured relative to the above reactions are known as standard electrode potentials which are designated as $E°$. The stability of a particular oxidation state of an element depends on the energy change involved in adding or removing electrons; the relative position of electrode reactions (Table 1.8) determines the ease with which oxidation or reduction occurs. The reduced form of any electrode reaction will reduce the oxidized form below it in the table.

The pH of a solution, which is a measure of the H^+ ion content, is important in controlling mineral dissolution and precipitation reactions of the major anionic species of the earth's crust (in addition, pH also affects such processes as ion exchange and complexing). These are given in Table 1.9 in order of abundance, excluding sulphates and chlorides which do not undergo protonation reactions in the normal range of pH in the surface environment.

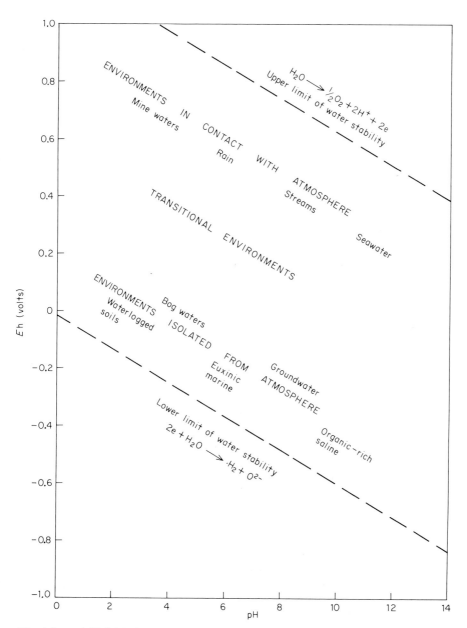

Fig. 1.4 E_h/pH fields for some common natural environments (after Garrels and Christ, 1965).

Table 1.8 Some standard electrode potentials

Reaction	Electrode potential E (volts)
$K \rightarrow K^+ + e$	-2.92
$Ca \rightarrow Ca^{2+} + 2e$	-2.87
$Na \rightarrow Na^+ + e$	-2.71
$Mg \rightarrow Mg^{2+} + 2e$	-2.36
$Mn \rightarrow Mn^{2+} + 2e$	-1.18
$Zn \rightarrow Zn^{2+} + 2e$	-0.76
$S^{2-} \rightarrow S + 2e$	-0.48
$Fe \rightarrow Fe^{2+} + 2e$	-0.41
$Fe \rightarrow Fe^{3+} + 3e$	-0.02
$Cu \rightarrow Cu^{2+} + 2e$	$+0.35$
$Cu \rightarrow Cu^+ + e$	$+0.52$
$^1I^- \rightarrow \frac{1}{2}I_2 + e$	$+0.54$
$Mn^{2+} + 2H_2O \rightarrow MnO_2 + 4H^+ + 3e$	$+1.23$
$Cl^- \rightarrow \frac{1}{2}Cl_2 + e$	$+1.36$
$Pb^{2+} + 2H_2O \rightarrow PbO_2 + 4H^+ + 2e$	$+1.46$

Table 1.9 The major anionic species in crustal materials in order of abundance and excluding chlorides and sulphates. Dissolution/precipitation reactions of minerals bearing these anions are influenced by pH

Silicates	$Mg_2SiO_4(s) + 4H^+(aq) \rightarrow 2Mg^{2+}(aq) + H_4SiO_4(aq)$ $2KAlSi_3O_8(s) + 2H^+(aq) + 9H_2O(l) \rightarrow$ $\qquad Al_2Si_2O_5(OH)_4(s) + 2K^+(aq) + 4H_4SiO_4(aq)$
Oxides/hydroxides	$Al_2O_3(s) + 6H^+(aq) \rightarrow 2Al^{3+}(aq) + 3H_2O(l)$ $Fe(OH)_3(s) + 3H^+(aq) \rightarrow Fe^{3+}(aq) + 3H_2O(l)$
Carbonates	$CaCO_3(s) + H^+(aq) \rightarrow Ca^{2+}(aq) + HCO_3^-(aq)$
Sulphides	$FeS(s) + 2H^+(aq) \rightarrow Fe^{2+}(aq) + H_2S(g)$

The chemistry of many elements in the surface environments may be represented in diagrams that have E_h and pH as axes and that are standardized for temperature, pressure and activity (effective concentration) of major dissolved species. The techniques involved in construction of such diagrams are described in detail by Garrels and Christ (1965), and are beyond the scope of the present text. The application of such diagrams is illustrated by reference to the E_h–pH relationships in the iron system (Fig. 1.5).

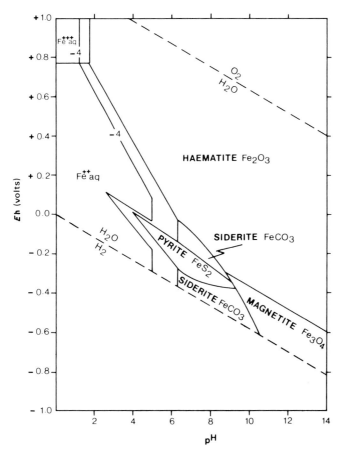

Fig. 1.5 E_h/pH stability relationships between iron oxides, sulphides and carbonates in water at 25°C and 1 atmosphere total pressure. Total dissolved sulphur = $10^{-6}\,\mathrm{mol\,l^{-1}}$, total dissolved carbonate = $10^{0}\,\mathrm{mol\,l^{-1}}$. Solid lines show boundaries plotted for concentrations (strictly activities) of dissolved species at $10^{-6}\,\mathrm{mol\,l^{-1}}$, fainter lines show boundaries at $10^{-4}\,\mathrm{mol\,l^{-1}}$ (after Garrels and Christ, 1965).

Four types of reaction can be identified:

(i) Reactions dependent on pH, for example the precipitation of aqueous ferric ions as ferric oxide or haematite:

$$2Fe^{3+}(aq) + 3H_2O(l) \rightarrow Fe_2O_3(s) + 6H^+(aq) \qquad (1.8)$$

$$ferric $$ Haematite

(ii) Reactions dependent on E_h, for example the oxidation of aqueous ferrous ions to ferric ions:

$$Fe^{2+}(aq) \rightarrow Fe^{3+}(aq) + e \qquad (1.9)$$

ferrous $$ferric

(iii) Reactions dependent on both E_h and pH, for example the oxidation of aqueous ferrous ions and their precipitation as ferric oxide:

$$2Fe^{2+}(aq) + 3H_2O(l) \rightarrow Fe_2O_3(s) + 6H^+(aq) + 2e \quad (1.10)$$

Haematite

(iv) Reactions dependent on the concentrations of anionic species, and on E_h and/or pH, for example the precipitation of ferrous ions as siderite (ferrous carbonate). Diagrams must be plotted for specified anion concentrations or activities:

$$Fe^{2+}(aq) + CO_2(g) + H_2O(l) \rightarrow FeCO_3(s) + 2H^+(aq) \quad (1.11)$$

Siderite

This reaction is dependent on both pH and CO_2 concentrations and the total activity of the carbonate species are given in Fig. 1.5, by expressing the total dissolved carbonate ($H_2CO_3 + HCO_3^- + CO_3^{2-}$) as 1 molar. Values for the partial pressure of CO_2 and total dissolved carbonate are related through the pH-dependent carbonate equilibria.

The E_h/pH diagram for iron thus provides a useful summary of the dissolution and precipitation reactions of the element in the environment (Fig. 1.5). Under acid conditions iron is stable as Fe^{2+} and Fe^{3+}, with the latter favoured by more oxidizing conditions. Mineral precipitation is primarily induced by increasing pH, although the Fe^{2+}/Fe_2O_3 boundary can be crossed by changes in E_h at constant pH. The stability fields of the ferrous minerals pyrite, siderite and magnetite, which are stable under conditions of negative E_h, depend principally on the concentrations of total dissolved carbonate and S. Pyrite forms even when the concentration of total dissolved S is low, but siderite has only a small stability field, although the concentration of total dissolved carbonate is six orders of magnitude larger, reflecting the much lower solubility product of FeS_2 compared with $FeCO_3$.

Although E_h/pH diagrams are of value in summarizing the environmental conditions that cause dissolution and precipitation of element species, they should nevertheless be used with caution, since in many natural situations the controls on redox states and on dissolution–precipitation reactions generally are kinetic rather than equilibrium factors. For example, E_h/pH conditions may indicate that Fe^{2+} is the stable species, although solid Fe_2O_3 may persist indefinitely if the rate of dissolution is slow. Similarly Fig. 1.5 indicates that pyrite should be unstable in oxidizing conditions, for example in contact with the atmosphere, but oxidation is very slow in the absence of moisture. Apart from kinetic effects, the assumptions used in construction of E_h/pH diagrams may not be valid; the thermodynamic data on which they depend often refer to pure substances, whereas many minerals have non-stoichiometric and/or variable compositions.

Finally, the diagrams are valid only for particular conditions of temperature and pressure (i.e., $25°C$, 1 atmosphere) and specified anion concentrations, and any variations, particularly in anionic composition, may affect predicted stability relationships. Table 1.10 summarizes the influence of E_h and pH on the solubility and mobility of a range of chemical elements.

The assumption that simple mineral–solution equilibria predominate is reasonable for the major elements in the surface environment. The behaviour of many trace elements is more complex, however, and is also determined by coprecipitation and surface effects and interactions with organic phases. These effects are considered below.

4. Colloids and particles of secondary phases

In natural waters both organic and inorganic compounds may occur as colloids that comprise very small particles of $1–10^{-4}$ μm in size.

The formation (peptization) and flocculation of colloids has been intensively studied because of the role of colloids in transporting large quantities of metals in solutions for which true solubility would otherwise be low. Some colloids are exceptionally stable and such particles may remain in suspension indefinitely. The most important property of colloids is their surface charge which affects their interactions with dissolved ions. Moreover, the surface area of colloids is very large in relation to their volume, and surface properties such as charge are therefore of greater significance than is the case for coarser particles.

The precise reasons for variation in the nature and magnitude of charges on different colloids and particles are not fully understood. In the case of clay minerals, the charge may be related to the isomorphous substitution of Al^{3+} for Si^{4+}, or of Mg^{2+} or Fe^{2+} for Al^{3+} which leaves an excess negative charge. In silica and oxide colloids generally, the surface charge arises initially because of broken bonds at the edge of particles which, depending on the pH of the solution causes quantities of H^+ ions to be absorbed. Some of the most important colloids with their typical charges are shown in Table 1.11. Sulphide and organic colloids generally have negative charges, whereas oxide and hydroxide colloids (with the important exceptions of silica and manganese) are positively charged. In natural situations, however, the surface behaviour of colloids and particles may be determined more by surface coatings than by the mineralogy of the particle; for example, organic material coating iron oxide particles may give an overall negative rather than a positive charge.

The process of ion exchange is important in the transport and redistribution of elements. Ions are held on colloids by electrostatic forces that range from weak to strong depending on the surface charge characteristics of the colloid

Table 1.10 Relative mobilities of major and trace elements as a function of E_h and pH

Relative mobilities	Environmental conditions			
	Oxidizing	Acid	Neutral to alkaline	Reducing
Very high	Cl, I, Br S, B	Cl, I, Br S, B	Cl, I, Br S, B Mo, V, U, Se, Re	Cl, I, Br
High	Mo, V, U, Se, Re Ca, Na, Mg, F, Sr, Ra Zn	Mo, V, U, Se Ca, Na, Mg, F, Sr, Ra Zn Cu, Co, Ni, Hg, Ag, Au	Ca, Na, Mg, F, Sr, Ra	Ca, Na, Mg, F, Sr, Ra
Medium	Cu, Co, Ni, Hg, Ag, Au As, Cd	As, Cd	As, Cd	
Low	Si, P, K Pb, Li, Rb, Ba, Se Bi, Sb, Ge, Cs, Tl	Si, P, K Pb, Li, Rb, Ba, Be Bi, Sb, Ge, Cs, Tl	Si, P, K Pb, Li, Rb, Ba, Be Bi, Sb, Ge, Cs, Tl	Si, P, K
Very low to immobile	Fe, Mn Al, Ti, Sn, Te, W Nb, Ta, Pt, Cr, Zr Th, Rare earths	Al, Ti, Sn Nb, Ta, Pt, Cr, Zr Th, Rare earths	Al, Ti, Sn, Te, W Nb, Ta, Pt, Cr, Zr Th, Rare earths Zn Cu, Co, Ni, Hg, Ag, Au	Al, Ti, Sn, Te, W Nb, Ta, Pt, Cr, Zr Th, Rare earths S, B Mo, V, U, Se, Re Zn Co, Cu, Ni, Hg, Ag, Au As, Cd Pb, Li, Rb, Ba, Be Bi, Sb, Ge, Cs, Tl

Table 1.11 Charge characteristics of some naturally occurring colloids

Hydroxides and hydrated oxides	
Silica	−
Aluminium hydroxide	+
Ferric hydroxide	Usually +; may be −
Manganese dioxide	−
Titanium dioxide	+
Zirconium dioxide	+
Thorium dioxide	+
Sulphides	−
Carbonates	Usually +
Organic colloids	−

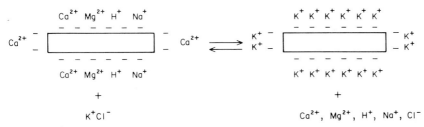

Fig. 1.6 Ion exchange equilibria on the surface of a clay particle. Addition of potassium ions to the soil water displaces the exchange equilibrium to the right. Removal of potassium ions from solution displaces the equilibrium to the left.

and the ion. In general, however, the attachment of adsorbed ions is sufficiently weak to enable them to be replaced easily by other ions (Fig. 1.6). Typical ranges of the cation exchange capacity of clay minerals and the mean ratio of cation to anion exchange capacity are shown in Table 1.12. The quantities of adsorbed ions generally reflect their abundance in solution. Divalent ions are generally held more strongly than univalent ions. However, for ions of equal charge the affinity for the exchanger increases with decreasing hydrated ion radius. For the alkaline earth elements the sequence of increasing ease of replacement is Ba > Sr > Ca > Mg, and for the alkalis, Cs > Rb > K > Na > Li. Studies of elements of higher ionic potential are complicated by their tendency to occur as complex species in solution.

H^+ ions which control pH also participate in ion exchange reactions, and clay minerals generally buffer pH changes in the soil–water system. Thus under conditions of low pH, soil systems display a reduced exchange capacity for metal ions because H^+ ions are not easily displaced.

Another important process by which elements become fixed on colloids and particles is complexation, whereby one or more central atoms or ions (usually

Table 1.12 Typical range of cation exchange capacities and relative proportions of cation:anion exchange capacity in common clay minerals

Clay mineral	Range of cation exchange capacity, me/100 g	Cation exchange capacity:anion exchange capacity
Kaolinite	3–15	0.5
Illite	10–40	2.3
Montmorillionite	80–150	6.7

Fig. 1.7 The formation of co-ordinate bonds in the complex $(Cu(NH_3)_4)^{2+}$ by the sharing of lone pairs of electrons between the nitrogen atom of NH_3 molecule and the Cu^{2+} ion.

metals) are attached to several ligands (ions or molecules). Bonds are formed by sharing a pair of electrons donated by the ligand (Fig. 1.7); the charge on the complex depends on the sum of the charges of the central metal atom and the ligands. In general, there is a correlation between the ionic potential of a metal ion and its ability to form complexes. Cations of high charge and small size such as the $+2$ and $+3$ transition metal ions form many stable complexes, whereas such large alkali metal ions as K^+ are poor complex formers. The electronic structure of the metal ion is also important. The co-ordination number and geometry of some complex ions is given in Table 1.13.

Ligands are generally molecules containing atoms of electronegative elements with an unshared pair of electrons (C, H, O, S, F, Cl, Br and I). Molecules containing more than one atom capable of donating a pair of electrons are known as chelating agents and include many natural organic compounds that are important in life processes. (For example, in chlorophyll, the central atom is Mg, in vitamin B12 it is Co, and in haemoglobin it is Fe.) In natural systems both solid and aqueous complexes are common and complexes share the same range of solubility and stability as ionic and covalent compounds. In soft water from areas of crystalline bedrock and in soils generally, organic complexes (mostly as colloids) are likely to be of

Table 1.13 Co-ordination number and geometry of some complex ions

Co-ordination No.	Geometry	Examples
2	Linear	Cu^+, Ag^+, Au^+
4	Square planar	Cu^{2+}, Ni^{2+}, Pt^{2+}, Pd^{2+}
4	Tetrahedral	Al^{3+}, Ni^{2+}, Co^{2+}, Zn^{2+}, Cd^{2+}
6	Octahedral	Al^{3+}, Cr^{3+}, Fe^{2+}, Fe^{3+}, Co^{2+}
		Co^{3+}, Ni^{2+}, Cu^{2+}, Zn^{2+}, Cd^{2+}, Pt^{4+}

overwhelming importance in binding metals, particularly those of the first row transition series. The organic complexes consist mainly of a complicated poorly defined group of humic compounds which comprise fulvic and humic acids and an insoluble humin fraction (Table 1.14). Fulvic and humic acids are by convention the fraction soluble in sodium hydroxide solution, the low molecular weight fulvic acids not precipitating at pH 2. These substances have the capacity to complex considerable quantities of metal ions; for example, some metals such as U are enriched in peat in a concentration 10 000 times that of water.

V. Regional geochemistry of Britain

In this section some aspects of environmental geochemistry of potential importance to health are considered with particular reference to Britain. Britain has particular advantages for such investigations because of its wide range of bedrock, types of metalliferous mineralization and surface conditions. Moreover, systematic geochemical data are available at 1:250 000 scale for Scotland and parts of northern England (IGS, 1978a,b, 1979, 1980, 1981) and at 1:2M for England and Wales (Webb *et al.*, 1978) (see Chapter 2).

Britain can be conveniently divided into three physiographic/geological regions (Fig. 1.8):

(1) The Precambrian crystalline basement rocks of northern Scotland.

(2) The Palaeozoic shale/greywacke sequences containing granite intrusions of southern Scotland, the Lake District, Wales and southwest England; these areas are associated with most of the important metallogenic provinces in Britain.

(3) The Devonian–Tertiary sedimentary cover succession of England and South Wales.

Table 1.14 Physical and chemical properties of humic and fulvic acids (from Snoeyink and Jenkins, 1980)

Property	Humid acids	Fulvic acids
Elemental composition (% by weight)		
C	50–60	40–50
H	4–6	4–6
O	30–35	44–50
N	2–4	<1–3
S	1–2	0–2
Solubility in strong acid (pH 1)	Not soluble	Soluble
Molecular weight range	Few 100–several million	180–10 000
Functional group distribution	Percent of oxygen in indicated functional group	
carboxyl —COOH	14–45	58–65
phenol —⬡—OH	10–38	9–19
alcohol —C—OH	13–15	11–16
carbonyl —C=O	4–23	4–11
methoxyl —O—CH$_3$	1–5	1–2

1. General features of the surface environment

Regions 1 and 2 are upland areas to the north and west of Britain where rainfall is high and impervious crystalline rocks give rise to rapid rates of run-off (IGS, 1977). Water–rock contact times are low, and are associated with low concentrations of the major cations and anions in water reflected by exceptionally low conductivity values (IGS, 1978, 1980, 1981). Concentrations of H^+ ions generally exceed Ca^{2+} ions and surface conditions are predominantly acid with large areas of peat bogs and/or acid soils. The acidity may be further increased by air masses containing acid gases (for example, SO_2) from industrial areas. In these surface waters, increased levels of heavy metals can be mobilized (Table 1.10) as a result of enhanced acidity and the presence of colloidal and dissolved organic substances, capable of adsorption and complexation. Moreover, soft water containing organic acids may dissolve quantities of heavy metals from unplasticized PVC or metal water-

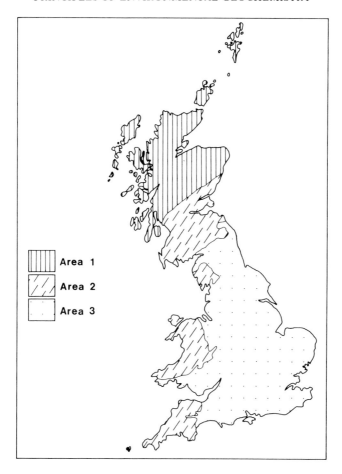

Area 1: Precambrian crystalline basement rocks of northern Scotland

Area 2: Palaeozoic shale/greywacke containing granites

Area 3: Devonian-Tertiary sedimentary cover

Fig. 1.8 The three physiographic/geological regions of Britain.

distribution systems, producing high levels of heavy metals in drinking water. (The increased concentrations of heavy metals in soft water should be considered in addition to the low levels of major ions such as Mg in determining the importance of the water hardness factor in epidemiology.) These environments are generally deficient in the major cations and anions, including the nutrient phosphate ion, although some adsorption (and

accumulation) may occur on clay and soil particles in river valleys. In such acid reducing conditions, Fe and Mn are soluble, but precipitation near to the soil surface (in iron pans) and in streams in equilibrium with atmospheric oxygen results in the formation of insoluble, hydrous manganic and ferric oxides. The ability of these oxides (together with organic material) to adsorb large quantities of trace elements (especially the first row transition elements) is an important control on trace element availability.

In contrast to these conditions, large areas of England (Region 3) consist of agricultural soils underlain by permeable sedimentary rocks. At the surface, waters are predominantly of the Ca^{2+}–HCO_3^- type underlain by permeable sedimentary rocks. E_h and pH levels of the major cations (Ca^{2+}, Na^+, Mg^{2+} and K^+) and anions are generally higher with a consequent increase in water hardness. The content of organic acids is low, since they are precipitated under such conditions. Mobilization of heavy metals by complexation and adsorption on colloidal organic matter is also correspondingly reduced.

In deep aquifers these waters evolve into chloride-rich brines with concentrations of Na^+, K^+, Ca^{2+} and Mg^{2+} increased by at least an order of magnitude. Increased concentrations of such elements as Sn, Zn, Ba and Pb are stabilized by chloride complexes. Such deep waters may also contain large quantities of fluoride, which is normally buffered at low levels in the surface environment by precipitation of CaF_2. In relatively deep waters (which provide the water supply in many parts of England) the controls on true element concentrations are chemical equilibria, speciation and the solubility of metals, rather than the nature of the host rock or anthropogenic influences.

Within each of the three regions and particularly Regions 1 and 2, bedrock geochemistry will be an important factor in determining the surface geochemistry.

2. Bedrock geochemistry: Region 1

Precambrian crystalline basement rocks of northern Scotland.

Marked regional and local variations in the concentrations of essential major and trace elements and some toxic elements occur in stream sediments over northern Scotland. Some examples are summarized in Table 1.15.

(a) *Major elements*

One of the principal changes in the levels of major elements over this region occurs between the crystalline basement of western and central Scotland on the one hand, and later sediments of the Old Red Sandstone of the east coast and Orkney on the other; the latter contains calcite and dolomite (as cement in

Table 1.15 Element concentrations in stream segments over four regions of northern Scotland from the Institute of Geological Sciences Regional Geochemical Atlas Series (in ppm except Fe in %)

	Clarke	Low	Background	High	Exceptionally high
Ba	1 425	180	180–560	560–1800	5600
	2 425	215	215–460	460–1500	6100
	3 425	300	300–600	600–2400	10 000
	4 425	—	—	ₑ —	—
Be	1 2.8	—	0.3	3–24	42
	2 2.8	<1	1.0	1.0	6
	3 2.8	<1	<1–3	>3	24
	4 2.8	<1	<1	—	10
B	1 10	<8	8–100	100–320	1000
	2 10	<52	52–75	75–320	320
	3 10	<10	10–56	56–320	320
	4 10	—	<6–13	—	240
Co	1 25	<8	8–32	32–130	420
	2 25	<4	4–12	12–56	180
	3 25	<4	4–18	17–60	180
	4 25	—	6–24	—	240
Cr	1 100	<50	50–180	180–1300	1000
	2 100	<34	34–67	67–390	390
	3 100	<42	42–85	85–560	600
	4 100	—	6–24	—	5600
Cu	1 55	<5	5–20	20–90	245
	2 55	<5	5–20	20–55	990
	3 55	<5	5–10	10–60	990
	4 55	—	5–15	—	345
Fe	1 5.63	3	3–13	13–42	75
	2 5.63	<2	2–8	8–24	24
	3 5.63	<1.7	1.7–6.0	6–24	75
	4 5.63	—	1.8–7.5	—	75
Pb	1 12.5	<10	10–40	40–180	320
	2 12.5	<10	10–30	30–200	310
	3 12.5	<20	20–40	40–200	1700
	4 12.5	—	10–30	—	300
Mn	1 950	<1000	1000–3200	3200–7500	100 000
	2 950	<10	320–1300	1300–7500	18 000
	3 950	<420	420–2000	2000–13 000	11 000
	4 950	—	850–4200	—	56 000

Table 1.15—*Continued*

		Clarke	Low	Background	High	Exceptionally high
Mo	1	1.5	<1	1	—	32
	2	1.5	<1	1	1–13	13
	3	1.5	<1	1–2	2–38	160
	4	1.5	<1	1	—	100
Ni	1	75	<7	7–37	37–180	5600
	2	75	<6	6–32	32–100	100
	3	75	<8	8–32	32–100	1800
	4	75	—	10–56	—	1800
U	1	2.7	<3	3–5	5–25	121
	2	2.7	—	2–3	3–12	12
	3	2.7	<3	3–6	6–30	151
	4	2.7	—	1.7–4.5	—	154
U+	1	0.026–13.0	<1	1	1–7	28
	2	0.026–13.0	<1	1–2	1–11	25
	3	0.026–13.0	<1	1–5	5–15	38
	4	0.026–13.0	—	1	—	45
V	1	135	<40	40–85	85–240	400
	2	135	<32	32–100	100–240	240
	3	135	<30	30–105	105–420	440
	4	135	—	56–100	—	1300
Zn	1	70	<40	40–110	110–210	1070
	2	70	<40	40–110	110–230	600
	3	70	<40	40–100	100–320	720
	4	70	—	30–90	—	660
Zr	1	165	<180	180–750	750–2400	4200
	2	165	<240	240–1000	1000–5600	10 000
	3	165	<320	320–860	860–5600	10 000
	4	165	—	240–750	—	10 000

Key	Definitions	
1 = Shetland	Low	Sample values below the twentieth percentile for the map sheet area.
2 = Orkney	Background	Sample values between the twentieth and eightieth percentile for the map sheet area.
3 = Caithness	High	Sample values above the eightieth percentile for the sheet map area.
4 = Sutherland		

The clarke is the average concentration of an element in the earth's crust.

the Old Red Sandstone). Cambrian sediments of western Sutherland and Ross-shire may also contain increased levels of Ca, Mg, K, Na and phosphate.

Over the crystalline basement rocks of Scotland, K is exceptionally low in the Outer Hebrides, the north western mainland of Scotland and over the ultrabasic and basic rocks of the Tertiary Province. Higher levels of K occur over some granites and the Moine metasediments, principally in K feldspar which is relatively insoluble. Levels of Ca, Mg and Fe may be relatively high over basic rocks such as the basalts of Skye and Mull, but where ultrabasic rocks occur (e.g., Unst, the Cuillins of Skye, Rhum and Aberdeenshire), Mg levels may be exceptionally high and Ca levels exceptionally low.

(b) *Trace elements*

(i) *Essential elements.* Exceptionally high levels of Cr and Ni which may be associated with poisoning of agricultural crops and forests occur over ultrabasic rocks, with moderate-high (probably adequate) levels over basic rocks of the Lewisian of the Outer Hebrides and western Mainland, and the Tertiary basalts of Skye, Rhum and Mull. Levels of Mn, Co, Cu, Zn and V are also relatively high over these basic rocks.

Elsewhere in northern Scotland levels of the first-row transition elements are often exceptionally low, particularly over the Moines of the central northern Highlands and northern Grampians, the Caledonian granites, and over the agricultural areas of parts of Caithness, South Orkney (especially Hoy), eastern Ross-shire, Cromarty and Inverness-shire which are underlain by Old Red Sandstone. Co, for example, is in the range 1–10 ppm and Cu, 1–15 ppm.

Levels of Mo, Sn and F are also low over most of northern Scotland, with the exception of some granites such as those of Grudie and Cairngorm. The regional distribution of Se and I are not known, although Se deficiency diseases have been reported in agricultural animals (Mills, pers. comm.).

(ii) *Potentially toxic elements.* In contrast to England and Wales, there is relatively little evidence of heavy metal pollution in northern Scotland. This is partly attributable to the lack of large mineral workings in the past. Some modification of trace element levels may have occurred as a result of the application of agricultural fertilizers (U and Ag in phosphates, for example) and as a result of liming (increase in pH) or manuring (decrease in E_h).

The main sources of potentially toxic trace elements are natural and include:

(1) Cr–Ni–(Mg) over serpentinized ultrabasics such as those of Unst, Sky, Rhum and Aberdeenshire—these elements are most likely to affect crops and vegetation.

(2) High levels of F–Mo–Li–Be and Sn over certain Caledonian granites including Grudie, Helmsdale, Cairngorm, Ballater and Hill of Fare.
(3) High levels of Mo (associated with low Cu levels and alkaline groundwater) over lacustrine facies of the Old Red Sandstone of South Orkney, Caithness and eastern Ross-shire.

The marked change in levels of radioactive elements across Scotland, with a range of U values of <1 ppm in stream sediments over western Scotland to values of >40 ppm over the Helmsdale and Cairngorm granites might be expected to be of environmental significance. The Helmsdale and Cairngorm granites give rise to similar U levels in stream sediments, but the U concentrations in stream water are very much higher in the former (IGS, 1980). In the Cairngorm granite, U is held in primary minerals such as zircon, which are resistant to chemical weathering and dissolution and are therefore unlikely to be of significance to health, whereas in the Helmsdale intrusion uranium mineralization has given rise to various secondary minerals such as autunite and Fe oxides, from which U is readily mobilized. The concentration of elements in stream waters only partly reflects bedrock abundance and may be modified substantially by mineral solubility.

Radon anomalies have also been reported from the Helmsdale/Ousdale area of Sutherland (Michie *et al.*, 1972) and the Yesnaby/Stromness area of South Orkney (Michie and Cooper, 1979).

(c) *Summary*

As a result of its geology and climate, levels of Ca, Na, Mg, K and P tend to be low in the surface environment of northern Scotland, except in areas underlain by sediment and basic rocks. Most of the region including much of the area underlain by Old Red Sandstone sediments is also low in Fe, Mn, Cr, Ni, Zn, Cu, Co and V. The mobility of these elements may also be limited by high pH and carbonate concentrations which occur in areas underlain by sediments. The same conditions increase the availability of Mo, Se and U in dissolved and/or colloidal phases. Elsewhere availability of the first-row transition elements may be enhanced by adsorption or complexing with colloidal oxides or organic matter. The high biological accessibility of these materials indicates that potentially toxic levels of trace elements may occur in an environment generally low in essential elements. The availability of F in the predominantly low Ca regime is likely to be increased, and in some cases (e.g., the high Mo levels in Caithness) toxic levels of an element may exacerbate a deficiency condition, as Mo does by blocking the utilization of Cu in ruminants. These patterns suggest that northern Scotland may be an area in which studies of environmental geochemistry and health might prove particularly fruitful.

Table 1.16 Element levels (ppm) over England and Wales (from Webb et al., 1978)

	Clarke value	Very low	Low	Normal	High	Very high
As	1.8		<8	8–29	>29	>70
Ba	425		<178	178–413	>413	>3257
Cd	0.2				>4	
Cr	100		<38	38–82	>82	>217
Co	25		<6	6–22	>22	>125
Cu	55	<6	<15	15–41	>41	>436
Pb	12.5		<24	24–104	>104	>678
Li	20		<25	25–93	>39	
Mn	950		<410	410–2220	>2220	>9400
Mo	1.5		<1	1–2.2	>2.2	73.6
Ni	75		<14	14–46	>46	>100
Sr	375		<38	38–143	>143	>4880
Sn	2				>125	
V	135		<33	33–94	>94	>2000
Sn	70		<87	87–244	>244	>450

3. Bedrock geochemistry: Region 2

Palaeozoic shale/greywacke belts with granite intrusions of England and Wales.

(a) *Major elements*

Systematic data are available only for Ca, K, Fe and Al. Levels of K are mostly moderate—average over most of the area with particularly high concentrations over evolved granites such as those of southwest England. In general, levels of Ca are low to average with moderate–high Fe concentrations. Some of the levels of major and trace elements over England and Wales are given in Table 1.16.

(b) *Trace elements*

(i) *Essential elements.* The levels of first-row transition elements including Co, Cu, Mn and Zn are moderate to high over the greywacke/shale sequences.

The granites of southwest England and the evolved granites of the Lake District are associated with exceptionally low levels of essential trace elements including Cu and Co. High levels of Sn (and F) are associated with the granites of southwest England while Mo levels over the region are generally low–average with the exception of areas underlain by black shales in

southwest England and mid and north Wales. No systematic regional data for Se or I are available.

(ii) *Potentially toxic elements.* Most of the areas where potentially toxic levels of trace elements occur are related to metalliferous mineralization or contamination from industrial processes. Moreover, in the past much smelting and refining was carried out near to the sites of the mineralization. Significantly larger amounts of elements may be released into surface waters and groundwaters over metalliferous mineralization and old mine dumps owing to the mineral phases in which the elements are held and the total concentration in bedrock. Metals are readily released from most sulphide phases by oxidation in the presence of water, and the accompanying liberation of hydrogen ions provides low pH solutions in which these elements are increasingly mobile. Natural poisoning of vegetation may result from the mobilization of Cu, Fe, Pb, Ni and Zn from their sulphides (Bølviken and Låg, 1977). Resulting anomalous vegetation patterns have been used in biogeochemical prospecting (Warren, 1972).

Areas of mineralization associated with potentially toxic trace element levels include:

(1) The Cu–Sn–As–U mineralization associated with the Cornubian granite batholith of southwest England.
(2) The Pb–Zn mineralization of the Mendips.
(3) The Cu–Pb–Zn mineralization of central and north Wales.
(4) The Pb–Zn–F mineralization of the Lake District.
(5) The Pb–Zn–F mineralization of the Pennine Orefield.

Increased levels of Cd are associated with Zn mineralization (areas 2–5) and processing (mining and refining)—particularly areas 2, 3 and 5 where the low Cd:Zn ratios characteristic of natural rocks and ores may be increased as a result of Zn refining processes.

In addition, high concentrations of some elements occur in unmineralized bedrock in some areas of Region 2. High levels of Cr and Ni are associated with the Lizard ultrabasic complex in Cornwall, whereas black shales, ranging in age from Cambrian (Harlech Dome) to Carboniferous (southwest England and Derbyshire), are associated with high concentrations of Mo and, in some areas, Cd and As. Systematic regional data on levels of radio-elements are not available but data on Palaeozoic shales (Bowie *et al.*, 1979) indicate average values in the range 3.6–7.2 ppm.

(c) *Summary*

As in northern Scotland, this region is likely to be characterized by deficiencies of major elements as a result of bedrock composition (low Ca), low mineral

solubility/high degree of leaching (K), and the formation of insoluble hydroxides, Fe and Mn. Levels of most essential trace elements are likely to be reasonably adequate, however, except over areas underlain by granite. Several extensive areas containing potentially toxic concentrations of heavy metals, As and F occur in the region mostly as a result of metalliferous mineralization and mineral workings.

3. Bedrock geochemistry: Region 3

Devonian to Tertiary sedimentary cover of England and Wales comprising:

(1) Sandstones—mostly Old Red Sandstones, Permo-Trias, Cretaceous Greensand and Tertiary Bagshot beds.
(2) Shales, mostly of Carboniferous and Jurassic age, but including London Clay.
(3) Limestones, mostly Carboniferous and Mesozoic.

(a) *Major elements*

Potassium levels are mostly low in areas underlain by shales and sandstones, with exceptionally low levels over the Bagshot Beds and areas underlain by limestones, including the Chalk. Amounts of Ca may be exceptionally low over sandstones with moderate values over shales (with the exception of the Lias which is high) and with the highest values over limestones, low to moderate over sandstones and moderate to high over shales, with the ironstone facies of the Jurassic clearly indicated in Northamptonshire.

(b) *Trace elements*

The levels of trace elements mostly reflect the lithology of the bedrock, and particularly the proportion of arenaceous, argillaceous or calcareous materials.

(i) *Essential elements.* Sandstones generally are characterized by low concentrations of Co, Cu, Cr, Mn, V and Zn, although some areas underlain by Old Red Sandstone and Keuper beds contain moderate amounts of these elements. The Old Red Sandstone in southeast Wales is enriched in Cr.

Areas underlain by shales and clays usually contain moderate amounts of these elements, with the exception of the Lower Lias which contains low levels of Co, Cu and Li. Mn is low over parts of the London Clay. Cr is high over parts of the Lias, London Clay and Coal Measures, and levels of V are high

over some parts of the Lias and London Clay. Areas underlain by limestones, including the Chalk in southern England, which is relatively drift free, are low in Co, Cu, Cr, Li, Mn, Ni, V and Zn, with the exception of areas of mineralized Carboniferous Limestone in the Mendips, Pennines and North Wales.

(ii) *Potentially toxic elements.* Anomalously high concentrations of Mo are found in regions underlain by black shale beds of the Lower Lias, and Oxford and Kimmeridge Clays of Jurassic age and over Nammurian Shales of the Carboniferous. Areas where drift is derived from these beds may also contain high levels of Mo. Carboniferous black shales are enriched in Cd, and in Northamptonshire, high levels of As are associated with Jurassic ironstone deposits.

(c) *Pollution*

The potentially toxic levels of heavy metals and As described above relate to naturally occurring concentrations of elements in unmineralized bedrock or to the presence of sulphide mineralization and contamination from mineral workings. In addition anomalously high levels of some heavy metals and in particular Pb, Zn and Cd are found (a) in the vicinity of industrial centres, including the present-day smelting complex at Avonmouth and the old smelting areas of the Swansea Valley in South Wales and (b) around some large industrial cities including Birmingham. High concentrations of metals occurring naturally or as pollutants are potentially hazardous, although the form of the elements and their availability depends on their source and the surface geochemical environment.

(d) *Summary*

The levels of both major and trace elements in Region 3 are closely related to lithology. Regions underlain by sandstones and limestones contain low or very low levels of most of the essential trace elements; limestones are also low in K and Fe and sandstones in Ca. Low levels of trace elements in sandstones are sometimes exacerbated by surface conditions which are frequently acid with excessive leaching. Potentially toxic amounts of Mo occur in black shales of Jurassic and Carboniferous age, and high levels of Pb, Zn and Cd in the region are associated with mineralization, old mineral workings and industrial centres.

VI. Conclusions

Much information on the distribution of chemical elements in rocks and their redistribution in the surface environment has been obtained as a result of

progress in geochemistry, particularly during the last decade. Nevertheless, levels of trace elements and to a lesser extent those of major elements cannot be predicted reliably using geological maps. Moreover, an understanding of the chemical and biological availability of trace elements requires considerable knowledge of such factors as soil type, drainage conditions, E_h/pH and vegetation.

Geochemical maps provide systematic data which reflect the content of chemical elements in bedrock and in overburden and soil. The data, where they are available in computer-readable form, can be used for interactive statistical analysis in relation to other environmental data and epidemiological information. The preparation of regional geochemical maps and their application to studies on animal and human health are considered more fully in the following chapters.

In humid, temperate climates such as Britain, a broad distinction may be drawn in the geochemical environment between areas underlain by impervious, crystalline rocks characterized by rapid rates of run-off and those underlain by permeable sedimentary rocks. In the former areas, surface conditions are characterized by low E_h and pH, with low contents of major cations and anions in waters (reflected by low conductivity values). Surface waters also contain increased levels of heavy metals which are mobilized as a result of the low pH and the presence of colloidal and dissolved organic substances capable of adsorption and complexation. Such environments are generally deficient in the major cations and anions, but available levels of such toxic elements as Pb might be expected to be higher. Geochemical maps for these areas should reflect the trace element content of waters with considerable precision, in addition to indicating changes in the geochemistry of rocks and soils. Hence studies of geochemistry in relation to human health should be particularly fruitful in areas of upland Britain.

In contrast, areas underlain by pervious, particularly calcareous, sedimentary rocks generally have agricultural soils and surface waters predominantly of the $Ca^{2+}-HCO_3^-$ type. E_h and pH and the levels of major cations and anions are generally high (and are associated with an increase in water hardness). The content of organic acids and of heavy metals bound by organic matter is correspondingly low since they are precipitated under such conditions. Major element deficiencies are unlikely to occur, but available levels of such potentially toxic elements as Mo and Se may be high. Where water supply is from relatively deep aquifers, which is the case in many parts of England, the concentration of trace elements will be determined by chemical equilibria, speciation and element solubility rather than the nature of the host rock or anthropogenic influences. Geochemical maps for such areas will be of relatively little value in predicting the trace element content of waters and vegetation. They will therefore be most applicable to studies of the health and

the trace element status of agricultural crops and animals which most closely reflect the geochemical nature of the soil.

Acknowledgements

The authors thank M. P. Atherton, University of Liverpool, and P. J. Moore and D. Ostle, Institute of Geological Sciences, for their critical comments on the manuscript. This chapter is published by permission of the Director, IGS/NERC.

References

Andrews-Jones, D. A. (1968). *Mineral. Ind. Bull.* **2** (6), 31.
Bølviken, B. and Låg, J. (1977). *Trans. Instn. Min. Metall. (Sect. B)* **86**, B173–180.
Bowie, S. H. U., Parker, A. and Raynor, E. J. (1979). *Trans. Instn. Min. Metall. (Sect. B)* **88**, B61–65.
Cawse, P. A. (1974). "A Survey of Atmospheric Trace Elements in the UK (1972–73)". AERE Report R7669. HMSO, London.
Cawse, P. A. (1981). "A Survey of Atmospheric Trace Elements in the UK (1979)". AERE Report R9886. HMSO, London.
Elmes, P. C. (1980). *J. geol. Soc. London* **137**, 525–535.
Fyfe, W. S. (1974). "Geochemistry". Clarendon Press, Oxford. Oxford Chemistry Series 16.
Garrels, R. M. and Christ, C. L. (1965). "Minerals, Solutions and Equilibria". Harper and Row.
Garrels, R. M. and MacKenzie, F. T. (1971). "Evolution of Sedimentary Rocks". W. W. Norton & Co., New York.
Institute of Geological Sciences (1977). "1:625 000 Hydrogeological map of England and Wales". Institute of Geological Sciences, London.
Institute of Geological Sciences (1978a). "Regional Geochemical Atlas of Great Britain: Shetland Islands". Institute of Geological Sciences, London.
Institute of Geological Sciences (1978b). "Regional Geochemical Atlas of Great Britain: Orkney Islands". Institute of Geological Sciences, London.
Institute of Geological Sciences (1979). "Regional Geochemical Atlas of Great Britain: Caithness and South Orkney". Institute of Geological Sciences, London.
Institute of Geological Sciences (1982). "Regional Geochemical Atlas of Great Britain: Sutherland". Institute of Geological Sciences, London. In press.
Institute of Geological Sciences (1981). "Regional Geochemical Atlas of Great Britain: Hebrides". Institute of Geological Sciences, London. In press.
Levinson, A. A. (1974). "Introduction to Exploration Geochemistry". Applied Publishing Ltd, Calgary.
Michie, U. McL. and Cooper, D. C. (1979). "Uranium in the Old Red Sandstone of Orkney". *Rep. Inst. Geol. Sci.* No. 78/6.
Michie, U. McL., Gallagher, M. J. and Simpson, A. (1972). In "Geochemical Exploration", Vol. 4, pp. 117–130. Institute of Mining and Metallurgy, London.
Oliver B. G., Milne, J. B. and Labarre, N. (1974). *J. Wat. Pollut. Control. Fed.* **46**, 766–771.
Plant, J. A. and Moore, P. J. (1979). *Phil. Trans. R. Soc. London* **B288**, 81–93.
Raiswell, R. W., Brimblecombe, P., Dent, D. L. and Liss, P. S. (1980). "Environmental Chemistry". Edward Arnold, London.

Snoeyink, V. L. and Jenkins, D. (1980). "Water Chemistry". John Wiley, New York.

Thornton, I. and Plant, J. A. (1980). *J. geol. Soc. London* **137**, 575–586.

Underwood, E. J. (1977). "Trace Elements in Human and Animal Nutrition", 4th Edn. Academic Press, London and New York.

Warren, H. V. (1972). *J. Roy. Coll. Gen. Practit.* **22**, 56–60.

Webb, J. S. and Howarth, R. J. (1979). *Phil. Trans. R. Soc. London* **B288**, 81–93.

Webb, J. S., Thornton, I., Thompson, M., Howarth, R. J. and Lowenstein, P. L. (1968). "The Wolfson Geochemical Atlas of England and Wales". Oxford University Press, Oxford.

2

Regional Geochemical Mapping and its Application to Environmental Studies

RICHARD J. HOWARTH and IAIN THORNTON

I. Introduction

The spatial distribution of rocks and soils derived from different parent materials will generally govern the levels of element abundance in the natural environment; although these may be affected to some extent by local modifying factors such as E_h and pH (see Chapter 1). For example, areas underlain by ultrabasic or basic rocks may have elevated levels of Cr and Ni, giving rise to toxicity in cereal crops (Mitchell, 1964), and the development of specialized floras tolerant to very high levels of these elements over serpentinites in various parts of the world is well known (Peterson, 1979). Very high levels of elements such as As, Cd, Cu, Cr, F, Mo, Ni, Pb, U and Zn are frequently associated with areas of metalliferous mineralization and old mining activity, and may lead to natural or man-induced poisoning of vegetation (Låg and Bølviken, 1974; Brooks, 1979; Cannon, 1979) or livestock (Grimmett, 1939; Colbourn et al., 1975; Colbourn and Thornton, 1978). Black shales often contain levels of Mo which may induce clinical or subclinical hypocuprosis in cattle (Kubota et al., 1961; Thomson et al., 1972). Elements such as Se and Tl may be elevated in some shales, or in association with sulphide mineral deposits and are known to give rise to toxic vegetation (Lakin, 1972; Zýka, 1972); however, lack of analytical data has prevented detailed knowledge of their distribution in nature so far, although they are of interest from the mineral exploration point of view. Deficiency in elements such as Cu, Co, Zn, Mn, Cr, Ni and V may cause clinical effects in crops (Mitchell, 1974) or animals (Mills, 1979). Areas underlain by predominantly carbonate rocks, such as

APPLIED ENVIRONMENTAL GEOCHEMISTRY
ISBN 0-12-690640-8

limestone or chalk, some sandstones, and acid igneous rocks, such as granite may contain naturally low levels of these essential elements. Copper deficiency in cereal crops, and cobalt deficiency in sheep have been recognized in such areas in the United Kingdom (Thornton and Webb, 1979).

The geologist will pay close attention to the detailed variation of rock types when field mapping for the compilation of a geological map. However, changes in the nature of the rock may occur within the same sedimentary formation, both laterally and vertically, owing to variation in the conditions of deposition when the rock was originally formed. As an example, the Lower Jurassic in Britain largely comprises argillaceous rocks, clays, shales and thin muddy limestones, and it is from the alternations of shales and limestones that the word "Lias" (an old word meaning "layers") was derived in the 1800s. The presence of Mo-rich marine black shales within the Lias formation is variable and the relationship between Mo in rock, stream sediment, soil and pasture associated with clinical molybdenosis and hypocuprosis in cattle was only clarified as a result of geochemical studies (Le Riche, 1959; Thompson *et al.*, 1972). In many cases published geological maps cannot be used as the basis for pinpointing localities in which such problems might arise owing to the reconnaissance scale of the mapping (e.g., 1:250 000–1:100 000), and/or generalization of the mapped formations without detail of internal changes in their lithology. It is common practice, for example, to represent mapped units on the basis of time intervals rather than their detailed lithology. Metamorphic rocks will also tend to be shown as generalized units, and without geochemical examination it will not be possible to deduce probable element concentration levels from the map alone. Similarly, all traces of former mining or smelting activities carried out before the present day may have vanished with the passage of time, and their presence cannot be deduced from the geological map.

Systematic mapping of element levels based on soil or vegetation samples would therefore provide valuable information which cannot be obtained from normal geological maps. In many countries there is little available information on either total or "available" levels of trace elements in soils. Nor is information readily obtainable on the rate of change of element concentration as a function of distance: in other words, what is the area for which a sample can be regarded as representative? Although establishment of a systematic sampling network on a grid basis, say, every 1 km, might be highly desirable, considerations of cost and time will preclude such a detailed survey on a country-wide scale in the first instance: compromise solutions must therefore be used.

Having recognized the need to establish multi-element atlases showing the distribution of elements on a regional scale as a prime requirement for effective study of environmental geochemistry in relation to health, several choices of

sampling methodology are available, dependent on the media used. There is as yet no consensus of opinion as to the best method available for the purpose. It may well be that different methods will be suited to particular geographical areas and climatic regimes. However, in many parts of the world, geochemical mapping both on reconnaissance and more detailed scales has become an accepted tool for mineral exploration. Many such surveys are carried out by commercial organizations and thus remain confidential, but there has been an increasing emphasis on the part of governmental and international bodies, such as geological surveys and the United Nations Development Program, to undertake multi-element surveys of very large areas. The data from such surveys are generally available for study in a wider context than that of the original exercise conceived for primarily exploration purposes. It may be that the suites of elements determined are confined in the initial programme to elements of interest from the point of view of mineral exploration (commonly Cu, Pb, Zn) but samples may be retained and therefore available for analysis for further elements at a later date. An excellent example of such a data base is the National Uranium Resource Evaluation (NURE) programme of the United States Department of Energy in which stream sediment and water samples have been taken over 60% of the conterminous United States and Alaska. Although main interest focused on U and Th, up to 43 elements were determined on a large proportion of the stream sediment samples. These data are open-filed by the US Department of Energy and are available for further study.

II. Sampling media

It is difficult to generalize about the advantages and disadvantages of the different sampling media available to the geochemist. These will vary to some extent depending on the objectives of the survey, ease of sampling, representativity of the samples in terms of areal extent, cost of sample collection, and range of elements to be monitored. This last criterion will, of course, interact with laboratory time and cost considerations. Methods such as X-ray fluorescence, induction coupled plasma spectrography, or neutron activation are used in some of the larger national programmes for multi-element analysis of 20–40 elements at a time; other techniques may be used either for reasons of cost, or to determine elements that are more difficult to analyse for. Analytical methods used by the geochemist are discussed in Chapter 3.

Possible media include rock, soil, stream sediment, lake sediment, surface waters and vegetation. Although each may be appropriate in a particular circumstance, only soils and stream sediments have been widely used as survey media. The reasons for this are briefly outlined below:

(a) *Rock*. This has the disadvantage that the sample is representative of only a small area about the sample locality; compositional variation will be dependent on the degree of weathering, unless great care is taken to ensure only fresh material is collected (this may necessitate core drilling); rock samples will provide little or no information with regard to man-made pollution; and furthermore are relatively costly to collect and prepare for analysis. A further difficulty is that bedrock is frequently not exposed at the surface, being masked by local or transported overburden. It is, however, important in its effect on the composition of derived soils, and on groundwater sources of water for consumption by humans or livestock.

(b) *Soil*. As with rocks, a soil sample is representative of only a small area and its characteristics can change markedly over short distances according to topography, drainage and other factors affecting the soil-forming process. However, it is easy to sample and analyse, reflects the composition of the parent material, and is a key link in the chain of element transport through crops to animals and man. High-density soil surveys would be an ideal, but will be uneconomic for large areas. Alternative sampling strategies have been used, and are discussed in Section III. For reviews of the use of soils for mineral exploration in glaciated and non-glaciated terrains, see Bølviken and Gleeson (1979) and Bradshaw and Thompson (1979).

(c) *Stream sediment*. The composition of active stream sediment (collected in the middle of a stream to avoid collapsed bank material) will represent a close approximation to a composite sample of the products of weathering and erosion of soil and rock in the catchment area upstream from the sampling site. The representativity of the sample will be related to catchment area. The sample is easy to collect and analyse, suitable drainage densities exist in many parts of the world, and useful results are obtainable in most climatic regimes.

The sample composition will be relatively stable compared with that of the stream waters, and, although the active stream sediment consists of mainly mineral material, there is usually a sufficient degree of relation between its composition and the soluble constituents of the associated stream water to allow it to be used as a guide to water quality (Thornton and Webb, 1979). Some care is needed in the interpretation of geochemical data derived from stream sediment mapping, since stream sediments are influenced by such factors as selective deposition during transport, the precipitation of Mn and Fe oxides, and in some area of calcareous rocks the precipitation of $CaCO_3$ in the surface drainage system can markedly reduce the content of other elements.

Scavenging of heavy metals by Fe and Mn oxides occurs when the E_h and pH of the ground waters are substantially lower than those of the stream

waters, resulting in the precipitation of Mn and Fe oxides in the drainage channel, with consequent enhancement of other metals (Fig. 2.1) by various mechanisms including coprecipitation and adsorption. Such conditions occur typically in cool, moist northern latitudes wherever imperfectly drained acid soils containing organic matter are found, particularly when the soils remain wet or waterlogged for considerable periods of the year, allowing an ample opportunity for leaching of soluble metals (Horsnail *et al.*, 1969). Manganese and Fe oxides in stream sediments have been reported from the UK, Scandinavia, Brazil, the southeastern United States, Canada and Alaska (Nolan, 1976; Meyer *et al.*, 1979).

In some areas of calcareous rocks, massive precipitation of $CaCO_3$ in the drainage system may dilute the content of other metals in the stream sediment samples. The presence of organic matter may also affect the element contents in the sediment. Organic stream sediments, derived from the decomposition of vegetable material, are not usually used as a sampling medium but have been used in cold regions of low relief in northern Scandinavia (Meyer *et al.*, 1979). In all these cases, multiple regression techniques may be used to normalize the observed element contents (Howarth and Martin, 1979). Other factors that should be taken into account when interpreting stream sediment data are that (i) minor seasonal variations may exist (particularly in those elements related to Mn and Fe oxide precipitation), and (ii) sediments may be locally contaminated as a result of human activity such as mining, agricultural, industrial and domestic sources.

(d) *Lake sediment.* Organic-rich sediments collected generally from the centre of small lakes have been used since the late 1960s for regional geochemical prospecting in Fennoscandia, Canada and the northeastern United States. Lake and pond sediments have also been collected from elsewhere in the United States during the Department of Energy's NURE programme. The glaciated Precambrian Shield regions of these areas contain numerous lakes in shallow depressions hollowed out by glacial action or formed in the surficial materials. Suspended inorganic matter brought into the lakes from the surrounding land area is analogous to the stream sediments discussed above. However, the mechanisms affecting metal transport, fixation, and accumulation in the lake sediment are complex and are thought to involve scavenging of metals by inorganic matter; sorption and coprecipitation by hydrous Fe and Mn oxides; sorption by clay minerals; chemical processes involving hydrolytic reactions; and variations in the gross physiochemical nature of the sediments (Coker *et al.*, 1979). The role of Fe and Mn oxides is not as important as that of the humic materials and organic-rich clays. In a summary of 50 lake sediment surveys carried out in the Canadian Cordillera, Shield and Appalachians (Coker *et al.*, 1979, Table 20.5), Ag, Ca, Cu, Fe, Mn, Ni, Pb and

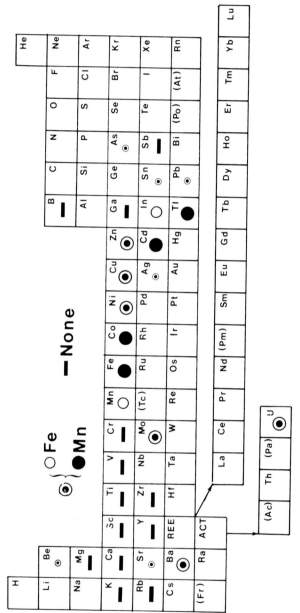

Fig. 2.1 Elements scavenged by Fe and/or Mn oxide precipitates in drainage sediments.

Zn were almost always determined; As, Ba, Hg, Mo, Ti and U were commonly determined, and Al, Bl, Bi, Ca, Cd, Cr, F, Ga, K, La, Li, Na, Ra, S, Sb, Sc, Sn, Si, V, Y and Zr were only occasionally reported. These studies have all been aimed at mineral exploration and their implications for environmental studies have yet to be fully investigated.

(e) *Surface waters.* These are not particularly well suited to broad-based geochemical mapping for environmental applications, primarily because of their diurnal and long-term variations in composition and suspended sediment load, and practical difficulties in sample collection, storage, and analysis. Obviously, water-quality monitoring is directly useful in relation to water supplies for consumption by animals or humans, particularly in the case of spring and well waters. For example, areas with well waters unfit for human consumption owing to high Rn contents have been discovered through the NURE regional uranium reconnaissance programme in the United States. Hydrogeochemical prospecting is becoming more widely used, although much work remains to be done to fully understand the geochemical cycles for many elements (Miller, 1979; Dyck, 1979), and may be useful for environmental studies in the long term in establishing base-line criteria. However, it is not as useful as stream sediment from the point of view of regional mapping with a view to establishing probable element levels in the surficial rock-soil environment.

(f) *Vegetation.* Biogeochemical prospecting has a role to play in the search for particular types of ore deposit through the analysis of indicator species, mainly for Au, Cu, Co, Mo, Pb and Zn (Cannon, 1979; Brooks, 1979). However, apart from multi-element maps based on vegetation in Missouri (Shacklette *et al.*, 1972) and the Colorado Oil Shale region (Klusman *et al.*, 1980), systematic vegetation sampling has not been widely used as a tool for regional geochemical mapping in relation to environmental geochemistry and health. The reasons for this are that difficulties in interpretation are imposed by variations in composition related to species, or sub-species, and to age of the plant. The extent to which elements are concentrated, and the concentrations in different tissues, will also vary according to the time of year.

It is evident from the discussion so far that tributary drainage sediments afford a widely available sampling medium, in which the samples are representative of the catchment area upstream of the sample point whose size is defined by the sampling density chosen. Ease of access and rapidity of sampling are also key criteria in setting up a regional geochemical survey over a large area, for instance when carried out on a national basis. An adequate drainage system is obviously essential, and where this does not exist soil would be the next choice. A combination of both sample types might be used to

obtain optimum coverage. The final choice of sample strategy will be dictated by the time and cost required to achieve a particular exploration density.

III. Methodology

The size of target sought in the geochemical mapping programme will dictate the ideal sampling density. For example, a far closer sample spacing would be required to pinpoint a source of natural element toxicity or man-made pollution at the farm or field level, than would be necessary to indicate a region associated with an element-related (deficiency or toxicity) environmental health problem. Further work would then be required to be carried out within such a region at a more detailed sampling interval to delineate specific problem areas. This latter investigation would often be based on a different sampling medium than that used for the initial survey.

In general, three main approaches have been used in attempting to derive multi-element geochemical maps for regional studies: (i) extrapolation of results obtained for type localities to surrounding regions; (ii) very low-density random sampling of well-defined "homogenous" mapped units; and (iii) semi-systematic sampling of the entire survey region.

The difficulties inherent in extrapolating geochemical changes from the geological map have already been mentioned. In addition, the geochemistry of the surficial materials may have been affected by the presence of transported glacial, fluvial or aeolean material on top of bedrock, and variations in weathering, climatic regime, and biological activity.

In the USSR, Kovalsky and his co-workers have applied the concept of biogeochemical mapping (Kovalsky, 1970, 1979), based on the establishment of zones characterized by relatively uniform soil-forming processes, climatic conditions, and comparable biogeochemical behaviour of the elements, and the response of organisms to geochemical and physical factors of the environment. However, this does not lead to the provision of multi-element maps as such, although data on the content of natural and pollutant chemical elements in soil and plants are taken into account in their compilation (Kovalsky, 1979).

An alternative approach to extrapolation based on the concept of "type" samples representing a region of similar soil type was used by Wells (1967) to compile geochemical maps for New Zealand. Fig. 2.2 shows a map of total Se in topsoils (A, horizon), based on analyses of 75 soil profiles and 125 topsoil samples, aided by 100 analyses of parent rocks. Maps such as this are only intended to indicate the broad patterns of variation and will have no significance at the level of farm or property.

Regional and detailed geochemical surveys are now routinely undertaken in

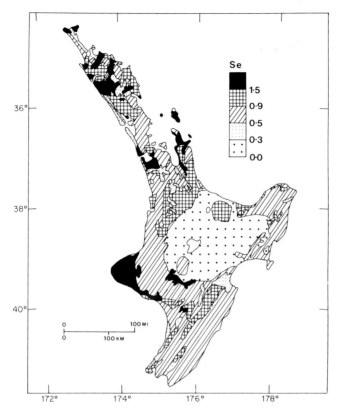

Fig. 2.2 Total Se (ppm) in A, horizon of topsoils, North Island, New Zealand, extrapolated from 200 key sites (after DSIR, 1967).

many parts of the world, although primarily aimed at mineral exploration, based on a variety of sampling media (Fig. 2.3). The *effective* exploration density (area mapped/number of sample locations) ranges from extremely high (1 to 100 samples km^{-2}) in the detailed soil surveys used to elineate an exploration drilling target, through intermediate in stream sediment and lake sediment surveys, to very low-density soil surveys. Webb and Howarth (1979, Table 1) list examples of regional geochemical surveys carried out since the mid-1960s in which the areas covered range from c. 1500 to 200 000 km^2 and the number of elements is generally in excess of 15. These multi-element surveys covering relatively large geographic areas are distinct from those carried out for mineral exploration purposes which have traditionally been based on a restricted suite of elements, often with a large number of samples over a relatively small survey area. The NURE programme of the US

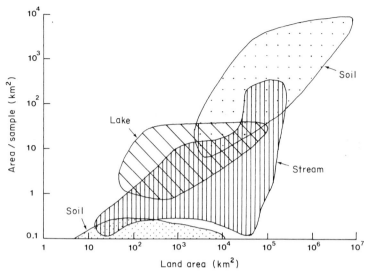

Fig. 2.3 Effective sampling density achieved by various geochemical surveys as a function of area surveyed, based on soil, stream sediment and lake sediment programmes reported in the literature.

Department of Energy is probably the largest multi-element stream sediment programme to have been undertaken at the present time, involving 16 to 48 elements at a nominal sampling density of 1 per 10 km^2 over much of the US. Major regional programmes have also recently begun, or have been undertaken in China, Northern Sumatra, South Africa, Australia, the Federal Republic of Germany and the UK.

1. Soil surveys

On the local scale, element values in a soil will change rapidly, and spatial correlation between a value at one site and another relatively close by may be low (Beckett and Webster, 1971). For example, Fig. 2.4 illustrates the rapidity of changes in Mo concentration in surface soil samples on a systematic grid with 0.5 mi (0.8 km) centres over the Eocene oil shale-bearing Green River Formation in the Piceance Creek Basin of Colorado (Klusman *et al.*, 1980). Soil-survey strategies need to be optimized with regard to the logistics of sample collection (an excellent review of methodology is given by Beckett, 1981) and the expected scale of variability. Generalized regional trends will broadly reflect behaviour on the local scale, but will loose detail on the local scale. This may be illustrated by applying a simple moving average (averaging

Fig. 2.4 Contoured concentrations of Mo (ppm) in surface soils over the Green River Formation oil shales in the Piceance Creek Basin, Colorado. Grid spacing 0.5 mi (0.8 km). (Original data from Klusman *et al.*, 1980, p. 73.)

the values of all data points within a 3 × 3 grid, and moving this window across the map with successive displacements of one row, or column, at a time) to the data of Fig. 2.4. The result (Fig. 2.5) shows a much smoother pattern (reflecting the broad trends in Fig. 2.4), but with the expected loss of local detail. In particular, the occasional high value (e.g., 9.7 ppm Mo) is lost owing to the averaging. This loss of information will also be inevitable in any survey carried out at a lower sampling density. However, broader scale trends should be retrievable on a scale commensurate with the sampling density and should reflect geological units, or areas worthy of more detailed study, provided there is some measure of systematic spatial correlation inherent in the data. If it is vital that all localities with, say, high Mo values are located on a scale of 2 km^2 then there is little choice but to carry out a survey at a compatible sampling density. In general, however, the cost would be far too great and one must have recourse to alternative methods.

Much of the pioneering work on low-density regional soil sampling was carried out by the Branch of Regional Geochemistry of the United States Geological Survey under A. T. Miesch and his co-workers, based on surveys carried out in the State of Missouri between 1969 and 1973. Details of the methodology are given in Miesch (1976a). Figure 2.6 shows the regional distribution of Pb in 1140 agricultural soils over the 180 500 km^2 of Missouri based on 10 samples from each of the 114 counties in the State (Tidball, 1972). The samples were selected from those submitted by farmers to county agents

Fig. 2.5 Contoured moving-average smoothed concentrations of Mo (ppm) in surface soils over the Green River Formation oil shales in the Piceance Creek Basin, Colorado. (Original data from Klusman *et al.*, 1980, p. 73.)

for fertilizer recommendations, and were from geographically separated farms. All samples were analysed in a randomized sequence in the laboratory, thus ensuring that any spatial patterns appearing on the map are valid. However, the possibility remains that there may be slight bias in the original sample collection which "could result from a desire, for example, to have the 'best' soils of a county represented in the sample set at the expense of either some minor soil type, or agriculturally unimportant soils" (Tidball, 1972). Two hundred and seventy-five different soil units (Series) have been mapped in the State (Miesch, 1976a). Nevertheless, the survey identified (Fig. 2.6) an area of high Pb values in specimens collected from the flood plain of Big River in southeastern Missouri. This river flows through the old Missouri Lead Belt and locally flows past the base of nine tailings piles. Lead production has been nearly continuous in the area since the first discovery in 1701 (Tidball, 1972). This type of low-density regional soil survey has found application in other areas where an understanding of broad-scale regional soil variations is required as a guide to environmental and agricultural management problems. For example, Castillo-Muñoz (1977) used 114 localities at a mean density of one sample (0.0–0.25 m horizon) per 25 km² over an area of 3000 km² tropical deciduous vegetation with deep lateritic soils in western Costa Rica. Figure 2.7 shows the levels of partial extractable Cu (using Na–EDTA at a pH of 8.5) in relation to soil pH. Cu is one of several elements judged by him to be

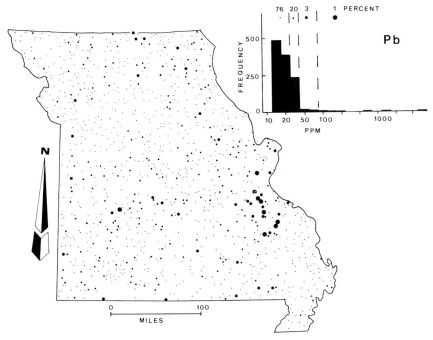

Fig. 2.6 Pb (ppm) in 1140 agricultural soils from the State of Missouri (after Tidball, 1972).

particularly high in relation to critical levels for plant and animal life, and warranting more detailed investigation (Castillo-Muñoz, 1977).

Miesch and his co-workers felt that it was important to establish a methodology to determine whether defined geological, soil, or vegetation units were distinct, in terms of the element concentrations association with them, on a sound statistical basis. In essence, this requires establishing the mean element concentration, with its associated confidence interval, for a given unit. If the variability between two units is high in relation to the confidence intervals about their respective mean concentrations, then one may be confident that they are indeed distinct. The statistical rationale for this approach has been well documented by Miesch (1967a, 1967b, 1976a, 1976b), Tourtelot and Miesch (1975) and Klusman et al. (1980). Early work was based on a strict hierarchical (nested) sampling scheme, using a balanced design with replication at all levels (Fig. 2.8). For example, for the population of classified soils one might consider the following hierarchy (Miesch, 1976a):

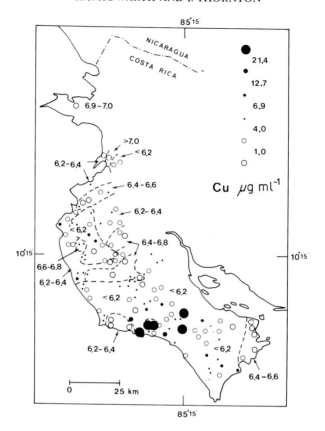

Fig. 2.7 Regional distribution of Na–EDTA extractable Cu ($\mu g \, ml^{-1}$) in 114 soils from the Nicoya Peninsula, Costa Rica, in relation to soil pH (after Castillo-Muñoz, 1977).

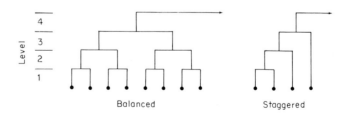

Fig. 2.8 Comparison of balanced and staggered 4-level nested sampling design (after Garrett and Goss, 1980).

Mapped unit: Soil suborders
 Soil subgroups
 Soil series
 Localities
 Samples within localities
 Duplicate analyses of samples

Standard analysis of variance techniques allow the determination of the proportion of the overall variability accounted for by each level in the design. This in turn allows the optimization of the number of localities, samples within localities, and number of analyses to best distinguish any geochemical differences which may exist between the mapped units, taking into account the costs of getting to a site and analysis (Miesch, 1976a,b). More recently, work by Garrett and Goss has considerably advanced our understanding of the problems of analysis of variance of unbalanced sampling designs (Garrett and Goss, 1978, 1980; Goss and Garrett, 1978) and enables a significant reduction to be made in the sampling requirements. The number of samples required tends to increase exponentially with the number of levels in a balance design, whereas it rises only linearly with a staggered unbalanced design. For example, the balanced 4-level design in Fig. 2.8 requires 8 individual samples, whereas only 4 are needed for the unbalanced equivalent. Once 4 levels of replication are exceeded, the unbalanced design will offer a reduction in the sampling and analytical requirement of over 50%. The staggered type of design is now being extensively used by the Geological Survey of Canada for regional geochemical reconnaissance work using lake sediments and other media.

Partially unbalanced hierarchical sampling schemes have been used in a recent study of the soils of the Piceance Creek Basin, Western Colorado, in relation to the geochemistry of the oil shales in the Eocene Green River Formation (Ringrose et al., 1976; Dean et al., 1979; Klusman et al., 1980). The following description of how such a sampling design is used in practice closely follows that of Klusman et al. (1980).

The main objective of the survey was to establish the extent and magnitude of regional variations in major and trace elements in soils. The sampling design (Fig. 2.9) was mainly intended to test geochemical variability at several geographic levels (distances between samples) as well as one physiographic (ridge top versus valley bottom) level. Thirty-seven elements were investigated. Thirty-six townships of 36 mi^2 (94 km^2) were selected for study. Sets of 4 contiguous townships were grouped into 9 supertownships. Within each township 2 sections (2.6 km^2) were chosen at random, and within each section 2 samples were collected 100 m apart (Fig. 2.10a). Because there is a difference between development of soils and vegetation ecosystems between ridge tops and valley floors over much of the region, the physiographic component was incorporated by sampling either from ridge tops or valley floors in alternate

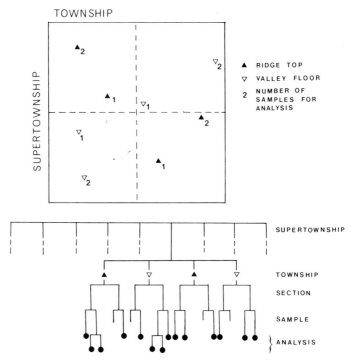

Fig. 2.9 Analysis of variance design for regional sampling of surface soils in the Piceance Creek Basin, Colorado (after Ringrose *et al.*, 1976; Klusman *et al.*, 1980).

townships (Fig. 2.9). To reduce the analytical load and costs, one of the four samples collected per township was randomly eliminated. The total number of samples used for analysis was thus $\frac{3}{4}(9 \times 4 \times 2 \times 2) = 108$. Of these, 32 were randomly selected for duplicate analysis, making a total of 140.

Analysis of variance (see Ringrose *et al.*, 1976; Klusman *et al.*, 1980, for details) showed that of the 37 elements studied, 27 have significant variance components at the section level. Taking Cu as a typical example, the percentage of the total variance associated with each level in the design was as follows (Ringrose *et al.*, 1976):

Between ridge tops and valley bottoms:	0%
Between supertownships (> 19 km):	$28\%*$
Between townships (3–19 km):	0%
Between sections (0.1–3 km)	$18\%*$
Between samples (0–100 m):	1%
Analytical error:	52%
	100%

* Indicates component significantly different from zero at the 0.05 probability level.

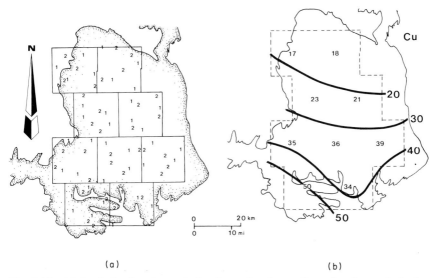

(a) (b)

Fig. 2.10 (a) Analysis of variance design for regional sampling of surface soils in the Piceance Creek Basin. Showing location of supertownships, sampling localities, and number of samples used for analysis. Lower contact of the Green River Formation shown stippled. (b) Contoured regional distribution of Cu (ppm) based on supertownship means (after Ringrose *et al.*, 1976).

These results suggest that, despite the analytical variability, a valid map can be constructed since there is a significant variance component at the supertownship level, but that resolution will be poor because there is also a significant component of variability on smaller geographic (section) scales. By averaging the data for each supertownship, a true regional trend is obtained (Fig. 2.10b). Map resolution could only be improved by sampling at closer sample spacings (e.g., below 3 km).

One of the practical difficulties in relation to environmental studies posed by such low-density sampling may be illustrated by returning to the Missouri study. A study of uncultivated B-horizon soils from the areas occupied by the six vegetation types (glaciated prairie, unglaciated prairie, oak–hickory forest, oak–hickory–pine forest, cedar glade, and flood plain forest) was based on sampling five randomly selected sites within each of 10 randomly selected $7\frac{1}{2}$-minute quadrangles (c. 100 km^2) in each of the 6 vegetation-type areas (Shacklette *et al.*, 1971), yielding a total of 300 soil samples for analysis. The variance components for Pb showed that the percentage contributions to the total variance were: between vegetation types, 7; between quadrangles, 10; between sites, 59; and between analyses, 24 (Shacklette *et al.*, 1971). Mapping of the geometric mean concentrations of Pb in the five samples from each $7\frac{1}{2}$-

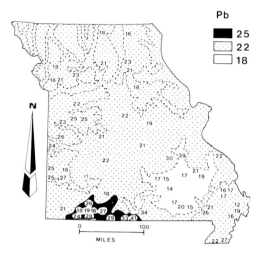

Fig. 2.11 Vegetation-type areas in Missouri classified according to geometric mean concentration of Pb (ppm) in the B-horizon of uncultivated soils. Each number on the map is the geometric mean concentration of five samples from 60 $7\frac{1}{2}$-minute quadrangles (after Shacklette *et al.*, 1972).

minute quadrangle (Fig. 2.11) shows no particularly strong spatial trend (as might be expected from the analysis of variance results); however, tests of the significance of the difference between mean lead levels in the six vegetation types using the Duncan multiple range test (Duncan, 1955; see Miesch 1976a,b, or Klusman *et al.*, 1980, for discussion) showed that two units, the cedar glade and oak–hickory forest with geometric means of 25 and 18 ppm Pb, respectively, were significantly different from the other four vegetation-type areas (Fig. 2.11). Comparison with Fig. 2.6 shows that *none* of the randomly selected quadrangles reflected the anomalously high lead values in the flood plain soils, and that this environmentally important factor could have been missed completely had not the independent study with high sample density been carried out.

It is concluded that, although the costs of compiling sufficiently detailed maps for a large region may be daunting, extrapolation and ultra-low-density hierarchical sampling approaches can at best provide no more than a very broad initial guide to areas within which more detailed surveys may be required. Furthermore, quite extensive geochemical patterns of environmental significance could remain undetected. These methods would therefore seem to be most applicable in those areas of the world where there are extensive relatively homogenous geological, pedological, and environmental units. They would not be applicable, however, in many countries, such as the United Kingdom, where the geology, soil type, and other factors vary rapidly on a

small scale. However, the methodology of unbalanced sampling design may have much to offer in the planning of initial reconnaissance or detailed follow-up studies in many areas.

2. Stream sediment surveys

Provided that the drainage network and access are suitable, stream sediment surveys are generally able to achieve a relatively even coverage of samples. First- or second-order tributary drainage is generally preferred in order to keep the catchment area relatively small. Costs in terms of field access, sampling and analysis are low. The majority of surveys for regional multi-element reconnaissance work are generally undertaken at nominal densities in the range 2–25 km^2 per sample (Fig. 2.3). Surveys of this type have been carried out in many parts of the world since the work by H. E. Hawks, J. S. Webb and others in the mid-1960s and are now a relatively standard technique. Several examples are cited in Webb and Howarth (1979).

Results for relatively small geographic areas are generally presented in the form of "point symbol" maps with a graded or proportionally sized symbol referring to the element concentration level at the sampling site. Figure 2.12 shows the distribution of Ni in stream sediments over a serpentinite in Quebec. The ultrabasic rocks are clearly identifiable from the very high Ni values in the streams draining off the serpentinite, which forms the highest ground in the area. Note the relatively short distance in which the values fall off to "background" levels once the geological boundary has been crossed.

In mapping larger geographic areas, however, it becomes difficult to represent individual sample sites adequately on map scales of 1:0.5M to 1:2M, and moving average smoothed regional maps are generally preferred. The effectiveness of very local smoothing in improving the visibility of the regional trends is apparent from comparison of unsmoothed and smoothed maps for the zinc distribution in stream sediments taken over England and Wales shown as coloured maps in Webb *et al.* (1978) and Webb and Howarth (1979). Plates 2.1 and 2.2 show the regional, moving average smoothed, distributions of Cu and Mo in c. 50 000 stream sediments for the whole of England and Wales; their applications are discussed in the following section.

The compilation of regional geochemical atlases based on stream sediments on synoptic scales in the United Kingdom (Webb *et al.*, 1973, 1978; Plant and Moore, 1979) and elsewhere (e.g., Baldock, 1977; Bolivar, 1980; Geological Survey of Uganda, 1973; Herzberg, 1980; Meyer *et al.*, 1979; Scott and Walker, 1980; Xie *et al.*, 1981) has shown that this approach to regional geochemical mapping has now become established as a useful tool in many areas of the world. The results to date have confirmed the value of the multi-

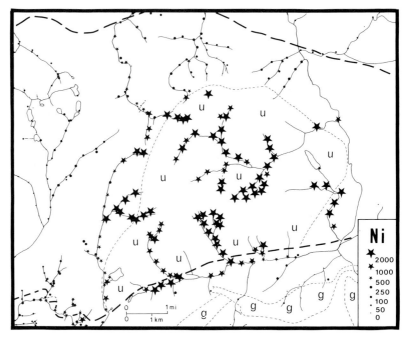

Fig. 2.12 The distribution of Ni (ppm) in stream sediments in the Mont Albert area, Gaspe Peninsula, Quebec. U = serpentinite, g = granites; otherwise, volcanic and sedimentary rocks. Faults shown as bold dashed lines (after Tremblay *et al.*, 1975).

element regional atlas based on stream sediment sampling as a rapid low-cost technique which is yielding maps of use in the study of trace element disorders in agriculture, regional pollution studies, river and estuarine fisheries problems, water supplies, public health and land use (Thornton and Webb, 1979).

IV. Regional geochemical mapping and its applications in the UK

1. Regional geochemical maps

The need for systematic geochemical data in the United Kingdom has been met in part by geochemical surveys carried out by the Applied Geochemistry Research Group (AGRG) of Imperial College, and the Institute of Geological Sciences (IGS); the data obtained by these surveys are available in published atlases and in machine readable form. The methods used in compiling the atlases—their development, advantages and limitations—have been described in detail by Webb and Howarth (1979) and Plant and Moore (1979) and are only briefly summarized in this chapter.

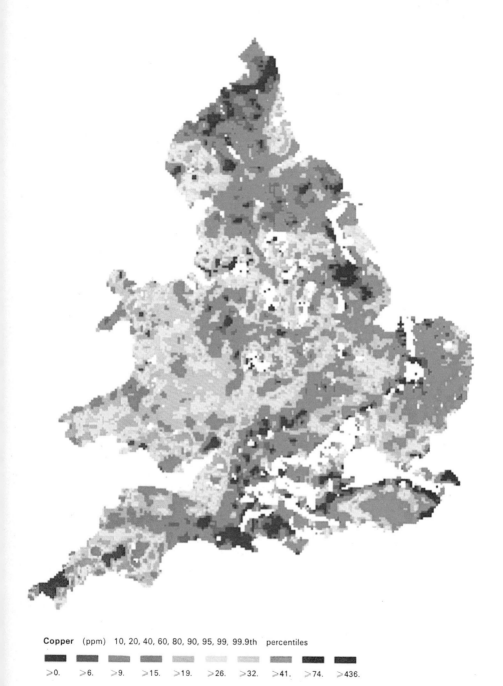

Copper (ppm) 10, 20, 40, 60, 80, 90, 95, 99, 99.9th percentiles

⩾0. ⩾6. ⩾9. ⩾15. ⩾19. ⩾26. ⩾32. ⩾41. ⩾74. ⩾436.

Plate 2.1 Map showing the distribution of Cu(ppm) in stream sediments in England and Wales (reproduced from Webb *et al.* (1978) by permission of Oxford University Press).

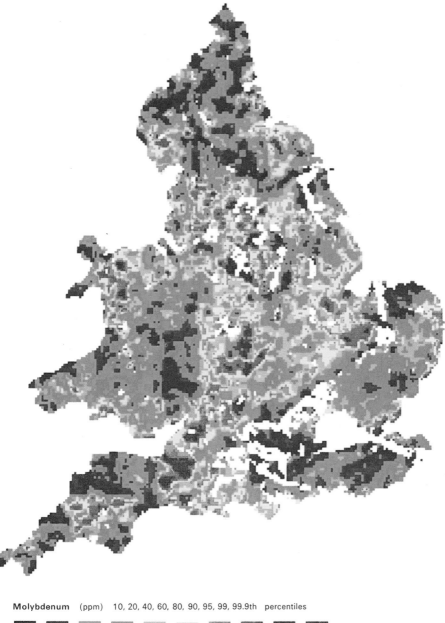

Molybdenum (ppm) 10, 20, 40, 60, 80, 90, 95, 99, 99.9th percentiles

⩾0.0 ⩾0.5 ⩾0.6 ⩾0.9 ⩾1.1 ⩾1.4 ⩾1.8 ⩾2.2 ⩾3.6 ⩾7.4

Plate 2.2 Map showing the distribution of Mo(ppm) in stream sediments in England and Wales (reproduced from Webb *et al.* (1978) by permission of Oxford University Press).

These geochemical surveys are based mainly on the systematic collection and analysis of stream sediment samples. Each sample of sediment reflects the mean concentration of elements in the catchment area (Hawkes and Webb, 1962). Water samples are also collected by the IGS for elements such as U and Zn which tend to be relatively soluble in surface waters, whereas measurements such as pH, conductivity, total dissolved carbonate, fluorine and total activity are made in the field or field laboratory. The samples of stream sediments have been analysed using low-cost high-productivity methods, such as direct reading or induction-coupled plasma spectrometry, for up to 30–35 chemical elements. Large quantities of data are generated by the geochemical surveys and automated methods of data handling and cartography have been developed to prepare summary statistics and maps of the distribution of elements or element associations (Howarth and Martin, 1979; Green, 1979).

The first trial surveys by AGRG in 1965 over 2800 sq. miles in England and Wales led to the recognition of broad-scale patterns of metal distribution reflecting both the composition of bedrock and soil and indicating specific geochemical facies within individual geochemical formations (Nichol et al., 1970a,b; 1971). A further geochemical survey was conducted by the AGRG in 1967 over the 5000 sq. miles of Northern Ireland in order to assess the problems of sampling, analysis and data handling involved in such a large-scale exercise, and a geochemical atlas of the province including maps for 20 elements was published at a scale of 1 in.:10 miles (Webb et al., 1973). The survey over the 64 000 sq. miles of England and Wales was carried out in 1969, and involved the collection of c. 50 000 stream sediment samples over a 10-week period. Large-scale maps (10 mi:1 in., 1:633 600 and 4 mi:1 in., 1:253 440) were placed on open-file at Imperial College in 1972–73. The Wolfson Geochemical Atlas of England and Wales at a scale of 1:2 million (Webb et al., 1978) comprises maps for 21 elements including those for Cu and Mo illustrated in Plates 2.1 and 2.2. The data for each element were presented in maps prepared using local moving-average data smoothing to reduce "noise" due to sampling and analytical error; this procedure also removes small-scale geochemical features that would relate to a specific farm or field, and is thus most appropriate for indicating broad-scale regional geochemical variation. Plots based on both empirical and percentile class intervals were included in the Wolfson Geochemical Atlas, and in addition maps showing the distribution of multi-element associations (e.g., Cu–Pb–Zn) by using a combination of 2 or 3 colours, each representing the distribution of an individual element.

The IGS survey is designed to produce larger scale maps, with point-source data at a scale of 1:250 000 and is based on specially designed sampling and analytical procedures (Plant, 1971) with stringent monitoring of procedural error (Plant, 1973; Plant et al., 1975). The distribution of each element is

shown on separate maps by lines proportional to the element concentration. The geochemical data are plotted in black over a modern compilation of the geology prepared by automated methods as a single colour plot. In addition, contour maps and geochemical "landscapes" prepared at an approximate scale of 1:625 000 and again using moving-average techniques are included in the most recent atlas to indicate broad-scale geochemical trends. Geochemical atlases have been published for Shetland, Orkney, South Orkney, Caithness and Sutherland (IGS, 1978a,b; 1979; 1983). Geochemical data in machine-readable form are available for most of the northern Highlands of Scotland and work on southern Scotland and the English Lake District has commenced. It is intended to extend the programme over the rest of Scotland and England and Wales.

A summary of chemical elements available in the published geochemical atlases in the United Kingdom is given in Table 2.1.

2. Interpretation

The geochemical maps for Britain reflect closely changes in bedrock composition and allow the geochemical characterization of the three main physiographic/geological regions described in Chapter 1.

In favourable circumstances, geochemical mapping is capable of indicating changes in the chemical composition of bedrock and hence soils, vegetation and water, which could not be deduced from other sources such as the geological map. There are many difficulties, however, in relating biological and geochemical activity of trace elements to the total concentrations indicated on geochemical maps. Some of the inorganic factors that affect the solubility and availability of trace elements shown on geochemical maps are discussed by Plant and Moore (1979), and Thornton and Plant (1980), and are detailed in Chapter 1 of this volume. There are, however, considerable gaps in the knowledge of processes in the surface weathering environment, particularly on the stability and rates of weathering of primary and secondary mineral phases, on the thermodynamic and kinetic factors which affect the reactions, and on the forms and chemical speciation of elements and their synergistic effects in surface waters and soils.

Research into the interpretation and application of geochemical maps to plant, animal and human health has been undertaken primarily in England and Wales and has been reviewed by Thornton and Webb (1979) and Thornton and Plant (1980).

3. Agriculture

The geochemical maps of Britain has confirmed relationships between regional geochemical data and the known distribution of a number of

Table 2.1 Summary of chemical elements available in geochemical atlases of the UK

Author	Published atlases	Elements
Applied Geochemistry Research Group, Imperial College	Northern Ireland	Al, As, Ba, Ca, Cr, Co, Cu, Ga, Fe, Pb, Mg, Mn, Mo, Ni, K, Sc, Si, Sr, V, Zn
	England and Wales	Al, As, Ba, Cd, Ca, Cr, Co, Cu, Ga, Fe, Pb, Li, Mn, Mo, Ni, K, Sc, Sr, Sn, V, Zn
Institute of Geological Sciences	Shetland	Ba, Be, B, Cr, Co, Cu, Fe_2O_3, Pb, Mn, Mo, Ni, U, V, Zn, Zr
	Orkney	Ba, Be, B, Cr, Co, Cu, Fe_2O_3, Pb, Mn, Mo, Ni, U, V, Zn, Zr
	South Orkney and Caithness	Ba, Be, B, Cr, Co, Cu, Fe_2O_3, Pb, Mn, Mo, Ni, Sr (partial data), TiO_2 (partial data), U, V, Zn, Zr
	Sutherland	Be, B, Cr, Co, Cu, Fe_2O_3, Pb, Mn, Mo, Ni, U, V, Zn, Zr
	Atlases on Open File	
	Lewis/Little Minch	Ba, Be, Bi, B, CaO, Cr, Co, Cu, Fe, K_2O, La, Pb, Li, MgO, Mn, Mo, Ni, Sr, TiO_2, U, V, Y, Zn, Zr
	Great Glen	Ba, Be, Bi, B, CaO, Cr, Co, Cu, Fe, K_2O, La, Pb, Li, MgO, Mn, Mo, Ni, Sr, TiO_2, U, V, Y, Zn, Zr
	Provisional maps available for purchase through NGDB	
	Argyll	Ba, Be, Bi, B, CaO, Cr, Co, Cu, Fe, K_2O, La, Pb, Li, MgO, Mn, Mo, Ni, Sr, TiO_2, U, V, Y, Zn, Zr
	Moray/Buchan	F

agricultural disorders, and have also indicated further suspect areas requiring detailed investigations. Of those elements included in the geochemical atlases, Cu, Co, Fe, Mn, Mo and Zn have long been recognized as essential for agricultural production. On the other hand, As, Cd, Cr, Cu, Ni, Pb, Zn and Mo if present in abnormally large amounts may adversely affect crop and animal health and production. Factors influencing the relationships between trace elements in the rock–soil–plant–animal relationship are complex and have been discussed by Thornton and Webb (1979) and are detailed in Chapter 8 of

this volume, together with the applications of the geochemical maps for several of the above elements.

The map for Mo in England and Wales (Plate 2.2) provides a good example and has considerable practical significance. Excess Mo in the soil and pasture may result in dietary excess to grazing cattle, leading to an induced Cu deficiency which can affect growth, maturity and production. An intensive study was undertaken in central England, where stream sediment reconnaissance indicated Mo anomalies extending to 150 km^2, in areas underlain by Carboniferous black shale of marine origin. Clinical symptoms of Cu deficiency had previously been recognized on a few farms within 25 km^2 of the area, but a subsequent survey of blood samples showed over 70% of the cattle in the entire high Mo pattern to be deficient in Cu. Although showing no clinical signs, these animals responded to Cu supplementation, with live weight gains of 30–70 lb per animal over a 6-month grazing season (Thornton et al., 1972). The Mo map shows similar suspect areas mostly underlain by marine black shales, totalling over 400 000 hectares (c. 1 000 000 acres) (Thompson et al., 1972; Thornton and Webb, 1975a).

The maps have also disclosed trace element patterns related to deficiencies of Co, Cu and Mn, and toxicities of As, Cu, Pb and Zn in crops or animals (Thornton and Webb, 1970, 1979).

4. Pollution

High concentrations of some metals in the environment may endanger the health of plants and animals and may also affect the suitability of foodstuffs and water supplies for human consumption. Metals such as Cd and Pb may be present as pollutants from industry or originate from the weathering products of natural metal-rich bedrocks. In order to evaluate man's contribution of such metals as contaminants, it is important to establish natural variations in metal distribution related to the geochemical composition of rock and soil.

The geochemical reconnaissance maps provide a useful catalogue of baseline information and at the same time highlight specific areas contaminated by past metalliferous mining and smelting and by present-day industry and urbanization (Thornton, 1975; Thornton and Webb, 1975b).

The Wolfson Geochemical Atlas has highlighted the principal mineralized areas in England and Wales. The map for Pb (Fig. 2.13) has drawn attention to extensive areas of contaminated agricultural soils, including an area of c. 250 km^2 in the mineralized areas of Derbyshire in Central England, where soils contain from several hundred to several thousand ppm Pb, with up to 3% Pb close to old workings and smelters (Colbourn, 1976). The normal amount in uncontaminated UK soils is in the range 10–150 ppm Pb. The map for Cd

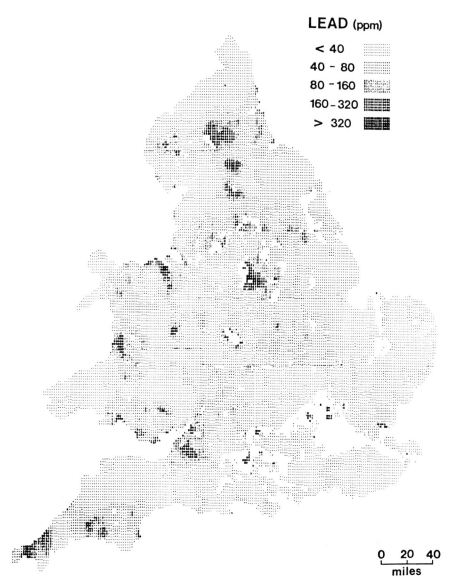

LEAD (ppm)

< 40

40 - 80

80 - 160

160 - 320

> 320

0 20 40
miles

Fig. 2.13 The distribution of Pb in stream sediments over England and Wales (ppm) (compiled by the Applied Geochemistry Research Group as part of the Wolfson Geochemical Atlas of England and Wales; Webb *et al.*, 1978).

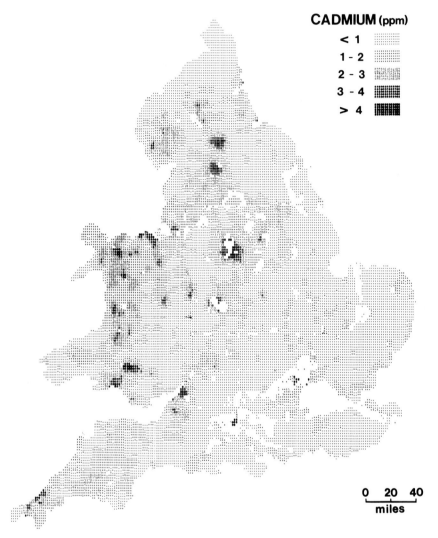

Fig. 2.14 The distribution of Cd in stream sediments over England and Wales (ppm).

(Fig. 2.14) discloses anomalous patterns due to contamination from past mining and smelting and from present-day industrial sources, and to natural Cd-rich soils derived from Carboniferous black shales (Marples and Thornton, 1980). In particular this map was instrumental in focusing attention on the extremely large amounts of Cd in soils around old Zn mines at Shipham, Somerset, leading to detailed agricultural and environmental health studies described in Chapters 8 and 10 of this volume.

Investigations have been carried out in several geochemically anomalous areas disclosed by the Wolfson Geochemical Atlas to determine possible effects on the composition of food crops. Although agricultural and horticultural soils sometimes contain heavy metals and As in very large amounts, particularly in old mining areas (over 4000 km^2 in England and Wales), metal uptake and translocation to the edible parts of barley, lettuce and strawberries (and pasture grass) was generally small and does not seem to pose an obvious threat to the local communities (Thoresby and Thornton, 1979).

5. Water supplies

Studies into the applications of geochemical reconnaissance maps to water quality assessment have been encouraging. As a follow-up to the maps published in the Wolfson Geochemical Atlas, studies in four metal contaminated and uncontaminated river systems in southwest England have shown that high concentrations of Cu, Pb and Zn are more likely to occur in the water of streams and rivers with higher than normal contents in the sediment (Aston *et al.*, 1974; Thornton and Webb, 1977). There is also a particular interest in As in water in southwest England (Fig. 2.15), which was the world's major producer in the latter half of the 19th century.

In this context the maps would seem useful in assisting in the siting of stations for water monitoring, as the sediment provides a more stable index of the metal status of the drainage than the waters themselves. The multi-element stream sediment data also indicate those suspect elements for inclusion in monitoring programmes.

6. Medicine and public health

Relationships between trace elements in the natural environment and human disease are discussed in Chapters 9 and 10. In Britain, local mortality and morbidity statistics are on the whole poor and it is difficult to obtain reliable information for comparison with the geochemical maps. The Wolfson Geochemical Atlas, however, provides a unique source of multi-element data for area selection in food, water and medical surveys, particularly in rural districts.

The map for Pb (Fig. 2.13) has been used to select areas to study the relationship between soil Pb and childhood Pb burdens in Derbyshire. When households were grouped according to the Pb content of their garden soils, Pb in the blood and hair of 2–4-year-old children increased with that in soil and house dust. However, none of the Pb values in children was high enough to be considered hazardous at that time, even though the amounts in soil and dust

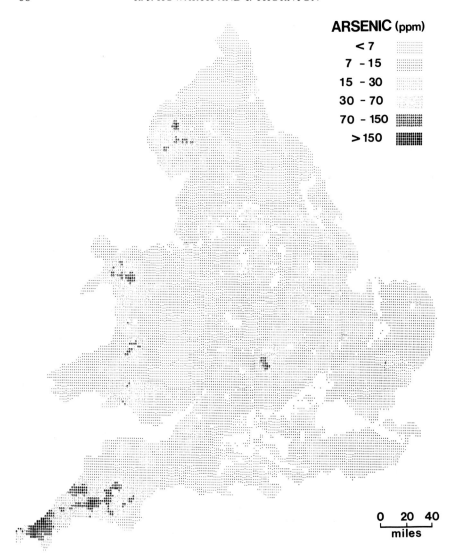

Fig. 2.15 The distribution of As in stream sediments over England and Wales (ppm).

were extremely high, peaking at 2.8 and 2.5% Pb, respectively (Barltrop *et al.*, 1975). The children's Pb status does, however, reflect that in the environment and, in the absence of evidence linking the human burden with Pb in foodstuffs or water supplies, it was suggested that the major pathway of Pb into the children is through inhalation and involuntary ingestion of dust particles (Barltrop *et al.*, 1975).

As mentioned above, the Cd map (Fig. 2.14) led to the discovery of extremely large concentrations of Cd and Zn in agricultural and garden soils around the village of Shipham in southwest England, ranging up to 800 $\mu g\ g^{-1}$ Cd and 70 000 $\mu g\ g^{-1}$ Zn (Marples and Thornton, 1980). Metals are present as contaminants from Zn mining activities from 1700 to 1850. Comprehensive environmental health studies in and around the village included detailed sampling of soils, house and road dusts, air and vegetables, a study of diets of the local population, and the measurement of metals and/or various biological indices in blood, urine and hair of adults and children (Thornton *et al.*, 1980; Moorcroft *et al.*, 1982). Unexpectedly perhaps, in view of the high Cd exposure, there were no obvious health effects in those members of the population studied (Strehlow *et al.*, 1983).

The application of geochemistry to health is a research area of growing interest in Britain and it is envisaged that more studies will be undertaken in the future.

7. Other applications

Regional geochemical data in Britain have also been used to define metal-rich drainage inputs to estuaries used for shellfish culture (Thornton *et al.*, 1975), and provide a valuable guide to area selection for many aspects of ecological and environmental research.

Mining history in Britain goes back to Phoenician and Roman times and it is not surprising that regional geochemical maps, such as that for Pb (Fig. 2.13), should have outlined all the old mining districts and that metal patterns have been enhanced by contamination from mining and smelting activities (Webb *et al.*, 1978). More subtle patterns, in areas which because of their geology and potentially favourable for mineralization, could assist in future exploration for types of deposit that were not prospected in the past and could possibly indicate the presence of "blind" deposits in the vicinity of the known mineral districts.

Many of the geochemical patterns reflect the known geology, particularly in drift-free areas covered by residual soil. However, nearly half of England and Wales is covered by superficial deposits and in those areas the patterns reflect the composition of the cover rather than the underlying bedrock. The geochemical maps can assist in defining both the source and extent of this cover. They also provide information on the geographical distribution of elements that would not be suspected from the geological map alone. Concentrations of groups of elements vary not only between individually recognized geological units but also correspond to lithological facies changes in individual igneous, metamorphic or sedimentary formations.

It is thus seen that multi-element regional geochemical maps are strictly complementary to the conventional geological map, in that they add substantially to the understanding of the geology and geochemistry of the country as a whole (Webb, 1970).

V. Conclusions

The multi-element nature of the geochemical data published in the atlases prepared by the Institute of Geological Sciences and the Applied Geochemistry Research Group is stressed. Associations between groups of several trace elements are recognized in stream sediments, soils and sometimes plants associated with particular geological materials. For example, acid-igneous and arenaceous deposits contain potentially deficient amounts of the essential elements Cu, Co, Mn and Zn and sometimes the "newer" essential elements Cr, Ni and V. Carboniferous black shales containing high levels of Mo are also enriched in Se, Cd, Ni, V and Zn. Soils in old metalliferous mining areas are generally contaminated with several of the potentially toxic metals Pb, Zn, Cd, Cu, Sn and As. It is concluded that multi-element associations in the published atlases will continue to be identified using computer-based techniques, and that these associations should be examined in the bedrock–parent material–soil–plant–animal system with the aim of investigating (a) possible combined deficiencies, perhaps at a sub-clinical level, and (b) possible synergistic or antagonistic effects additional to those already known.

Thornton and Webb (1979) concluded:

> "Interpretation of geochemical reconnaissance data is by no means straightforward and their application to agricultural and human problems should therefore be conducted in consultation or preferably collaboration with geochemists with an understanding of their uses and limitations. Provided this is the case, the geochemical atlases will continue to provide a unique source of multi-element data for area selection in food, water and medical surveys, particularly in rural districts."

References

Aston, S. R., Thornton, I. and Webb, J. S. (1974). *Water, Air Soil Pollut.* **3**, 321–325.

Baldock, J. W. (1977). *Trans. Instn. Min. Metall., London* **B86**, 63–72.

Barltrop, D., Strehlow, C. D., Thornton, I. and Webb, J. (1975). *Postgrad. Med. J.* **51**, 801–804.

Beckett, P. (1981). *Agric. Admin.* **8**, 177–208.

Beckett, P. H. T. and Webster, R. (1971). *Soils Fertilisers* **34**, 1–15.

Bolivar, S. L. (1980). "An Overview of the National Uranium Resource Evaluation Hydrogeochemical and Stream Sediment Reconnaissance Program". Los Alamos Scientific Laboratory Informal Report LA-8457-MS, 24pp.

Bølviken, B. and Gleeson, C. F. (1979). *In* "Geophysics and Geochemistry in the Search for Metallic Ores" (Hood, P. J., ed.). Geol. Surv. Can., Econ. Geol. Rept. 31, pp. 295–326.

Bradshaw, P. M. D. and Thompson, I. (1979). *In* "Geophysics and Geochemistry in the Search for Metallic Ores" (Hood, P. J., ed.). Geol. Surv. Can., Econ. Geol. Rept. 31, pp. 327–338.

Brooks, R. R. (1979). *In* "Geophysics and Geochemistry in the Search for Metallic Ores" (Hood, P. J., ed.). Geol. Surv. Can., Econ. Geol. Rept. 31, pp. 397–410.

Cannon, H. L. (1979). *In* "Geophysics and Geochemistry in the Search for Metallic Ores" (Hood, P. J., ed.). Geol. Surv. Can., Econ. Geol. Rept. 31, pp. 385–395.

Castillo-Muñoz, R. (1977). *Rev. Trop. Biol.* **25**, 219–255.

Coker, W. B., Hornbrook, E. H. W. and Cameron, E. M. (1979). *In* "Geophysics and Geochemistry in the Search for Metallic Ores" (Hood, P. J., ed.). Geol. Surv. Can., Econ. Geol. Rept. 31, pp. 435–478.

Colbourn, P. (1976). "The Application of Geochemical Reconnaissance Data to Trace Metal Pollution in Agriculture". Unpublished Ph.D. Thesis, Univ. Lond.

Colbourn, P. and Thornton, I. (1978). *J. Soil Sci.* **29**, 513–526.

Colbourn, P., Alloway, B. J. and Thornton, I. (1975). *Sci. Tot. Envir.* **4**, 359–363.

Dean, W. E., Ringrose, C. D. and Klusman, R. W. (1979). "Geochemical Variation in Soils in the Piceance Creek Basin, Western Colorado". US Geol. Surv. Bull. 1479, 47pp.

Department of Scientific and Industrial Research (DSIR) (1967). "Soil Bureau Atlas". DSIR, Wellington, New Zealand.

Duncan, D. B. (1955). *Biometrics* **11**, 1–42.

Dyck, W. (1979). *In* "Geophysics and Geochemistry in the Search for Metallic Ores" (Hood, P. J., ed.). Geol. Surv. Can., Econ. Geol. Rept. 31, pp 489–510.

Garrett, R. G. and Goss, T. I. (1978). *In* "Geochemical Exploration 1978" (Watterson, J. R. and Theobald, P. K., eds). Assoc. Explor. Geochemists, Toronto, pp. 371–383.

Garrett, R. G. and Goss, T. I. (1980). *Comput. Geosci.* **6**, 35–60.

Geological Survey of Uganda. (1973). "Geochemical Atlas of Uganda". Geological Survey of Uganda, Entebbe, 42pp.

Goss, T. I. and Garrett, R. G. (1978). Amer. Stat. Assoc., Statistical Computing Proceedings, pp. 360–365.

Green, P. G. (1979). Regional Geochemical Mapping. Proc. NERC G-EXEC Users Group Meeting, NERC, London.

Grimmett, R. E. R. (1939). *N.Z. J. Agric.* **58**, 383–391.

Hawkes, H. E. and Webb, J. S. (1962). "Geochemistry in Mineral Exploration". Harper and Row, New York.

Herzberg, W. (1980). *In* "Abstracts, 8th Intern. Geochem. Explor. Symp., Hannover", p. 25. Bundesanstalt für Geowissenschaften und Rohstoffe, Hannover.

Horsnail, R. F., Nichol, I. and Webb, J. S. (1969). *Q. J. Colo. Sch. Mines* **64**, 307–322.

Howarth, R. J. and Martin, L. (1979). *In* "Geophysics and Geochemistry in the Search for Metallic Ores" (Hood, P. J., ed.). Geol. Surv. Can., Econ. Geol. Rept. 31, pp. 545–574.

Institute of Geological Sciences. (1978a). "Geochemical Atlas of Gt. Britain: Shetland Islands". Institute of Geological Sciences, London.

Institute of Geological Sciences. (1978b). "Geochemical Atlas of Gt. Britain: Orkney Islands". Institute of Geological Sciences, London.

Institute of Geological Sciences. (1979). "Geochemical Atlas of Gt. Britain: South Orkney and Caithness". Institute of Geological Sciences, London.

Institute of Geological Sciences. (1983). "Geochemical Atlas of Gt. Britain: Sutherland". Institute of Geological Sciences, London.

Klusman, R. W., Ringrose, C. D., Candito, R. J., Zuccaro, B., Rutherford, D. W. and Dean, W. E. (1980). US Department of Energy Report DOE/EV/10298-2, 180pp.

Kovalsky, V. V. (1970). *In* "Trace Element Metabolism in Animals" (Mills, C. F., ed.), pp. 385–396. Livingstone, London.

Kovalsky, V. V. (1979). *Phil. Trans. R. Soc. Lond.* **B288**, 185–191.

Kubota, J., Lazar, V. A., Langan, L. N. and Beeson, K. C. (1961). *Soil Sci. Soc. Amer. Proc.* **25**, 227–232.

Låg, J. and Bølviken, B. (1974). *Norg. Geol. Unders.* No. 304, pp. 73–96.

Lakin, H. W. (1972). Geol. Soc. Am. Special Paper No. 140, pp. 45–53.

Le Riche, H. H. (1959). *J. Soil Sci.* **10**, 133.

Marples, A. E. and Thornton, I. (1980). *In* "Proc. 2nd Int. Cadmium Conf., Cannes, 1974". Metal Bulletin Ltd, London.

Meyer, W. T., Theobald, P. K. Jr and Bloom, H. (1979). *In* "Geophysics and Geochemistry in the Search for Metallic Ores" (Hood, P. J., ed.). Geol. Surv. Can., Econ. Geol. Rept. 31, pp. 411–434.

Miesch, A. T. (1967a). "Theory of Error in Geochemical Data". US Geol. Surv. Prof. Pap. 574-A, 17pp.

Miesch, A. T. (1967b). "Methods of Computation for Estimating Geochemical Abundance". US Geol. Surv. Prof. Pap. 574-B, 15pp.

Miesch, A. T. (1976a). "Geochemical Survey of Missouri—Methods of Sampling, Laboratory Analysis and Statistical Reduction of Data". US Geol. Surv. Prof. Pap. 954-A, 39pp.

Miesch, A. T. (1976b). "Sampling Designs for Geochemical Surveys—Syllabus for a Short Course". US Geol. Surv. Open-file Rept. 76-772, 130pp.

Miller, W. R. (1979). *In* "Geophysics and Geochemistry in the Search for Metallic Ores" (Hood, P. J., ed.). Geol. Surv. Can., Econ. Geol. Rept. 31, pp. 479–487.

Mitchell, R. L. (1964). *In* "Chemistry of the Soil" (Bear, F. E., ed.), 2nd Edn, pp. 320–368. Reinhold Publ. Co., New York.

Mitchell, R. L. (1974). *Neth. J. Agric. Sci.* **22**, 295–304.

Moorcroft, S., Watt, J., Thornton, I., Wells, J., Strehlow, C. D. and Barltrop, B. (1982). *In* "Trace Substances in Environmental Health XVI" (Hemphill, D. D., ed.). University of Missouri, Columbia.

Nichol, I., Thornton, I., Webb, J. S., Fletcher, W. K., Horsnail, R. F., Khaleelee, J. and Taylor, D. (1970a). "Regional Geochemical Reconnaissance of the Derbyshire Area". Rep. No. 70/2, Inst. Geol. Sci., London.

Nichol, I., Thornton, I., Webb, J. S., Fletcher, W. K., Horsnail, R. F., Khaleelee, J. and Taylor, D. (1970b). "Regional Geochemical Reconnaissance of the Derbyshire Area". Rep. No. 70/8, Inst. Geol. Sci., London.

Nichol, I., Thornton, I., Webb, J. S., Fletcher, W. K., Horsnail, R. F. and Khaleelee, J. (1971). "Regional Geochemical Reconnaissance of Part of Devon and North Cornwall". Rep. No. 71/2, Inst. Geol. Sci., London.

Nolan, G. A. (1976). *J. Geochem. Explor.* **6**, 193–210.

Peterson, P. J. (1979). *Phil. Trans. R. Soc. Lond.* **B288**, 169–177.

Plant, J. (1971). *Trans. Instn. Min. Metall.* **B80**, 324–344.

Plant, J. (1973). *Trans. Instn. Min. Metall.* **B82**, 64.

Plant, J. and Moore, P. J. (1979). *Phil. Trans. R. Soc. Lond.* **B288**, 95–112.

Plant, J., Jeffrey, K., Gill, E. and Page, C. (1975). *J. Geochem. Explor.* **4**, 467–486.

Ringrose, C. D., Klusman, R. W. and Dean, W. E. (1976). *In* "Geochemistry of the Western Energy Regions". Third annual progress report. US Geol. Surv. Open-file Rept. 76-729, pp. 101–111.

Scott, P. A. and Walker, K. R. (1980). *In* "Abstracts, 8th Intern. Geochem. Explor. Symp., Hannover", p. 110. Bundesanstalt für Geowissenschaften und Rohstoffe, Hannover.

Shacklette, H. T., Erdman, J. A. and Keith, J. R. (1971). *In* "Geochemical Survey of Missouri. Plans and Progress for Fourth Six-Month Period (January–June, 1971)". US Geol. Surv. Open-file Rept., pp. 27–46.

Shacklette, H. T., Erdman, J. A. and Keith, J. R. (1972). *In* "Geochemical Survey of Missouri. Plans and Progress for Sixth Six-Month Period (January–June, 1972)". US Geol. Surv. Open-file Rept., pp. 58–79.

Strehlow, C. A., Wells, J., Barltrop, D., Moorcroft, S., Watt, J. and Thornton, I. (1983). "Minerals and the Environment". In press.

Thompson, I., Thornton, I. and Webb, J. S. (1972). *J. Sci. Fd Agric.* **23**, 871–891.

Thoresby, P. and Thornton, I. (1979). *In* "Trace Substances in Environmental Health XIII" (Hemphill, D. D., ed.). University of Missouri, Columbia.

Thornton, I. (1975). *In* "Minerals and the Environment" (Jones, M. J., ed.), pp. 87–102. Institute of Mining and Metallurgy, London.

Thornton, I. and Plant, J. (1980). *J. Geol. Soc. London* **137**, 575–586.

Thornton, I. and Webb, J. S. (1970). *In* "Trace Element Metabolism in Animals". Proc. WAAP/IBP Int. Symp. (Mills, C. F., ed.), pp. 397–407. Livingstone, London.

Thornton, I. and Webb, J. S. (1975a). "Proc. Copper in Farming Symp". Copper Development Association, London.

Thornton, I. and Webb, J. S. (1975b). *In* "Trace Substances in Environmental Health IX" (Hemphill, D. D., ed.), pp. 77–88. University of Missouri, Columbia.

Thornton, I. and Webb, J. S. (1977). *J. Inst. Wat. Engrs. Scient.* **31**, 11–25.

Thornton, I. and Webb, J. S. (1979). *Phil. Trans. R. Soc. Lond.* **B288**, 151–168.

Thornton, I. and Webb, J. S. (1980). *In* "Applied Soil Trace Elements" (Davies, B. E., ed.), pp. 381–439. John Wiley, London.

Thornton, I., Kershaw, G. F. and Davies, M. K. (1972). *J. Agric. Sci. Camb.* **78**, 157–171.

Thornton, I., Watling, H. and Darracott, A. (1975). *Sci. Total Envir.* **4**, 325–345.

Thornton, I., Moorcroft, S., John, S., Watt, J., Strehlow, C. D., Barltrop, D. and Wells, J. (1980). *In* "Trace Substances in Environmental Health XIV" (Hemphill, D. D., ed.), pp. 27–37. University of Missouri, Columbia.

Tidball, R. R. (1972). *In* "Geochemical Survey of Missouri. Plans and Progress for Sixth Six-Month Period (January–June, 1972)". US Geol. Surv. Open-file Rept., pp. 19–57.

Tourtelot, H. A. and Miesch. A. T. (1975). *Geol. Soc. Amer. Spec. Pap.* **155**, pp. 107–118.

Tremblay, R. L., Cockburn, G. H. and Lalonde, J. P. (1975). "Stream Sediment Geochemistry of the Mount Albert Area". Government of Quebec, Mineral Deposits Service, Geochemical Section Report ES-19, 20pp., 7 maps.

Webb, J. S. (1970). *Proc. Geol. Assoc.* **81**, 585.

Webb, J. S. and Howarth, R. J. (1979). *Phil. Trans. R. Soc. Lond.* **B288**, 81–93.

Webb, J. S., Nichol, I., Foster, R., Lowenstein, P. L. and Howarth, R. J. (1973). "Provisional Geochemical Atlas of Northern Ireland". Applied Geochemistry Research Group, Imperial College of Science and Technology, London, 36pp.

Webb, J. S., Thornton, I., Thompson, M., Howarth, R. J. and Lowenstein, P. L. (1978). "The Wolfson Geochemical Atlas of England and Wales". Clarendon Press, Oxford, 70pp.

Wells, N. (1967). *NZ J. Geol. Geophys.* **10**, 198–208.

Xie, X., Sun, H. and Li, S. (1981). *J. Geochem. Explor.* **15**, 489–506.

Zýka, V. (1972). Thallium in plants from Alšar. Sborn. *Geol. Ved. Tech. Geochem.* No. 10, 91–95.

3

Analytical Methods in Applied Environmental Geochemistry

MICHAEL THOMPSON

I. The development of analytical geochemistry

Geochemical surveys were first undertaken for mineral exploration purposes, when samples of rock, soil, stream sediment and herbage representing relatively large areas were analysed to provide reconnaissance information on a broad scale. Areas that contained unusually high concentrations of relevant metals were identified, and subsequently examined in greater detail with a view to establishing their mode of origin, and where possible, finding the exact location of any related mineral deposits. When a small, easily obtainable sample of, for example, soil, sediment or herbage is taken to reflect the geochemical nature of a large area (perhaps 1 km^2 or more) sampling variations are necessarily large. Thus there is little point using analytical methods with a variance markedly better than the sampling variance. This factor, in combination with the absolute necessity for cost-effectiveness in all stages of mineral exploration, has given rise to a special brand of analysis by which many samples are analysed with a rapid turnaround, in which unnecessarily precise methods are avoided, and time-consuming and labour-intensive refinements eliminated (Webb and Thompson, 1977). However, far from leading to careless work and correspondingly unreliable data, this approach has led to a keen appreciation by the analysts of the real requirements of those interpreting the data, a disciplined and critical approach towards the analytical methods that is sometimes found lacking in other fields of endeavour, and a prodigious output of data.

Investigations into the applications of geochemical surveys to the environ-

APPLIED ENVIRONMENTAL GEOCHEMISTRY
ISBN 0-12-690640-8

ment were initiated when it was realized that systematic regional data originally collected for exploration purposes contained additional information of direct use to studies into the occurrence of trace element disorders in farm livestock and crops, and trace element related diseases in man, and at the same time could identify areas of both natural and man-made metal pollution. As the sampling methods developed were often very similar to those used in mineral exploration, many analytical methods could be used unchanged, and the essential characteristic of surveys producing large numbers of samples remained unchanged. However, there are features of environmental science which are inherently more demanding on the analyst than mineral exploration, where the main purpose is to identify the small proportion of anomalously high samples. In exploration surveys, the "background" samples are then of no further interest, and it matters little if they are not accurately determined, or values fall even below the detection limit of the method.

In environmental geochemistry, however, the "background" levels are of great interest in themselves and must be accurately determined. Indeed, anomalously *low* areas are also of considerable interest for studying trace element deficiencies. In addition, environmental analysis is much more open to public scrutiny and even legal action, so that the requirement of comparability of accuracy between different laboratories and various methods is much more evident. In contrast, nearly all exploration work is surrounded by secrecy, and only consistency *within* a single laboratory is required. As a result of these changing requirements, practitioners of analysis in the field of applied geochemistry have had to provide a remarkable improvement in the quality of the analysis (at least in terms of accuracy at low levels), at the same time retaining the high productivity and cost-effectiveness characteristic of mineral exploration.

As a consequence of the requirement for cost-effectiveness, applied geochemistry tends to employ analytical methods with a high rate of throughput. High capital cost of equipment is not a restricting factor if the cost can be distributed over many samples. This has, in fact, been the trend as successively more powerful methods have been employed, with a progression from colorimetric methods (from 1940), to atomic absorption spectrophotometry (AAS) (introduced in the early 1960s) and increasingly to inductively coupled plasma optical emission spectrometry (ICP) (first used in the late 1970s). These methods, although powerful, cannot in themselves determine the speciation of elements present, and the applied geochemist often has to employ indirect methods of inferring speciation by, for instance, a consideration of equilibrium constants, or the use of selective extraction procedures. There is a strong current trend towards the search for methods that enable various species to be determined.

Although most of the routine analytical procedures can be used with safety

and success by trained but not necessarily qualified personnel, the presence of a professional analytical chemist in a supervisory capacity is regarded as a requisite, because of the unexpected difficulties that can arise in any kind of analytical work.

II. Sample decomposition procedures

At present, the analytical methods most frequently used in applied geochemistry require decomposition of solid samples and liberation of the analyte elements into solution, before determination can be conducted, for example by AAS or ICP. For elements of very low abundance, preconcentration procedures may need to be carried out to bring the analyte concentrations within the working range of the methods. This is a routine requirement for example in the determination of heavy metals in water. There is a general trend for these chemical manipulations before instrumental determination to be reduced in scale and complexity, and for minimal quantities of reagents to be used. Several benefits result from this trend. Small scale working implies saving in the use of costly reagents, and a reduction in the environmental impact of analysis, for example, the emission of acid fumes from digestions. Again, the small scale enables space, especially fume cupboard space, to be used more effectively, and smaller quantities of reagents mean lower reagent blanks. The increasing use of the ICP, with its low sample volume requirement, tends to reinforce this trend.

The requirements of sample decomposition in environmental geochemistry are less exacting than those in exploration work because minerals that require rigorous conditions to solubilize them are unlikely to have any environmental impact. (This is not universally true, however. Some plants can take up Sn from soils containing cassiterite, but the mineral is unaffected by the normal acid mixtures.) Nevertheless, the methods requiring strong mineral acids are regularly used, perhaps because the results are more reproducible and easy to interpret. Selective extraction procedures, employing milder reagents to solubilize that fraction of the analyte which is in a specific chemical form or in a particular phase, give results that are more related to environmental processes, such as the uptake of elements by plant roots. However, they are rarely specific for a particular form of the element, and rather imprecise, in that they have arbitrary limits of reagent concentrations, temperature, and duration of the exposure of the sample. Thus their effectiveness may vary from sample to sample in an unpredictable way, in contrast to the so-called "total" attacks based on strong acids. Fusion attacks are seldom required in analysis of environmental materials.

1. Decomposition vessels

Most sample decomposition is carried out in borosilicate glassware. Wherever possible, test-tubes are used as they can be handled in large batches without occupying a large working area. A convenient type of tube is a medium-wall rimless type, size 190 × 15 mm. These are suitable for sample weights between 0.1 and 0.5 g. Usually the whole decomposition plus the determination is carried out in the same tube. This minimizes loss of trace elements through exposure to large surfaces, and also the risk of contamination through excessive handling. For selective extractions, where a common procedure requires shaking a relatively large sample at room temperature, the decompositions are carried out in wide-mouth screw cap bottles of borosilicate glass or polypropene (50 ml or 100 ml). After the attack the solution containing the extracted elements is decanted into disposable polystyrene 10 ml centrifuge tubes for centrifuging and instrumental analysis. Some brands of polystyrene tubes can be used direct from the sealed packs, as no detectable quantities of trace elements can be leached from them by mild reagents, such as dilute acids. This may not be true of all brands, and care is needed to ensure that the quality of the tubes remains consistently high.

Decompositions involving hydrofluoric acid are most conveniently carried out in small (50 ml) polytetrafluorethylene (PTFE) beakers, which can be heated in reasonably large batches on suitable hot plates. The beakers are completely unaffected by regular exposure to strong mineral acids, including hydrofluoric and perchloric acids, and use at temperatures up to at least 200°C.

Cleaning of glassware and PTFE-ware that is in regular use does not require such stringent treatment as normally undertaken, except in water analysis. New glassware can be treated with a warm solution of laboratory detergent to remove gross mechanical dirt, and subsequently soaked in dilute nitric acid to remove adsorbed trace elements. Vessels in regular use do not seem to get seriously contaminated, even by samples containing high concentrations of analyte, so that cleaning is straightforward. After unused liquid has been poured away, solid residue is washed out with a jet of tap water. The tube is then rinsed successively with dilute nitric acid (1 + 100) and purified water, and dried in an inverted position in a plastic coated rack. Wire-stemmed tube brushes must be avoided, because of the high risk of contamination from heavy metals.

Glassware used for water analysis often needs to be "run in" after the initial cleaning. That is, the analytical procedure is carried out on successive samples of purified water until the blank result is satisfactorily low.

2. Heating equipment

The preferred method of heating large batches of test tubes is in thermo-statically controlled metal heating blocks. Shallow blocks (20–40 mm deep) can be used for heating test tubes up to the boiling point of the contents without much loss of the acid used, as the unheated upper part of the tube acts as an air condenser. Deep blocks, from which the test-tubes protrude only 10–15 mm, are admirably suited for sample attacks that require evaporation to dryness of the acid mixture. The fine temperature control obtainable means that smooth boiling can be obtained, and overheating of the residue avoided. The latter is especially important where volatile analytes such as Se are being extracted. Heating blocks suitable for batches of test-tubes as large as 200 are available. The uniformity and reproducibility of the temperature in such blocks means that sample treatment is unusually consistent.

Layered blocks suitable for pressurized acid leaching in stout capped test-tubes at temperatures of up to 175°C, can also be made. These consist of a lower heated block separated by thermal insulation from the upper water-cooled section. The blocks are drilled out through both layers to accommodate the tubes, the capped tops of which protrude above the cooled layer for protection against heat damage. This type of attack has only recently been introduced, and despite the potential hazards of destructive failure of the tubes, has some attractive features, namely: (i) efficient attacks; (ii) no loss of volatile analytes such as mercury and arsenic; (iii) no liberation of large quantities of acid fume into the environment.

3. Diluters and dispensers

Diluters and dispensers are essential aids to cost-effective analysis. Reagent dispensers that can provide precise ($\pm 1\%$ relative) volumes in the range 0.1–10 ml are available from several manufacturers. Many types are con-structed only from glass and inert plastics, and are completely suitable for continuous use with most concentrated mineral acids, including perchloric acid. However, a convenient dispenser for hydrofluoric acid (which attacks glass), has yet to be devised. By such means aliquots of a reagent can be added to a large batch of test tubes in a few minutes. As the volumes of liquid added to a sample from a dispenser are reasonably precise, such additions can be used in high-speed analysis as an alternative to making solutions up to volume in volumetric flasks. The volume errors introduced are surprisingly small and acceptable for most applications in environmental geochemistry.

As analyte concentration ranges can be wide in environmental samples,

dilution of sample solutions is routinely required for instrumental methods (such as AAS) which have a limited working range of calibration. The ICP, however, is almost free of this requirement. There are many varieties of automatic diluter that give precise dilutions over a reasonable range. A dilution of 10 times is usually most convenient.

Diluters vary from simple manually adjusted models to sophisticated instruments under electronic control with digital keyboard selection of dilution ratios. All commercial diluters, however, operate by means of a pair of barrel-and-piston pumps for the concentrate and diluent. A small but consistent leakage is inevitable. Although this leakage has no perceptible effect on the volumes delivered, the acid vapours released invariably cause corrosion of the metal parts of the diluter. Thus diluters need constant attention to maintain them in a corrosion-free condition, and to avoid the danger of contamination of the sample solutions by corrosion products.

Where precise volumes of a sample solution need to be transferred to vessel to vessel, the use of modern disposable-tip pipettes is to be recommended. As the tips are water repellant, the amount of solution held back after the transfer is very small. A single tip can therefore be used for a large batch of transfers without significant cross-contamination between the samples, especially if a water-wash is employed between the samples. Pipettes covering the range 10 μl to 10 ml are available, and with a little practice, fast rates of working can be achieved. Relative precisions better than $\pm 1\%$ should be obtained, which is within the range suitable for environmental geochemistry.

4. Reagent quality

For most applications when analyte concentrations are reasonably high, analytical grade reagents (e.g., "AnalaR" or equivalent) have a suitable degree of freedom from traces of impurities. Where analyte levels are very low, as in water analysis for heavy metals, or when large amounts of reagent are used, high purity reagents (e.g., Aristar grade) are usually required. However, no assumptions should be made about purity, and blanks in a reasonable proportion (2–5%) should be included in every batch as a check on reagent purity (and also on contamination from glassware and the laboratory environment). Water of good quality, either deionized or distilled should be used. If distilled water is used, the subsequent use of a deionizer is good practice and of very low cost. Deionized water may contain traces of organic matter derived from the resin, but this is rarely of significance.

It is often cost-effective to use the standard solutions prepared by chemical supply houses for most of the elements of interest. Their use obviates problems due to incorrectly prepared standards. However, caution is required in using

these solutions to prepare multi-element standards, because although the concentration is guaranteed, the purity is not.

5. Laboratory safety

Chemical analysis should be carried out under the supervision of a professionally qualified chemist who can ensure that correct procedures are being used, that data of adequate quality are obtained, and that safe methods of operation are adhered to. In particular, the hazards of perchloric acid and hydrofluoric acid must be well understood, and provision for emergency action including first aid must be provided in a readily accessible place.

Perchloric acid must be used only in properly designed fume cupboards, made so that the vapour or condensate cannot come into contact with wood, which will form an explosive or self-igniting mixture. Perchloric acid mixtures can be used with complete safety on rocks, soils and sediments, even peaty soils, so long as nitric acid is present in the initial stages of the sample decomposition. The only exception is that of samples containing oil or bitumen, which will nearly always form explosive mixtures. For the destruction of organic matter such as plant material, perchloric acid is excellent, but a preliminary treatment with nitric acid to oxidize the bulk of the organic matter is essential. A guide to the safe use of perchloric acid should be studied before practical work with it is undertaken (SAC, 1959). The acid should not be used on oil or fatty tissues (e.g., seeds or nuts) which will usually cause violent explosions with the acid.

Hydrofluoric acid causes burns of unusual severity and for handling it a face mask, tested rubber gloves and a disposable plastic apron are essential. The special first aid treatment for burns from the acid should be at hand in the laboratory (a gel of calcium gluconate).

6. The mechanical reduction of samples

Samples have generally to be reduced to a fine powder, firstly to allow a good access of the decomposition reagents and thereby increase the effectiveness of the attack, and secondly to render the sample more homogeneous, so that a reasonably small representative sub-sample can be utilized.

(a) Rocks

Rocks are reduced to a 1–2 mm size range by means of a jaw crusher or percussion mortar, then reduced to a fine powder by treatment in a swing mill. Agate mortars for swing mills do not contaminate the sample with heavy

metals, but are relatively expensive and fragile. If traces of Cr and Fe contamination can be tolerated, a hard steel mortar can be used as an alternative, and this is cheaper and more robust. A stainless steel hammer mill can be used as an alternative to the swing mill, but will contaminate the sample with Cr and Ni.

(b) *Soils and sediments*

The dried soil is gently disaggregated (not crushed) in a porcelain mortar, and the particles greater than 2 mm sieved out and discarded. The − 2 mm fraction is then crushed in a swing mill or hammer mill as described for rock samples. Non-metallic sieves can be constructed from perspex tubing (100–150 mm diameter) and nylon or polyester bolting cloth. Sediments are prepared by sieving the natural material after drying and disaggregation. The most widely used size fraction is the − 200 μm fraction, which is analysed without any further preparation.

(c) *Herbage*

Herbage samples must be milled to pass a 1 mm sieve before analysis. This can be achieved by a carbon-steel beater mill without measurable contamination, or with a stainless steel hammer mill if a very small degree of contamination with Cr and Ni is tolerable.

7. Sample decomposition with strong acids

Working methods for sample decomposition will not be given as they are described in detail elsewhere (e.g., Thompson and Wood, 1982), and have been comprehensively reviewed both in general (Dolezal *et al.*, 1968; Bock, 1979), and specifically in relation to applied geochemistry (Fletcher, 1981).

(a) *Hydrofluoric acid*

Mixtures containing hydrofluoric acid, especially in admixture with nitric acid and perchloric acids, will completely decompose most siliceous minerals, leaving on evaporation a residue of metal perchlorates. This can be subsequently dissolved in hydrochloric acid for instrumental determination. Dilute hydrochloric acid, nitric acid or perchloric acid are the preferred media for determination by AAS methods, as anions such as sulphate or phosphate cause interference effects. No such restriction applies to the ICP, however. Samples containing much Ca may need extended treatment with perchloric

acid to decompose the calcium fluoride initially formed. Undecomposed calcium fluoride can incorporate a large proportion of any Pb present in the sample and thus cannot be tolerated as an undissolved residue.

(b) *Perchloric and nitric acid*

A (1 + 4) mixture of perchloric and nitric acid if slowly evaporated to dryness with 0.25 g samples of rock, soil or sediment, provides a powerful decomposition that solubilizes the greater part of any heavy metal present, after treatment of the residue with 10 ml of M hydrochloric acid. A residue of silica from clay minerals plus resistant silicates remains insoluble, and the common practice is to let this residue settle to the bottom of the test-tube, and analyse the liquid standing above it. The following elements can be determined satisfactorily after this type of extraction: Cu, Pb, Zn, Cd, Mn, Fe, Co, Ni, Mo and P. The method is also suitable for Se if the final temperature does not rise above 170°C.

(c) *Nitric acid*

Concentrated nitric acid alone (e.g., at 100°C for one hour) has a less vigorous effect than the mixed acid and, in particular, Fe(III) oxide minerals are not attacked strongly. However, this is an efficient method for Cu, Pb, Zn, Cd, Hg and Ag.

(d) *Hydrochloric acid*

Hot concentrated hydrochloric acid is a good solvent for Fe minerals and is a good solvent for As and Sb. The volatility of the reagent and of the chlorides of As and Sb requires that the attack be performed in airtight capped test tubes (Pahlavanpour *et al.*, 1980).

(e) *Aqua regia*

This mixture of hydrochloric acid and nitric acid (3 + 1) has similar extraction characteristics to nitric acid–perchloric acid, but is more effective in the dissolution of some sulphides, notably pyrite. Care has to be taken to remove all of the Cl formed, by boiling the mixture well, otherwise the final solution may be excessively corrosive on nebulizers and other metal parts in AAS instruments.

(f) *Herbage*

The destruction of organic matter has also been extensively reviewed (Gorsuch, 1970). For non-fatty plant material nitric acid–perchloric acid mixture is the method of choice. The sample has to be almost completely destroyed by nitric acid before the perchloric acid can be safely added. Drawbacks of this method include: (i) the explosive hazard from perchloric acid if it is incorrectly used; (ii) the high cost of perchloric acid; and (iii) the formation of sparingly soluble potassium perchlorate crystals, which may occlude some of the trace elements. Alternative procedures exist, for example using sulphuric acid–nitric acid–hydrogen peroxide, and these may be acceptable where the choice of acid for the final solution is unrestricted, as for the ICP.

Dry ashing methods are reliable if ashing aids such as magnesium nitrate are used. Loss of trace elements (even some volatile ones such as As) is prevented by the bulk of magnesium oxide formed. The residue can easily be dissolved in acid for instrumental analysis. However, the high salt content of the resulting solutions causes problems in nebulization techniques. In contrast, it may be an ideal method if a spectrophotometric method or hydride generation is to be employed, where the high salt content has no deleterious effects.

8. Selective extractions

Many selective extractions have been designed to extract the trace elements from specific phases or molecular environments in a complex mixture such as a soil (see Chapter 14). It is doubtful whether any such method is truly specific, and the validation of such a method relies completely on empirical comparisons with environmental situations. A common practical problem encountered with these methods is the tendency for the high salt content of the solutions to block burners and nebulizers, etc. This is especially the case for ICP, in which problems can arise with the most commonly used nebulizer if the salt content of the analyte solution is greater than 0.5% m/v.

Extractants commonly used include: (i) 0.5 M acetic acid for "plant available metals" (especially toxic metals) in soils; (ii) M ammonium acetate (pH 7) for "exchangeable metals", i.e., metals that are bound to ion-exchange sites in clay minerals, etc.; (iii) the diammonium salt of EDTA (0.05 M solution at pH 4) for available copper in soils; (iv) neutral ammonium acetate (M) containing a reducing agent, such as quinol or hydroxyammonium chloride, which extract apart from exchangeable metals, ions that are bound in precipitated hydrous manganese(IV) oxide (MAFF, 1973; Rose *et al.*, 1979).

9. Water analysis for heavy metals

Whereas the major ions in water can be determined directly, the background levels of most heavy metals, including Cu, Pb, Zn and Cd are too low for direct determination, even by ICP. Some can be determined by anodic stripping voltammetry at appropriate levels, but the most general methods involve the extraction and preconcentration of a wide range of heavy metals simultaneously. This concept is especially attractive when ICP facilities are available and many elements can be determined simultaneously on the extracts. Preconcentration schemes used include ion-exchange with chelating resins, and solvent extraction with organic ligands, usually of the dithiocarbamate class. Current methods require large volumes of water (e.g., one litre) and give concentration factors of up to 50. The relatively large volume of concentrate is required for the successive determination of a number of elements by AAS. In principle, however, much smaller volumes could be used for a multi-element analysis conducted by ICP, so that the concentration factor could be greater, or the starting volume much lower. There is almost certainly, however, a limiting value beyond which the concentration factor could not be usefully taken, because of rapidly increasing problems of contamination from reagents, glassware and the environment.

III. Atomic absorption analysis in environmental geochemistry

At present, atomic absorption spectrophotometry is the most widely and intensively used analytical method in environmental geochemistry, and the conventional technique of nebulization into a flame is the preferred method of sample atomization. An alternative technique, based on hydride generation followed by atomization in a low-temperature flame or silica tube furnace, shows promise as a sensitive method for elements of great environmental interest (especially As and Se), but is not net fully developed. Graphite furnace atomization can provide the lowest detection limits generally available in atomic spectroscopy, but the method is still not widely used in geochemistry, possibly because it is slower than the conventional method, and more prone to complex interference effects. This is an important factor when batches of samples of rather variable matrix are to be analysed. The determination of Hg by cold vapour methods is now well established and probably the most widely used for this metal.

AAS instruments vary widely in the degree to which convenience features are incorporated, and the cost varies just as widely. In environmental geochemistry, where an instrument would be expected to provide a million

determinations in a few years, features that enable samples to be analysed more quickly soon pay for themselves. It is doubtful whether full automation can improve on the productivity obtainable by human operators, but it relieves the tedium of repetitive work, and for carbon furnace atomization, provides an important improvement in precision. Improvements in calibration curve linearization save time directly by simplifying the calibration procedure, and indirectly by extending the usable calibration range substantially and thereby reducing the number of dilutions required.

1. Conventional nebulization of aqueous samples into a flame

(a) *Detection limits and precision*

If a soil or rock sample is treated by one of the acid dissolution methods outlined above, a minimum dilution factor of 40 is introduced, and thus theoretical detection limits of elements should be 40 times higher than the level obtainable in aqueous solution. However, for samples analysed under realistic conditions, with variable background absorptions and analysed over a time span representing a typical batch, effective detection limits are higher than this, and a factor of 100–200 is more appropriate. This is confirmed by the analysis of randomized blind duplicates for the estimation of realistic detection limits (Thompson and Howarth, 1978).

Table 3.1 shows these realistic detection limits (d) for a variety of elements of

Table 3.1 Practical detection limits for selected elements determined by conventional nebulizer-flame AAS following a simple sample decomposition compared with median levels found in soils

Element	Median level in soil (m) $(\mu g\ g^{-1})$	Practical detection limit (d) $(\mu g\ g^{-1})$	m/d
Ag	0.1	1.2	0.08
As	7.5	40	0.2
Ca	20 000	1.2	16 000
Cd	0.2	0.6	0.3
Co	10	4	2.5
Cu	15	2	7.5
Fe	21 000	2	10 000
Hg	0.05	50	0.001
K	11 000	2	5500
Mg	1000	0.2	5000
Mn	320	2	160
Mo	1	10	0.1
Ni	20	2	10
Pb	17	5	3.4
Se	0.3	100	0.003
Te	0.01	20	0.0005
Zn	36	0.6	60

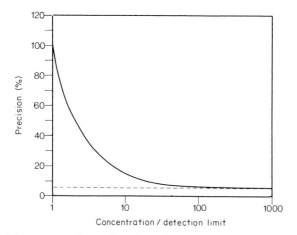

Fig. 3.1 Precision expressed as a function of analyte concentration (c) divided by detection limit (c_d), during the rapid determination of trace elements in geological materials by AAS. The precision (=twice the coefficient of variation expressed as a percentage) falls from 100% at $c/c_d = 1$ asymptotically towards a constant value of 6% at high concentrations.

environmental interest compared with the median levels (m) found in soils in the UK. Where the ratio m/d is somewhat greater than unity the method will reliably detect unusually high concentrations of the analyte, but the value needs to exceed 10 for the reliable detection of anomalously low values. Thus it can be seen that several elements are satisfactorily determined by conventional AAS (Cu, Zn, Fe, Mn, Ni, Ca, Mg) a few are marginal (Pb, Co) and for many the method is quite unsuitable (As, Se, Mo, Te, Ag, Hg). Where the conventional method *is* suitable, it is the method of choice as it is very convenient, is most cost-effective among AAS techniques, and is also more cost-effective than ICP for the determination of <4 elements.

The same general range of elements is also determined by the conventional techniques in other materials. In herbage samples the lower concentration levels present are mitigated by the use of large samples (2–5 g) and thus more favourable dilution factors. With water samples where the analyte levels are very low, even more favourable factors are obtained by pre-concentration methods. In principle preconcentration could be used for the lower sensitivity analytes in soils but, so far, methods for doing this have yet to be perfected, and it is only resorted to when no other method is available (e.g., Ag, Tl).

The precision of conventional AAS analysis has been realistically estimated for several elements by the method of Thompson and Howarth (1978) and conforms to the pattern shown in Fig. 3.1. At high concentrations relative to the detection limit the precision tends towards a lower limit of about 3% relative standard deviation.

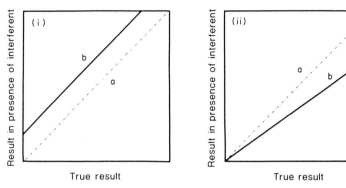

Fig. 3.2 Schematic account of possible biases produced by a fixed level of interferent in the determination of trace elements by AAS, *viz*: (i) "translational" (constant) bias usually caused by background absorption, and (ii) "rotational" (proportional) bias due *inter alia* to changes in atomization efficiency (*a* = no interferent present, *b* = interferent present at a fixed level).

(b) *Accuracy*

Accuracy is limited mainly by the interference effects produced when trace elements are determined in solutions containing major sample constituents (Na, K, Ca, Mg, Fe, Al) not present in the calibrators. As the concentrations of the major constituents are variable, no allowance can be made during calibration. This interference has been evaluated for geochemical analysis by conventional AAS (Thompson *et al.*, 1979). The results distinguish between two principal effects illustrated in Fig. 3.2, translational bias, produced by flame background absorption, and rotational bias, where the release of analyte atoms in the flame is affected by the interferent. Important levels of translational bias were observed on the analytes Cd, Co, Ni and Pb due to Ca and on Pb due to Al. These biases can be reduced to almost undetectable levels by the use of background correction with a continuum lamp *if it is correctly aligned*. Correct alignment is difficult or impossible in some AAS instruments fitted with continuum lamps and serious errors can ensue.

 Important levels of rotational bias were found for Li due to Al. In principle rotational effects can be eliminated by the method of standard additions, by matrix matching the standards, or by separating the analyte from its matrix. None of these methods have found favour in applied geochemistry because of cost factors, and for the most part the errors are simply ignored. For the determination of major constituents, however, matrix modification is quite common, for example by the addition of La salts in the determination of Ca to prevent interference from other major constituents.

2. Gas-phase sample introduction

The introduction of the analyte into the atom chamber in the gas phase has so far been limited to elements that form volatile hydrides easily in aqueous solution (Ge, Sn, Pb, As, Sb, Bi, Se, Te), and Hg which forms a monatomic vapour at ambient temperatures. Despite the small number of elements in this group, the method has assumed an importance because it provides high sensitivity for elements of considerable environmental interest that were previously difficult to determine (Robbins and Caruso, 1979; Godden and Thomerson, 1980).

(a) *The volatile hydride elements*

The technique has progressed rapidly since the demonstration that all of the above mentioned elements could be readily reduced to their hydrides by sodium tetrahydroborate, and that good sensitivities could be obtained (Thompson and Thomerson, 1974). The reducing reagent can be used as a solid or in aqueous solution and the reaction is complete within a few seconds, the hydrogen produced by the excess reagent helping to transport the hydrides out of the aqueous phase. Many manufacturers now produce hydride generators for AAS and such attachments are all of the "discrete addition" type, where a fixed volume of test solution is suddenly mixed with an aliquot or a pellet of the reducing agent. The hydrides formed are transferred to the atom chamber by an inert carrier gas, and a transient signal is obtained from the AAS instrument. The maximum value of this signal is a function of the concentration of the analyte if the physical conditions are kept constant. Atomization depends on the pyrolysis of the hydrides in a low-temperature flame (such as the hydrogen–argon diffusion flame) (Fernandez, 1973) or in a heated silica tube fixed in the burner position of the AAS instrument (Thompson and Thomerson, 1974).

An alternative method of generation described below, that of mixing the test solution and reducing reagent solution continuously by means of a peristaltic pump, is more convenient to use, and is now produced commercially. The somewhat smaller sensitivity of this technique is offset by the greater reproducibility obtained by integration of a continuous steady signal.

The method is prone to interference effects from transition metals in the test solution (Smith, 1975), which may inhibit the liberation of hydrides, but the extent of the interference depends markedly on the particular analyte, on the composition of the test solution (especially the acid content), and on the mixing technique, and so is difficult to summarize. It can be inhibited by the use of masking agents (Fleming and Ide, 1976) or by pre-separation of the analytes with lanthanum hydroxide (Bedard and Kerbyson, 1976). Generally,

analytes forming the more acidic (Se, Te) and the less stable hydrides (Sn, Pb, Bi) are more prone to this interference, and the principle interferents are Cu and Ni. Mutual interference between the analytes themselves by compound formation in the atom chamber is also possible. Detection limits reported rarely exceed 5 μg l^{-1}. The method has been used for the analysis of rocks, soils, waters and herbage, but cannot yet be regarded as fully developed. A degree of selectivity for As species can be obtained by the use of different acid conditions for the reduction (Howard and Arbab-Zavar, 1981).

(b) Mercury cold-vapour methods

An amazing variety of techniques have been described for determining Hg by this AAS method. Many are based on the liberation of elemental Hg by reduction of Hg(II) in aqueous solution by means of tin(II) chloride, following the work of Hatch and Ott (1968). The Hg vapour is then removed from the solution, usually by a stream of nitrogen, which is then dried and stripped of acid vapours if necessary, and passed through an absorption cell which fits into the burner compartment of a conventional AAS instrument. Detection limits of 0.2 ng of Hg can readily be achieved. Methods of sample decomposition require strongly oxidizing conditions and moderate temperatures to avoid losses by volatilization, for example, nitric acid at 80°C for soils and sediments or potassium permanganate in sulphuric acid for organic tissues.

The pyrolytic release of Hg is suitable for geological materials which contain little organic matter. The vapours released are normally unsuitable for direct determination of Hg, because of background absorption due to smoke, so the Hg is adsorbed onto a Au or Ag surface while the interfering components pass on. The Hg is then released from the Au by a second pyrolysis and carried into the atomic absorption cell as before. Many references to these methods are listed in Kirkbright and Sargent (1974).

IV. Environmental analysis with inductively coupled plasma atomic emission spectrometry

The use of the ICP in geochemical and environmental studies is now rapidly spreading, and the method is likely to become predominant in inorganic elemental analysis generally. The second and third generation instruments now available are relatively simple to use and seem likely to fulfill most of the early promise of the method (Thompson and Walsh, 1983).

The ICP is an optically thin emission source formed by coupling radio-frequency power into a stream of argon gas. The argon is constrained into three concentric streams in a plasma torch fabricated from fused silica, as

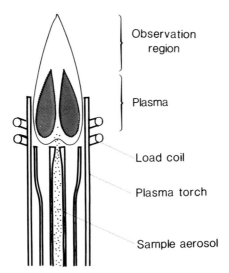

Fig. 3.3 The inductively coupled plasma, showing the geometry of the torch and load coil and the introduction of sample aerosol through the toroidal shaped plasma for atomization and excitation.

shown in Fig. 3.3. A toroidal shaped plasma is formed, and the sample is injected through the central tunnel, heated to a high temperature (c. 8000 K) and thereby atomized to a large extent. Emission from the excited atoms and ions is observed at a hight of 10–20 mm above the load coil by a conventional spectrometer system (Scott *et al.*, 1974; Boumans and de Boer, 1974; Greenfield *et al.*, 1975).

1. Analytical characteristics of the ICP

The ICP has analytical characteristics that make it a uniquely powerful analytical method. The detection limits obtainable by the conventional techniques are normally lower than can be obtained by atomic absorption, especially for elements with refractory oxides (Fig. 3.4), and many non-metals can be determined with ease (S, B, P, C) (Greenfield, 1980). In addition, the range of linear calibration is wide, always exceeding four orders of magnitude above the detection limit. In contrast to AAS, a wide range of possible emission lines is invariably available, usually allowing a convenient concentration range to be chosen. Interference effects from the chemical matrix of the analyte are small, allowing a problem-free determination of elements like Be and Ti. Emission intensities are such that short integrations (typically 5 s) can be used after signal stabilization (typically 20 s), so that relatively small volumes of

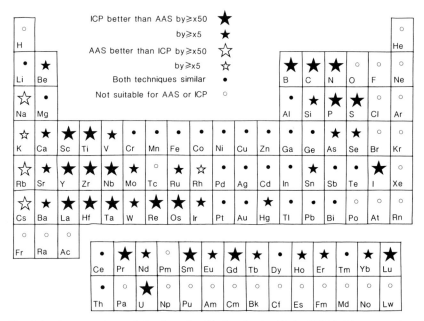

Fig. 3.4 A comparison of the detection limits obtainable by ICP (with conventional pneumatic nebulization) and by AAS (nebulization into a suitable flame). The superiority of the ICP is marked for the non-metals and for the metallic elements which form refractory oxides.

sample solution are required for the analysis. If a polychromator is used, many elements can be determined simultaneously, 20–30 in typical analytical systems. The main limitation on simultaneous analysis is the problem of devising a sample decomposition that will render soluble in the sample solution a range of elements with very diverse chemical properties.

The precision available under conditions pertaining to routine analysis for applied geochemistry is about 3–5% RSD at concentrations well above the detection limit. The precision that can be obtained from the ICP under ideal conditions is of the order of 0.3–1% RSD.

2. Choice of equipment

ICP instruments were originally produced only in polychromator form for simultaneous multi-element determination, but they are now obtainable with a scanning monochromator for fast sequential analysis (Floyd *et al.*, 1980). A choice between these possibilities depends on the application. With a monochromator the choice of emission line for any element is usually wide, so

that the best possible line can be selected for any particular application. This is a useful feature if sample batches of widely differing types are to be analysed. In such cases interference from overlap with lines of the major constituents can be avoided, and a line of the appropriate calibration range chosen. Elements that are not in the normal program of work can be chosen at will. In addition the monochromator versions are considerably cheaper, approximately half of the cost of a polychromator equipped with 40 channels.

Polychromators, however, have alternative advantages. They are substantially faster if more than a few elements are to be determined, thereby cutting down both recurrent costs and capital costs on a per sample basis. Also on a polychromator the optics of each channel can be individually optimized in relation to secondary slit width, choice of secondary slit filtering and choice of photomultiplier, whereas only a compromise is available in a monochromator. The reliability of the scanning monochromator has yet to stand up to the test of time, but as the system contains moving parts (the wavelength drive) built for very high performance requirements, it presumably needs more routine maintenance than the polychromator. It must also be stated that, at the time of writing, a determination of an element on a scanning monochromator ICP system requires a considerably longer time than the same determination (where possible) on an AAS instrument, so that an AAS workload cannot be directly transferred to a scanning ICP system.

All ICP systems, regardless of their construction, require the dedicated attention of a small computer system to run them efficiently. The function of the computer is twofold. One function is to control the operation of the spectrometer, in respect of the integration cycle timing, autosampler and other instrumental parameters. This is especially true of scanning instruments, where the computer controls the search for the successive wavelengths required. In addition, the computer organizes the data processing and storage, making analytical information rapidly available to the operator in a comprehensible form, and tabulating the results at the end of a batch of samples.

Evacuated spectrometers, giving access to the wavelength region of 170–200 nm, are very useful in ICP. There are several vacuum uv lines that are especially useful, including some of the best lines for C, N, P, S, Hg and Sn, so the extra cost of the vacuum system is a worthwhile investment.

3. Limitations of the ICP

Because the ICP is a very versatile spectroscopic source, analysts' expectations of the method tend to be very high. There are several points about the operation of the plasma that, in relation to this high expectation, are seen as

problems. In other methods the corresponding operational points are regarded as routine analytical precautions.

The most serious limitation stems from the fact that the sensitivity depends critically on the injector gas flow rate. If this parameter can be kept stable, then sensitivities and backgrounds are stable for many hours, so that no recalibration is required. However, because of limitations of nebulizer and torch design, this flow rate varies, especially if high salt-content solutions ($>0.5\%$ m/v) are being continually nebulized. Mere changes in slope and intercept of a calibration can of course be easily accommodated by "normalization". Unfortunately when the nebulizer or torch gets blocked with sample solids, the curvature of certain calibration graphs changes as well, and interference effects are modified, so that normalization is ineffective. For a complex multi-element system with concentrated solutions, recalibration may take many hours (McQuaker et al., 1979) and thus cannot be incorporated into a daily routine. This limitation on solids content is probably the major defect with the ICP and will not be resolved until a better nebulizer is designed.

Another limitation stems from the change in background emission caused by the major constituents of a complex mixture. If low levels of trace elements are to be measured a correction has to be applied for this background shift. The "off peak" correction system operates by scanning the background at both sides of the analyte wavelength and using these data to calculate by interpolation the background at the peak. The background is then subtracted from the total analytical signal. This method cannot be applied if an emission line from another element falls near the background line. It also increases the time of an analysis. The alternative "on peak" correction relies on relating the background at the analyte wavelength to the concentration of major constituents, notably Ca, which are determined simultaneously with the affected trace element. Again a correction is applied to the measured analyte concentration. Although both of these systems undoubtedly improve the accuracy of the determination, the error in correction is often substantial when compared with the detection limit for pure aqueous solutions of the analyte. Therefore the effective detection limits in complex environmental samples may be higher by an order of magnitude than the expected value.

4. Gas-phase sample injection

Elements that are easily reducible in aqueous solution to form volatile covalent hydrides (Ge, Sn, Pb, As, Sb, Bi, Se, Te) can be injected into the ICP in the gas phase, together with Hg as the elemental vapour (Thompson et al., 1978a,b; Thompson and Pahlavanpour, 1979). A greatly improved sensitivity can be obtained, mainly because of the greater rate at which the analytes can

be injected, owing to the high efficiency of the hydride formation compared with pneumatic nebulization (c. 2% efficient). In addition, the background of the plasma is reduced and stabilized, owing to the removal of the analytes from their original complex matrix. The result is a determination with exceptionally low detection limits, well below $1 \mu g \, l^{-1}$ for all of the analytes. The determination is trouble-free because of the stable background and freedom from nebulizer problems. However, the sensitivity of the system is responsive to temperature changes (as chemical reactions are involved), so long-term drifts are more noticeable.

A major difference from the AAS/hydride system is that discrete addition hydride generation is incompatible with the ICP, as the plasma cannot tolerate the effect of sudden injections of a large volume of H_2 gas. With the continuous generators the rate of H_2 production can be made virtually constant, and the impedance of the plasma generator can be accurately "tuned" to that of the resultant Ar/H_2 plasma.

In principle all of the volatile elements could be determined simultaneously by ICP, as mutual interference in the atom chamber does not occur. However, there are two limitations on this. The first is that optimal reduction is obtained under different conditions of acidity for the various elements. The second is that because of the varying aqueous chemistry and mode of occurrence of these elements, a common sample dissolution procedure has not been devised. The best approaches so far reported are the simultaneous determination of 5 elements (As, Sb, Bi, Se and Te) in waters (Thompson et al., 1981), and of three elements (As, Sb and Bi) in soils (Pahlavanpour et al., 1980) and herbage (Pahlavanpour et al., 1981).

V. Other methods of analysis

Despite the combined power of AAS and ICP analysis, there are some determinations that can be carried out only by other methods. Principal among these are the determination of the halogens F, Cl and Br. (I can be sensitively determined on the ICP, but there have been no reported applications so far.) Use of the selective ion electrode is the preferred method for F, whereas there are various methods suitable for Cl ranging from titration to electrochemical methods. The ion chromatograph can be applied to determining anions generally, as well as those of the halogens, and is especially applicable in speciation studies.

One of the metallic elements for which neither ICP nor AAS provide a suitably direct determination is Mo. All of the most sensitive ICP lines for Mo are prone to interference, and sufficiently low detection limits cannot be obtained for the study of Mo deficiency in the soil–plant system. The favoured

method relies on the extraction into a hydrocarbon solvent of the green complex formed by Mo with toluenedithiol, followed by a spectrophotometric determination. In this last method, however, and in many other circumstances, it is likely that an even better determination could be accomplished by an ICP analysis of the solvent extract, with direct nebulization of the organic liquid. This would be a powerful method of separating a wide range of heavy metals from their matrix of interfering elements and pre-concentrating them at the same time, thus providing a very sensitive analysis. No such applications have yet been reported, but they would be appropriate for a large range of metals of low abundance, such as the noble metals, Mo, W, U, etc.

Another limitation of AAS and ICP is that they provide no direct information on speciation. Normally a method that relies on a selective chemical or electrochemical reaction is required for this. In this context, spectrophotometry and the various forms of polarography can provide a useful adjunct to ICP and AAS. For example, the colorimetric reagent diphenylcarbazide is specific for Cr^{6+} and can be used to determine this toxic species separately in a mixture with the less harmful Cr^{3+}. Normally, however, a study of speciation is carried out by the selective extractions discussed above and in detail in Chapter 14, usually on an empirical basis (e.g., water-soluble boron), and these methods combine well with AAS and ICP.

VI. The quality control of analytical data

Analytical quality control is an essential part of the mass production of analytical data, just as it is in the mass production of any other commodity. There is a fundamental difference in the problem, however. In the manufacturing industry it is relatively easy to set up control limits for samples taken from a batch of the product, because the correct value and tolerances are completely determined by the design specification. By analogy, an analytical determination should be compared with the correct value for the appropriate sample, but this correct value remains unknown and can be estimated only by the analysis itself. Of course a series of concurrent analyses, each produced by a method based on a different physical principle, allows the extraction of a consensus value that may be deemed the correct value. This is not a practical proposition for routine analysis, but is always resorted to for the production of certified reference materials (CRMs). In the quality control of analytical data, the correctness of any individual result has to be inferred, partly on statistical grounds and partly on less certain premises. It is reasonable to spend as much as 20% of the analytical effort in quality control, to ensure the validity of the remaining 80% of the data.

1. Accuracy and precision

In a series of analyses on a batch of samples by a given analytical method, an error can be associated with each value (c_i) produced. This error can be conceptually divided into two components, a systematic error and a random error. The systematic component is reproduced every time the sample is reanalysed by the same procedure, but the random error is different every time, varying according to a distribution law which is usually the Gaussian (normal) distribution (Thompson and Howarth, 1981). The systematic error or *bias* is estimated by the central tendency of this distribution (usually the arithmetic mean \bar{c}). The closeness of \bar{c} to the true value is called the *accuracy*. The random error is estimated by the standard deviation of the results (s_c):

$$s_c = \sqrt{\frac{\sum (c_i - \bar{c})^2}{n - 1}}$$

where n is the number of observations. The term *precision* is used in many circles to denote relative variation, often specifically the measure $2s_c/\bar{c}$.

Accuracy, standard deviation, and precision are likely to vary from sample to sample in the batch, but if all of the samples are of the same type (i.e., differ essentially only in the concentration of the analyte and not in the bulk composition), there is a definite relationship between accuracy or standard deviation with the concentration of the analyte. Thus in this circumstance if the accuracy and standard deviation can be ascertained at particular analyte values they can be inferred at other levels. This is done by the insertion, into each batch of samples, of reference materials (RMs) which simulate the behaviour of the samples, but for which the true values (or at least accepted values) of the analyte concentrations are known.

In large surveys samples are normally analysed in discrete batches, so that circumstances which affect the accuracy and precision may vary from batch to batch. Consequently the errors may be conceptually separated as follows:

(i) Within-batch precision and accuracy—this is self-explanatory;
(ii) between batch errors—both variable precision and variable bias are possible on a batch-to-batch basis;
(iii) overall bias—this affects the whole survey in a systematic manner.

2. Routine control procedures

Accuracy and precision can be controlled by the use of reference materials inserted into every batch of samples. However, certain precautions must be observed to ensure that the RMs give realistic results (i.e., that their accuracy and precision characteristics match those of the samples under all conditions,

even error conditions). For this reason RMs have to be physically and chemically of the same type as the samples, that is, have the same bulk composition, mineralogy and state of comminution. They also need to be available in large amounts, homogeneous and compositionally stable over long periods. So that they receive no special attention, they should be distributed at random positions in the analytical sequence and must be impossible to identify at the time of analysis. Where possible, at least two RMs should be used together, one representing normal levels, the other anomalous levels of the analyte.

The within-batch precision can be gauged from the range or, if the RMs are in sufficient numbers, the standard deviation of the results for each RM. Between-batch variations are monitored by the means (or medians) of the RM values. Overall accuracy is related to the value of the grand mean over all the batches (or the rolling mean over a limited number if in an indefinite sequence) compared with the "true" value if known. Control charts (see Fig. 3.5), based on normal statistical inference may be used to identify outlying, and therefore suspect, batches of results. However, it is important to realize that a deviation which may be *significant* in the sense of falling outside a given confidence limit, may not be *important*, i.e., may not affect the interpretation of the data. This can be judged only by user requirements.

The use of RMs is convenient but may be prone to the drawing of over-optimistic conclusions. In other words, the RMs may be "better behaved" than the samples are. This follows from the wider range of the composition of the real samples, and possibly the greater care taken to grind and mix the RMs.

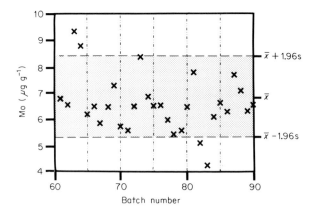

Fig. 3.5 Part of control chart for the determination of molybdenum by a rapid spectrophotometric method. Each point represents the mean result obtained on a reference material in a batch of samples. In the period represented by the chart the general tendency of the results was slightly low, and four batches fell outside the rejection limits.

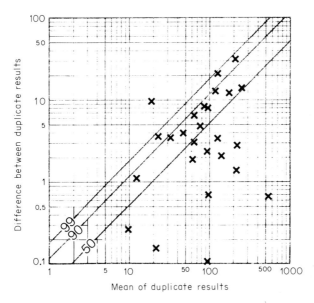

Fig. 3.6 A control chart for duplicate analyses with percentile lines drawn for 10% precision. In an analytical system exhibiting this precision, apart from chance variations the results tend to be distributed equally on either side of the median (50th percentile), as in the example shown above. The inconsistently large proportion of points falling above the higher percentiles (90th and 99th) would suggest fliers among the results.

An independent check on this can be made by means of duplicate analysis. The duplicate analysis should be performed on selected samples randomly picked from the batch and randomly re-inserted into the analytical sequence, in the same batch, so that systematic errors are converted into random ones. The within-batch precision can be controlled by the method of Thompson and Howarth (1978) (Fig. 3.6). Between batch variations can be similarly demonstrated by the re-analysis of samples in the next batch in the sequence, again with random selection and insertion. However, in this case systematic differences between the pairs of results as well as random differences should be sought by statistical tests.

Apart from the use of RMs, long-term or overall bias can be controlled by several means. CRMs can be used occasionally or may even be required as a matter of routine by legislation. They are often too expensive or too precious to use for routine control procedures. Again they should be indistinguishable from the samples at the time of analysis, otherwise optimistically biassed results may be obtained.

Given sufficient planning the use of RMs and duplicates can be combined with the insertion of blanks and batch randomization in routine operations to

provide a comprehensive data control system. Without such care serious errors and inconsistencies may be included in data sets.

VII. Conclusions—the future

There is every indication that ICP will increase in popularity and may eventually dominate inorganic elemental analysis. This is especially the case if manufacturers succeed in their attempts to introduce a "mini-ICP" that compares in price with the AAS systems, but without any loss of the desirable characteristics of the standard ICP.

Some progress has been made in the direct analysis of solids by ICP, without chemical dissolution, by vaporization of samples by means of a laser followed by flushing of the resulting aerosol into the plasma. The Babbington nebulizer has been used to nebulize slurries of animal tissues into flames for AAS determination, with considerable success (Mohamet and Fry, 1981). The same technique may also allow the direct analysis of rock and soil samples where the higher temperature of the ICP is available to atomize the sample.

The considerable current interest in speciation will undoubtedly develop as suitable analytical methods become available. The bulk of these methods will still depend on selective extraction or selective chemical or electrochemical reactions for the foreseeable future. However, a favourable cases, speciation can be inferred from thermodynamic considerations. Computer programs that manipulate the many chemical equilibrium equations needed for these methods are now available, and can produce realistic models of speciation (see Chapter 5).

References

Bedard, M. and Kerbyson, J. D. (1976). *Canad. J. Spectrosc.* **21**, 64–69.

Bock, R. (1979) (tr. Marr, I. L.). "Decomposition Methods in Analytical Chemistry." Blackie, Glasgow. 444pp.

Boumans, P. W. J. M. and de Boer, F. J. (1974). *Spectrochim. Acta* **30B**, 309–334.

Dolezal, J., Povondra, P. and Sulcak, Z. (1968) (tr. Hughes, D. O., Floyd, P. A. and Barratt, M. S.). "Decomposition Techniques in Inorganic Analysis." Iliffe Books, London. 224pp.

Fernandez, F. J. (1973). *Atom. Absorpt. Newsl.* **12**, 93–97.

Fleming, H. D. and Ide, R. G. (1976). *Anal. Chim. Acta* **83**, 67–82.

Fletcher, W. K. (1981). "Analytical Methods in Geochemical Prospecting." Elsevier, Amsterdam. 255pp.

Floyd, M. A., Fassel, V. A. and D'Silva, A. P. (1980). *Anal. Chem.* **52**, 2168–2172.

Godden, R. G. and Thomerson, D. R. (1980). *Analyst* **105**, 1137–1156.

Gorsuch, T. T. (1970). "The Destruction of Organic Matter." Pergamon Press, Oxford and New York. 151pp.

Greenfield, S. (1980). *Analyst* **105**, 1032–1044.

Greenfield, S., Jones, I. L., McGeachin, H. M. and Smith, B. P. (1975). *Anal. Chim. Acta* **74**, 225–245.

Hatch, W. R. and Ott, W. L. (1968). *Anal. Chem.* **40**, 2085.

Howard, A. G. and Arbab-Zavar, M. H. (1981). *Analyst* **106**, 213–220.

Kirkbright, G. F. and Sargent, M. (1974). "Atomic Absorption and Fluorescence Spectroscopy", pp. 640–641. Academic Press, London.

McQuaker, N. R., Kluckner, P. D. and Chang, G. N. (1979). *Anal. Chem.* **51**, 888–895.

Ministry of Agriculture, Fisheries and Food (MAFF) 1973). Technical Bulletin 27. HMSO, London.

Mohamet, N. and Fry, R. C. (1981). *Anal. Chem.* **53**, 450–455.

Pahlavanpour, B., Thompson, M. and Thorne, L. (1980). *Analyst* **105**, 756–761.

Pahlavanpour, B., Thompson, M. and Thorne, L. (1981). *Analyst* **106**, 467–471.

Robbins, W. B. and Caruso, J. A. (1979). *Anal. Chem.* **51**, 889A–899A.

Rose, A. W., Hawkes, H. E. and Webb, J. S. (1979). "Geochemistry in Mineral Exploration", pp. 52–53. Academic Press, London and New York.

Scott, R. H., Fassel, V. A., Knisely, R. N. and Nixon, D. E. (1974). *Anal. Chem.* **46**, 76–80.

Smith, A. E. (1975). *Analyst* **100**, 300–306.

Society for Analytical Chemistry (SAC) (1959). *Analyst* **84**, 214–216.

Thompson, K. C. and Thomerson, D. R. (1974). *Analyst* **99**, 595–601.

Thompson, M. and Howarth, R. J. (1978). *J. Geochem. Exploration* **9**, 23–30.

Thompson, M. and Howarth, R. J. (1981). *Analyst* **105**, 1188–1195.

Thompson, M. and Pahlavanpour, B. (1979). *Anal. Chim. Acta* **109**, 251–258.

Thompson, M. and Walsh, J. N. (1983). "A Handbook of Inductively Coupled Plasma Spectrometry". Blackie, Glasgow, 273pp.

Thompson, M. and Wood, S. J. (1982). *In* "Atomic Absorption Spectrometry", Cantle, J. E. (ed.), pp. 261–284. Elsevier, Amsterdam.

Thompson, M., Pahlavanpour, B., Walton, S. J. and Kirkbright, G. F. (1978a). *Analyst* **103**, 568–579.

Thompson, M., Pahlavanpour, B., Walton, S. J. and Kirkbright, G. F. (1978b). *Analyst* **103**, 705–713.

Thompson, M., Walton, S. J. and Wood, S. J. (1979). *Analyst* **104**, 299–312.

Thompson, M., Pahlavanpour, B. and Thorne, L. T. (1981). *Water Research* **15**, 407–411.

Webb, J. S. and Thompson, M. (1977). *Pure Appl. Chem.* **49**, 1507–1518.

4

Soils and Plants and the Geochemical Environment

JOE KUBOTA

I. Introduction

This chapter assesses the geochemical environment as it is reflected in the mineral composition of plants grown on soils. Greater emphasis thus is given to the biologically reactive forms of mineral elements in soils than to unreactive forms that are tied up in soil particles and are reflected in total soil content. The reactive forms absorbed by plants are often forms that are leached from soils. Thus, they become part of the food and feed chain and can cycle in the environment as well. Consequently, they are likely to affect man more directly than the unreactive forms.

Soils are a mixture of many elements, but the relative abundance of a mineral element in soil is often a poor indicator of its biological importance to man. Iron is a prime example. Most soils have percentage amounts of Fe, yet Fe deficiency is common in many crop plants and is probably the most common mineral deficiency in people, especially pregnant women (NAS, 1979). Trace elements in soils are present in microgram amounts, but many exert a biological effect far out of proportion to their concentration.

A simplified view of the origin and movement of mineral elements from soils to plants is illustrated in Fig. 4.1. A direct influence of a rock on the mineral composition of a soil is often difficult to establish because many soils are formed in unconsolidated surficial deposits of mixed rock origin. This is especially true in the US, where most of the agricultural productive soils are formed in alluvium, glacial drift, loess and coastal plain deposits.

The rock origin of soil parent material, however, is important because it

APPLIED ENVIRONMENTAL GEOCHEMISTRY
ISBN 0-12-690640-8

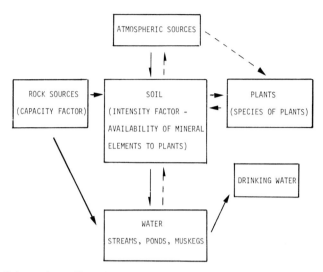

Fig. 4.1 Schematic outline of sources and pathways of mineral element movement from soils to plants.

provides an estimate of mineral reserves—the capacity factor—a soil has. Weathering triggers the release of the mineral elements in soils to plants and provides an estimate of the intensity factor. The capacity factor together with the intensity factor can be used to estimate the mineral supplying power of soils.

II. Soil–plant relationship

The likelihood that soil parent materials may basically be rich or poor in an element or of a group of elements can be assessed from the depositional nature of the deposits coupled with information about rock sources (Goldschmidt, 1954). An impact of rocks on the geochemical environment, however, may vary from place to place because similar kinds of rocks do not necessarily have uniform concentrations of a given element throughout their extent. Cretaceous rocks of the Niobara and Pierre formations, for example, are often implicated with Se toxicity (selenosis) in grazing animals in parts of the Rocky Mountain and the Northern Plains states in the United States. The Se concentration in these rocks, however, has been shown to vary from strata to strata within the formations (Lakin, 1961), so not all soils formed in or influenced by these rocks have uniformly high Se levels (Fig. 4.2). Thus, the severity of selenosis in the animals is not coextensive with the distribution of

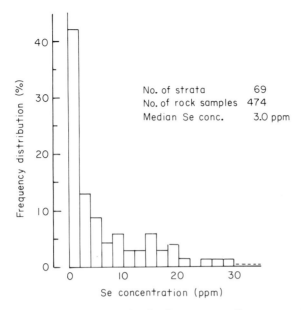

Fig. 4.2 Variations in Se concentration in Cretaceous sedimentary rocks sampled from various strate of the Pierre and Niobara formations (generalized from Lakin, 1961).

these rocks. Moreover, rocks that crop out on land surfaces are more likely to be biologically important to man than those deep in the earth's crust.

1. Soils

Soil wetness and pH are two factors that strongly influence the release of mineral elements to plants. Soils associated with Se toxicity in animals are mostly well drained and calcareous and have a pH near 8 or higher. Selenate forms of Se that are readily available to plants can occur in these soils. Selenosis is rarely observed in areas with acid soils, even though acid soils may have as much Se as the Se-rich calcareous soils. The term "non-toxic seleniferous soils" has been used for the Se-rich soils in Hawaii and Puerto Rico to distinguish them from the calcareous "toxic seleniferous soils" in the central United States (Lakin *et al.*, 1938). Selenosis has been observed locally in an acid soil area in Ireland (Fleming, 1962) where wet bottomland soils, underlain by marl, have accumulated large amounts of Se from the surrounding uplands over a long period of time.

 Wetness is a soil factor that often dramatically affects the concentrations of certain elements in plants. For example, the concentration of Cd in rice grain

(brown rice) was lowered by keeping the rice plant continuously standing in water during growth (Iimura, 1981b). The decreases in plant Cd concentration largely paralleled decreases in soluble (extractable) Cd and sulfide in soils, with a concomitant drop in redox potential (Iimura, 1981a).

Soil wetness, on the other hand, markedly increases the Mo concentration in plants (Kubota et al., 1963). These increases were clearly evident in forage plants grown on wet soils downslope on alluvial fans and on narrow floodplains of small streams, where the influence of Mo contributed from granite in the surrounding uplands was apparent (Kubota et al., 1967b). The increase in Mo concentration due to soil wetness was more clearly evident in plants grown on soils formed in granitic alluvium than in those grown on soils formed in alluvium derived from shale (Kubota, 1976).

Sometimes, a relationship between soil concentration and that in the plant determined for one soil group is not applicable to another soil group having similar weathering pattern and soil morphology. Such differences have been traced to soil parent materials in which the soils formed. For example, a deficiency of Co is associated with the sandy Humaquods on the lower Coastal Plain of the southeastern United States (Kubota and Lazar, 1958) and the sandy Spodosols in parts of New England (Kubota, 1964). The Co concentration in the plants grown on these soils is 0.04 to 0.07 ppm or less, even though the sandy Coastal Plain soils have about 0.4 ppm of Co and the sandy glaciated soils of New England have about 3 to 5 ppm of Co (Kubota and Lazar, 1960). Much of the Co in soils formed in the glacial deposits appears to be tied up in primary minerals. Such observations indicate that a given level of Co may not be equally available biologically in all soils. Many highly weathered soils in the southeastern United States (Ultisols) have only 2 ppm of Co, but they supply plants with enough Co to meet the dietary needs of the animals. A biopedological cycling of Co in these soils has been proposed to account for the adequate levels of Co in the plants grown on the soils (Kubota, 1965).

2. Plants

All species of plants do not respond equally to the soils on which they grow. Compared with legumes, grasses generally are poor feeders of many mineral elements present in soils and thus are poor indicators of the geochemical environment. Differences between grasses and legumes, evident at high concentrations of an element, are often less evident at lower concentrations. Some legumes also are better feeders of some elements than other elements. For example, alsike clover (Trifolium hybridum) had more Co than red clover (Trifolium pratense) when grown on both well drained (Fig. 4.3) and poorly

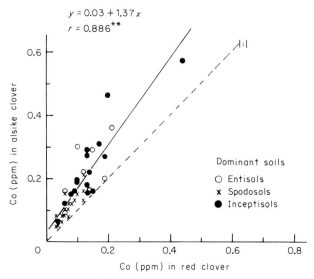

Fig. 4.3 Concentration of Co in alsike clover and red clover sampled from a number of well drained soils in New England.

drained (Fig. 4.4) soils in New England. Alsike clover, on the other hand, had less Cu than red clover (Fig. 4.5) over a range of soil textures from sand to clay.

The growing of accumulator or indicator plants often magnifies soil effects, but such plant responses are highly element specific. More than a 300-fold difference in Se concentration was found among seven species of plants growing on a seleniferous soil in South Dakota (Table 4.1). Accumulator plants like *Stanleya bipinnata* and *Astragalus racemosus* are often found on seleniferous soils and have been associated with acute selenosis in grazing animals in the United States.

Specific plant parts often differ in the concentration of any given element. Leaves of forage plants generally have higher concentrations of selected elements than stems (Fig. 4.6) and concentrations often differ with plant maturity (Beeson and Macdonald, 1951). The distribution of mineral elements in different plant parts probably is more important in food plants than in forage plants, because people usually eat specific parts of the plant. The analysis of outer husks, inner husks, silk and grain of corn separately illustrates this point (Table 4.2). The presence of the least amount of Cd and Pb in the corn grain in the presence of 21 ppm of Zn seems nutritionally important. Zinc is reported to have a protective effect against Cd (Mills, 1979).

Not all species of plants and animals are equally sensitive to excesses or deficiencies of any element, but collectively they seem to help maintain a mineral balance in man's food supply. For example, species of plants sensitive

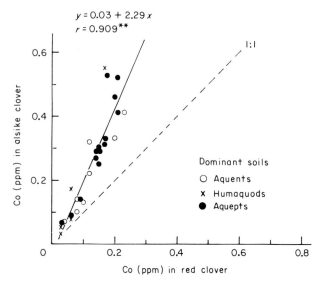

Fig. 4.4 Concentration of Co in alsike clover and red clover sampled from a number of poorly drained soils in New England.

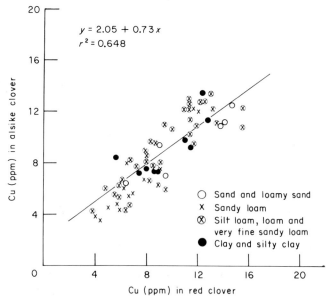

Fig. 4.5 Concentrations of Cu in alsike clover and red clover sampled from a wide range of soils in New England.

Table 4.1. Selenium concentration in several species of plants grown on a uniform area [~ 460 m^2 (5000 ft^2)] of seleniferous soil in South Dakota.*

Plant		Se
Common name	Scientific name	(ppm)
—	*Stanleya bipinnata*	2380
—	*Astragalus racemosus*	760
White aster	*Aster multiflorus*	320
Gumweed	*Grindelia squarrosa*	260
Broom snakeweed	*Gutierrezia sarothrae*	220
Western wheatgrass	*Agropyron smithii*	27
Sagebrush	*Artemisia canadensis*	6.8

* Adapted from Moxon *et al.* (1939).

to B toxicity (Eaton, 1944) help to prevent excessive movement of B, and Zn is applied to plants sensitive to a deficiency of Zn (Viets *et al.*, 1954).

3. Geographic patterns

Broad regional patterns of Co (Kubota, 1968), Mo (Kubota, 1976) and Se (Kubota *et al.*, 1967a) in plants have been presented for the United States. The map presented in Fig. 4.7 depicts the distribution of Mo concentration in legumes from the calcareous soils in the West to the acid soils in the East. Decreases in Mo in legumes tend to parallel decreases in availability of soil Mo from calcareous to non-calcareous soils. The endemic Mo toxic areas for grazing animals in the West are principally in the broad intermountain valleys. Within one such as Baker Valley in Oregon, however, the problem areas occur only on wet parts of the floodplains (Fig. 4.8) where soils have 1 ppm or more of Mo: North Powder (1.3 ppm), Hot Creek (4.3 ppm) and Willow Creek (2.4 ppm). The distribution of the problem areas thus is not coextensive with all poorly drained soils formed in granitic alluvium. Granite in the surrounding mountains is the source of the Mo, but the Mo has not been uniformly distributed in alluvium of all streams. The broad organic soil area in Florida is the only naturally occurring Mo-toxic area in the East. Some soils in the East have as much or more Mo (Robinson *et al.*, 1951) as many western soils, but the Mo is less available to plants in the East because the soils are acid. The median concentration of Mo in United States soils is about 1.5 ppm.

 The Cu concentration in legumes (8 to 9 ppm) sampled across the United States is nearly uniform (Kubota, unpublished data). Significantly, plants of Mo-toxic areas have as much Cu as do those from non-problem areas (Kubota

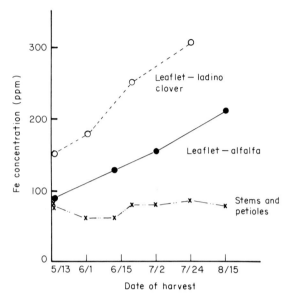

Fig. 4.6 Distribution of Fe in leaves, stems and petioles of ladino clover and alfalfa (adapted fromBeeson and Macdonald, 1951).

Table 4.2 Distribution of Cd, Pb, Zn and Cu in parts of the ear corn*

Part of plant	Cd (ppm)	Pb (ppm)	Zn (ppm)	Cu (ppm)
Outer husks	0.21 ± 0.10†	0.58 ± 0.07	13.3 ± 2.1	2.9 ± 0.4
Inner husks	0.25 ± 0.09	0.21 ± 0.04	17.2 ± 2.4	2.7 ± 0.3
Silk	0.15 ± 0.07	1.99 ± 0.10	72.1 ± 6.7	10.3 ± 1.0
Grain	0.06 ± 0.02	0.16 ± 0.04	21.3 ± 1.3	1.8 ± 0.1

* Two samples, each three ears, were taken at each of five sampling sites on an Aeric Fragiaqualf soil over a distance of 40 km (25 miles). The three ears were sampled from each of two parallel rows separated by a row that was left unsampled. Each of the three ears was separated into parts, composited and analysed.
† Mean and SE.

et al., 1961, 1967b). Two areas in this country where legumes have low Cu (5 to 6 ppm) concentrations are the low Co area in New England (Kubota, 1964) and the lower Coastal Plain in southeastern United States (Kubota and Lazar, 1958). The relationship of low Cu to low Co concentrations in plants from a low Co area in New England is shown in Fig. 4.9, and that in plants from an adequate Co area is shown in Fig. 4.10. The weathering processes that make soil Cu available to plants are essentially the same, so the differences noted between the two soil areas in plant Cu may be due to differences in soil Cu

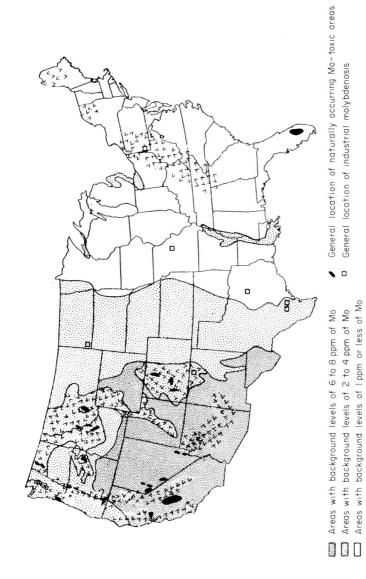

■ Areas with background levels of 6 to 8 ppm of Mo ◖ General location of naturally occurring Mo-toxic areas

░ Areas with background levels of 2 to 4 ppm of Mo □ General location of industrial molybdenosis

□ Areas with background levels of I ppm or less of Mo

Fig. 4.7 Generalized regional pattern of Mo concentration in legumes of the US.

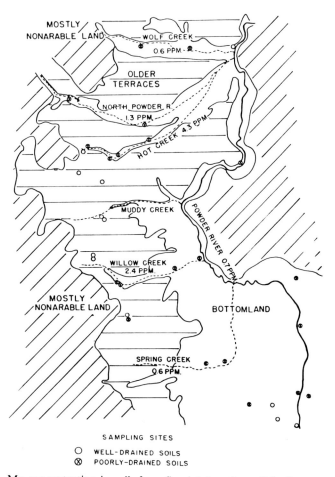

Fig. 4.8 Mo concentration in soils from floodplains of parallel tributary streams of Powder River, Baker Valley, Oregon.

reserves. The soils of the low Co area have about 21 ppm of Cu compared with 25 ppm of Cu in soils of the Co adequate area. The magnitude of differences between soils of New England, however, is small compared with differences in soil Cu between soils of the low Co area of New England (21 ppm) and the sandy soils of the Lower Atlantic Coastal Plain (5 ppm). As with soil Co, much of the Cu in soils developed in glacial till appears to be tied up in primary minerals.

Geographic areas associated with nutritional problems in animals have several soil characteristics in common. Those associated with areas of Co deficiency, Mo toxicity, Se deficiency and toxicity, and Mg deficiency in

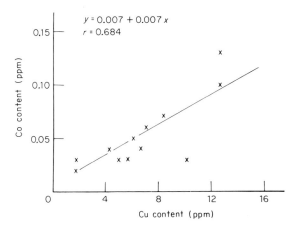

Fig. 4.9 Cu and Co concentration in legumes from a low-Co area associated with Co deficiency in animals in New England.

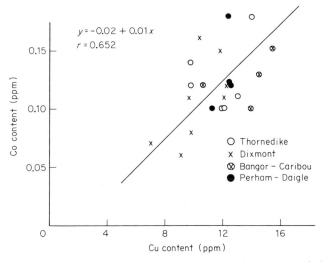

Fig. 4.10 Cu and Co concentration in legumes from Co-adequate areas in Maine (the soil series represent Haplorthods, Fragiaqualfs, Fragiochrepts and Eutrochrepts).

grazing animals are presented in Table 4.3. The characteristics are most evident in endemic areas of acute toxicities or deficiencies and illustrate how weathering processes (intensity factor) and soil parent materials (capacity factor) when combined affect plant concentration of these elements. Because relatively few soils meet both requirements, this contributes to limit the geographic distribution of Mo-toxic areas and areas of Co deficiency in ruminant animals in the US.

Table 4.3 Characteristics of soils and soil parent materials associated with nutritional problems in animals in the US

Trace element	Nutritional problem-animals	Significant plant conc.	Characteristics	
			Soil	Soil parent material
Co	Deficiency	0.04–0.07 ppm or less	Sand texture, acid, poor drainage (Humaquods)	Coastal plain deposit; glacial drift—White Mountain granite
Mo	Toxicity	10–20 ppm or more	Poor drainage, neutral to alkaline reaction	Granitic alluvium, alluvium from shale
Se	Toxicity	4–5 ppm or more	Alkaline reaction, calcareous, good drainage	Seleniferous rocks, Cretaceous shales
	Deficiency	0.05 ppm or less	Acid reaction	Mixed, non-seleniferous deposits
			Neutral to alkaline	Volcanic ash
Mg	Deficiency	0.15% or less (?)	Mesic soil zone; limited available soil moisture	Mixed, unconsolidated deposits, volcanic ash

Table 4.4 Absorption by rats of Zn in pea seeds (freeze dried)*

Source of Zn	Level in diet	Consumed (μg)	Absorbed† (%)	Absorbed (μg)
Peas, mature	Low	16.2	94.9[a]	15.4
	High	36.4	90.3[ab]	32.9
Peas, immature	Low	6.8	77.4[cd]	5.3
	High	32.8	74.9[d]	24.6
$ZnSO_4$	Low	11.4	88.3[ab]	10.1
	High	54.1	83.6[bc]	45.3

* Modified from Welch *et al.* (1974) using Zn-depleted rats.
† Values followed by the same letter were not significantly different ($P < 0.05$).

III. Soil–plant–animal relationships

A direct role of soils in the geochemical environment could become less pronounced as mineral elements in soils are passed from plants to animals in the feed chain. How animals respond and affect the transfer of a mineral element to people could vary with their nutritional status as well as with levels of the mineral element in the feed, because animals have homeostatic mechanisms that maintain mineral balance. Such an animal response is illustrated in Table 4.4.

Table 4.5 Movement of Se in a soil–plant–animal chain, evident the
second year after Se was applied to the soil (1 ppm)*

Observation	No Se applied	Se applied
Alfalfa (ppm)	<0.01	0.43–0.57
Animals in experiment (No.)		
Ewes	20	20
Lambs	25	21
Lambs lost prior 6 weeks (No.)		
W/WMD† lesions	4	0
Wo/WMD lesions	0	1
Lambs surviving 6 weeks	21	20
W/WMD lesions (No.)	10	0
Wo/WMD lesions (No.)	11	20
Weight (kg)	14.9	14.7
Tissue Se (ppm dry weight basis)		
Skeletal	0.02	0.85
Liver	0.04	4.02
Kidney	0.52	3.28
Heart	0.03	1.53

* Adapted from Allaway et al. (1966).
† W/WMD—lambs with lesions of White Muscle disease; Wo/WMD—lambs
without lesions of White Muscle disease.

When rats were depleted of Zn, they absorbed more Zn from their feed, even
though the levels of Zn were low (Welch et al., 1974). An important
observation also was that Zn incorporated in the pea grain was as available or
slightly more available to the rats than $ZnSO_4$, a Zn salt commonly used as a
standard Zn source in dietary studies. Some species of animals are more
sensitive or tolerant to a mineral element than others (Underwood, 1977) and
similar differences are recognized among plant species (Chapman, 1966).
Recognition of causes of nutritional problems often leads to development of
alternative practices of crop and animal production, so that exposure of either
to excessive levels tends to be minimized with time.

The transfer of a mineral element like Se from a parent to offspring may
mask direct effects of soils as well. When a low-Se soil in Oregon was fertilized
with Se (Table 4.5), the Se concentration in the alfalfa grown on the fertilized
soil was raised from a level deficient for sheep to an adequate level (Allaway et
al., 1966). Lambs from ewes fed hay from the Se-fertilized soil had no lesions of
White Muscle disease and had more Se in their body tissues than lambs from
ewes fed hay from soil not fertilized with Se. Weight gains were the same for
both groups of lambs, so weight gains alone were inadequate to assess quality
of the feed.

Information currently available for the United States suggests that

incidences of White Muscle disease in animals (Muth and Allaway, 1963) and, to a lesser degree, blood Se levels in people (Allaway et al., 1968) show some relationship to a broad regional pattern of low and adequate Se areas as identified by Se concentrations in common forage plants (Kubota et al., 1967a). Any relationship of this nature, however, tends to become increasingly weakened as the soil–plant information is applied to further members in the food and feed chain. Few exceptions arise when plant Se concentrations are evaluated in relationship to soils, because this is the shortest link in the chain. A broad regional pattern of an adequate Se area arises because broad regions of calcareous soils have formed in glacial drift, alluvium and loess in the Central States where surficial deposits have benefited from Se contributed by Cretaceous and Tertiary seleniferous rocks in the Rocky Mountain states. The eastern part of the country, conversely, has acid soils that largely have formed in surficial deposit with no identifiable Se-rich rock source.

IV. Biological appraisal of man's geochemical environment

When soils are assessed biologically in relation to plants and animals, as in this chapter, the soil–plant–animal chain emerges as a series of natural systems that buffer man against excesses of many mineral elements. The basis for this point of view is presented in Table 4.6. Eighteen elements are classed into four groups according to whether they are required and how they are tolerated by plants, animals or both. A comparable table outlining the biochemical role and symptoms of nutritional disorders in animals associated with most of these trace elements has been presented by Mills (1979).

Boron and Mo are included in the first group; both are essential to plants but their essentiality to animals remains to be established. Because many plants are sensitive to a deficiency as well as to an excess of B, recognition and solution of nutritional problems in plants effectively controls levels of B passing through the food chain. The possibility that lambs may be susceptible to B toxicity in Russia (Nutr. Abstra. Rev. 30, 1138, 1960) suggests that livestock also could effectively serve as a buffer against high B concentration. The susceptibility of plants to Mo deficiency tends to maintain a minimum flow of this element even though the essentiality of this element to animals remains to be established. Naturally occurring cases of Mo toxicity in plants have not been observed, but the movement of excessive Mo in the feed chain is buffered by ruminants. Cattle suffer from molybdenosis or Mo-induced Cu deficiency when they graze forage plants with 10–20 ppm or more of Mo. Legumes with as much as 400 ppm or more of Mo have been found. Reports from New Zealand (Healy et al., 1961), the UK (Anderson, 1966) and Hungary (Adler and Staub, 1953) indicate that children born and raised in a high Mo

Table 4.6 Nutritional problems in plants and animals and their possible relationship to man

Element	Plant	Animal	Man
Essential to plants			
B	D/T*	(?)	(−)
Mo	D	T(Cu-induced)	(+ ?/teeth)
Essential to plants and animals			
Cu	D	D(Mo-induced)	D
Zn	D/T	D	D
Fe	D	D(pigs)	D
Mn	D/T	D	(−)
Co	D(Leg.)	D(ruminants)	(−)
Si	D	D(expt.)	(−)
Essential to animals but not to plants			
F	T	T	(±teeth)
Se	(−)	D/T	(±excess in teeth)
I	(−)	D	D
Cr	(−)	D(expt.)	D
V	(−)	D(expt.)	(−)
Ni	(−)	D(expt.)	(−)
Sn	(−)	D(expt.)	(−)
As	(−)	D(expt.)	T
Not essential to plants or animals			
Pb	(−)	T	T
Cd	(−)	(−)	T

* Key: D—deficiency; T—toxicity; expt.—experimental; (−) not known or established; (+) beneficial.

area have fewer decayed, missing and filled teeth than children of other areas, but the reason for this difference is not known.

The second group includes trace elements that are essential to both plants and animals. Deficiency of Zn in crop plants is widespread in the United States (Berger, 1962); deficiency of Mn is less common. Both Cu and Zn deficiencies are widespread in crop plants in Australia (Anderson and Underwood, 1959), so fertilizers containing these trace elements are applied to specific crops. Naturally occurring Zn toxicity in crop plants is rare, but has been recognized in New York State in plants grown on an organic soil underlain by a substratum rich in ZnS. The problem surfaced when the soil was drained and put into crop production (Staker, 1943). Among animals, ruminants are sensitive to excess Mo and a deficiency of Co, but poultry are sensitive to a deficiency of Mn. Problems with deficiencies seem to be dominant in this group of trace elements, and supplemental sources are provided at various steps in the food chain.

The third group includes trace elements that primarily affect animals and are generally considered to be not essential to plants. Problems of F toxicity in animals are mostly of industrial origin (NAS, 1971), but may occur naturally near some thermal springs (Kubota et al., 1982). Animal deficiencies and toxicities of F occur at concentrations that do not affect the growth of most plants. Iodine deficiency and its relationship to goitre is well established. The high incidence of goitre in people who live inland, especially in mountainous areas, indicates that transport of I in sea mist may be important. The essentiality of Cr, V, Ni, Sn and As to animals has been demonstrated experimentally, but the biological role of most of these elements in plants remains to be established (summary by Underwood, 1977). Dixon et al. (1975) reported Ni to be an essential component of metalloenzyme urease in jack beans (Canavalia ensiformis). "Glucose tolerance factor" is reported to be the biologically active form of Cr (Mertz, 1969).

Cadmium and Pb are two elements (fourth group) that have no known biological role in plants or animals. Both, however, are universally present in the geochemical environment and in all plants. Appreciably less Cd and Pb and more Zn and Cu have been found in the seed than in other parts of common grain crops grown on a wide range of soils in the United States (Kubota, unpublished data). Such observations may be tied to the selective transfer of mineral elements into seed, a role attributed to vascular transfer cells in wheat grain by Zee and O'Brien (1971) and in selected legume seeds by Hocking and Pate (1977). To this extent, edible seed crops may serve to buffer man against excesses of Cd and Pb. Selective transfer of Cd (Jarvis et al., 1976) and Pb (Jones et al., 1973) by roots to tops may be an additional barrier that restricts Cd and Pb from plants, except possibly for the leafy vegetables. Because crops are grown under widely different conditions, the possibility remains that changes in Cd and Pb concentrations may result from their interaction with other elements as well. The association of both elements with toxicities in man suggests that man may have a lower tolerance for the two metals than plants.

Many common food plants grown in solution culture with added Cd tolerated fairly high concentrations of this element (Page et al., 1972). A 50% reduction in growth due to the added Cd was observed in field bean with 22 ppm of Cd; cabbage at the same level of injury had 800 ppm. A fern, Athyrium yokoscense, in Japan (Hiroi, 1981) is reported to be an accumulator of Cd (highest 1200 ppm). By comparison, 1 ppm is set as the maximum allowable concentration of Cd in unpolished rice (brown) for a basic foodstuff in Japan (Asami, 1981); this limit is based on an average daily consumption of 335 g of rice per person. Estimates of Cd intakes between 55 and 70 μg day^{-1} have been given, but critical levels for humans worldwide are difficult to establish because Zn, Cu, Fe and Se all interact with Cd (Underwood, 1977).

Underwood has recognized three characteristics of Cd important to man: an absence of an effective homeostatic control mechanism, long body retention time and interactions with other metals.

Much of the information on Pb concentration in plants stems from studies of the effects of Pb arsenical sprays. A summary of Pb concentrations in plants (Brewer, 1966) indicates that concentrations can vary widely between different species of plants and that plants can tolerate fair amounts of Pb. It seems evident that substantial amounts of Pb, unlike many other elements, can move atmospherically (Lagerwerff, 1972). Atmospheric Pb is returned to land in rain, snow and dust. Reviews by both Brewer (1966) and Lagerwerff (1972) suggest that Pb is strongly adsorbed in soils and is not readily available to plants. More Pb is often found in surface than in subsoil horizons of soils, so that leaching losses of Pb from soils may be minimal.

Investigators in a wide range of scientific disciplines study various aspects of trace element properties and behaviour to determine their sources in soils and rocks and their role and tolerance levels in biological systems. The impact of any single report on the understanding of the geochemical environment of man, however, is often difficult to assess, because man is exposed to trace elements from multiple sources. Problems of deficiencies and toxicities in plants and animals most often are viewed as research problems to be solved. This viewpoint may be shortsighted, because correction of nutritional problems in plants and animals moderates the movement of excesses of trace elements in the food chain of man.

The transformation of "trace-element deserts" to productive land in Australia through fertilization with Cu, Zn and Mo (Anderson and Underwood, 1959) has unquestionably increased man's food supply, but it seems likely that it has probably also improved his geochemical environment as well.

In assessing the geochemical environment, it is apparent that relatively few soils strongly affect man and most soils affect him indirectly or minimally. For example, of the 613 million ha (1513 million acres) of privately owned land in the United States, about 25% is rangeland and pasture, about 25% forest, and about 27% in crops, including grain crops fed primarily to animals. The geographic distribution of the agricultural production areas in the United States is presented in Fig. 4.11. Soils used for crop production must have greater impact on man than soils of rangeland and forested land combined. Any comparisons of soils, even the agriculturally productive soils, on a hectare-to-hectare basis must be quite tenuous. Many soils in the warmer areas are used to grow food plants consumed directly by people, and most are used to grow two and sometimes three crops per year. Most of the agriculturally productive soils in the United States, moreover, are formed in unconsolidated surficial deposits of mixed rock origin, so that any direct influence of the original bedrock often becomes obscure.

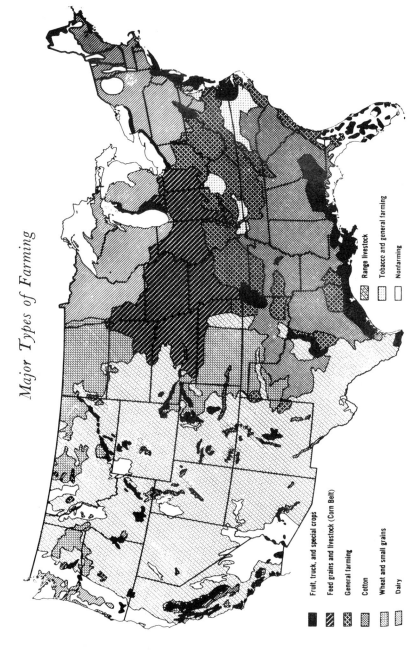

Major Types of Farming

Fruit, truck, and special crops

Feed grains and livestock (Corn Belt)

General farming

Cotton

Wheat and small grains

Dairy

Range livestock

Tobacco and general farming

Nonfarming

Fig. 4.11 An overview of the principal agricultural production areas by crops in the US (USDA, 1958).

Other considerations that tend to weaken any direct relationship between mineral composition of soils and human health are food preparation, interregional shipment of foods and feeds, and minerals in drinking water. Underwood (1977) has indicated that the selection and choice of foods still remains a major health consideration of people in different parts of the world.

References

Adler, P. and Staub, J. (1953). *Acta Med. Acad. Sci. Hungarica* **4**, 221.

Allaway, W. H., Moore, D. P., Oldfield, J. E. and Muth, O. H. (1966). *J. Nutr.* **88**, 411–418.

Allaway, W. H., Kubota, J., Losee, F. and Roth, M. (1968). *Arch. Environ. Health* **16**, 342–348.

Anderson, R. J. (1966). *British Dental J.* **120**, 271–275.

Anderson, A. J. and Underwood, E. J. (1959). *Scient. Amer.*, (Jan.), 1–6.

Asami, T. (1981). *In* "Heavy Metal Pollution in Soils of Japan" (K. Kitagashi and I. Yamane, eds.), pp. 257–285. Japan Science Society Press, Tokyo.

Beeson, K. C. and Macdonald, H. A. (1951). *Agronomy J.* **43**, 589–593.

Berger, K. C. (1962). *J. Agric. Food Chem.* **10**, 178–181.

Brewer, R. F. (1966). *In* "Diagnostic Criteria for Plants and Soils" (H. D. Chapman, ed.), pp. 213–217. University of California, Division of Agricultural Science.

Chapman, H. D. (ed.) (1966). "Diagnostic Criteria for Plants and Soils", p. 793. University of California, Division of Agricultural Science.

Dixon, N. E., Gazzola, C., Blakely, R. L. and Zerner, B. (1975). *J. Amer. Chem. Soc.* **19**, 4431–4133.

Eaton, F. M. (1944). *J. Agric. Res.* **69**, 237–277.

Fleming, G. A. (1962). *Soil Sci.* **94**, 28–35.

Goldschmidt, V. M. (1954). "Geochemistry." The Clarendon Press, Oxford.

Healy, W. B., Ludwig, T. G. and Losee, F. L. (1961). *Soil Sci.* **92**, 359–366.

Hiroi, T. (1981). *In* "Heavy Metal Pollution in Soils of Japan" (K. Kitagashi and I. Yamane, eds.), pp. 219–231. Japan Science Society Press, Tokyo.

Hocking, P. J. and Pate, J. S. (1977). *Ann. Bot.* **41**, 1259–1278.

Iimura, K. (1981a). *In* "Heavy Metal Pollution in Soils of Japan" (K. Kitagashi and I. Yamane, eds.), pp. 27–35. Japan Science Society Press, Tokyo.

Iimura, K. (1981b). *In* "Heavy Metal Pollution in Soils of Japan" (K. Kitagashi and I. Yamane, eds.), pp. 37–50. Japan Science Society Press, Tokyo.

Jarvis, S. C., Jones, L. H. P. and Hopper, M. J. (1976). *Plant and Soil* **44**, 179–191.

Jones, L. H. P., Clement, C. R. and Hopper, M. J. (1973). *Plant and Soil* **38**, 403–414.

Kubota, J. (1964). *Soil Sci. Soc. Amer. Proc.* **28**, 246–251.

Kubota, J. (1965). *Soil Sci.* **99**, 166–174.

Kubota, J. (1968). *Soil Sci.* **106**, 122–130.

Kubota, J. (1976). *In* "The Geochemistry, Cycling and Industrial Uses of Molybdenum" (W. R. Chappell and K. K. Petersen, eds.), vol. II, pp. 555–581. Marcel Dekker, Inc., New York.

Kubota, J. and Lazar, V. A. (1958). *Soil Sci.* **86**, 262–268.

Kubota, J. and Lazar, V. A. (1960). *Intl Congr. Soil Sci. Trans., 7th (Madison, WI)*, **II**, 134–140.

Kubota, J., Lazar, V. A., Langan, L. N. and Beeson, K. C. (1961). *Soil Sci. Soc. Amer. Proc.* **25**, 227–232.

Kubota, J., Lemon, E. R. and Allaway, W. H. (1963). *Soil Sci. Soc. Amer. Proc.* **27**, 679–683.

Kubota, J., Allaway, W. H., Carter, D. F., Cary, E. E. and Lazar, V. A. (1967a). *J. Agric. Food Chem.* **15**, 448–453.

Kubota, J., Lazar, V. A., Simonson, G. H. and Hill, W. W. (1967b). *Soil Sci. Soc. Amer. Proc.* **31**, 667–671.

Kubota, J., Naphan, E. A. and Oberly, G. H. (1982). *J. Range Management* **35**, 188–192.

Lagerwerff, J. V. (1972). *In* "Micronutrients in Agriculture" (J. J. Mortvedt, P. M. Giordano and W. L. Lindsay, eds), pp. 593–636. Soil Science Society of America, Madison, Wisconsin.

Lakin, H. W. (1961). *In* "Selenium in Agriculture", pp. 3–24. USDA Agric. Handbook 200, Washington, DC.

Lakin, H. W., Williams, K. T. and Byers, H. G. (1938). *Ind. Eng. Chem.* **30**, 599–600.

Mertz, W. (1969). *Physiological Rev.* **49**, 163–238.

Mills, C. F. (1979). *Chem. in Britain* **15**, 512–520.

Moxon, A. L., Olson, O. E. and Searight, W. V. (1939). *South Dakota Agric. Exp. Sta. Tech. Bull.* **2**, 1–94.

Muth, O. H. and Allaway, W. H. (1963). *J. Amer. Vet. Med. Assoc.* **142**, 1379–1384.

NAS Committee on Biol. Effects of Atmos. Pollutants (1971). "Fluorides", pp. 295. National Academy of Sciences, Washington, DC.

NAS Subcommittee on Iron (1979). "Iron", pp. 248. University Park Press, Baltimore, MD.

Page, A. L., Bingham, F. T. and Nelson, C. (1972). *J. Environ. Qual.* **1**, 288–291.

Robinson, W. O., Edgington, G., Armiger, W. H. and Breen, A. V. (1951). *Soil Sci.* **72**, 267–274.

Staker, E. V. (1943). *Soil Sci. Soc. Amer. Proc.* **7**, 387–392.

Underwood, E. J. (1977). "Trade Elements in Human and Animal Nutrition", 4th edn, p. 545. Academic Press, New York, San Francisco, London.

US Department of Agriculture (1958). "Land—Yearbook of Agriculture", pp. 605. Government Printing Office, Washington, DC.

Viets, F. G., Boawn, L. C. and Crawford, C. L. (1954). *Soil Sci.* **78**, 305–316.

Welch, R. M., House, W. A. and Allaway, W. H. (1974). *J. Nutr.* **104**, 733–740.

Zee, S. Y. and O'Brien, T. P. (1971). *Aust. J. Biol. Sci.* **24**, 35–49.

5

The Chemical Forms of
Trace Metals in Soils

GARRISON SPOSITO

I. Introduction

A soil can be described as an open, multicomponent chemical system that contains solid, liquid and gaseous phases influenced by living organisms and by the terrestrial gravitational field. From this strictly chemical point of view, soils are complex assemblies of matter whose properties continually are modified by the actions of biological, hydrological and geological agents. The labile aqueous phase in soil, the soil solution, is the principal seat of this activity, a dynamic, open, natural water system whose properties represent the effects of soluble complex formation, oxidation–reduction, adsorption and precipitation–dissolution reactions that proceed concurrently. The net outcome of these many reactions is a dense web of chemical interrelations mediated by variable fluxes of matter and energy from the atmosphere, hydrosphere and biosphere.

It is within this very complicated setting that the chemistry of trace metals in soil must be investigated. This fact alone is sufficient to give precedence to approaches that interpret trace metal behaviour in soils on the basis of a unified theoretical structure. With respect to the problem of describing the chemical forms of trace metals in soils and natural waters, the most prominent of these approaches is chemical thermodynamics (Sposito, 1981a; Stumm and Morgan, 1981). This discipline of physical chemistry will provide the conceptual framework onto which the descriptive content of the present chapter will be fastened. Thus an emphasis will be given to the chemical *states* of trace metals in soils, not to the chemical *processes* by which these states may

APPLIED ENVIRONMENTAL GEOCHEMISTRY
ISBN 0-12-690640-8

be changed. This choice is made only for reasons of clarity in exposition and simplicity in conceptualization, with no illusion entertained that all soil phenomena involving trace metals can be accounted for by a thermodynamic analysis. In particular, the essential role of non-equilibrium states in fundamental processes concerning living organisms, such as metal uptake by plants grown in soil, is recognized fully (Nye and Tinker, 1977). It is hoped simply that the perspective of chemical thermodynamics can serve to provide constraints subject to which more general concepts of transport phenomena can be developed.

The term "trace metal" is not defined precisely in soil chemistry, but it has come generally to mean those metal elements of the Periodic Table whose typical concentrations in soil solutions are significantly below $1 \, mol \, m^{-3}$ (Mattigod et al., 1981). In this chapter, a narrower definition will be used most of the time, in that "trace metal" species will be considered synonymous with the set of "borderline-to-Class b" metal species as defined by inorganic chemists (see, e.g., Huheey, 1978; Nieboer and Richardson, 1980). The advantages to be gained from this somewhat arbitrary restriction are a resultant set of metal species of well-established environmental concern (Nieboer and Richardson, 1980; Mattigod and Page, 1983) and the avoidance of calling metal species that are in fact abundant in the solid phases of soils "trace metals" (e.g., Al(III) and Fe(III)).

The following three sections of this chapter describe the three principal chemical forms of trace metals in soils: solid, adsorbed and aqueous. Some familiarity with basic soil chemistry (e.g., Sposito, 1982; Bohn et al., 1979) is assumed in the discussion and frequent referral is made to advanced monographs on soil physical chemistry (e.g., Lindsay, 1979; Sposito, 1981a) for detailed treatments. The fifth section discusses the influence of oxidation–reduction reactions on the chemistry of trace metals in soils. The final, culminating section of the chapter reviews the use of computer-based chemical equilibrium models to predict the quantitative distribution of trace metals among their principal chemical forms. This last section is intended both to illustrate the utility of these computer models and to impart some feeling for how the models are handled in representative applications.

II. Solid species

1. Solubility equilibria

The solid phases in soils that contain trace metals often are investigated through solubility experiments in which the extracting medium is water. Solubility studies also have been conducted frequently with other, more reactive extractants, on the premise that they would be selective for particular

solid forms of trace metals (see, e.g., Davies, 1980; Mattigod and Page, 1983). But this expectation usually has proven to be too optimistic, with the present consensus being that reagent extraction schemes are used at best as a means to correlate data on trace metal bioavailability or mobility for agricultural or ecological instead of geochemical purposes (Cottenie et al., 1979; Davies, 1983).

The criteria to be observed in the design of experiments to measure aqueous solubility equilibria have been reviewed in an especially clear fashion by Brown (1973). These criteria, outlined below, form a set of necessary conditions to be met to ensure an unambiguous interpretation of aqueous solubility data on trace metal solid phases in soils.

(a) Analysis of the solid phase

The nature of the solid phase containing a trace metal usually cannot be ascertained with classical techniques, such as X-ray diffraction or differential thermal analysis, because of the very low concentration of the metal in soil. More sensitive analytical methods, such as electron probe microanalysis (Norrish, 1975) and X-ray photoelectron spectroscopy (Koppelman et al., 1980), are applicable directly to the identification of trace metals in soil particles.

(b) Establishment of equilibrium

Solubility equilibria should be approached both from supersaturation and from undersaturation, should involve variations in the equilibration time, and should be monitored through two or more variables that can be measured with high precision. The range of concentrations studied should be as large as practicable.

(c) Description of the reaction

The stoichiometry of the precipitation–dissolution reaction should be verified through analysis of the aqueous solution phase. The state of the solid phase in relation to stability (i.e., metastability versus true stability) should be established.

The solubility equilibrium of a two-component solid that contains the trace metal cation, M^{m+}, can be expressed:

$$M_aL_b(s) = aM^{m+}(aq) + bL^{l-}(aq) \qquad (5.1)$$

where the ionic valences and stoichiometric coefficients of the metal, M, and ligand, L, are subject to the electroneutrality condition: $am = bl$. The

thermodynamic description of the reaction in Eqn (5.1) is contained entirely in the expression (Guggenheim, 1967, Chap. 6):

$$\mu[M_aL_b(s)] - a\mu[M^{m+}] - b\mu[L^{l-}] = 0 \qquad (5.2)$$

where $\mu[\]$ refers to the chemical potential of the species enclosed in the square brackets. Upon introducing into Eqn (5.2) the well known relation:

$$\mu[\] = \mu^0[\] + RT \ln (\) \qquad (5.3)$$

where $\mu^0[\]$ is a Standard State chemical potential and $(\)$ refers to a thermodynamic activity, one can derive the identity:

$$\Delta G^0_{dis} + RT \ln K_{dis} = 0 \qquad (5.4)$$

In Eqn (5.4):

$$\Delta G^0_{dis} \equiv a\mu^0[M^{m+}] + b\mu^0[L^{l-}] - \mu^0[M_aL_b(s)] \qquad (5.5)$$

and

$$K_{dis} \equiv (M^{m+})^a(L^{l-})^b/(M_aL_b(s)) \qquad (5.6)$$

are the standard free energy change and equilibrium constant, respectively, for the reaction in Eqn (5.1). The standard free energy change, ΔG^0_{dis}, can be used both to assess the stability of the solid M_aL_b relative to its component ions *in the Standard State* and to calculate, with Eqn (5.4), the value of the equilibrium constant, K_{dis} (Sposito, 1981a, Chap. 2). For ΔG^0_{dis} measured in kJ mol^{-1} and $T = 298.15$ K ($25°$C), Eqn (5.4) takes on the practical form:

$$\Delta G^0_{dis} = -5.708 \log K_{dis} \qquad (5.7)$$

where "log" refers to the common logarithm. This equation can be used to compute K_{dis} if precise values of the Standard State chemical potentials in Eqn (5.5) are available. Equations (5.1), (5.2), (5.5) and (5.6) can be generalized readily to describe the dissolution reactions of trace metal solid phases containing more than one metal or ligand.

2. The ion activity product

For the reaction in Eqn (5.1), the *ion activity product* (IAP) is defined by the equation:

$$IAP \equiv (M^{m+})^a(L^{l-})^b \qquad (5.8)$$

When the reaction in Eqn (5.1) comes to equilibrium, $IAP = K_{dis}(M_aL_b(s))$ according to Eqn (5.6). Thus, the IAP is a variable that can be monitored to assess the approach of a solubility experiment to equilibrium. An illustration of this use of the IAP is given in Fig. 5.1 for an experiment in which 50 ml of 1.75×10^{-3} M $Cd(CH_3CO_2)_2$ were reacted at $25°$C with 0.5 g of Nibley silty

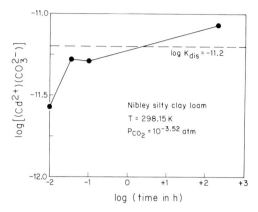

Fig. 5.1 Approach of IAP = $(Cd^{2+})(CO_3^{2-})$ to the value of K_{dis} for otavite after the addition of cadmium acetate to Nibley silty clay loam (Santillan-Medrano and Jurinak, 1975).

clay loam, an Aquic Argiustoll (Santillan-Medrano and Jurinak, 1975). After about 200 h of reaction under $P_{CO_2} = 10^{-3.52}$ atm, IAP = $(Cd^{2+})(CO_3^{2-})$ was observed to approach a value near $10^{-11.1}$. From the compilation of thermodynamic data by Robie $et\ al.$ (1978), one finds the Standard State chemical potentials: $\mu^0[CdCO_3(c)] = -669.44 \pm 2.64$ kJ mol^{-1}, $\mu^0[Cd^{2+}]$ $= -77.58 \pm 0.12$ kJ mol^{-1}, and $\mu^0[CO_3^{2-}] = 527.90 \pm 0.12$ kJ mol^{-1}. These data along with Eqns (5.5) and (5.7) lead to the value log $K_{dis} = -11.2 \pm 0.5$, which agrees well with the limiting value of log (IAP) indicated in Fig. 5.1. Therefore, within the limits imposed by the present experimental precision, Fig. 5.1 shows that IAP approaches a value in the Nibley soil that is consistent with the presence of otavite, $CdCO_3(c)$, at unit activity.

If the IAP pertaining to a trace metal solid of interest is determined accurately in a soil solution, and if it does not equal to K_{dis}, then the conclusion to be drawn is one or more of the following statements:

(i) Equilibrium with a solid phase does not exist.
(ii) The solid phase controlling the trace metal ion activity is not the one suspected.
(iii) The solid phase controlling the trace metal ion activity is the one suspected, but the solid is not in its Standard State.

With respect to conclusion (iii), the state of the precipitated solid can influence the IAP by causing it to reach a steady value that is significantly *larger* than K_{dis} for the dissociation of the macroscopic, crystalline solid. According to Eqn (5.8), this result is evidence for the formation of a metastable solid whose activity is larger than that of the crystalline phase at the Standard

State temperature and pressure. Frequently this phenomenon occurs in soils because solid phases that have been precipitated onto the surfaces of previously existing soil minerals (instead of onto the bottom of a laboratory flask) can exhibit more defects and structural irregularities, or a smaller particle size, than do the crystalline phase to which K_{dis} refers (Corey, 1981). Under these circumstances, the activity of the precipitate at the Standard State temperature and pressure will be larger than 1.0 (indicating ultimate instability relative to the pure crystalline phase), and IAP will remain larger than K_{dis} as long as the metastable solid persists.

3. Activity ratio diagrams

Equation (5.6) can be written in logarithmic form as an expression for (M^{m+}):

$$\log (M^{m+}) = \frac{1}{a} \left[\log (M_a L_b(s)) - b \log (L^{l-}) + \log K_{dis} \right] \tag{5.9}$$

This equation shows clearly the two principal factors that regulate the activity of a trace metal cation in the soil solution. For example, if the solid phase in equilibrium with the metal cation is not in the Standard State, then $(M_a L_b(s))$ will not be equal to 1.0 and the first term on the right side of Eqn (5.9) will contribute to $\log (M^{m+})$. If an X-ray amorphous or structurally irregular form of the solid is present, this contribution will increase the activity of M^{m+}. On the other hand, if the solid has formed a coprecipitate in the soil, $(M_a L_b(s))$ usually will be smaller than 1.0 and the activity of M^{m+} will be decreased. This latter possibility will be discussed in Section II.4.

The contribution of (L^{l-}), in principle, links (M^{m+}) to the activities of all of the other metals and ligands present, because L could be participating in a variety of complexation, adsorption and precipitation reactions in a soil. Thus (L^{l-}) in general will be determined by the composition and pH value of the soil solution, as well as by the values of P_{CO_2}, the electron activity (redox potential), temperature and pressure.

For almost any trace metal cation, there will be several different solid phases containing it that can precipitate under given conditions in a soil solution. The question then arises as to which of these solids actually is expected to form and control the activity of the metal cation. This question can be answered readily on the basis of an *activity ratio diagram*, which is a graph of the variable, log [(solid phase)/(free metal cation)] *versus* some important parameter, such as the pH value, where () refers, as usual, to a thermodynamic activity. The graph will include plots of the common logarithm of the activity ratio for each possible solid phase containing the trace metal of interest. For a chosen value of the soil solution parameter being treated as the independent variable, and

under the assumption that all solid phases are in their Standard States, that solid which produces the *largest* value of the logarithm of the activity ratio is the one which is *most stable* and, therefore, the only one that will form at equilibrium. This conclusion follows directly from the fact that the activity ratio is largest when the activity of the trace metal cation is made smallest. According to Eqn (5.3), the chemical potential of the metal cation also is least under this condition and the solid phase controlling it will receive metal at the expense of any other competing solid in the soil (Sposito, 1981a, Chap. 2).

As an example of the use of an activity ratio diagram, consider the problem of deciding which solid phase containing Pb can be expected to form in Redding fine sandy loam, a kaolinitic Abruptic Durixeralf whose pH value is near 5.6. The most stable Pb solid phases in natural water systems are phosphates (Rickard and Nriagu, 1978; Lindsay, 1979, Chap. 20). The crystalline solids relevant to the present example of an acid soil are $Pb_3(PO_4)_2(c)$, $Pb_5(PO_4)_3Cl(c)$ and $PbAl_3(PO_4)_2(OH)_5 \cdot H_2O(c)$. The dissolution reactions of these three solids at 298.15 K can be expressed:

$$Pb(PO_4)_{0.67}(c) + \tfrac{4}{3} H^+ = Pb^{2+} + \tfrac{2}{3} H_2PO_4^-$$
$$\log K_{dis} = -1.80 \quad (5.10a)$$

$$Pb(PO_4)_{0.6}Cl_{0.2}(c) + \tfrac{6}{5} H^+ = Pb^{2+} + \tfrac{3}{5} H_2PO_4^- + \tfrac{1}{5} Cl^-$$
$$\log K_{dis} = -5.06 \quad (5.10b)$$

$$PbAl_3(PO_4)_2(OH)_5 \cdot H_2O(c) + 9 H^+ = Pb^{2+} + 3 Al^{3+} + 2 H_2PO_4^- + 6 H_2O(l)$$
$$\log K_{dis} = 9.74 \quad (5.10c)$$

The values of $\log K_{dis}$ in Eqns (5.10) were calculated with the help of Eqns (5.5) and (5.7) and the Standard State chemical potentials listed in Table 5.1. The relation between K_{dis} and the activities of the reactants and products for each

Table 5.1 Standard state chemical potentials for the reactants and products in Eqn (5.10)*

Component	μ^0, (kJ mol^{-1})	Component	μ^0 (kJ mol^{-1})
Al^{3+}(aq)	− 489.4	$Pb_3(PO_4)_2$(c)	− 2378.9
Pb^{2+}(aq)	− 24.4	$Pb_5(PO_4)_3Cl$(c)	− 3809.9
H^+(aq)	0.0	$PbAl_3(PO_4)_2(OH)_5 \cdot H_2O$(c)	− 5134.7
Cl^-(aq)	− 131.3	H_2O(l)	− 237.14
$H_2PO_4^-$(aq)	− 1137.4		

* Thermodynamic data from Lindsay (1979, Appendix), except for μ^0 of $PbAl_3(PO_4)_2(OH)_5 \cdot H_2O$(c), which was calculated with the help of $\log K_{dis}$ in Table 8.4 of Rickard and Nriagu (1978).

reaction in Eqns (5.10) lead to the three equations:

$$\log\left[(Pb(PO_4)_{0.67}(c))/(Pb^{2+})\right] = 1.8 + \tfrac{2}{3}\log(H_2PO_4^-) + \tfrac{4}{3}pH \quad (5.11a)$$

$$\log\left[(Pb(PO_4)_{0.6}Cl_{0.2}(c))/(Pb^{2+})\right] = 5.06 + \tfrac{3}{5}\log(H_2PO_4^-)$$
$$+ \tfrac{1}{5}\log(Cl^-) + \tfrac{6}{5}pH \qquad (5.11b)$$

$$\log\left[(PbAl_3(PO_4)_2(OH)_5\cdot H_2O(c))/(Pb^{2+})\right]$$
$$= -9.74 + 2\log(H_2PO_4^-) + 9\,pH + 3\log(Al^{3+}) + 6\log(H_2O(l))$$
$$(5.11c)$$

In order to plot an activity ratio diagram from Eqns (5.11), one of the soil solution parameters, $\log(H_2PO_4^-)$, pH, $\log(Cl^-)$, $\log(Al^{3+})$ or $\log(H_2O(l))$, must be chosen as an independent variable, while the others either are held fixed or are expressed as functions of the independent variable. The obvious choice for the independent variable is pH in the present example. For an acid soil, the value of the parameter $\log(H_2PO_4^-)$ may not change much in the pH range 3.0 to 7.0 if no particular solid phase controls phosphate solubility. Ryden and Pratt (1980) have examined data on the concentration of $H_2PO_4^-$ in many acid soil solutions and have shown that it remains between 10^{-5} M and $10^{-6.5}$ M for pH values between 4 and 7, with the average concentration being about $10^{-5.8}$ M. Thus $\log(H_2PO_4^-)$ can be set equal to -6.0 in the present example. The value of $\log(Cl^-)$ is -2.9 in the Redding soil near water saturation; the activity of liquid water is very nearly equal to 1.0 in this case. Finally, since the Redding soil is in the kaolinitic mineralogy class, the value of $\log(Al^{3+})$ can be estimated with the help of the dissolution reaction of kaolinite:

$$Al_2Si_2O_5(OH)_4(c) + 6H^+ = 2Al^{3+} + 2Si(OH)_4^0(aq) + H_2O(l) \quad (5.12)$$

for which $\log K_{dis} = 5.96$ at 298.15 K (Bassett et al., 1979). At pH values near 6.0, $(Si(OH)_4^0) \approx 10^{-4.5}$ in the presence of kaolinite (Rai and Lindsay, 1975). With this information, $\log(Al^{3+})$ can be expressed by the equation:

$$\log(Al^{3+}) = \tfrac{1}{2}[\log K_{dis} - 2\log(Si(OH)_4^0) - \log(H_2O(l)) - 6\,pH]$$
$$= 7.48 - 3\,pH \qquad (5.13)$$

where $(H_2O(l))$ has been set equal to 1.0.

The working forms of Eqns (5.11) now can be written down:

$$\log\left[(Pb(PO_4)_{0.67}(c))/(Pb^{2+})\right] = -2.2 + \tfrac{4}{3}pH \qquad (5.14a)$$

$$\log\left[(Pb(PO_4)_{0.6}Cl_{0.2}(c))/(Pb^{2+})\right] = 0.88 + \tfrac{6}{5}pH \qquad (5.14b)$$

$$\log\left[(PbAl_3(PO_4)_2(OH)_5\cdot H_2O(c))/(Pb^{2+})\right] = 0.70 \qquad (5.14c)$$

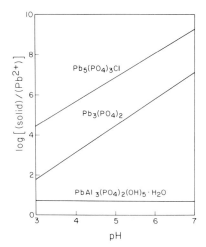

Fig. 5.2 Activity ratio diagram for lead phosphate solid phases in Redding fine sandy loam under the conditions: $(H_2PO_4^-) = 10^{-6}$, $(Cl^-) = 10^{-3}$, $(H_2O(l)) = 1.0$, and control of (Al^{3+}) by kaolinite with $(Si(OH)_4^0) = 10^{-4.5}$.

These equations are plotted in Fig. 5.2 for the range of pH values expected in acid soils. The activity ratio diagram shows clearly that, when $(H_2PO_4^-)$ $= 10^{-6}, (Cl^-) = 10^{-3}, (H_2O(l)) = 1.0$ and (Al^{3+}) is controlled by kaolinite, the most thermodynamically stable solid at pH <7.0 is $Pb_5(PO_4)_3Cl(c)$, chloropyromorphite. Note that this conclusion will not be changed by lowering the activity of water from its Standard State value of 1.0, since this would only increase the value of the right side of Eqn (5.11b) while decreasing the right side of Eqn (5.11c) for any reasonable variation in $(H_2PO_4^-)$, $(Si(OH_4)^0)$ and (Cl^-) at fixed pH value.

4. Coprecipitation phenomena

In natural water systems, such as soil solutions, it is well known that precipitation occurs from multicomponent aqueous phases and that the solids so formed often are mixtures instead of being single compounds (Corey, 1981). The term *coprecipitation* refers to this phenomenon and is defined to be the simultaneous precipitation of a chemical element in conjunction with other elements by any mechanism and at any rate (Gordon *et al.*, 1959; Walton, 1967). Three broad categories of coprecipitation phenomena have been identified in soils: *mixed solid formation*, *adsorption* and *inclusion*.

Mixed solid formation is common, for example, when minerals such as montmorillonite and Fe or Mn oxides precipitate from the soil solution. These solids are characterized by a wide range of isomorphous substitutions, in

which metal cations in their structures may be replaced by trace metal ions of the same charge sign and comparable size. Examples of this solid solution phenomenon occur during the formation of clay minerals, if trace metal cations replace either Si^{4+} in the tetrahedral sheet or Al^{3+} in the octahedral sheet; during the formation of $CaCO_3(s)$, if Fe^{2+}, Mn^{2+}, Zn^{2+} or Cd^{2+} replaces Ca^{2+}; during the formation of goethite, α-FeO(OH)(c), if Fe^{3+} is replaced by Al^{3+} or Zn^{2+}, and during the formation of hydroxyapatite, $Ca_5OH(PO_4)_3(c)$, if Ca^{2+} is replaced by Pb^{2+}. In every case of coprecipitation through the formation of a solid solution, the solid phase is a homogeneous mass with its minor substituents distributed uniformly. Thus, two requirements for this type of coprecipitation are the free diffusion and relatively high structural compatibility of the minor substituents within the precipitate as it is forming (Gordon et al., 1959).

If free diffusion within the precipitate is not possible for a trace metal cation, that ion may still coprecipitate by an adsorption process. For example, if an iron or manganese hydrous oxide were precipitating in a soil solution to form colloidal material with a relatively large specific surface area, and if the pH value were sufficiently high, trace metal cations would adsorb on the surface of the precipitate. These coprecipitated metals might not be able to diffuse freely into the bulk solid and, therefore, the development of a true solid solution would be prevented. Trace metal adsorption will be discussed in detail in Section III. Generally, it can be expected that coprecipitation through adsorption will be much more dependent on the kinetics of precipitation and on the composition of the soil solution than is solid solution formation (Gordon et al., 1959). The conditions that favour adsorption would be rapid precipitation initiated under pronounced supersaturation conditions and a relatively high degree of incompatibility between the adsorbing trace metal species and the molecular structure of the precipitate.

If the coprecipitating metals naturally would tend to form solids with very different molecular structures, it is likely that a mixed solid comprising the metals will be a heterogeneous system instead of a solid solution. This type of coprecipitation is illustrated by the inclusion of CuS solid phases within silicates and of separate TiO_2 and o-phosphate solid phases within clay minerals.

The extent to which coprecipitation phenomena influence the solid forms of trace metals in non-polluted soils can be assessed through an examination of Tables 5.2 and 5.3, which indicate the chemical speciation observed for several trace metals in primary and secondary soil minerals. The primary minerals found in soils are those inherited directly from parent rock materials through physical weathering processes. By definition, they have not been subjected to either geochemical or pedochemical weathering and, therefore, they tend to be found in the larger particle-size fractions of soils, which are less reactive

Table 5.2 Modes of occurrence of transition and heavy metals in primary soil minerals

Metal	Occurrence in primary minerals
V	Isomorphous substitution for Fe in pyroxenes and amphiboles and for Al in micas; substitution for Fe in oxides
Cr	Chromite ($FeCr_2O_4$); isomorphous substitution for Fe or Al in other minerals of the spinel group
Co	Isomorphous substitution for Mn in oxides and for Fe in pyroxenes, amphiboles and micas
Ni	Sulphide inclusions in silicates; isomorphous substitution for Fe in olivines, pyroxenes, amphiboles, micas and spinels
Cu	Sulphide inclusions in silicates; isomorphous substitution for Fe and Mg in olivines, pyroxenes, amphiboles and micas, and for Ca, K or Na in feldspars
Zn	Sulphide inclusions in silicates; isomorphous substitution for Mg and Fe in olivines, pyroxenes and amphiboles, and for Fe or Mn in oxides
Mo	Molybdenite (MoS_2); isomorphous substitution for Fe in oxides (?)
Cd	Sulphide inclusions and isomorphous substitution for Cu, Zn, Hg and Pb in sulphides
Pb	Sulphide and phosphate inclusions; isomorphous substitution for K in feldspars and micas, for Ca in feldspars, pyroxenes and phosphates, and for Fe and Mn in oxides

Table 5.3 Coprecipitated trace metals in secondary soil minerals

Mineral	Coprecipitated trace metals
Fe oxides	V, Mn, Ni, Cu, Zn, Mo
Mn oxides	Fe, Co, Ni, Zn, Pb
Ca carbonates	V, Mn, Fe, Co, Cd
Illites	V, Ni, Co, Cr, Zn, Cu, Pb
Smectites	Ti, V, Cr, Mn, Fe, Co, Ni, Cu, Zn, Pb
Vermiculites	Ti, Mn, Fe

chemically because of their smaller specific surface areas (Loughnan, 1969; Carroll, 1970). As chemical weathering proceeds in a soil, primary minerals dissolve and their elemental components subsequently can precipitate in secondary minerals, form complexes with inorganic and organic surfaces, or remain temporarily in the soil solution.

Table 5.2 lists the principal modes by which several environmentally important trace metals have been found to occur in primary soil minerals

(Vlasov, 1966; Carroll, 1970; Krauskopf, 1972; Norrish, 1975; Dixon and Weed, 1977). Table 5.3 lists the trace metals that have been detected as components of the major secondary soil minerals (McKenzie, 1972; Norrish, 1975; Jenne, 1976; Dixon and Weed, 1977; Mosser, 1979). These summaries make clear the point that, with the possible exceptions of Cr and Mo, the trace metal-containing solids in soils are predominately mixtures.

Insofar as the soil solution is concerned, the principal effect of coprecipitation is on the solubility of the trace metals found in the solid mixture. If the soil solution is in equilibrium with the mixture, the aqueous phase activity of an ion which is a trace element of the solid may be significantly smaller than what it would be in the presence of a pure solid phase comprising that element. This effect is especially pronounced in the case of adsorption phenomena, to be discussed in Section III, but it also is apparent when solid solutions are formed. For a solid solution of the binary compounds $A_mL_n(a)$ and $B_pL_q(s)$, the governing chemical reaction is:

$$(b/m)A_mL_n(s) + aB^{b+}(aq) = bA^{a+}(aq) + (a/p)B_pL_q(s) \qquad (5.15)$$

where A^{a+} is the major metal cation, B^{b+} is the trace metal cation and L^{l-} is a ligand anion. Equation (5.15) describes the replacement of metal A by metal B and is subject to the electroneutrality condition: $(am/n) = (pb/q) = l$. The equilibrium constant for this reaction is:

$$K = (B_pL_q(s))^{a/p}(A^{a+})^b/(A_mL_n(s))^{b/m}(B^{b+})^a$$
$$= [f_B N_B]^{a/p}(A^{a+})^b/[f_A N_A]^{b/m}(B^{b+})^a \qquad (5.16)$$

where f_A and f_B are rational activity coefficients and N_A and N_B are mole fractions of $A_mL_n(s)$ and $B_pL_q(s)$, respectively, in the solid–phase mixture. Regardless of their phase, pure or mixed, the two solids in the mixture dissolve according to the IAP expressions:

$$(B^{b+})^p(L^{l-})^q = K_B(B_pL_q(s)) \qquad (5.17a)$$

$$(A^{a+})^m(L^{l-})^n = K_A(A_mL_n(s)) \qquad (5.17b)$$

where K_A and K_B are dissociation equilibrium constants. The combination of Eqns (5.17) with Eqn (5.16) yields the expression:

$$K = K_A^{b/m}/K_B^{a/p} \qquad (5.18)$$

The thermodynamic exchange constant, K, therefore, is related directly to the pure-phase dissociation constants, K_A and K_B.

Equation (5.17a) can be used to illustrate the suppression of the aqueous-phase activity of B^{b+} through solid-solution formation. Upon solving this equation for (B^{b+}), one finds:

Table 5.4 Calculation of the ratio f_{Cd}/f_{Zn} in solid solutions of $CdCO_3$ and $ZnCO_3$ precipitated in neutral British soils*

Soil sample	$N_{Cd} \times 10^3$	$(Cd^{2+})/(Zn^{2+})$	f_{Cd}/f_{Zn}
1	4.36	0.0134	15
2	4.93	0.0158	16
3	5.03	0.0108	11
4	6.03	0.0257	21
5	6.06	0.0337	28
6	4.91	0.0202	21
7	4.80	0.0224	23
8	4.96	0.0160	16
9	5.55	0.0145	13
10	4.97	0.0117	12

* Based on analyses for Cd in whole soils and their saturation extracts.

$$(B^{b+}) = [K_B(B_pL_q(s))/(L^{l-})^q]^{1/p}$$
$$= (B^{b+})_0(B_pL_q(s))^{l/p} \tag{5.19}$$

where $(B^{b+})_0$ is the activity of B^{b+} when $B_pL_q(s)$ is in the Standard State. Equation (5.19) relates (B^{b+}) in equilibrium with a mixed solid containing $B_pL_q(s)$ to $(B^{b+})_0$ in equilibrium with pure $B_pL_q(s)$, whereas (L^{l-}) remains the same in both cases. Since $B_pL_q(s)$ is a trace component, $(B_pL_q(s)) \ll 1.0$ and Eqn (5.19) shows that the activity of B^{b+} will be reduced much below the value it has in the presence of a pure solid phase.

An illustration of the use of Eqns (5.16) and (5.18) is given in Table 5.4 for the case of a suspected coprecipitate of $CdCO_3(c)$ and $ZnCO_3(c)$ in 10 neutral surface soils from England. These soils have very high contents of Cd and Zn. Because the pH values of their saturation extracts lie between 7.0 and 7.4, and because both otavite and smithsonite, $ZnCO_3(c)$, crystallize into the calcite structure (Bragg and Claringbull, 1965), it was proposed that a solid solution of these two minerals might control the activities of Cd^{2+} and Zn^{2+} in the aqueous phases of the soils. The governing chemical reaction in Eqn (5.15) becomes in this case:

$$ZnCO_3(c) + Cd^{2+} = CdCO_3(c) + Zn^{2+} \tag{5.20}$$

after clearing a common factor of 2 from each term. The equilibrium constant for this exchange reaction is:

$$K = f_{Cd}N_{Cd}(Zn^{2+})/f_{Zn}N_{Zn}(Cd^{2+})$$
$$= K_{ZnCO_3}/K_{CdCO_3} = 10^{-10.5}/10^{-11.2} = 10^{0.7} = 5.0 \tag{5.21}$$

where the dissociation constant for smithsonite, K_{ZnCO_3}, was calculated with the help of μ^0 values compiled by Sadiq and Lindsay (1979). The ratio f_{Cd}/f_{Zn} can be estimated by rearranging Eqn (5.21):

$$(f_{Cd}/f_{Zn}) = 10^{0.7}[N_{Zn}(Cd^{2+})/N_{Cd}(Zn^{2+})] \tag{5.22}$$

Equation (5.22) has been used, along with the data in the second and third columns of Table 5.4, to compute the activity coefficient ratios listed in the fourth column of the table. Since $N_{Zn} \approx 0.995$ for all of the soils, it is reasonable to assume that $f_{Zn} \approx 1.0$ and that the fourth column actually gives f_{Cd}. Returning to Eqn (5.19), one can then make the estimate:

$$\frac{(Cd^{2+})}{(Cd^{2+})_0} = (CdCO_3(s)) = f_{Cd}N_{Cd} \approx 18 \times 5 \times 10^{-3} = 0.09 \tag{5.23}$$

where the mean value of the f_{Cd} listed in Table 5.4 has been used. According to this model calculation, solid solution formation has reduced the activity of $Cd^{2+}(aq)$ to about 9% of what it would be in the presence of pure otavite for the same value of (CO_3^{2-}).

III. Adsorbed species

1. Empirical adsorption isotherms

An extensive literature exists concerning the partitioning of trace metals at equilibrium between soil solutions and the surfaces of reactive soil minerals (see, for example, the reviews by Jenne, 1976; Förstner and Wittmann, 1979; Pickering, 1979, 1980a,b; Kinniburgh and Jackson, 1981). Much of the published experimental data at constant temperature and pressure can be described by special cases of the adsorption isotherm equation:

$$n_M = \frac{n_M^0 K_{MB}^\beta (a_M/a_B)^\beta}{1 + K_{MB}^\beta (a_M/a_B)^\beta} \tag{5.24}$$

where n_M is the quantity of trace metal, M, adsorbed in competition with ion B, n_M^0 is the maximum value of n_M, K_{MB} is a constant measure of the affinity of metal M for the surface relative to ion B, β is an empirical parameter whose value is between 0 and 1.0, and a_M and a_B are the thermodynamic activities of metal M and ion B, respectively. In Eqn (5.24), the units of n_M and n_M^0 are arbitrary so long as they are the same (e.g., g per kg adsorbent or mol per m^2 adsorbent) and the parameters K_{MB}, β, a_M and a_B are dimensionless.

Four important special cases of Eqn (5.24) that have been employed widely in studies of trace metal adsorption by soils and soil minerals are illustrated in Fig. 5.3. These four cases can be enumerated as follows.

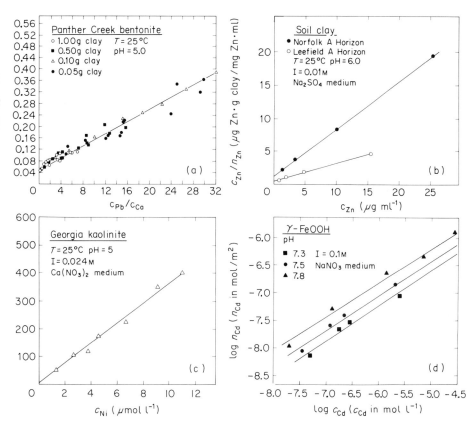

Fig. 5.3 Special cases of Eqn (5.24). (a) Competitive Langmuir plot for Pb and Ca adsorption by a montmorillonite (Griffen and Au, 1977). (b) Classical Langmuir plot for Zn adsorption by two soil clays in a Na_2SO_4 background electrolyte (Shuman, 1976). (c) Constant partition isotherm for Ni adsorption by a kaolinite in a $Ca(NO_3)_2$ background electrolyte (Mattigod *et al.*, 1979). (d) Van Bemmelen–Freundlich isotherm (as a log–log plot) for Cd adsorption by lepidocrocite in a $NaNO_3$ background electrolyte (Benjamin and Leckie, 1980).

(a) *Competitive Langmuir isotherm*

If β is set equal to 1.0 in Eqn (5.24) and the activities are replaced by molar concentrations, the resulting adsorption isotherm is:

$$n_M = \frac{n_M^{0\,c}K_{MB}(c_M/c_B)}{1 + {}^cK_{MB}(c_M/c_B)} \tag{5.25}$$

where c refers to a molar concentration. The parameter ${}^cK_{MB}$ in Eqn (5.25) depends on the pH value and ionic strength of the soil solution as well as the

stoichiometry of the exchange between metal M and ion B on the adsorbent. For example, if M is a bivalent trace metal cation, M^{2+}, B is Ca^{2+}, and both metal ions must compete with H^+ for adsorption sites, then $^cK_{MB}$ has the form (cf. Sposito et al., 1979, Appendix):

$$^cK_{MCa} = \frac{\gamma_M K_M^{Ca}/\gamma_{Ca}}{1 + K_H^{Ca}(H^+)^2/(Ca^{2+})} \tag{5.26}$$

where γ is a single-ion activity coefficient, and K_M^{Ca} and K_H^{Ca} are exchange equilibrium constants. Equation (5.26) makes clear the point that $^cK_{MB}$ in Eqn (5.25) is a conditional parameter dependent on the composition of the soil solution.

(b) Traditional Langmuir isotherm

If the activity of ion B is held constant during an experiment on the adsorption of trace metal M and β is set equal to 1.0, then Eqn (5.24) can be rewritten in the form:

$$n_M = \frac{n_M^0 {}^cK_M c_M}{1 + {}^cK_M c_M} \tag{5.27}$$

where $^cK_M = \gamma_M K_{MB}/a_B$. Equation (5.27) is clearly a special case of Eqn (5.25).

(c) Constant partition isotherm

If β is set equal to 1.0 in Eqn (5.24) and experimental conditions are arranged so that a_B is held constant and $n_M \ll n_M^0$, the resulting adsorption isotherm is:

$$n_M = n_M^0 {}^cK_M c_M \tag{5.28}$$

Equation (5.28) provides for a linear relationship between n_M and c_M if the properties of the soil solution and the adsorbent that determine the value of cK_M are controlled in an experiment.

(d) van Bemmelen–Freundlich isotherm

If the conditions leading to Eqn (5.28) are met except that the value of β is not fixed, the resulting adsorption isotherm is:

$$n_M = n_M^0 {}^cK_M^\beta c_M^\beta \tag{5.29}$$

which was popularized by Freundlich (1909) after its discovery by van Bemmelen (Sposito, 1981b).

The general adsorption isotherm, Eqn (5.24), can be derived by a model in which the adsorbent is assumed to comprise a heterogeneous set of sites, with

each class of sites reacting with the trace metal A according to Eqn (5.25) and having characteristic values of the parameters $^cK_{MB}$ and n_M^0 (Sposito, 1980). If the affinity parameter, $^cK_{MB}$, follows essentially a log–normal distribution (i.e., ln $^cK_{MB}$ is distributed normally) over all the adsorption sites, then Eqn (5.24) is uniquely the resultant adsorption isotherm and K_{MB} is the most probable value of $^cK_{MB}$ among the sites. The parameter β is a measure of the uniformity of the adsorption sites, in that, as β increases from 0 to 1.0, the distribution of $^cK_{MB}$-values about K_{MB} becomes increasingly sharp, with $\beta = 1$ being the limit of a uniform distribution (Sposito, 1980). Thus β is a *surface heterogeneity parameter*. From this conclusion it follows that Eqns (5.25), (5.27) and (5.28) describe adsorbents whose distribution of affinity parameters is essentially uniform. (The possibility that the parameter $^cK_{MB}$ in Eqn (5.25) may be constant as a result of the compensating effects of a slight degree of site heterogeneity and interactions among the adsorbed ions cannot be ruled out.) The van Bemmelen–Freundlich isotherm, on the other hand, permits an arbitrary degree of surface heterogeneity.

As Fig. 5.3 suggests, the available data on trace metal adsorption do not lead to a simple set of conclusions regarding the capacities, affinities and heterogeneities of soils and soil minerals. Different trace metals may react with the same adsorbent according to different special cases of Eqn (5.24), and a given trace metal in different concentration ranges can react according to different isotherm expressions with the same or different adsorbents. Because of this complexity, it appears that conformity of data (within some statistical criterion of fit) to adsorption isotherms cannot be used to deduce much about the surface speciation of trace metals in soils. The most justifiable application of Eqn (5.24) is the prediction of either n_M or a_M under conditions where the use of previously measured values of n_M^0, K_{MB} and β is considered to be valid.

2. Ligand effects on trace metal adsorption

The effects of inorganic and organic ligands in the soil solution on the adsorption of trace metals by soil constituents can be classified into four general categories:

(i) The ligand has a high affinity for the metal, forms a soluble complex with it, and this complex has a high affinity for the adsorbent.
(ii) The ligand has a high affinity for the adsorbent, is adsorbed, and the adsorbed ligand has a high affinity for the metal.
(iii) The ligand has a high affinity for the metal, forms a soluble complex with it, and this complex has a low affinity for the adsorbent.
(iv) The ligand has a high affinity for the adsorbent, is adsorbed, and the adsorbed ligand has a low affinity for the metal.

A fifth, trivial category would be the ligand that has a low affinity for both the metal and the adsorbent and, therefore, would have little or no effect on trace metal adsorption. The four main categories listed emphasize the competition between the metal and the adsorbent for the ligand. Categories (i) and (ii) should result in enhanced adsorption of the trace metal relative to the situation in which the ligand is absent, whereas category (iii) should result in decreased adsorption of the trace metal. If the ligand and metal do not adsorb on the same sites, category (iv) will produce little effect on trace metal adsorption; if there is competition, trace metal adsorption will be reduced.

Perhaps the most important soil solution ligand that affects trace metal adsorption is the hydroxyl ion. Figure 5.4 shows four representative examples of the effect of increasing OH^- activity on trace metal adsorption by inorganic

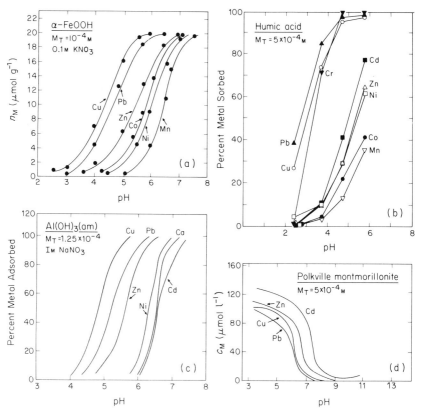

Fig. 5.4 Effect of OH^-(aq) activity on trace metal adsorption. (a) Goethite (McKenzie, 1980). (b) Coagulated humic acid (Kerndorff and Schnitzer, 1980). (c) Aluminum hydroxide gel (Kinniburgh *et al.*, 1976). (d) Polkville montmorillonite (Farrah and Pickering, 1977).

and organic surfaces of soil constituents. Data pertaining to this effect are almost always summarized in a graph that pairs some quantitative measure of the extent of adsorption with the pH value of the aqueous phase. In each of the graphs in Fig. 5.4, the adsorption of trace metals from solutions containing a given total metal concentration are compared at different pH values. The curves show that increasing the OH^- activity always increases the extent of trace metal adsorption. Therefore, OH^- is a ligand whose effects on adsorption fall into categories (i) and (ii) above. At present, there are different opinions about which category is the more appropriate. For example, James and Healy (1972) have argued that hydrolytic species of trace metals exhibit a very high affinity for proton-selective surfaces, such as those on oxide minerals, whereas Farrah and Pickering (1977) have proposed that OH^- is adsorbed by proton-selective surfaces with great affinity and then serves as a bridge between the adsorbent surface and an adsorbed trace metal cation. In either mechanism, the ultimate end product in the case of an inorganic adsorbent is a metal-hydroxy polymer on the adsorbent surface. This polymer may bear some structural resemblance to a metal hydroxide, but it invariably forms on the adsorbent at a pH value significantly below that required for the formation of the hydroxide (Kinniburgh *et al.*, 1976; Farrah and Pickering, 1977; McKenzie, 1980).

Figure 5.5 shows examples of other categories of ligand effects on the adsorption of copper. In the case of $Fe(OH)_3(am)$ (Fig. 5.5a), glutamic acid is

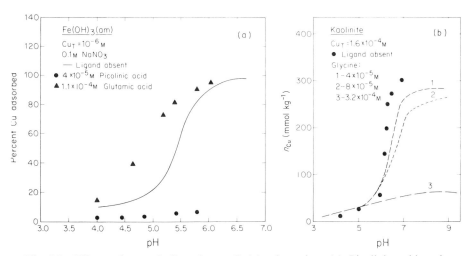

Fig. 5.5 Effects of organic ligands on Cu(II) adsorption. (a) Picolinic acid and glutamic acid on amorphous iron hydroxide (Davis and Leckie, 1978b). (b) Glycine on kaolinite (Farrah and Pickering, 1976).

expected to bind through a carboxyl group to a protonated surface site, leaving a zwitterion group exposed to the aqueous phase, whereas picolinic acid is thought to bind through a carboxyl and a nitrogen donor, leaving no complexing group exposed (Davis and Leckie, 1978b). The effects on metal adsorption of these two different arrangements on the surface belong to categories (ii) and (iv), respectively. In the case of picolinic acid, category (iii) also applies, with the result that copper adsorption is severely reduced, relative to the ligand-free situation, at any pH value. In the case of glutamic acid, category (i) also applies and copper adsorption is enhanced at any pH value. For kaolinite (Fig. 5.5b), the presence of glycine in the aqueous phase at increasing concentrations reduces copper adsorption because of the increasing formation of an uncharged Cu–glycine complex (Farrah and Pickering, 1976), corresponding to category (iii).

3. Surface complexation models

The interactions of trace metals in soil solutions with the inorganic and organic solid surfaces in soils properly are described as surface functional group complexation reactions (Anderson and Rubin, 1981). The metal-complexing functional groups exposed on the solid surfaces in soils are varied and include the hydroxyl groups that protrude from the edge surfaces of layer silicates and from the surfaces of metal oxides; the ditrigonal cavities in the basal planes of clay minerals, and the carboxyl, amine and phenolic hydroxyl groups that reside on the surfaces in soil organic matter (Sposito, 1981c). The coordination chemistry of these surface groups forms the basis for the trace metal adsorption phenomena in soil. In recent years, several chemical models have been developed to account in quantitative terms for trace metal adsorption behaviour as surface complexation reactions (see, for example, the reviews by Westall and Hohl, 1980, and Anderson and Rubin, 1981). Two of these models will be discussed in the present section, their selection having been determined by their broad applicability over environmentally significant ranges of pH value and ionic strength, and their past use of model trace metal adsorption data for various soil minerals.

James and Healy (1972) have developed a model of the adsorption of trace metal cations by mineral surfaces containing proton-selective functional groups, such as the surfaces of oxide minerals. This model takes into account several aspects of the experimental adsorption data summarized in Fig. 5.4:

(i) Adsorption depends strongly on pH and goes to completion over the narrow range of one or two pH units.

(ii) The pH value at which the most rapid increase in adsorption occurs differs among trace metals and is correlated with both the first hydrolysis

constants and the hydroxide solubility product constants for the metals (Kinniburgh et al., 1976). However, as noted in Section 2, adsorption is essentially complete at pH values below those necessary for solid hydroxide formation.

(iii) The parameter $\log[(M^{2+})(OH^-)]$ is constant over the pH range where the most rapid increase in adsorption takes place (Farrah and Pickering, 1977); on the other hand, the ion activity product, $(M^{2+})(OH^-)^2$, is not constant over this pH range, where M^{2+} refers to a bivalent trace metal cation in aqueous solution.

These facts suggest that the hydrolytic species of trace metals play an important role in adsorption, although the adsorption process is not simply the precipitation of a metal hydroxide onto a proton-selective surface. The model of James and Healy (1972) represents a simple attempt to describe trace metal adsorption in terms of hydrolytic species according to the outer-sphere complexation reaction (James and MacNaughton, 1977):

$$SO^-(s) + M^{m+}(aq) + nH_2O(l) = SO^--[M(OH)_n]^{m-n}(s) + nH^+(aq)$$

$$(5.30)$$

where $SO^-(s)$ refers to an ionized proton-selective surface functional group, M^{m+} is the trace metal cation, and $M(OH)_n^{m-n}$ is a hydrolytic species of the metal. It should be noted that this reaction is consistent with both mechanisms of adsorption for hydrolytic species mentioned in Section 2. The adsorption isotherm for a trace metal in the James–Healy model has the mathematical form of Eqn (5.27) with cK_M generalized to account for competing adsorbed hydrolytic species (James et al., 1975):

$$n_M = \frac{n_M^{0c} K_M c_M}{1 + {^cK_M} c_M} \tag{5.31}$$

where

$$^cK_M = \sum_n {^cK_n} {}^*\beta_n/(H^+)^n \tag{5.32}$$

$$^*\beta_n = \frac{(M(OH)_n^{m-n})(H^+)^n}{(M^{m+})(H_2O(l))^n} \quad (n = 0, 1, 2, \ldots) \tag{5.33}$$

is an equilibrium constant for the formation of the nth aqueous hydrolytic species, and cK_n is a conditional equilibrium constant for the adsorption of that species. James and Healy (1972) argued that cK_n should have the form:

$$^cK_n = \exp\left[-(m-n)\frac{F\psi_0}{RT} - \frac{\Delta G_{solv,n}}{RT} - \frac{\Delta G_{chem}}{RT}\right] \tag{5.34}$$

where $(m-n)F\psi_0$ is the change in electrostatic energy upon adsorption of a

Table 5.5 Values of the James–Healy parameter $\Delta G_{chem}/RT$ for surface trace metal complexation by oxide adsorbents[a]

Metal	α-FeOOH	Adsorbent MnO$_x$	SiO$_2$	TiO$_2$
Cr(III)	-9.11^b	-8.19^b	-11.8^b	—
Co(II)	—	—	-11.0^c	-6.75^c
Ni(II)	-10.1^b	-7.17^b	-11.0^b	—
Cu(II)	-9.11^b	-8.73^b	-13.5^b	—
Zn(II)	-12.5^b	-8.19^b	-11.0^b	-11.0^d
Cd(II)	$-10.1^b, -18.6^e$	-8.19^b	-11.0^b	-6.78^e
Pb(II)	-9.11^b	-8.19^b	-11.0^b	—

[a] $R = 8.3144 \text{ J mol}^{-1} \text{ K}^{-1}$, $T = 298.15$ K
[b] Theis and Richter (1979)
[c] James and Healy (1972)
[d] $\Delta G_{chem}/RT$ for Zn(II) adsorption by HgS(s), James and MacNaughton (1977)
[e] James et al. (1975)

free metal cation or a hydrolytic species, F being the Faraday constant and ψ_0, an electrical double layer surface potential controlled by (H^+); $\Delta G_{solv,n}$ represents the Gibbs energy shift created by changes in the outer solvation shell of a hydrolytic species when it is adsorbed, and ΔG_{chem} accounts for all contributions to cK_n not included in the electrostatic Gibbs energy change and in $\Delta G_{solv,n}$. Explicit model expressions for ψ_0 and $\Delta G_{solv,n}$ are given by James and Healy (1972). The parameter ΔG_{chem}, which, for a given adsorbent, has the same value for each hydrolytic species of the trace metal M, is primarily a curve-fitting parameter in the model (James and MacNaughton, 1977). Representative values of $\Delta G_{chem}/RT$, compiled from some published applications of Eqn (5.31) to trace metal adsorption on oxide surfaces, are listed in Table 5.5. Figure 5.6 shows the degree of fit of the model to experimental adsorption data for a typical example, Cd adsorption by goethite in a background medium of 0.01 M KNO$_3$ (James et al., 1975). The chemical basis for Eqn (5.34) and, therefore, the James–Healy model, derives from a competition between $[(m - n)F\psi_0 + \Delta G_{chem}]$, which is negative in sign, and $\Delta G_{solv,n}$, which is always positive and proportional to the square of the species valence, $m - n$ (James and Healy, 1972). For a hydrolytic species with $m - n < 2$, $\Delta G_{solv,n}$ is small and is dominated by $[(m - n)F\psi_0 + \Delta G_{chem}]$. Therefore, these species correspond to large values of cK_n and are favoured in the adsorption process. When the pH value of the aqueous phase increases to the point that the concentrations of the hydrolytic species of a trace metal are no longer completely negligible relative to that of the free metal cation, adsorption of the metal begins to increase sharply as well, according to the model.

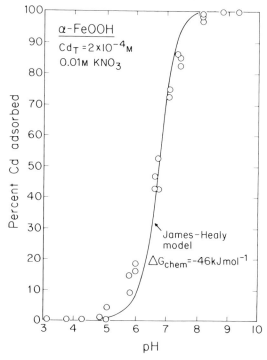

Fig. 5.6 Fit of the James–Healy model to data on Cd adsorption by goethite in KNO$_3$ background electrolyte (James *et al.*, 1975).

A surface complexation model that is much broader in scope than the James–Healy approach has been developed by Davis *et al.* (1978), and by Davis and Leckie (1978a, 1979, 1980). This model permits complexes between proton-selective surfaces and trace metal species of any kind, not just the free metal cation and hydrolytic species. Moreover, surface complexes with trace metal anions (e.g., CrO_4^{2-}) can be described by the model (Davis and Leckie, 1980). The application of the model to the adsorption of the trace metal species M^{2+} and MOH^+ will be illustrated here, but it should be understood clearly that many other adsorbed species could be considered either separately or simultaneously.

For a system in which the only adsorbed species are H^+, M^{2+}, MOH^+ and OH^-, the basic equations of the Davis–Leckie model are:

$$N_s = [SOH_2^+] + [SO^-] + [SO^- - M^{2+}]$$

$$+ [SO^- - MOH^+] + [SOH] \qquad (5.35)$$

$$\sigma_s = F\{[SOH_2^+] - [SO^-] - [SO^- - M^{2+}]$$
$$- [SO^- - MOH^+]\} \tag{5.36}$$

$$\sigma_\beta = F\{2[SO^- - M^{2+}] + [SO^- - MOH^+]\} \tag{5.37}$$

$$\sigma_d = -\sigma_s - \sigma_\beta \tag{5.38}$$

$$\psi_s = \psi_\beta + \sigma_s/C_1 \tag{5.39}$$

$$\psi_\beta = \psi_d - \sigma_d/C_2 \tag{5.40}$$

$$K_H^{int} = f_{SOH}[SOH](H^+)/f_H[SOH_2^+] \tag{5.41}$$

$$K_{OH}^{int} = f_{OH}[SO^-](H^+)/f_{SOH}[SOH] \tag{5.42}$$

$$K_M^{int} = f_M[SO^- - M^{2+}](H^+)/f_{SOH}[SOH](M^{2+}) \tag{5.43}$$

$$K_{MOH}^{int} = f_{MOH}[SO^- - MOH^+](H^+)^2/f_{SOH}[SOH](M^{2+}) \tag{5.44}$$

$$f_H/f_{SOH} = \exp(F\psi_s/RT) = f_{SOH}/f_{OH} \tag{5.45}$$

$$f_M/f_{SOH} = \exp\{F(2\psi_\beta - \psi_s)/RT\} \tag{5.46}$$

$$f_{MOH}/f_{SOH} = \exp\{F(\psi_\beta - \psi_s)/RT\} \tag{5.47}$$

In these equations, N_s is the total number of moles of surface sites, [] refers to the number of moles of a surface species, such as SOH_2^+; σ_s is the surface charge created in the plane where H^+ and OH^- are adsorbed (the adsorption of OH^- creates SO^-); σ_β is the surface charge created in the plane where M^{2+} and MOH^+ are adsorbed; σ_d is the surface charge neutralized by the diffuse swarm of ions in the aqueous phase; ψ_s and ψ_β are double-layer potentials in the two planes of adsorption; C_1 and C_2 are integral capacitances for the regions between the two planes of adsorption and between the β-plane and the plane marking the onset of the diffuse ion swarm, respectively; the K^{int} are equilibrium constants for the surface complexation reactions that create SOH_2^+, SO^-, $SO^- - M^{2+}$ and $SO^- - MOH^+$, and the f are activity coefficients for these surface species (Sposito, 1981a, Chap. 6). Equation (5.35) represents the surface mole balance; Eqns (5.36), (5.37) and (5.38) represent the balance of surface charge, and Eqns (5.39) and (5.40) relate the surface potentials according to the physics of the parallel-plate capacitor (Davis et al., 1978). The expressions for the surface activity coefficients in Eqns (5.45) to (5.47) derive from the assumption that the only difference between the activity coefficient of SOH and that of a charged surface species (e.g., SOH_2^+) comes from the effect of coulomb interactions on the latter that can be epitomized in the double-layer potentials ψ_s and ψ_β. The surface potential ψ_d can be related to σ_d through standard Gouy–Chapman diffuse double layer theory (Davis et al., 1978a). The equilibrium constants K^{int} and the capacitance C_1 can be

determined through potentiometric titration experiments (Davis *et al.*, 1978; Westall and Hohl, 1980; Anderson and Rubin, 1981). Therefore, given also a measured value of N_s, the numbers of moles of SOH and of the four surface complexes, the double-layer potentials ψ_s, ψ_β and ψ_d, the surface charges σ_s, σ_β and σ_d, and the capacitance C_2 (an adjustable parameter) can be calculated by the simultaneous numerical solution of Eqns (5.35) to (5.44) plus the Gouy–Chapman equation relating σ_d to ψ_d. A computer method for solving these equations has been described by James and Parks (1978).

The chemical foundation of the Davis–Leckie model develops from the equations of mass and charge balance combined with the laws of chemical equilibrium extended to surface complexation reactions. The molecular features of the model enter only after expressions are given for the activity coefficients of the surface species (Eqns 5.45 to 5.47) and it is only these expressions that require concepts relating to the electrical double layer. The basic chemical assumptions in the Davis–Leckie model are that the configurations of the surface species are random, except for the influence of the potentials ψ_s and ψ_β, and that these two potentials can be defined through classical Helmholtz and Gouy–Chapman double-layer equations. A representative example of the degree to which the Davis–Leckie model can describe trace metal adsorption is shown in Fig. 5.7 for the interaction of Pb^{2+} with γ-Al_2O_3 in a background of 0.1 M $NaClO_4$ (Davis and Leckie, 1978a). In this example, the trace metal surface species considered were $SO^- - Pb^{2+}$ and $SO^- - PbOH^+$.

It should be evident from this brief survey of surface complexation models that the adsorbed species of trace metals in soils can be expected to be

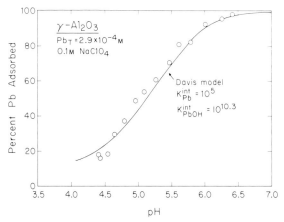

Fig. 5.7 Fit of the Davis model to data on Pb adsorption by γ-Al_2O_3 in $NaClO_4$ background electrolyte (Davis and Leckie, 1978a).

numerous. In principle, for a given trace metal, the free metal cation, all of its hydrolysed forms, and any complex of the metal that exists in the aqueous phase can be adsorbed by the solid surfaces in soils, both mineral and organic. These many possible species must be included with all other surface complexes in the mass and charge balance equations for each type of surface and equilibrium constant expressions for each species must be written down. The determination of the concentration of each species then awaits an estimate of the relevant activity coefficients according to some model prescription, for example, that of double-layer theory.

IV. Aqueous species

1. Trace metal species in soil solutions

The development of sophisticated instrumentation in atomic absorption spectrophotometry and in polarography has led to accurate determinations of the total concentrations of trace metals in natural waters such as soil solutions. However, misleading information can result if these data are used to interpret environmentally oriented experiments, such as toxicity or bioavailability studies and subsurface mobility investigations. Much of the recent literature in environmental chemistry indicates that the chemical speciation of a trace metal in a natural water system is more significant than its total concentration (see, for example, the reviews in Florence, 1977, and Allen *et al.*, 1980). With respect to dissolved species, this fact means that the complexation reaction:

$$aM^{m+}(aq) + bL^{l-}(aq) = M_aL_b^q(aq) \tag{5.48}$$

must be investigated in detail, where M refers to a trace metal, L, a complexing ligand, a and b, stoichiometric coefficients and $q = am - bl$, the valence of the trace metal complex, $M_aL_b^q(aq)$. The equilibrium constant for the reaction in Eqn (5.48) is called a *stability constant*:

$$K_s = (M_aL_b^q)/(M^{m+})^a(L^{l-})^b \tag{5.49}$$

In experiments on trace metal complexes, the *conditional stability constant*,

$$^cK_s = [M_aL_b^q]/[M^{m+}]^a[L^{l-}]^b \tag{5.50}$$

often is measured instead of K_s, where [] refers to a molar or molal concentration. The parameter cK_s in general will be a function of the ionic strength and composition of a soil solution, as well as the temperature and pressure (Sposito, 1981a, Chap. 2).

The focus of research on trace metal speciation in natural waters has been on the detection of the complexes, $M_aL_b^q(aq)$, and the measurement of the stability constants, K_s and cK_s. Florence and Batley (1977) recently have

Table 5.6 Experimental criteria for speciating trace metals in soil solutions

Species	Retained by 0.45 μm filter	Detected by ASV* in acetate buffer	Removed by Chelex-100	Destroyed by uv radiation
Adsorbed or solid species	Yes			
Soluble species	No			
Free metal ion	No	Yes	Yes	No
Labile inorganic complexes	No	Yes	No	No
Labile organic complexes	No	Yes	No	Yes
Non-labile inorganic complexes	No	No	Some	No
Non-labile organic complexes	No	No	Some	Yes

* ASV = anodic stripping voltammetry.

summarized the laboratory methods available for determining the concentrations of trace metal complexes in natural waters. They emphasized the requirements of sensitivity (mmol m^{-3} or better), avoidance of adsorbed and solid trace metal species in the water sample and preservation of the sample before analysis. With these requirements in mind, Florence and Batley (1977) presented a laboratory scheme for speciating trace metals into free metal ions, labile inorganic and organic complexes, and non-labile inorganic and organic complexes. The empirical criteria for their analytical scheme are outlined in Table 5.6. These criteria have been applied by Florence (1977) to speciate Cu, Zn, Cd and Pb in both surface and subsurface fresh waters. The principal aqueous chemical forms of these and other trace metals that would be expected in well aerated acid and alkaline soils are listed in Table 5.7. The ordering of the species from left to right is roughly that of decreasing concentration. The importance of free metal cations and sulphate complexes in acid soils and of carbonate and borate complexes in alkaline soils is noteworthy. If anoxic conditions prevailed instead of the oxic conditions assumed in Table 5.7, sulphate and nitrate complexes would be replaced by sulphide and amine complexes, as is appropriate for a reducing environment.

Florence and Batley (1980) have stressed that the analytical scheme given in outline in Table 5.6 provides for an *operationally defined* set of aqueous trace metal species that may not reflect the true chemical speciation in the original water sample in all cases. For example, those trace metals that are adsorbed on colloidal oxide particles of diameters less than 0.45 μm will be classified as

Table 5.7 Principal chemical species of trace metals in acid and alkaline soil solutions (oxic conditions)

Metal	Principal species	
	Acid soils	Alkaline soils
Mn(II)	Mn^{2+}, $MnSO_4^0$, Org*	Mn^{2+}, $MnSO_4^0$, $MnCO_3^0$, $MnHCO_3^+$, $MnB(OH)_4^+$
Fe(II)	Fe^{2+}, $FeSO_4^0$, $FeH_2PO_4^+$	$FeCO_3^0$, Fe^{2+}, $FeHCO_3^+$, $FeSO_4^0$
Ni(II)	Ni^{2+}, $NiSO_4^0$, $NiHCO_3^+$, Org*	$NiCO_3^0$, $NiHCO_3^+$, Ni^{2+}, $NiB(OH)_4^+$
Cu(II)	Org*, Cu^{2+}	$CuCO_3^0$, Org*, $CuB(OH)_4^+$, $Cu(B(OH)_4)_2^0$
Zn(II)	Zn^{2+}, $ZnSO_4^0$	$ZnHCO_3^+$, $ZnCO_3^0$, Zn^{2+}, $ZnSO_4^0$, $ZnB(OH)_4^+$
Cd(II)	Cd^{2+}, $CdSO_4^0$, $CdCl^+$	Cd^{2+}, $CdCl^+$, $CdSO_4^0$, $CdHCO_3^+$
Pb(II)	Pb^{2+}, Org*, $PbSO_4^0$, $PbHCO_3^+$	$PbCO_3^0$, $PbHCO_3^+$, $Pb(CO_3)_2^{2-}$, $PbOH^+$

* Organic complexes (e.g., fulvic acid complexes).

soluble species (probably complexes). The trace metal complexes whose concentrations are lowered dramatically when mixed with an acetate buffer at pH 4.8 will be classified as "labile", regardless of their stability at the pH value and ligand composition of the original water sample (Skogerboe et al., 1980). Thus "lability" must be understood to represent not only the relative lack of kinetic stability of a complex during an anodic stripping voltammetry measurement, but also its lack of stability under changes in pH value and in ligand distribution. In the same vein, "free metal ion" has to be interpreted to include any complex whose trace metal component can be extracted by the oxygen- and nitrogen-containing ligands on the Chelex-100 resin. These caveats should make clear the point that the chemical speciation of trace metals in soil solutions cannot be separated from the instrumental techniques by which it is determined.

Once the identities of the important trace metal complexes in soil solutions have been established, their thermodynamic stabilities as epitomized in Eqns (5.49) and (5.50) can be measured in well defined aqueous solutions under carefully controlled conditions. The most reliable experimental methods for determining complex stability constants have been reviewed in a volume edited by Martell (1971). Critically selected values of these constants are available in compilations by Martell and Smith (1974–1977), Perrin (1979) and Högfeldt (1982). If evidence exists for a certain trace metal complex in soil solutions but its stability constant is not yet measured, the value of $\log K_s$ often can be estimated by the method of Linear Free Energy Relations (LFER). The chemical basis of this method (Sposito, 1981a, Chap. 2) is the assumption that ΔG^0 for the reaction in Eqn (5.48) can be correlated linearly with a few parameters that characterize the metal and ligand components of the complex (for example, the valence and electronegativity of the metal cation). The LFER

approach has been applied successfully to estimate $\log K_s$ for inorganic complexes of bivalent trace metal cations important in soil solutions (Mattigod and Sposito, 1977).

In numerical work it often is necessary to convert between the two stability constants K_s and cK_s. The relationship of these parameters is specified by the equation:

$$^cK_s = \gamma_M^a \gamma_L^b K_s / \gamma_{ML} \tag{5.51}$$

where γ_M, γ_L and γ_{ML} are single-ion activity coefficients for the metal, ligand and complex in Eqn (5.48), respectively. In soil solutions and other multi-component aqueous phases, single-ion activity coefficients can be calculated accurately with the help of the expression:

$$\log \gamma = -\frac{Z^2 A \sqrt{I}}{1 + \sqrt{I}} + BI \tag{5.52}$$

where Z is the valence of the species whose activity coefficient is γ, A is the Debye–Hückel limiting law constant ($A = 0.5116$ dm$^{3/2}$ mol$^{-1/2}$ at 25°C), I is the true ionic strength, and:

$$B = \begin{cases} 0.3Z^2 A & \text{for charged species} \\ k \text{ (salting coefficient)} & \text{for neutral species} \end{cases} \tag{5.53}$$

For charged species, Eqn (5.52) is the Davies Equation, which gives an excellent estimate of γ at ionic strengths below 0.5 mol dm^{-3} (Sun et al., 1980). For neutral complexes (i.e., $q = 0$ in Eqn 5.48), the salting coefficient, k, often can be set equal to 0, or to a small positive or negative number, at ionic strengths below 0.1 mol dm^{-3} (Sposito, 1981a, Chap. 2). Note that I here is the *true* ionic strength, i.e.:

$$I = \frac{1}{2} \sum_i Z_i^2 c_i \tag{5.54}$$

where the sum includes the molar concentration, c_i of each free ion and charged complex in the soil solution.

2. Distribution coefficients

The principal quantitative measure of trace metal speciation in a soil solution is the *distribution coefficient*. For a species containing a given trace metal component with a stoichiometric coefficient equal to n, the corresponding distribution coefficient is equal to the product of n and the molar (or molal) concentration of the species, divided by the total soluble molar (or molal) concentration of the trace metal. Therefore:

$$\alpha_{nb}^L \equiv n \frac{[M_n L_b(aq)]}{M_{TS}} \tag{5.55}$$

is the distribution coefficient for the trace metal M in the species $M_n L_b(aq)$, where L is some complexing ligand and M_{TS} is the total soluble molar concentration of M. With the convention that:

$$\alpha_{10}^L \equiv \alpha_{10}^M = [M^{n+}]/M_{TS} \tag{5.56}$$

it is clear that the sum of the α_{nb}^L for a given trace metal always must equal to 1.0. The same property holds for the distribution coefficient of the ligand, L, in the species $M_n L_b(aq)$, since the equations:

$$\beta_{bn}^M \equiv b \frac{M_n L_b(aq)]}{L_{TS}} \qquad \beta_{10}^L \equiv [L^{l-}]/L_{TS} \tag{5.57}$$

define that parameter.

As an illustrative example of the use of distribution coefficients in speciation calculations, consider the soluble forms of Cu(II) in an acid soil solution. According to Table 5.7, the principal species of copper in acid soil solutions are Cu^{2+} and organic complexes. The organic complexes can be expected to resemble closely the complexes of Cu^{2+} with soil-derived fulvic acid (Schnitzer and Khan, 1978). Bresnahan et al. (1978) have studied these complexes and found through a Scatchard plot analysis of potentiometric titration data that two classes of (formal) 1:1 complexes exist. Thus the species to be considered may be denoted Cu^{2+}, CuFul1 and CuFul2, where Ful1 and Ful2 refer to the two classes of complexing fulvate ligands.

The equation of mole balance for copper in an acidic soil solution evidently can be approximated very well by the expression:

$$Cu_{TS} = [Cu^{2+}] + [CuFul1] + [CuFul2] \tag{5.58}$$

To proceed further, thermodynamic data are needed. At pH 5.0 and at an ionic strength of 0.1 M, the relevant chemical data are (Bresnahan et al., 1978):

$$Cu^{2+} + Ful1 = CuFul1 \quad {}^cK_1 = 10^{6.0} \tag{5.59a}$$

$$Cu^{2+} + Ful2 = CuFul2 \quad {}^cK_2 = 10^{4.1} \tag{5.59b}$$

where ${}^cK_i = [CuFuli]/[Cu^{2+}][Fuli]$ at 298.15 K and 1 atm pressure. With the help of Eqns (5.59), Eqn (5.58) can be expressed in terms of the distribution coefficients α_{10}^{Cu}, α_{11}^{Ful1} and α_{11}^{Ful2}:

$$Cu_{TS} = [Cu^{2+}]\left\{1 + \frac{[CuFul1]}{[Cu^{2+}]} + \frac{[CuFul2]}{[Cu^{2+}]}\right\}$$

$$= [Cu^{2+}]\{1 + {}^cK_1[Ful1] + {}^cK_2[Ful2]\}$$

and

$$\alpha_{10}^{Cu} = \frac{[Cu^{2+}]}{Cu_{TS}} = \{1 + {}^cK_1[Ful1] + {}^cK_2[Ful2]\}^{-1} \tag{5.60a}$$

$$\alpha_{11}^{Ful1} = \frac{[CuFul1]}{Cu_{TS}} = \frac{[CuFul1]}{[Cu^{2+}]}\frac{[Cu^{2+}]}{Cu_{TS}} = {}^cK_1[Ful1]\alpha_{10}^{Cu} \tag{5.60b}$$

$$\alpha_{11}^{Ful2} = \frac{[CuFul2]}{Cu_{TS}} = {}^cK_2[Ful2]\alpha_{10}^{Cu} \tag{5.60c}$$

Equations (5.60) have the undesirable feature of showing an explicit dependence on the molar concentrations of the free ligand species of Ful1 and Ful2. This feature can be eliminated by considering the ligand mole balance equations:

$$Ful1_{TS} = [Ful1] + [CuFul1]$$
$$= [Ful1]\{1 + {}^cK_1[Cu^{2+}]\}$$
$$= [Ful1]\{1 + {}^cK_1\alpha_{10}^{Cu}Cu_{TS}\} \tag{5.61a}$$

$$Ful2_{TS} = [Ful2] + [CuFul2]$$
$$= [Ful2]\{1 + {}^cK_2\alpha_{10}^{Cu}Cu_{TS}\} \tag{5.61b}$$

from which it follows that:

$$\beta_{01}^{Ful1} = \{1 + {}^cK_1\alpha_{10}^{Cu}Cu_{TS}\}^{-1} \quad \beta_{01}^{Ful2} = \{1 + {}^cK_2\alpha_{10}^{Cu}Cu_{TS}\}^{-1} \tag{5.62}$$

These equations permit Eqns (5.60) to be written in the form:

$$\alpha_{10}^{Cu} = \{1 + {}^cK_1\beta_{01}^{Ful1}Ful1_{TS} + {}^cK_2\beta_{01}^{Ful2}Ful2_{TS}\}^{-1} \tag{5.63a}$$

$$\alpha_{11}^{Ful1} = {}^cK_1\beta_{01}^{Ful1}Ful1_{TS}\alpha_{10}^{Cu} \tag{5.63b}$$

$$\alpha_{11}^{Ful2} = {}^cK_2\beta_{01}^{Ful2}Ful2_{TS}\alpha_{10}^{Cu} \tag{5.63c}$$

Equations (5.62) and (5.63a) are a set of coupled, non-linear algebraic equations for the distribution coefficients, $\alpha_{10}^{Cu}, \beta_{01}^{Ful1}, \beta_{01}^{Ful2}$, that can be solved for chosen values of the parameters Cu_{TS}, $Ful1_{TS}$, $Ful2_{TS}$, cK_1 and cK_2. The coefficients α_{11}^{Ful1} and α_{11}^{Ful2} then can be calculated directly with the help of Eqns (5.63b and c).

To get an idea of the numerical work involved in solving Eqns (5.62) and (5.63), consider the representative example: $Cu_{TS} = 10^{-7}$ M, $Ful1_{TS} = 3 \times 10^{-6}$ M and $Ful2_{TS} = 7 \times 10^{-6}$ M. In this case, $\beta_{01}^{Ful2} \approx 1.0$ and $\alpha_{10}^{Cu} \approx \{1 + {}^cK_1\beta_{01}^{Ful1}Ful1_{TS}\}^{-1}$, according to Eqns (5.62) and (5.63a). Therefore, the equations to be solved are:

$$\beta_{01}^{Ful1} = \{1 + 0.1\alpha_{10}^{Cu}\}^{-1} \approx \{1 + 0.1(1 + 3\beta_{01}^{Ful1})^{-1}\}^{-1}$$

$$\alpha_{10}^{Cu} \approx \{1 + 3\beta_{01}^{Ful1}\}^{-1}$$

with the results:

$$\beta_{01}^{\text{Ful1}} \approx 0.975 \quad \alpha_{10}^{\text{Cu}} \approx 0.25 \quad \beta_{01}^{\text{Ful2}} \approx 1.0$$

$$\alpha_{11}^{\text{Ful1}} \approx 0.75 \quad \alpha_{11}^{\text{Ful2}} \approx 0.002$$

Thus, about 25% of the copper is Cu^{2+} and 75% is in the complex, CuFul1.

The general procedure for calculating distribution coefficients, in the case of a multi-electrolyte soil solution containing Cu and a number of other metals of interest, can be developed by induction from the illustrative example just considered:

(i) Mole balance equations are written down for each metal and each ligand in the soil solution in terms of the molar concentrations of all species known from experiment to exist in the solution.

(ii) Chemical reactions are written for the formation of each complex of interest and the corresponding thermodynamic stability constants are compiled.

(iii) The mole balance equations then are rewritten in terms of conditional stability constants, total concentrations of metals and ligands and free ionic concentrations of metals (including H^+) and ligands to provide a set of coupled, non-linear algebraic equations.

(iv) The set of coupled equations is solved numerically to obtain the free ionic concentrations or, equivalently, the distribution coefficients for the free ionic species. These distribution coefficients may be used, in turn, to compute those for all the complex species.

This procedure is straightforward in concept, but may be quite involved numerically. Usually the set of coupled algebraic equations is too complicated to solve analytically and numerical approximation procedures carried out with the help of a digital computer are required.

V. The influence of oxidation–reduction reactions

1. Direct and indirect effects on trace metal speciation

The most important chemical elements that undergo oxidation–reduction reactions, or redox reactions, in soils are C, N, O, S, Mn and Fe. For contaminated soils, Cr, Cu, As, Ag, Hg and Pb could be added to the list. Thus there are two ways in which redox reactions can influence the chemical forms of environmentally significant trace metals in the soils: directly, through a change in the oxidation state of the trace metal itself, or indirectly, through a change in the oxidation state of a different element contained in a ligand that can form chemical bonds with the metal. An example of a direct redox effect

would be the oxidation of Cr(III) to Cr(VI), whereas an indirect redox effect would be exemplified by the oxidation of C(II) to C(IV) in an organic ligand that can form a soluble complex with a trace metal cation in a soil solution.

2. Redox reactions in soils

The chemistry of redox reactions in natural water systems has been reviewed comprehensively by Stumm and Morgan (1981) and the characteristics of these reactions in soils have been described in detail by Bohn (1971), Ponnamperuma (1972), Lindsay (1979), Bartlett (1981) and Sposito (1981a). For the purpose of the present chapter, only a few salient points concerning redox reactions need be recalled.

Redox equilibria in soils are governed by the negative common logarithm of the aqueous free electron activity, the pE value (Sposito, 1981a). Large, positive values of pE strongly favour the existence of oxidized species (free electron donors), whereas small values of pE favour reduced species (free electron acceptors). The pE values in soil solutions tend to lie in the range -6.8 to $+13.5$. At pH 7.0, oxidized soils usually have $+7 < pE < 13.5$; moderately reduced soils have $+2 < pE < 7$; reduced soils have $-2 < pE < +2$, and highly reduced soils have $-6.8 < pE < -2.0$. For the typical reduction half-reaction:

$$mA_{ox} + nH^+(aq) + e(aq) = pA_{red} + qH_2O(l) \qquad (5.64)$$

where A represents a chemical species in any phase, "ox" and "red" denoting its oxidized and reduced states, H^+ is the proton, e is the electron and m, n, p and q are stoichiometric coefficients, the pE value is given by the expression:

$$pE \equiv -\log(e) = \log K_R + m \log(A_{ox}) - p \log(A_{red}) - n\,pH \quad (5.65)$$

where K_R is the equilibrium constant for the reaction in Eqn (5.64). The parameter K_R is a thermodynamic equilibrium constant that can be determined by solubility, thermochemical, spectroscopic or electrochemical experiments. Once it is known, the value of pE can be calculated if it is possible to measure (A_{ox}), (A_{red}) and pH in the soil solution. Alternatively, if pE can be measured directly with an electrochemical cell, then the relationship:

$$pE = E_H/0.059155 \qquad (5.66)$$

can be used to calculate pE in terms of E_H, the electrode potential of the cell in volts at 298.15 K. Often in soil solutions it is not possible to make an accurate electrochemical measurement of E_H (Bohn, 1971; Stumm and Morgan, 1981). In this case, Eqn (5.66) offers no particular advantage for the determination of pE.

Redox reactions in soils frequently are very slow reactions, in part because reduction and oxidation half-reactions often do not couple well to one another. The lack of effective coupling and the slowness of redox reactions mean that catalysis is required if equilibrium is ever to come about. In soil solutions, the catalysis of redox reactions is mediated by microbial organisms. In the presence of the appropriate microbial species, a redox reaction can proceed quickly enough in a soil to produce activity values of the reactants and products which agree with thermodynamic predictions. Of course, this possibility is dependent entirely on the growth and ecological behaviour of the soil microbial population and on the degree to which the products of the attendant biochemical reactions can diffuse and mix in the soil solutions. In some cases, redox reactions will be controlled by the highly variable dynamics of an open biological system, with the result that redox products at best will correspond to local conditions of partial equilibrium in a soil. In other cases, for example in flooded soils, redox reactions will be controlled by the behaviour of a closed, isobaric, isothermal chemical system that is catalysed effectively by bacteria and for which a thermodynamic description is especially apt. Regardless of which of these two extremes is the more appropriate to characterize the redox reactions in a given soil, the role of organisms deals only with the kinetics aspect of redox. *Soil organisms affect the rate of a redox reaction, not its standard free energy change.* If a redox reaction is not favoured thermodynamically, microbial intervention cannot change that fact.

3. Oxidation states of trace metals in soils

The direct effect of pE on the speciation of trace metals in soils can be assessed by calculating the "critical value", pE_{crit}, at which either the activity of A_{ox} becomes "undetectable" or the activity of A_{red} becomes "just detectable" in the soil solution at a given pH value (Sposito, 1981a, Chap. 4). This can be done with the help of Eqn (5.65) and the arbitrary assumption that the "undetectable" value of (A_{ox}) or the "just detectable" value of (A_{red}) equals 10^{-8} for aqueous species. All solid phase activities and that of $H_2O(l)$ are arbitrarily set equal to 1.0 in this illustrative calculation. Table 5.8 lists values of pE_{crit} found in this way for seven metals whose oxidation states are expected to change in the normal ranges of soil pE (-6.8 to 13.5) and pH values (4 to 9). It is evident from Table 5.8 that changes in oxidation states are expected thermodynamically in oxidized and moderately reduced acid soils and in moderately reduced and reduced alkaline soils. Lindsay (1979) has prepared activity ratio diagrams that fill out the details of these expected changes in speciation for all of the metals listed in Table 5.8, except Cr. Bartlett and James (1979) have studied the redox behaviour of Cr in soils and have demonstrated experimen-

Table 5.8 "Critical values" of pE for changes in the redox speciation of trace metals in soils at 298.15 K

Oxidation states	Reduction half-reaction	pE_{crit}	
		pH 5	pH 8
Mn(III)/Mn(II)	$MnOOH(s) + 3H^+ + e = Mn^{2+} + 2H_2O(l)$	15.9	6.9
Mn(IV)/Mn(II)	$\frac{1}{2}MnO_2(s) + 2H^+ + e = \frac{1}{2}Mn^{2+} + H_2O(l)$	14.7	8.7
Cr(VI)/Cr(III)	$\frac{1}{6}Cr_2O_7^{2-} + \frac{4}{3}H^+ + e = \frac{1}{3}Cr(OH)_3(s) + \frac{1}{6}H_2O(l)$	13.0	8.0
Hg(II)/Hg(I)	$HgO(s) + 2H^+ + e = \frac{1}{2}Hg_2^{2+} + H_2O(l)$	11.8	5.8
Fe(III)/Fe(II)	$Fe(OH)_3(s) + 3H^+ + e = Fe^{2+} + 3H_2O(l)$	8.9	−0.1
Cu(II)/Cu(I)	$CuO(s) + 2H^+ + e = Cu^+ + H_2O(l)$	8.3	2.3
Ag(I)/Ag(0)	$Ag^+ + e = Ag(s)$	5.5	5.5
Mo(VI)/Mo(IV)	$\frac{1}{18}MoO_4^{2-} + \frac{1}{9}SO_4^{2-} + \frac{4}{3}H^+ + e$	0.5*	−3.9*
	$= \frac{1}{18}MoS_2(s) + \frac{2}{3}H_2O(l)$		

* $(SO_4^{2-}) = 10^{-3}$ assumed in calculating pE_{crit}.

tally that the half-reactions involving Mn couple well with that for Cr in moist soils sufficiently high in Mn.

4. Indirect regulation of trace metal speciation

There are three principal ways in which the pE value can produce indirect effects on the chemical forms of trace metals, including those whose oxidation state is not changed as the pE value is varied (Gambrell et al., 1976). First, if the pE value falls below -2.0 ($E_H < -120$ mV), SO_4^{2-} can be transformed to S^{2-} and the formation of trace metal sulphide solids becomes possible (Connell and Patrick, 1968). Engler and Patrick (1975), for example, have shown that the sulphides of Mn, Fe, Cu, Zn and Hg undergo little or no dissolution in a flooded soil and that uptake of S by rice under this condition is related exponentially to the solubility of the metal sulphide. Thus the formation of insoluble sulphide precipitates can exert a significant influence on trace metal chemistry at low pE values.

A second indirect effect that occurs at low pE values is the preservation or production of organic compounds that can form stable complexes with trace metals. Under reducing conditions, soil microbial activity tends to shift from the degradation of large-molecular-weight organic materials to the production of organic acids. For example, Sims and Patrick (1978) reported that Fe, Cu and Zn in a silty clay loam soil at $pE = -2.5$ tended to be associated with organic matter, whereas at $pE = +5.0$ these metals were associated with inorganic fractions of the soil.

The third indirect effect of low pE values is the solubilization of oxides and hydroxides of Mn and Fe, indicated by the reactions in the first, second and

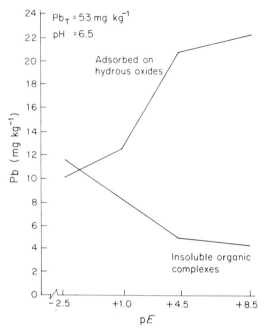

Fig. 5.8 Estimated concentrations of Pb adsorbed by hydrous oxides and complexed by organic matter in an incubated soil sample subject to varying pE values (Gambrell *et al.*, 1976).

fifth rows of Table 5.8. As suggested in Sections II.4 and III.3, these minerals are coprecipitated with or adsorb significant amounts of trace metal cations in soils. Therefore, the dissolution of these solids at low pE values, especially when the pH value also is low, is expected to release trace metals to the soil solution. This trend is illustrated in Fig. 5.8 for Pb extracted from incubated soil material at pH 6.5 by Gambrell *et al.* (1976). A sharp decrease in Pb associated with hydrous oxides of Mn and Fe occurs when the pE value falls below $+4.5$ and there is a concomitant increase in organic forms of Pb.

VI. Computer calculation of trace metal speciation

1. Chemical equilibrium programs

Computer-based, chemical equilibrium models of natural water systems, such as soils, have undergone a great deal of development in recent years and have become useful adjuncts to studies of water quality criteria (Jenne, 1979). More than a dozen chemical equilibrium programs presently are available for use by natural water chemists; the most comprehensive and widely applied of these

are REDEQL2, GEOCHEM and MINEQL (Nordstrum, 1979; Steele and Stefan, 1979). The programs GEOCHEM and MINEQL, which will be discussed in this section, are progeny of the program REDEQL2 developed by Morel, McDuff and Morgan at the California Institute of Technology (Morel and Morgan, 1972; McDuff and Morel, 1973). The details of the subroutines in REDEQL2 are discussed by McDuff and Morel (1973) and Ingle *et al.* (1978). The methods of numerical analysis employed in the program are discussed by Morel and Morgan (1972) and are compared with the methods used in other computer programs by Leggett (1977). GEOCHEM differs from REDEQL2 principally in containing more than twice as much thermodynamic data; in using thermodynamic data that have been selected critically especially for soil systems; in containing a method for describing cation exchange; and in employing a different subroutine for correcting thermodynamic equilibrium constants for the effect of non-zero ionic strength. MINEQL differs from REDEQL2 primarily in the input format, in the subroutine that describes solid phases and in the subroutine that describes adsorption phenomena.

GEOCHEM is a multipurpose computer program for calculating the equilibrium speciation of the chemical elements in a soil solution (Sposito and Mattigod, 1980). The method of calculation used in the program is based directly on chemical thermodynamics. For each component of a soil solution, a mole balance equation is set up and thermodynamic equilibrium constants corrected for ionic strength are incorporated into the various terms of this equation according to the law of mass action. The solution of the set of non-linear algebraic equations that results from mole balance applied to all the components simultaneously ultimately provides the concentration of each dissolved, solid and adsorbed species in the soil system under consideration. Some typical applications of GEOCHEM would include:

(i) prediction of the concentrations of inorganic and organic complexes of a metal cation in a soil solution;

(ii) calculation of the concentration of a particular chemical form of a nutrient element in a solution bathing plant roots so as to correlate that form with nutrient uptake;

(iii) prediction of the chemical fate of pollutant metal added to a soil solution of known characteristics; and

(iv) estimation of the effect of changing pH, ionic strength, redox potential, water content or the concentration of some constituent on the solubility of a chemical element of interest in a soil solution.

GEOCHEM is written in IBM 370 FORTRAN IV and requires about 200K of core. For any soil solution data to be analysed by the program, the chemical components are identified as metals and unprotonated ligands. The principal variables considered by the program are the free ionic concentrations of the

metals and ligands. The reason for this fact may be seen directly by considering the mole balance equation for the soluble forms of a metal M in a soil solution at equilibrium:

$$M_{TS} = [M^{m+}] + \sum \alpha \, {}^cK_{\alpha\gamma\beta}[M^{m+}]^\alpha[H^+]^\gamma[L^{l-}]^\beta \qquad (5.67)$$

where M_{TS} is the total soluble molar concentration of the metal, ${}^cK_{\alpha\gamma\beta}$ is the conditional stability constant for the soluble compound $M_\alpha H_\gamma L_\beta$, H refers to the proton and L refers to a ligand. The conditional stability constant, ${}^cK_{\alpha\gamma\beta}$, and the notation employed for a soluble compound are discussed by Sposito and Mattigod (1980). It is evident that the expression above for M_{TS} and the analogous expression which could be written for the total soluble molar concentration of a ligand, L_{TS}, are non-linear algebraic equations in the free ionic concentrations of metals, ligands and protons.

The numerical analysis problem solved by GEOCHEM is to calculate the set of free ionic concentrations that satisfies a given set of mole balance equations (one equation for each metal and each ligand in the system being investigated), subject to values of M_T and L_T, the total input concentrations, along with the thermodynamic equilibrium constants, $K_{\alpha\gamma\beta}$, which are stored in the data file of the program. To initiate the computation, the ionic strength is estimated and the ${}^cK_{\alpha\gamma\beta}$ are computed in the usual way using values of $K_{\alpha\gamma\beta}$ and single-ion activity coefficients. A slight modification of the well known Newton–Raphson algorithm is employed to solve the mole balance equations simultaneously for the free ionic concentrations. The resulting values then are used to compute the concentrations of all species in the system. These concentrations are introduced into the mole balance equations to calculate values of M_T and L_T which then are compared with their input values as a check for convergence. The calculation is repeated until the computed total concentrations differ from the input values by less than 0.01%. After convergence is obtained, a search is made for any solid considered in the computation whose calculated concentration turned out to be negative and for any solid not previously considered whose ion activity product exceeds its solubility product constant. These solids then either are eliminated from consideration or are included in a new round of computations, whichever is appropriate. When all species are properly accounted for, the program prints their molar concentrations as well as the percentage distribution among species for each metal and ligand.

Figure 5.9 illustrates the computational scheme in GEOCHEM. The input data comprise total molar concentrations of the metals and ligands to be considered as well as certain solution properties, such as the pH value, the redox potential and the partial pressure of $CO_2(g)$. Mole balance equations are set up that include the aqueous species (free ions and complexes), solids and adsorbed metal species. The concentrations of the solids permitted to form are

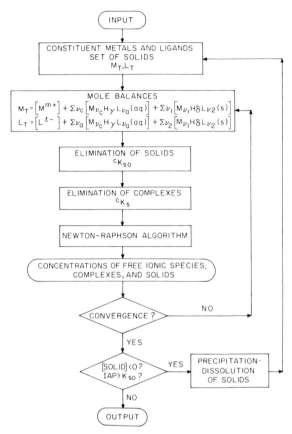

Fig. 5.9 The computational scheme of the chemical equilibrium program GEOCHEM.

eliminated from the mole balance equations by forming appropriate linear combinations of the equations (see Morel and Morgan, 1972, for examples of this procedure). The adsorbed species, in accordance with the discussion in Section III.3, are treated as complexes. The mole balance equations then are expressed in terms of $[M^{m+}]$, $[H^+]$ and $[L^{l-}]$, with some components subject to the constraint imposed by the condition $K_{so} = \text{IAP}$, where K_{so} is the solubility product constant (cf. Section II.2). The Newton–Raphson method is employed to solve these equations; if any iterated solution contains negative values (which are impossible), those values are set equal to 0.1 times the previous iterated value. When convergence is obtained, the concentrations of all species are printed along with their distribution coefficients.

GEOCHEM currently stores thermodynamic data for 36 metals and 69

ligands that form more than 2000 complexes and solids. The metals and ligands are listed in Table 5.9 along with their code numbers and code symbols. For a given metal–ligand combination, up to six soluble complexes and up to three solids can be considered by the program. In addition to the three solids per metal–ligand combination, mixed solids, containing more than one metal or ligand, are included in the program. Formation constants for up to 20 mixed solids may be incorporated into GEOCHEM; at present there are 18 mixed solids considered, including the clay minerals illite, muscovite, chlorite, vermiculite and several montmorillonites. Adsorbed metal species are described in GEOCHEM by the James–Healy model (Section III.3). Adsorbed ligand species will be considered by the program in the future. However, the program can describe soil solution equilibria in which the partial pressure of N_2, O_2 and CO_2 are permitted to vary. The variation in O_2 pressure actually is treated as an oxidation-reduction phenomenon through the inclusion of 24 redox equations in the program. These redox equations are discussed fully by Sposito and Mattigod (1980).

The program MINEQL (Westall et al., 1976; James and Parks, 1978) is very similar in scope and structure to GEOCHEM, but requires only 130 K of core and is usually applied to study chemical equilibria in natural water bodies instead of soils. MINEQL can describe complex formation, the precipitation and dissolution of pure solid phases, redox equilibria and adsorption phenomena. Mixed solids are not considered by the program. Adsorbed species are described by the Davis–Leckie model (Section III.3). A principal difference between MINEQL and GEOCHEM is that the former program can accept the concentrations of free ionic species, complexes or gases as input data to be held constant during a calculation, whereas the latter program can do this only for H^+, $CO_2(g)$ and $N_2(g)$. Thus, for example, the concentration of Cu^{2+}(aq) can be specified as a fixed input datum in MINEQL, if desired. This feature endows the program with a great deal of flexibility in the execution of speciation calculations.

2. Model calculations of trace metal speciation in soils

One important kind of research problem that can be treated effectively by a chemical equilibrium program is the prediction of the speciation of potentially hazardous trace metals added to a soil in a wastewater (Iskandar, 1981). The composition of the aqueous phase of the soil receiving the wastewater will be initially just a mixture of the unperturbed soil solution and the added effluent. As time passes, complexation, ion exchange, adsorption and precipitation–dissolution reactions occur and some stable distribution of the trace metals among aqueous, adsorbed and solid phase species results, at least

Table 5.9 Code numbers and symbols for the metals and ligands considered by GEOCHEM

Metals

1. Ca^{2+}	5. Na^+	9. Cu^{2+}	13. Ni^{2+}	17. Co^{3+}	21. Cs^+	25. TiO^{2+}	29. Ce^{3+}	33. Cu^+
2. Mg^{2+}	6. Fe^{3+}	10. Ba^{2+}	14. Hg^{2+}	18. Ag^+	22. Li^+	26. Sn^{2+}	30. Au^+	34. CH_3Hg^+
3. Sr^{2+}	7. Fe^{2+}	11. Cd^{2+}	15. Pb^{2+}	19. Cr^{3+}	23. Be^{2+}	27. Sn^{4+}	31. Th^{4+}	35. Rb^+
4. K^+	8. Mn^{2+}	12. Zn^{2+}	16. Co^{2+}	20. Al^{3+}	24. Sc^{3+}	28. La^{3+}	32. UO_2^{2+}	50. H^+

Ligands

1. CO_3^{2-}	9. PO_4^{3-}	17. CIT^{3-}	25. $GLUT^{2-}$	33. ARG^-	41. MET^-	49. SO_3^{2-}	57. NO_3^-	65. FOR^-
2. SO_4^{2-}	10. $P_2O_7^{4-}$	18. OX^{2-}	26. PIC^-	34. ORN^-	42. VAL^-	50. SCN^-	58. $DTPA^{5-}$	66. $FUL1^-$
3. Cl^-	11. $P_3O_{10}^{5-}$	19. SAL^{2-}	27. NTA^{3-}	35. LYS^-	43. THR^-	51. NH_2OH	59. SeO_4^{2-}	67. $FUL2^-$
4. F^-	12. $SiO_2(OH)_2^{2-}$	20. $TART^{2-}$	28. $EDTA^{4-}$	36. HIS^-	44. PHE^-	52. MoO_4^{2-}	60. MAL^{2-}	68. $EDHG^{4-}$
5. Br^-	13. $S_2O_3^{2-}$	21. EN^0	29. $DCTA^{4-}$	37. ASP^-	45. ISO^-	53. WO_4^{2-}	61. BES^-	90. ADS1
6. I^-	14. CN^-	22. DIP^0	30. $CYST^{2-}$	38. SER^-	46. LEU^-	54. AsO_4^{3-}	62. ClO_4^-	91. ADS2
7. NH_3^0	15. AC^-	23. $SUSAL^{3-}$	31. NOC^{3-}	39. ALA^-	47. PRO^-	55. HVO_4^{2-}	63. $CBER^-$	92. ADS3
8. S^{2-}	16. $ACAC^-$	24. GLY^-	32. $PHTH^{2-}$	40. TYR^{2-}	48. $B(OH)_4^-$	56. SeO_3^{2-}	64. CHAM	93. ADS4
								94. ADS5
								99. OH^-

KEY: AC, acetate; ACAC, acetylacetate; CIT, citrate; OX, oxalate; SAL, salicylate; TART, tartrate; EN, ethylenediamine; DIP, dipyridyl; SUSAL, sulfosalicylate; GLY, glycine; GLUT, glutamate; PIC, picolinate; NTA, nitrilotriacetate; EDTA, ethylenediaminetetraacetate; DCTA, 1,2-diaminocyclohexanetetraacetate; CYST, cysteine; NOC, nocardamine (desferri-ferrioxamine); PHTH, phthalate; ARG, arginine; ORN, ornithine; LYS, lysine; HIS, histidine; DTPA, diethylenetriaminepentaacetate; ASP, aspartate; SER, serine; ALA, alanine; TYR, tyrosine; MET, methionine; VAL, valine; THR, threonine; PHE, phenylalanine; ISO, isoleucine; LEU, leucine; PRO, proline; MAL, maleate; BES, benzylsulphonate; CBER, Camp Berteau montmorillonite; CHAM, Chambers bentonite; FOR, formate; FUL1, fulvic acid ligand; FUL2, fulvic acid ligand; EDHG = EDDHA, ethylene dihydroxyphenyl glycine; ADS1–ADS5, adsorption surfaces.

on a time scale that is short compared with that over which the influence of biological agents in the soil is significant. It is this distribution of species that computer-based chemical equilibrium models are designed to predict.

Results from the application of the program GEOCHEM to speciate Ni(II), Cu(II), Zn(II), Cd(II) and Pb(II) in Hanford fine sandy loam (Typic Xerorthent) and Holtville silty clay (Typic Torrifluvent) will be presented in this section. The Hanford soil contains about 9% clay of mixed mineralogy, has a cation exchange capacity near 0.08 meq g^{-1} and exhibits a pH value of 5.4 in its saturation extract. The Holtville soil contains 41% clay, has a cation exchange capacity of 0.27 meq g^{-1} and a pH value of 7.9 in its saturation extract. Its clay fraction is composed primarily of montmorillonite and it is calcareous (Mahler et al., 1978).

Table 5.10 lists analytical data pertaining to oxic wastewater–soil solution mixtures in the Hanford and Holtville soils. These data are based on numerous saturation extract analyses of the soils both in the uncontaminated state, as a medium for plant growth, and after contamination by a wastewater or wastewater solids. The molar concentrations of the trace metals Ni, Cu, Zn, Cd and Pb listed are considered representative of possible contamination levels in soil solutions (Page et al., 1981). The molar concentrations of the eight organic acids listed in Table 5.10 are based on a model of the metal-complexing, organic functional groups in the aqueous phases of soils amended with sewage sludge (Mattigod and Sposito, 1979; Mahler et al., 1980). This model is a

Table 5.10 Analytical input data for an acid and a calcareous soil mixed with a wastewater containing trace metals*

Com-ponent	$M_T{}^a$		Com-ponent	$L_T{}^a$		Com-ponent	$L_T{}^a$	
	Acid	Calc.		Acid	Calc.		Acid	Calc.
Ca	1.66	2.28	CO$_3$	3.06	2.40	ORN	4.29	5.66
Mg	2.23	2.64	SO$_4$	2.14	2.12	LYS	4.29	5.66
K	2.88	2.89	Cl	2.74	2.03	VAL	4.29	5.66
Na	2.74	2.00	F	4.15	4.15	B(OH)$_4$	4.42	4.42
Cu	5.50	5.33	PO$_4$	3.38	4.19	NO$_3$	1.38	3.56
Cd	7.57	7.57	CITb	4.07	5.27	MAL	3.89	5.44
Zn	4.87	4.97	SAL	4.19	5.57	pH	5.40	7.90
Ni	4.99	5.99	PHTH	3.89	5.57	% Ads.c	1.5	7.4
Pb	7.02	7.02	ARG	4.41	5.79	$\theta_{sat}{}^d$	0.23	0.50

* Analytical data courtesy of Dr R. J. Mahler: acid soil = Hanford fine sandy loam; calcareous soil = Holtville silty clay.
a Expressed as $-\log$ (molar concentration).
b Symbols for organic ligands are defined in Table 5.9.
c Weight percent of adsorbent in the soil.
d Gravimetric water content at saturation (g H$_2$O/g soil).

qualitative attempt to represent the effect of soluble organic ligands on trace metal speciation. The levels of organic acids correspond to about 270 g C m^{-3} in the Hanford soil solution and to about 40 g C m^{-3} in the Holtville soil solution; these estimates also are based on analyses of saturation extracts from contaminated soils.

There is much evidence that bivalent trace metal cations are not exchanged selectively for Ca^{2+} on non-oxidic soil mineral surfaces (see, for example, Pickering, 1979, 1980a,b). Therefore, given the differences of three or more orders of magnitude between the concentrations of Ca (and Mg) and the trace metals listed in Table 5.10, it is very unlikely that significant effects from cation exchange reactions will occur on the non-proton-selective surfaces in the Hanford and Holtville soils. For this reason, cation exchange on these surfaces was not considered in the speciation calculation performed by GEOCHEM, although this can be done by the program (Sposito and Mattigod, 1980). However, competitive metal cation adsorption on proton-selective surfaces, such as hydrous oxide surfaces and the edge surfaces of clay minerals, was considered in the speciation calculation. The minerals bearing these surfaces were assumed to account for about 18% of the clay fraction in each soil (Table 5.10) and to possess a specific surface area equal to 85 m^2 g^{-1}, a value representative of iron oxyhydroxides as well as the edge surface of montmorillonite. To apply the James–Healy model, it was necessary to specify the saturation water content of each soil (Table 5.10), the zero point of charge of the adsorbent (pH = 5.50) and its dielectric constant ($\varepsilon = 14.0$) and the values of ΔG_{chem} in Eqn (5.34) (Sposito and Mattigod, 1980). For the trace metals, the data on ΔG_{chem} in Table 5.5 for goethite (with $\Delta G_{chem} = -10.1\,RT$ for Cd^{2+}) were used; for Ca^{2+}, Mg^{2+}, Na$^+$ and K$^+$, the values employed were -10.0, -8.0, -0.1 and -0.2 in units of RT, as suggested by Sposito and Mattigod (1980).

The speciation of the five trace metals predicted by GEOCHEM for the Hanford and the Holtville soils is summarized in Tables 5.11 and 5.12. The computation took into consideration the simultaneous formation of 334 soluble complexes and the possible precipitation of 58 solids comprising the 10 metals (including H$^+$) and 16 ligands (including OH$^-$) for which input analytical data were provided as in Table 5.10. Perhaps the most striking feature of the speciation data is the effectiveness of the adsorbent at reducing the total soluble concentrations of the trace metals, especially in the Holtville soil, where 75 to 100% of the added metals are adsorbed species. In the Hanford soil, the pH value is lower, suppressing the formation of hydrolytic species, and adsorption is less effective at reducing M$_{TS}$. Moreover, because soluble complex formation tends to be decreased at low pH (because of proton competition for the ligands), most of M$_{TS}$ is contributed by the free metal cation, as shown in columns 3 and 4 of Table 5.10. Only Cu^{2+}, because of its

Table 5.11 Equilibrium speciation of trace metals in Hanford fine sandy loam as predicted by GEOCHEM

Metal	% Adsorbed	M_{TS}*	$[M^{2+}]$*	Principal aqueous species†
Ni(II)	82.1	5.76	5.91	Ni^{2+}, $NiSO_4^0$, Org‡
Cu(II)	32.6	5.69	6.39	Org, Cu^{2+}, $CuSO_4^0$
Zn(II)	98.1	6.62	6.75	Zn^{2+}, $ZnSO_4^0$
Cd(II)	78.7	8.25	8.43	Cd^{2+}, $CdSO_4^0$, $CdCl^+$
Pb(II)	42.1	7.27	7.68	Pb^{2+}, Org, $PbSO_4^0$, $PbHCO_3^+$

* Expressed as $-\log$ (molar concentration).
† Listed in order of decreasing importance.
‡ Organic complexes (e.g., fulvic acid).

Table 5.12 Equilibrium speciation of trace metals in Holtville silty clay as predicted by GEOCHEM

Metal	% Adsorbed	M_{TS}*	$[M^{2+}]$*	Principal aqueous species†
Ni(II)	99.1	8.02	9.02	$NiCO_3^0$, $NiHCO_3^+$, Ni^{2+}, $NiB(OH)_4^+$
Cu(II)	75.6	5.95	8.05	Org, $CuCO_3^0$, $CuB(OH)_4^+$
Zn(II)	100.0	8.46	9.04	$ZnHCO_3^+$, Zn^{2+}, $ZnSO_4^0$, $ZnCO_3^0$
Cd(II)	99.7	10.14	10.53	Cd^{2+}, $CdSO_4^0$, $CdCl^+$
Pb(II)	76.4	7.65	9.62	$PbCO_3^0$, $PbHCO_3^+$, $Pb(CO_3)_2^{2-}$

* Expressed as $-\log$ (molar concentration).
† Listed in order of decreasing importance.

great affinity for organic ligands, deviates from the general rule that the free metal cation is the dominant aqueous species in the Hanford soil. In the Holtville soil, by contrast, the free metal cation is either unimportant or of considerably reduced importance in the soil solution, except for Cd^{2+}. In the case of Cd, however, the value of M_{TS} is so low that the free metal cation still can be regarded as an unimportant species. The important role played by carbonate complexes in reducing the significance of the free ionic species is noteworthy, since conventional wisdom might have predicted that organic complexes would be the most abundant aqueous species at high pH values for any trace metal. The data in Tables 5.11 and 5.12 indicate that the aqueous phase chemistry of trace metals—with the important exception of Cu(II)—is essentially the chemistry of inorganic species. Another result of broad significance is the absence of predicted solid phases in Tables 5.11 and 5.12. Under the conditions imposed through the data in Table 5.10, adsorption, not

precipitation, exerts the controlling influence on trace metal solubility in both acidic and alkaline soil solutions. To the extent that the model calculation by GEOCHEM can be accorded general validity, it would appear that the most important chemical forms of trace metals in soils are adsorbed species and inorganic complexes, except for $Cu(\text{II})$, where organic forms may well dominate in both the aqueous and solid phases of soils regardless of the soil pH value.

Acknowledgements

This review was prepared with support from National Science Foundation Grant CME-79-16336 and from a Matching Grant of the Office of Water Research and Technology (OWRT Project No. B-212-CAL) and the University of California Water Resources Center (WRC Project UCAL-WRC-W-583). The contents of this chapter do not necessarily reflect the views and policies of OWRT, USDI. Gratitude is expressed to Dr P. B. Tinker, Dr J. R. Sanders and Dr I. Thornton for many helpful comments regarding the format and content of this chapter. Thanks also are expressed to Mr Karoly Fogassy for preparing the illustrations and to Ms Joyce Thompson, Mrs Sharon Conditt and Ms Martha Stephans for their careful typing of the manuscript.

References

Anderson, M. A. and Rubin, A. J. (1981). "Adsorption of Inorganics at Solid–Liquid Interfaces". Ann Arbor Science, Ann Arbor, Michigan.

Allen, H. E., Hall, R. H. and Brisbin, T. D. (1980). *Environ. Sci. Technol.* **14**, 441–443.

Bartlett, R. J. (1981). *In* "Chemistry in the Soil Environment" (R. H. Dowdy *et al.*, eds), pp. 77–102. Soil Science Society of America, Madison, Wisconsin.

Bartlett, R. J. and James, B. (1979). *J. Environ. Qual.* **8**, 31–35.

Bassett, R. L., Kharaka, Y. K. and Langmuir, D. (1979). *In* "Chemical Modeling in Aqueous Systems" (E. A. Jenne, ed.), pp. 389–400. ACS Symp. Ser. No. 93, American Chemical Society, Washington, DC.

Benjamin, M. M. and Leckie, J. O. (1980). *In* "Contaminants and Sediments" (R. A. Baker, ed.), Vol. 2, pp. 305–322. Ann Arbor Science, Ann Arbor, Michigan.

Bohn, H. L. (1971). *Soil Sci.* **112**, 39–45.

Bohn, H. L., McNeal, B. L. and O'Connor, G. A. (1979). "Soil Chemistry". John Wiley, New York.

Bragg, L. and Clarinbull, G. F. (1965). "Crystal Structures of Minerals". Cornell University Press, Ithaca.

Bresnahan, W. T., Grant, C. L. and Weber, J. H. (1978). *Anal. Chem.* **50**, 1675–1679.

Brown, W. E. (1973). *In* "Environmental Phosphorus Handbook" (E. J. Griffith, A. Beeton, J. M. Spencer and D. T. Mitchell, eds), pp. 203–239. John Wiley, New York.

Carroll, D. (1970). "Rock Weathering". Plenum Press, New York.

Connell, W. E. and Patrick, W. H. (1968). *Science* **159**, 86–87.

Corey, R. B. (1981). *In* "Adsorption of Inorganics at Solid–Liquid Interfaces" (M. A. Anderson and A. J. Rubin, eds), pp. 161–182. Ann Arbor Science, Ann Arbor, Michigan.

Cottenie, A., Camerlynck, R., Verloo, M. and Dhaese, A. (1979). *Pure Appl. Chem.* **52**, 45–53.

Davies, B. E. (1980). "Applied Soil Trace Elements". John Wiley, Chichester, UK.

Davies, B. E. (1983). *In* "Applied Environmental Geochemistry" (I. Thornton, ed.), pp. 425–462. Academic Press, London.

Davis, J. A. and Leckie, J. O. (1978a). *J. Colloid Interface Sci.* **67**, 90–107.

Davis, J. A. and Leckie, J. O. (1978b). *Environ. Sci. Technol.* **12**, 1309–1315.

Davis, J. A. and Leckie, J. O. (1979). *In* "Chemical Modeling in Aqueous Systems" (E. A. Jenne, ed.), pp. 299–317. ACS Symposium Series No. 93, American Chemical Society, Washington, DC.

Davis, J. A. and Leckie, J. O. (1980). *J. Colloid Interface Sci.* **74**, 32–43.

Davis, J. A., James, R. O. and Leckie, J. O. (1978). *J. Colloid Interface Sci.* **63**, 480–499.

Dixon, J. B. and Weed, S. B. (1977). "Minerals in Soil Environments". Soil Science Society of America, Madison, Wisconsin.

Engler, R. M. and Patrick, W. H. (1975). *Soil Sci.* **119**, 217–221.

Farrah, H. and Pickering, W. F. (1976). *Aust. J. Chem.* **29**, 1167–1176.

Farrah, H. and Pickering, W. F. (1977). *Water, Air and Soil Pollut.* **8**, 189–197.

Florence, T. M. (1977). *Water Res.* **11**, 681–687.

Florence, T. M. and Batley, G. E. (1977). *Talanta* **24**, 151–158.

Florence, T. M. and Batley, G. E. (1980). *Anal. Chem.* **52**, 1962–1963.

Förstner, U. and Whittmann, G. T. W. (1979). "Metal Pollution in the Aquatic Environment". Springer-Verlag, Berlin.

Freundlich, H. (1909). "Kapillarchemie". Akademische Verlagsgesellschaft, Leipzig.

Gambrell, R. P., Khalid, R. A., Collard, V. R., Reddy, C. N. and Patrick, W. H. (1976). *In* "Dredging: Environmental Effects and Technology", pp. 581–604. Proc. WODCON VII, San Francisco.

Gordon, L., Salutsky, M. L. and Willard, H. H. (1959). "Precipitation from Homogeneous Solution". John Wiley, New York.

Griffen, R. A. and Au, A. K. (1977). *Soil Sci. Soc. Amer. J.* **41**, 880–882.

Guggenheim, E. A. (1967). "Thermodynamics". North-Holland, Amsterdam.

Högfeldt, E. (1982). "Stability Constants of Metal-Ion Complexes: Part A, Inorganic Ligands". Pergamon Press, Oxford.

Huheey, J. E. (1978). "Inorganic Chemistry". Harper and Row, New York.

Ingle, S. E., Schuldt, M. D. and Shults, D. W. (1978). "A User's Guide for REDEQL-EPA". US Environ. Prot. Agency Rpt. EPA-600/3-78-024. Corvallis, Oregon.

Iskandar, I. K. (1981). "Modeling Wastewater Renovation: Land Treatment". John Wiley, New York.

James, R. O. and Healy, T. W. (1972). *J. Colloid Interface Sci.* **40**, 65–81.

James, R. O. and MacNaughton, M. G. (1977). *Geochim. et Cosmochim. Acta* **41**, 1549–1555.

James, R. O. and Parks, G. A. (1978). "Application of the Computer Program 'MINEQL' to Solution of Problems in Surface Chemistry". Technical Note, Stanford University, Stanford, California.

James, R. O., Stiglich, P. J. and Healy, T. W. (1975). *Faraday Disc. Chem. Soc.* **59**, 142–156.

Jenne. E. A. (1976). "Symposium on Molybdenum in the Environment" (W. Chappel and K. Petersen, eds), Vol. 2, pp. 425–553. Marcel Dekker, New York.

Jenne, E. A. (1979). "Chemical Modeling in Aqueous Systems". ACS Symposium Series No. 93, American Chemical Society, Washington, DC.

Kerndorff, H. and Schnitzer, M. (1980). *Geochim. et Cosmochim. Acta* **44**, 1701–1708.

Kinniburgh, D. G. and Jackson, M. L. (1981). *In* "Adsorption of Inorganics at Solid–Liquid Interfaces" (M. A. Anderson and A. J. Rubin, eds), pp. 91–160. Ann Arbor Science, Ann Arbor, Michigan.

Kinniburgh, D. G., Jackson, M. L. and Syers, J. K. (1976). *Soil Sci. Soc. Amer. J.* **40**, 796–799.

Koppelman, M. H., Emerson, A. B. and Dillard, J. G. (1980). *Clays and Clay Minerals* **28**, 119–124.

Krauskopf, K. B. (1972). *In* "Micronutrients in Agriculture" (J. J. Mortvedt, P. M. Giordano and W. L. Lindsay, eds), pp. 7–40. Soil Science Society of America, Madison, Wisconsin.

Leggett, D. J. (1977). *Talanta* **24**, 535–542.

Lindsay, W. L. (1979). "Chemical Equilibria in Soils". John Wiley, New York.

Loughnan, F. C. (1969). "Chemical Weathering of the Silicate Minerals". American Elsevier, New York.

McDuff, R. E. and Morel, F. M. M. (1973). "Description and Use of the Chemical Equilibrium Program REDEQL2". Tech. Rpt. EQ-73-02, California Institute of Technology, Pasadena, California.
McKenzie, R. M. (1972). Z. Pflanzenernahr. Bodenkunde 131, 221–242.
McKenzie, R. M. (1980). Aust. J. Soil. Res. 18, 61–73.
Mahler, R. J., Bingham, F. T. and Page, A. L. (1978). J. Environ. Qual. 7, 274–281.
Mahler, R. J., Bingham, F. T., Sposito, G. and Page, A. L. (1980). J. Environ. Qual. 9, 359–364.
Martell, A. E. (1971). "Coordination Chemistry". ACS Monograph Series No. 168. Van Nostrand Reinhold, New York.
Martell, A. E. and Smith, R. M. (1974–1977). "Critical Stability Constants", 4 Vols. Plenum Press, New York.
Mattigod, S. V. and Page, A. L. (1983). In "Applied Environmental Geochemistry" (I. Thornton, ed.), pp. 355–394. Academic Press, London.
Mattigod, S. V. and Sposito, G. (1977). Soil Sci. Soc. Amer. J. 41, 1092–1097.
Mattigod, S. V. and Sposito, G. (1979). In "Chemical Modeling in Aqueous Systems" (E. A. Jenne, ed.), pp. 837–856. ACS Symp. Ser. No. 93, American Chemical Society, Washington, DC.
Mattigod, S. V., Gibali, A. S. and Page, A. L. (1979). Clays and Clay Minerals 27, 411–416.
Mattigod, S. V., Sposito, G. and Page, A. L. (1981). In "Chemistry in the Soil Environment" (R. H. Dowdy et al., eds), pp. 203–221. Soil Science Society of America, Madison, Wisconsin.
Morel, F. and Morgan, J. (1972). Environ. Sci. Technol. 6, 58–67.
Mosser, Ch. (1979). Phys. Chem. Earth 11, 315–329.
Neiboer, E. and Richardson, D. H. S. (1980). Environ. Pollut. 1B, 3–26.
Nordstrum, K. (1979). In "Chemical Modeling in Aqueous Systems" (E. A. Jenne, ed.), pp. 857–892. ACS Symposium Series No. 93, American Chemical Society, Washington, DC.
Norrish, K. (1975). In "Trace Elements in Soil–Plant–Animal Systems" (D. J. D. Nicholas and A. R. Egan, eds), pp. 55–81. Academic Press, New York.
Nye, P. H. and Tinker, P. B. (1977). "Solute Movement in the Soil–Root System". University of California Press, Berkeley and Los Angeles.
Page, A. L., Chang, A. C., Sposito, G. and Mattigod, S. V. (1981). In "Modeling Wastewater Renovation: Land Treatment" (I. K. Iskandar, ed.), pp. 182–222. John Wiley, New York.
Perrin, D. D. (1979). "Stability Constants of Metal–Ion Complexes: Part B, Organic Ligands". Pergamon Press, Oxford.
Pickering, W. F. (1979). In "Copper in the Environment" (J. O. Nriagu, ed.), Part I, pp. 217–253. John Wiley, New York.
Pickering, W. F. (1980a). In "Zinc in the Environment" (J. O. Nriagu, ed.), Part I, pp. 71–112. John Wiley, New York.
Pickering, W. F. (1980b). In "Cadmium in the Environment" (J. O. Nriagu, ed.), pp. 365–397. John Wiley, New York.
Ponnamperuma, F. N. (1972). Advan. Agron. 24, 29–96.
Rai, D. and Lindsay, W. L. (1975). Soil Sci. Soc. Amer. J. 39, 991–996.
Rickard, D. T. and Nriagu, J. O. (1978). In "The Biogeochemistry of Lead in the Environment" (J. O. Nriagu, ed.), Part A, pp. 219–284, Elsevier, Amsterdam.
Robie, R. A., Hemingway, B. S. and Fisher, J. R. (1978). US Geol. Survey Bull. 1452.
Ryden, J. C. and Pratt, P. F. (1980). Hilgardia 48, 1–36.
Sadiq, M. and Lindsay, W. L. (1979). Colorado St. Univ. Exp. Sta. Tech. Bull. 134. Colorado State University, Fort Collins.
Santillan-Medrano, J. and Jurinak, J. J. (1975). Soil Sci. Soc. Amer. Proc. 39, 851–856.
Schnitzer, M. and Khan, S. U. (1978). "Soil Organic Matter". Elsevier, Amsterdam.
Shuman, L. M. (1976). Soil Sci. Soc. Amer. J. 40, 349–352.
Sims, J. L. and Patrick, W. H. (1978). Soil Sci. Soc. Amer. J. 42, 258–262.
Skogerboe, R. K., Wilson, S. A. and Osteryoung, J. G. (1980). Anal. Chem. 52, 1960–1962.
Sposito, G. (1982). In "McGraw-Hill Encyclopedia of Science and Technology" (S. P. Parker, ed.), Vol. 12, pp. 548–555. McGraw-Hill, New York.
Sposito, G. (1980). Soil Sci. Soc. Amer. J. 44, 652–654.
Sposito, G. (1981a). "The Thermodynamics of Soil Solutions". Oxford University Press, Oxford and New York.

Sposito, G. (1981b). *In* "Chemistry in the Soil Environment" (R. H. Dowdy *et al.*, eds), pp. 13–30. Soil Science Society of America, Madison, Wisconsin.

Sposito, G. (1981c). *Soil Sci. Soc. Amer. J.* **45**, 292–297.

Sposito, G. and Mattigod, S. V. (1980). "GEOCHEM: A Computer Program for the Calculation of Chemical Equilibria in Soil Solutions and Other Natural Water Systems". Kearney Foundation of Soil Science, University of California, Riverside.

Sposito, G., Holtzclaw, K. M. and LeVesque-Madore, C. S. (1979). *Soil Sci. Soc. Amer. J.* **43**, 1148–1155.

Steele, T. D. and Stefan, H. G. (1979). *Rev. Geophys. Space Phys.* **17**, 1306–1335.

Stumm, W. and Morgan, J. J. (1981). "Aquatic Chemistry". John Wiley, New York.

Sun, M. S., Hariss, D. K. and Magnuson, V. R. (1980). *Canad. J. Chem.* **58**, 1253–1257.

Theis, T. L. and Richter, R. O. (1979). *Environ. Sci. Technol.* **13**, 219–224.

Vlasov, K. A. (1966). "Geochemistry of Rare Elements". Israel Program for Scientific Translations, Jerusalem.

Walton, A. G. (1967). "The Formation and Properties of Precipitates". John Wiley, New York.

Westall, J. and Hohl, H. (1980). *Advan. Colloid Interface Sci.* **12**, 265–294.

Westall, J. C., Zachary, J. L. and Morel, F. M. M. (1976). "MINEQL: A Computer Program for the Calculation of Chemical Equilibrium Composition of Aqueous Systems". Tech. Note 18. Ralph M. Parsons Laboratory, Massachusetts Institute of Technology, Cambridge, Massachusetts.

6

Geochemistry and Water Quality

ERNEST E. ANGINO

I. Introduction

At first glance, the title of this chapter can be misleading. It is not my intent to present a detailed discussion of the multitude of geochemical interactions in water that determine the chemistry, or water quality, of the substance itself. The words "water quality" are used to mean the chemical composition, primarily inorganic, that determines the fitness of the water for some specific use. The suspended load is included as it clearly affects the concentration of both inorganic and organic components and therefore the water's quality.

Given this approach, this chapter centres on some of the effects that the various chemical reactions and processes have on the geochemistry of water destined for various uses.

II. Analysis

To understand properly the geochemistry of any water system, one must first determine its chemistry; consequently, a brief statement on sources of analytical methods is in order. Many different analytical methods are available for the analysis of specific water constituents (for example, potassium and magnesium). In certain instances, different analytical techniques are used for waters of different composition. Experience, however, has convinced those involved with carrying out chemical analyses of water that certain analytical methods are more dependable than others. Different manuals and techniques

APPLIED ENVIRONMENTAL GEOCHEMISTRY
ISBN 0-12-690640-8

are used and endorsed by different groups. Nonetheless, several of those volumes are quite similar in their approach.

Comparison of the methods for chemical analysis given in *Water and Wastes* (US Environmental Protection Agency, 1974) with for example the Annual Book of ASTM Standards (ASTM, 1974; the number changes with each edition) and other analytical manuals is recommended. The methodology advocated for each element or compound in these manuals is satisfactory for most purposes. Many other manuals exist and are used internationally. All are fundamentally sound and offer proper procedures for carrying out different chemical analyses under many different conditions.

III. Water hardness

A common property used to determine water quality for many purposes is that of water hardness. Brown *et al.* (1970) present a most useful definition: "The hardness of water is that property attributable to the presence of alkaline earths". The major alkaline earth elements present in most natural waters are Ca and Mg. Other elements such as Sr, Ba (also alkaline earths), Fe, Mn and Al are normally not present in waters in sufficient amount to affect a test for hardness.

Many definitions of hardness exist world-wide (Höll, 1972; Angino, 1979). Table 6.1, modified from Höll (1972), provides a comparison of various scales of water hardness.

Table 6.1 Various scales of hardness of water

1 German degree of hardness (German dH°)	= 10 mg CaO l^{-1}
	= 7.14 mg Ca l^{-1}
	= 17.9 mg Ca(HCO$_3$)$_2$ l^{-1}
	= 1.25 English H°
	= 1.79 French H°
1 French degree of hardness (French°)	= 10 mg CaCO$_3$ l^{-1}
	= 0.56 German dH°
	= 0.7 English H°
1 English degree of hardness (English H°)	= 10 mg CaCO$_3$ 0.7 l^{-1}
	= 0.8 German dH°
1 American degree of hardness	= 1 mg CaCO$_3$ l^{-1}
	= 0.056 German dH°
1 International degree of hardness (mval)*	= 1 meq l^{-1}
	= (German dH°)2.8

* An mval is 1 meq l^{-1} of material concerned and is the proposed international unit of hardness.

Water hardness is primarily the result of interaction between water and the geological formations containing it, or over which the water flows. Since Ca and Mg are the major contributors to hardness, one must especially examine the chemistry of Ca in natural water systems. It is necessary to review briefly calcium carbonate solubility and ionic equilibria in water.

The Ca^{2+} ion forms weakly soluble species with carbonate and bicarbonate ions, both of which are common in natural water systems, to form $CaCO_3^0$ and $CaHCO_3^+$ and with hydroxides to form $CaOH^+$. Various reactions of these species with carbon dioxide dissolved in the water as CO_2, H_2CO_3, HCO_3^- and CO_3^{2-}, along with OH^- and H^+ leads to a state of dynamic equilibrium which is commonly described by the reactions given below:

$$H_2O + CO_2 \rightleftharpoons H_2CO_3 \tag{6.1}$$

$$H_2CO_3 \rightleftharpoons H^+ + HCO_3^- \tag{6.2}$$

$$HCO_3^- \rightleftharpoons CO_3^{2-} + H^+ \tag{6.3}$$

$$H_2O \rightleftharpoons H^+ + OH^- \tag{6.4}$$

A series of dissociation equations can be developed that will yield the concentrations of each species in water. Knowledge of these species is critical if one wishes to follow, for example, the interaction between limestones ($CaCO_3$), atmospheric CO_2 and water. Detailed discussions of carbonate equilibria under many natural conditions are presented by several authors, including Stumm and Morgan (1970), Loewenthal and Marias (1976) and Snoeyink and Jenkins (1980). Each of these volumes discusses in much greater detail the topics covered in this brief review chapter. The interested reader is strongly urged to review those volumes and other references given herein for an in-depth coverage of specific topics of interest. The most practical approach to understanding the geochemistry of natural water systems is given in Garrels and Christ (1970), where the most likely reactions between the geochemical environment (limestones, etc) and water are presented for various sets of conditions.

A case of considerable environmental importance is that of the reaction of $CaCO_3$ (calcite—common limestone) in a relatively fresh water system in contact with the atmosphere—the latter at a fixed CO_2 partial pressure. This system is representative of many natural waters, such as lakes, streams and ground waters of low ionic strength (<0.1). Little ionic complexing occurs in such waters. In these instances the pH of the system is controlled by the carbonate equilibria.

Garrels and Christ (1970) present a detailed discussion of five cases involving the chemistry of carbonates in dilute solutions covering many situations of geological interest. They refer all calculations to calcite, recognizing that similar approaches can be taken for any metal carbonate.

An excellent description of the part that geochemistry plays in controlling water quality has also been given by Hem (1970), p. 1:

The chemical composition of natural water is derived from many different sources of solutes, including gases and aerosols from the atmosphere, weathering and erosion of rocks and soil, solution or precipitation reactions occurring below the land surface, and cultural effects resulting from activities of man. Some of the processes of solution or precipitation of minerals can be closely evaluated by means of principles of chemical equilibria, including the law of mass action and the Nernst equation. Other processes are irreversible and require consideration of reaction mechanisms and rates. The chemical composition of the crustal rocks of the earth and the composition of the ocean and the atmosphere are significant in evaluating sources of solutes in natural fresh water.

The ways in which solutes are taken up or precipitated and the amounts present in solution are influenced by many environmental factors, especially climate, structure and position of rock strata, and biochemical effects associated with life cycles of plants and animals, both microscopic and macroscopic.

More than 60 constituents and properties are included in water analyses frequently enough to provide a basis for consideration of the sources from which each is generally derived, most probable forms of elements and ions in solution, solubility controls, expected concentration ranges and other chemical factors. Concentrations of elements that are commonly present in amounts less than a few tens of micrograms per litre cannot always be easily explained, but present information suggests many are controlled by solubility of hydroxide or carbonate or by sorption of solid particles.

Just about every activity of man involves the use of water. In all of these uses the chemistry of the water has been influenced by the interactions between it and the earth. Hence, any discussion of geochemistry and water quality, no matter how brief, has to touch or illustrate in what way these reactions affect water chemistry. Many of the principles involved are discussed extensively in books by Garrels and Christ (1970), Krauskopf (1979) and several others.

It is assumed that a person interested in this topic has the requisite basics in geology and chemistry and is basically familiar with material in the volumes noted. Given this assumption, it is then possible to discuss briefly the basic principles and processes controlling the chemistry (or water quality) of natural water. The outline is essentially that followed by Hem (1970).

The approach touches briefly upon the processes and principles involved in:

(i) the reactions involved in natural radiation and its effects on radioactivity of water;

(ii) those chemical reactions of different types involving water, and the dissolved gases and solutions in it; and

(iii) those reactions related to those environmental factors influencing the chemistry of water as it moves through the hydrologic cycle.

As is known, it is difficult to present a water composition representative of all rivers, ground water or rainwater. Only the *major* element composition of the

Table 6.2 Natural light and heavy source radionuclides that occur significantly in nature (modified from Eisenbud, 1973)

Radionuclide	Half-life (years)	Elemental abundance (%)
Tritium	12.3	
Carbon-14	5730	
Potassium-40	1.26×10^9	0.012
Vanadium-50	6×10^{15}	0.25
Rubidium-87	4.8×10^{10}	27.9
Lanthanum-138	1.12×10^{11}	0.09
Neodymium-144	2.4×10^{15}	23.0
Samarium-147	1.05×10^{11}	15.1
Lutetium-176	2.2×10^{10}	2.6
Thorium-232	1.41×10^{10}	100
Uranium-238	4.51×10^9	99.28
Uranium-235	7.1×10^8	0.72

ocean is, and has remained relatively, constant over long periods of geologic time.

IV. Radiation and radioactivity

The radionuclides that occur in water are of three sources:

 (i) Those that occur naturally. The light nuclides ^{12}C and ^{40}K and the heavy radionuclides of uranium (^{238}U, ^{235}U and ^{232}Th).
 (ii) The radioactive daughter products of the heavy nuclides.
 (iii) Fission and transmutation products that are the result of man's activities.

A brief list of some naturally occurring radioisotopes is given in Table 6.2 modified from Eisenbud (1973).

In many waters it is easy to identify such isotopes as ^3H, ^{14}C, ^{40}K and the daughter products of Th and U. Each of the latter two elements initiate a distintegration series of shorter-lived species that finally end in a stable isotope of lead (for example, ^{238}U \rightarrow ^{206}Pb and ^{232}Th \rightarrow ^{208}Pb). The three natural decay series are common (Lee et al., 1977) in the earth's crust and account for a large part of the radiation present and found in water, especially in the form of the three short lived species of radon gas, ^{219}Rn, ^{220}Rn and ^{223}Rn. A short-lived isotope of Rn is present in each of the decay chains of ^{238}U, ^{235}U and

^{232}Th. The decay products of these are introduced into water via man's activities (such as cooling water from nuclear reactors). Several species from this source can be routed to man via the pathway of drinking water or aquatic biota. Among these are ^3H, ^{137}Cs and several isotopes of the transition metals, such as Fe, Co, Zn and Mn. Lee et al. (1977, p. 17) have presented an overall water exposure dose equation covering this concern, namely:

$$D_w = Q/M[I_w F(DF)e^{-\lambda t_i} + R(DF)(e^{-\lambda t_i})(ICF + I_s CF_s)] \qquad (6.5)$$

where Q = release (μCi yr^{-1}), M = mass flow of receiving waters (cm^3 yr^{-1}), t_i = time between emission and exposure (days), DF = stream dilution factor upon entrance to pathway, I_w = drinking water consumption rate (cm^3 yr^{-1}), I_s and I = intake of shellfish and fish respectively (cm^3 yr^{-1}), R = food preparation loss factor, F = water treatment loss factor and CF_s and CF = shellfish and fish concentration factors, respectively.

Approaches such as this are becoming more important with time given the recent identification of higher than anticipated natural levels or radioactivity in stream waters and ultimately drinking waters (for example, Cowart, 1980; Hathway and MacFarlane, 1980; Asikainen, 1981).

V. Chemical reactions, activities and rates

1. Chemical reactions

The chemical composition of natural water systems is fundamentally controlled by two types of chemical reactions (Hem, 1970). The first includes those reactions likely to occur in waters at the earth's surface and that commonly lead to a condition of chemical equilibrium. The second type involves those reactions or processes that do not lead readily to equilibrium states owing to some barrier, such as an extremely slow reaction rate.

Water quality is ultimately affected by these reactions in many and complicated ways. The first type of reaction is essentially one of reversible reactions. These latter can be divided into three subtypes (Hem, 1970):

1. Reversible solution and deposition reactions in which the water is not chemically changed. Included among such reactions are:
 (a) dissolutions of crystalline material:

 $$KCl(s) \rightarrow K^+ + Cl^-$$

 (b) reactions involving various aqueous species or complexes:

 $$Mg^{2+} + SO_4^{2-} \rightarrow MgSO_4(aq)$$

2. Those reversible solution and deposition reactions in which water is broken down into its constituent units of H^+ and OH^-. These are

essentially the many types of hydrolysis and dissociation reactions that occur in water of all types such as:

$$Na_2CO_3(s) + H_2O \rightleftharpoons 2Na^+ + HCO_3^- + OH^-$$

3. Ionic reactions involving changes in oxidation state and reversible solution–deposition reactions. An example is:

$$Mn^{4+} + 2e \rightleftharpoons Mn^{2+}$$

As noted, these examples involve reversible reactions that normally lead to equilibrium conditions in water systems.

The second common type is represented by those reactions that are affected by slow reaction rates, require energy input, or require the involvement of organisms in some steps leading to completion.

The chemical composition or water quality of a water system at a given time is the end product of all the reactions to which the water has been exposed in the hydrologic cycle. Solution and dissolution are continuous processes that go on as long as water is in contact with soluble substances or until complete equilibrium is reached—none of which is ever completely attained. As a consequence, the chemical composition of water (water quality) is in continuous chemical transition. Water quality then depends, for practical purposes, on the content of dissolved substances; consequently, it is essential that those concerned with water quality have a basic understanding of simple chemical equilibrium and the reaction velocities involved in aqueous solutions.

2. Chemical activities

A chemical reaction can be generalized as follows:

$$aA + bB \rightleftharpoons xX + yY \tag{6.6}$$

where A, B are reactants and X, Y are products in the equilibrium equation. At equilibrium, the reaction velocities are equal and the law of mass action applies:

$$\frac{[X]^x[Y]^y}{[A]^a[B]^b} = K \tag{6.7}$$

where K = equilibrium constant, and items in brackets are effective molar concentrations of reactants and products.

The law of mass action only applied to "effective concentrations" (Hem, 1970, p. 18) or to the "thermodynamic concentration" or activity. Commonly molal concentrations are used for activities in ionic reactions in water.

Activities, which can be measured for some species by ion-specific electrodes, can be determined by multiplying the measured concentration of a given component by the activity coefficient. In many waters of interest the activity coefficient for a given ionic component (for example, Ca^{2+}) can be estimated from the well known Debye–Hückel equation—given as:

$$-\log \alpha_i = \frac{AZ_i^2 \sqrt{I}}{1 + Ba_i \sqrt{I}} \tag{6.8}$$

where α_i = activity coefficient of ion; A and B = constants relating to the solvent (for water at 25°C, these are 0.5085 and 0.3281, respectively); Z_i = valency (charge) of the ion; a_i = constant related to effective diameter of ion in solution; and I = ionic strength of solution, where:

$$I = \sum \frac{M_i Z_i^2}{2} \tag{6.9}$$

the standard equation for ionic strengths, where M_i = concentration of given ion in solution in moles l^{-1}, and Z_i = charge of specific ion.

Care should be taken in using these equations to determine effects of water quality on use. The constants B and A include the dielectric constant of water; consequently, Debye–Hückel theory is applicable to dilute solutions in which the dielectric constant is not changed significantly by ionic concentrations (less than about 0.1 molal). For dilute solutions (essentially all fresh waters) the value of Ba_i can be taken as 1. For very dilute solutions (< 100 mg l^{-1} dissolved solids as $CaCO_3$) the denominator of Eqn (6.8) can be omitted without appreciable error.

In many chemical reactions involving water quality, we are interested in the oxidation or reduction reactions that can effect specific species. Basically, these reactions involve the addition or subtraction of electrons to a given element. The process is shown by the reactions:

$$Mn^{4+} + 2e = Mn^{2+} \quad \text{Reduction}$$

$$Mn^{2+} - 2e = Mn^{4+} \quad \text{Oxidation}$$

when e is an electron.

These reactions are referred to as redox couples or "half reactions". Under standard conditions (25°C, 1 atm), and following activity theory these considerations lead to the concept (at equilibrium) of a standard energy potential (see any basic text on thermodynamics) represented by the symbol E^0.

When the activities of ionic species taking part in chemical reactions are different from unity, the potential measured at equilibrium is called the "redox potential E_h".

The relationships between these parameters and the activities of the reacting ions is expressed by the well known Nernst equation where:

$$E_h = E^0 + \frac{RT}{nF} \ln \frac{[A_o]}{[B_r]} \tag{6.10}$$

where R = gas constant, T = temperature in Kelvin, F = Faraday constant, n = electrons in the balanced redox couple and $[A_o]$ and $[B_r]$ = activities of participating ions in solution when subscripts o and r represent oxidizing and reducing species, respectively.

This equation is commonly given in terms of standard conditions and to base 10 logarithms as:

$$E_h = E^0 + \frac{0.0592}{n} \log \frac{[A_o]}{[B_r]} \tag{6.11}$$

It must be noted that the Nernst equation is applicable only when chemical equilibrium has been attained.

The change in *free-energy* involved in an oxidation–reduction reaction is also related to the standard potential via the equation:

$$\Delta G^0 = nFE^0 \tag{6.12}$$

where ΔG^0 = free energy of formation is given by:

$$\Delta G_R^0 = RT \ln K \tag{6.13}$$

where K is equilibrium constant defined earlier.

Other relationships between the standard thermodynamic functions, standard potentials and half reactions are shown in many texts (including Stumm and Morgan, 1970; Snoeyink and Jenkins, 1980).

Given these equations, tabulations of free energy data, potentials, etc., it is possible to calculate or estimate the ion activities and potentials that can be expected at equilibrium. Application of these principles can usually provide useful information as to those reactions expected in natural systems and hence lead to a better understanding of those reactions occurring in any natural water system. From this point, it is only a short step to predicting reactions to be expected in those systems where water quality is the function of direct interest.

3. Chemical reaction rates, reaction order, effect of T

A basic understanding of the effects of reaction rates on geochemical processes occurring in water systems is necessary before it is possible to describe properly the reactions taking place. Nonetheless, it must be said that the

kinetics of many of the processes occurring in natural water systems are still not predictable or are imperfectly understood. For many of the more complex solution–dissolution reactions occurring between aqueous solutions and rock materials, the reaction rates are extremely slow, such that no equilibrium can or will be reached nor are any means for revising the reactions known. For a detailed explanation one should consult any standard physical chemistry text.

For a general irreversible reaction, where A, B, C, etc., are reactants and S, T, etc., are products we can write:

$$A + B + C \cdots \rightarrow S + T + \cdots$$

The rate law can then be written simply as:

$$\frac{d[A]}{dt} = -k[A]^a[B]^b[C]^c[S]^s[T]^t \cdots$$

where the term on the left is the time rate of change of species A, all concentrations are molar, $-k$ is the reaction rate constant and a, b, c, s, etc. are reaction constants. The negative sign indicates that it is the rate of decrease of A that is being measured or observed.

By observing the decreasing concentration of a given chemical species undergoing reaction it is often possible to plot a species decay curve ("die away" curve of Hem, 1970). Such a curve can be used to ascertain the reaction order.

Knowledge of the reaction order is a useful concept based on the actual number of atoms, ions, etc. whose concentrations determine the rate of the reaction under study. It should be noted that reaction order is not determined by the stoichiometry of the overall reaction, but has to be determined by laboratory experimentation.

Hem (1970) gives a useful formulation of the rate equation as:

$$\frac{-dC_A}{dt} = kC_A^n \tag{6.15}$$

where n is the order of reaction of the equation with respect to the concentration of species A, and k is the rate constant. From this approach it is seen that a first-order reaction is one where the rate is proportional to the first power of the concentration of A, which could be any dissolved species of interest in any water system. If the rate is proportional to the square of the concentration of A, the reaction is second order, and so on. Zero-order reactions are also known: that is a situation in which the reaction rate is constant and independent of dissolved species concentration.

Integrating Eqn (6.15) leads to a common expression for k:

$$k = 1/t \ln (C_{A_0}/C_A) \tag{6.16}$$

where C_{A_0} = concentration at the beginning of the reaction or at time 0; and C_A = concentration of A at some later time.

This equation leads to the concept of half-time or $t_{1/2}$. This is a common rate measure defined as the time required for one half of the concentration of a component present at the beginning of a reaction to be used up.

Many times complex reactions occurring in a water system are themselves of different reaction orders. In such cases it is usual to deal with the beginning reactants and final products, and speak of an "overall" reaction rate which may be approximated as first or second order. In many instances chemical reactions between dissolved species in an aqueous media may proceed via several possible paths. In these instances the most likely reaction path will be the one that occurs with the most rapid rate.

Following any consideration of rate reactions, it is common to inquire of the effect of temperature on geochemical reactions occurring in water systems. Normally, the higher the temperature, the faster the reaction rate.

A useful expression tying together the temperature, the rate constant and other thermodynamic parameters is the well-known Arrhenius equation:

$$k = A \exp(-E/RT_k) \tag{6.17}$$

where k = rate constant, A = frequency factor, E = activation energy needed to cause a reaction, R = universal gas constant and T_k = temperature in Kelvin.

Reference to any standard text on thermodynamics will show the relations between E and the standard thermodynamic functions. The volumes by Stumm and Morgan (1970) and Garrells and Christ (1970) provide a good and detailed review of these principles as applied to natural water systems.

VI. Solubility concepts

In any practical application to natural water systems of the concepts discussed, one must of necessity consider the amount (or concentration) of any given species dissolved in the system. Solubility is usually discussed in terms of chemical equilibrium.

If the constituents taking part in a reaction are present (dispersed) as single ions in solution, then any reactions occurring are homogeneous. If on the other hand, one or more of the constituents are present as a solid or liquid the reaction is called *heterogeneous*. The activities of these constituents are constant through any reaction, as long as any solid or liquid is present. It should be clear that in almost any natural water system, such as a stream or lake, the reactions taking place are likely to be heterogeneous.

For this reason, reported concentrations values for ions dissolved in water

systems commonly are indicative of the total amount of a given species present in the system, including complexes and ion pairs.

Situations *commonly* involving heterogeneous equilibria in natural water systems include:

(i) solid-phase precipitates dissolving in water to produce reactive solutes; a typical example is $CaCO_3$ (solid) dissolving in water to produce Ca^{2+}, HCO_3^- and CO_3^{2-} ions; and

(ii) solids dissolving in solutions containing the same species as those that result from solution of the precipitate. This situation leads to the *common ion* effect where the presence in solution of a common ion strongly affects the solubility of the solid being dissolved.

An example of the former situation is found in Angino *et al.* (1969), where a high reported value for Sr dissolved in a major river system was traced to the presence of a celestite rich stratigraphic unit in the drainage basin of the river. The dissolved Sr in the stream showed a step increase after the river passed over the outcrop of the stratigraphic unit. Strontium concentration then slowly decreased by dilution downstream in the system until the value present above the outcrop was reached. The greater solubility of the celestite contributes to this occurrence. Such situations are quite likely to be much more common in natural water systems than has been documented in the literature.

As the dissolved concentration of a given water system increases other factors come into prominence and cannot be ignored. The level of ion pairing and complexing have a strong influence on the solubility of dissolved species in waters of high ionic strength. As a general rule, the solubility of salts in a solution increases with increasing ionic strength. This effect can be assessed by use of the Debye–Hückel equation noted earlier. Ion activities of interest can also be approximated by a simple technique outlined in Hem (1961). For practical purposes, the influence of these reactions (complexing, ion pairing) can be ignored in waters where the dissolved concentration is less than 1500 mg l^{-1}.

It should also be clear that in many natural water systems (lakes, streams, etc.) the solution can be in equilibrium with more than one solid having a common ion (the common ion effect noted earlier). For these species a combined solubility equation can be written relating the species involved. Hem (1970) gives the following example that is common in many stream or lake systems. At saturation with both calcite ($CaCO_3$) and gypsum ($CaSO_4 \cdot 2H_2O$) the equation is:

$$CaCO_3(s) + H^+ + SO_4^{2-} \rightleftharpoons HCO_3^- + CaSO_4(s) \qquad (6.18)$$

and

$$K_{eq} = \frac{[HCO_3^-]}{[H^+][SO_4^{2-}]}$$

Many other examples could be cited.

It should be obvious that as the concentrations of various ionic species in solution change, their effect on the quality of water intended for different uses also changes.

VII. Reactions at interfaces

The major source of the dissolved load of most natural water systems is the geologic environment present at the land surface—in other words the minerals and rocks of the earth's crust. Many chemical reactions occurring in natural waters take place at those surfaces where water is in contact with both solid and gas phases. These reactions at interfaces fall basically into three categories: gas–liquid, liquid–solid and adsorption–desorption.

1. Gas–liquid interactions

Gases from the atmosphere pass into and dissolve in many water systems at the earth's surface. The concentration of these gases in water can have a decided effect on both the water quality and those reactions occurring in the aqueous system. Oxygen, carbon dioxide and nitrogen have the most influence.

The solution of these gases in an aqueous system is dependent on several physical and chemical parameters. Among the more important are the water temperature and the concentration of gas already present in a given system. Dissolved oxygen concentration is of primary interest, especially as regards water pollution and the basic question of oxygen reaeration rates in any water body. Langbein and Durum (1967) provide an excellent review of the essentials of this issue as related to stream geometry and stream flow rates.

A brief but clear explanation of the carbon dioxide exchange process is given by Stumm and Morgan (1970). The CO_2–H_2O system is important because of the important interaction it has with the carbonate equilibrium system and system pH. An extent discussion of the complete system can be found in Loewenthal and Marais (1976). Other processes occurring in water systems such as photosynthesis, respiration, nitrification, denitrification, etc. all play a part in effecting the concentration of O_2, CO_2 and N_2 in water. Many of these processes are competing and hence rate considerations need to be considered. All, however, play some part in affecting water quality and under some

conditions are the major control on water quality. Many of these reactions are microbiologically controlled.

2. Liquid–solid interactions

Many chemical reactions that occur in natural waters take place at liquid–solid interfaces. The importance of these reactions is obvious if one considers the ubiquity of the dispersed phase in the form of clays, metal oxides, metal carbonates, silica, organic detrital matter and even micro-organisms—living and dead. Many details of the processes occurring at solid–liquid interfaces are not known. These processes, however, obviously affect the rate at which many sediment–water reactions occur—especially in the complex processes related to the chemical weathering of rocks and minerals. In those reactions occurring at the rock–water interface, adsorption–desorption–absorption influences on water chemistry are considerable. Consider three typical weathering reactions: a congruent dissolution; an incongruent one; and a redox reaction (additional examples are given in Table 6.3):

(i) $CaCO_3(s) + 2H_2O \rightleftharpoons Ca^{2+} + HCO_3^- + OH^-$

Problems related to the dissolution of calcite are important in understanding the carbonate equilibrium system and in determining hardness.

(ii) $Al_2Si_2O_5(OH)_4(s) + 5H_2O \rightleftharpoons 2H_4SiO_4 + Al_2O_3 \cdot 3H_2O(s)$

This reaction between kaolinite clay and water to yield gibbsite is important as a typical silicate weathering reaction and as an illustration of a reaction that adds alkalinity to water systems. Kaolinites are themselves a main alteration product of feldspar weathering. Montmorillonites and micas are also potential products of silicate rock weathering.

(iii) $4FeS_2(s) + 14H_2O + 15O_2 \rightleftharpoons 4Fe(OH)_3(s) + 16H^+ + 8SO_4^{2-}$

This is obviously an important weathering reaction in the breakdown of pyrite rich shales, limestones and coals. This reaction, taking place in coal rich regions, contributes directly to the so-called acid mine drainage problem so important in environmental geochemical considerations.

Water chemistry is clearly affected by most weathering reactions. As Bricker and Garrels (1967) have emphasized, the concentration of Ca^{2+}, HCO_3^- and Mg^{2+} in natural water systems may be controlled by dissolution of carbonate

Table 6.3 Example of typical weathering reactions

1. Congruent dissolution reactions

$SiO_2(s) + 2H_2O = H_4SiO_4$
quartz

$Al_2O_3 \cdot 3H_2O(s) + 2H_2O = 2Al(OH)_4^- + 2H^+$
gibbsite

$Ca_5(PO_4)_3(OH)(s) + 3H_2O = 5Ca^{2+} + 3HPO_4^{2-} + 4OH^-$
apatite

2. Incongruent dissolution reactions

$MgCO_3(s) + 2H_2O = HCO_3^- + Mg(OH)_2(s) + H^+$
magnesite brucite

$NaAlSi_3O_8(s) + \frac{11}{2}H_2O = Na^+ + OH^- + 2H_4SiO_4 + \frac{1}{2}Al_2Si_2O_5(OH)_4(s)$
albite kaolinite

$3KAlSi_3O_8(s) + 2H_2CO_3 + 12H_2O$
K-feldspar (orthoclase)

$$= 2K^+ + 2HCO_3^- + 6H_4SiO_4 + KAl_3Si_3O_{10}(OH)_2(s)$$
 mica

$KMg_3AlSi_3O_{10}(OH)_2(s) + 7H_2CO_3 + \frac{1}{2}H_2O$
biotite

$$= K^+ + 3Mg^{2+} + 7HCO_3^- + 2H_4SiO_4 + \frac{1}{2}Al_2Si_2O_5(OH)_4(s)$$
 kaolinite

$KAlSi_3O_8(s) + Na^+ = K^+ + NaAlSi_3O_8(s)$
orthoclase albite

$CaMg(CO_3)_2(s) + Ca^{2+} = Mg^{2+} + 2CaCO_3(s)$
dolomite calcite

3. Redox reactions

$3Fe_2O_3(s) + H_2O + 2e = 2Fe_3O_4(s) + 2OH^-$
haematite magnetite

$PbS(a) + 4Mn_3O_4(s) + 12H_2O = Pb^{2+} + SO_4^{2-} + 12Mn^{2+} + 24OH^-$
galena

rocks. Silicate minerals (clays, olivene, pyroxene, etc.) are the likely source of Na^+, K^+, H_4SiO_4 and even Ca^{2+} and Mg^{2+} in both ground and surface waters.

3. Adsorption–desorption reactions

The finely divided suspended material present in many stream and lake waters have an extremely large surface area, especially those in the colloidal size range. As a result, these particles have a large capacity for physical adsorption and absorption of ionic species in natural water systems. In such systems chemical bonding is most common and hence this type or reaction is commonly called "chemisorption". The exchange process between ions

already attached to the adsorbing layer and those in the water system is called "ion exchange".

In natural water systems negative changes exceed the positive ones on the absorbing media present, and consequently positively charged ions (cations) are attracted more readily than negatively charged ones (anion exchange). The order of attraction is $X^{3+} > Y^{2+} > Z^+$, where X, Y and Z are dissolved ionic species. Adsorption capacities in any medium are also affected by the ionic radii and hydration degree of an ion in addition to the charge on the ions. Adsorption effects can be evaluated by either the Freundlich or Langmuir isotherm equations. The former is given by:

$$\frac{X}{m} = kc^n \tag{6.19}$$

where X/m = weight of absorbed ions per weight of adsorbent; c = concentration of adsorbate remaining in solution; and k, n = constants. The Langmuir isotherm is expressed by the relation:

$$\frac{X}{m} = \frac{kec}{1 + kc} \tag{6.20}$$

where e = total exchange capacity of weight m of adsorbent. The other notation is the same as in the Freundlich isotherm.

Excellent reviews of ion-exchange reactions and appropriate theory of interest in environmental geochemistry are presented by Robinson (1962) and in Stumm and Morgan (1970).

VIII. Other factors influencing water quality

1. Influence of clays

Clays in the colloidal size range in water have an effect on water quality out of all proportion to their concentration. Of the common clays—montmorillonite, illite and kaolinite—montmorillonite has the greatest exchange capacity. The effect of these exchange reactions on the concentration of both organic and inorganic contaminants cannot be overestimated.

For some of the reactions, the process is irreversible, for others it is reversible. This applies to gases as well as liquids. The reactions are temperature, pH and concentration dependent.

It should be emphasized in this regard that the largest proportion of the dissolved trace element content in natural water systems is usually tied up by the suspended load in the water bodies the largest part of which are usually clays. The trace metals are tied up primarily in two forms—as weathered solids of precipitates or adsorbed on the surfaces of particulate material—such as

organic debris or clays. Many metals are also present in water as hydroxo- (Angino *et al.*, 1971), carbonato- (Long and Angino, 1977) and sulphato- complexes. These complexes tend to be adsorbed more strongly at clay surfaces than do free metal ions.

2. Environmental influences

It is through the processes and principles discussed to this point that the chemical composition of natural water systems is determined. It is the interaction of these processes with the geologic and man-made environment that produces and determines the chemistry of natural water systems.

3. Climate and geological effects

One of the greatest controls on the geochemistry of natural water systems is that of climate. It affects the chemical and physical processes acting to control rock weathering both of which in turn lead to controls of the pH, oxygen content, redox potential, etc., of the water environment.

Weathering also involves the breakdown of natural and man-made materials by mechanical processes such as freezing, expansion due to temperature changes, volumetric changes of minerals due to hydration, etc. These effects are not discussed here.

Climate, on the other hand, through temperature and precipitation controlled reactions, affects the formation of soils, the development of specific plant communities, controls the rate of rock decay and determines the chemical composition of water draining a given area.

The process of chemical weathering is an attempt to attain equilibrium in a system composed of air, rocks and water. Studies of these reactions in a natural system are hindered because many of them are sluggish, hard to define, incomplete and many times irreversible. Their effects on water quality, however, are real.

Some of the components present in water are more affected than others. Streams in the polar regions, for example, tend to be more acidic than those in the tropics. More CO_2 can dissolve in colder water than warm which leads to the greater acidity of polar or subpolar streams. Carbon dioxide (CO_2) affects reactions by forming carbonic acid in water solution. *All* natural waters including ground water, if exposed to air at any time, are dilute solutions of H_2CO_3. This slight acidity—down to a pH of 5.5 in many instances—makes the water a natural solvent. Streams draining areas of profuse vegetation (i.e., highly wooded) are coloured brown or yellow at certain seasons, reflecting a higher tannic acid content derived from large-scale plant decay. This is

especially noticeable in the fall season in areas of deciduous forests. No doubt complexing of the metals moving in the solution with tannic acid are influenced by this phenomenon.

Streams flowing in tropical rain forest areas tend to be very low in dissolved solids content, whereas those draining a desert or evaporitic environment usually carry a considerably higher load of dissolved solids. In both instances the amount of oxygen present in the water has a great effect on the dissolution characteristics of the geologic materials of various origin encountered along the flow path; these materials include compounds such as silicates, carbonates, sulphates and chlorides. The presence of water speeds up all reactions with oxygen, particularly where ionic species are concerned. Water may in many instances, enter the reactions in the case of hydrates. Knowledge of reaeration rates in streams and within bodies of water have been of considerable interest for a long time (see Langbein and Durum, 1967).

Seasonal variations in climate as well as the chemical reactions resulting from the processes mentioned earlier have a measurable and observable effect on the natural water chemistry of oceans, streams, lakes and ground waters. In brief, as Hem (1970, p. 41) has stated "the influence of climate on water quality may thus be displayed not only in amounts and kinds of solute ions, but also in the annual regime of water quality fluctuation".

In many instances the acids of nitrogen, namely, HNO_3 and HNO_2 likely play a minor role in effecting the reactions occurring in natural waters. The origin of these acids most likely is in the decay of organic materials and in the bacterial action taking place in soils (nitrification and denitrification). The exact influence of these acids in determining low pH values is uncertain. In areas of heavy agricultural use of fertilizers, however, the influence of nitrogen compounds on soil and water acidity must be of some concern. Much more work on the environmental geochemistry of nitrogenous compounds is required.

Of much greater concern to water quality and environmental geochemical studies are the effects of sulphuric (H_2SO_4) acid and its sister acid H_2SO_3. The reactions and effects of these acids are particularly noticeable in waters draining areas of volcanic rock and the oxidized zones of sulphide ore deposits, such as ZnS (sphalerite), PbS (galena) and especially FeS_2 (pyrite).

Knowledge of those reactions affecting pyrite is of extreme importance in any study of water quality because of the controlling influence it has on the generation of sulphuric acid, whose presence leads to problems of acid mine drainage ("red water") in areas of coal production and sulphide ore production.

Detailed knowledge of the oxidation chemistry of pyrite (FeS_2) in nature is extremely important in environmental geochemistry. The acid waters gene-rated are particularly strong because of formation of the very insoluble ferric

oxide. This reaction can be given as:

$$4FeS_2 + 15O_2 + 8H_2O \rightarrow 2Fe_2O_3 + 8SO_4^{2-} + 16H^+ \qquad (6.21)$$

Note the simultaneous production of H^+ and the insoluble iron mineral, limonite (Fe_2O_3), a yellow-brown iron oxide which commonly stains the landscape in areas where this reaction is common (for example, vicinity of abandoned coal strips).

Many dissolved ions in solution are the result of chemical weathering of rocks at or in the vicinity of the land surface. Some of the more common rocks are the silicates. As is widely known, silicate weathering occurs primarily by hydrolysis reactions. Most silicate reactions are slow and essentially irreversible. Where aluminum silicates (such as common feldspars) are involved, clay minerals are typically products of the reaction.

These reactions can be typified by the following simplified reaction:

$$4KAlSi_3O_8 + 22H_2O \rightarrow 4K^+ + 4OH^- + Al_4Si_4O_{10}(OH)_8 + 8H_4SiO_4$$

K-feldspar Kaolinite clay (6.22)

which at normal atmospheric temperatures and pressures is a very slow process. The exact steps in this hydrolysis reaction are still not completely understood.

The importance of silicate reactions occurring in natural water systems and their effect on water quality cannot be overestimated. As Krauskopf (1979) emphasizes: "any solution in contact with silicate minerals cannot long remain appreciably acid, and if contact is continued, the solution must eventually become alkaline". Since most soils materials and that in suspension in most natural water systems consists of silicate, minerals their control and effect on water quality is obvious.

4. Biological effects

Chemical processes associated with biologically induced reactions via the life forms (primarily microscopic) present in water systems, clearly affect the chemistry and water quality of a given water system. Extensive discussions can be found in many texts (Camp, 1963; McCarty and Sawyer, 1967) of the effects of man-made pollution on water quality. These aspects will not be discussed here.

What is of concern is to highlight the importance of knowledge of biological factors in understanding the chemistry of natural water systems. Clearly the chemistry of water or its water quality has to be affected by the life processes of the animals and plants residing in it. Hem (1970) has classified the life processes of principal interest in water chemistry into four simple categories:

(i) Processes using energy captured from the sun or some other source to promote chemical reactions requiring a net energy input. An example is photosynthesis—a process by which O_2 is added to a water system and CO_2 is depleted.

(ii) Processes redistributing chemically stored or available energy. Metabolism and decay reactions are examples. The latter affects the O_2 and CO_2 content in water systems.

(iii) Processes that convert chemically stored energy to other forms of energy. Reactions promoting oxidation–reduction are examples.

(iv) Processes without significant energy transfer. Among examples here would be the interaction between soluble organic compounds in water and their effect on colloids. These could be adsorption–desorption reactions on colloidal organic debris or the formation of organo-metallic compounds in natural water systems.

Although it may be argued that in groundwater aquifers little if any effect of these processes is evident, it should be clear that all water comes under the influence of these processes at some point in the hydrologic cycle.

5. Microbiological effects

Life forms of many kinds are present in most natural water systems; consequently, biochemically controlled chemical processes associated with living forms have a direct influence on the water in which they reside and on the dissolved components of the water. These reactions range from those controlling nitrification and denitrification and therefore the nitrogen content of the water to those bacteria affecting iron (*Leptothrix*) and sulphate rich (*Thiobacillus*) waters.

Two typical and common reactions carried out by bacteria illustrate this point:

(i) $H_2S + O_2 \rightleftharpoons H_2SO_4$ + energy (*Thiobacillus*)
(ii) $Fe^{2+} \rightleftharpoons Fe^{3+} + e^-$ (*Ferrobacillus ferroxidans*)

Many microorganisms are able to affect the oxygenation of ferrous iron as well as other metal ions. Many of these processes of concern in fresh water systems are discussed in Hutchinson's (1957) classic treatise on limnology.

The overall influence of algae as well should not be overlooked. Their relation to dissolved oxygen content in rivers, lakes and estuaries has been clearly demonstrated by many investigators.

Problems of the geochemical effects of nitrate and nitrite in ground water and soils have been discussed by Swoboda (1977). DeMarco and others (1969) discuss in considerable detail the influence of environmental factors on the

nitrogen cycle in water. Many nutrient element (N, P) reactions occurring in natural waters are microbially controlled.

Examples of some oxidation–reduction reactions in simplified form are:

(i) $NH_4^+ + 3H_2O \rightarrow NO_3^- + 10H^+ + e^-$ (oxidation)

(ii) $NO_3^- + 6H^+ + e^- \rightarrow 0.5N + 3H_2O$ (reduction)

In ways too numerous to list it should be clear that biochemical reactions influenced or controlled by the life processes of plants and animals occurring in natural water systems impact upon and have some control over the geochemical reactions acting to influence water quality—be it drinking water, water pollution problems, industrial use of water, irrigation or many others. The study of the geochemistry and water quality of natural water systems cannot be conducted without also considering the influence of the ecological processes involved as well.

6. Sources of solutes

Most of the water present on the earth's surface has passed through the atmosphere at some time in its history. This water, before it becomes part of any "pool" (lakes, streams, groundwater) has therefore been influenced by its passage through the atmosphere to the extent that we must consider atmospheric contributions to the water chemistry. The major gases present in atmospheric precipitation are CO_2, O_2 and N_2. Other gases that may be present depending on local conditions (volcanic eruptions, pollution, etc.) include NH_3, HF, SO_2, HCl, H_2O). Of considerable concern is the dust fraction or component. Its effect on water quality has not been adequately evaluated yet although its effects are likely to be considerable.

Data on the major element chemistry of precipitation is extensive. Some typical concentration values are given in Table 6.4 (taken from Hem, 1970). Trace element values are less common; Table 6.5 gives typical amounts of Ag in snow and rain in the United States.

These components when added to by weathering reactions and man-made and natural pollution in streams all affect the general geochemistry of water and hence the water quality of the natural water systems. All water of interest is in essentially constant movement whether it is through soils, sediments, streams (suspended load) or the unconsolidated sediments (groundwater). In all steps along the path to the ocean, solution, precipitation, ion-exchange, absorption and other processes and reactions are at work at all times so that the geochemistry of any water system is in a constant state of change—from slow rates of chemical change present in ground waters to rapid rates induced by man-made effects of serious pollution, from industrial wastes, sewage

Table 6.4 Composition (mg l^{-1}) of rain and snow (from Hem, 1970, p. 50)

Constituent	1	2	3	4	5
SiO$_2$	0.0	—	1.2	0.3	—
Al	0.01	—	—	—	—
Fe	0.00	—	—	—	—
Ca	0.0	0.65	1.2	0.8	1.41
Mg	0.2	0.14	0.7	1.2	—
Na	0.6	0.56	0.0	9.4	0.42
K	0.6	0.11	0.0	0.0	—
NH$_4$	0.0	—	—	—	—
HCO$_3$	3	—	7	4	—
SO$_4$	1.6	2.18	0.7	7.6	2.14
Cl	0.2	0.57	0.8	17	0.22
NO$_2$	0.02	—	0.00	0.02	—
NO$_3$	0.1	0.62	0.2	0.0	—
Total dissolved solids	4.8	—	8.2	38	—
pH	5.6	—	6.4	5.5	—

[1] Snow, Spooner Summit, US Highway 50, Nevada (east of Lake Tahoe), alt. 7100' (Feth *et al.*, 1964).
[2] Average composition of rain August 1962 to July 1963 at 27 points in North Carolina and Virginia (Gambell and Fisher, 1966).
[3] Rain, Menlo Park, Calif., 7:00 pm Jan. 9 to 8:00 am Jan. 10, 1958 (Whitehead and Feth, 1964).
[4] Rain, Menlo Park, Calif., 8:00 am to 2:00 pm Jan. 10, 1958 (Whitehead and Feth, 1964).
[5] Average for inland sampling stations in the United States for 1 year. Data from Junge and Werby (1958).

Table 6.5 Representative Ag concentrations in rainwater and snow (from Bickford *et al.*, 1978)

Location	Date	Ag conc. (g g^{-1})
Southwest Montana	2/71–7/71	0.1–0.9 × 10^{-10} (snow)
Eastern Sierra Nevada	1966–1969	0.04 × 10^{-10} av. (snow)
Lake Erie, New York State	1968–1969	0.21 × 10^{-10} av. (snow)
Climax, Colorado	1966–1969	0.4 × 10^{-10} av. (snow)
Quillayute, Washington	12/68	0.1–10 × 10^{-10} (rain)
Nebraska-South Dakota	4/70	0.05–0.5 × 10^{-10} (rain)
Coral Gables, Florida	6/72–10/73	0.5 × 10^{-10} av. (rain)
Seawater		15.0–29.0 × 10^{-10}

effluent, etc. The study of the chemical effects caused by man and affecting water pollution has come to be included by some workers in their studies of environmental geochemistry. These effects are pervasive and take many forms. All, however, have a major influence on the geochemistry of the system by way

of many of the processes briefly discussed earlier. These processes in turn control the water quality of a system. In summary, man-made influence on water chemistry extends from the accidental (pollution) to the deliberate (water treatment).

7. Influence of man

Man's ability to affect, change and alter his surroundings is impressive. We do not always appreciate the subtle balances existent in natural systems—including water systems. By the very nature of his presence, man pollutes the environment and has been doing so since he appeared on this planet. These changes or effects are broadly and loosely referred to as pollution—although the term does not mean the same thing to different people. For this discussion the definition of Hem (1970) is preferred: "pollution is not exactly definable but ... restrict it to adverse effects on natural water quality that are definitely man-produced".

Pollutions occurs under many guises:

(i) as direct input such as run-off from excessive fertilization, accidental industrial waste spills of toxic materials and even direct input of raw untreated sewage; and

(ii) as indirect or subtle inputs such as those of excess nitrates and phosphates resulting from algal blooms and eutrophication in ponds and lakes. All these components undergo chemical reaction in the natural water system such that they have a strong, sometimes controlling, effect on the aqueous concentrations of nitrates, phosphates, carbon dioxide, oxygen, ammonia and many trace elements. In many instances where insufficient oxygen is present, production of methane, ammonia and even hydrogen sulphide occurs.

Another source of contamination affecting the chemistry of natural water systems is effluent from improperly buried wastes, both organic and inorganic. These wastes have in many cases rendered unusable the groundwaters with which they have come in contact. Trace metals in groundwater for example may derive from either a natural source or be the result of man's activities.

For many dissolved species for which detailed knowledge of the geochemical cycle is known, the problem may not be severe. Natural processes, for example oxygenation, in streams are capable of handling some of the organic and inorganic waste inputs to streams. For some of the common ionic species, dispersal into the environment is possible (for example, Cl, Na, K, Ca, Mg) with little deleterious effects, providing their concentrations are maintained at low enough levels.

In all instances, the possible reactions these components may undergo by means of the processes discussed earlier need careful assessment before their release into the water system. This statement should not be taken in any way as one that condones pollution. It is intended, however, to put into context and emphasize the fact that natural processes operable in natural water systems can in many instances be used as an aid in controlling the water quality of different water bodies.

Other solutes, including the more toxic trace elements (for example, Hg, Cd and Pb), when acted upon by the processes discussed previously, can accumulate and become concentrated by biota present in the system or on suspended or bottom sediments. They then can be transported long distances and if desorption reactions occur, they may reappear in surprising places. A good example for Hg in an Ohio lake has been given by Armstrong and Hamilton (1973).

Other controls on the concentration of many trace elements in transit include the presence of fulvic acid, humic acid, large suspended loads and organic detritus. Many articles have been published over the years describing the results of both laboratory and stream studies on these processes. Examples for fulvic acid are given by Gamble and Schnitzer (1973) and for coagulation processes and humic acids by Sholkovitz and Copland (1981).

There are other geochemical controls on water quality, including those exerted by the presence of chemical complexes and ion pairs on the concentrations of many element species, and especially trace elements in water systems. Metal complexing is discussed in detail by Stumm and Morgan (1970) and Lerman and Childs (1973).

IX. Drinking water quality

The importance of a knowledge of the geochemistry of drinking water and its relation to water quality and hence health cannot be overestimated. Water along with food are universal essentials. The efforts exerted just to understand one aspect of this problem—that of the proposed relationship between cardiovascular diseases and water hardnesses—are considerable. The existence of a water factor has been argued for years (see Chap. 10). Surprisingly no direct relation has been unequivocally established, but the interest has been so high that three independent studies were commissioned within a short time period of 1977–1980. Essentially, the conclusions are similar—water chemistry may play a small part in cardiovascular mortality but the exact causal agent (Mg is implicated) is still unidentified (see Angino, 1979; Marier et al., 1979; and Pocock et al., 1980).

1. Effects of treatment on water

All water treatment processes, such as chlorination, pH adjustment and softening, change the chemical composition of water (Durfor and Becker, 1964). The prevalent Na^+, K^+ and Cl^- ions are not removed in conventional water treatment, but the CO_3^{2-}, HCO_3^- and SO_4^{2-} ions are removed by precipitation in some water-softening processes. Obvious changes in water chemistry include a lowering of the Ca and Mg concentrations to obtain soft water and a raising of the F level for dental prophylaxis. Other changes are, in many ways, less dramatic but of equal significance. The levels of Fe and Mn in drinking water are usually monitored and often lowered, for reasons of taste, from those normally present in the raw water. Though affecting Fe and Mn, and in some instances Cu and Zn, routine water treatment processes, such as chlorination, do little or nothing to remove As, Ba, Cd, hexavalent Cr, cyanide, Pb, phenols, Se and Ag from drinking water, even though drinking water standards (maximum permissible concentrations) have been established for many of these contaminants. This discussion does not consider bacteriological changes. The concentrations of many other constituents, especially those present in trace amounts (10 ppm or less), are not changed to any significant degree. Some of the major changes that occur in water during lime treatment, lime–soda treatment and cation-exchange processes are discussed in Durfor and Becker (1964).

Treatment of water with lime $[Ca(OH)_2]$ (softening) removes what is called carbonate hardness (Clark *et al.*, 1971). Calcium and bicarbonate are removed about equally from water by lime treatment, if the water hardness is primarily caused by Ca. The resulting $CaCO_3$ precipitation also removes minor amounts of Mg. If most of the carbonate hardness is caused by Mg (which is uncommon), additional lime will increase the removal of Mg, as $Mg(OH)_2$, along with the softening precipitate or sludge. Coprecipitation of Fe, Mn, Sr and other trace metals with the Ca and Mg occurs with lime softening. Removal of Ca and Mg by precipitation may be accomplished by the addition of soda ash (Na_2CO_3) by itself. Trace elements present may be removed in these processes but the data are scanty; this is a point of considerable concern to any reviewer of the relation between trace elements, geochemistry, the environment and human health.

In brief, softening of water by the addition of soda ash and lime $[Ca(OH)_2]$—the so-called lime–soda softening process—causes a decrease in the Ca, Mg, Sr, HCO_3 and SO_4 concentration of the water, but it simultaneously increases the Na content, a commonly overlooked side result. An increase in Na content is not beneficial to individuals restricted to a low-salt diet, as is the case for some cardiovascular disorders. In the lime and lime–soda treatment processes, the Cl, NO_3 and F content of the water

remains essentially unchanged, as do the concentrations of many trace components such as As and Se.

During the chlorination process, the soluble Cl remains in the system and increases the Cl content. However, the Cl reacts with the water, releasing O_2, which then acts as a disinfecting agent. It also forms HCl, which lowers the pH of the water. Therefore the chlorination process is in itself an acidification step, which is usually counteracted to reduce corrosion in the distribution lines by the subsequent addition of lime. This latter step increases the water hardness and the Sr content slightly. The use of sodium carbonate will raise the pH without increasing water hardness.

Acids and alkalies are commonly added to water to adjust the pH for one purpose or another. Typical acids used to lower the pH are sulphuric and phosphoric acids. Their use, of course, increases the SO_4 and PO_4 concentrations, respectively. Alkalis used to raise the pH are lime and soda ash; the latter leads to a direct increase in the carbonate content of the water. The soda ash also increases the sodium content.

A coagulation process is used to remove turbidity and suspended solids from drinking water. Two commonly used coagulants, aluminum sulphate and iron sulphate, lower the bicarbonate and carbonate concentration in water, by precipitation of $Al_2(CO_3)_3$ and $FeCO_3$, and increase the sulphate concentration.

Aluminum sulphate is the standard coagulant used in the water treatment process. Addition of this agent causes a decrease in water alkalinity and a simultaneous increase in carbon dioxide. This increase in CO_2 is undesirable, as it lowers the pH of the water, thereby increasing its corrosiveness. Because both aluminum and iron sulphate are acidic in nature, the pH of the water so treated is reduced. However, it is often readjusted upward by the addition of lime. The pH of drinking water is commonly raised before the water is passed into the distribution system as a means of reducing corrosion in the distribution lines.

2. Changes brought about through water distribution

To understand properly the chemical changes that can occur in water in distribution systems, one must understand the problem of corrosion in pipes. Some reliable data on the distribution of pH values and selected elements in drinking water distributed by different piping materials have been provided by Schreiber *et al.* (1976).

In most non-rural areas, water undergoes some treatment before it is consumed, even if it consists of little more than chlorination. Attention paid to natural surface or groundwater composition may be misleading, if we ignore

the changes wrought by treatment on the chemistry of a particular water source.

The chemical form of any element in natural water or water entering a treatment plant affects the efficiency of its removal. For example, stable water soluble complexes of metals with either organic or inorganic liquids can pass through a treatment plant unaffected. Sand filters are generally less effective for metal removal than treatments involving coagulation. Chlorination of water following other treatment will often degrade organic complexes of metals and again alter availability.

As water leaves the plant and enters the distribution system, it is again subject to concentration and species variation through interaction with other water constituents and reactions with the distribution system. Ca and Mg salts associated with water hardness are excellent coprecipitators of divalent ions such as Zn, Cd and Pb and often accumulate on the wall of pipes in the distribution system. Later, use of an operational home water softener will remove essentially all divalent elements present in finished water.

The trace element content of surface water, and hence drinking water, is extremely variable on a seasonal basis (Angino et al., 1969). Some of these elements may be removed by various treatment processes. Fe, Ni, Co, Cd, Pb, Zn and Cu are most likely to be removed under certain conditions, while Li, Se, Mo and As are apt to pass into the delivery system pipes relatively untouched. For the latter components, knowledge of natural concentrations is important. Again it must be stressed, it is possible that the trace element chemistry of the water as it emerges from a tap may bear little relation chemically to the water that went into the delivery system.

3. Effects of storage on treated water

Little detailed research has been done on the effects of allowing water to stand on its chemical composition. However, for the major elements present in drinking water, certain changes are predictable. With a rise in pH to above 8.5 and a rise in temperature, precipitation of $CaCO_3$ can occur; under certain pH and temperature conditions, even gypsum and silica precipitate. This action will cause scavenging of selected trace elements (such as Fe, Mn, Ni, Cd, Zn and Pb) from solution and removal of some of the CO_3, Ca and Mg from the system. Coprecipitation will have little effect on constituents such as As, Se, Mo, Li, NO_3, PO_4 and Cl. Similar precipitation reactions can occur in the distribution system (pipes) itself.

Chemical changes in standing water are clearly affected by whether or not the container is open to the air. If open, an equilibrium will likely be set up between atmospheric CO_2 and O_2 and CO_2 and O_2 in the water. These reactions will have no effect on the Mg, Na, K and Cl content of the water.

As a whole, chemical changes in standing water are not major. These changes are not likely to be detrimental to the water quality or one's health. The hardness and alkalinity of the water will be changed by precipitation of $CaCO_3$, $CaSO_4 \cdot 2H_2O$ and SiO_2. Again, the changes are not likely to be of critical importance to health.

References

American Society for Testing and Materials (ASTM) (1974). "Annual Book of ASTM Standards: Part 31, Water". ASTM, Philadelphia, Pennsylvania.

Angino, E. E. (1979). In "Geochemistry of Water in Relation to Cardiovascular Disease", pp. 3–13. National Academy of Science, Washington, DC.

Angino, E. E., Galle, O. K. and Waugh, T. C. (1969). Water Resourc. Res. 5, 698–705.

Angino, E. E., Hathaway, L. R. and Worman, T. (1971). Adv. Chem. 106, 299–308.

Armstrong, F. A. J. and Hamilton, A. L. (1973). In "Trace Metals and Metal Organic Interactions in Natural Waters" (P. C. Singer, ed.), pp. 131–156. Ann Arbor Science, Ann Arbor, Michigan.

Asikainen, M. (1981). Geochem. Cosmochem. Acta 45, 201–206.

Bickford, M. E., Silka, L. R., Shuster, R. D., Angino, E. E. and Ragsdale, C. R. (1978). Anal. Chem. 50, 469–471.

Bricker, O. P. and Garrels, R. M. (1967). In "Principles and Applications of Water Chemistry" (S. D. Faust and J. V. Hunter, eds), pp. 449–469. John Wiley, New York.

Brown, E., Skougstad, M. W. and Fishman, M. J. (1970). In "Techniques of Water Resources Investigations of US Geological Survey: Book 5". US Government Printing Office, Washington, DC.

Camp, T. R. (1963). "Water and Its Impurities". Reinhold Publishing Co., New York.

Clark, J. W., Viessman, W. and Hammer, M. J. (1971). "Water Supply and Pollution Control". International Textbook Co., Scranton, Pennsylvania.

Cowart, J. B. (1980). "Uranium Isotopes and Ra^{226} Content in the Deep Groundwaters of the Tri-State Region USA". Presented at IUGG Meeting, Paris, France (unpublished MS).

DeMarco, J., Kurbiel, J. and Symons, J. M. (1969). In "Water Quality Behavior in Reservoirs" (compiled by J. M. Symons), pp. 207–228. Public Health Service Publication 1930, US Government Printing Office, Washington, DC.

Durfor, C. N. and Becker, E. (1964). "Public Water Supplies of 100 Largest Cities in the United States". US Geological Survey Water Supply Paper 1812, 364pp. US Government Printing Office, Washington, DC.

Eisenbud, M. (1973). "Environmental Radioactivity", 2nd Edn. Academic Press, New York.

Feth, J. H., Rodgers, S. M. and Roberson, C. E. (1964). "Chemical Composition of Snow in the Northern Sierra Nevada and Other Areas". US Geological Survey Water Supply Paper 1535-J, 39pp. US Government Printing Office, Washington, DC.

Gambell, A. W. and Fisher, D. W. (1966). "Chemical Composition of Rainfall Eastern North Carolina and Southeastern Virginia". US Geological Survey Water Supply Paper 1535-K, 41pp. US Government Printing Office, Washington, DC.

Gamble, D. S. and Schnitzer, M. (1973). In "Trace Metals and Metal Organic Interactions in Natural Waters" (P. C. Singer, ed.), pp. 265–302. Ann Arbor Science, Ann Arbor, Michigan.

Garrels, R. M. and Christ, C. L. (1970). "Solutions, Minerals, and Equilibria". Harper and Row, New York.

Hathaway, L. R. and MacFarlane, P. A. (1980). "Water Quality in the Lower Paleozoic Aquifers of the Tri-State Area", pp. 148–154. Vol. 14. Trace Substances and Environmental Health. University of Missouri Press, Colombia.

Hem, J. D. (1961). "Calculation and Use of Ion Activity". US Geological Survey Water Supply Paper 1535-C, Washington, DC.

Hem, J. D. (1970). "Study and Interpretation of the Chemical Characteristics of Natural Water".

US Geological Survey Water Supply Paper 1473, Washington, DC.

Höll, K. (1972). "Water: Examination, Assessment, Conditioning, Chemistry, Bacteriology, Biology". Walter de Gruyter, Berlin.

Hutchinson, G. E. (1957). "A Treatise on Limnology", Vol. I. John Wiley, New York.

Junge, C. E. and Werby, R. T. (1958). *J. Meteorology* **15**, 417–425.

Krauskopf, K. B. (1979). "Introduction to Geochemistry". McGraw-Hill, New York.

Langbein, W. B. and Durum, W. H. (1967). "The Geration Capacity of Streams". US Geological Survey, Circular 542, Washington, DC.

Lee, H., Peyton, T. O., Steele, R. V. and White, R. K. (1977). "Potential Radioactive Pollutants Resulting from Expanded Energy Programs". EPA 600/7-77-082, Environment Protection Agency, Washington, DC.

Lerman, A. and Childs, C. W. (1973). *In* "Trace Metals and Metal Organic Interactions in Natural Waters" (P. C. Singer, ed.), pp. 201–236. Ann Arbor Science, Ann Arbor, Michigan.

Loewenthal, R. E. and Marais, R. u. R. (1976). "Carbonate Chemistry of Aquatic Systems—Theory and Application". Ann Arbor Science, Ann Arbor, Michigan.

Long, D. T. and Angino, E. E. (1977). *Geochem. Cosmochem. Acta* **41**, 1183–1191.

Marier, J. R., Neri, L. C. and Anderson, T. W. (1979). "Water Hardness, Human Health, and the Importance of Magnesium". National Research Council Canada, No. 17581, Ottawa, Canada.

McCarty, C. N. and Sawyer, P. L. (1967). "Chemistry for Sanitary Engineers", 2nd Edn. McGraw-Hill, New York.

Pocock, S. J., Shaper, A. G., Cook, D. G., Packham, R. F., Lacey, R. F., Powell, P. and Russell, P. F. (1980). The British Regional Heart Study: Geographic Variations in Cardiovascular Mortality and the Role of Water Quality. *Br. Med. J.* **280**, 1243–1249.

Robinson, B. P. (1962). "Ion-Exchange Minerals and Disposal of Radioactive Wastes—A Survey of Literature". US Geological Survey Water Supply Paper 1616, Washington, DC.

Schreiber, G. B., Comstock, G. W. and Helsing, K. J. (1976). "Arterioscleroit Heart Disease Mortality and Water Quality in Washington County, Maryland". Training Center for Public Health Research, Johns Hopkins University, Hagerstown, Maryland (unpublished data).

Sholkovitz, E. R. and Copland, D. (1981). *Geochem. Cosmochem. Acta* **45**, 181–190.

Snoeyink, V. L. and Jenkins, D. (1980). "Water Chemistry". John Wiley, New York.

Stumm, W. and Morgan, J. J. (1970). "Aquatic Chemistry". Wiley-Interscience, New York.

Swoboda, A. R. (1977). "The Control of Nitrate as a Water Pollutant". EPA-600/2-77-158, Environment Protection Agency, Washington, DC.

US Environmental Protection Agency (1974). "Methods for Chemical Analysis of Water and Wastes". EPA-625/6-74-003, Office Technology Transfer, Washington, DC.

Whitehead, H. C. and Feth, J. H. (1964). *J. Geophysical Res.* **69**, 3319—3333.

7

Microbial Mediation of Biogeochemical Cycling of Metals

BETTY H. OLSON

I. Introduction

The interaction of microbes with the formation and alteration of minerals can be traced with certainty to proterozoic, and possibly to Archean times. The earliest interrelationships between metals and micro-organisms were viewed as changes in the redox potential of mineral complexes or their associated free ions in aquatic environments (Bowen, 1966) (Fig. 7.1). Many of these elements are essential to organisms and thus circulate in the biosphere, moving from organisms to environment in a continuous cycle.

Vernadsky (1944) is credited with having first applied the concept of biogeochemistry by integrating the fields of biology, geology and chemistry. From both experimental and theoretical evidence Vernadsky concluded that biogeochemists should study the role of micro-organisms in the dissemination of elements in the biosphere. Biogeochemical cycling thus encompasses dispersion, concentration, new geochemical formulations of elements and the influence of all three factors on the evolution of organisms. Through the delineation of such microbially mediated cycles as N and S, the concept of biogeochemical cycling has become well established.

The basic phenomena that drive many of these cycles are microbial energy and carbon requirements. The major micro-organisms involved in these processes are bacteria, blue-green algae, green algae, fungi and protozoa. The major differences between the cellular structure of these groups is shown in Table 7.1. The characteristics describing the major subdivisions of micro-

APPLIED ENVIRONMENTAL GEOCHEMISTRY
ISBN 0-12-690640-8

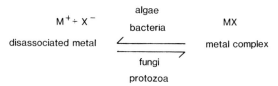

Fig. 7.1 Relationship between metal complexes and micro-organisms in aqueous solution.

organisms are shown in Table 7.2. These groups of micro-organisms are involved in biogeochemical cycles. Thus, autotrophic bacteria are those bacteria using inorganic carbon as a carbon source, whereas heterotrophic bacteria obtain both cellular carbon and energy from preformed organic complexes; the importance of this latter group in mineral cycling has only recently been fully recognized. As can be seen from the information provided in Table 7.2, compounds under consideration are usually part of two reservoirs in the biosphere: the hydrosphere or the lithosphere.

Trudinger *et al.* (1979) delineated three reasons why micro-organisms are important in the cycling of minerals: (i) micro-organisms comprise most of the earth's biomass and have rapid generation times; (ii) micro-organisms occupy the widest diversity of habitats; and (iii) micro-organisms colonized the earth 4–5 times earlier, in time, than higher forms of life.

Thus, the cycling of metals by micro-organisms is hardly a new phenomenon, although our understanding of the subject is continually increasing. Historically, our knowledge of mineral cycling was almost exclusively

Table 7.1 Principal differences between procaryotic and eucaryotic cells

	Procaryotic cell	Eucaryotic cell
Unit of structure	Bacteria, cyanobacteria	Most algae, fungi, protozoa, higher plants and animals
Nuclear membrane	—	+
Mitotic division	—	+
Chromosome number	1(?)	Always greater than one
Cytoplasmic streaming	—	+ or −
Mitochondria	—	+
Chloroplasts	—	+ or −
Contractile locomotor organelles	Bacterial flagella axial filaments + or −	Multistranded flagella or cilia + or −
Amaeboid movement	—	—

Table 7.2 Metabolic and nutrient requirements of selected classes of organisms important in biogeochemical cycling

Class	Carbon source	Energy source	Nitrogen source	Oxygen requirement
Chemoheterotrophs Nitrogen fixing bacteria	Carbon dioxide/ organic compounds	Organic compounds	Nitrogen gas	Aerobic/ anaerobic
Pseudomonas	Organic compounds	Organic compounds	Combined nitrogen	Aerobic
Chemoautotrophs Nitrifiers	Carbon dioxide	Ammonium ion, nitrite	Inorganic nitrogen	Aerobic
Thiobacillus thiooxidans	Carbon dioxide	Iron sulphide	Nitrate	Aerobic
Photoautotrophs Cyanobacteria	Carbon dioxide	Sunlight	Nitrogen gas	Aerobic
Green algae	Carbon dioxide	Sunlight	Combined nitrogen	Aerobic
Photoheterotrophs Purple sulphur bacteria	Organic compounds	Sunlight	Combined nitrogen	Anaerobic
Green sulphur bacteria	Organic compounds	Sunlight	Combined nitrogen	Anaerobic

restricted to metals involved in the mining industry. Microbially enhanced leaching of ores is important, as are the unwanted side effects of mine wastes, such as acid drainage. Although over the course of the last 100 years, many processes involved in microbial biogeochemical cycling have been identified, there remain many questions. As answers to these questions become known, our knowledge of this field will be significantly increased.

Micro-organisms affect the redistribution of metals by oxidation and reduction or by metal binding (Fig. 7.1). Metals may be solubilized by oxidation, as in the case of U, or by reduction as in the case of Fe and Mn. Some metal oxidations, as well as reductions, are microbially mediated. When microbes reduce oxidized metals, part of their respiration may depend on using the metal as a terminal electron acceptor. In some metal oxidations, the metal furnishes the only source of electrons and therefore of energy, for the microbe. Both oxidations and reductions are fundamental in the redistribution of metals (Ehrlich, 1978). Moreover, all micro-organisms require some metal-organic complexes in their biochemistry (Table 7.3).

Table 7.3 Selected metals essential to microbial processes

Metal	Function
Iron	Component of cytochromes
Manganese	Co-factor
Copper	Co-factor for oxidases
Cobalt	Constituent of vitamin B_{12} complexes
Zinc	Co-factor for alkaline phosphatase and alcohol dehydrogenase
Molybdenum	Co-factor for nitrogenase and nitrate reductate

Many metals, essential to biochemical processes, are actively sought in the metabolism of micro-organisms, as shown in Table 7.3. Association between the metal and the organism is established in several ways. In general, metabolically controlled mechanisms or passive ones, such as binding to ligands at the cell surface of diffusion into the cell, accomplish this phase. Once the organism–metal complex is established, the metal may: (i) remain chemically unaltered; (ii) form an active site in an enzyme complex; (iii) alter cell function through binding; or (iv) substitute for essential metals in biosynthetic pathways, forming unusual end products. To date the scientific data available suggest that all four general cases occur in biogeochemical cycling.

In the case of some toxic elements, such as Hg and Cd, evidence is being gathered that shows mechanisms of resistance or detoxification to be genetically based (Chopra, 1971; Summers and Silver, 1972). What is not clearly understood, as yet, is whether these detoxification mechanisms are specific for a given metal or are more broadly based on applicable to other elements.

Studies of metal resistance during the last decade have identified an association between metal resistance and drug resistance in bacteria. There is a large body of literature that indicates drug-associated metal resistance to be a global phenomenon extending to all environments thus far studied. The scientific basis for this association and its effect, if any, on biogeochemical cycling has not been addressed and remains another part of the puzzle to be supplied from results of future studies.

The concept of biogeochemical cycles was expanded dramatically during the 1970s. The finding that Hg could be biologically methylated to a volatile and highly toxic form (Jensen and Jernelov, 1969) renewed interest in metal cycles and their biological mediation. During this period of intense research, information concerning volatile metal complexes became widely known, and it became clear that changes in valence were no longer adequate for accurate description of the role of micro-organisms in biogeochemical cycles.

II. Mechanisms of bacterial–metal interactions

The binding of metals to micro-organisms can be divided into two types: (a) metabolically-mediated, intracellular uptake mechanisms and (b) non-specific binding of metal to surface slime layers, or extracellular matrices of the cell. The non-specific binding of metal to the cell surface or cellular products will occur with non-viable organisms, whereas only viable microbes carry out metabolic uptake processes. Many of these processes are specific for a given element in a complex, but other elements, similar in chemical properties or ionic structure, can be substituted for the mechanistically specified ones.

1. Metabolically mediated mechanisms

(a) *Divalent cation transport*

Divalent cation transport systems have been shown to be important in trans-location of metals, a phenomenon characteristic of several bacterial genera. The mechanism for Ni uptake by *Alcaligenes eutrophus* during chemotrophic growth appears to be a temperature and energy dependent process, with only slight inhibition of Ni^{2+} uptake by Zn^{2+}, Co^{2+}, Mn^{2+} or Cu^{2+} (Tabillon and Kaltwasser, 1977). Highly specific energy dependent and temperature dependent transport systems for Mn have been reported for *Bacillus subtilis*, *Rhizobium capsulata* and *Escherichia coli* (Silver and Jasper, 1977). In *E. coli*, a Mn^{2+} specific mechanism has also been shown. Silver *et al.* (1972) demonstrated that the high affinity Mn^{2+} uptake system was important only when external Mn concentrations were less than 2.2 mg $Mn^{2+} l^{-1}$. Above this concentration, Mn^{2+} uptake preceded via a less specific Mn^{2+} transport system.

Evidence exists that less specific cation transport systems may also be important in mobilizing metals from the environment into a bacterial cell. The uptake mechanisms for Mn in Gram-positive bacteria are different from those operating for transition metals in Gram-negative bacteria, such as *E. coli*. For example, transport of Mn^{2+}, Ni^{2+}, Co^{2+} and perhaps Zn^{2+}, results in cellular accumulation of these elements by the Mg^{2+} transport system in *E. coli* (Jasper and Silver, 1977). Webb (1970) concluded that the same transport systems for Ni^{+2}, Co^{+2} and Zn^{+2} were present in *E. coli*, *Enterobacter aerogenes* and *Bacillus megaterium*.

Metals can replace Mg in several enzyme and co-enzyme systems involving phosphate transfer. The metals thus far identified in this process are Mn, Zn, Cd, Co and Ni (Abelson and Aldous, 1950). In the Gram-positive bacterium, *B. subtilis* metal transport of divalent forms of Co, Mn and Ni occurs via formation of a citrate divalent cation complex. This citrate-inducible energy

dependent system involves primarily Mg uptake into the cell (Willecke et al., 1973).

Divalent cation transport systems for micro-organisms, other than bacteria, are less well understood. In the filamentous fungus, Neocosmospora vasinfecta, Zn^{2+} uptake is inhibited by Mg^{2+}, except at high Zn^{2+} concentrations. Further, competitive inhibition appears to operate between Mg^{2+} and Zn^{2+}. Some inhibition was noted for the uptake of the divalent cation of Zn by divalent forms of Co, Ni and Cu (Paton and Budd, 1972). Saccharomyces cerevisiae possesses a Mg transport system for which Co^{2+}, Ni^{2+}, Mg^{2+} and Zn^{2+} are competitive substrates (Fuhrmann and Rothstein, 1968). Divalent Co uptake by S. cerevisiae is inhibited most strongly by cations with similar ionic radii. Furthermore, uptake decreased across the series Zn > Ni > Mg > Mn > Cd > Ca (Norris and Kelly, 1977).

Similarly, cation radius size appears to influence the extent of inhibition of Cd^{2+} uptake by other cations in S. cerevisiae (Norris and Kelly, 1977) and of Ca^{2+} uptake in Schizosaccharomyces pombe (Bewley et al., 1977). However, this pattern cannot be generalized to all combinations of metal cations or to all yeasts. For example, Norris and Kelly (1977) have shown Co uptake in S. cerevisiae was most strongly inhibited by Zn, but the rate of Ni uptake in the same strain and by another strain of the same species was only slightly inhibited by Zn. Therefore similar uptake rates from solution of Ni, Co and Zn, all of similar ionic radii, in the absence of other cations (Norris and Kelly, 1979) indicate chemical specificity mechanisms dependent on characteristics of the element other than ionic radius.

(b) Monovalent cation transport

The observation that there is high intracellular concentration of K in micro-organisms has encouraged study on monovalent cation uptake. Four kinetically and genetically distinct K transport systems are reported for E. coli (Rhoads et al., 1976). The affinity series for monovalent cation uptake by S. cerevisiae have been given as K^+, Rb^+, Cs^+, Na^+ and Li^+ (Armstrong and Rothstein, 1964). The characteristic uptake of Tl, a toxic heavy metal, which may be present in the effluents of certain mining processes, suggests that it should be included close to K in the affinity series (Norris et al., 1976).

(c) Anionic transport

Anionic complexes occur in aquatic environments and may be important in metal transport into micro-organisms. The most completely described anion transport system involves sulphate permease. Energy dependent uptake of chromate (CrO_4^{2-}) has been described in the fungus, Neurospora crassa.

Binding and transport of sulphate by *Salmonella typhimurium*, a Gram-negative bacteria rod, was inhibited by anions structurally similar to the tetrahedral sulphate ion with an inhibition sequence as follows: CrO_4^{2-} > SeO_4^{2-} > MoO_4^{2-} > WO_4^{2-} > VO_4^{2-} (Pardee *et al.*, 1966). Springer and Huber (1973) reported anion transport was mediated in *E. coli* in diffusion rather than an active uptake mechanism. Selenate resistant cells did not incorporate Se as readily into cell proteins and produced a sulphate permease that was resistant to selenate inhibition. Selenium granules have been observed in the cytoplasm of *E. coli* and other bacteria (Silverberg *et al.*, 1976).

Arsenate uptake in *Streptococcus faecalis* (Harold and Spitz, 1975) is energy-dependent, requiring ATP and is stimulated by K^+ and other permeate cations. Further, a neutral to basic cytoplasmic pH is important in the uptake of this compound.

2. Undefined metal uptake mechanisms

Cadmium uptake is temperature dependent in *Staphylococcus aureus* (Tynecka *et al.*, 1975), and exclusion from the cell in *S. aureus* and other bacteria is plasmid (extra-chromosomal DNA) mediated. However, Cd is accumulated by an energy-dependent uptake in *S. cerevisiae* (Heldwein *et al.*, 1977; Norris and Kelly, 1977), although the mechanism of uptake at this time is unknown. Two hypotheses have been suggested by Norris and Kelly. One is based upon the ability of Cd to form complexes similar to Zn, and the other is based on the similar ionic radii of Ca and Cd. Either process enables the cation to substitute for other ions in transport systems. Lead, on the other hand, can reach similar cellular concentrations as Co and Cd in *S. cerevisiae* but does not require an energy source (Heldwein *et al.*, 1977).

Cadmium, Pb, Ag, Hg and several other heavy metals have been shown to affect yeast cell membrane permeability. Changes in permeability can result in loss of either K^+ or Mg^{2+} and entry of given metals. Thus, loss in membrane permeability, rather than active cation transport can explain the intracellular metal concentrations observed to occur in several species.

3. Non-energy-dependent mechanisms

(a) *Cation adsorption of metals to microbial surfaces*

Metal cations readily adsorb to negatively charged sites at the surface of micro-organisms. This process is rapid, reversible and independent of temperature and energy metabolism. Anionic ligands at the cell surface responsible for cation adsorption include phosphoryl, carboxyl, sulphydryl

and hydroxyl groups of proteins and lipids in the membrane and cell wall components, such as peptiodoglycans and associated polymers. Cation binding behaviour for Gram-positive bacteria has been linked to carboxylic ion exchange resins with an affinity series of $H^+ \gg La^{3+} \gg Cd^{2+} > Ca^{2+} > Mg^{2+} > K^{1+} > Na^{1+}$ (Marquis et al., 1976). The process of binding of metal cations to cell surfaces is competitive action. For example, Norris and Kelly (1979) have shown, in competitive pair testing with *E. coli*, the following metal cation affinity sequence: Zn, Cd > Mg, Co, Ni > Mn, Ca.

However, the process of metal binding to cell surfaces appears to be more complex than relatively non-specific absorption to anionic sites (Kelly et al., 1979), evidenced by the findings of Rothstein and Hayes (1956). These workers showed yeast surface adsorption capacity accounted for only 2% of the total cation content of the organism. Further evidence indicated that *S. cerevisiae* cell walls bound their own weight of Hg^{2+} at high affinity sites, and this metal retention could not be correlated with available wall protein or phosphate binding sites (Murray and Kidby, 1975).

(b) *Metal deposition at the cell surface*

Certain bacteria can immobilize large quantities of metal at the cell surface by forming aggregations of insoluble metal complexes. Beveridge and Murray (1976) found that Fe^{3+} was bound at discrete sites on *B. subtilis* wall fragments. Tornabene and Edwards (1972) reported *Micrococcus luteus* bound 490 $\mu g\ g^{-1}$ Pb at the cell surface. *Zoogloea*, a typical sewage organism that excretes an extracellular polysaccharide matrix, has been shown to be important in the removal of Cu^{2+}, Co^{2+}, Ni^{2+}, Zn^{2+} and Fe^{3+} from wastewater effluents (Friedmann and Dugan, 1967).

Micro-organisms that accumulate Fe have long been known and are characterized as slime-producing or Fe bacteria. Many other organisms, including *Pseudomonas*, *Mycobacterium*, *Escherichia*, *Corynebacterium* and *Caulobacter*, also can become heavily encrusted with Fe, as a result of adsorption of colloidal ferric ion (Macrae and Edwards, 1972). Some strains of *Pseudomonas* and *Moraxella* cause precipitation of Fe after the organic fractions of the soluble organic Fe compounds, such as ferric gallate, have been degraded (Macrae et al., 1973).

Various bacteria, fungi and algae deposit metals on their surfaces (Fig. 7.2 and Fig. 7.3). *Gallionella*, an Fe bacterium, shown in Fig. 7.2, is an example of one organism capable of growing where Fe^{2+} oxidation is the source of energy. The oxidized Fe compounds are deposited along the stalks of the organism. There is little evidence that the deposition of oxidized Fe compounds in the organic sheaths of the *Sphaerotilus/Leptrothrix* group (Fig. 7.3) results directly from metabolism of Fe. Growth and final protein yield of

Fig. 7.2 View of *Gallionella* microcolonies associated with the surface of a galvanized iron pipe. Note typical striated helices of individual *Gallionella* stalks. Bar = 5 µm. (Photo credit: Harry F. Ridgway.)

Sphaerotilus discophorus was found to be independent of the Fe concentration of the medium, but the concentration of Fe present probably determined the amount of Fe deposited. This deposition apparently was mediated by the constituents of the sheaths (Rogers and Anderson, 1976).

Hyphomicrobium is reported to be the predominant organism involved in the deposition of Fe, particularly in freshwater pipelines throughout the world (Tyler, 1970; Trudinger, 1976). *Metallogenium* has been implicated in the formation of Mn ore (Dubinina, 1973). Gregory *et al.* (1980) have found *Metallogenium* to be common in the hypolimnion of an eutrophic lake in the Pacific Northwestern United States. *Leptothrix*, a sheathed bacterium also contains Mn in the sheath material. *Sphaerotilus/Leptothrix* group and

Fig. 7.3 View of *Leptothrix* sheath associated with a biofilm on a concrete raw water aqueduct. The organism has deposited manganese in its sheath. Note the nodular appearance of the sheath. Bar = 0.5 μm. (Photo credit: Alan Kelly.)

Gallionella are representative of the iron bacteria (Cullimore and McCann, 1977). The *Leptothrix* sheath, shown in Fig. 7.3, was recovered from a raw water aqueduct surface slime. Manganese was found to be the major component of the sheath and the source of the Mn appeared to be from the cement lining of the aqueduct.

III. Genetic control of metal transformations in microbial populations

Plasmids have been shown to be significant in the mediation of metal resistance in bacteria. Many bacteria possess extra chromosomal DNA, as well as the chromosome DNA. Those genetic elements that are totally independent of the chromosome are called plasmids, whereas those that can

unite with the chromosome are called episomes. Plasmids are usually referred to by function; for example, resistance to antibiotics is referred to as drug-resistance (R) factors and to metal as metal resistance factors (Meynell, 1972).

S. aureus has been shown to be resistant to Cd, if the Mn transport system will not transport Cd. In sensitive cells of S. aureus, the Mn transport system also transports Cd into the cell. The interrelationship between Cd and Zn has been well demonstrated for plants (see Chap. 8). However, in S. aureus no significant difference between Cd uptake, in relationship to the Zn transport system, was observed between resistant and sensitive strains, suggesting that Cd transport into the cell does not occur via a Zn transport mechanism.

Resistance in S. aureus appears to be genetically controlled because growth in the absence of Cd results in appearance of susceptible cells (Mitra et al., 1975; Weiss et al., 1978). Novick and Roth (1968) demonstrated that plasmid resistance to Cd in S. aureus also conferred resistance to Zn. Furthermore, mutants that became susceptible to Cd simultaneously became sensitive to Zn, suggesting linkage of Cd and Zn resistance on the same plasmid. These workers further demonstrated that the plasmid that controlled penicillin resistance also determined metal resistance to arsenate, arsenite, Pb, Cd, Hg, Bi, Sb and Zn. The patterns of metal resistance appeared to be strain specific, with certain strains being resistant only to Cd, whereas others were resistant only to Bi. Thus, multiple metal resistance may be carried on penicillinase plasmids, but it certainly does not imply that all penicillinase plasmids in S. aureus confer multiple metal resistance.

Chopra (1975) demonstrated that resistance to Cd in the form of cadmium chloride occurred at the membrane level. Protoplasts (cells with the cell wall removed) of resistant cells retained a barrier to Cd uptake. Further, resistance to Cd was observed in the lipid structure of the membrane of resistant cells and no differences could be ascertained in membrane proteins between resistant and sensitive cells (Chopra, 1975).

Williamsmith (1978) demonstrated that resistance to arsenite was, in general, plasmid-borne and occurred with greater frequency in bacteria isolated from animals than from humans. Resistance to arsenite is common among Klebsiella pneumoniae and Salmonella strains, but is less frequently encountered in E. coli, Proteus and Shigella strains, again indicating generic as well as strain differences in metal resistance patterns. Commonly, arsenite resistance in K. pneumoniae is linked with drug resistance, but, in some strains, metal resistance was not associated with R factors nor any other transmissible characteristic.

IV. Heavy metal resistance and antibiotic resistance

Evidence has been gathered showing heavy metal contamination of an ecosystem can result in selective pressure for antibiotic resistant bacteria in

that system. Timoney *et al.* (1978) found that multiple and single metal resistance in *Bacillus* spp. was associated with ampicillin resistance in isolates from a New York Bight sewage sludge disposal site. Since there was a differential occurrence of these traits between the disposal site and the control site, the authors suggested that the genes for Hg resistance and those for beta-lactomase production (ampicillin resistance) were simultaneously selected for in *Bacillus*.

Strain differences to antibiotic and multiple metal resistance patterns were also noted by Pickett and Dean (1976). Strains of *Klebsiella aerogenes* resistant to Cd and Zn also demonstrated multiple antibiotic resistance patterns to chloramphenicol, gentamycin, nalidixic acid and streptomycin. A strain resistant to Cu was found to show antibiotic resistance to chloramphenicol and gentamycin, but was sensitive to streptomycin (Baldry *et al.*, 1977).

Heavy metal tolerant bacteria isolated from surface waters and sediments in Chesapeake Bay and its tributaries also showed multiple resistance to antibiotics suggesting metal-drug resistance linkages. Most of the bacterial strains resistant to Co, Pb, Hg or Cd (defined as $< 50\%$ of the population Hg sensitive) were also resistant to ampicillin and chloramphenicol. The concentration of the metals in the medium was 100 μg g^{-1} for all metals except Hg which was 10 μg g^{-1}. Only three of the sixteen generic isolate groupings were sensitive to Hg. All genera tested were resistant at the 50% level or greater to molybdenum tetroxide. Resistance to metals ranked as follows: Pb $>$ Co $>$ Cd $>$ Cr. Sixty-seven per cent of the isolates that were resistant to Co were also resistant to chloramphenicol, whereas less than 50% of the Co resistant population was resistant to the other antibiotics tested (ampicillin, gentomycin, kantomycin, streptomycin and tetracycline). Antibiotic resistance in Pb resistant organisms was even lower with 10 and 21% of the bacterial strains resistant to ampicillin and chloramphenicol, respectively. For two metal resistant groups chloramphenicol resistance was observed in approximately 30% of the population. Ampicillin resistance was not widely spread among the metal-resistant populations. Antibiotic resistance in relationship to metal resistance for the remaining antibiotics tested was always present in less than 20% of the isolates, and in most instances less than 10% (Allen *et al.*, 1977).

The findings of these workers and many others demonstrate that metal and drug resistance factors are common in the environment, especially in hospital environments, and are genetically linked on plasmids in certain cases (Dyke *et al.*, 1970). The reasons for a drug–metal genetic association from an environmental viewpoint is far less clear. No work to date has demonstrated if these traits are linked by the response of the organism to a set of environmental conditions or, because of a linkage, occur simultaneously.

V. Effects of metals on cycling of carbon and nitrogen

Doelman (1978) has suggested that Gram-negative bacteria may be less sensitive to Pb than coryneform bacteria, and this agrees with the isolation of Gram-negative rods as the dominant groups in Pb polluted anaerobic sediment (Wong *et al.*, 1975). Doelman demonstrated that, in soils amended with $PbCl_2$ at a level of 2000 ppm, the bacterial population shifted from Pb sensitive to Pb resistant. It is important to recall that micro-organisms may also influence the chemical state of a metal in a soil system (Doelman, 1978).

Ernst (1974) concluded that soils polluted with heavy metals would have lower numbers of nitrogen fixing organisms because of a lower water holding capacity of the soil, lack of organic matter and lower nitrogen concentrations. Rother *et al.* (1982) showed that nitrogen fixation was not inhibited in soils which had been historically polluted with high levels of Cd, Pb and Zn from mining activities, which ceased more than a century before. Brierly and Thornton (1979) found similar results for Pb contaminated soils in Derbyshire, England.

Recent work by Olson *et al.* (1982) has shown that the apparent bio-availability of metals to micro-organisms varies depending upon the source of metal input and length of residence in the environment. Certain discrepancies in the literature may be explained by factors, such as metal bioavailability, which are only recently gaining attention.

VI. Metal cycles

Microbial ecosystems can drastically alter the fate of metals in the lithosphere or hydrosphere. Bacteria and fungi can alter the valence state of the metal via methylation, chelation, complexation, absorption, oxidation and reduction. Thus, micro-organisms affect the bioavailability and dispersion of metals in both aquatic and soil ecosystems, ultimately influencing the movement of the metals into and up the food chain. The concentration of the metal available, the types and numbers of micro-organisms present, the period between exposure to the metal and the form in which the metal enters the environment determine its ultimate fate. The presence of other chemicals, such as natural inorganic and organic materials, and physical parameters such as pH, temperature, redox potential, sunlight and texture of the soil or sediment, are also important mediating variables in metal transformation processes (Saxena and Howard, 1977).

Some basic characteristics of elements of interest are shown in Table 7.4. Most likely all elements have the ability to be cycled in the environment, but

Table 7.4 Characteristics of some elements involved in biogeochemical cycles (adapted from Smithells and Brandes, 1976, and Ehrlich, 1978)

Element	Abundance (mg g^{-1})	Formulae	Valence states	Toxicity range for micro-organisms*	Country produced
Arsenic	2.0	FeAsS As$_2$S$_3$ AsS	As^{3-}, As^{2+}–As^{5+}	3.3	Sweden, France, Mexico, UK
Cadmium	0.15	in sphalerite	Cd^{1+}–Cd^{2+}	74–83	USA, Japan, USSR, Germany, Belgium, Canada
Iron	50 000	FeCO$_3$, HFeO$_2$ Fe$_2$O$_3$, FeFe$_2$O$_4$ FeS$_2$ FeTiO$_3$ hydrous iron oxides	Fe^{2+}, Fe^{3+}	26	USSR, USA, France, Australia, Canada, China, Sweden, Brazil, India
Lead	15.0	PbCO$_3$ PbSO$_4$ PbS	Pb^{2+}–Pb^{4+}	0.1–67	USA, USSR, Germany, UK, Japan, Australia
Mercury	0.03	HgS	Hg^{1+}–Hg^{2+}	0.1–7.4	USA, Italy, Spain, Mexico, Canada, USSR, Turkey, Yugoslavia
Selenium	0.09		Se^{2-}, Se^{4+}, Se^{6+}		USA, Canada, Belgium, Germany, Japan, Sweden

* Values may be based on a single organism (Ehrlich, 1978).

the biogeochemical cycles described here have been selected for their industrial importance and health significance as environmental pollutants. Arsenic and Hg are elements with long histories of both health and/or environmental significance. Arsenic has an infamous and well-documented history as a poison. Mercury toxicity has been recorded in some of the earliest medical writings, dating from 746 BC. Both of these elements also have beneficial uses as biocides or in industrial processes.

The occurrence of environmental Hg poisoning in Minimata, Japan, in the late 1950s, caused a sharply renewed interest in this heavy metal. The fact that methylmercury was the causative agent of the Minimata disease supported the theory that inorganic Hg is methylated biologically. Although this was shown not to be the case, the overall effect was salubrious, since a great deal of research on microbial transformation of metals in the environment was initiated. Biogeochemical cycling by micro-organisms, resulting in organo-metallic complexes of Pb and Hg has been described during the last decade. Cadmium, an important metal in industrial processes has only recently been recognized as an environmental pollutant. Cadmium, As and Hg are readily translocated from soils or sediment into the food chain, whereas Pb is less biologically available. Of these elements only Cd and Hg have caused human deaths via translocation into the food chain.

The chemical properties of an element are extremely important in determining its ultimate fate in the environment. Cadmium and Hg are limited in oxidation states, with valences no higher than two and are not regarded as transition elements, being more electropositive and having lower melting points. These elements readily form complexes with ammonia, amines, halides and cyanide, and react with sulphur and phosphorous (Vallee and Ulmer, 1972). Cadmium occurs in smaller concentration in the earth's crust than Hg or Pb. Cadmium contamination in the environment has increased in the last 20 years from anthropogenic activities, whereas the distribution of Hg is divided approximately evenly between industrial activities and natural sources.

Among the Group IV elements, Pb is the most electropositive and has the most stable divalent state. It is moderately chemically reactive and dissolves in several acids. Lead is widely distributed in the environment, and is also readily identified in most plant and animal tissues. Most importantly, the distribution, metabolism and toxicity of Pb appears to be significantly influenced by other elements. Excess amounts of organic As, Pb and Hg compounds and inorganic compounds of As, Pb, Hg and Cd are toxic to micro-organisms (Vallee and Ulmer, 1972).

Lead, Cd and Hg all have a strong affinity for ligands such as phosphate, cysteinyl and histidyl side chains of proteins, purines, pyrimidines and porphyrins (Vallee and Ulmer, 1972). Therefore each of these elements has the

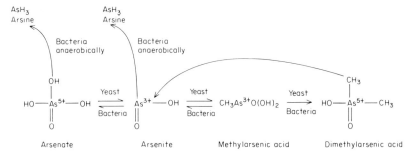

Fig. 7.4 Biologically mediated As cycle (after Wood, 1974).

ability to interact with many molecules that affect the nature and rate of their biogeochemical cycles.

1. Arsenic

Arsenic is not a heavy metal, although it is often grouped with these elements. Arsenic in many respects goes through similar environmental processes and thus, logically is considered as the same time as cycling of heavy metals. The cycling of As is controlled by sediments and soils phases. The observed low concentrations of As in waters appears to be due to the adsorption and precipitation of As compounds. Factors which affect the release of As in the environment are oxidation–reduction potential, pH and organic content of the sediment. Clays appear to absorb varying amounts of arsenite, arsenate and monosodium methyl arsenate. Overall most of the absorbance occurs with the organic arsenic compound (Abdelghani *et al.*, 1981).

The arsenic cycle is described in Fig. 7.4. The ability of fungi, *Mucor*, *Aspergillus* and *Penicillium*, to alter the forms of As was first reported by Gusio (1897). Since the early discoveries many micro-organisms have been shown to possess the ability to oxidize or reduce As compounds, whereas others produce methylated arsenicals.

Johnson (1972) showed that though the ratio of arsenate to arsenite should be $\sim 10^{26}$ in sea water, in fact it ranges from 10^{-1} to 10^{1}. This dramatic reduction was attributed to the ability of bacterial populations to reduce, but not accumulate, arsenate. A marine bacterium, *Serratia marinorubra*, and a yeast, *Rhodotorula rubra* produce arsenite (As^{3+}) and methylarsenic acid (MeAs) from arsenate. *R. rubra* also produced dimethylarsenic acid $(Me)_2AsO(OH)$ and volatile alkylarsenites. The bacterium did not produce volatile As compounds, but retained end products intracellularly. The yeast did not accumulate arsenite, but transported it into the culture medium, and

As which remained internally was transformed into methylarsenic and then to dimethylarsenic acid (Vidal and Vidal, 1980).

Arsenic compounds are also reduced and detoxified by terrestrial organisms. Challenger et al. (1933) demonstrated that the fungus, Scopulariopsis brevicaulis formed methylarsonate and dimethylarsinate from arsenic acid. The mechanism for the formation of trimethylarsine was postulated as AsO_3^{3-} → $(Me)AsO_3^{2-}$ → $(Me)_2AsO_2^{1-}$ → $(Me)_3As$. McBride and Wolfe (1971) were able to validate the pathway to dimethylarsine with cultures of Methanobacterium. Numerous fungi: Trichophyton (Zussmann et al., 1961), Candida, Gliocladium and Penicillium (Cox and Alexander, 1973) were capable of forming methylated arsenate products. Cheng and Focht (1979) demonstrated that arsine was the major product released from soils containing arsenate, arsenite, methylarsenate or dimethylarsenate. They concluded that methylated arsenical substrates were demethylated (oxidized or decarboxylated) first to arsenite and then reduced to arsine, since no monomethylarsines were observed in their experiments. Further, they demonstrated that Alcaligenes and Pseudomonas both reduced arsenate to arsenite and then to arsine, under anaerobic conditions. Neither of these bacterial genera produced any methylated arsenic compounds. Thus, they concluded that the major form of As leaving soils through volatilization was in the form of arsine gas.

Organisms also oxidize arsenite compounds to arsenate. Alcaligenes faecalis, isolated from sewage and resistant to 0.01 M sodium arsenite in solution, carried out the oxidation of this compounds by an intracellular oxygen sensitive enzyme, which was part of an inducible portion of the electron transport system that appeared in the stationary phase of growth (Phillips and Taylor, 1976). Another Alcaligenes strain isolated from soil oxidized arsenite to arsenate via an inducible enzyme system. Again, oxidative phosphorylation was indicated at the mechanism with O_2 as the final electron acceptor (Erlich, 1964; Osborne and Erlich, 1976). Pseudomonas fluorescens isolated from sewage has been shown to reduce arsenate to arsenite, and aerobic parts of sewage treatment oxidize arsenite (Myers et al., 1973). Pseudomonas putida and Aeromonas entrophus isolated from Au ore deposits can oxidize As^{2+} to As^{5+}. This reaction was temperature dependent and resulted in a reduction of pH in the medium (Abdrashitova et al., 1981). The formation of methylated arsenicals occurred over the pH range of 5.5–7.5 in lake sediments with the optimum pH being < 5.5 (Baker et al., 1981).

Arsenic inhibits certain cellular functions linked with energy metabolism in bacteria (Demaster and Mitchell, 1973; Ordal and Goldman, 1975). However, in nutrient rich warm water experiments no such effects were observed for As^{3+} and As^{5+} (Brunskill et al., 1980). These differences in effects on microbial metabolism may be due to the bioavailability of the compound; this emphasizes the complex nature of metal interactions in given environments.

The influence of environmental factors in As cycling is described by Holm *et al.* (1980). These authors discuss the importance of the phenomenon of adsorption in determining biological availability of As compounds and in microbial mediation of this biochemical cycle. Anderson *et al.* (1978) found that Langmuir isotherms described the removal of As species from solution; these also indicated that adsorption controlled the availability of these chemical species to micro-organisms.

There is now a clearer understanding of the role of As cycling in several environments. The balance in sea water is toward the reduction of arsenate to arsenite; this is important because it reduces the toxicity of As. For certain organisms, both in sea water and soil environments, the chemical equilibrium is toward the formation of volatile end products, such as dimethylarsenate. Holm *et al.* (1980) found that methylarsenic acid added to anaerobic sediments was degraded by micro-organisms over time into the demethylated product, arsenate. This observation demonstrates that organisms not only alter the form of the element but also aid in its translocation from one sphere of the environment to another. It is easy to ascertain from the above discussion that although the formation of volatile arsenicals by micro-organisms has been known for almost 100 years, the basic cellular mechanisms controlling these changes are just beginning to be defined.

2. Lead

The distribution of Pb in the environment has been dramatically altered via activities of man. A 400-fold increase in the Pb concentration (Fig. 7.5) of a Greenland glacier has occurred since 800 BC (Murozumi *et al.*, 1969). Most of the increase occurred after 1800 and provides evidence that Pb contamination arises from industrialization. Because of the worldwide contamination, natural background levels of Pb are seldom found in abiotic or biotic samples.

Lead carbonates, oxides and sulphates are released into the environment by mining activities, and elemental Pb is emitted by the smelting process (Craig, 1980). The chemistry of Pb in soils is largely controlled by absorption of Pb to soil mineral surfaces, and by formation of stable organo–Pb lead complexes and insoluble organo–Pb chelates, particulates and residues. The effect of Pb on microbial populations is usually greater in sandy soils (Doelman, 1978).

Micro-organisms have been exposed to increasing levels of Pb for 2500 years. However, the greatest increases have occurred in the last century (Fig. 7.5) and are confined to areas near active industries in which lead is used as a source material. The highly insoluble nature of most Pb compounds makes its bioavailability less than that of Cd, Hg, As or Zn. Few studies have measured the amount of soluble Pb in solution while determining lead resistance in

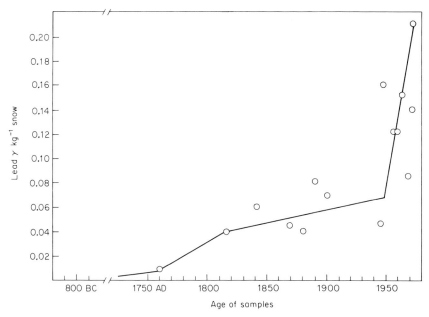

Fig. 7.5 Increase of industrial lead in pollution in Camp County snow with time since 800 BC.

bacterial populations. Barkay *et al.* (1979) reported that all bacterial isolates tested from Chesapeake Bay sediment were resistant to 100 μg g^{-1} Pb on an agar medium. The results of Ramamoorthy and Kushner (1975) indicate that all the available Pb in this medium would most likely be complexed with organic compounds. Olson *et al.* (1982) demonstrated, using an agar medium containing compounds less likely to bind Pb, that 1000 μg g^{-1} were required to demonstrate Pb-tolerant bacterial populations. Bacterial resistance to Pb appears to be a widespread environmental phenomenon, with highest resistance patterns found in areas where active smelting was occurring. Lead resistance, or tolerance, as indicated by correlation coefficients shown in Table 7.5 is less readily demonstrated in bacterial populations than Cd or Zn resistance, which may reflect the greater bioavailability of the latter metals. These workers also found no evidence of metal resistance in bacteria isolated from soil surrounding a smelter which had been dismantled ten years previously. Thus, in this situation, it appeared that though the soil contained elevated concentrations of Pb, Cd and Zn, the availability of these elements, reflected by metal resistance, was extremely low. Nevertheless, metal resistance or tolerance to Pb remains an important question, because of increasing industrial processes which will further increase the soil and sediment Pb burden. Increasing concentrations of Pb in these environments

Table 7.5 Correlative relationships between growth of bacterial populations on metal-amended media and soil metal concentrations

	Soil metal concentration $\mu g\ g^{-1}$	Growth medium concentration $\mu g\ g^{-1}$	r^*
Somerset, England			
Cd	2–416	100	0.52
		200	0.94
Pb	96–11 600	1000	ND†
Zn	220–66 400	200	0.77
Derbyshire, England			
Cd	1.6–12.8	100	0.77
Pb	129–290 554	1000	0.47
Zn	75.2–1258.0	250	0.57
		500	0.83

* All values reported significant to $p < 0.05$ (from Troyer et al., 1981). Correlation coefficient between percentage of resistant bacteria grown on metal amended medium and soil metal concentration.
† ND = not determined.

will undoubtedly have some effect on the natural populations of micro-organisms.

Biogeochemical cyling of Pb has focused on microbial resistance to various Pb compounds, rather than changes in chemical species of this element. Several studies reported in the literature have addressed the issue of Pb in the environment and its effect on microbial populations. Bewley and Campbell (1978) showed that phyllosphere microflora were abundant in the presence of high Cd, Zn and Pb on oak leaf surfaces that contained approximately 1200 $\mu g\ g^{-1}$ Zn, between 830–1601 $\mu g\ g^{-1}$ Pb, and between 11–14 $\mu g\ g^{-1}$ Cd.

The effect of Zn, Pb and Cd on fungi colonizing Hawthorne leaves affected by aerial fallout from a Zn–Pb smelter showed that *Sporobolomyces roseus* was absent from the most heavily contaminated leaves, although the occurrence of *Aureobasidium pullulans* increased with increasing Pb concentrations. Gadd (1981) had hypothesized that the metal resistance of the polymorphic fungus, *A. pullulans* is related to pigment development. Filamentous fungi isolated by leaf washing from Pb contaminated areas were only slightly inhibited by Zn, Cd and Pb and mycelial proliferation on senescent leaves was only moderately affected by heavy metal pollution (Bewley and Campbell, 1980).

Bacterial numbers were only slightly reduced in areas surrounding a Zn–Pb smelter, but total numbers of bacteria decreased as the concentration of Pb increased (Bewley and Campbell, 1980). In Pb amended soils, Gram-negative rods became increasingly dominant over coryneforms. Doelman and Haans-

tra (1979) concluded that the dominance of Gram-negative bacteria might be explained by their association with the interior of soil aggregates. Thus, these organisms were protected from exposure to Pb. In this case Pb resistance or tolerance would not be a population characteristic but rather a passive physicochemical phenomenon.

Other workers have demonstrated what appears to be bacterial resistance to Pb. Troyer et al. (1980) showed Pb resistance in bacterial populations from English soils containing anomalous concentrations of Pb, Cd and Zn. Varma et al. (1976) have isolated Pb resistant bacteria from domestic sewage; these bacteria were also resistant to antibiotics. The metal and drug resistance appeared to be plasmid mediated either on separate plasmids or by resistance transfer factors.

The methylation of Pb in aquatic environments appears to be carried out by both biotic and abiotic processes. Wong et al. (1975) demonstrated that Pseudomonas, Alcaligenes, Acinetobacter, Flavobacterium and Aeromonas isolated from lake sediments could transform certain inorganic and organic Pb compounds into volatile tetramethyl-Pb, $(Me)_4Pb$. Trimethyl-Pb, $(Me_3)_3Pb$, was mostly readily methylated to form $(Me_3)_4Pb$. However, occasionally inorganic Pb in the form of $Pb(NO_3)_2$ or $PbCl_2$ was methylated to form tetramethyl-Pb. Laboratory studies by Baker et al. (1981) of acidic oligotrophic lake Ontario sediments indicated that over the pH range of 3.5–7.5 the majority of tetramethyl-Pb formed from $(Me_3)PbOAc$ was biological in nature. However, the rate of transformation was very small, varying from 0–0.009% of the total added Pb. This very limited rate of transformation may explain some of the controversy surrounding the question of biologically mediated methylation of Pb.

Craig (1980) demonstrated that the methylation of $(Me)_3PbOAc$ in Lake Minnetonka, Minnesota sediments was a biological process explained by disproportionation processes. Reisinger et al. (1981) could not demonstrate biological methylation of inorganic Pb or $(Me)_3PbOAc$, $(Et)_3PbOAc$ and $(Et)_3PbCl$ in river sediments, sewage sludge or with the bacterium, Methano-sarcina barkeri. Thompson (1981) found that the formation of tetramethyl-Pb from $Pb(NO_3)_2$, PbS or PbOAc was inconsistent and time independent in marine sediments of high and low organic content suggesting non-biological methylation. However, when $(Me)_3PbOAc$ was used as the Pb source, $(Me)_4Pb$ was recovered. The highest levels were recovered from anoxic sediments low in organic matter. Sediment spiked with $Pb(NO_3)_2$ did not produce any tetramethyl-Pb. The low organic sediment which methylated the organo-lead compound contained 116 $\mu g\ g^{-1}$ Pb and 5.5 $\mu g\ g^{-1}\ S^{2-}$, whereas the organically rich sediment contained 12.8 $\mu g\ g^{-1}$ Pb and 1877 $\mu g\ g^{-1}\ S^{2-}$ (dry weight). The lower rate of methylation in the organically rich sediment may have been due to the high concentration of S which could have made Pb

unavailable by the formation of PbS.

Because of the labile nature of alkyl Pb compounds in the environment and the low rate of transformation of Pb into organo-lead compounds, the importance of microbial populations in this pathway of the Pb cycle is far less significant than anthropogenic sources (Röderer, 1981).

Cole (1979) found that several heterotrophic soil bacteria were capable of solubilizing $PbSO_4$. The bacteria were identified as belonging to the genera *Pseudomonas* or *Xanthomonas*. For all the isolates tested, solubilization occurred during active growth phase; this suggests that the process is linked to active cellular metabolism. Depending upon the isolate and the medium composition, the isolates solubilized between 0.3 and 56 μg Pb^{2+} ml^{-1} of medium during 24 h. These bacteria were also able to solubilize ZnS, CdS and PbS, but not $PbSO_4$, PbO or Pb_3O_4. The addition of a simple sugar (glucose) stimulated the solubilization of both ZnS and PbS.

In conclusion, the understanding of the cycling of Pb is less well delineated than that for As, although much information has been gathered on tolerance to Pb and appears to have genetic linkages. The methylation of Pb is predominantly abiological. However, trimethyl-lead acetate is biologically methylated under certain circumstances.

3. Cadmium

Cadmium, an element with no known biological function has also been dispersed into the environment from anthropogenic sources. Approximately 70% of the world's total production of Cd has occurred within the past 20 years. Cadmium has been found to be closely associated with Zn, and therefore is present in ores of zinc, lead–zinc and lead–copper–zinc. The amount of Cd present increases as the Zn concentration of the ore increases. No natural organic compounds of Cd have been detected from environmental samples. Organo-cadmium compounds are chemically unstable (Babich and Stotzky, 1978). The bioavailability of Cd in soils like most heavy metals is affected by several physicochemical properties, such as oxidation–reduction potential, pH, cation exchange capacity, type of clay fraction and nature of organic matter. Clays have been shown in certain instances to protect micro-organisms from Cd toxicity. Montmorillonite and kaolinite protect bacteria, actinomycetes and filamentous fungi from Cd toxicity: the greater the cation exchange capacity of the soil the higher its protective ability. Babich and Stotzky (1977) suggest that the availability of Cd is closely linked to the cation exchange capacity of the environment.

Competitive metal uptake between elements can also influence the bio-geochemical cycle of Cd. Both Zn and Mg have been shown to reduce Cd

toxicity to micro-organisms through this process (Babich and Stotzky, 1977).

Oak saplings sprayed with Zn, Pb and Cd to simulate smelter effects indicated little change in viable counts of bacteria, yeast and filamentous fungi. However, actual examination of micro-organisms at a smelter site revealed lower numbers on oak leaves compared with those at a control site (Bewley, 1980). Examination of bacteria, yeast and filamentous fungi resistance to Zn, Pb and Cd *in vitro* and *in vivo* indicated that bacteria were less tolerant *in vitro*, but were found in high numbers under field conditions at all metal concentrations. Yeasts probed to be very tolerant under both *in vitro* and *in vivo* conditions, while filamentous fungi appeared to be more resistant than bacteria *in vitro* but their numbers were decreased by Pb contamination (Bewley, 1979).

Houba and Remacle (1980) showed that in environments heavily polluted with Cd, 16% of the Gram-negative strains of bacteria could grow on a medium containing 100 μg ml^{-1} Cd. This medium contained bactotryptone, yeast extract, sodium chloride, glucose, agar and water. Resistance was demonstrated for these strains, because the organic compounds used in the growth medium did not bind the metal (Ramamoorthy and Kushner, 1975).

Cadmium in the divalent state has a significantly greater effect on micro-organisms than Cd (CN_4^{2-}) (Cenci and Morozzi, 1977). Complexing Cd with cyanide appeared to decrease inhibitory effects on microbial growth in activated sludge systems. Further, Cd^{2+} caused a greater delay in the initiation of growth of a mixed microbial population from activated sludge system than Cd (CN_4^{2-}); however, there were no differences between total substrate usage (Sterritt and Lester, 1980). These findings indicate the importance of the chemical species of metal complexes in determining availability, which ultimately determines the ability of a metal to cycle. At this time it appears that Cd will bioaccumulate through the Zn and Mn transport routes rather than through biomethylation (Craig, 1980). Cadmium has been shown to be mobilized from sediments by the blue-green alga, *Anabaena* 7120 and the green alga, *Ankistro-desmes braunii* (Laube *et al.*, 1980).

4. Mercury

The high affinity of Hg compounds for thiol groups, the enhanced properties of covalent Hg compounds, and the stability of the mercury–carbon bonds increase this metal's availability to micro-organisms in aquatic or terrestrial environments and its ability to be translocated into the food chain. Bacteria and fungi can reduce inorganic Hg salts, degrade and reduce organomercurial compounds into elemental Hg (Spangler *et al.*, 1973) or methylate inorganic mercuric ions. These biologically mediated chemical processes form the basis of the Hg cycle. As with any biological process and as discussed in descriptions

of other metal cycles, physicochemical factors influence these reactions in the environment.

The first information gathered on microbial alteration of mercurial compounds was based on observations of decreased biocidal properties of Hg containing fungicides in both aquatic and soil environments. Mercuric ion is volatilized from the soil or the sediment and these volatile forms enter the atmosphere or the water column. For example, *Pseudomonas* can convert divalent Hg into metallic Hg^0 (Magos *et al.*, 1964; Furukawa *et al.*, 1969). Fifty percent of methoxyethyl-Hg is degraded to inorganic Hg^0 by these organisms in most environments. The formation of elemental Hg by these organisms is important in the global cycling of Hg and is also accomplished by non-biological phenomena such as weathering.

Simultaneously, other groups of bacteria and certain fungi can methylate inorganic Hg forming either mono- or dimethylmercury (Yamada and Tonomura, 1972; Vonk and Sijpesteijn, 1973; Hamdy and Noyes, 1975). This reaction is pH dependent, with monomethylmercury being predominant in acidic environments, whereas dimethylmercury is formed only under alkaline conditions. Ability to methylate Hg is not confined to a limited number of species of micro-organisms; thus conditions that promote growth in many environments can enhance methylation. In natural environments groups of bacteria are present which carry out both processes. Thus, methylation and demethylation probably occur simultaneously (Fig. 7.6).

Volatilization and methylation of Hg appear to occur at the highest rates under aerobic conditions (Spangler *et al.*, 1973; Hamdy and Noyes, 1975;

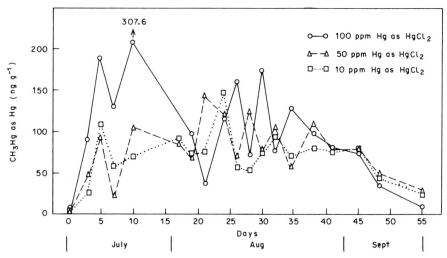

Fig. 7.6 Net methylmercury production from 18 July 1975 to 12 September 1975 by estuarine sediment.

Olsen and Cooper, 1976). Under anaerobic conditions the rate of volatilization by Hg reducing strains has been shown to be reduced, and methylation though affected, is not inhibited to the same degree (Olson, 1978; Barkay et al., 1979). Thus, in the environment when methylmercury is produced under aerobic conditions it may be rapidly degraded to Hg^{2+} or reduced to Hg^0 by demethylating micro-organisms. Methylmercury accumulation can best be shown when conditions are anoxic and demethylation is inhibited (Olson and Cooper, 1974).

Elemental Hg^0 and HgS are oxidized in the environment, and Hg vapour can be oxidized to Hg^{+2} in water (Wallace et al., 1971). This oxidation is favoured when organic substances are present (Jensen and Jernelov, 1972). Inorganic Hg or complexed Hg may be absorbed or adsorbed on sediment particles and then can be reduced or methylated. If methylated, some will enter biological tissues as CH_3Hg^+. Other forms enter the sediment–water interface as Hg^0, which may then be reoxidized to the divalent state and returned to the sediment adsorbed to particulate matter. If the pH is basic, dimethylmercury is formed, which rapidly leaves the environment because it is highly volatile. Last, there is a natural movement of Hg^{2+} from the biologically active zone of the biosphere to the inorganic mineralized zones (Jensen and Jernelov, 1972).

The genetic basis of demethylation has been shown to be plasmid mediated for several hospital strains of bacteria and several environmental strains (Summers and Silver, 1972; Olson et al., 1979). It has been suggested that methylation and demethylation of Hg are controlled by one plasmid. After the removal of a plasmid from a bacterial strain of *Clostridium cochlearum*, it no longer demethylated methylmercury but was capable of methylating Hg. Pan-Hou et al. (1980) also showed ability to methylate or demethylate Hg depending on experimental conditions, which also supports this hypothesis, and further suggests that environmental conditions might override or trigger genetic mechanisms.

Therefore, biologically mediated cycling of Hg encompasses degradation of organomercurial compounds, reduction of Hg^{2+} to volatile forms, and the transformation of Hg^{2+} into alkylmercury compounds. The global cycling of this metal is believed to be divided into anthropogenic phenomena, natural chemical processes, and biologically mediated biochemical reactions. The information gained from understanding of the cycle of this element has provided a better conceptual delineation of geochemical cycles for several elements besides those discussed in this chapter.

VII. Conclusions

The concept of microbially mediated geochemical cycling was originally developed in the late nineteenth century. Since that time biogeochemistry has

become a well-established discipline, the focus of which has been toward determining toxicity to, or tolerance of, micro-organisms to groups of elements. These investigations have provided information on several important levels, forming the basis of our knowledge of metal cycles. These include generalized chemical properties of elements, environmental conditions, genetic mechanisms and microbial adaptations. Each of these can be the controlling factor in a given cycle, depending on the set of circumstances at the time. The basic understanding of cycles, of course, varies with the element under investigation. Thus, Fe and Hg cycling is well understood, whereas Cd and Pb are characterized in terms of toxicity rather than cycling.

Undoubtedly, as in other areas of biology, the focus of biogeochemical cycling will go to the cellular level, centring on organism–chemical interactions and genetic control mechanisms. Sophisticated tools, such as the gene probe, exist that will allow scientists to penetrate in detail the mechanisms of metal resistance and/or chemical modification mechanisms in organisms involved in cycling metals. The new methods will take biogeochemical cycling into molecular biology. Thus, future research will allow scientists to gain an understanding of the interaction of micro-organisms with the specific chemical species of elements at the environment–organism and chemical–organism interface.

Acknowledgements

The author thanks R. R. Colwell, University of Maryland, and K. Temple, Montana State University, for their review of this manuscript.

References

Abdelghani, A. A., Reimers, R. S., Anderson, A. C., Englande, A. J. Jr, Lo, C. P. and Shariatpanahi, M. (1981). *In* "Heavy Metals in the Environment", pp. 665–668, International Conference, Amsterdam, Sept. 1981. CEP Consultants Ltd, Edinburgh.

Abdrashitova, S. A., Mynbayeva, B. N. and Ilyaletdinob, A. N. (1981). *Microbilogiya* **5** (1), 41–45.

Abelson, P. H. and Aldous, E. (1950). *J. Bacteriol.* **60**, 401–413.

Allen, D. A., Austin, B. and Colwell, R. R. (1977). *Antimicrob. Agents Chemother.* **12** (4), 545–547.

Anderson, M. A., Holm, J. R., Iverson, D. G. and Stanforth, R. R. (1978). "Mass Balance and Speciation of Arsenic in the Mehominee River, Wisconsin". Project Rep. 6, U.S. Environment Protection Agency, Environmental Research Laboratory, Athens, Georgia.

Armstrong, W. McD. and Rothstein, A. (1964). *J. Gen. Physiol.* **48**, 61–71.

Babich, H. and Stotzky, G. (1977). *Appl. Environ. Microbiol.* **33** (3), 696–705.

Babich, H. and Stotzky, G. (1978). *Adv. Appl. Microbiol.* **23**, 55–117.

Baker, M. D., Wong, P. T. S., Chau, Y. K., Mayfield, C. I. and Inniss, W. E. (1981). *In* "Heavy Metals in the Environment", pp. 645–648. International Conference, Amsterdam, Sept. 1981.

Baldry, M. G. C., Hogarth, D. S. and Dean, A. C. R. (1977). *Microbios Letters* **4**, 7–16.

Barkay, T., Olson, B. H. and Colwell, R. R. (1979). *In* "Management and Control of Heavy Metals in the Environment", pp. 356–363. CEP Consultants Ltd, Edinburgh, U.K.

Beveridge, T. J. and Murray, R. G. E. (1976). *J. Bacteriol.* **127**, 1502–1518.

Bewley, R. J. F. (1979). *J. Gen. Microbiol.* **110**, 247–254.

Bewley, R. J. F. (1980). *Appl. Environ. Microbiol.* **40** (6), 1053–1059.

Bewley, R. J. F. and Campbell, R. (1978). *Trans. Br. Mycol. Soc.* **71**, 508–511.

Bewley, R. J. F. and Campbell, R. (1980). *Microb. Ecol.* **6**, 227–240.

Bewley, M., Foury, F. and Goffeau, A. (1977). *Biochim. Biophys. Acta* **464**, 602–612.

Bowen, H. J. M. (1966). "Trace Elements in Biochemistry". Academic Press, London and New York.

Brierley, C. L. and Thornton, I. (1979). *Miner. Environ.* **1**, 112–119.

Brunskill, G. J., Graham, B. W. and Rudd, J. W. M. (1980). *Can. J. Fish. Aquat. Sci.* **37**, 415–423.

Cenci, G. and Morozzi, G. (1977). *Sci. Tot. Environ.* **7**, 131–143.

Challenger, F., Higginbottom, C. and Ellis, L. (1933). *J. Can. Sol. Chem. Co.* **1933**, 95–101.

Cheng, C. N. and Focht, D. D. (1979). *Appl. Environ. Microbiol.* **38**, 494–498.

Chopra, I. (1971). *J. Gen. Microbiol.* **63**, 265–267.

Chopra, I. (1975). *Antimicrob. Agents Chemother.* **7** (1), 8–14.

Cole, M. A. (1979). *Soil Sci.* **127** (5), 313–317.

Cox, D. P. and Alexander, M. (1973). *Bull. Environ. Contam. Toxicol.* **9**, 84–88.

Craig, P. J. (1980). *Environ. Tech. Letters* **1**, 17–20.

Cullimore, D. R. and McCann, A. E. (1977). *In* "Aquatic Microbiology" (Skinner, F. A. and Shewan, J. M., eds), pp. 219–261. Academic Press, London and New York.

Demaster, E. G. and Mitchell, R. A. (1973). *Bio. Chem.* **12**, 3616–3621.

Doelman, P. (1978). *In* "The Biogeochemistry of Lead in the Environment" (Nriagu, J. O., ed.), pp. 343–353. Elsevier/North-Holland Biomedical Press, New York.

Doelman, P. and Haanstra, L. (1979). *Soil Biol. Biochem.* **2**, 487–491.

Dubinina, G. A. (1973). *Verhandlungen, Internationale Vereinigung fur Theoretische und Angewandte Limnologie* **18**, 1261–1272.

Dyke, K. G. H., Parker, N. T. and Richmond, M. H. (1970). *J. Med. Microbiol.* **3**, 125–136.

Ehrlich, H. L. (1964). *Econ. Geol.* **50**, 1306–1312.

Ehrlich, H. L. (1978). *In* "Microbial Life in Extreme Environments" (Kusher, D. J., ed.), pp. 381–408. Academic Press, London and New York.

Ernst, W. (1974). "Schwermetallvegetation der Erde". Gustav Fischer Verlag, Stuttgart.

Friedman, B. A. and Dugan, P. R. (1967). *Dev. Ind. Microbiol.* **9**, 381–388.

Fuhrmann, G. F. and Rothstein, A. (1968). *Biochim. Biophys. Acta* **163**, 325–330.

Furukawa, K., Suzuki, T. and Tonomura, K. (1969). *Agr. Biol. Chem.* **33** (1), 128–130.

Gadd, G. M. (1981). *In* "Heavy Metals in the Environment", pp. 285–288. International Conference, Amsterdam, Sept. 1981. CEP Consultants Ltd, Edinburgh.

Gusio, B. (1897). *Berichte (der deutschen chem. ges.)* **30**, 1024–1026.

Gregory, E., Perry, R. S. and Stanley, J. T. (1980). *Microb. Ecol.* **6**, 125–140.

Hamdy, M. K. and Noyes, O. R. (1975). *Appl. Microbiol.* **30**, 424–432.

Harold, F. M. and Spitz, E. (1975). *J. Bacteriol.* **122** (1), 266–277.

Hawker, L. E. and Linton, A. H. (1979). "Microorganisms: Function, Form and Environment". University Park Press, Baltimore, Maryland.

Heldwein, R., Tromballa, H. W. and Broda, E. (1977). *Z. Allg. Mikrobiol.* **17**, 299–308.

Holm, T. R., Anderson, M. A., Stanforth, R. R. and Iverson, D. G. (1980). *Limnol. Oceanogr.* **25** (1), 23–30.

Houba, C. and Remacle, J. (1980). *Microb. Ecol.* **6**, 55–69.

Jasper, P. and Silver, S. (1977). *In* "Microorganisms and Minerals" (Weinberg, E. D., ed.), pp. 7–47. Marcel Dekker, New York.

Jensen, S. and Jernelov, A. (1969). *Nature, Lond.* **223**, 753–754.

Jensen, S. and Jernelov, A. (1972). *In* "Mercury Contamination in Man and his Environment". Vies. Int. A.T. En. Ag., Technical Report Series, No. 137, 43.

Johnson, D. L. (1972). *Nature, Lond.* **239** (5375), 44–45.

Kelly, D. P., Norris, P. R. and Brierley, C. J. (1979). "Microbial Technology", Society for General Microbiology Symposium 29, pp. 263–308. Society for General Microbiology, Ltd, Great Britain.

Laube, V. M., McKenzie, C. N. and Kushner, D. J. (1980). *Can. J. Microbiol.* **26**, 1300–1311.

Macrae, I. C. and Edwards, J. F. (1972). *Appl. Microbiol.* **24**, 819–823.
Macrae, I. C., Edwards, J. F. and Davis, N. (1973). *Appl. Microbiol.* **25**, 991–995.
Magos, L., Tuffery, A. A. and Clarkson, T. W. (1964). *Brit. J. Ind. Med.* **21** (4), 294–298.
Marquis, R. E., Mayzel, K. and Cartensen, E. L. (1976). *Can. J. Microbiol.* **22**, 975–982.
McBride, B. C. and Wolfe, R. S. (1971). *Biochem.* **10**, 4312–4317.
Meynell, G. G. (1972). "Bacterial Plasmids: Conjugation, Colicinogeny and Transmissible Drug Resistance", 164pp. Macmillan Press Ltd, London and Basingstoke.
Mitra, R. S., Gray, R. H., Chin, B. and Bernstein, I. A. (1975). *J. Bacteriol.* **121** (3), 1180–1188.
Murozumi, J., Chow, T. J. and Patterson, C. (1969). *Geochim. Cosmochim. Acta* **33**, 1274–1294.
Murray, A. D. and Kidby, D. K. (1975). *J. Gen. Microbiol.* **86**, 66–67.
Myers, D. J., Heimbrook, M. E., Osteryrung, J. and Morrison, F. M. (1973). *Environ. Letters* **5** (1), 51–56.
Norris, P. R. and Kelly, D. P. (1977). *J. Gen. Microbiol.* **99**, 317–324.
Norris, P. R. and Kelly, D. P. (1979). *Dev. Ind. Microbiol.* **20**, 299–308.
Norris, P. R., Man, W. K., Hughes, M. N. and Kelly, D. P. (1976). *Arch. Microbiol.* **110**, 279–286.
Novick, R. P. and Roth, C. (1968). *J. Bacteriol.* **95** (4), 1335–1342.
Olson, B. H. (1978). *In* "Microbiol Ecology" (Loutit, M. W. and Miles, J. A. R., eds), pp. 416–422. Springer-Verlag, Berlin, Heidelberg and New York.
Olson, B. H. and Cooper, R. D. (1974). *Nature, Lond.* **252**, 682–683.
Olson, B. H. and Cooper, R. C. (1976). *Water Res.* **10**, 113–116.
Olson, B. H. and Thornton, I. (1982). *J. Soil Sci.* **33**, 271–279.
Olson, B. H., Barkay, T., Nies, D., Bellama, M. and Colwell, R. R. (1979). *Dev. Ind. Microbiol.* **20**, 275–284.
Ordal, G. W. and Goldman, D. J. (1975). *Science* **189**, 802–805.
Osborne, F. H. and Ehrlich, H. L. (1976). *J. Appl. Bacteriol.* **41** (2), 295–305.
Pan-Hou, H. S. K., Hosono, M. and Imura, N. (1980). *Appl. Environ. Microbiol.* **40** (6), 1007–1011.
Pardee, A. B., Prestridge, L. S., Whipple, M. B. and Dreyfuss, J. (1966). *J. Biol. Chem.* **241**, 3962–3969.
Paton, W. H. N. and Budd, D. (1972). *J. Gen. Microbiol.* **72**, 173–184.
Phillips, S. E. and Taylor, M. L. (1976). *Appl. Environ. Microbiol.* **31** (3), 392–399.
Pickett, A. W. and Dean, A. C. R. (1976). *Microbios. Letters* **1**, 165–167.
Ramamoorthy, S. and Kushner, D. J. (1975). *Microb. Ecol.* **2**, 162–176.
Reisinger, K., Stoeppler, M. and Nürnberg, H. W. (1981). *In* "Heavy Metals in the Environment", pp. 649–652. International Conference, Amsterdam, Sept. 1981. CEP Consultants Ltd, Edinburgh.
Rhoads, D. B., Waters, F. B. and Epstein, W. (1976). *J. Gen. Physiol.* **67**, 325–341.
Röderer, G. (1981). *In* "Heavy Metals in the Environment", pp. 250–253. International Conference, Amsterdam, Sept. 1981.
Rogers, S. R. and Anderson, J. J. (1976). *J. Bacteriol.* **126**, 257–263.
Rother, J. A., Millbank, J. W. and Thornton, I. (1982). *J. Soil Sci.* **33**, 101–113
Rothstein, A. and Hayes, A. D. (1956). *Arch. Biochem. Biophys.* **63**, 87–99.
Saxena, J. and Howard, P. H. (1977). *Adv. Appl. Microbiol.* **21**, 185–226.
Silver, S. and Jasper, P. (1977). *In* "Microorganisms and Minerals" (Weinberg, E. D., ed.), pp. 105–149. Marcel Dekker, New York.
Silver, S., Johnseine, P., Whitney, E. and Clark, D. (1972). *J. Bacteriol.* **110**, 186–195.
Silverberg, B. A., Wong, P. T. S. and Chau, Y. K. (1976). *Arch. Microbiol.* **107**, 1–6.
Smithells, C. J. and Brandes, E. A. (eds) (1976). "Metals Reference Book", 5th Edn, 1566pp. Butterworths, London and Boston.
Spangler, W. J. Spigarelli, J. L., Rose, J. M., Flippin, R. S. and Miller, H. M. (1973). *Appl. Microbiol.* **25**, 488–493.
Springer, S. E. and Huber, R. E. (1973). *Arch. Biochem. Biophys.* **156**, 595–603.
Sterritt, R. M. and Lester, J. N. (1980). *Sci. Totl. Environ.* **14**, 5–17.
Summers, A. O. and Silver, S. (1972). *J. Bacteriol.* **112**, 1228–1236.
Tabillion, R. and Kaltwasser, H. (1977). *Arch. Microbiol.* **113**, 145–151.
Thompson, J. A. J. (1981). *In* "Heavy Metals in the Environment", pp. 653–656. International Conference, Amsterdam, Sept. 1981.
Timoney, J. F., Port, J., Giles, J. and Spanier, J. (1978). *Appl. Environ. Microbiol.* **36** (3), 465–472.

Tornabene, T. G. and Edwards, H. W. (1972). *Science* **176**, 1334–1335.

Troyer, I. S., Olson, B. H., Hill, D. C., Thornton, I. and Matthews, H. (1980). *In* "Trace Substances in Environmental Health XIV" (Hemphill, D. D., ed.), pp. 129–141. University of Missouri, Columbia.

Trudinger, P. A. (1976). *In* "Handbook of Strata-bound and Stratiform Ore Deposits" (Wolf, K. H., ed.), pp. 135–190. Elsevier, Amsterdam.

Trudinger, P. A. Swaine, D. J. and Skyring, G. W. (1979). *In* "Biogeochemical Cycling of Mineral-forming Elements" (Trudinger, P. A. and Swaine, D. J., eds), pp. 1–27. Elsevier Scientific Pub. Co., New York.

Tyler, P. A. (1970). *Antonie van Leeuwenhoek, J. Microbiol. Serol.* **36**, 567–578.

Tynecka, Z., Zajac, J. and Gos, Z. (1975). *Acta Microbiologica Polonica, Ser. A.* **7**, 11–20.

Vallee, B. L. and Ulmer, D. D. (1972). *Ann. Rev. Biochem.* **41**, 91–128.

Varma, M. M. Thomas, W. A. and Prasad, C. (1976). *J. Appl. Bacteriol.* **41**, 347–349.

Vernadsky, V. I. (1944). "Problems of Biogeochemistry", vol. 11, pp. 453–517. Conn. Acad. Arts and Sci.

Vidal, F. V. and Vidal, V. M. V. (1980). *Mar. Biol.* **60** (1), 1–7.

Vonk, S. W. and Sijpersteijn, A. K. (1973). *Antonie van Leeuwenhoek, J. Microbiol. Serol.* **39**, 505–513.

Wallace, R. A., Fulkerson, W., Shatts, W. D. and Lyon, S. W. (1971). "Mercury in the Environment—The Human Element". URNL-NSF, EP-1, Oak Ridge National Laboratory, Oak Ridge, Tenn.

Webb, M. (1970). *Biochim. Biophys. Acta* **222**, 423–439.

Weiss, A. A., Silver, S. and Kinscherf, T. G. (1978). *Antimicrob. Agents Chemother.* **14**, 856–865.

Willecke, K., Gries, E. M. and Oehr, P. (1973). *J. Biol. Chem.* **248**, 807–814.

Williamsmith, H. (1978). *J. Gen. Microbiol.* **109** (1), 49–55.

Wong, P. T. S., Chau, Y. K. and Luxon, P. L. (1975). *Nature, Lond.* **253**, 263–264.

Wood, J. M. (1974). *Science* **183**, 149–152.

Yamada, M. and Tonomura, K. (1972). *J. Ferment Technol.* **50**, 159–166.

Zussman, R. A., Vicher, E. E. and Lyon, I. (1961). *J. Bacteriol.* **81**, 157.

8

Geochemistry Applied to Agriculture

IAIN THORNTON

I. Introduction

Successful agricultural production is essential to meet the ever increasing demands for foodstuffs for an expanding world population. This need coupled with the results of research into crop and animal husbandry has led to the more intensive use of land in many parts of the world. This, in turn, has resulted in pressure on the earth's natural resources, requiring increased use of artificial fertilizers and animal feedstuffs to optimize agricultural production. The basic resource of the farmer is the soil both as a substrate for plant roots and as a supplier of nutrients.

For convenience these nutrients are termed major or trace elements, depending on their normal concentrations in soils, plants and animal tissues and on their requirements for healthy growth. In plants, C, H, O, N, P, S, K, Ca, Mg (Na) may be defined as macronutrients and Fe, Mn, Cu, Zn, Mo, B, Cl and Si as micronutrients (Mengel and Kirkby, 1978). Those elements nutritionally essential for animals comprise the major or macronutrients Ca, N, P, S, K, Na, Cl, Mg and S (together with C, H and O), and the trace elements or micronutrients Cu, Co, I, Fe, Mn, Mo, Se and Zn (Underwood, 1966). In addition, essential roles for Ni, Si, Sn, V, As and F have been established (Mertz, 1974). Of those elements listed as essential for animals, F, Ni, Si, Sn and V are usually present in plants at well above deficiency levels, and deficiencies in grazing livestock are not likely to occur.

In excess quantities many of the trace elements present in soils may be toxic to plants and/or animals or may affect the quality of foodstuffs for

APPLIED ENVIRONMENTAL GEOCHEMISTRY
ISBN 0-12-690640-8

human consumption. These potentially toxic elements include As, B, Cd, Cu, F, Pb, Hg, Mo, Ni, Se and Zn.

The removal of major elements from the soil in crop and livestock products is largely compensated for by the application of fertilizers, lime and organic residues, in particular "farmyard manure" and animal faeces, which may be enriched in minerals given to the animal in feeding stuffs. The trace elements or micronutrients may be depleted, particularly with intensive land use, and are not normally replaced. Naturally deficient soils also exist and problems would be expected to be exacerbated by intensification, and in particular with the increased use of nitrogenous fertilizers to support higher grain yields and more efficient use of grassland.

The nutrient requirements of crops and livestock are not met by natural resources in many parts of the world and geochemical mapping techniques described in Chapter 2 can play a useful contributory role in identifying such areas, and in particular areas where supplies may be marginal and where intensification of agricultural enterprise may give rise to serious livestock or crop disorders. It is important to remember that rarely is one element alone present in either a deficient or excess quantity; it is usually necessary to take into account several elements that may react in an additive, synergistic or antagonistic fashion in the soil–plant–animal system.

This chapter aims primarily to discuss (a) the sources and pathways of trace elements in the rock–soil–plant–animal system, (b) relationships between geology and geochemistry and agricultural problems, and (c) geochemical methods of mapping trace element distribution to assist in the identification of deficient or excess areas. Some of these points are also partially discussed in Chapters 1, 2, 4, 12 and 14.

II. Sources of trace elements in soils

1. Unmineralized bedrock and other materials

The main sources of trace elements in soils are the parent materials from which they are derived. Usually this is weathered bedrock or overburden that has been transported by wind, water or glacial activity. Overburden may be local or exotic, though in Britain, transported material is mainly of local origin. Ninety-five percent of the earth's crust is made up of igneous rocks and 5% sedimentary rocks; of the latter about 80% are shales, 15% sandstones and 5% limestones (Mitchell, 1964). Sedimentary rocks tend to overlie the igneous rocks from which they were derived and hence are more frequent in the surface weathering environment. The abundance of some trace elements and heavy metals in common igneous and sedimentary rocks is shown in Table 8.1.

Table 8.1 Range and mean concentrations of some metals and metalloids in igneous and sedimentary rocks (ppm)

Element	Basaltic igneous	Granitic igneous	Shales and clays	Black shales	Limestones	Sandstones
As	0.2–10	0.2–13.8	—	—	0.1–8.1	0.6–9.7
	2.0	2.0	10	—	1.7	2.0
Cd	0.006–0.6	0.003–0.18	0–11	<0.3–8.4	—	—
	0.2	0.15	1.4	1.0	0.05	0.05
Cr	40–600	2–90	30–590	26–1000	—	—
	220	20	120	100	10	35
Co	24–90	1–15	5–25	7–100	—	—
	50	5	20	10	0.1	0.3
Cu	30–160	4–30	18–120	20–200	—	—
	90	15	50	70	4	2
Hg	0.002–0.5	0.005–0.4	0.005–0.51	0.03– 2.8	0.01–0.22	0.001–0.3
	0.05	0.06	0.09	0.5	0.04	0.05
Pb	2–18	6–30	16–50	7–150	—	<1–31
	6	18	20	30	9	12
Mo	0.9–7	1–6	—	1–300	—	—
	1.5	1.4	2.5	10	0.4	0.2
Ni	45–410	2–20	20–250	10–500	—	—
	140	8	68	50	20	2
Se	—	—	—	—	—	—
	0.05	0.05	0.6	—	0.08	0.05
Zn	48–240	5–140	18–180	34–1500	—	2–41
	110	40	90	100	20	16

Adapted from table compiled by M. Fleischer and H. L. Cannon (Cannon *et al.*, 1978).

The degree to which trace elements in igneous rocks become available on weathering depends on the type of minerals present (see Chapter 1). The more biologically important trace elements such as Cu, Co, Mn and Zn occur mainly in the more easily weathered materials such as hornblende and olivine (Mitchell, 1974). Of the sedimentary rocks, sandstones contain minerals that weather slowly and usually contain only small amounts of trace elements. On the other hand, shales may be of organic or inorganic origin, and usually contain large amounts of trace elements (Mitchell, 1964). For example, Table 8.1 shows typical low levels of Cu in granitic igneous rocks and in limestones and sandstones, compared with larger amounts in basaltic igneous rocks, clays and shales. Black shales in particular are

enriched in a number of elements including Cu, Pb, Zn, Mo and Hg (Table 8.1), sometimes at levels deleterious to agriculture.

Soils derived from these parent materials tend to reflect their chemical composition. Thus those developed from the weathering of coarse-grained sediments such as sands and sandstones, and from acid igneous rocks such as rhyolites and granites tend to contain smaller amounts of nutritionally essential elements such as Cu and Co, than those derived from fine-grained sedimentary rocks such as clays and shales and from basic igneous rocks. Trace element concentrations, however, may range widely within soils developed from different lithological beds within a mapped unit (see Chapter 2); this is illustrated in individual beds within sandstone formations, where the Cu content of soil is generally lowest in the coarser-grained material, increasing with decreasing grain size (Table 8.2; Wood, 1975).

Potentially toxic amounts of trace elements in soils may be derived as the result of weathering of metal-rich source rocks (Table 8.3). For example, some calcareous soils developed from inter-bedded shales and limestones of the Lower Lias formation (Jurassic) in southwest England contain 20 ppm Mo or more, and are associated with molybdenosis and molybdenum-induced copper deficiency in grazing cattle (Ferguson et al., 1943; Lewis, 1943; Le Riche, 1959). This problem will be discussed in detail in Section V. A further example is provided in Scotland where soils derived from ultra-basic rocks containing nickel-rich ferromagnesium minerals, when poorly drained, may give rise to nickel toxicity in cereal and other crops (Mitchell, 1974).

Where residual soils are formed in situ from the underlying bedrock, the trace element content of the soil may be directly related to bedrock geochemistry. Where parent materials have been mixed or redistributed by alluvial transport, wind or glacial activity, the influence of the underlying rock may be either modified or completely masked; at times the effect of

Table 8.2 Average copper content and texture of soils derived from individual beds of the Old Red Sandstone formation (Upper Devonian) in South Wales (Wood, 1975)

| | Soil texture (%) | | | |
	Coarse sand	Fine sand	Silt and clay	Total Cu (ppm)
Raglan Marl	14	50	36	28
St. Maughans Group	13	60	27	21
Brownstones	66	14	26	18
Tintern Sandstones	51	25	24	13

Table 8.3 Trace elements in soils derived from normal and geochemically anomalous parent materials

Normal range in soil (ppm)		Metal-rich soils (ppm)	Sources	Possible effects
As	< 5–40	up to 2500	Mineralization	Toxicity in plants and
		up to 250	Metamorphosed rocks around Dartmoor	livestock; excess in food crops
Cd	< 1–2	up to 30	Mineralization	Excess in food crops
		up to 20	Carboniferous black shale	
Cu	2–60	up to 2000	Mineralization	Toxicity in cereal crops
Mo	< 1–5	10–100	Marine black shales of varying age	Molybdenosis or molybdenum induced hypocuprosis in cattle
Ni	2–100	up to 8000	Ultra-basic rocks in Scotland	Toxicity in cereal and other crops
Pb	10–150	1% or more	Mineralization	Toxicity in livestock, excess in foodstuffs
Se	< 1–2	up to 7	Marine black shales in England and Wales	No effect
		up to 500	Namurian shales in Ireland	Chronic selenosis in horses and cattle
Zn	25–200	1% or more	Mineralization	Toxicity in cereal crops

bedrock composition may be smeared in the direction of water flow or ice movement.

The influence of parent materials on the total content and form of trace elements in soils is modified to varying degrees by pedogenetic processes that may lead to the mobilization and redistribution of trace elements both within the soil profile and between neighbouring soils (Swaine and Mitchell, 1960; Mitchell, 1964). In the United Kingdom and similar temperate areas, most of the soils are relatively young and the parent material remains the dominant factor. Under tropical climates and on more mature land surfaces, such as those in Australia, weathering processes have been more vigorous or of much greater duration and relationships between the chemical composition of the original parent materials and the soil may be completely overriden by the mobilization and secondary distribution of chemical elements and the formation of secondary minerals.

The processes of gleying, leaching, surface organic matter accumulation and podzolization, together with soil properties such as reaction (pH) and redox potential (E_h) may affect the distribution, the form and the mobility of trace elements in the soil. The solubility and mobility of individual trace elements varies considerably. Iron, Mn, Co, Cd and Zn are relatively mobile

Table 8.4 Cadmium, zinc and lead in soils developed from Carboniferous black shale in Derbyshire

Depth (cm)	Top of slope (ppm dry soil)			Depth (cm)	Waterlogged valley bottom (ppm dry soil)		
	Cd	Zn	Pb		Cd	Zn	Pb
0–10	4	248	316	0–10	10	312	204
10–20	4	228	252	40–50	14	660	414
20–50	3	240	160	70–80	36	1000	328
50–75	3	356	44	80–90	52	2280	400
75–100	9	536	100				

compared to Pb and Mo, and the former are sometimes redistributed in the course of soil formation and maturity. Redistribution of Cd and Zn in the course of soil formation from Carboniferous marine shale in Derbyshire is illustrated in Table 8.4; both metals have been leached from freely and imperfectly drained soils on hill tops and slopes and accumulated under reducing conditions in poorly drained soils at the base of slope (Marples, 1979).

Trace elements are often leached from the surface layers of podzols and enriched in the B horizon. This is illustrated in Fig. 8.1, which shows the distribution of Se in a peaty podzol profile in North Wales (Smith, 1983).

2. Other sources

(a) Weathered mineralized rocks and associated parent materials

Soils in mineralized areas are often enriched in the ore metals and in Britain frequently contain high concentrations of one or more of the elements Cu, Pb, Zn, Cd and As. Factors controlling metal dispersion from mineralized sources in residual soils, glacial drift, alluvial soils and organic soils have been reviewed by Hawkes and Webb (1962), Levinson (1974) and Siegal (1974), and are discussed in Chapters 12 and 14.

(b) Other anthropogenic sources

These include (i) industrial emissions and effluents, (ii) traffic, (iii) urban development and dumped waste materials, (iv) contaminated dusts and rainfall, (v) sewage sludge, pig slurry and composted refuse and (vi) fertilizers, soil ameliorants and pesticides. The impact of these metal sources on

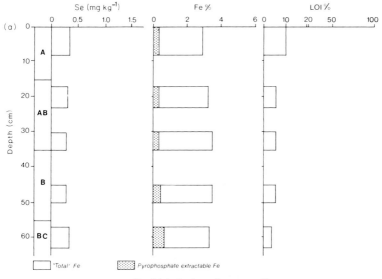

Denbigh Series – brown earth

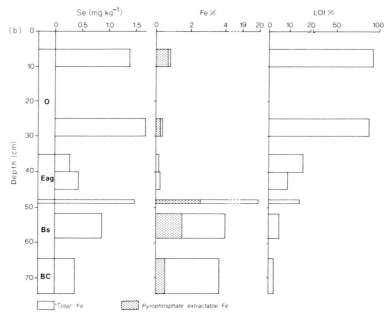

Hiraethog Series – Ironpan stagnopodzol

Fig. 8.1 Distribution of Se, "total" and pyrophosphate extractable Fe, and organic matter (loss on ignition) in soil profiles of (a) the Denbigh series, a freely drained brown earth, and (b) the Hiraethog series, a ferric stagnopodzol, both developed on Silurian shale in North Wales (Smith, 1983).

agricultural soils is discussed in Chapter 12 and further information pro-
vided by Purves (1977).

III. The soil–plant–animal relationship

The subject of "availability" of both naturally occurring and contaminating
sources of trace elements in soils to plants is discussed in detail in Chapters
4, 12 and 14, and in this chapter will be confined to some practical
illustrations. The concentrations of trace elements in plant tissues are
governed by their total concentration in the soil, the forms in which they
occur (see Chapter 5) and by some soil and plant factors influencing their
mobilization in soils, availability and uptake by plants and subsequent
translocation within crop plants (recently reviewed by Mitchell and Burridge,
1979; West, 1981; and Tinker, 1981).

The practical significance of some of these factors is illustrated in the
following two examples.

1. Copper: an essential element

Copper in soils is held strongly on inorganic and organic exchange sites and
in complexes with organic matter. A large proportion of the total Cu
content of soils is not available for uptake by plants. Deficiencies in crops
may be due to an inherently low total Cu content of the soil (for example,
derived from coarse sandstone) or to only a small amount being in an
available form. Deficiencies may be aggravated by soil micro-organisms.
The amount of Cu in soil solution decreases with increasing pH (Lindsay,
1972). The application of lime to soil and the associated rise in pH, usually
but not always decreases the availability of Cu to crops. For example, heavy
liming decreased Cu deficiency in oats (Henkens, 1957); however, Cu levels
in cereals were lowered when an acid peat in eastern England was limed at
low and extremely high levels, but increased at moderate levels (Caldwell,
1971). In organic soils, the availability of Cu depends not only on the
concentration of Cu in soil solution, but also on the form in which it is
present; Cu complexes of molecular weight < 1000 have been found to be
more available to plants than those of molecular weights exceeding 5000
(Mercer and Richmond, 1970).

Levels of EDTA-extractable Cu were increased in intensely gleyed hori-
zons of Scottish soils because of increased mobilization (Mitchell, 1971).
However, the moisture level in soils was found to have little effect on Cu
uptake by plants when Cu was present in sufficient amounts (Kubota et al.,
1963); though Cu deficiency was prevented by maintaining a high water

Table 8.5 Mean concentrations of copper and lead in contaminated and uncontaminated soils and associated pasture herbage

	No. of sites	Soil (mg kg^{-1})	Herbage (mg kg^{-1} in dry matter) August	Herbage (mg kg^{-1} in dry matter) Oct./Nov.
Copper				
Tamar Valley				
Contaminated alluvium	5	398	11.5	20.8
Contaminated upland	5	201	14.1	23.7
Control upland	6	39	8.7	15.1
Halkyn Mountain	14	34	10.6	9.7
Southend	12	25	8.1	16.4
Midhurst	10	15	10.0	10.1
Lead				
Tamar Valley				
Contaminated alluvium	5	413	5.5	23.0
Contaminated upland	5	387	6.7	20.0
Control upland	6	73	5.0	15.4
Halkyn Mountain	14	1456	20.0	33.3
Southend	12	63	9.2	20.3
Midhurst	10	42	6.1	11.4

table in peaty soils in eastern England, leading to the suggestion that Cu availability is lower when peat is dried than when it is moist (Caldwell, 1971). It has been observed in Britain that Cu deficiency is more severe in dry, sunny years than in dull, moist conditions (Caldwell, 1971).

2. Metal contaminants from mining and smelting

Usually the high concentrations of trace metals found in agricultural soils due to contamination from mining and other anthropogenic sources are only reflected in the herbage to a small degree (see Chapters 12 and 14). It would seem that either the metals are present in the soil in forms relatively unavailable for uptake or that uptake and/or translocation are limited by regulatory processes within the plant. This is illustrated in Table 8.5 for Cu and Pb at mine contaminated sites in the Tamar Valley (southwest England) and Halkyn Mountain (North Wales) areas and at several uncontaminated control sites (Thornton, 1980). Five- to tenfold enhancement of Cu in the soil is reflected by only a twofold rise in the Cu content of the pasture

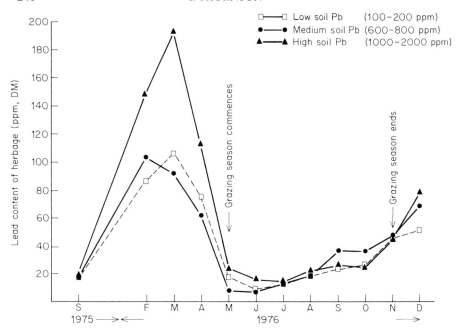

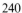

Fig. 8.2 Seasonal variations in the Pb contents of pasture herbage growing in contaminated and uncontaminated soils in Derbyshire.

herbage dry matter; the Pb content of pasture at the contaminated Tamar sites is only marginally higher than at the uncontaminated sites.

Marked seasonal effects on the Pb contents of grass has been previously noted (Mitchell and Reith, 1966). The practical significance of this variation is shown by comparisons between Pb contaminated and control soils in the Derbyshire mining areas, where herbage Pb contents are relatively low, irrespective of soil content, throughout the grazing season of cattle (Fig. 8.2). However, the marked seasonal rise in herbage Pb content in winter is a possible hazard to grazing sheep.

Some recent studies on Cd in the soil–plant system at Shipham (southwest England), where agricultural soils contain extremely elevated Cd and Zn levels due to past mining, clearly show the relatively small uptake of Cd by the grass *Holcus lanatus* and the decreasing concentration gradient from root to stem, etc. (Fig. 8.3) (Matthews and Thornton, 1982). Here, low rates of metal translocation within the grass gives some degree of protection to the grazing animal. Again of practical significance on contaminated land is the marked differences between metal uptake in different species within the same sward, illustrated for Cd in common pasture species at Shipham (Fig. 8.4). In this situation it obviously pays the farmer to keep his grassland free

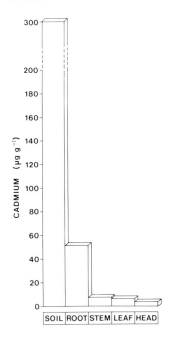

Fig. 8.3 An example of the cadmium content of soil and the root, stem, leaf and seed head of *Holcus lanatus* at Shipham, Somerset, an area heavily contaminated by past Zn mining (from Matthews and Thornton, 1982).

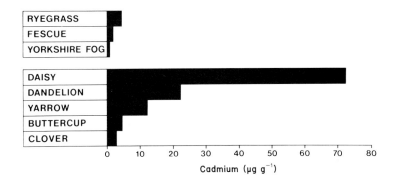

Fig. 8.4 Variations in the cadmium contents of the aerial parts of common pasture species growing in a contaminated soil at Shipham, Somerset.

from weed species such as dandelion, which may in some situations make a considerable contribution to cropped silage for instance.

The relation between trace elements in plants and amounts absorbed and utilized by the grazing animal is affected by various factors, including the proportion of grass in the animals' diet, digestability of the diet and other dietary trace element constituents, the form and the availability of the ingested trace elements. It is obvious that a dairy cow fed supplementary hay and mineral concentrates will reflect the natural geochemical environment to a lesser extent than young dairy followers, fattening beef animals or sheep that for the most part depend on the grass sward as their main diet source.

IV. Soil ingestion by grazing animals

In addition to grass, grazing livestock also involuntarily ingest soil, thus bypassing the soil–plant–animal pathway discussed in the previous section. Studies in Britain and in New Zealand have shown that cattle may ingest from 1 to over 10% of their dry matter intake in the form of soil, and up to 30% or more in sheep, which graze closer to the ground (Field and Purves, 1964; Healy, 1967, 1968, 1970; Thornton, 1974; Suttle *et al.*, 1975). The role of soil ingestion is thought to be of particular importance as a pathway of metals into the animals in areas where soils are contaminated with or contain naturally high concentrations of heavy metals. In addition, ingested soil may be important as a source of nutrients, possibly providing beneficial quantities of Co, Cu, Se and Zn (Healy, 1967; Healy *et al.*, 1970). It has been suggested that ingestion of a clay soil could supplement I in potentially goitrous grazing sheep in Tasmania (Statham and Bray, 1975).

Recent studies in old mining areas in Derbyshire and Cornwall have clearly demonstrated ingested soil to be an important pathway of both Pb and As into grazing cattle (Tables 8.6 and 8.7; Thornton and Kinniburgh, 1978; Thornton and Abrahams, 1981). In these studies soil ingestion was calculated using the Ti content of the animals' faeces as a stable marker. Titanium is present in relatively high concentrations in soil (several thousand ppm), and in very small amounts in herbage (usually less than 10 ppm). Soil ingestion was calculated, assuming a herbage digestability of 70% and a dietary intake of 13.6 kg day^{-1}, using the equation:

$$\% \text{ soil ingestion} = \frac{(1 - D_h)\text{Ti}_f}{\text{Ti}_s - D_h\text{Ti}_f} \times 100$$

where D_h = digestability of herbage, Ti_s = titanium in soil and Ti_f = titanium in herbage.

Table 8.6 Mean contribution of soil to total daily intake of Pb, Zn and Cu in eleven herds of cattle in Derbyshire, England

Farm type (based on soil Pb)	Mean % soil ingested	Soil content (μg g^{-1})			Total daily intake (mg day^{-1})			% element ingested as soil		
		Pb	Zn	Cu	Pb	Zn	Cu	Pb	Zn	Cu
100–500 μg g^{-1} Pb n = 4	2.9	276	87	19	289	590	134	40	6	6
600–1000 μg g^{-1} Pb n = 4	3.7	856	311	37	621	860	170	71	19	11
1000–4000 μg g^{-1} Pb n = 3	2.9	2942	287	39	1700	714	152	66	15	9

Table 8.7 Mean contribution of soil to total daily intake of As and Cu in eleven herds of cattle in Cornwall, England

Farm type (based on soil As)	Mean % soil ingested	Soil (μg g^{-1})		Faeces (μg g^{-1})		Total daily intake (mg day^{-1})		% Element ingested as soil	
		As	Cu	As	Cu	As	Cu	As	Cu
20–40 μg g^{-1} As n = 3	1.4	24	26	1.3	32	7	140	67	4
55–140 μg g^{-1} As n = 3	1.4	85	93	3.1	46	21	175	76	10
160–250 μg g^{-1} As n = 5	1.1	202	199	8.1	51	52	190	58	16

Table 8.8 Concentrations of lead in surface soils (0–15 cm) and bovine blood on 10
farms in the old Pb-mining district of Derbyshire

Soil Pb (ppm)	No. of farms	No. of cattle	Mean blood Pb (μg Pb/100 g blood)
95–440	4	60	11
520–670	2	30	13
980–5100	4	60	26

The contribution of soil to the total Pb intake of cattle on 11 farms studied in Derbyshire ranged from 9 to over 80% and on most of the farms exceeded 40%. Not surprisingly the higher values represented those farms where soils were most heavily contaminated. The contribution of soil to the intakes of Zn and Cu was less, ranging from 3 to 36% and 5 to 11%, respectively. This investigation also demonstrated a relationship between Pb in soil and blood Pb in cattle (Table 8.8) with approximately 10 μg Pb/100 ml blood on "low lead" farms (100–500 ppm Pb in soil) compared with 30 μg Pb/100 ml blood on "high lead" farms (1000–5000 ppm Pb in soil) (Thornton and Kinniburgh, 1978). As little soil Pb was reflected in the herbage (Fig. 8.2), this would seem to demonstrate that part of the lead ingested as soil was bioavailable.

In the Cornwall study, where rates of soil ingestion were fairly low, not exceeding 2% of the dry matter intake (Table 8.7), total intake of As ranged from 7 mg day^{-1} on low As soils to 52 mg day^{-1} on high As soils: the contribution of soil to the intake of As was large, exceeding 58% on each of the three groups of farms tested. On one farm, soil ingestion accounted for 90% of As intake in spring where the rate of soil ingestion was highest (Thornton and Abrahams, 1981). Soil ingestion is almost certainly largest in the winter months and in early spring, and in very dry summers when grass is in short supply.

The total daily intake of Pb and As in these two experiments was related to both the total soil content and to the amount of soil ingested. However, little is known about the "availability" to and absorption of soil-born metals by the animal. The former will depend on the chemical forms of the metals present, and the latter on other dietary constituents. Of course, much of the ingested metal is not available and is found in the animals' faeces, which, incidentally is an excellent indicator of the amount of metal ingested.

Indirect effects of soil ingestion have been shown under experimental conditions when sheep were fed with soil at 10% of their dry matter intake; soil reduced the availability of Cu supplemented to hypocupraemic ewes by 50%. This suggested that either the soil was occluding Cu in the alimentary tract or was releasing a Cu antagonist (Suttle *et al.*, 1975). Recent experimen-

tal work has led to the theory that Fe released from soil in the rumen inhibits the absorption of Cu (Suttle *et al.*, 1982); however, the actual mechanism involved still requires detailed study.

V. Trace element problems in crops and livestock and their relation to geology in Britain

The subjects of trace element deficiencies and toxicities related to the geology of Britain and of North America has been respectively reviewed by Thornton and Webb (1980) and Kubota (1980), and in this chapter will be limited to problems associated with Cu, Co, Mo and Se, with brief comments on the effects of those elements enriched in soils from minerali-zation, mining and smelting which are covered in more detail in Chapter 14.

1. Copper

Copper deficiency in crops (Caldwell, 1971) and grazing cattle and sheep (Russell and Duncan, 1956; Underwood, 1966) have been reported in many parts of the world; excess of the metal can give rise to toxicity in ruminants (Underwood, 1977). In Britain, Cu deficiency in cereals, which can lead to serious reductions in yield, was first reported on recently reclaimed peat in Norfolk (Pizer *et al.*, 1966) and has since been recorded on various soils derived from peaty, sandy and calcareous parent materials (Caldwell, 1971). Absolute Cu deficiency in cattle and sheep is not widely recognized in Britain, though it has been reported on sandy soils in parts of Scotland (Mitchell, 1974) and on soils developed from calcareous sands in Southern Australia.

Caldwell (1971, 1976) has mapped those areas of Cu deficiency in crops recognized by soil scientists of the Ministry of Agriculture (Fig. 8.5). He has also listed areas where deficiencies have been found on the basis of their underlying geology and susceptible soil series (Table 8.9).

Although the total Cu content of the soil has been successfully used to diagnose deficient soils developed from chalk in England (Davies *et al.*, 1971) and deficient sandy soils in southeast Scotland (Purves and Ragg, 1962), where total Cu values of 2 ppm or less are found, deficiency problems are often found in soils with more Cu. This is because part of the soil Cu may be present in forms that are not readily available to the plant. In particular it has been suggested that organically bound Cu is important for plant uptake; and EDTA has been shown to be a useful extractant for diagnostic purposes (Caldwell, 1976) and is widely used by the Agricultural

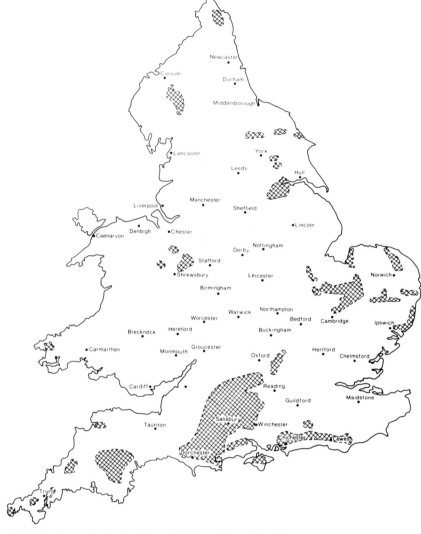

Fig. 8.5 Areas in England and Wales where Cu deficiency can occur in crops (reproduced from Caldwell, 1976, with the permission of the Controller of Her Majesty's Stationery Office).

Table 8.9 Geological formations and soil series susceptible to copper deficiency in crops*

Region	Geological formation	Soil series (examples)
Northern	Triassic sandstone	Bowscar
	Fell sandstone	—
	Lower calcareous grit	Firby
Yorks and Lancs	Fen-carr peat and raised moss	Altcar association
	Postglacial sands	
West Midlands	Alluvium	Gilberdyke
	Triassic sandstone	Grannymoor
East Midlands	Fen peat	Adventurers
Wales	Acid igneous	Ceiri
	Triassic sandstone	Crannymoor
Southwest	Granite head	Moretonhampstead
	Chalk	Icknield (organic phase)
	Upper greensand	—
Southeast	Chalk	Icknield (organic phase)
	Lower greensand	—
Eastern	Fen peat	Adventurers, Fordham
	Glacial sands	Prickwillow, Red Lodge, Freckenham

* Reproduced from Caldwell (1976) with the permission of the Controller of Her Majesty's Stationery Office.

Development and Advisory Service (ADAS) in Britain. However, on sandy, peaty and calcareous arable soils, a close correlation between "total" and EDTA-extractable Cu has been found ($r = 0.850$, $p < 0.001$; Jordan, 1975).

2. Cobalt

Cobalt deficiency in sheep, resulting from a deficiency of vitamin B_{12} of which Co is a part, gives rise to a debilitating disease known as "pine" or "pining" and was first recognized in Britain on soils developed from granite (Patterson, 1938). It has since been reported on soils developed from a range of acid igneous rocks, sandstones and limestones in England and Wales (Table 8.10) and on soils developed from granitic and arenaceous parent materials in parts of Scotland and the Orkney Islands (Mitchell et al., 1941, and several other authors). Cobalt deficiency in sheep and cattle occurs over extensive areas in many other countries (Young, 1979), including Australia, New Zealand, Brazil, USA and USSR, where the incidence and severity is determined by soil Co status (Underwood, 1981). Sheep are more susceptible than cattle.

Table 8.10 Soil parent materials associated with Co deficiency in livestock in England and Wales*

Geological origin of soil		Area
Acid igneous	Granite	Cornwall
	Rhyolite	Caernarvonshire
	Mixed	Anglesey, Caernarvonshire
Sandstones	Old Red Sandstone	Breconshire, Radnorshire, Herefordshire, Worcestershire, Shropshire
	Triassic sandstones	Cumberland
	Scottish calciferous sandstone	Northumberland
Limestones	Carboniferous	Yorkshire, Northumberland, Cumberland
	Oolites	Yorkshire, Gloucestershire
	Cornbrash	Oxfordshire
Shales	Silurian	Podzolic soils in Wales and
	Ordovician	Westmorland
Sands	Post-glacial	Yorkshire
	Brown sands	Anglesey
	Folkestone	West Sussex

* Reproduced from Archer (1971) with the permission of the Controller of Her Majesty's Stationery Office.

The critical minimum content of pasture, below which deficiency may be produced, is 0.07 ppm Co in the dry matter. Deficient herbage is usually limited to soils containing less than 5 ppm total Co, though a more reliable estimate of availability in Scottish soils has been demonstrated by extraction with dilute acetic acid (Mitchell, 1964). Cobalt availability to pasture is decreased by raising soil pH with lime, and uptake is favoured by poor soil drainage. Cobalt deficiency in livestock has been precipitated by the introduction of high yielding herbage plants in areas with soils marginally low in Co; this has recently been demonstrated with cattle on improved pastures in Malaysia, where the problem had previously not been recorded (Underwood, 1981).

3. Molybdenum

Molybdenum excess in soils may lead through the food chain to dietary excess in grazing animals. This, in turn, may cause molybdenosis or "teartness" in cattle with severe scouring or loss of condition (Ferguson *et al.*, 1943); moderate excess in the diet may cause depletion of Cu reserves in

the ruminant and Mo-induced deficiency, with symptoms of scouring, loss or change of coat colour, stunted growth, immaturity and unthriftiness. This conditioned Cu deficiency is caused by the antagonistic action of Mo on the usage of dietary Cu, which may be synergized by both organic and inorganic sources of dietary S as detailed by Mills (1979).

"Teartness" was first recognized in Britain on calcareous soils derived from the Lower Lias formation in Somerset, containing 20 ppm or more total Mo, on which pastures could contain as much as 20–100 ppm Mo in the dry matter (Ferguson et al., 1943; Lewis, 1943). The source of the Mo was found to be a zone of interbedded black shales and limestone at the base of the Lower Lias (Jurassic) formation (Le Riche, 1959). At about the same time a similar condition was reported in parts of California, on alluvial soils downstream of Mo mineralization. In New Zealand 10 ppm Mo or more in the pasture has been shown to be toxic to cattle if the Cu content is normal, with 3–10 ppm Mo harmful if Cu intake is low (Dick, 1969). In England and Wales, Mo induced Cu deficiency is often found when pastures contain 2 ppm Mo or more (Thornton, 1977), and it has been shown experimentally that at this dietary level Mo restricts the retention and storage of Cu in the liver (Suttle, 1977).

Swayback, a nervous disorder of lambs, characterized by incoordination of movement and high mortality, has also been associated with high Mo land and a low Cu:Mo ratio in the dry matter of winter herbage (Alloway, 1973); the disease has been experimentally produced by feeding diets high in Mo and sulphate to ewes of low Cu status (Suttle and Field, 1968). The biogeochemistry of Mo in Britain has been previously reviewed (Thornton, 1977) and several papers on Mo in soil and plants, and effects of dietary excesses on animals, have been published in the Proceedings of an International Symposium on Molybdenum in Environment (Chappell and Petersen, 1977).

In England and Wales soils developed from marine black shales ranging in age from Cambrian to Holocene may contain from 1–100 ppm Mo, while the majority of soils derived from other shales, sandstones and limestones contain less than 2 ppm Mo. In Scotland, high Mo has been associated with lacustrine facies sediments of the Middle Old Red Sandstone of Caithness and S.W. Orkney (IGS, 1979), with local anomalies associated with mineralization and with some granites (Plant and Moore, 1979).

Relationships between Mo in rocks, stream sediments, soils and plants have now been established for many parts of Britain, particularly those underlain by marine black shales; in many of these areas clinical hypocuprosis and/or low blood copper (perhaps indicating a sub-clinical problem) has been found. The wide distribution of low-blood Cu (hypocupraemia) in cattle is shown clearly in Fig. 8.6, in which over 1700 herds

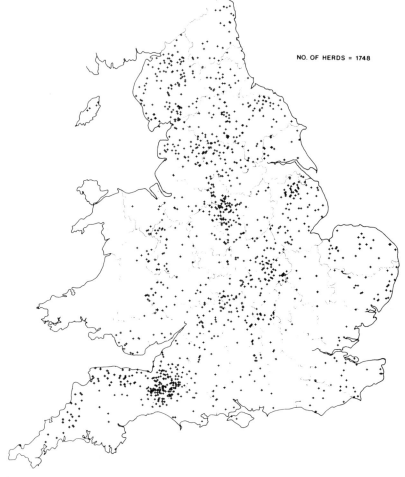

NO. OF HERDS = 1748

Fig. 8.6 Distribution of bovine hypocupraemia in 1748 herds in England and the Welsh borders, 1977–1980 (blood Cu levels of 0.05 mg/100 ml or less) (from Leech *et al.*, 1982).

were found to be "copper" deficient over the period 1977 to 1980, many of which were located in areas with molybdeniferous soils (Leech *et al.*, 1982).

Under UK conditions the availability of Mo to plants increases with soil pH over the range 4–8 and also with increasing organic carbon content and the degree of soil wetness (Mitchell, 1971; Thomson *et al.*, 1972). On the other hand, grass has been found to take up relatively large amounts of Mo from organic soils with low pH (Walsh *et al.*, 1953; Mitchell, 1964), and it has been suggested that organically bound Mo may be available to plants

over a wide pH range, perhaps reduced by organic matter to exchangeable cationic forms (Szalay, 1964, 1969). The use of empirical chemical extractants including ammonium oxalate, neutral N ammonium acetate and 0.05 M EDTA to diagnose "available" Mo levels has met with limited success. It is suggested that with the present state of knowledge, information based on the "total" Mo content of the soil, soil pH, organic matter content and drainage is likely to provide the most useful means of recognizing soils likely to give rise to Cu–Mo problems in grazing animals.

4. Selenium

Excess dietary Se was shown to be the cause of the acute conditions "alkali disease" and "blind staggers" in grazing animals in parts of North America in the 1930s, mostly confined to semi-arid regions and areas of impeded drainage (Frank, 1934; Lakin, 1973). In the Republic of Ireland, chronic selenosis in cattle has been reported on soils associated with Se-rich parent materials derived from marine black shales of Carboniferous age; these soils occur in small areas of Counties Limerick, Tipperary, Meath and Dublin and may contain as much as 30 to over 3000 ppm Se. Horses and cattle grazing pasture with more than 5 ppm Se (dry matter) have lost hair, shown abnormal growth of hooves and suffered from weight loss (Walsh et al., 1951; Fleming and Walsh, 1957). In England and Wales, Se-rich soils limited to areas underlain by marine shale facies of the Carboniferous in Staffordshire and Devon, and the Ordovician in Clwydd (Webb et al., 1966), have not as yet been associated with either acute or chronic selenosis in livestock.

An essential role for Se in animal nutrition has been known since the 1950s, and the dietary insufficiency may give rise to "white muscle disease" in grazing livestock. Selenium-responsive diseases in the US are discussed in Chapter 4, and their occurrence has been related to both the geology of soil parent materials and soil type (Kubota et al., 1967). In Scotland, response to Se supplementation in sheep has been recorded on soils developed from granitic and arenaceous parent materials (Blaxter, 1963; Mitchell, 1974).

In Britain a normal pasture level of Se is 0.06–0.08 ppm Se (dry matter) and white muscle disease is usually found when pasture levels are 0.03 ppm Se or below. The soil is generally considered to be the main supplier of Se to plants, and soil and plant levels have been related to those in soil parent materials in New Zealand (Andrews et al., 1968), the United States (Kubota et al., 1967) and Canada (Doyle and Fletcher, 1977). Although the geochemistry of the parent material plays a dominant role in determining the total Se content of the soil, this may be modified both by soil-forming factors, such

as podzolization, and by the biogeochemical cycling of Se, leading to an accumulation in the organic surface horizon.

A survey of blood glutathione peroxidase activity in sheep in Britain showed that nearly 50% of those animals tested were potentially Se deficient (Anderson *et al.*, 1979). This rather startling result led to the initiation of a range of investigations aimed at understanding the sources and behaviour of Se (and Vitamin E) in the rock–soil–plant–animal system. The possibility of a geochemical basis for Se-deficiency has been studied and the analysis of a wide range of soils representing major soil-forming parent materials is summarized in Table 8.11. It is seen that soils developed from sandstones and limestones in general contain less Se than those from shales and clays, with the largest values recorded for soils in mineralized areas and those of an organic nature (Thornton *et al.*, in press). However, the relationship between total Se in soil and that in pasture herbage requires detailed study and the forms of Se in soils will almost certainly influence plant uptake. Nye and Peterson (1975) have shown that selenite is the predominant form extracted from British soils and established a linear relationship between Se in several pasture species and both "total" Se and free selenite-Se in the soil. Recent studies have focused on soil factors that may influence the amounts of Se in the rooting zone and in particular podzolization would seem to lead to solubilization and removal of a significant proportion of Se from the surface horizons, with accumulation at depth in the soil profile (Fig. 8.1; Smith, 1983).

5. Elements associated with mineralization, mining and smelting

As indicated in Section II, the main source of metal contamination in the soils of England and Wales is historical mining and smelting; in addition, some metals in agricultural land originate from the natural weathering of underlying mineralized rocks or associated overburden. It is usually not possible to distinguish between this natural metal enhancement and that resulting from the mining, transport and processing of the ore minerals. This subject is discussed in detail in Chapter 14. In the present context, it is emphasized that under certain conditions of farm management, the contaminating elements may be hazardous to farm livestock, toxic to crop plants, and adversely affect the chemical composition of crop and animal products for human consumption. In Britain, one or more of the elements Cu, Cd, Pb, Zn, As and Hg may be enriched, sometimes by several orders of magnitude in mineralized areas. The areas of contaminated land are relatively large and probably total 4000 km² or more.

In practical farming terms, the effects are far from clearly understood,

Table 8.11 Concentrations of "total" Se in some surface soils (0–15 cm) in England and Wales

	Chalk	Lime-stone	Sand-stone	Clay	Mud-stone	Shale	Mineral-ized granite and shale	Peat	All soils
Number of samples	41	25	190	134	43	38	16	30	517
Se content, mean (μg g^{-1})	0.33	0.38	0.36	0.43	0.45	0.64	1.14	1.20	0.48

though toxicities to crops are probably limited to those of Cu or Zn in the immediate vicinity of old mine workings or waste tips and fatalities in farm livestock resulting from direct ingestion of ore minerals (particularly PbS and $PbCO_3$) when animals stray onto mine waste. However, sub-clinical effects are as yet undefined but may be more common. Raised blood Pb values in cattle grazing Pb contaminated land have already been mentioned earlier in this chapter, though there are no known adverse effects of this additional Pb burden on the health or production of the animals.

Soil and plant factors limiting the uptake of metals from the soil into plant roots and translocation from root to shoot are discussed in Chapters 4, 12 and 14 and earlier in this chapter; these, in a way, provide a natural barrier between the plant, the animal and its geochemical environment. It is, however, important to remember the direct soil:animal pathway for metal intake due to accidental ingestion of contaminated soil. It has been shown quite clearly that this direct soil:animal pathway could well be the most important route of metal intake by animals when soils are heavily contaminated.

6. Other elements

Boron, Mn and I are also worthy of mention in a discussion of geological effects on plant and animal health.

Boron deficiency in crops in Britain is most prevalent in eastern England on sandy soils with high pH and is also recognized on soils derived from a wide range of arenaceous coarse-grained parent materials (Farrer, 1976). In this case the "total" soil content of B is of little use in diagnosing deficient areas, as the element is mostly present in the rather insoluble mineral tourmaline; rather the hot-water soluble fraction is used (Batey, 1971).

Geological formations susceptible to Mn deficiency have been listed by Archer (1976), though deficiencies in crops have been found on various soils ranging from peats and sands to clays. Usually problems are induced by over-liming or are due to a naturally high soil pH which reduces Mn availability to plants. Most susceptible soils are peats, mineral soils with high organic matter content and cultivated podzols, where the pH is over 6.0 (Batey, 1971). Manganese deficiency in farm livestock in Britain has not as yet been fully proven, though if it does occur it will most likely be found on very sandy soils with low Mn content.

The relation between I_2 deficiency and endemic goitre in man is one of the few cases in which geochemistry and human health have been firmly causally established. However, in Britain it was recently concluded that as yet there is insufficient systematic data on I_2 in soils and pasture plants to

establish any regional patterns of distribution that may affect the health of farm livestock (Thornton and Webb, 1980). Soils contain more iodine than the rocks from which they were weathered, probably mainly due to sources of marine origin. Underwood (1966) concluded that low soil I_2 levels tend to be associated with (a) distance from the sea, (b) low annual rainfall (iodine is easily leached down the soil profile) and (c) recent glaciation in which I_2-enriched topsoils are removed. No comparisons have been made in Britain between geology and soil I_2 content, though peak levels have been found in marine alluvium (Whitehead, 1973).

VI. The application of regional geochemical mapping to problems of crop and animal health and production

As described in Chapter 2, regional geochemical maps of Britain have been widely used to define suspect areas of low and high trace element/heavy metal distribution, in which to concentrate more detailed, time consuming and costly investigations based on soil, plant and animal tissue. In particular, as well as confirming areas in which clinical deficiencies or toxicities are recognized in agricultural crops and grazing animals, maps have also proved useful in drawing attention to large areas in which sub-clinical problems may be found, and which may be of considerable economic significance. The maps also highlight areas where regional contamination with one or more heavy metals may affect the chemical composition and quality of food crops grown for human consumption.

1. Essential elements: Cu, Co, Mn and Zn

(a) *Copper*

The regional geochemical map for Cu (Chapter 2, Plate 2.1) confirmed most of the known areas of absolute deficiency in cereals in England and Wales (see Fig. 8.5). However, a number of low-Cu areas underlain by sandstones and other arenaceous materials were delineated where crop deficiencies (based on visual deficiency symptoms) are not recognized. Evidence for subclinical Cu deficiency resulting in yield reduction is conflicting, though field trials with barley in some of these areas have shown responses to foliar-application of Cu, ranging up to 20% even in the absence of visual deficiency symptoms (Jordan *et al.*, 1975). Recent trials reported by Tills and Alloway (1981, in press) indicated yield responses to applied copper of 21% for barley and 18% for sugar beet on sandy Breckland soils in East Anglia and nearly 16% for wheat on a humic rendzina in southern England.

There have been few systematic comparisons between levels of Cu in stream sediments and soils, though a good relationship was found between total Cu levels in stream sediment, total Cu in surface soil (0–15 cm) and EDTA-extractable Cu in soil in arable areas of east and southeast England (Fig. 8.7; Jordan et al., 1975). Further work is necessary to assess fully the significance of low Cu patterns in stream sediment in terms of subclinical Cu deficiencies in arable crops and in grazing livestock. Although the latter is intimately associated with concentration of Mo and possibly other elements in the diet, absolute deficiencies of Cu have been recognized in Britain and areas underlain by very low-Cu parent materials must be regarded as suspect. Geological formations associated with the lowest stream sediment Cu values are the Folkestone and Sandgate Beds of the Lower Greensand in Sussex, the Upper Greensand in Wiltshire and the Breckland Sands in Suffolk. In general, there is little livestock farming in these areas.

(b) Cobalt

Geochemical reconnaissance mapping in Co. Wicklow and Carlow, Eire, indicated a correlation between the Co content of stream sediment and the occurrence and severity of Co pine in sheep and cattle on soils derived from granite (Webb, 1964). More detailed studies over an area of 2600 km^2 in Devon and Cornwall showed patterns of low Co concentration (< 10 ppm) in stream sediments derived from granite on Dartmoor, reflecting soils of low Co status on which pining in sheep has been recognized for over 40 years (Fig. 8.8; Patterson, 1938; Thornton and Webb, 1970). Patterns of moderately low values (10–15 ppm Co) on Namurian and Westphalian rocks (previously called the Culm Measures) to the north and west of the granite indicate areas where pine is occasionally reported and where the problem may be present at a sub-clinical level. The Wolfson Geochemical Atlas has shown similar patterns of moderately low Co including an area underlain by Triassic drift in the Vale of Clwydd, North Wales, and areas underlain by sands and sandstones of the Bagshot Beds in Dorset, the Old Red Sandstone of the Welsh Borders, Devonian Sandstones in north Devon, the Bunter Sandstone in Derbyshire, and the Greensand in southern and southeast England. Cobalt deficiency in sheep is occasionally reported in some of these areas but has not been systematically investigated (Thornton and Webb, 1980).

(c) Manganese

Low patterns of Mn distribution in stream sediment are usually coincident with those of Co as the two elements behave in a similar geochemical

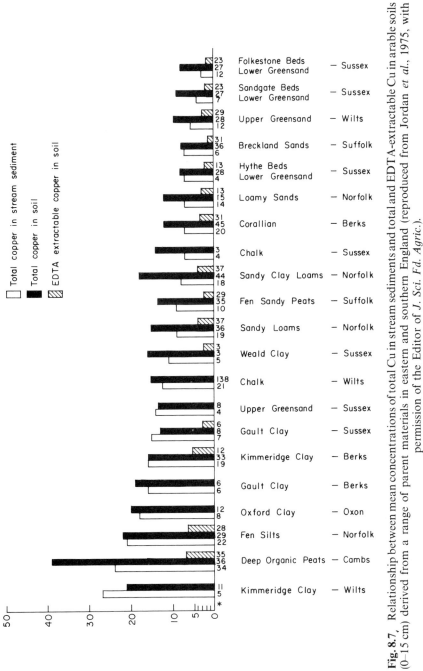

Fig. 8.7. Relationship between mean concentrations of total Cu in stream sediments and total and EDTA-extractable Cu in arable soils (0–15 cm) derived from a range of parent materials in eastern and southern England (reproduced from Jordan *et al.*, 1975, with permission of the Editor of *J. Sci. Fd. Agric.*).

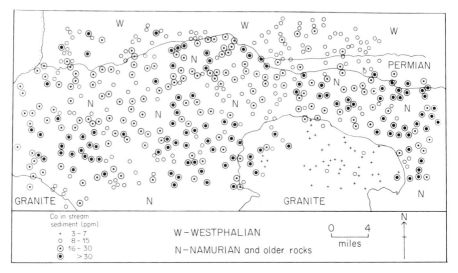

Fig. 8.8 Distribution of Co in stream sediment in parts of Devon and Cornwall.

fashion and tend to occur in association with one another in rocks and soils. Such patterns have been found over granite in Devon (< 300 ppm Mn) and on the Bagshot Beds in Dorset (< 100 ppm Mn). The interpretation of these patterns in terms of agriculture is complicated by the fact that Mn availability to crops and pasture is largely a function of soil pH, but it can be argued that deficiencies will occur if the total Mn content of the soil is low enough. Low levels of Mn in stream sediments and soils in parts of Devon have been associated with infertility problems in cattle attributed to Mn deficiency (Wilson, 1965; Thornton and Webb, 1970). Moderately low levels (< 500 ppm Mn) in stream sediments in the Vale of Clwyd have been associated with low concentrations of Mn in pasture herbage (30 to 70 ppm in dry matter) and unthriftiness in livestock (Thornton and Webb, 1970). In both these areas soils are deficient in both Mn and Co.

(d) *Zinc*

Although deficiencies of Zn are not as yet recognized in either field crops or grazing livestock in Britain, low concentrations in stream sediments coincide with patterns of low Cu, Co and Mn described in (a), (b) and (c) above. Soils in these areas may be regarded as suspect, particularly if subjected to intensive farming at some future date, and if the sensitive crop maize is grown (Alloway, 1976).

2. Naturally occurring toxic elements: Mo and Se

(a) Molybdenum

As described in Section V.3 of this chapter, dietary excess of Mo may lead to Mo poisoning or Mo-induced Cu deficiency in grazing cattle and may contribute towards the cause of swayback in sheep. Copper deficiency in cattle is of great economic significance and at a subclinical level is thought to be widespread and often undetected.

Geochemical reconnaissance in Britain has been particularly successful in focusing attention in areas where excess Mo in soils and herbage is causing agricultural problems. The geochemical map for England and Wales (see Chapter 2, Plate 2.2), indicates the considerable extent of high Mo areas which are a potential hazard. In several of these geochemically defined areas, relationships have been established between Mo in rock, stream sediment, soil and pasture, sometimes associated with clinical hypocuprosis in cattle (Table 8.12; Thomson et al., 1972).

The implication of stream sediment patterns of high Mo is clearly illustrated in a "case history" from Derbyshire and north Staffordshire. Here Mo anomalies in stream sediment led to the recognition of areas totalling 150 km² in which over 75% of the cattle were hypocupraemic but showed no clinical signs of hypocuprosis (Thornton et al., 1972). The problem areas were underlain by black Carboniferous shale, enriched in Mo, which weathered to form soils with 10 to 60 ppm Mo and herbage with 3 to 12 ppm Mo and 3 to 15 ppm Cu in the dry matter (Webb et al., 1968). On these soils young cattle responded to copper supplementation with live weight gains ranging from 14 to 32 kg per animal over a grazing season of six months. Similar high Mo areas occur widely in other parts of England and Wales, usually reflecting bedrock geology containing marine black shales (Webb et al., 1978), and have also been recently delineated by regional geochemical surveys of Scotland (IGS, 1979 and others). The distribution of herds of beef cattle with low Cu in Northern Ireland in part corresponded with low Cu and high Mo areas mapped by a geochemical survey of the province (Webb et al., 1973; Thompson and Todd, 1976).

(b) Selenium

The Wolfson Geochemical Atlas of England and Wales (Webb et al., 1978) does not include a map for Se in stream sediments, nor do the new geochemical atlases of Scotland compiled by IGS. However, geochemical reconnaissance in Eire has shown Se-high anomalies in surveys in Co. Limerick (Webb and Atkinson, 1965), where anomalously high Se patterns in the drainage reflected an outcrop of black marine shales with peak values

Table 8.12 Range and mean Mo content (ppm) of stream sediment, rock, soil and herbage in four areas of England and Wales
(Thomson *et al.*, 1972)

Area and source rock	Stream sediment	Rock	Soil depth (12 to 18 in.)	Pasture herbage	Bovine copper deficiency
Bowland Forest					
Black shale (Bowland Shale)	3–60	13 <2–40 (26)*	12 <2–85 (190)	2.9 0.8–7.2 (33)	Recognized in part of area
Other rocks (Carboniferous grey shales, limestones and sandstones)	<2	<2 <2–2 (10)	<2 <2–4 (89)	0.9 0.7–1.0 (5)	
Shaftesbury					
Black shale (Kimmeridge Clay and Oxford Clay)	3–13	12† (1)	4 <2–40 (105)	2.4 0.6–6.4 (35)	Not recognized
Other rocks (Jurassic calcareous clays, limestones and Cretaceous sandstones)	<2	<2 <2 (9)	<2 <2–5 (70)	0.7 0.2–2.4 (20)	
Bicester					
Black shale (Oxford Clay)	3–8	5 2–14 (15)	3 <2–8 (33)	1.7 1.0–2.4 (8)	Recognized in local districts, infertility reported
Other rocks (Jurassic calcareous clays, limestones and boulder clay)	<2	<2 <2 (13)	<2 <2 (122)	0.7 0.1–1.3 (37)	
Meidrim					
Black shale (Dicranograptus shales)	3–30	4 <2–7 (23)	7 <2–30 (66)	1.5 0.1–3.8 (32)	Not recognized
Other rocks (Ordovician grey shales, grits, flags)	<2	<2 <2 (13)	<2 <2–5 (63)	0.9 0.3–2.6 (15)	

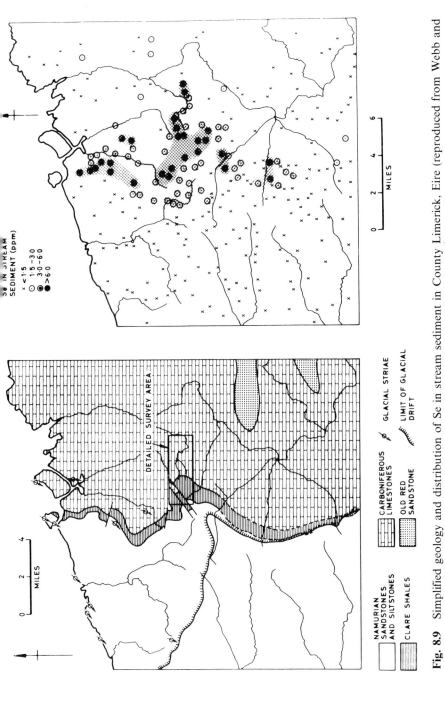

Fig. 8.9 Simplified geology and distribution of Se in stream sediment in County Limerick, Eire (reproduced from Webb and Atkinson, 1965, with permission of the Editor of *Nature*).

of 110 ppm Se in stream sediment near the shale outcrop (Fig. 8.9). Soils within this anomalous Se pattern were also high in Se, though toxic vegetation only occurred when seleniferous soils were poorly drained, organic and had a pH of over 5.5 (Webb and Atkinson, 1965). Thus interpretation of the stream sediment data for Se in relation to Se in pasture herbage can only be made with a detailed knowledge of the soils. This illustrates the complementary nature of geochemical and soil surveys.

3. Heavy metals in mineralized areas, usually enhanced by contamination due to mining and smelting: Pb, Zn, Cd, Cu and As

The Wolfson Geochemical Atlas highlights the principal mineralized areas in England and Wales, illustrated by the map for Pb (see Chapter 2, Fig. 2.13) and those for Cd and As (Figs. 2.14 and 2.15). Geochemical patterns reflecting mineralization, mining and smelting have been the subject of several interpretative studies in southwest England (Cu, As) (Colbourn et al., 1975; Thornton, 1975, 1980), North Wales (Cd, Pb, Zn) (Thoresby and Thornton, 1979), Derbyshire (Cb, Pb, Zn) (Colbourn, 1976; Colbourn and Thornton, 1978) and the Mendips (Marples and Thornton, 1980; Matthews and Thornton, 1982). In all these areas the metal anomalous patterns in stream sediment indicated that the majority (but not necessarily all) of the soils in the geochemically defined areas contained high concentrations of one or more metals, though these were found in grass and vegetable crops in only limited amounts. The geochemical maps indicate that somewhere in the region of 4000 km of agricultural land is contaminated in varying degrees. In Shipham, Somerset, Cd uptake by pasture plants is extremely species dependent, with common grasses and clover containing little toxic metal (Matthews and Thornton, 1982). Large amounts of As in soils in parts of Cornwall and Devon were taken up into grasses and the edible parts of vegetables in only small amounts (Thoresby and Thornton, 1979). However, both Cd and Pb are taken up and translocated to the edible portions of some vegetable crops (Davies, 1980) and vegetable growing in these contaminated soils should be viewed with caution. Although grass takes up little metal into its aerial parts, soil ingestion by grazing livestock presents an alternative and more important pathway for toxic metals in soils and mine spoil to the animal (see Section IV, this chapter).

VII. Conclusions

It is seen that deficiency and toxicity diseases in crops and farm animals are frequently related to geology and more precisely to the geochemical nature

of the soil forming parent material. This relationship is complicated by several factors at the soil–plant root, root–shoot, plant–animal interfaces, and in particular by the form and mobility of elements, and the presence of other interacting elements or ligands.

The relationship between grazing animals and the geochemical nature of their environment is strengthened by the fact that animals accidentally ingest soil, sometimes in large amounts. This ingested soil is an important pathway of toxic elements such as Pb and As into the animal and may also provide significant quantities of nutritionally essential elements such as Co and Se.

Regional geochemical maps, based on stream sediment sampling, which may be produced rapidly and at relatively low cost, have been shown to be valuable in defining areas where agricultural problems caused by trace element deficiency or heavy metal excess are located. This is particularly important where problems are of a sub-clinical or latent nature, and where they may be exacerbated with change in agricultural practice.

The interpretation of geochemical maps for agricultural use is complex and is best undertaken by a multidisciplinary team including a geochemist. For example, factors in the surface weathering environment, including the pH and E_h of soils and groundwaters, have a marked influence on the redistribution of elements and on their forms in both the soil profile and in the stream bed; where soil maps are available, they are complementary to geochemical maps and are of considerable practical use in the interpretation of the latter.

Finally, although most examples quoted in this chapter are from research experience in Britain, it must be emphasized that the major potential for the future applications of geochemical surveys to agriculture will be in the developing parts of the world, where knowledge of soils and geology often lacks detail and where the need for increased food production is of paramount importance.

Acknowledgements

Examples are cited from the continuing research programme of the Applied Geochemistry Research Group funded by the Agricultural Research Council; the author is grateful to many postgraduate students and colleagues who have contributed to this work.

References

Alloway, B. J. (1973). *J. Agric. Sci., Camb.* **80**, 521–524.
Alloway, B. J. (1976). *J. Agric. Sci., Camb.* **86**, 93–101.

Anderson, P. H., Berrett, S. and Patterson, B. S. T. (1979). *Vet. Rec.* **104**, 235.
Andrews, E. D., Hartley, W. J. and Grant, A. R. (1968). *N.Z. Vet. J.* **16**, 3–17.
Archer, F. C. (1971). *In* "Trace Elements in Soils and Crops", Ministry of Agriculture, Fisheries and Food Tech. Bull. 21, pp. 150–158. HMSO, London.
Batey, T. (1971). *In* "Trace Elements in Soils and Crops", Ministry of Agriculture, Fisheries and Food Tech. Bull. 21, pp. 137–149. HMSO, London.
Blaxter, K. L. (1963). *Br. J. Nutr.* **17**, 105.
Caldwell, T. H. (1971). *In* "Trace Elements in Soils and Crops", Ministry of Agriculture, Fisheries and Food Tech. Bull. 21, pp. 62–87. HMSO, London.
Caldwell, T. H. (1976). *In* "Trace Element Deficiencies in Crops", ADAS Advisory Paper No. 17, pp. 12–21. HMSO, London.
Cannon, H. L., Connally, G. G., Epstein, G. B., Parker, J. G., Thornton, I. and Wixson, B. G. (1978). *In* "Geochemistry and the Environment", Vol. III, pp. 17–31. National Academy of Sciences, Washington, DC.
Chappell, W. R. and Petersen, K. K. (eds) (1977). "Molybdenum in the Environment". Marcel Dekker, New York and Basel.
Colbourn, P. (1976). "The Applications of Geochemical Reconnaissance Data to Trace Metal Pollution in Agriculture". Unpublished Ph.D. Thesis, University of London.
Colbourn, P. and Thornton, I. (1978). *J. Soil Sci.* **29**, 513–526.
Colbourn, P., Alloway, B. J. and Thornton, I. (1975). *Sci. Total Environ.* **4**, 359–363.
Davies, B. E. (1980). *In* "Inorganic Pollution and Agriculture", Ministry of Agriculture, Fisheries and Food Reference Book 326, pp. 142–156. HMSO, London.
Davies, D. B., Hooper, L. J., Charlesworth, R. R., Little, R. C., Evans, C. and Wilkinson, B. (1971). *In* "Trace Elements in Soils and Crops", Ministry of Agriculture, Fisheries and Food Tech. Bull. 21, pp. 88–118. HMSO, London.
Dick, A. T. (1969). *Outlook on Agriculture* **6**, 14–28.
Doyle, P. J. and Fletcher, W. K. (1977). *Can. J. Plant. Sci.* **57**, 859.
Farrer, K. (1976). *In* "Trace Element Deficiencies in Crops", ADAS Advisory Paper No. 17, pp. 1–12. HMSO, London.
Ferguson, W. S., Lewis, A. H. and Watson, S. J. (1943). *J. Agric. Sci.* **33**, 44–51.
Field, A. C. and Purves, D. (1964). *Proc. Nutr. Soc.* **23**, 24–25.
Fleming, G. A. and Walsh T. (1957). *R. Irish Acad. Proc. Sect. B58*, 151–166.
Frank, K. W. (1934). *J. Nutr.* **8**, 597.
Hawkes, H. E. and Webb, J. S. (1962). "Geochemistry in Mineral Exploration", 415pp. Harper and Row, New York and Evanston.
Healy, W. B. (1967). *Proc. N.Z. Soc. Animal Production* **27**, 109–120.
Healy, W. S. (1968). *N.Z. J. Agric. Res.* **11**, 487–499.
Healy, W. B. (1970). *Proc. N.Z. Soc. Animal Production* **30**, 11–19.
Healy, W. B., McCabe, W. J. and Wilson, G. F. (1970). *N.Z. J. Agric. Res.* **13**, 503–521.
Henkens, C. H. (1957). *Landbouwvoorlichting* **14**, 581–589.
Institute of Geological Sciences (1979). "Geochemical Atlas of Great Britain: South Orkney and Caithness". IGS, London.
Jordan, W. J. (1975). "The Application of Regional Geochemical Reconnaissance to Arable Cropping in England and Wales". Unpublished Ph.D. Thesis, University of London.
Jordan, W. L., Alloway, B. J. and Thornton, I. (1975). *J. Sci. Fd. Agric.* **26**, 1413–1424.
Kubota, J. (1980). *In* "Applied Soil Trace Elements" (Davies, B. E., ed.), pp. 441–466. Wiley, Chichester.
Kubota, J., Lemon, E. R. and Allaway, W. H. (1963). *Soil Sci. Soc. Am. Proc.* **27**, 679–682.
Kubota, J., Allaway, W. H., Carter, D. L., Carz, E. E. and Lazar, V. A. (1967). *J. Agric. Fd. Chem.* **15**, 448.
Lakin, H. W. (1973). *In* "Trace Elements in the Environment", Advances in Chemistry Series, No. 123, pp. 96–111. American Chemical Society, Washington, DC.
Leech, A., Howarth, R. J., Thornton, I. and Lewis, G. (1982). *Vet. Rec.* **111**, 203–204.
Le Riche, H. H. (1959). *J. Soil Sci.* **10**, 133.
Levinson, A. A. (1974). "Introduction fo Exploration Geochemistry", 611pp. Applied Publishing Ltd, Calgary.

Lewis, A. H. (1943). *J. Agric. Sci., Camb.* **33**, 52–57.

Lindsay, W. L. (1972). *In* "Micronutrients in Agriculture", pp. 41–57. Soil Science Society of America, Madison, Wisconsin.

Marples, A. E. (1979). "The Occurrence and Behaviour of Cadmium in Soils and its Uptake in Pasture Grasses in Industrially Contaminated and Naturally Metal-rich Environments". Unpublished Ph.D. Thesis, University of London.

Marples, A. E. and Thornton, I. (1980). *In* "Proceedings of the 2nd International Cadmium Conference, Cannes (1974)". Metal Bulletin Ltd, London.

Matthews, H. and Thornton, I. (1982). *Plant and Soil* **66**, 181–193.

Mengel, K. and Kirkby, E. A. (1978). "Principles of Plant Nutrition". International Potash Institute, Worblanfen, Bern.

Mercer, E. R. and Richmond, J. L. (1970). "Fate of Nutrients in Soil: Copper". Letcombe Laboratory Annual Report, 9.

Mertz, W. (1974). *Proc. Nutr. Soc.* **33**, 307–313.

Mills, C. F. (1979). *Phil. Trans. R. Soc. Lond.* **B288**, 51–63.

Mitchell, R. L. (1964). *In* "Chemistry of the Soil" (Bear, F. E., ed.), 2nd edn, pp. 320–368. Reinhold, New York.

Mitchell, R. L. (1971). *In* "Trace Elements in Soils and Crops", Ministry of Agriculture, Fisheries and Food Tech. Bull. 21, pp. 8–20. HMSO, London.

Mitchell, R. L. (1974). *Neth. J. Agric. Sci.* **22**, 295–304.

Mitchell, R. L. and Burridge, J. C. (1979). *Phil. Trans. R. Soc. Lond.* **B288**, 15–24.

Mitchell, R. L. and Reith, J. W. S. (1966). *J. Sci. Fd. Agric.* **17**, 437–440.

Mitchell, R. L., Scott, R. O., Stewart, A. B. and Stewart, J. (1941). *Nature, Lond.* **148**, 725.

Nye, S. M. and Peterson, P. J. (1975). *In* "Trace Substances in Environmental Health", vol. IX (Hemphill, D. D., ed.), pp. 113–121. University of Missouri, Columbia, Missouri.

Patterson, J. B. E. (1938). *Emp. J. Expt. Agric.* **6**, 262–267.

Pizer, N. H., Caldwell, T. H., Burgess, G. R. and Jones, J. L. O. (1966). *J. Agric. Sci., Camb.* **66**, 303–314.

Plant, J. and Moore, P. J. (1979). *Phil. Trans. R. Soc. Lond.* **B288**, 95–112.

Purves, D. (1977). "Trace-Element Contamination of the Environment", 260pp. Elsevier Scientific Publishing Co., Amsterdam.

Purves, D. and Ragg, J. M. (1962). *J. Soil Sci.* **13**, 241–246.

Russell, F. C. and Duncan, D. L. (1956). "Minerals in Pasture: Deficiencies and Excesses in Relation to Animal Health", Animal Nutrition Tech. Commun. No. 15, 2nd edn. Commonwealth Bureau, London.

Seigel, F. R. (1974). "Applied Geochemistry", 353pp. Wiley, New York.

Smith, C. (1983). "The Distribution of Selenium in some Soils Developed on Silurian, Carboniferous and Cretaceous Systems in England and Wales". Unpublished Ph.D. Thesis, University of London.

Statham, M. and Bray, A. C. (1975). *Aust. J. Agric. Res.* **26**, 751–768.

Suttle, N. F. (1977). *Anim. Feed Sci. Technol.* **2**, 235–246.

Suttle, N. F. and Field, A. C. (1968). *J. Comp. Path.* **78**, 351–362.

Suttle, N. F., Alloway, B. J. and Thornton, I. (1975). *J. Agric. Sci., Camb.* **84**, 249–254.

Suttle, N. F., Abrahams, P. W. and Thornton, I. (1982). *Proc. Nutr. Soc.* **41**, 83A.

Swaine, D. J. and Mitchell, R. L. (1960). *J. Soil Sci.* **11**, 347–368.

Szalay, A. (1964). *Geochim. Cosmochim. Acta* **28**, 1605–1614.

Szalay, A. (1969). *Arkw. Mineraologi. Geologi.* **5**, 23–36.

Thompson, R. H. and Todd, J. R. (1976). *Br. J. Nutr.* **36**, 299–303.

Thomson, I., Thornton, I. and Webb, J. S. (1972). *J. Sci. Fd. Agric.* **23**, 781–891.

Thoresby, P. and Thornton, I. (1979). *In* "Trace Substances in Environmental Health" (Hemphill, D. D., ed.), vol. XIII. University of Missouri, Columbia, USA.

Thornton, I. (1974). *In* "Trace Element Metabolism in Animals", 2nd edn (Hoekstra, W. G., *et al.*, eds.), pp. 451–454. University Park Press, Baltimore.

Thornton, I. (1975). *In* "Minerals and the Environment" (Jones, M. J., ed.), pp. 87–102. Institution of Mining and Metallurgy, London.

Thornton, I. (1977). *In* "Molybdenum in the Environment", vol. 2 (Chappell, W. R. and Petersen,

K. K., eds.), pp. 341–369. Marcel Dekker, New York and Basel.

Thornton, I. (1980). *In* "Inorganic Pollution and Agriculture". Ministry of Agriculture, Fisheries and Food Reference Book 326, pp. 105–125. HMSO, London.

Thornton, I. and Abrahams, P. W. (1981). *In* "Trace Substances in Environmental Health", vol. XV (Hemphill, D. D., ed.). University of Missouri, Columbia, USA.

Thornton, I. and Kinniburgh, D. G. (1978). *In* "Trace Element Metabolism in Animals", vol. 3 (Kirchgessner, M., ed.), p. 499. Institut fur Ernahrungsphyiologie Technische Universitat, Munchen.

Thornton, I. and Webb, J. S. (1970). *In* "Trace Element Metabolism in Animals", Proc. WAAP/IBP International Symposium (Mills, C. F., ed.), pp. 397–407. Livingston, London.

Thornton, I. and Webb, J. S. (1980). *In* "Applied Soil Trace Elements" (Davies, B. E., ed.), pp. 381–439. Wiley, Chichester.

Thornton, I., Kershaw, G. F. and Davies, M. K. (1972). *J. Agric. Sci.* **78**, 157–171.

Thornton, I., Kinniburgh, D. G., Abrahams, P., Gay, C., Rundle, S., Pullen, G. and Smith, C. (In press). *J. Sci. Fd. Agric.*

Tills, A. R. and Alloway, B. J. (1981). *J. Agric. Sci., Camb.* **97**, 473–476.

Tills, A. R. and Alloway, B. J. (In press). *J. Sci. Fd. Agric.*

Tinker, B. (1981). *Phil. Trans. R. Soc. Lond.* **B294**, 41–55.

Underwood, E. J. (1966). "The Mineral Nutrition of Livestock", 237 pp. Commonwealth Agricultural Bureau and FAO.

Underwood, E. J. (1977). "Trace Elements in Human and Animal Nutrition", 4th edn. Academic Press, New York and London.

Underwood, E. J. (1981). *Phil. Trans. R. Soc. Lond.* **B294**, 3–8.

Walsh, T., Fleming, G. A., O'Connor, R. and Sweeney, A. (1951). *Nature, Lond.* **168**, 881.

Walsh, T., Neenan, M. and O'Moore, L. B. (1953). *Nature, Lond.* **171**, 1120.

Webb, J. S. (1964). *New Scient.* **23**, 504–507.

Webb, J. S. and Atkinson, W. J. (1965). *Nature, Lond.* **208**, 1056.

Webb, J. S., Thornton, I. and Fletcher, W. K. (1966). *Nature, Lond.* **211**, 327.

Webb, J. S., Thornton, I. and Fletcher, W. K. (1968). *Nature, Lond.* **217**, 1010–1012.

Webb, J. S., Nichol, I., Foster, R., Lowenstein, P. L. and Howarth, R. J. (1973). "Provisional Geochemical Atlas of Northern Ireland", 36pp. Applied Geochemistry Research Group, Imperial College of Science and Technology, London.

Webb, J. S., Thornton, I., Thompson, M., Howarth, R. J. and Lowenstein, P. L. (1978). "The Wolfson Geochemical Atlas of England and Wales", 70pp. Clarendon Press, Oxford.

West, T. (1981). *Phil. Trans. R. Soc. Lond.* **B294**, 19–39.

Whitehead, D. C. (1973). *J. Soil. Sci.* **24**, 260–270.

Wilson, J. G. (1965). *Vet. Rec.* **77**, 489.

Wood, P. (1975). "Regional Geochemical Studies in Relation to Agriculture in Areas Underlain by Sandstones". Unpublished Ph.D. Thesis, University of London.

Young, R. S. (1979). "Cobalt in Biology and Biochemistry", 147pp. Academic Press, London and New York.

9

Geochemistry and Man:
Health and Disease
1. Essential Elements

ROBERT G. CROUNSE, WALTER J. PORIES,
JOHN T. BRAY and RICHARD L. MAUGER

The trace elements are more important to life than the vitamins, (because) they cannot be synthesized, as can the vitamins, but must be present in the environment within a relatively narrow range of concentration ... Their only sources are the earth's crust and sea water, and without them life would cease to exist.

Schroeder, H. (1965). *J. Chronic Dis.* **18**, 217–228.

I. Introduction

A direct relationship between geochemistry and human health is highly plausible, potentially exciting, repeatedly tantalizing and to date rarely proven. Such a relationship is plausible, if only because many elements of the earth's crust are essential to biochemical and physiological function. It is potentially exciting because proper amounts of several elements may help prevent several kinds of disorders now of intense interest, such as some cancers and some types of cardiovascular disease. It is tantalizing because controlled animal experiments repeatedly demonstrate such effects. Yet such a direct relationship between geochemistry and health has rarely been proven in man, largely because the number of variables is legion, human experiments are difficult to arrange and conduct and epidemiologic evidence seldom proves causality.

Condensed consideration of geochemistry and health in this and the

APPLIED ENVIRONMENTAL GEOCHEMISTRY
ISBN 0-12-690640-8

following chapter requires a restrictive definition of terms. Concentrative and processing geochemical procedures, such as smelting of ores, that give rise to serious on-site occupational health threats will not be emphasized, since they do not represent average or ambient relationships between geochemical features and man but are rather civilization induced perturbations of natural relationships. Similarly, the indirect effects of climatologic and geographic features, such as elevation above sea level, latitude and rainfall (which influence such indirect events ᴀₛ ᵢₙₛₑct vectors of infectious disease) are not included, but are considered in relation to their direct influence on soil types, availability of elements to the human food chain, drinking water content and the like. Thus, the main emphasis in these chapters is on direct interactions between man and the chemical constituents of his immediate natural geologic environment.

There exists no central dogma that purports to explain the function of all elements, or all "essential" or "trace" elements in living tissues. It is plausible to construct, however, a blanket-like hypothesis with more than a single thread. On the one hand are the anions and cations in extracellular fluids that maintain a sea-water-like milieu of balanced proportions creating an·internalized environment enabling vertebrates to survive in dry terrestrial surroundings. A host of elements derived necessarily from the earth's crust, which serve various electron or charge transfer functions necessary for biologic life, are extensively compartmentalized within living cells. The compartmentalization may be anatomic in the traditional sub-cellular sense (organelles, membranes, cytoskeletons) or macromolecular, as in the molecular internalization in enzymes, in transport or detoxifying molecules. Thus the living organism can select, transport and compartmentalize those elements that serve critical oxidation–reduction, catalytic or binding functions while guarding against biologically toxic interactions. The ubiquitous and vital functionings of Fe, for example, can then be used without permitting (quite literally) rust to form internally; or, on the other hand, macromolecules can sequester Fe in a manner such that the Fe is less available for optimal nurture of invading organisms. Such mechanisms are rarely overcome unless nutrient sources are unusually unbalanced, disease states interfere with evolutionary mechanisms to preserve an equilibrium with the environment, or commercial and civilization-induced perturbations exceed by some magnitude these mechanisms. In essence, many biochemical mechanisms are in place to permit inorganic reactions while limiting toxicity from uncontrolled interactions.

No convincing systematic relationship between the periodic table of elements and human requirements has yet been documented, though several attempts have been recorded. It is true that no element above atomic number 53 has yet been shown to be essential, though several are under

consideration. The terms "trace element", "essential", "mineral", "heavy metal" and so on are used with an imprecision that may surprise analytic and earth scientists. Some distinguish macroelement from microelement dependent upon large vs small amounts in body fluids or tissues; for example, Na, K, Ca and P are termed "macro", and Cu, Zn, Mo, etc., as "micro". Yet Zn is present in humans in gram amounts only a little less than Fe. It is best simply to refer to each element by name, recognizing even then that chemical speciation of each element will ultimately be critical to understanding biologic interactions. It is of seeming importance, however, to define "essential" with more care. The intent is to convey essentiality of a given element to normal functioning in man (though all known essential elements can also be toxic in larger amounts). Presumably the absence, or more likely deficiency, of an essential element will result in some disordered human function, which can be restored to normal by providing an appropriate amount and correct chemical species of that element.

Many elements were first shown to be essential in plants or animals, either by deficiency observed in the field or by purposeful experimentation with synthetic diets. One interesting notion is that essential elements are regulated by some metabolic means to within certain equilibrium amounts in animals and man, whereas non-essential elements are not so regulated and may simply be stored in ever-increasing amounts in some tissues. However, even Fe, a well regulated and critically essential element, can under some circumstances be overloaded in man (for instance, from multiple blood transfusions) leading to pathologic conditions. By and large, the essential trace elements, that is those present in relatively small amounts in fluids/ tissues, are believed to function primarily as integral parts of enzymes. However, there is increasing evidence that cell surface events, be they membrane functions, membrane integrity, cell–cell interactions or hormone–receptor affinities, are also strongly influenced by several elements. It is likely that most or all essential elements act by amplification of regulatory reactions in body chemistry (Mertz, 1981) thus explaining their enormous influence even in trace amounts. Obviously involvement of a given element in many different functions simultaneously will be reflected in a multiplicity of signs or symptoms when that element is deficient, rendering discovery of individual deficiencies quite difficult (as in the case of vitamin deficiencies). It must be remembered also that a given element conceivably can be (and many elements are) essential, therapeutic, toxic and/or carcinogenic–mutagenic depending upon their concentration and chemical form.

If this review was limited to proven direct causal relationships between man's health and the elements in his immediate environment, only I, F, Se and As would be considered together with brief notes on industrially derived

exposure to known toxic elements. Populations living in geographic areas whose surface soils are deficient in I have a very high prevalence of enlarged thyroid glands (goitre); addition of I to the diet (for example, as NaI in table salt) can reduce this occurrence dramatically. Fluorine (as fluoride) in correct amounts reduces dental decay. Children supplemented with tiny doses of Se in the soil-Se deficient areas of certain provinces in China reportedly are prevented from developing (and dying from) a peculiar myocarditis. Nearly 100% of individuals drinking water from As-contaminated wells in Taiwan develop signs of As toxicity or carcinogenesis. Most of the rest of the story of geochemistry and human health is suggestion, hypothesis, speculation and conjecture. This review attempts to acquaint the reader with current hypotheses and data that suggest the importance of geochemistry to health. References have been limited as far as possible to recent texts, chapters and review articles to provide convenient indirect access to the thousands of pertinent articles for the motivated reader. The elements will be grouped according to the categories defined by the National Academy of Sciences, Recommended Dietary Allowances slightly modified (Anderson, 1977a) as follows:

In this chapter

 A. Essential macronutrients (100 mg day^{-1} or more are needed):
 Ca, Cl, Mg, P, K, Na, S
 B. Essential micronutrients (no more than a few mg day^{-1} needed):
 Cr, Co, Cu, F, I, Fe, Mn, Mo, Se, Zn

In Chapter 10

 A. Micronutrients that are likely to be essential:
 Ni, Si, Sn, V
 B. Trace contaminants (though some of these are being investigated for possible essentiality):
 Al, As, Cd, Pb, Hg
 C. Others:
 Sb, Ba, Be, Bo, Br, Li, Rb, Ag, Sr, Ti

II. Essential macronutrients

The essential macroelements are reviewed even though geochemical implications are relatively minor. The reason for doing this is to provide for the reader consideration, albeit highly condensed, of *all* elements important to man, to provide perspective on which elements are and are not of geochemi-

cal importance to man's health. The careful homeostatic regulation of those macroelements so important in water and electrolyte balance are believed to be an evolutionary adaptation by which vertebrates were enabled to leave the sea in favour of a terrestrial existence. It is perhaps not so surprising then that internal homeostatic mechanisms relegate terrestrial availability of these elements to a minor role; potential exceptions will be noted.

1. Calcium

Calcium is a critical element in all animals and man. A healthy human adult contains about 1.25 kg Ca, of which 99% is deposited as phosphates resembling the mineral hydroxyapatite, $Ca_{10}(PO_4)_6(OH)_2$, in bones and teeth. The small remainder is in body and cellular fluids, partly ionized, partly protein bound (Anderson, 1977b). Calcium homeostasis is regulated very tightly by controlled gastrointestinal absorption, renal excretion, and bone deposition–resorption (DeLuca, 1980). The parathyroid gland via the peptide parathormone, the thyroid gland via the hormonal peptide calcitonin and the active vitamin metabolite $1,25(OH)_2D_3$ derived from ultraviolet activation of α-dehydrocholesterol in the skin or from vitamin D_2 (ergosterol) in dietary plant materials, all interact to maintain Ca homeostasis.

The prime dietary source of Ca is milk (65–75%), with smaller amounts derived from meat, fish and eggs (5–10%), and still less from non-dairy foods such as nuts, fruits, beans, etc. (Parfitt and Kleerekoper, 1980). Hard water may contain up to 3 mmol l^{-1} of Ca (mainly bicarbonate) compared with an average daily intake of Ca in the United States of 25 mmol (mM); thus water will not normally constitute a major source of Ca intake (see also Section V in Chapter 10).

Dietary deficiency of Ca is not a common problem in nations with high dairy product and protein intake, particularly since normal individuals can regulate intestinal absorption and renal conservation mechanisms with great precision. Hence, human health problems related to geochemical distribution of Ca, its entry into the human food chain and its bioavailability are relatively uncommon. Exceptions include very poor diets (such as those low in milk and animal proteins) or unusual physiologic requirements (periods of very rapid growth, pregnancy, the menopause or other illness, such as intestinal malabsorption). Most human disorders of Ca metabolism relate to endocrine abnormalities or vitamin D deficiency, for example, rickets in children and osteomalacia or osteoporosis in adults. Postmenopausal osteoporisis appears to relate to under production of $1,25(OH)_2D_3$ (DeLuca, 1980). Major reduction in overall dietary intake from whatever cause can

drop dietary Ca to well below the US Recommended Dietary Allowances (RDA); an estimated 400 mg day^{-1} on a 1000 calorie diet (Harland *et al.*, 1980). In such circumstances, decreased plant uptake from acidic soils or very sandy soils (Beeson, 1978), or decreased amounts of Ca in soft water supplies might contribute to deficiency.

However, dietary Ca may be very important in relationship to its interactions with other elements, not only P but also Cd, F, Sr and Pb, which are potentially toxic to humans. The extraordinary example of "Itai-Itai" disease in Japan, secondary to Cd-induced osteomalacia (softening of the bones), plus renal tubular damage, lent dramatic evidence to the experimental observations of enhanced Cd retention secondary to low dietary Ca (Calabresi, 1981a). Affected Japanese women were found to have low dietary Ca and vitamin D (Emmerson, 1970). Excessive Cd probably both inhibits Ca absorption in the gastrointestinal (GI) tract (Kazantzis, 1979) and increases Ca excretion in the urine (Ingersell and Wasserman, 1971), which contributed to the osteomalacia seen in Itai-Itai disease. The source of the Cd was contaminated rice grown in water polluted by a mine many miles upstream, resulting in daily Cd intake up to 300 μg or more, compared with an average 50 μg day^{-1} in other parts of the world (Prasad, 1978a).

Low dietary Ca in various animal species also enhances gastrointestinal absorption of F, though human evidence is controversial. Since excessive F can cause teeth (and bone) "mottling", the widespread practice of fluoridating drinking water might have been expected to spur major additional human investigations. It is strongly suggested that further research is needed, especially in those parts of the world where mottled tooth enamel (fluorosis) is endemic (Calabresi, 1981a).

In this "atomic" age, possible health hazards associated with contamination of the biosphere with ^{90}Sr have caused much concern. Strontium-90 is handled metabolically much like Ca, and is known to enter the human food chain in shellfish, plants, animals, milk and drinking water; human intestinal absorption of Sr (including ^{90}Sr) is reported to be inversely related to Ca intake (Nordin *et al.*, 1967; Hodgkinson *et al.*, 1967). Since children especially would be subject to increased deposition of Sr in association with rapid growth and new bone formation, Ca supplementation as a means of decreasing body Sr deserves at least consideration.

Since the issue of Pb toxicity in humans remains an international concern, the known ability of Ca (and P) to diminish Pb absorption might have received more attention; some (Six and Goyer, 1970) speculate that development of chelating agents such as ethylenediaminetetra-acetic acid (EDTA) for treatment of Pb poisoning resulted in decreased interest in the Ca effect. Calcium in the diet, although potentially preventive, is apparently of little value in releasing

Pb already stored in bones (Quarterman *et al.*, 1978). Thus, though the geochemical distribution and bioavailability of Ca seems of relatively minor importance as a direct cause of human illness, combinations of poor diet, individual disease processes and local exposures to toxic elements via environmental sources might be of special importance where low levels of Ca in diet or drinking water (or extensive use of water softeners) are known to exist.

2. Chlorine

Chlorine gas is a highly corrosive and irritating substance; exposure to the gas as a by-product of industry or secondary to transportation accidents is extremely dangerous.

Chlorine as the Cl^- anion, on the other hand, is a major constituent of the electrolytes in body tissues and fluids. A 70 kg man contains about 82 g (2300 meq) Cl (Anderson, 1977a) of which about 91% is exchangeable (i.e., in dynamic exchange equilibrium). Along with other major electrolytes (Na, K, HCO_3^-) Cl is essential in water balance, acid–base equilibrium and osmotic pressure regulation. The major dietary source is NaCl (salt). There are no human health implications of the geochemistry of Cl as long as salt is available (see also Na).

3. Magnesium

Magnesium, an abundant element in the earth's crust, is vital to both plant and animal life. Chlorophyll pigment in plants is a Mg-porphyrin complex, and all enzymatic reactions in animals and man that are catalysed by ATP require Mg as a co-factor (Rude and Singer, 1981). Oxidative phosphorylation, DNA transcription, RNA function, protein synthesis and critical cell membrane functions are all dependent upon optimal Mg concentrations (Wacker and Parisi, 1968). An average man contains about 24 g (2000 meq) Mg. Though it is the fourth most abundant body cation, over 99% is either intracellular or in bone (Rude and Singer, 1981). Of the 60% in bone, two-thirds is tightly incorporated into the mineral lattice, but one-third is in an apparently exchangeable bone surface pool. Only the latter correlates well with serum Mg concentrations.

Magnesium deficiency in humans has been receiving increasing attention. Tightly regulated homeostasis via GI absorption and renal excretion maintains serum Mg concentrations in normal humans at quite remarkably constant levels (total 1.809 ± 0.132 meq l^{-1}; ultrafilterable 1.175 ± 0.096 meq l^{-1}). However, these levels may not necessarily be a good measure of

body stores. Nevertheless renal conservation mechanisms are so efficient that Mg deficiency due to inadequate amounts in the diet is probably unlikely if the kidneys are normal, except under unusual circumstances such as severe gastrointestinal disease, extensive loss (through the skin via excessive sweating or severe burns), alcoholism with malnutrition, starvation, etc.

Dietary sources high in Mg include nuts, seafoods, legumes and vegetables; meat is intermediate in Mg content, and refined sugars and fats (major sources of caloric energy) are very low in Mg. Very hard water can contribute up to 20% of an individual's daily Mg intake (Sharrett, 1977), and hence hard water could be quite important where Mg in the diet is marginal or inadequate (Sharrett, 1981). Several reports indicate that Ca and Mg concentrations in human tissues vary with the hardness of municipal water supplies (McMillan, 1978). These suggest an important geochemical influence. Since cardiac arrhythmias (irregular heart rhythms) are a serious manifestation of Mg deficiency (possibly by effect on the ATP-requiring Na pump mechanism which maintains intracellular K levels), sudden cardiac deaths in geographic areas with soft water (low Mg content) *might* be related. This is an hypothesis as yet unproven (see Section V in Chapter 10).

Further relationship between Mg and cardiovascular disease is suggested by the finding (Manthey *et al.*, 1981) of significantly lower serum Mg in patients with severe coronary heart disease compared with those without coronary lesions.

There is also evidence that Mg may relate to formation of kidney stones; individuals prone to develop stones were found to excrete urine with a lower urinary Mg in relation to urinary Ca than controls (Johansson *et al.*, 1980a) and prophylactic treatment of stone-formers with Mg resulted in greatly decreased stone formation both in comparison to the treated patients' former histories and in comparison to an untreated group of stone-formers (Johansson *et al.*, 1980b).

Experimental induction of Mg deficiency in man (Shils, 1980) demonstrate both clinical and chemical evidence of hypocalcaemia (low blood Ca), even when Ca intake is adequate and there is no evidence of negative Ca balance. Magnesium is apparently required to labilize (cause release of) bone Ca, and to maintain adequate release of parathyroid hormone. If a soft water source low in both Ca *and* Mg served an individual on marginal dietary intake, it is plausible that illness or death might be related to a combined effect of both deficiencies.

Finally, experimental evidence that fidelity of DNA synthesis can be decreased by replacing Mg with a series of potentially carcinogenic elements such as Mn, Co and Ni (Zakour *et al.*, 1979) suggests further avenues of exploration of the epidemiology of Mg geochemical distribution and human cancer. Magnesium deficiency has been linked to pathogenesis of cancer both

experimentally in animals and epidemiologically in man (Seelig, 1979); projected mechanisms include cell membrane damage and interference with anti-cancer immune surveillance mechanisms. There is some evidence that geochemical availability may indeed relate to human tissue Mg levels (Blondell, 1980); such evidence is essential to the hypothesis that the geochemistry of Mg might relate to human disease.

4. Phosphorus

An adult human contains an average of about 650 g P, 80% of which is combined with Ca in bone (Anderson, 1977a). The essentiality of P is readily documented by its role in high-energy phosphate bonds and as a component of energy releasing vitamin cofactors, as well as by its contribution to electrolyte balance. Though long recognized by physicians as a reciprocal factor in Ca balance, it may be the routine determination of P by automated laboratory procedures that has drawn attention with increasing frequency to the induction of hypophosphataemia (low blood P) as a consequence of medical interventions such as antacid therapy (Fitzgerald, 1978).

Phosphorus is widely distributed in foods, meat, fish, poultry, eggs and cereals, all being rich sources. In whole grains, P is present as inositol hexaphosphate (phytic acid), an organic form that may chelate and prevent absorption of several elements including Zn, Ca and Fe. Gastrointestinal absorption of P requires conversion to the inorganic phosphate, a process normally so efficient that renal excretion is the predominant mechanism for controlling phosphorus equilibrium in man. Phosphoric acid present in the ubiquitous "soft drinks" (up to 500 mg per bottle) can serve as a significant dietary source. Some Western diets high in P (for example, meat and soft drinks) result in a Ca/P ratio lower than optimal to maintain skeletal integrity, and may stimulate secondary hyperparathyroidism in man (Avioli, 1980). Conversely, antacid therapy can cause GI phosphate depletion with consequent clinical illness.

The potential inter-relationship of dietary Ca to Pb toxicity has already been discussed. Interestingly, P is required for deposition of Pb in bone. A high Ca diet (or additive) could be potentially dangerous if P intake were low, since rather than insoluble deposition in bone, the Pb could remain soluble and result in greater toxicity in other organs.

There seems little direct relationship between the geochemical distribution of P and man's health, unless one considers the direct exposure to toxic P compounds in industrial processes. However, most kidney stones are composed of Ca oxalate or Ca oxalate mixed with Ca phosphate. The high incidence of renal lithiasis (the formation of kidney stones) in some areas

known to have predominantly soft water (Davis, 1978) (for example, the Coastal Plain region of the southeastern US) requires that investigations continue to consider at least the Ca/P ratio as it might relate to renal stone formation.

5. Potassium

An adult human contains approximately 145 g (3700 meq) K, of which >90% is both intracellular and exchangeable (K is the predominant cation in intracellular water) (Hays, 1980). Since muscle contains most of the body's intracellular water, it also contains most of the K. Plasma concentrations are regulated between 3.5 and 4.5 meq l^{-1}, predominantly by the actions of glucoregulatory hormones, such as insulin, epinephrine and adrenal mineralo-corticoids. Since K is found in most animal and vegetable foods, dietary deficiency is exceedingly rare except under unusual conditions (such as diets very high in refined sugars, alcoholic individuals deriving most of their calories from low-K alcoholic beverages, states of starvation, etc.) (Schultz and Nissenon, 1980). Excessive gastrointestinal or renal losses may accompany various disease states or medical therapies. There are no known relationships between geochemical K distribution or bioavailability and human health, except the possible protective effect of increased dietary K on Na-induced hypertension (see Section II.6 and Section V of Chapter 10) and instances of severe human K deficiency (hypokalaemia) in association with the ingestion of large amounts of clay (Gonzales *et al.*, 1982), a dietary practice known as geophagia (see also Section III.10).

6. Sodium

Sodium is the predominant extracellular cation in animals and man. An adult human contains about 83 g (3600 meq) Na; about 24% is located in bone and about 65% in extracellular water. Sodium equilibrium is regulated primarily by the kidney, the key organ in water and electrolyte balance. Sodium chloride (salt) is the predominant dietary source. Although excessive dietary Cl appears to have no significant ill effects on health, there is much evidence that excessive Na intake results in elevated blood pressure (hypertension), and that reduced Na intake or increased K intake (MacGregor *et al.*, 1982) helps to reduce high blood pressure. Epidemiologic studies abound that equate "high salt" with "high blood pressure" societies; "low salt" with "low blood pressure" societies (Kark and Oyama, 1980), and demonstrate development of hypertension in individuals who move from low-salt to high-salt societies. The presumed mechanism is expansion of extracellular fluid volume, increased cardiac

output, compensatory increased peripheral resistance to normalize cardiac output and resultant higher blood pressure. Since higher blood pressure is believed to predispose individuals to strokes and heart attacks as well as compounding renal disease and diabetes, high salt intake can be detrimental indeed to human health.

Geochemical factors, however, may play little role in pathogenesis, since salt as a condiment, preservative and high trade commodity since ancient times has received wide distribution to most populations. Historic references are legion; our word "salary" derives from "salarium", the salt that was part of the Roman soldier's pay. Western dietary habits have grown to include salt as a major item, a trend that increases with canned (and some frozen) foods, salted snacks, convenience and fast-food items, and salt-shakers on every table. Even water softeners exchange Na for Ca and Mg; and red wine processing removes Ca and K bitartrate (to prevent sedimentation) and adds Na.

7. Sulphur

An average human adult contains about 175 g S, mostly in the form of the S-containing amino acids, cysteine and methionine. Animals and man are unable to incorporate S as sulphite or sulphate into cysteine, and must therefore obtain cysteine (or methionine) from other dietary sources; man then depends upon plant or animal sources. Sulphite derived from cysteine metabolism in man is oxidized to sulphate by the liver enzyme sulphite oxidase, the inherited deficiency of which leads to severe neurologic disease. Sulphate is incorporated into glycosaminoglycans (mucopolysaccharides) and conjugated with steroids, bile salts and phenolic compounds for detoxification/excretion. There are no known important links between the geochemistry of sulphate and human illness.

III. Essential micronutrients

1. Cobalt

Cobalt is an essential element for humans, but its pathway through the food chain to man is complex. Only a little over 1 mg Co is present in an adult human. It is useful to man, insofar as is known, only in the form of vitamin B_{12} (cobalamin). This is a large organic molecule containing four pyrrole rings (reminiscent of the porphyrins) plus the α-ribofuranoside of dimethyl-benzimadozole, the latter related to riboflavin (Metzler, 1977). Vitamin B_{12} deficiency in man (due to poor absorption) results in the syndrome called pernicious anaemia, characterized by larger than normal (macrocytic) red

blood cells plus neurologic abnormalities. Vitamin B_{12} is synthesized only by bacteria. In man and many animals, such bacterial synthesis occurs in the colon, which does not provide adequate B_{12} absorption to meet requirements. In ruminant animal species, however, proximal intestinal bacterial synthesis affords adequate absorption; the vitamin then enters the human food chain as animal organs or muscle.

The ruminant animals are much more susceptible to Co deficiency than man, presumably because of major differences in metabolic energy sources (Underwood, 1977a) (a vitamin B_{12} requiring proprionate pathway in ruminants versus a glucose pathway in man). In man, dietary Co deficiency is only likely among strict vegetarians, or when the intrinsic factor from the stomach that facilitates B_{12} absorption is absent or severely decreased, as in pernicious anaemia. Though plant Co concentrations vary widely as a result of soil concentrations and with the effect of competitive elements such as Mn (Beeson, 1978), humans are little affected for the reasons stated above. Excessive Co added as a foam stabilizer to beer, however, produced severe cardiomyopathy, haematologic, neurologic and thyroid abnormalities in humans consuming excessive amounts (Cavalieri, 1980). The presence of concomitant high alcohol intake plus possibly low dietary protein may have produced a synergistic effect. Five litres day^{-1} of the treated beer would have supplied only 8 mg Co day^{-1} (Underwood, 1977a), an amount less than that expected to cause toxicity.

A relationship between thyroid disorders and Co might exist in another context, however, that of Co/I ratios in the geochemical environment (Underwood, 1977a). Russian investigators have reported an inverse correlation between Co in water and soil and thyroid enlargement in animals and man (Kovalsky, 1970).

2. Chromium

The designation of Cr as an element essential to animals and man is quite recent. Insofar as is known, the major biologic function of Cr (Schwarz and Mertz, 1959) is as an integral part of an organic complex originally isolated from yeast termed "glucose tolerance factor" (GTF). This complex apparently includes one Cr(III) ion and two nicotonic acid molecules and may coordinate with three amino-acid molecules, probably glycine, cysteine and glutamic acid. Experimental data indicate that GTF functions in conjunction with insulin, and may in fact aid in binding insulin to sites of action (Mertz *et al.*, 1974). Other GTF activities apparently include a lowering of serum cholesterol and triglycerides (Doisy *et al.*, 1976). Chromium also affects several enzyme systems and is found in high concentration in combination with nucleic acids (Saner, 1980).

An adult human contains about 6 mg Cr. Trivalent Cr is absorbed in the upper gastrointestinal tract, but only in very small amounts (hexavalent Cr is better absorbed, but only trivalent Cr is biologically active as an essential element). Trivalent Cr as GTF is apparently absorbed much better. Thus conversion to GTF in the gastrointestinal tract may be important, and may vary with age of the individual (Saner, 1980). Zinc interference with Cr absorption (and the reverse) suggests a possible competitive absorption pathway (Hahn and Evans, 1975), which is as yet unknown. Transported by siderophilin (an Fe binding protein) and B-lipoproteins, Cr is excreted (and reabsorbed) via the kidneys. Chromium values reported for human tissue and fluids have been progressing steadily downward over the past several years, a reflection not of an increasing incidence of deficiency but rather a manifestation of better analytic techniques and less preparative and laboratory contamination (Saner, 1980). However, human deficiency is also suspected to be more common than believed previously. Geochemical sources may be important.

Documented in several animal species initially (Mertz and Schwarz, 1959; Schroeder et al., 1965), glucose intolerance responsive only to Cr administration has been verified in two instances in man (Jeejeebhoy et al., 1977; Freund et al., 1979). Both occurred during prolonged total parenteral nutrition (TPN). (The circumstances of TPN, where all nutrients are artificially pre-mixed and delivered intravenously over prolonged periods to patients who are unable to sustain nutrition by the gastrointestinal route, has resulted in production/discovery of several deficiencies in man.)

Severe protein deficiency states or total caloric deprivation in humans also induce hypoglycaemia and impaired glucose utilization following an intravenous glucose load. Some groups of patients show improvement with Cr treatment, others do not. It appears (Saner, 1980) that those groups residing in areas with low dietary Cr (for example, Jordan, Nigeria, Turkey) respond, but those residing in areas with higher dietary Cr (such as Egypt) do not. The Cr content of scalp hair appears to be a useful measure of moderate Cr deficiency (Hambidge, 1974). Drinking water content from 100 cities in the US (Durfor and Becker, 1964) are very low in Cr content when compared with water from several other countries including Japan, Italy, India, Egypt and South Africa (Mertz, 1969). Refined sugar and grains contain far less Cr than the raw substances. However, there is no relationship between total Cr content of a food and the biological availability of that Cr (Toepfer et al., 1973). Relative "biologic values" of several foods are brewer's yeast (44.88), black pepper (10.21), calf's liver (4.52), compared with egg white (1.77), chicken breast (1.75) and skimmed milk (1.59). Vegetables are a poor source of Cr: indeed plants may restrict transfer of Cr from soil and water to animal and human diets (Huffman and Allaway, 1973), most Cr remaining in the roots.

Thus both geographic Cr distribution and dietary availability or preference could severely affect Cr intake. These possibilities are especially important to specific individuals, including diabetics and their families, pregnant women, older individuals and conceivably to individuals from families in which coronary artery disease occurs at an early age. Several investigations summarized by Saner (1980) and Prasad (1978b) have shown that Cr can reduce insulin requirements in individuals with insulin-dependent diabetes, and that diabetics handle Cr differently from normals (i.e., are Cr-losers). Children of diabetic families are prone to show abnormal glucose tolerance, and this can be returned to normal with supplemental Cr, yeast, or GTF. Consideration must be given then to Cr or GTF as a prophylactic measure in such families.

Similar relationships between tolerance to a glucose load and urinary Cr excretion has been found during pregnancy, raising the possibility of Cr deficiency in pregnant women. Restoration of normal glucose tolerance in elderly subjects by administration of GTF (Doisy *et al.*, 1976), the decreased tissue levels of Cr with age, and the frequent association of diabetes and cardiovascular disorders suggest that dietary Cr may be important in the elderly. Though far from proven in humans, Cr deficiency in rats leads to hyperlipidaemia and increased aortic plaque formation, both reversed with Cr addition (Schroeder and Balassa, 1965). In one study, aortas of humans who died from accidents contained Cr, whereas aortas from individuals dying of atherosclerotic heart disease lacked Cr, interpreted as possible deficiency (Schroeder *et al.*, 1970).

Chromium supplementation (as Cr-enriched yeast) in normal human volunteers "normalized" glucose tolerance and caused elevation of HDL-C (high density lipoprotein-cholesterol, believed by many to be protective against cardiovascular disease) in some (Polanski and Anderson, 1982). Inorganic Cr administration to volunteers as compared with controls in a double-blind experiment (Riales and Albrink, 1981) also increased HDL-C, indicating that in normal adults response is not dependent upon organically bound (yeast) Cr. Thus, drinking-water Cr could be important. So may the Cr content of beer and wine! Moderate drinkers have a lower risk of coronary mortality, and beer and wine Cr content can vary considerably, in some cases enough to substantially alter Cr intake (Anderson, 1982).

Preliminary studies suggest Cr metabolic abnormalities comparable to diabetes and protein-calorie malnutrition in families (including children) with early onset of coronary artery disease (Saner, 1980) are reversible with Brewer's yeast. If fully confirmed, Cr or GTF prophylaxis in such families might also be considered. The enormous potential importance of these suggestions should suffice to stimulate widespread interest and design of critical supportive or non-supportive investigations. It must be noted,

however, that if (as has been postulated) a defect exists in any such population in the ability to convert trivalent Cr into a form biologically available (GTF), then geochemical or drinking water considerations would be less important than direct dietary manipulation.

Chromium can also cause illness in man. Severe and prolonged allergic contact dermatitis to Cr contained in cement can be a disabling process in workers exposed to cement (Fregert, 1981). Water-soluble hexavalent Cr is the sensitizer, at concentrations of 5 μg g^{-1} or more. This Cr can be reduced to the non-sensitizing trivalent Cr by the addition of ferrous sulphate [Fe(II)], but must be added at the time mortar or concrete is made.

Chromium in excess amounts can be quite toxic, dependent upon the chemical species of Cr and the route of exposure. In general, trivalent Cr is much less toxic than the hexavalent form. Electroplating can release chromic acid spray and air-borne Cr trioxide, both of which can result in direct damage to skin and lungs. Chromium dust has long been incriminated as a potential cause of lung cancer (Hyodo et al., 1980) and Cr has been shown to be mutagenic in micro-organisms, causing infidelity (mis-reading) during synthesis of DNA copies (Tkeshelashvili et al., 1980). Thus the story of Cr once again illustrates the principle of essentiality in small amounts, a broad middle range of physiologic regulation and potential toxicity in large amounts (Mertz, 1981).

3. Copper

Normal adult humans contain about 100–150 mg Cu; highest concentrations are found in liver, kidney, heart and brain (Li and Vallee, 1980). The prototype functional deficiency of Cu in humans is an X-linked inherited disorder called Menke's syndrome (kinky or steely hair syndrome); Cu insufficiency was first suspected by analogy with abnormal wool in Cu-deficient sheep (Danks et al., 1972). The defect appears to be decreased gastrointestinal absorption and/or cellular utilization of Cu (Bonewitz and Howell, 1981).

Additional human inherited metabolic disorders in which Cu metabolism has been determined to be abnormal includes the sex-linked types of cutis laxa (Beyers et al., 1980) (a peculiar occurrence of loose skin) and a subtype of Ehlers–Danlos syndrome (Kuivaniemi et al., 1982), a group of disorders with clinical manifestations resulting from abnormal connective tissues, in which Cu-containing enzymes may be involved (see below). These functional deficiencies are not necessarily responsive to dietary supplementation, hence may have little or no geochemical or dietary implications; thus, if Cu present in the body is not handled normally, or the enzyme requiring Cu is structurally abnormal, even excess Cu intake may not alter the disease process.

The prototype functional excess of Cu in humans is an autosomal recessive disorder known as Wilson's disease (hepatolenticular degeneration) (Mason, 1979). It is characterized by gradual accumulation of Cu throughout the life of the patient with progressive impairment of Cu-laden tissues until death results.

The essentiality of Cu is the consequence of its role in metalloenzymes involving several critical biochemical pathways (Hsieh and Hsu, 1980). Several of these enzymes are noted here. Superoxide dismutase (originally thought to be simply a storage protein in red blood cells—erythrocuprein—or in liver—hepatocuprein) is a cytosol-derived enzyme with two atoms each of Cu and Zn per molecule (see also Section III.7) which further metabolizes the potentially damaging superoxide anion. Lysyl oxidase is a monoamine oxidase required for cross-linking collagen and elastin, the structural macromolecules of connective tissue. Dopamine β-hydroxylase, amine oxidase and tyrosinase are all Cu containing enzymes that interconvert the major neurotransmitters dopamine, noradrenaline and adrenaline, probably accounting for the high concentration of Cu in the brain (Osterberg, 1980). The latter enzyme, tyrosinase, is also a key step in pigment production. Cytochrome c oxidase is the key and terminal enzyme of the respiratory chain, accounting for more than 90% of the energy of muscular contraction. Ferroxidase (better known as ceruloplasmin before its role in mobilizing and oxidizing Fe from storage sites was recognized) is believed to account for 95% of serum Cu, and appears to be a multi-functional protein serving as a major transport system for Cu as well.

Copper is widely distributed in the food chain, a notable exception being cow's milk. Copper concentration ranges from 1400 μg g^{-1} in Atlantic oysters to 20–60 μg g^{-1} in animal tissues to less than 2 μg g^{-1} in leafy green vegetables and fruits to less than 0.2 μg g^{-1} in cow's milk, which is much less than in human milk. Infants, especially if premature and not breast-fed, are therefore most susceptible to dietary deficiencies; excessive loss of Cu from gastrointestinal tract due to diarrhoea is the most common precipitating factor.

Human dietary Cu deficiency was first described in malnourished Peruvian children who showed a syndrome of neutropaenia, anaemia and bone demineralization which were all reversed by Cu supplementation (Cordano *et al.*, 1964). A similar syndrome in adults (but without bone demineralization) has been reported during total parenteral nutrition with Cu-deficient solutions.

The widespread presence of Cu in foods and drinking water, often unintentionally supplemented by passage of water through Cu pipes, makes it difficult to devise a human diet truly deficient in Cu (Schroeder *et al.*, 1966). Geochemical factors therefore seem of relatively little importance. Copper toxicity, however, can occur in conjunction with the spraying of grapes with a Cu sulphate fungicide (Bordeaux mixture). Vineyard workers developed

fibrotic lesions in their lungs (Pimentel and Marques, 1969) presumably owing to inhaled Cu. Conversely, Cu miners do not seem to suffer ill effects from years of exposure (Scheinberg and Sternlieb, 1969). Copper poisoning from accidental or purposeful ingestion, or during dialysis using Cu tubing (Burch et al., 1975) can result in severe gastrointestinal symptoms and a haemolytic anaemia probably secondary to red blood cell enzyme inhibition. In India, individuals who commit suicide by ingesting large amounts of copper sulphate show severe hepatic necrosis and renal damage (Chuttani et al., 1965). Contamination of vegetation and soils near smelters does occur (Cannon and Anderson, 1971) and excessive Cu in drinking water has been reported to have caused a toxic syndrome ("pink disease") in an infant (Salmon and Wright, 1971).

Finally, extensive interactions between Cu, Zn, Fe, Mo and Pb in various animal systems (Davis, 1980) suggest that imbalance of these elements in the diet might lead to various deficiencies or excesses, mediated at least in part via transport proteins such as ceruloplasmin, transferrin and a high cysteine-containing protein termed "metallothionein" (see also Section III.10 and Section III.3 in Chapter 10). Geochemical factors involving ratios of these elements certainly affect animals, and they could theoretically affect humans, certainly those with limited diets, increased nutritional requirements (growth, pregnancy) or disease states which alter absorption or metabolism. The complexity of these interactions is typified by the Zn–Cu hypothesis of ischaemic heart disease (Klevay, 1980), which proposes in essence that decreased Cu intake especially if exaggerated by Zn excess (which increases Cu excretion) may play an aetiologic role in cardiac deaths in both animals and man.

4. Fluorine

Recognition that a fluoride content of drinking water higher than 1.0 ppm could result in human fluorosis in humans (mottled staining of the teeth being the predominant sign) but also less tooth decay (fewer cavities) occurred early in this century (Strain et al., 1975). Gradual introduction of public water fluoridation on a community-by-community basis in those areas with F concentrations of less than 1 ppm has resulted in a 50% decrease in dental decay (Strain et al., 1975), though some major communities have only recently (Boston, Mass., 1978) or even not yet accepted or accomplished fluoridation (Houston, Texas; Los Angeles, California) (Shaw and Sweeney, 1980). Though the overall benefit of fluoridation of water supplies is unquestioned, advances in knowledge of different stages of tooth development and F effects suggest that application of F directly to the teeth just *after* eruption may be maximally

Table 9.1 Dose relationship between F in drinking water, cavities and F excess (fluorosis)

Fluoride in drinking water (ppm)	Cavities (and tooth loss)	Signs of fluorosis
0	Many	None
1	Few	None
2	Few	Very mild mottling of teeth
4	Few	Mild mottling of teeth
8	—	Moderate mottling of teeth plus early signs of systemic calcification
> 16	—	Severe mottling plus severe crippling skeletal deformities

effective (Navia *et al.*, 1976), while decreasing mottling concommitant with F supplementation during pre-eruptive development.

Natural F concentrations in surface waters used for drinking and cooking generally range from 0.1 to 1.0 ppm; in some parts of the world, water from deep well or artesian well contains 4–8 ppm, and in some areas of southern India and South Africa concentrations up to 40 ppm have been measured (Underwood, 1977b). In the latter areas, fluorosis includes oestosclerosis, ligamentous and tendinous calcification and can lead to crippling deformities; genu valgum (knock-knee) has been reported in the younger population from areas of endemic fluorosis in southern India. Other elements may be involved; dietary Ca is low and Mo is high.

Table 9.1 illustrates the relationship between F in drinking water and health effects. Precise numbers are not recorded for cavities or fluorosis because they will vary considerably depending upon age, duration of exposure, water intake per individual (Spencer *et al.*, 1981) and other factors. In general, reduction of cavities by 50–75% can be expected if drinking water low in F is fluoridated up to 1 ppm.

Inhibitory effects of Ca, P and Mg on F absorption in animals could not be confirmed in man (Spencer *et al.*, 1980). However, Al in the hydroxide form commonly used as a gastric antacid does decrease F absorption significantly. Dietary sources other than water are quite variable. Fish and tea (and sea salt where used) are quite high in F content (up to 5–10 ppm or even 55 ppm in some sea salt from India!) compared with most other foods (> 0.5 ppm). Even the introduction of preparations designed to provide new sources of nutrition may be of potential risk if trace element concentrations are ignored. Fish meal (flour) protein concentrate can contain up to 760 ppm F (Ke *et al.*, 1970), an amount for genuine concern from the point of view of toxicity.

Additional factors that may complicate interpretation include the effects of Mo, which may suppress dental decay, and Se, which at higher levels may promote dental decay. Clearly associations of human health or illness that consider only a single element can be misleading.

5. Iodine

The inter-relationships of soil and water, the human food chain and human illness illustrate dramatically the story of I as an essential trace element, its deficiencies, excesses and modifications of the story by man's intervention. An adult human contains 15–20 mg I, of which 70–80% is concentrated in the thyroid gland (which itself weighs only about 0.03% of the total body) (Underwood, 1977c). Certain other tissues, the salivary gland, breast, gastric mucosa and choroid plexus, also concentrate I. However, the essentiality of I to man appears to be based primarily upon its incorporation into the thyroid hormones thyroxin (tetraiodothyronine or T4) and triiodothyronine (T3), and the thyroid gland plays the largest role in I balance. T3 and T4 are critical hormones in growth and development, oxygen consumption, protein synthesis, etc. Specific T3 and T4 receptors have been identified in both nuclear and mitochondrial sites (Cavalieri, 1980). The incorporation of I and final release of T3 and T4 is a multi-step process, including active transport into the thyroid gland, iodination of tyrosine by a peroxidase, condensation of two molecules to form thyroxin, binding to thyroglobulin as a storage site, and release of T3 and T4 by intracellular proteolysis. T3 and T4 are largely bound in serum to thyroxin binding globulin (TBG) and to albumin. About one-third of the daily T4 turnover is via conversion of T4 and T3 (by monodeodination) in the liver and kidney, which accounts for about 80% of total T3 production. T3 is three times as potent biologically as T4.

Thyroidal I uptake and hormone synthesis and release are all governed by a pituitary hormone TSH (thyroid stimulating hormone) which in turn is released by a hypothalamic tri-peptide termed TRH (thyrotropin-releasing-hormone). T3 and T4 inhibit TRH and TSH release thereby completing a feedback cycle which autoregulates the system. If I is lacking or T3 and T4 diminished, increased TSH amounts cause enlargement of the thyroid gland, a condition called goitre (Fig. 9.1).

Iodine-rich seaweed and sponge were used to treat goitre in ancient Greece, China, Egypt and by the Incas of South America, though I was not then a known substance. Iodine was discovered in 1811. It was a corrosive contaminant of Chilean saltpetre which was being processed into gunpowder for Napoleon's army; it was named by Guy-Lussac for its violet colour. Iodine as KIO_3 was prescribed for simple goitre as early as 1816, and by 1819 it was

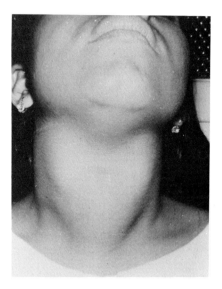

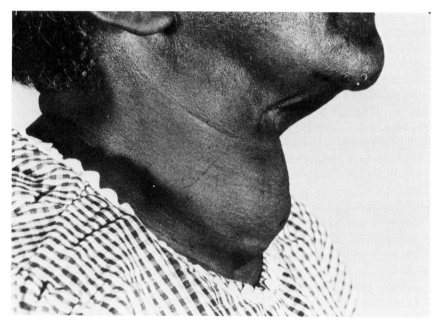

Fig. 9.1 Enlargement of the thyroid gland caused by I deficiency results in characteristic swelling of the neck, often quite prominent. (Courtesy of Dr Eugene D. Furth, Chairman, Department of Medicine, East Carolina University School of Medicine.)

on the formulary of St Thomas Hospital in London. In the mid 1800s, I-poor drinking water was proposed as the cause of "endemic" goitre (large numbers of people affected in localized areas), and attempts were made to measure I in air, water and soil from different regions. The later discovery of I in the thyroid gland and the isolation of thyroxin around the turn of the century began to complete the story begun by the empiric therapies of ancient times. Interestingly, T3 was not discovered until 1952; the availability of radioactive I as a tracer provided the key (Cavalieri, 1980).

Iodide concentrations in water, soil, plant and animal tissues are low in endemic goitre areas all over the world, in comparison to areas with low incidence of goitre. In the Great Lakes region of the US, the Congo River Basin, the island of New Guinea, the Himalayas, the Andes, Switzerland, parts of England, Ireland, Latvia, Egypt, India, Indonesia, wherever there is low I in water, soil and milk, pockets of goitre exist that can be dramatically reduced by supplementation with iodides or iodates, addition to common table salt being the most common route.

Endemic cretinism is also associated with endemic goitre. Cretinism is characterized by early childhood mental retardation, impaired growths, deaf–mutism and neurologic abnormalities (Underwood, 1977c; Moynahan, 1979) and is apparently due to I deficiency in the mother during the first trimester of pregnancy. Iodine repletion before conception can prevent this condition.

Indirect supplementation can also reduce goitre prevalence, as with fertilizer containing Chilean nitrate (and iodide), or with fertilizers derived from fish, other seafood, etc. Plants, and then animals, will take up the I and pass it on to man via the food chain. The whole story is probably as neat an example of geochemical influence on human health as can be provided.

But many individuals in I-deficient areas do not develop goitre; I replacement does not prevent development of goitre in some individuals; and some individuals develop goitre in areas where I in the diet is plentiful. In the latter instances, several individuals have been identified with a defect in one or the other of the enzymatic steps in the production of T3 and T4 and some are responsive to I therapy. It is possible therefore, that some persons with goitre in an endemic area might represent examples of inherited metabolic defects uncovered by deficiency of I (Cavalieri, 1980).

Other possible influences on the I–goitre relationship include naturally occurring substances in plants called "goitrogens" (Underwood, 1977c; Prasad, 1978c) that interfere with thyroid hormone synthesis. Some, such as cyanogenetic glucosides in white clover (*Trifolium repens*) produce thiocyanate in tissues; thiocyanate inhibits incorporation of I into the thyroid gland; the effect is reversible with additional I. Others, such as "goitrin" (L-5-vinyl-2-thiooxalidone) inhibit iodination of tyrosine; additional I does not reverse this

type of inhibition. Goitrin and probably several other compounds, found especially in *Brassica* species (cabbage, kale, rutabaga, etc.) could reach humans in sufficient amounts to influence goitrogenesis, perhaps especially where I supply was borderline. Underwood (1977c) summarizes a few examples of goitrogens in cow's milk, and one instance in a goitrous area in the Congo where direct human ingestion of cassava (*Manihot utilissima*) caused inhibition of thyroidal I uptake.

Goitrogens are used in medicine to treat individuals whose thyroid glands produce excessive T3 and T4 (hyperthyroidism, thyrotoxicosis); thiouracil derivatives (not unlike those occurring in plants) and methimazole are examples.

Though it is usually taught that the only function of I is via the thyroid hormones, the concentration of I by a few other tissues suggests the possibility of additional functions. Eskin (1978) presents persuasive arguments for the following effects of I: (i) it is a "compulsory element" for breast tissue growth and development; (ii) atypical histologic changes result from I deficiency (in rats) even when adequate thyroid hormones are present; (iii) breast carcinogenesis is enhanced; and (iv) there are alterations in cellular RNA/DNA, estrogen receptors and ^{125}I uptake. Epidemiologic association between high breast cancer rates in humans and regions of endemic goitre is reviewed (Eskin, 1978) as well. Mechanisms for providing adequate I in areas geochemically deficient may prove to be important in breast cancer prevention.

Follicular cancer of the thyroid is said to be the type of malignancy associated with endemic goitre in I-deficient regions (Moynahan, 1979); however, papillary cancer of the thyroid is five times more prevalent (and hyperthyroidism common) in Ireland, a high I area, in comparison with Scotland (Moynahan, 1979). Thyrotoxicosis is more frequent in some endemic goitre areas, and deaths from thyrotoxicosis have declined significantly in the US since widespread introduction of iodized salt plus other antithyroid therapies; yet the prevalence of thyroid cancer has not decreased (Strain *et al.*, 1975).

Finally, excessive I intake can cause cessation of thyroxine synthesis in animals and man (Cavalieri, 1980), usually followed by adaptive reversal to normal synthesis. In some individuals, however, hypothyroidism and goitre develop. A peculiar example appears to affect up to 10% of the population along the coast of the Northern Island of Japan, where very high dietary intake of I is due to the consumption of seaweed. A partial biochemical defect in the thyroid glands of these individuals is postulated (Cavalieri, 1980). In addition, some individuals with goitre who are treated with I develop hyperthyroidism, called "jodbasedow" (literally Basedow's disease secondary to iodine). Clearly I availability and intake influence human health in many ways.

6. Iron

The average human adult contains about 4–5 g Fe. Of this amount, about 60–70% is present in haemoglobin in the red blood cell (haemoglobin is the chief oxygen transport protein), 3–5% is in muscle myoglobin, 15% is bound to the Fe storage cellular protein, ferritin, 0.2% occurs as a component of critical respiratory enzymes, and 0.004% is bound to the serum transport protein, transferrin (Anderson, 1977a).

Iron is required by all living organisms except the lactic acid bacteria (Nielands, 1977). Though many micro-organisms could survive with anaerobic glycolysis, thus by-passing the Fe-requiring Krebs tricarboxylic acid cycle and the cytochrome respiratory chain, they require Fe for synthesis of the sugar moiety of DNA. Iron, like other transition elements, can exist in more than one stable oxidation state, ferrous, Fe(II), and ferric, Fe(III). It is the Fe(III) ion (unstable as an isolated ion at physiologic pH) that is vital; complex stabilizing natural chelators such as ferritin and transferrin have evolved to deal with this precious element.

Though essential to oxygen transport and cellular respiration (i.e., to life itself), Fe is poorly absorbed and unlike the case for many other essential elements lacks mechanism for regulation of body levels by excretion if in excess (Prasad, 1978d). A paradox exists therefore between the high prevalence of Fe deficiency throughout the world (Beutler, 1980), and the potential dangers of excessive Fe accumulation via governmental food enrichment policies. With Fe (as with other elements such as F and Se), what is good for a population may be harmful to some individuals, bringing public health medicine into conflict with one physician–one patient medicine (Forbes, 1978). The inability to excrete excess Fe further jeopardizes persons suffering from several conditions where Fe overload leads to pathologic changes. However, despite the widespread practice of Fe enrichment of foods, particularly cereals, not only is there little evidence for overload but little evidence for decreased prevalence of Fe deficiency as a result of this practice (Forbes, 1978).

Iron balance in humans has been the subject of an extraordinary number of investigations, many dependent upon the availability of radioactive isotopes as tracers. An adult male loses about 1 mg Fe day^{-1}, mostly via the gastrointestinal tract (blood, desquamating epithelial cells, bile) and the skin (desquamating cells, sweat). A female in the child-bearing age loses in addition about twice that much via the menstrual cycle. Dietary intake averages 10–20 mg day^{-1}, about 10% of which is actually absorbed, just off-setting losses. Poor diet, blood loss and periods of higher requirements (growth, child-bearing) are therefore the most common causes of deficiency. Poor diet (by choice, habit or economics) is the most common cause of insufficient dietary Fe. Animal organs, seafoods, eggs, whole wheat and some green vegetables are

good sources. Poor sources include milk and milk products, refined flour and sugar, polished rice, potatoes and most fruits. In many parts of the world poor sources form the bulk of the diet. Geochemical considerations can affect the amounts of Fe in food. Turnip greens grown on poor sandy soils contain only 50–60 $\mu g \, g^{-1}$ Fe compared with 250 or more in greens grown on better soils; where turnip greens are an important part of the diet, as in rural Florida (Prasad, 1978d), nutritional anaemia can be related to growth in poor soil.

Iron absorption is affected not only by the amounts of Fe in different foods, but also by the form of Fe and mixture of foods. Non-haeme (free) Fe requires reduction by ascorbic acid for absorption (Lynch and Cook, 1980); haeme Fe is absorbed in higher amounts (20% as opposed to 10%). Other plant substances (phytate) or dietary elements (Co, Cu, Zn and Mn) can inhibit Fe absorption (Underwood, 1977d). The relatively common practice of geophagy or geophagia (clay-eating) among poor and rural populations may be of unusual interest to geochemists. Such individuals are often Fe (and/or Zn) deficient. There is disagreement among many observers as to whether clay-eaters are instinctively seeking Fe or other minerals because of a deficiency in their diet, or simply following a cultural practice. Some report that Fe therapy results in cessation of geophagia. Others argue that the ingested clay prevents Fe absorption, resulting in Fe deficiency (as well as increasing parasitic worm infestation, adding to Fe deficiency). Scientific experiments are not in evidence.

The fascinating details of Fe biochemistry, storage, transport, deficiency and excess are beyond the scope of this chapter, and are discussed at length in the major references. An additional paradox in the story of Fe deficiency or excess in man provides adequate stimulus for continued investigation of Fe metabolism and also of the geochemical availability of Fe and its dietary variations. It has been suggested that Fe deficiency leads to immunologic abnormalities and predisposes to infection, whereas Fe excess in effect feeds invading micro-organisms (Chandra *et al.*, 1977), and may play a role in carcinogenesis (Willson, 1977).

7. Manganese

Manganese is essential to a wide variety of birds and animals; it is generally present as a metalloenzyme or can substitute for other metals in many metal–enzyme complexes, often with changes in enzyme kinetics or substrate specificities (Metzler, 1977; Underwood, 1977e; Prasad, 1978e). Yet no specific Mn deficiency syndrome has been identified in man, save one incidental occurrence in an individual during experimental vitamin K deficiency, where Mn supplementation corrected a prolonged prothrombin time (a laboratory test of blood clotting) (Doisy, 1974). Many of the varied signs of Mn deficiency

in animals are theoretically attributable to Mn required by glycosyl trans-
ferases, the enzymes needed for synthesis of glycosaminoglycans (mucopoly-
saccharides) and glycoproteins. Additional Mn metalloenzymes include
pyruvate carboxylase and superoxide dismutase. In some species superoxide
dismutase activity appears to be regulated by levels of dietary Mn (DeRosa *et
al.*, 1980).

An adult human contains 12–20 mg Mn, with highest concentrations in
bone, liver and kidney (Underwood, 1977e). Mitochondria are richer than
cytosol or other organelles. Mn is poorly absorbed: only about 1–4% of
dietary Mn, depending upon animal species. It is transported in serum by a β-
globulin, supposedly specific for Mn and termed transmaganin by some
(Cotzias and Bertinchamps, 1960). However, Mn binding to transferrin is also
reported. Excretion is via the gastrointestinal tract (Grant, 1980). Serum Mn is
said to be elevated following coronary occlusion, and in red blood cell Mn is
elevated in rheumatoid arthritis (Underwood, 1977e), but the significance of
these observations remains unknown.

Many consequences of deficiencies in animals are known, particularly
skeletal abnormalities and postural defects and especially in the offspring of
deficient mothers (Hurley, 1981), probably due to defective mucopoly-
saccharide synthesis. Pancreatic islet cell abnormalities, defects in carbohyd-
rate metabolism, reproductive malfunction, impaired cholesterol biosynthesis
and alterations in mitochondrial respiration have been linked to Mn
deficiencies in one species or another, and emphasize the widespread
deficiencies in various animals. One wonders why human deficiency (or
disease involvement) is not evident.

Nuts, whole cereals and teas are rich in Mn, vegetables are intermediate and
meat, fish and dairy products are low. Mn levels in forage crops appear to vary
more with plant species than with soil type or fertilizer used.

Manganese is less toxic than many elements. Human poisoning is ap-
parently limited to industrial exposure, by inhalation or by ingestion.
Neurologic (Parkinson's-like) and psychiatric (schizophrenia-like) disorders
are the consequences, and these can be prolonged or permanent. Manganous
dust can produce a pneumonia with high mortality rate. Since Mn is released
from burning coal, is added to fuel oils and gasoline and is used in steelmaking
and manufacture of batteries (Gray and Laskey, 1980), continued human
exposure can be anticipated.

8. Molybdenum

The essentiality of Mo in animals and man is assumed from its presence in the
metalloenzymes xanthine oxidase and aldehyde oxidase (both

flavin–adenine–dinucleotide enzymes with iron also present in a non-porphyrin setting). Molybdenum is also part of the enzyme sulphite oxidase, an inherited deficiency of which causes severe neurologic disorders and early death in humans (Calebresi *et al.*, 1980). However, no naturally occurring Mo deficiency has ever been documented in animals or man, even though several animal deficiencies have been produced experimentally, particularly by using the Mo antagonist, W (tungsten) (Underwood, 1977f).

Molybdenum is present in very small quantities in man, in amounts roughly comparable to Mn. Molybdenum appears to be readily absorbed from the GI tract, and excreted primarily through the kidneys (though human studies are lacking). In tissues with higher concentration, such as bone, liver and kidney, the Mo content can be varied with dietary intake, as can the activity of xanthine oxidase. There is evidence that dietary Mo affects Cu metabolism in animals and man, higher Mo intakes causing mobilization and excretion of Cu. These effects can be elicited in man even with naturally occurring dietary sources of Mo such as high-Mo sorghum grain (Underwood, 1977f). Since Mo concentrations in grains and vegetables varies enormously (differences up to 500 times!) and varies with soil content (Underwood, 1977f) the possibility of Mo-induced Cu deficiency in man is conceivable, though not reported (see below).

Studies of blood and urine Mo and Cu levels (as well as serum ceruloplasmin and uric acid) in individuals from the State of Colorado, USA, exposed to excess Mo either from industrial sources or drinking water (EPA, 1979) showed some elevation of blood and urinary Mo and urinary Cu, plus increased serum ceruloplasmin (though also dependent upon sex, altitude above sea level and occupation). However, Cu excretion was not judged to be excessive even when significantly higher than in control subjects. Precise adverse health effects in a group of 25 individuals with high industrial exposure were difficult to quantitate and relatively non-specific; no gout was documented.

High dietary Mo in man is reported to induce gout in certain areas of Russia (Kovalsky, 1979) presumably by increasing uric acid synthesis via increased xanthine oxidase activity. The diets consumed in these areas contained up to 10–15 mg Mo day^{-1}, compared with 1–2 mg day^{-1} in nearby areas, and 0.1–0.4 mg day^{-1} in many parts of the world (Underwood, 1977f; Tsongas *et al.*, 1980).

In animals, especially ruminants, Mo absorption and the interactions between Mo, Cu and S have received special attention, since each element appears to influence the other dramatically, with profound effects on the health of the animals. In ruminants, thiomolybdate formation in the rumen is believed to influence strongly Mo and Cu absorption and metabolism (Suttle, 1980); in non-ruminant (monogastric) animals, thiomolybdate formation has

been postulated to occur systemically (i.e., in the body tissues and fluids following absorption). However, the Cu–Mo–S interactions in monogastric species may be of significantly less importance than in ruminants (Calebresi, 1981b). In cattle and sheep excess Mo intake causes a syndrome called scouring, characterized by weight gain less than normal, anaemia, poor appetite, diarrhoea, hair (fur or wool) loss and neurological damage (Pitt, 1976). These are all signs of Cu deficiency induced by the effect of Mo on Cu metabolism! Sulphate accentuates this effect in ruminants, but prevents Mo toxicity in monogastric species (Calebresi, 1981b). Clearly the soil contents and *ratios of elements* can affect the human food chain directly.

Another possible effect of Mo imbalance in humans can be postulated by virtue of known human sulphite oxidase enzyme deficiencies and reports of bisulphite toxicity in rats made deficient in Mo with consequent reduction of hepatic bisulphite oxidase (Cohen *et al.*, 1973). If persons with partial enzyme defects were exposed to SO_2 as an environmental contaminant, or to large amounts of bisulphite as a food preservative, serious toxicity might develop. However, the frequency of this gene defect in humans is apparently rare, and the exposure levels in animal experiments was much higher than likely to be encountered by humans (Calebresi, 1981c).

Finally, dental caries have been reported to be less prevalent in high Mo areas (high vegetable content) in New Zealand (Ludwig *et al.*, 1960) and England; however, in California, children from high and low Mo areas had equal prevalence of caries and the reported differences elsewhere might have been due to F differences, as summarized by Underwood (1977f).

9. Selenium

The discovery by Klaus Schwarz that Se is an essential element that is needed to prevent dietary liver necrosis in rats (Schrauzer, 1979) has culminated in the remarkable demonstration of a geochemically based Se-deficient endemic human cardiomyopathy in China, which can be prevented by Se supplementation (Chen *et al.*, 1980). In addition, Se, an element that 30 years ago was referred to only as a poison (and possibly carcinogenic as well), is now believed by many to be important in the prevention of many types of cancer (Schrauzer, 1978; Baumgartner, 1979; Jannson, 1980), an hypothesis proven in experimental animal studies and postulated in man.

Total Se content in humans is only a few milligrams; no tissue normally contains more than $1.0\,\mu\mathrm{g\,g^{-1}}$. However, Se concentrations are related directly to dietary intake, and both deficiencies and excesses can result from low and high Se intakes in animals and man. Deficiency syndromes had been discovered or induced in 40 animal species before a human deficiency was

documented. Certain syndromes now known to be due to excess Se have been recorded in animals since ancient times, but have been only poorly identified in man (Smith *et al.*, 1936; Smith and Westfall, 1937), even in those populations living in high Se areas. These deficiencies and excesses appear to relate directly to the concentrations of Se in soil, since the concentration of Se in water is very low and probably plays little or no role in health or disease except when water is used to irrigate food-producing soils. The effects of soil Se may be modified by its chemical forms and by several interactions with other elements, including Cd, As, Hg, Cu and Ag (see also individual sections in this chapter).

Plants convert much Se to selenoamino acids, which in turn are especially available via the GI tract of animals. Animals contain Se primarily in protein-bound form; the essentiality of Se is believed to be based primarily on its role as the selenoenzyme glutathione peroxidase. This enzyme is a tetrameric molecule ranging in weight (from different species by different isolation technics and analytical methods) from 68 000 to 95 000 daltons, with one Se atom as selenocysteine in each sub-unit (Flohe *et al.*, 1979). However, other mammalian selenoproteins exist (Stadtman, 1980a,b). One of these, about 10 000 daltons in weight, is present in heart and muscle of lambs, but missing in Se-deficient animals with white muscle disease (nutritional dystrophy). Another of about 15 000 daltons is found in rat testes and rat sperm (possibly related to reproduction). Finally, a small molecular weight cytochrome *c* containing complex has been isolated from animal muscle. It is likely that one or more of these proteins will also relate to the essentiality of Se to mammals.

The geochemical distribution and availability of Se has influenced man since the time of Marco Polo, who, in his report on travel from Venice to China in 1295, noted that only indigenous pack animals who had learned to avoid certain poisonous plants in the Asian Highlands could be relied upon; animals imported from other areas ate such plants and lost their hooves. This probably represented a form of alkali disease or "blind staggers" which is so prevalent in seleniferous areas (Diplock, 1976) such as the north central plains of North America. Ingestion of the accumulator plant species (such as *Astralagus* species, so-called loco-weed) in particular can provide enormous amounts of organic, and therefore available, Se to grazing animals.

Direct effects upon man, however, even in seleniferous areas with a high incidence of animal selenosis, are apparently slight, or at least they have been little studied since the investigations of Smith (Smith *et al.*, 1936; Smith and Westfall, 1937) in the 1930s. They reported a series of "minor" disturbances such as gastrointestinal complaints, jaundice, skin hyperpigmentation, nail changes, bad teeth, ill-defined arthritis, dizziness, fatigue, etc., that correlated to some degree with increased concentrations of Se in the urine. The lesser incidence of toxicity of Se in humans living in seleniferous areas is presumably based upon the fact that most of his dietary Se is derived from animal organs,

meat and fish, from which Se is not as available as plant Se, and that his diet does not include the high Se plant varieties. Nevertheless, a higher incidence of deformed offspring by several farm animals in seleniferous areas (Lo and Sandhi, 1980), reports of higher blood Se levels in humans from areas where high Se vegetation is found (for example, the States of South Dakota, Wyoming in the north-central US) (Losee and Adkins, 1971), and a report of very high rates of birth deformities in human infants from the same area (Greene et al., 1965) suggest that investigation of human health in seleniferous areas should continue. Evidence for a higher incidence of dental caries in children born and raised in high Se US towns is summarized by Underwood (1977g).

Selenium deficiencies in many animal and bird species also relate directly to soil Se content and include muscular dystrophies (including cardiac muscle) increased vascular permeability, pancreatic and hepatic disorders and immunologic and reproductive deficiencies (Underwood, 1977g).

Only very recently has rather dramatic evidence for a human deficiency of major consequence been reported. Keshan disease is an endemic cardiomyopathy of unknown cause first described in 1935. It occurs in the provinces of Heilonjiang (where Keshan is located) and Jilin in northeast China between Mongolia and Korea and in a long belt stretching southwest through Shanxi, Hubei, Sichuaun and Yunnan provinces located north of Laos between Burma and Vietnam (Fig. 9.2). Pockets of endemicity (high local prevalence) in this mountainous and hilly belt are often surrounded by, or adjacent to, areas of low prevalence of Keshan disease, or even areas that are known to be high in Se.

Clinical characteristics range from acute heart failure, shock, pulmonary oedema, arrhythmia and death through lesser degrees of heart failure, electrocardiographic abnormalities and mild cardiac enlargement. Because of the remarkably localized geographic occurrence of many cases, even to the extent that "safety islands" were surrounded by endemic areas, local residents are said to have considered it a soil-related geochemical disease (Chen et al., 1980). Selenium deficiency was suspected in the 1960s, and large scale studies of Se in locally grown food staples, and in hair, blood and urine of residents, and whole blood glutathione peroxidase activities were undertaken. Most important, placebo-containing clinical trials of Se prophylaxis were undertaken in the 1970s. The results were presented at international meetings and published in English only recently (Chen et al., 1980).

During the years 1974 and 1975 in Manning County, Sichuan Province, 11 277 children were given sodium selenite tablets orally once a week, 0.5 mg to 1–5 year olds, 1.0 mg to 6–9 year olds: 9420 children received placebo tablets to which garlic flavour was added to mimic the taste of Se (a characteristic that led Schwarz to identify Se as an essential element in 1957!).

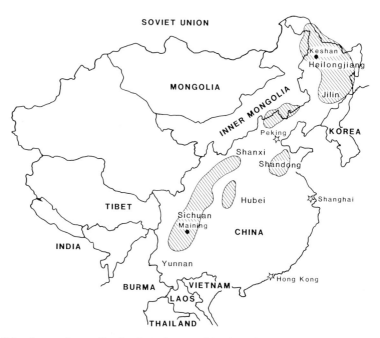

Fig. 9.2 Approximate distribution of cases of Keshan disease in China. Within these general areas are gradations of greater or lesser prevalence, corresponding rather well with greater or lesser amounts of Se in the water or soil (Chen *et al.*, 1980, from which this figure was adapted).

In the placebo group, 106 children developed Keshan disease; 53 died. In the treated group, 17 children became ill; 1 died. Because of the dramatic results, all children were treated from 1976 on. During the next two years, 25 326 children received Se tablets; only 4 cases of Keshan disease occurred. Similar Se treatment programs involving over 500 000 subjects in several other provinces are said to have achieved similar results (Chen *et al.*, 1980). Furthermore, those few children who developed Keshan disease despite ingestion of Se tablets showed a milder form of the illness with fewer electrocardiographic changes. Many recovered fully.

In all regions studied, the affected areas had low Se levels in foods, blood, hair, urine and low blood glutathione peroxidase levels. This was in contrast to non-endemic areas even if in close geographic proximity. All correlations were highly significant. Blood Se levels reported from other parts of the world considered to be low Se areas (average 0.068 μg g^{-1} from Egypt and New Zealand) can be compared with levels of less than 0.01 μg g^{-1} in persons from areas endemic for Keshan's disease. Some urban–rural differences in both disease incidence and Se levels were attributed to differences in dietary pattern.

An analogous case of cardiomyopathy and dietary Se deficiency in a two-year-old girl in the US reportedly responded well to oral Se supplementation (Collipp and Chen, 1981), and a 43-year-old man on long-term parenteral nutrition who developed cardiac arrhythmia and failure was found to have Se (and vitamin E) deficiency. He died despite Se supplementation; autopsy showed low Se levels in heart muscle, and pathologic changes compatible with those demonstrated in Keshan disease (Johnson et al., 1981). Se deficiency in association with parenteral nutrition had been reported earlier (van Rij et al., 1979), but was manifested clinically by severe muscle pain rather than cardiac disease. It was reversed with Se supplementation.

In the strictest sense, Keshan disease has not been proven to be purely a Se deficiency; other conditioning factors such as viral etiology, etc., could be present (Chen et al., 1980). Clearly, however, Se supplementation can prevent Keshan disease, i.e., is protective against it. Interestingly, Se and vitamin E can decrease adriamycin-induced cardiomyopathy in experimental animals (Van Vleet et al., 1978), though they do not reduce pathology induced in other organs. Selenium deficiency has also been reported to cause myocardial damage in farm animals. Selenium supplementation reduces lipid peroxide release (expressed as thiobarbituric acid values) in patients with myocardial infarction (Chen et al., 1980). Selenium addition is reported to reduce thiobarbituric acid values, area of infarction (tissue necrosis) and ECG changes in animals after coronary ligation (Nekolaef et al., 1980).

The histopathologic changes in heart tissue from individuals who died from Keshan disease include alterations in mitochondrial cristae and membranes. In this regard it is interesting that Se is "strikingly localized in the mitochondria ... of the liver in adequately fed rats" (Underwood, 1977g) and mostly in the form of glutathione peroxidase.

It should be noted that in a host of species (including man-made Se-deficient), the Se content of blood, urine and hair Se correlate directly with Se intake, and with (erythrocyte) glutathione peroxidase activity. However, increase in enzyme activity may not continue with added dietary Se supplementation when Se status is adequate (Valentine et al., 1980). Thus measurement of Se levels cannot be assumed to predict glutathione peroxidase levels in all circumstances.

A host of additional geochemical considerations derive from extensive evidence of interactions of Se with many inorganic and organic substances (Calebresi, 1981d). Dietary Se reduces the toxicity of Hg, both inorganic and organic, a finding of potential importance with respect to current awareness of high Hg levels in several types of fish which commonly enter the human food chain (Ganther, 1978). Though most such studies have been performed in animals, there is evidence that suggests that Hg and Se concentrations are related in humans as well. Selenium was also shown to reduce or prevent

toxicity from Cd, including Cd-induced hypertension in animals (Perry *et al.*, 1974), although replication of these studies has not been satisfactory (Whanger, 1979). The differences obtained in experimental studies may relate to dose, form and route of Se administered. For example, only in the selenide form does Se divert Cd protein binding and offer protection against Cd toxicity in the testes (Whanger *et al.*, 1980).

The possible role of Cd in human hypertension received support in a study of blood Se and Cd levels in populations residing in the southeastern Coastal Plain of the US, an area of relative Se deficiency. High-school seniors with hypertension had higher Cd blood levels than their normotensive classmates (Andrews *et al.*, 1980). This agrees with earlier reports of higher Cd levels in hypertensives. If Se is protective, then the higher rates of cardiovascular disease in the Se-deficient coastal plain might relate to the lower availability of Se.

The toxicity of excess Se can be prevented with several inorganic and organic forms of As (Calebresi, 1981d), and *vice versa*; it is even conceivable that one could be used to treat poisoning by the other (Levander, 1977), an hypothesis that should be investigated further. However, in some animal experiments As enhances toxicity of some methylated Se compounds. This effect was reported recently for Hg compounds as well (Parizek *et al.*, 1980), but it probably occurs only in Se-deficient settings (see also Section III.10 and Sections III.2 and III.3 of Chapter 10).

The potential protective effects of Se against ozone, ionizing radiation, benzene, carbon tetrachloride, paraquat, polychlorinated biphenyls (PCBs) and tri-*o*-cresyl phosphate (TOPC) (Calebresi, 1981d) as well as the multitude of reports of additive or synergistic (i.e., greater effect than predicted by adding together the effect of each) protective effects of vitamin E are best understood by a consideration of the biological roles (projected and proven) of glutathione peroxidase.

Glutathione peroxidase (and therefore Se) is believed to play a critical role in antioxidant defence mechanisms at the cellular level (Chow, 1979); particularly with respect to its ability to reduce organic hydroperoxides such as fatty acid peroxides as well as hydrogen peroxide. Peroxide is reduced also by another enzyme, catalase, but catalase cannot utilize the organic peroxides as substrate. In essence, cellular mechanisms for defence against highly toxic substances such as free radicals, superoxide ions, hydroxide ions, singlet oxygen atoms and hydrogen peroxide itself, relate to: (i) superoxide dismutase (a Cu and Zn or Mn-containing enzyme that dismutes superoxide anion to H_2O_2 and H_2O); (ii) glutathione peroxidase; (iii) vitamin E (believed to protect membrane fatty acids from peroxidation and/or other toxic effects of free radicals); (iv) a non-Se containing glutathione-S-transferase that shows increased activity in anti-oxidant deficient (vitamin E and Se) animal tissues

(Stone and Dratz, 1980); (v) an adequate supply of reduced glutathione, NADH and NADPH reductases; and (vi) several other cellular oxidizing and reducing substances (for example, vitamin C).

Glutathione peroxidase has been shown to be important in normal metabolism and membrane protection in red blood cells, phagocytes, lymphocytes, platelets, liver, lens of the eye and probably all tissues. Selenium and glutathione peroxidase are implicated therefore in some disorders of red blood cells, platelets, some infectious diseases, cataracts, immunologic disorders, radiation protection and carcinogenesis. However, in some experimental settings, Se is reported to *impair* defence against oxidative damage and enhance or induce animal cataract formation (Bhuyan *et al.*, 1981).

It is quite possible that Se, either as glutathione peroxidase or in conjunction with some other metabolic pathway (Diplock, 1976), may play additional biochemical roles. Blood platelets from Se-deficient rats show considerable alterations in the production of highly active compounds of the prostaglandin series (Bryant and Bailey, 1980). Prostaglandins are potent biochemicals derived from arachidonic acid and other unsaturated fatty acids via endoperoxide intermediates. They appear to be key regulators of many vascular and immunologic processes; hence effects of Se deficiency or excess might be mediated by mechanisms other than purely anti-oxidant.

The role of Se in carcinogenesis is currently receiving considerable attention (Schrauzer, 1978; Baumgartner, 1979; Jannson, 1980). In summary, Se added to animal diets can decrease the development of various tumours induced by oral, cutaneous or subcutaneous administration with many chemical carcinogens including 3-methyl-4-dimethylaminoazobenzene, dimethylbenzanthracene, 2-acetylaminofluorene, 1,2-dimethylhydrazine and methylazoxymethanol acetate. In addition, the incidence of spontaneous mammary tumours in one strain (C_3H) of aged mice can be reduced from 80% to 10% with long-term non-toxic selenite administration (Schrauzer and Ishmael, 1974). This is especially interesting because these cancers are now known to be caused by horizontal transmission of a virus through mother's milk, suggesting that some mechanism other than antioxidation via Se might be responsible, such as a stimulating effect on immune surveillance mechanisms (Baumgartner, 1979).

Conversely, Se deficiency can enhance tumour development in animal systems (Ip and Sinha, 1981). These and many other animal experiments are particularly interesting when they are related to extensive epidemiologic evidence that suggests a negative correlation between the frequency of occurrence of several human cancers, especially gastrointestinal and breast cancer, and calculated dietary Se (and Zn) intake (Schrauzer, 1978), and correlations between the prevalence of various cancers and high and low Se areas (Shamberger *et al.*, 1976). Since Se is added to animal feed in many areas,

but restricted to a 10 μg l^{-1} standard in drinking water by the Environmental Protection Agency, and yet freely available as over-the-counter supplements for human nutrition, there is much reason to resolve these issues. Since Se can be toxic, *excessive* dietary intake from non-prescription sources by individuals hoping to prevent cancer (based upon inadequate evidence to date) could be potentially dangerous (Young, 1981).

Selenium, then, stands as the outstanding example of the relationship between geochemistry and human health for the decade of the 1980s. There is a dramatic and preventable geochemically linked deficiency syndrome on the one hand, and on the other hand, there is an equally dramatic potential link to several human cancers. Under such circumstances, a flood of new publications on Se, both in the scientific and lay literatures, can be expected, together with the probable abuse of Se supplements purchased in excess as a non-prescription item. It may well be necessary for health professionals to anticipate and recognize Se poisoning (Snodgrass *et al.*, 1981).

10. Zinc

There are said to be 5.1 \times 10^{20} atoms of Zn in a newborn baby (Shaw and Sweeney, 1980), which is probably roughly comparable to the number of words published in articles and texts on Zn in the last few years, including several comprehensive reviews (Prasad and Oberleas, 1976; Underwood, 1977h; Prasad, 1978f; Hambidge and Nichols, 1978; Karcioglu and Sarper, 1980). An adult contains about 1.5–3.0 g Zn, with the largest amounts being in liver and bone. There is evidence that Zn concentrations in blood and several tissues vary considerably in response to many stimuli.

Zinc appears to be critical to so many functions that some frustration exists in attempting to define "the" role of Zn as an essential element. Human Zn deficiency in an inherited form in infants is termed acrodermatitis entero-pathica (Moynahan, 1979) and is characterized by behavioural disturb-ances, diarrhoea, hair loss, severe peri-orificial skin rash, and secondary yeast infection due apparently to an immunologic deficiency, all of which respond with remarkable promptness to Zn administration. Similar syn-dromes have now been reported many times with penicillamine treatment of other disorders (Klingberg *et al.*, 1976), presumably due to chelation of Zn, as well as during total parenteral nutrition when Zn was not added to the nutritional solutions for even as short a time as two weeks (McClain *et al.*, 1980). A more chronic dietary deficiency of Zn (combined with other deficiencies) includes dwarfism, hypogonadism and sexual immaturity, the latter reversed with Zn therapy (Prasad, 1978f). There is much evidence for marginal dietary deficiencies in humans. The effects include decreased acuity

of taste (hypogeusia), impotance, delayed wound healing (Pories *et al.*, 1971; Strain *et al.*, 1975), hypogonadism and oligospermia (Abbasi *et al.*, 1980), poor development and possibly foetal wasting and teratogenesis (Hurley, 1981).

Dietary sources range in Zn concentrations from 1400 μg g^{-1} (Atlantic oysters) to 2 μg g^{-1} or less in fresh fruit and vegetables (Solomons, 1980). Bioavailability of Zn is especially high for Zn from animal tissues, and is low from milk and from grains. The latter effect is apparently due to binding to phytic acid and fibre. Calculated dietary intakes of institutionalized individuals in the US (Murthy *et al.*, 1971), low income Mexican-Americans (Hunt *et al.*, 1978) and school children (Hambidge *et al.*, 1976), and absorption studies in vegetarians (Freeland-Graves *et al.*, 1980) all suggest that marginal deficiencies may not be uncommon. Additional factors may include inhibition of Zn absorption by other elements, such as Ca, Cd and Cu.

Zinc is absorbed from the small intestine, possibly by binding with a prostaglandin (Song and Adham, 1979) derived from arachidonic acid metabolism. The reversal of signs of Zn deficiency in some circumstances by administration of unsaturated fatty acids (Horrobin and Cunnane, 1980) implies further relationship between Zn, prostaglandins and fatty acids. Zinc is bound intracellularly in gastrointestinal epithelial cells (Cousins, 1979) by a specific protein of about 10 000 daltons molecular weight with unusually high cysteine content called metallothionein. This protein (or group of proteins) is also found in liver and kidney in particular (and originally detected as a Cd-binding protein in kidney). Zinc is transported in the blood bound in part to transferrin (see Section III.6); most is tightly bound to α-2-macroglobulin. It is then sequestered in liver and presumably other tissues by an intracellular metallothionein, and/or utilized for its many biochemical functions.

Zinc is bound stoichiometrically to a series of vital enzymes (metallo-enzymes) and serves either active site catalysis or regulation of protein conformation. Zinc also serves as co-factor for many additional enzymes (Roth and Kirchgessner, 1980) to which it is loosely linked, and is readily substituted for by certain other metals *in vitro*. There is also considerable evidence that Zn serves some non-enzymatic functions, particularly with respect to cell membrane properties and behaviour (Bettger and O'Dell, 1981). Many of these effects may be due to competition with Ca in membrane function.

Primary geochemical influences on Zn in man are not nearly as evident as with I, F or Se unless one considers Zn in the immediate environment of smelters, mining operations, etc. Nevertheless, with the suspicion that widespread marginal deficiencies exist, individual dietary practice coupled with local food sources could be quite important. Perhaps the most bizarre practice linked with dietary Zn in several reports is that of clay-eating, or geophagia (or its modern substitute, starch-eating; Furuseth, 1975). Con-

troversy continues over inhibition of Zn (and Fe) absorption by ingested clay or whether indeed the clay is instinctively or culturally sought as a source of needed elements (Prasad, 1978f). There are reports of "immediate" cessation of geophagia with administration of Zn, and some clay-eaters go to great lengths to import better quality clay from distant soils (Furuseth, 1975).

Stimulus to continued investigation of geochemistry and marginal Zn deficiency in humans is derived also from evidence relating Zn deficiencies to: (i) enhanced carcinogenesis in a wide variety of animal experiments (Seelig, 1979); (ii) immune deficiency in animals (Pories *et al.*, 1978; Chandra, 1980; van Rig and Pories, 1980) and humans; (iii) cardiovascular disease (Borhani, 1981); (iv) sexual dysfunction during haemodialysis (Mahajan *et al.*, 1980, 1982); and (v) congenital malformations in animals (Hurley, 1981) and man (Jameson, 1976; Hambidge *et al.*, 1976; Soltan and Jenkins, 1982; Hurley, 1982). Perversely, reports of negative or opposite correlations reflect the many interactions between Zn, Cu, Cd and Mg and of their potential effects on the various diseases. The geochemistry of Zn might affect human health in other ways. Zinc concentration can be increased in cereal and legume crops by manipulation of nutrients (Underwood, 1977h), which might be important if marginal deficiencies in man are as common as now suspected. On the other hand, Zn deficiency in the growth medium can "virtually eliminate aflatoxin production from toxigenic strains of *A. flavus*" (Hopps, 1978) (excess Cd or Cu also inhibits toxin production); aflotoxins are suspect in the causology of human liver cancers. Choice of correct amounts of Zn in the human food chain can be complex indeed!

References

Abbasi, A. A., Prasad, A. S., Rabbani, P. and DuMouchelle, E. (1980). *J. Lab. Clin. Med.* **3**, 544–550.

Anderson, C. E. (1977a). *In* "Nutritional Support of Medical Practice" (Schneider, H. A., Anderson, C. E. and Coursin, D. B., eds), pp. 57–72. Harper & Row, Hagerstown, Maryland.

Anderson, C. E. (1977b). *In* "Nutritional Support of Medical Practice" (Schneider, H. A., Anderson, C. E. and Coursin, D. B., eds), p. 69. Harper & Row, Haggerstown, Maryland.

Anderson, R. (1982). *J. Am. Med. Assoc.* **247**, 3046–3047.

Andrews, J. W., Hames, C. G. and Metts, J. C. (1980). "Trace Substances in Environmental Health. XIV", pp. 38–42. University of Missouri, Columbia, Missouri.

Avioli, L. V. (1980). *In* "Modern Nutrition in Health and Disease" (Goodhart, R. S. and Shils, M. E., eds.), pp. 294–309. Lea and Febiger, Philadelphia.

Baumgartner, W. A. (1979). *In* "Trace Metals in Health and Disease" (Kharasch, N., ed.), pp. 278–305. Raven Press, New York.

Beeson, K. G. (1978). *In* "Geochemistry and the Environment. Volume III: Distribution of Trace Elements Related to the Occurrence of Certain Cancers, Cardiovascular Diseases and Urolithiasis", pp. 59–78. National Academy of Sciences, Washington, DC.

Bettger, W. J. and O'Dell, B. L. (1981). *Life Sci.* **28**, 1425–1438.
Beutler, E. (1980). *In* "Modern Nutrition in Health and Disease", 6th edn (Goodhard, R. S. and Shils, M. E'. eds), pp. 324–354. Lea and Febiger, Philadelphia.
Beyers, P. H., Siegel, R. C., Holbrook, K. A., Narayanan, A. S., Bornstein, P. and Hall, J. G. (1980). *New Eng. J. Med.* **303**, 61–65.
Bhuyan, K. C., Bhuyan, D. K. and Podos, S. M. (1981). *Pharmacology* **9**, 195–196.
Blondell, J. M. (1980). *Medical Hypothesis* **6**, 863–871.
Bonewitz, R. L. and Howell, R. R. (1981). *J. Cell. Physiol.* **106**, 339–348.
Borhani, N. O. (1981). *Circulation* **63**, 260A–263A.
Bryant, R. W. and Bailey, J. M. (1980). *Biochem. Biophys. Comm.* **92**, 268–276.
Burch, R. E., Itahn, H. J. K. and Sullivan, J. F. (1975). *Clin. Chem.* **21**, 501–520.
Calebresi, E. J. (1981a). "Nutrition and Environmental Health: The Influence of Nutritional Status on Pollutant Toxicity and Carcinogenicity. Volume II: Minerals and Macronutrients", pp. 1–64. Wiley, New York.
Calebresi, E. J. (1981b). "Nutrition and Environmental Health: The Influence of Nutritional Status on Pollutant Toxicity and Carcinogenicity. Volume II: Minerals and Macronutrients", pp. 74–75. Wiley, New York.
Calebresi, E. J. (1981c). "Nutrition and Environmental Health. The Influence of Nutritional Status on Pollutant Toxicity and Carcinogenicity. Volume II: Minerals and Macronutrients", pp. 213–216. Wiley, New York.
Calebresi, E. J. (1981d). "Nutrition and Environmental Health: The Influence of Nutritional Status on Pollutant Toxicity and Carcinogenicity. Volume II: Minerals and Macronutrients", pp. 119–175. Wiley, New York.
Calebresi, E. J., Moore, G. S., Tuthill, R. W. and Sieger, T. L. (eds) (1980). *J. Environ. Path. Toxicol.* **4** (2, 3), 1–326.
Cannon, H. L. and Anderson, B. M. (1971). *In* "Environmental Geochemistry in Health and Disease", pp. 155–177. The Geological Society of America, Inc., Memoir 123.
Cavalieri, R. R. (1980). *In* "Modern Nutrition in Health and Disease", 6th edn (Goodhart, R. S. and Shils, M. E., eds), pp. 395–441. Lea and Febiger, Philadelphia.
Chandra, R. K. (1980). *Am. J. Clin. Nutr.* **33**, 736–738.
Chandra, R. K., Au, B., Woodford, G. and Hyam, P. (1977). *In* "Iron Metabolism", pp. 249–268. Ciba Foundation Symposium 51. Elsevier, Amsterdam.
Chen, X., Yang, G., Chen, J., Chen, X., Wen. Z. and Ge, K. (1980). *Biol. Trace Elem. Res.* **2**, 91–107.
Chow, C. K. (1979). *Am. J. Clin. Nutr.* **32**, 1066–1081.
Chuttani, H. K., Gupta, P. S., Gulatti, S. and Gupta, D. N. (1965). *Am. J. Med.* **39**, 849.
Cohen, H. J., Drew, R. T., Johnson, J. L. and Rajagopalan, K. V. (1973). *Proc. Natl. Acad. Sci. U.S.A.* **70**, 3655–3659.
Collipp, P. J. and Chen, S. Y. (1981). *New Eng. J. Med.* **304**, 1304–1305 (Letter).
Cordano, A., Baertl, J. M. and Graham, G. G. (1964). *Pediatrics* **34**, 324–336.
Cotzias, G. C. and Bertinchamps, A. J. (1960). *J. Clin. Invest.* **39**, 979.
Cousins, R. J. (1979). *Am. J. Clin. Nutr.* **32**, 339–345.
Danks, D. M., Campbell, P. E., Stevens, B. J., Mayne, V. and Cartwright, E. (1972). *Pediatrics* **50**, 188–201.
Davis, G. K. (1978). *In* "Geochemistry and the Environment. Volume III: Distribution of Trace Elements Related to the Occurrence of Certain Cancers, Cardiovascular Diseases, and Urolithiasis", pp. 133–138. National Academy of Sciences, Washington, DC.
Davis, G. K. (1980). *Ann. N.Y. Acad. Sci.* **355**, 130–139.
DeLuca, H. F. (1980). *In* "Trace Metals in Health and Disease" (Kharasch, N., ed.), pp. 189–215. Raven Press, New York.
DeRosa, G., Keen, C. L., Leach, R. M. and Hurley, L. S. (1980). *J. Nutr.* **110**, 795–804.
Diplock, A. T. (1976). *Crit. Rev. Toxicol.* **4**, 271–329.
Doisy, E. A. Jr. (1974). *In* "Trace Element Metabolism in Animals" (Hoekstra, *et al.*, eds), pp. 668–670. University Park Press, Baltimore.
Doisy, R. J., Streeten, D. H. P., Fresberg, J. M. and Schneider, A. J. (1976). *In* "Chromium Metabolism in Man and Biochemical Effects in Trace Elements in Human Health and Disease", Volume II (Prasad, A., ed.), pp. 79–104. Academic Press, New York and London.

Durfor, C. N. and Becker, E. (1964). "Public Water Supplies of the 100 Largest Cities in the United States", Geologic Survey Water Supply Paper 1812. US Government Printing Office, Washington, DC.

Emmerson, B. T. (1970). *Ann. Int. Med.* **73**, 854–855.

United States Environmental Protection Agency (EPA) (1979). "Human Health Effects of Molybdenum in Drinking Water", pp. 65–77. EPA-600:1-79-006.

Eskin, B. A. (1978). *In* "Inorganic and Nutritional Aspects of Cancer" (Schrauzer, G. N., ed.), pp. 293–304. Plenum Press, New York.

Fitzgerald, F. T. (1978). *In* "Advances in Internal Medicine", vol. 23 (Stollerman, G. H., ed.), pp. 137–157. Year Book Medical Publishers, Chicago.

Flohe, L., Gunzler, A. and Loschen, G. (1979). *In* "Trace Metals in Health and Disease" (Kharasch, N., ed.), pp. 263–286. Raven Press, New York.

Forbes, A. L. (1978). *In* "Geochemistry and the Environment, Volume III, Distribution of Trace Elements Related to the Occurrence of Certain Cancers, Cardiovascular Diseases and Urolithiasis", pp. 70–71. National Academy of Sciences, Washington, DC.

Freeland-Graves, J. H., Ebangit, M. L. and Hendrikson, P. J. (1980). *Am. J. Clin. Nutr.* **33**, 1757–1766.

Fregert, S. (1981). *Br. J. Dermat.* **105** (Suppl. 21), 7–9.

Freund, H., Atamian, S. and Fischer, J. E. (1979). *J. Amer. Med. Assoc.* **241**, 496–498.

Furuseth, O. J. (1975). *In* "North Carolina: A Reader" (Smith, V. M., Steila, D. and Stephenson, R. A., eds), pp. 115–125. Paladin Horse Publishers, Geneva, Ill.

Ganther, H. E. (1978). *Environ. Health Perspect.* **25**, 71–76.

Gonzales, J. J., Owens, W., Ungaro, P. C., Werk, E. E. and Wentz, P. W. (1982). *Arch. Int. Med.* **96**, 65–66.

Grant, J. P. (1980). "Handbook of Total Parenteral Nutrition", p. 161. W. B. Saunders Co., Philadelphia.

Gray, L. E. Jr. and Lasky, J. W. (1980). *J. Toxicol. Environ. Health* **6**, 861–867.

Greene, J. C., Vermillion, J. R. and Hay, S. (1965). *Cleft Palate J.* **2**, 141–156.

Hahn, C. J. and Evans, G. W. (1975). *Am. J. Physiol.* **228**, 1020–1023.

Hambidge, K. M. (1974). *Am. J. Clin. Nutr.* **27**, 505–514.

Hambidge, K. M. and Nichols, B. L. Jr. (eds) (1978). "Zinc and Copper in Clinical Medicine". Spectrum Publications, Jamaica, NY.

Hambidge, K. M., Walravens, P. A., Brown, R. M., Webster, J., White, S., Anthony, M. and Roth, M. L. (1976). *Am. Clin. Nutr.* **29**, 734–738.

Harland, B. F., Johnson, R. D., Blendermann, E. M., Prosky, L., Vanderveen, J. E., Reed, G. L., Forbes, A. L. and Roberts, H. R. (1980). *J. Am. Dietetic Assoc.* **77**, 16–20.

Hays, R. M. (1980). *In* "Clinical Disorders of Fluid and Electrolyte Metabolism" (Maxwell, M. H. and Kleeman, C. R., eds), pp. 1–36. McGraw-Hill, New York.

Hodgkinson, A., Nordin, B. E. C., Hambleton, J. and Oxby, C. B. (1967). *Can. Med. Assoc. J.* **97**, 1139–1143.

Hopps, H. C. (1978). *In* "Geochemistry and the Environment. Volume III: Distribution of Trace Elements Related to the Occurrence of Certain Cancers, Cardiovascular Diseases, and Urolithiasis", pp. 81–113. National Academy of Sciences, Washington, DC.

Horrobin, D. F. and Cunnane, S. C. (1980). *Med. Hypotheses* **6**, 277–296.

Hsieh, S. H. and Hsu, J. M. (1980). *In* "Zinc and Copper in Medicine" (Karcioglu, Z. A. and Sarper, R. M., eds), pp. 94–125. Charles C. Thomas, Springfield, Illinois.

Huffman, E. W. D. Jr. and Allaway, W. H. (1973). *J. Agric. Food Chem.* **21**, 982–986.

Hunt, I. F., Ostergard, N. J. and Shroads, J. (1978). *Fed. Proc.* **37**, 890.

Hurley, L. S. (1981). *Johns Hopkins Med. J.* **148**, 1–10.

Hurley, L. S. (1982). *Teratol.* **25**, 123 (Letter).

Hyodo, K., Susuki, S., Furuya, N. and Meshiazuka, K. (1980). *Arch. Occup. Environ. Health* **46**, 141–150.

Ingersell, R. J. and Wasserman, R. H. (1971). *J. Biol. Chem.* **246**, 2802–2814.

Ip, C. and Sinha, D. K. (1981). *Cancer Res.* **41**, 31–34.

Jameson, S. (1976). *Acta Medica Scand. Suppl.* 593.

Jansson, B. (1980). *In* "Metal Ions in Biological Systems. Volume 10, Carcinogenicity and Metal Ions" (Sigel, H., ed.), pp. 281–311. Marcel Dekker.

Jeejeebhoy, K. N., Chu, R., Marliss, E. B., Greenberg, G. R. and Robertson, A. B. (1977). *Am. J. Clin Nutr.* **30**, 531–538.

Johansson, G., Backman, U., Danielson, B. G., Ljunghall, S. and Wilkstrom, B. (1980a). *Invest. Urol.* **18**, 93–96.

Johansson, G., Backman, U., Danielson, B. G., Fellstrom, B., Ljunghall, S. and Wilkstrom, B. (1980b). *J. Urol.* **124**, 770–774.

Johnson, R. A., Baker, S. S., Fallon, J. T., Maynard, E. P., Ruskin, J. R., Wen, Z., Ge, K. and Cohen, H. J. (1981). *New Eng. J. Med.* **304**, 1210–1212.

Karcioglu, Z. and Sarper, R. M. (1980). "Zinc and Copper in Medicine". Charles C. Thomas, Springfield, Illinois.

Kark, R. M. and Oyama, J. H. (1980). *In* "Modern Nutrition in Health and Disease" (Goodhart, R. S., and Shils, M. E., eds), 6th edn, pp. 998–1044. Lea and Febiger, Philadelphia.

Kazantzis, G. (1979). *Environ. Health Perspect.* **28**, 155–159.

Ke, P. J., Power, H. E. and Regier, L. W. (1970). *J. Sci. Food Agric.* **21**, 108–109.

Klevay, L. M. (1980). *Ann. N.Y. Acad. Sci.* **355**, 140–151.

Klingberg, W. G., Prasad, A. S. and Oberleas, D. (1976). *In* "Trace Elements in Human Health and Disease. Vol. I. Zinc and Copper", pp. 51–65. Academic Press, New York and London.

Kovalski, V. V. (1970). *In* "Trace Elements Metabolism in Animals", Vol. I (Mills, C. F., ed.), p. 385. Livingstone, Edinburgh.

Kovalski, V. V. (1979). *Phil. Trans. R. Soc. Lond.* **B288**, 185–191.

Kuivaniema, H., Peltonen, L., Palotie, A., Kaitila, I. and Kivirikko, K. I. (1982). *J. Clin. Invest.* **69**, 730–733.

Levander, O. A. (1977). *Environ. Health Perspect.* **19**, 159–164.

Li, T. K. and Vallee, B. L. (1980). *In* "Modern Nutrition in Health and Disease", 6th edn (Goodhart, R. and Shils, M. E., eds), pp. 408–441. Lea and Febiger, Philadelphia.

Lo, M. and Sandi, E. (1980). *J. Environ. Path. Toxicol.* **4**, 193–218.

Losee, F. L. and Adkins, B. L. (1971). *In* "Environmental Geochemistry in Health and Disease" (Cannon, H. L. and Hopps, H. C., eds), pp. 203–209. Memoir 123, The Geological Society of America Inc., Boulder, Colorado.

Ludwig, T. G., Healy, W. B. and Losee, F. L. (1960). *Nature, Lond.* **186**, 695–696.

Lynch, S. R. and Cook, J. D. (1980). *Ann. N.Y. Acad. Sci.* **355**, 32–44.

MacGregor, G. A., Smith, S. J., Markando, N. D., Banks, R. A. and Sagnella, G. A. (1982). *Lancet* **2**, 567–570.

Mahajan, S. K., Prasad, A. S., Briggs, W. A. and McDonald, F. D. (1980). *Trans. Am. Soc. Artif. Intern. Organs* **26**, 139–141.

Mahajan, S. K., Abbasi, A. A., Prasad, A. S., Rabbani, P., Briggs, W. A. and McDonald, F. D. (1982). *Ann. Int. Med.* **97**, 357–361.

Manthey, J., Stoeppler, M., Morgenstern, W., Nussel, E., Opherk, D., Weintraut, A., Wesch, H. and Kubler, W. (1981). *Circulation* **65**, 722–729.

Mason, K. E. (1979). *J. Nutr.* **109**, 1980–2005.

McClain, G. J., Soutor, C., Steele, N., Levine, A. S. and Silvas, S. E. (1980). *J. Clin. Gastroenterol.* **2**, 125–131.

McMillan, G. (1978). *In* "Geochemistry and the Environment. Vol. III. Distribution of Trace Elements Related to Certain Cancers, Cardiovascular Diseases and Urolithiasis", pp. 114–132. National Academy of Sciences, Washington, DC.

Mertz, W. (1969). *Physiol. Rev.* **49**, 169–239.

Mertz, W. (1981). *Science* **213**, 1332–1338.

Mertz, W. and Schwarz, K. (1959). *Am. J. Physiol.* **196**, 614–618.

Mertz, W., Toepfer, E. W., Roginsky, E. E. and Polansky, M. M. (1974). *Fed. Proc.* **33**, 2275–2280.

Metzler, D. E. (1977). "Biochemistry: The Chemical Reactions of Living Cells". Academic Press, New York and London.

Moynahan, E. J. (1979). *Phil. Trans. R. Soc. Lond.* **B288**, 65–79.

Murthy, G. K., Rhea, U. and Peeler, J. T. (1971). *Environ. Sci. Tech.* **5**, 436.

Navia, J. M., Hunt, C. E., First, F. B. and Narkates, A. J. (1976). *In* "Trace Elements in Human

Health and Disease", Vol. II (Prasad, A. S., ed.), pp. 249–268. Academic Press, New York and London.

Nekolaef, C. M. *et al.* (1980). Summarized by Chen *et al.* (1980).

Nielands, J. B. (1977). *In* "Iron Metabolism", pp. 107–124. Ciba Foundation Symposium 51. Elsevier, Amsterdam.

Nordin, B. E. C., Smith, D. A., Shimmins, J. and Oxby, C. (1967). *Clin. Sci.* **32**, 39–48.

Osterberg, R. (1980). *Pharmac. Ther.* **9**, 121–146.

Parfitt, A. M. and Kleerekoper, M. (1980). *In* "Clinical Disorders of Fluid and Electrolyte Metabolism" (Maxwell, M. H. and Kleeman, C. R., eds), pp. 269–398. McGraw-Hill, New York.

Parizek, J., Kalouskova, J., Benes, J. and Pavlik, L. (1980). *Ann. N.Y. Acad. Sci.* **355**, 347–360.

Perry, H. M. Jr., Perry, E. F. and Erlanger, M. W. (1974). *In* "Trace Substances in Environmental Health" (Hemphill, D. D., ed.), pp. 51–57. University of Missouri, Columbia.

Pimentel, J. C. and Marques, F. (1969). *Thorax* **24**, 678–688.

Pitt, M. A. (1976). *Agents and Actions* **6**, 758–769.

Polanski, M. and Anderson, R. (1982). Reviewed in *J. Am. Med. Assoc.* **247**, 3046–3047.

Pories, W. J., Strain, W. H. and Rob, C. G. (1971). *In* "Environmental Geochemistry in Health and Disease" (Cannon, H. L. and Hopp, H. C., eds), pp. 73–95. The Geological Society of America, Inc., Boulder, Colorado.

Pories, W. J., van Rij, A. M. and Bray, J. T. (1978). *In* "Trace Substances in Environmental Health", Vol. 12 (Hemphill, D. D., ed.). University of Missouri, Columbia.

Prasad, A. S. (1978a). *In* "Trace Elements and Iron in Human Metabolism" (Hemphill, D. D., ed.), pp. 349–362. Plenum Press, New York.

Prasad, A. S. (1978b). *In* "Trace Elements and Iron in Human Metabolism" (Hemphill, D. D., ed.), pp. 3–15. Plenum Press, New York.

Prasad, A. S. (1978c). *In* "Trace Elements and Iron in Human Metabolism" (Hemphill, D. D., ed.), pp. 63–75. Plenum Press, New York.

Prasad, A. S. (1978d). *In* "Trace Elements and Iron in Human Metabolism" (Hemphill, D. D., ed.), pp. 77–157. Plenum Press, New York.

Prasad, A. S. (1978e). *In* "Trace Elements and Iron in Human Metabolism" (Hemphill, D. D., ed.), pp. 191–201. Plenum Press, New York.

Prasad, A. S. (1978f). *In* "Trace Elements and Iron in Human Metabolism" (Hemphill, D. D., ed.), pp. 251–346. Plenum Press, New York.

Prasad, A. S. and Oberleas, D. (eds) (1976). "Trace Elements in Human Health and Disease. Vol. I. Zinc and Copper". Academic Press, New York and London.

Quarterman, J., Morrison, J. N. and Humphries, W. R. (1978). *Environ. Res.* **17**, 60–67.

Riales, R. and Albrink, M. J. (1981). *Am. J. Clin. Nutr.* **34**, 2670–2678.

Roth, H.-P. and Kirchgessner, M. (1980). *Wld. Rev. Nutr. Diet.* **34**, 144–160.

Rude, R. K. and Singer, F. R. (1981). *Ann. Rev. Med.* **32**, 245–259.

Salmon, M. A. and Wright, T. (1971). *Arch. Dis. Child.* **46**, 108–110.

Saner, G. (1980). "Chromium in Nutrition and Disease". Alan R. Liss, Inc., New York.

Scheinberg, I. H. and Sternlieb, I. (1969). *In* "Duncan's Diseases of Metabolism, Endocrinology and Nutrition", Vol. II, 6th edn (Bondy, P. K., ed.), pp. 1321–1334. Saunders Philadelphia.

Schrauzer, G. N. (1978). *Adv. Exptl. Med. Biol.* **91**, 323–344.

Schrauzer, G. N. (1979). *In* "Trace Metals in Health and Disease" (Kharasch, N., ed.), pp. 251–261. Raven Press, New York.

Schrauzer, G. N. and Ishmael, D. (1974). *Ann. Clin. Lab. Sci.* **4**, 441–447.

Schroeder, H. A. and Balassa, J. J. (1965). *Am. J. Physiol.* **209**, 433–437.

Schroeder, H. A., Balassa, J. J. and Tipton, I. H. (1964). *J. Chronic Dis.* **17**, 483–502.

Schroeder, H. A., Ballasa, J. J. and Vinton, W. H. Jr. (1965). *J. Nutr.* **86**, 51–66.

Schroeder, H. A., Nason, A. P., Tipton, I. H. and Balassa, J. J. (1966). *J. Chron. Dis.* **19**, 1007–1034.

Schroeder, H. A., Nason, A. P. and Tipton, I. H. (1970). *J. Chronic Dis.* **23**, 123–142.

Schultz, R. G. and Nissenon, A. R. (1980). *In* "Clinical Disorders of Fluid and Electrolyte Metabolism" (Maxwell, M. H. and Kleeman, C. R., eds), pp. 113–143. McGraw-Hill, Inc., New York.

Schwarz, K. and Mertz, W. (1959). *Arch. Biochem. Biophys.* **85**, 292–295.

Seelig, M. S. (1979). *Biol. Trace Element Res.* **1**, 273–297.
Shamberger, R. J., Tytko, S. A. and Willis, C. E. (1976). *Arch. Environ. Health* **31**, 231–235.
Sharett, A. R. (1977). *Sci. Total Environ.* **7**, 217–226.
Sharett, A. R. (1981). *Circulation* **63**, 247A–250A.
Shaw, J. H. and Sweeney, E. A. (1980). *In* "Modern Nutrition in Health and Disease" (Goodhart, R. S. and Shils, M. E., eds), pp. 855–891. Lea and Febiger, Philadelphia.
Shils, M. E. (1980). *Ann. N.Y. Acad. Sci.* **355**, 165–180.
Six, K. M. and Goyer, R. A. (1970). *J. Lab. Clin. Med.* **76**, 933–942.
Smith, M. I., Franke, K. W. and Westfall, B. B. (1936). *U.S. Publ. Hlth. Rep. (Wash.)* **51**, 1496–1505.
Smith, M. I. and Westfall, B. B. (1937). *U.S. Publ. Hlth. Rep. (Wash.)* **52**, 1375–1384.
Snodgrass, W., Rumack, B. H. and Sullivan, J. B. (1981). *Clin. Toxicol.* **18**, 211–220.
Solomons, N. W. (1980). *In* "Zinc and Copper in Medicine" (Karcioglu, Z. and Sarper, R. M., eds), pp. 224–275. Charles C. Thomas, Springfield, Illinois.
Soltan, M. H. and Jenkins, D. M. (1982). *Br. J. Obs. Gyn.* **89**, 56–58.
Song, M. K. and Adham, N. F. (1979). *J. Nutr.* **109**, 2152–2159.
Spencer, H., Kramer, L., Osis, D., Wiatrowski, E., Norris, C. and Lender, M. (1980). *Ann. N.Y. Acad. Sci.* **355**, 181–194.
Spencer, H., Osis, D. and Lender, M. (1981). *Sci. Tot. Environ.* **17**, 1–12.
Stadtman, T. C. (1980a). *Ann. Rev. Biochem.* **49**, 93–110.
Stadtman, T. C. (1980b). *Trends Biochem. Sci.* August, 203–206.
Stone, W. L. and Dratz, E. A. (1980). *Biochim. Biophys. Acta* **631**, 503–506.
Strain, W. H., Pories, W. J., Mansour, E. G. and Flynn, A. (1975). *In* "Trace Element Geochemistry in Health and Disease" (Freedman, J., ed.), pp. 83–105. The Geologic Society of America, Special Paper 155.
Suttle, N. F. (1980). *Ann. N.Y. Acad. Sci.* **355**, 155–203.
Tkeshelashvili, L. K., Shearman, C. W., Zakour, R. A., Koplitz, R. M. and Loeb, L. A. (1980). *Cancer Res.* **40**, 2455–2460.
Toepfer, E. W., Mertz, W., Roginski, E. E. and Polansky, M. M. (1973). *J. Agric. Food Chem.* **21**, 69–73.
Tsongas, T. A., Meglen, R. R., Walravens, P. A. and Chappel, W. R. (1980). *Am. J. Clin. Nutr.* **33**, 1103–1107.
Underwood, E. J. (1977a). *In* "Trace Elements in Human and Animal Nutrition", 4th edn (Hemphill, D. D., ed.), pp. 132–158. Academic Press, New York and London.
Underwood, E. J. (1977b). *In* "Trace Elements in Human and Animal Nutrition", 4th edn (Hemphill, D. D., ed.), pp. 347–374. Academic Press, New York and London.
Underwood, E. J. (1977c). *In* "Trace Elements in Human and Animal Nutrition", 4th edn (Hemphill, D. D., ed.), pp. 271–304. Academic Press, New York and London.
Underwood, E. J. (1977d). *In* "Trace Elements in Human and Animal Nutrition", 4th edn (Hemphill, D. D., ed.), pp. 13–55. Academic Press, New York and London.
Underwood, E. J. (1977e). *In* "Trace Elements in Human and Animal Nutrition", 4th edn (Hemphill, D. D., ed.), pp. 170–195. Academic Press, New York and London.
Underwood, E. J. (1977f). *In* "Trace Elements in Human and Animal Nutrition", 4th edn (Hemphill, D. D., ed.), pp. 109–131. Academic Press, New York and London.
Underwood, E. J. (1977g). *In* "Trace Elements in Human and Animal Nutrition", 4th edn (Hemphill, D. D., ed.), pp. 302–346. Academic Press, New York and London.
Underwood, E. J. (1977h). *In* "Trace Elements in Human and Animal Nutrition", 4th edn (Hemphill, D. D., ed.), pp. 196–257. Academic Press, New York and London.
Valentine, J. L., Kang, H. K., Dang, P. and Schluchter, M. (1980). *J. Toxicol. Environ. Health* **6**, 731–736.
van Rij, A. M., Thompson, C. D., McKensie, J. M. and Robinson, M. F. (1979). *Am. J. Clin. Nutr.* **32**, 2076–2085.
van Rij, A. M. and Pories, W. J. (1980). *In* "Metal Ions in Biological Systems. Vol. 10. Carcinogenicity and Metal Ions" (Sigel, H., ed.), pp. 207–251. Marcel Dekker, New York.
Van Vleet, J. F., Greenwood, L., Ferrans, V. J. and Rebar, A. H. (1978). *Am. J. Vet. Res.* **39**, 997–1010.
Wacker, W. E. C. and Parisi, A. F. (1968). *N. Engl. J. Med.* **278**, 658–663, 712–717, 772–776.

Whanger, P. D. (1979). *Environ. Health Perspect.* **28**, 115–121.
Whanger, P. D., Ridlington, J. W. and Holcomb, C. L. (1980). *Ann. N.Y. Acad. Sci.* **355**, 333–345.
Willson, R. L. (1977). *In* "Iron Metabolism", pp. 331–354. Foundation Symposium 51, Elsevier, Amsterdam.
Young, V. R. (1981). *New Eng. J. Med.* **304**, 1228–1229.
Zakour, R. A., Loeb, L., Kunkel, T. A. and Koplitz, R. M. (1979). *In* "Trace Metals in Health and Disease" (Kharasch, N., ed.), pp. 135–153. Raven Press, New York.

10

Geochemistry and Man:
Health and Disease
2. Elements Possibly Essential,
Those Toxic and Others

ROBERT G. CROUNSE, WALTER J. PORIES,
JOHN T. BRAY and RICHARD L. MAUGER

I. Introduction

Many of the elements to be considered in this chapter have been known in biomedicine as elements clearly toxic to animals and man: Hg, Cd and Pb are classic examples. Indeed, some are considered so dangerous as to be potential health hazards even if present in human fluids/tissues at levels considered acceptable only a few years ago. Some authors argue that environmental contamination in some instances (as for Pb) is so widespread that there are no normal or absolutely safe blood/tissue levels; that all individuals, and all laboratories are already above normal; that subtle forms of toxicity, such as learning disorders, mild neurologic disorders not formerly considered as possible poisoning, may indeed be related to metal levels believed to be within the (upper) normal range.

Even as the alarmists (and they may be right) warn us of global pollution with resultant health effects, others continue to probe the possible *essential* role of known toxic elements, including Ni, Cd, As and Pb. All of this leads to much controversy, much excitement, and demands openmindedness, as well as illustrating the rich opportunities for future research and rewarding career directions. These topics are covered in Section II (Micronutrients Likely to be Essential—Ni, Si, Sn, V) and Section III (Trace Contaminants, Some Possibly Essential—Al, As, Cd, Pb, Hg).

APPLIED ENVIRONMENTAL GEOCHEMISTRY
ISBN 0-12-690640-8

In addition, many elements, some known to be present in man in surprisingly large amounts in at least some organs, some used quite widely as therapeutic agents (Au, Li) will be considered briefly in Section IV (Others). The chapter concludes with brief review from the general perspective of two of the most important categories of human illness, cancer and cardiovascular disease, in Section V (Special Problems of Health and Environment). Geographic clustering of both cancer and cardiovascular disease, two of the most common causes of death, suggests at least the possible role of geochemical factors, and there is currently much investigation considering such relationships.

II. Micronutrients that are likely to be essential

1. Nickel

Nickel is found in human tissues in very low concentrations (about $0.02-1.5 \mu g \, g^{-1}$) though it is concentrated several-fold in hair and in sweat with respect to plasma. Nickel deficiency has been produced in chicks, rats and swine (Prasad, 1978a). Deficiency in chicks results in shorter, lighter-coloured legs, decreased plasma cholesterol and increased liver cholesterol, and ultrastructural changes in liver cells. Deficiency in rats causes rough hair, slower growth and apparent dissociation of hepatocyte polysomes. In pigs, the results are impaired reproduction and poor growth of offspring (Nielsen, 1976). Some of these changes may relate to alterations in prolactin metabolism (LaBella *et al.*, 1973), or to DNA and RNA (Sunderman, 1965) or other biochemical interactions. A far more detailed summary is available (Kirchgessner and Schnegg, 1980).

Plant tissues contain much more Ni than animal tissues, and they are therefore more important in supplying adequate amounts to the diet of man. Though knowledge of the chemical form of Ni in foods is limited, some plants translocate Ni as an amino acid complex (Tiffin, 1971). Indeed, some plants are Ni accumulators, and are recognized as indicator species in high Ni soil derived from ultramafic (serpentine and other ferromagnesium) rocks (Peterson, 1979). However, food chain deficiencies of Ni are not known in animals or man. Practical information on sources of Ni in human diets has been put to a rather unusual test in attempts to decrease dietary Ni in humans with dermatitis known or suspected to be hypersensitive to Ni (Kaaber *et al.*, 1978). Even sources such as stainless-steel cooking utensils have also received attention (Brun, 1979). Increased amounts of Ni in serum, urine and sweat following oral administration of Ni (as sulphate) have been reported in studies of human Ni hypersensitivity (Menne *et al.*, 1978; Christensen *et al.*, 1979). In related studies, urinary excretion of body Ni was significantly increased with

chelation therapy (Spruit *et al.*, 1978; Kaaber *et al.*, 1979). Though human Ni deficiency has not been recognized, it is conceivable that it might be induced by such therapy! It is suggested that patients with liver and renal disease, malabsorption syndromes, or severe stress should be watched for Ni depletion (McNeely *et al.*, 1971).

Nickel excess is perhaps of more concern to man than Ni deficiency. Nickel carcinogenicity has been reported in both animals (Furst, 1971) and humans (Flessel *et al.*, 1980). Mechanisms might involve alterations in cytochrome-P-450 microsomal enzyme inhibition (Maines and Kappas, 1977), suppression of immunity (Graham *et al.*, 1978) or other effects. From the environmental point of view, Ni-related cancers of the respiratory tract in workers (but only among those who smoke) in Ni refineries can be significantly decreased in numbers or prevented by work-site clean-up, attention to personal hygiene, use of masks, and transfer if necessary (Barton and Hogetviet, 1980).

2. Tin

There is no evidence at the moment that Sn is essential to humans. On the other hand, essentiality of other elements has been frequently demonstrated in animals long before it is accepted in man. In order to investigate the possible essentiality of Sn, Schwarz *et al.* (1970) developed a highly specialized "trace element controlled environment". This consisted of a combination of ultra-clean laboratories, plastic isolator cages, filters and highly purified diets containing all known important nutrients but free of Sn (Schrauzer, 1979). Under these conditions there was a 59% enhancement of the growth of rats when 0.5–2.0 μg g^{-1} Sn as stannous sulphate was added to the base diet, a finding that was highly statistically significant (Underwood, 1977a). The animals who did not receive supplemental Sn "lost hair, developed a seborrheic-like condition, and were lacking in energy and (muscle) tonicity" (Anderson, 1977). These signs are very non-specific and somewhat similar to other deficiencies, and no other laboratories have published confirming evidence. However, it should be pointed out that Schwarz was responsible for establishing the essentiality of Se, Cr, F, probably V and Si, and possibly Pb, Cd and As (Schrauzer, 1979), so these results should not be readily dismissed. Tin in tetravalent state can form many coordination compounds, and may participate in oxidation–reduction reactions; the oxidation–reduction potential of Sn is within the physiologic range (0.13 volt) and is near that of flavin-containing enzymes (Nielson, 1976). Biomethylation of Sn by reduction of methyl-B12 has been demonstrated in purified laboratory solutions (Wood *et al.*, 1979) and methyl-Sn compounds are found in urine, tissues and the aquatic food chain. Tin is found in small amounts (about 0.1–1.5 μg g^{-1}) in most

human tissues (Underwood, 1977a) and at levels related to geographic location, implying a geochemical relationship.

Calculations of human intake range from 1 mg day^{-1} or less in diets using fresh meats, cereals and vegetables to 38 mg day^{-1} when many canned items are used (Schroeder *et al.*, 1964). Concentrations of Sn in foods stored in tin-plated cans can reach 700 μg g^{-1}, but resin coating reduces these amounts about tenfold (Underwood, 1977a). Tin is poorly absorbed by man, and short-term experimental ingestion of high Sn concentrations (up to 1370 μg g^{-1} in fruit juice) has not resulted in any severe signs of toxicity.

3. Silicon

Silicon was established in 1972 as an essential element for rats (Schwarz and Milne, 1972) and chicks (Carlisle, 1972). The effects of deficiency are most evident in bone, cartilage, skin and arterial walls. Silicon appears to be essential to mucopolysaccharide (glycosaminoglycan) synthesis and cross-linking, possibly to collagen cross-linking, and is present in high concentrations (greater than Ca) in the mitochondria of bone-forming cells (Mertz, 1981). Purified hyaluronic acid can contain as much as 500 μg g^{-1} or more of Si, and soluble rat skin collagen almost 2000 μg g^{-1} (Underwood, 1977b)! Despite the lack of direct evidence to date, there is every reason to expect that Si is essential also to humans. Most human tissues contain anywhere from 3–60 μg g^{-1}, with more in lymph nodes (which approach 500 μg g^{-1}) and with lung concentrations dependent upon exposure to asbestos (see below).

Most dietary sources are high in Si (even beer contains substantial amounts) (Nielsen and Sandstead, 1974), and naturally occurring human deficiency is unlikely. However, little is known about the bioavailability via the gastro-intestinal (GI) tract of the different chemical forms such as monosilicic acid, solid silica and that bound to pectin or mucopolysaccharides. If human deficiency were to occur, it would be most likely during periods of maximum growth and mucopolysaccharide synthesis, such as during foetal life, infancy and childhood, or when extensive repair or remodelling of connective tissue or bone is required, such as healing of fractures or wounds. Perhaps careful studies in patients receiving artificial intravenous feedings following severe trauma or burns will reveal deficiencies.

From a geochemical point of view, Si is a component of asbestos, a material of critical importance to public health. Asbestos fibres are very dangerous to humans. They can cause serious and fatal illness not only in those with heavy occupational exposure, but also in people who live near the industrial site or even simply in the same house with an exposed worker (Frank, 1980). These illnesses include potentially crippling pulmonary fibrosis (asbestosis) and

secondary heart disease, highly malignant lung cancer (especially in workers who smoke), pleural and peritoneal cancer (mesothelioma), and possibly some cases of gastrointestinal (oesophagus, colon and rectum), laryngeal, oropharyngeal and renal cancer. It is estimated that 35–45% of the 4 million heavily exposed workers will die of asbestos related cancers. The total number of deaths are predicted to be $60\,000$–$75\,000$ year^{-1}, which will account for 13–18% of all US cancer deaths (Lemen et al., 1980).

Asbestos is used throughout the world in such ubiquitous products as insulation, roofing materials, cement (including $2\,000\,000$ miles of asbestos-cement water pipes in the US) (Millette et al., 1980), interior wall coverings, brake linings, indeed, in thousands of products. Asbestos is made most commonly from two fibrous groups of silicates, chrysotile (a serpentine mineral with the empirical formula $Mg_3Si_2O_5(OH)_4$) and an amphibole series (including amosite (brown asbestos), anthophyllite, crocidolite (blue asbestos), and smaller amounts of actinolite and tremolite) with the general formula $W_{0-1}X_2Y_5(Si_4O_{11})_2(O, OH, F)_2$, where W is either not filled or contains Ca, Na or K, X and Y are Mg, some Al, Fe and Ca. Several other trace minerals can be found in amounts less than 1%. They occur as highly ordered sheets, crystals and fibres, and are mined purposely or occur in the tailings and water run-off of other mining operations (for example, Fe). Chrysotile fibrils have a surface hydroxyl layer contributing a net positive surface change; the amphiboles have an oxygen surface contributing a negative charge.

The factors that may relate to lung carcinogenesis (Langer and Wolff, 1978) include: (i) fibre size (smaller sizes form stable aerosols that increase potential for inhalation and fibres less than 8 μm in length can penetrate to the smallest lung spaces); (ii) Mg release (chrysotile solubilizes slowly in vivo); (iii) the presence of traces of other potentially toxic elements including Ni, Cr and Co; (iv) the presence of polycyclic aromatic hydrocarbons (known carcinogens either occurring naturally or introduced during mining, processing, or concomitant human exposure); and (v) silicates themselves may exhibit "phenolic-like" surfaces highly interactive in biologic settings. The latter reactions might proceed via hydrogen or oxygen ions or radicals, a mechanism currently believed important in carcinogenesis and discussed briefly in Section III.9 of Chapter 9.

Additional considerations (Craighead and Mossman, 1982) include the type of exposure (duration, frequency, nature); the type of asbestos (crocidolite appears to be more carcinogenic than chrysotile); the confounding effects of cigarette smoking (heavy smokers have an 80–90-fold increased risk compared to a 2–5-fold increased risk in non-smokers exposed to crocidolite and/or chrysotile); the presence of other carcinogens (asbestos may act primarily as a promotor of cancer, the initiating carcinogen being some other substance).

There is sufficient concern about the widespread distribution of asbestos in

the environment, even in the indoor air of buildings constructed 10 years before using crocidolite-containing ceiling spray and vinyl-chrysotile floor tiles (Sebastian *et al.*, 1982), that some question existant regulations of permissible dust concentrations (Becklake, 1982).

Mesothelioma is a much less common malignancy than the type of lung cancer discussed above. (A mesothelioma derives from the linings of the chest and abdomen, rather than from lung tissue itself). It has been linked closely to exposure to asbestos, especially from World War II shipyards, and takes many years to develop. Indeed, some individuals may have died from lung cancer before a malignant mesothelioma had time to develop, which could account for the lack of association of smoking and mesothelioma. Some associate nearly all cases of mesothelioma with heavy asbestos exposure (Tagnon *et al.*, 1980; Craighead and Mossman, 1982); however, it must be noted that such tumours were reported to occur many years before asbestos became an important commercial product (McDonald and McDonald, 1977; Becklake, 1982).

"Silicosis" refers to pulmonary disease quite different than asbestos-related illness. The health professions use a bewildering variety of terms to describe lung disease due to inhalation of inorganic dusts. The general term is "pneumoconiosis", recently defined by the International Labor Organization to mean "the accumulation of dust in the lungs and the tissue reactions to its presence". Tissue reactions vary with the specific type of dust inhaled, and medical terms vary as well. "Silicosis" is the term most frequently used to describe the lung disease that results from exposure to free crystalline silica dust (SiO_2), such as dust released during tunnelling, sandblasting or hardrock mining of many sorts. When in this form, Si exposure results in a nodular pulmonary fibrosis, different from the diffuse disease produced by asbestos, and not predisposing to cancer. This difference has led to use of the term "benign pneumoconiosis". Further reviews of this complex subject are detailed by Becklake (1979) and Elmes (1980).

4. Vanadium

Vanadium has been identified as an essential element in chicks and rats, where deficiency causes impaired growth and reproduction (Underwood, 1977c; Prasad, 1978b). Effects of V deficiency include modest alterations in serum cholesterol, phospholipids and triglycerides, but confirmation of direction and degree of alteration is needed. Pharmacologic amounts of V inhibit squalene synthetase in microsomal enzyme systems (Curran and Burch, 1967). Pentavalent V is also a potent inhibitor of membrane ATPases, and is present in mammalian tissues at concentrations suggesting that it has an endogenous regulator function. Several natural activators of human red blood cell

Ca^{2+}–ATPase (Mg^{2+}, K^+, Na^+ and calmodulin) facilitate the inhibition by increasing the apparent affinity of the enzyme for vanadate (Bond and Hudgins, 1980). Vanadate can also inhibit avian progesterone receptor activation (Nishigori et al., 1980) in submillimolar concentrations. Radioactive V is incorporated especially into areas of mineralization bone and teeth, hence V may influence development of these tissues (Underwood, 1977c). To date, data from different species and from widely variant in vitro and in vivo conditions have not yielded any unifying hypothesis with respect to V in metabolism.

Vanadium is found in very low levels in animal and human tissues (ng g^{-1}—parts per billion—rather than μg g^{-1}). The total human body pool in man has been estimated at about 100 μg (Byrne and Kosta, 1978). Though found in higher amounts in some plants, there seems to be no bioaccumulation in the human food chain, even when plants are grown in areas where industrial operations have contributed high V contents to the soil (Parker et al., 1978).

Vanadium is released as airborne V trioxide and V pentoxide especially from the burning of heavy fuel oil, and can be a pulmonary irritant and toxin (Waldbott, 1978a). Exposure to a high V bottom ash from an oil-fired boiler caused temporary diminution in pulmonary functional capacity in several workers, and an increase in urinary V concentration (Lees, 1980), despite use of protective clothing and masks. However, other than direct industrial exposures, there seems little relationship between the geochemistry of V and human health.

III. Trace contaminants (some possibly essential)

1. Aluminium

Aluminium has not been shown to be essential to animals or man, despite its abundance in the earth's crust and solar system, its place in the periodic table of elements (Valkovic, 1980), and its presence in mammalian tissues in concentrations averaging 0.4 μg g^{-1} (Underwood, 1977f). Lung and lymph nodes contain appreciably more, the additional Al probably relating to aerosol exposure and particle transport to lymph tissues. Early attempts to create experimental animal deficiency failed, and average diets probably contain many-fold higher amounts of Al than could possibly be needed.

Interest in Al and man's health centres around only a few considerations. Aluminium hydroxide compounds administered as oral antacids can significantly decrease phosphate and fluoride absorption, resulting in hypophosphataemia (Fitzgerald, 1978) and possibly skeletal demineralization (Spencer et al., 1980). Increased Al levels in renal insufficiency, especially in patients on long-term dialysis, are believed to relate to a CNS syndrome termed "dialysis

dementia" (Alfrey *et al.*, 1976). It has been hypothesized (Crapper *et al.*, 1973; Caster and Wang, 1981) that a very common form of senile dementia termed "Alzheimer's disease" may relate to accumulation of Al in critical parts of the brain; Al cross-links between DNA chains are a proposed mechanism of damage (Eichorn *et al.*, 1979) (and consistent with the cross-linking theory of ageing). However, workers exposed to Al do not seem to have a higher rate of dementia (Beck *et al.*, 1982); a causal effect of Al is far from established.

Others (Perl *et al.*, 1982) report higher concentrations of Al in certain brain cells from natives of Guam with the neurological disorders termed "amyotrophic lateral sclerosis" and "Parkinsonism-dementia" than in similar brain cells from natives of Guam with the neurological disorders termed "amyotrophic lateral sclerosis" and "Parkinsonism-dementia" than in similar brain diagnoses (in Japan and New Guinea) are said to have high levels of Al (and low Ca and Mg).

Patients with severe kidney disease requiring maintenance haemodialysis often also develop abnormalities of bone (renal osteodystrophy) resulting in pain and even multiple fractures. Demonstration of significant amounts of Al deposition in such bones (Ott *et al.*, 1982) correlates both with type of bone abnormality and response or lack of response to treatment with vitamin D sterols. The incidence of such bone disease is said to relate to areas in which the Al content of dialysate water is higher (Parkinson *et al.*, 1979; Walker *et al.*, 1982) and in one individual chelation therapy helped reduce Al levels and decrease bone disease (Ackrill *et al.*, 1980). Keeping Al levels in dialysate water below 15 μg l^{-1} is currently advised (Hodge *et al.*, 1981).

Should life-time cumulative Al levels in humans prove to relate causally to senile dementia or other age-associated or neurological disorders, Al in the environment and food chain will assume even greater importance. At the moment, the chief direct geochemical consideration is related to that of another pollutant (F) derived from smelting operations; fluoride (derived from cryolite used as flux in electrolytic reduction of Al ores) is released in amounts sufficient to cause "neighborhood fluorosis" (Waldbott, 1978b).

2. Arsenic

Arsenic has been referred to as "both a destroyer and saviour of mankind" (Bechet, 1931). It has been used in both homicidal and medicinal preparation since the time of Hippocrates (Morse *et al.*, 1979), is an intracellular poison, and is possibly a causative agent leading to the development of skin cancer and perhaps other forms of internal cancers (Wagner *et al.*, 1979).

The importance of the geochemistry of As to man's health is clear. Dose-related development of keratotic lesions of palms and soles followed, after a

latent period of many years, by cancer of the skin in a distributive pattern over the body different than other known cutaneous carcinogens (for example, sunlight), has been documented carefully in patients receiving known amounts of As as medication (Fierz, 1965). The same association of cutaneous keratoses and cancer plus severe peripheral vascular disease has been demonstrated in a population whose drinking water was high in As (Tseng et al., 1968; Yeh et al., 1968; Yeh, 1973). These epidemiological and dose-response data confirm the conclusions reached from a long series of reports beginning in 1888 (Hutchinson) and summarized recently (Sanderson, 1976).

Chronic exposure to As in drinking water is related not only to skin cancer, however, but also to an increase in cancer deaths of many types. The incidence of lung cancer in males is especially high in areas of geochemically derived high-As water, such as Cordoba, Argentina (Bergolio, 1964). Air-borne As from industrial chemical operations in Baltimore, Maryland, in the US (Mabuchi et al., 1979), and from Cu smelters in northern Sweden (Axelson et al., 1978) and other locations is also associated with a high incidence of lung cancer.

Arsenic concentrations range from undetectable in normal human blood to 2066 μg g^{-1} in water–methanol extracts from kidneys of the giant clam (Tridacna maxima) from the Great Barrier Reef (Benson and Summons, 1981). Marine invertebrates concentrate As remarkably well; however, they concentrate organic forms (for example, methylated) that are apparently non-toxic to man, a most fortunate circumstance for seafood lovers! Plants by contrast assimilate very little As, or when they do are themselves poisoned, and are therefore unlikely to contribute As to the human food chain in significant amounts (Beeson, 1978). Therefore direct (natural water supplies) and indirect (commercial operations) geochemical sources appear to be critical.

Interestingly, evidence that As may be essential to mammals has been presented from several laboratories, the most convincing being the demonstration of slower growth rate, rougher coat, cell defects and enlarged iron-laden spleens in the offspring of pregnant females on As deficient diets (Nielson et al., 1975). However, the rat handles As metabolically in ways quite different than other species, storing methylated species in red blood cells.

Finally, Se is a strong antagonist to most effects of As and vice versa. Therefore the absence of effects from As exposure could be due to adequate or excessive Se, or conversely the presence of effects to inadequate Se (see Section III.9 in Chapter 9). Such an antagonism could account for some of the difficulty in establishing an animal model for As carcinogenesis or difference in reported toxicity. Overall, the poor success in establishing As as a carcinogen in animals remains a puzzle.

The story of As demonstrates several principles critical to understanding of

trace elements and their effects on health: (i) Elemental speciation is of vital importance, though poorly studied—inorganic arsenicals are far more toxic or carcinogenic to man than many organic forms. (ii) Animal species differences prevent cross-species assumptions from being readily made. (iii) Antagonistic elements may confound experimental or epidemiological investigations. (iv) Elements are often essential in trace amounts, quite toxic in higher amounts.

3. Cadmium

Cadmium is generally classified as a toxic trace element. There is no substantial evidence indicating its essentiality to humans, nor is there well-documented evidence of homeostatic mechanisms that maintain concentrations within physiologic limits. Rather, Cd appears to accumulate with age, especially in the kidney and it is suspect in the aetiology of cancer and cardiovascular diseases, both of which are in turn age-related. Cigarette smoking is a generally accepted risk potentiator of both cancer and cardiovascular disease. Cadmium in cigarettes is suspect in contributing to these cigarette-smoking related disorders. The known geochemical implications of Cd in human health relate to: (i) bone and renal disease in populations exposed to (industrially) contaminated drinking water; (ii) lung and renal dysfunction in industrial workers exposed to air-borne Cd; and (iii) implication (via substantial animal but limited and conflicting human data) in human hypertension. These subjects have been reported on in great depth in two recent multi-author publications (Webb, 1979a; Calebresi *et al.*, 1980).

Current thinking on the metabolism and toxicity of Cd is influenced heavily by two factors. First, Cd absorption, accumulation and the expression of toxic effects are strongly influenced by "antagonist" elements, especially Ca, Zn and Se. Second, a series of unique metal binding proteins termed collectively "thioneins" (for example, Zn metallothionein, Cd metallothionein) in several tissues appear to modify or modulate metabolism of such elements as Cd, Cu, Hg and Zn. The metallothioneins were first sought as renal Cd binding proteins (Webb, 1979b). They are relatively low molecular weight (6000–12 000 daltons) proteins of very high cysteine content (the sulphydryl groups of cysteine being the presumed metal binding sites) and notably lacking in tyrosine. They are inducible, in that acute and chronic exposure to several metals as well as other chemical and physical stresses induce synthesis of larger amounts of the protein, and then larger amounts of metal can be bound. Their precise role is unknown; one of the obvious hypotheses is protective storage as an adaptive response to potentially toxic elements. A less obvious hypothesis includes guarantee of an adequate supply of cysteine in the face of multiple elemental binding that could decrease available free cysteine. In any case these

proteins are capable of binding large amounts of Cd (and Zn and Cu and Hg, etc.). Analytic techniques for subfractionation and purification of these proteins versus artificial fragmentation by chemical damage during isolation and purification are topics currently under investigation (Webb, 1979b).

The development of a specific radioimmunoassay for detecting small amounts of metallothionein (Tohyama and Shaikh, 1981) will both aid basic investigations and may serve as a marker of cadmium exposure in humans. Urinary metallothionein (as well as B_2-microglobulin and Cd) appear to be potentially good measures of extent and duration of Cd exposure and renal damage in both industrially exposed (Tohyama et al., 1981a) and environmentally exposed (Tohyama et al., 1981b) individuals, as well as patients suffering from Itai-Itai disease (see next paragraph). Whether or not metallothionein itself is nephrotoxic or even potentially capable of inducing immunologically mediated renal damage (Shaikh, 1982) remains to be determined.

Medical interest in Cd was sparked by reports from Japan (Emmerson, 1970) of "Ouch-Ouch" disease (Itai-Itai in Japanese), titles guaranteed to become fixed in the jargon of medical syndromes (see also Section II.1 in Chapter 9). Itai-Itai disease was noted as a syndrome in Toyama, Japan, characterized by bone pain, multiple bone fractures, and renal loss of protein and large amounts of Ca, which is presumed to be the result of bone resorption. Death resulted from kidney failure, and autopsies showed high Cd tissue concentrations. The Cd was traced to rice and soybeans grown in local soils that were contaminated from a Pb/Zn mining operation 40 km upstream from the farming area. Those persons most affected were those who were living where soil Cd levels were the highest and who had been the most stressed from malnutrition, multiple pregnancies or the menopause (Waldbott, 1978c; Lauwerys, 1979). Epidemiologic estimates from Japan suggest that daily Cd intake by the oral route should be kept below 180–250 µg to prevent damage to the kidney.

The kidney is the critical organ with respect to toxicity from inhalation of airborne Cd, though lung function is also impaired by inhalation of Cd dust and fumes (Lauwerys, 1979). Air concentrations around $20 \, \mu g \, m^{-3}$ are calculated to result in sufficient exposure over many years to result in kidney damage. Much higher concentrations are sometimes found in work-places, and severe or acute toxicity can result from only a few minutes or hours of exposure.

Human diets are estimated to contain between $50–150 \, \mu g \, day^{-1}$ of Cd (Underwood, 1977e); the latter level seems sufficiently high to cause at least subtle effects in man, especially if combined with predisposing factors (for example, multiple pregnancies, malnutrition), additional Cd sources (for example, smoking, occupation) or diet containing unusually rich sources of Cd

(beef liver, 20 μg per serving; oysters, 40 μg per serving) (Prasad, 1978c).

Significant elevations of Cd in local soils at Shipham in southwest England (Thornton *et al.*, 1980) were correlated with increased Cd (plus Zn and often Pb) in both house dust and local garden produce. The area was the site of mining in previous centuries, the result of which appears to include contamination of surface agricultural soils. Health studies are in progress, though no special problems had emerged at the time of the report.

Recent concern with the effects of acid rain must include the possible lowering of pH of streams, lakes and drinking water. Many metal concentrations, including that of Cd, are increased (they are more soluble) in the acid pH range as compared with neutral or alkaline waters. One source of increased acidity in rain is the burning of coal. Oxides of sulphur and nitrogen if not trapped by some means can contribute substantially to the acidification as detailed in Chapter 12.

Coal burning is also a potential source of many elements, including Cd, that can be released to the atmosphere through volatilization, trapped in smoke particles, contained in residual slurries, or distributed as fly-ash after combustion (Wixson and Page, 1980, and Chapter 15, this volume).

Interpretation of the consequences of borderline-high Cd intake in man is quite complex. Modest epidemiologic evidence suggests a relationship between Cd and renal cancer, supported by several types of animal and *in vitro* experiments related to carcinogenesis (Stout and Rawson, 1981; Degraeve, 1981). To date no studies have reported the association of specific cancer risk from the Japanese populations with Itai-Itai disease. Follow-up studies after a sufficient latent period will undoubtedly be published. Experimental interactions may be critical; Se, for example, seems to be one of the most protective substances against Cd (and Hg) toxicity (Magos and Webb, 1980). Alternatively, Cd might neutralize the protective effects of Se in other settings or systems. Calcium inhibits Cd absorption. The metallothioneins may play an important role; induction of metallothionein synthesis by one element could provide protective binding sites for another element. The same mechanisms might play a role in Cd and hypertension (*if* indeed Cd proves to have a role in hypertension). Alternatively, it has been suggested that Cd in the blood alters norepinephrine levels, possibly contributing to hypertension (Revis and Zinsmeister, 1981) (see also Section V).

Suggestions that toxic elements in small amounts may be related to behavioural and learning disorders in children (Pihl *et al.*, 1980) include reports of increased Cd levels in hairs from affected individuals (Capel *et al.*, 1981; Thatcher *et al.*, 1982). The problems of hair elemental analysis are many (Valkovic, 1977), and include external contamination, laboratory preparative losses or contamination, interelemental analytic interference (matrix effect) and adequate selection and collection controls. However, as a convenient

source of tissue possibly reflective of internal and cumulative events, hair analysis is being performed with increasing frequency, and will be increasingly standardized (Brown and Crounse, 1980). The concept of clinically sub-toxic metal levels affecting human performance is receiving more and more attention, and may render current interpretations of safe environmental levels less acceptable in the future (see Section III.4).

Finally, the production of facial birth defects in offspring by Cd injections into pregnant hamsters (Tassinari and Long, 1982) suggests at least the possibility of such teratogenic effects in man.

4. Lead

It is well recognized that Pb in large excess is toxic to man, and many scientists agree that Pb even slightly in excess (i.e., above "normal" blood and tissue levels) is toxic. Indeed, some consider that levels currently defined as normal are actually toxic, and that most of the civilized world is at least slightly Pb poisoned! To complete the spectrum, Schwarz before his death was accumulating evidence to suggest that Pb is an element essential to the growth of rats (Schrauzer, 1979), a concept supported by demonstration of anaemia, possibly of Fe deficiency origin, in the offspring of rats fed low Pb diets (Kirchgessner and Reichlmayr-Lais, 1981).

Lead is relatively common in the earth's crust, and reasonably available to man. The first "cases" of Pb poisoning date back to the introduction of Pb glazes (on earthenware pots), Pb water pipes (in Roman aquaducts), and Pb salts (in ancient cosmetics). All of these sources of exposure are still available today! Industrialization has remarkably intensified human exposure to Pb. The transportation industry contributes leaded gasoline and Pb storage batteries, the paint industry leaded paints, the plumbing and electronics industry leaded solder, and the food industry Pb-containing cans. Most of this Pb is recycled and re-distributed back into the environment, providing continued opportunity for exposure. By comparing the Pb content of ancient skeletons, isolated uncontaminated soil or snow, and blood or tissue from isolated primitive tribes some have reached the following conclusions: (i) that "the present body burden of lead in western populations is grossly above the natural levels and that it reflects a high degree of environmental pollution" (Piomelli, 1980); (ii) that "these relatively low levels of exposure to Pb (low only by comparison with the extreme levels observed in Pb workers and in children ingesting lead paint) are associated with clearly detectable biochemical abnormality"; and (iii) that "no one has yet studied natural interactions of Pb in human cells, because all reagents and nutrients used in laboratory and field studies, as well as controls, have been excessively contaminated with

industrial Pb ... and present-day man is subjected to exposures that elevate concentrations of Pb in skeletons about 500-fold above natural levels" (Ericson *et al.*, 1979).

Some of the emotional concern demonstrated in such statements relates to evidence that blood or tissue Pb levels in the higher part of the accepted normal range are reasonably firmly associated with poor intellectual performance and/or neurological abnormalities in children who have had no specific known environmental exposure (Needleman *et al.*, 1979; Burchfiel *et al.*, 1980). These and related topics are discussed in depth in two recent compilations on low-level Pb exposure (Needleman, 1980) and Pb toxicity (Singhal and Thomas, 1980). There are considerable complexities in establishing current ambient Pb concentrations as causal factors in deviations of human behaviour close to the accepted norm but without clear-cut medical disease. The reasoning is based upon careful and step-wise extrapolation downward from the now classic signs and symptoms in clear-cut cases of human poisoning, be it among workmen in Pb industries, among families living within close proximity to smelters, among children ingesting Pb paint or among those simply exposed to dust brought home by parents exposed via their occupation. Urgency in resolution of the problem is vital, because it is now recognized that early pregnancy and perinatal exposure coupled with unusual susceptibility of young children to lesser amounts of Pb (greater gastrointestinal absorption, for example) may produce subtle neurological defects. These defects may not be fully reversible even with treatment to remove Pb from the body (currently with chelators) and by removal of the source of Pb.

There is concern well beyond obvious cases of toddlers who eat Pb containing paint flakes (the most common cause of overt Pb poisoning in children), potential poisoning from Pb-containing cans (for example, of baby food or seafood), direct adult exposure through industry or occupation, etc. Atmospheric Pb especially in areas of automotive pollution, drinking water of low pH from lead-lined tanks and water pipes (or Pb-soldered copper pipes) are all suspect. These sources have been correlated with increased human blood and tissue Pb levels and with biochemical abnormalities (decreased erythrocyte δ-amino levulinic acid dehydrase enzyme activities) in individuals even without symptoms or signs of Pb poisoning. It is well beyond the scope of this chapter to detail the numerous papers and reports.

It is not the relationship of "natural" geochemistry to man's health that is under discussion as much as the degree to which man's perturbations have so altered the environment such that "natural" conditions no longer exist. Perhaps if the environment is "at fault", it is by making Pb too readily available to man! Ease of mining and the many uses of Pb have resulted in apparent worldwide contamination, even of the snow in sparsely inhabited parts of the world.

5. Mercury

Mercury is a toxic element that is widespread in the environment. It is not known to be essential in any way to animals or man, yet it is capable of entering the human food chain in many ways. It can be toxic by ingestion or inhalation, but the toxicity is highly dependent upon the chemical form. Inorganic Hg is poorly absorbed from the gastrointestinal tract, but some organic Hg compounds, especially methylmercuric compounds, are rapidly absorbed and are much more toxic than inorganic mercury. The methylated forms are not known to be produced in animals or man, but rather are synthesized by microorganisms from inorganic Hg in soil or water (see Chapter 7), and methylmercury constitutes a variable but sizeable percentage of total Hg in fish (Cappon and Smith, 1982). Since man's industrial processing appears to be releasing more and more Hg to the environment, especially through chloralkali and plastics production as well as extensive use of Hg compounds as a fungicide, there is mounting concern over the possible impact on man's health.

It should be noted that governmental regulations and modifications of industrial processing are reducing environmental contamination in some locations. Several examples of large-scale human poisoning have been recorded. Toxic amounts of Hg were attained via ingestion of fish from industrially polluted waters in Minamata Bay and separately on Hon Shu Island in Japan, and from the ingestion of bread baked from fungicide-treated grain in Iraq. A classic example of food-chain transfer was observed in the passage of Hg from grain to hen to egg to meat to humans in Sweden (Waldbott, 1978d). Many waters have been closed to commercial fishing because of high Hg levels in several species. Even wide-ranging ocean fish, such as tuna and swordfish, have been found to contain significant concentrations of Hg, although it must be noted that museum specimens of tuna caught almost 100 years ago (presumably before widespread pollution) were found to have comparable concentrations (Miller et al., 1972).

Even more obvious exposures to Hg with resultant poisoning are recorded where occupations include the direct handling of Hg compounds. Goldsmiths, mirror-makers and persons employed in the manufacture of felt hats have been poisoned. The phrase "mad as a hatter" immortalized in Lewis Carroll's "Alice-in-Wonderland" is believed by many to have been derived from the latter occupation. Among scientists, no less than Sir Isaac Newton may have suffered from Hg poisoning by direct exposure in his laboratory (Broad, 1981). Hairs believed to have been collected from his head (but their authenticity questioned by doubters) were analysed recently and found to contain up to 197 μg g^{-1} of Hg; hair from individuals without known Hg exposure contain only about 5 μg g^{-1}.

Several points are of concern: (i) Even moderately severe Hg poisoning can be hard to diagnose, largely because it is rarely suspected, and because reliable and readily interpreted Hg assays are not always available. Little work has been done on low level toxic potential. (ii) In several instances, children of mothers exposed to Hg showed signs of toxicity while the mother was without signs or symptoms. Placental transfer is rapid, and may even protect the mother while endangering the child! (iii) Inter-elemental interactions may prove important. Since Se is a strong Hg antagonist (mechanism not clear), individuals in low Se areas might be affected adversely by much lower Hg concentrations than those from high Se areas. In the words of the late E. J. Underwood (1979): "Tolerance to mercury can depend not only on what you eat, but where you live". Therefore, although the geochemistry of Hg is primarily related to human health via industrial processing, a direct geochemical influence might also be associated with the Se/antagonist mechanism. The only exception perhaps was an obese lady who chose a swordfish diet for reduction of weight (Underwood, 1979). (iv) Mercury also binds to the "metallothionein" group of metal binding proteins, and could consequently perturb the metabolism of Zn, Cu and Cd, for example. (v) Since the discovery of bacterial biomethylation of Hg in 1968, much has been learned about B12 dependent methyl-transfer to several toxic elements (Wood *et al.*, 1979). One mechanism involves free (methyl) radical intermediaries. The interactions of vitamin E and Se that protect against the toxic effects of methyl-Hg may relate to such reactions (Ganther, 1978).

IV. Other elements

There are many other elements that can influence human health or that are found in human tissues but are of unknown significance. Detailed consideration of each is beyond the scope of this chapter. None have adequate geochemical implications save for occasional concentrated industrial exposure to warrant lengthy discussion. This does not mean that important discoveries could not be made that would raise one or the other element to sudden interest or concern. Underwood (1977a,b,c,d) serves as an excellent overall reference for these elements.

1. Antimony

Antimony is present at levels less than $1.0 \ \mu g \ g^{-1}$ in all human tissues measured. Lungs, lymph nodes and hair contain the largest amounts. Trivalent Sb salts are still used to treat several tropical parasite infections of

humans (Goodman and Gilman, 1975), but they are also suspected of causing bladder cancer in patients so treated. Therapeutic doses of Sb exceed amounts encountered from natural sources by many orders of magnitude.

2. Barium

"Natural man" is said to contain about 20 mg Ba, mostly in bone. It is not known to be essential. Barium is toxic to most plants, yet some seem to be accumulators. Brazil nuts contain 3000–4000 μg g^{-1}, and some walnuts and portions of the ash tree contain up to 1700 μg g^{-1}. The average human diet contains less than 1 mg day^{-1}. Barium salts, if soluble, are readily absorbed by humans, and are quite toxic (hypokalaemia, muscle spasm). Barium sulphate (insoluble) has received widespread use as an agent for showing contrast in diagnostic X-rays. Barium dust from barite mining can cause severe pulmonary disorders, but these are usually reversible if exposure is discontinued.

3. Beryllium

By contrast, Be is a severe pulmonary toxicant not only to workers industrially exposed, but to their families via dust carried home; indeed, to anyone living nearby ("neighbourhood berylliosis"). Another common source of exposure has been in the manufacture (or disposal) of fluorescent lamps that contain Be. Chronic exposure leads to a severe and prolonged granulomatous type of inflammation in lungs and lymph nodes. Beryllium is thought to be a modest carcinogen or co-carcinogen in some animal species. Beryllium was the first inorganic substance found to be carcinogenic in animal experiments—but by accident (Reeves, 1978)! Evidence in man is still inconclusive.

4. Boron

Boron is essential for higher plants, but apparently not animals or man. Some soils and plants in the Soviet Union contain enough boron to cause illness when eaten by lambs. Boron concentration in human tissues is generally less than 0.6 μg g^{-1} on a wet weight basis, with much higher concentrations in bone and teeth. Boric acid and borax are only toxic to man when accidentally ingested or applied in large amounts to damaged skin. Boron dust or B hydrides (used in jet and rocket fuel) can be airborne toxins.

5. Bromine

Bromine is ubiquitous in nature though in low amounts, but has not been shown to have a specific function in plants, animals or man. Amounts in

human tissues and blood range from about 0.3–5.1 μg g^{-1} wet weight (*much* higher than I—except for the thyroid gland). Bromides have been used as sedatives for over 100 years, and may result in toxicity in humans. Bromine gas is extremely toxic.

6. Gold

Gold affects human health primarily because of its monetary value rather than because of its elemental properties. Gold salts are used in the treatment of some human ills, especially arthritis, with some success. Gold leaf has been used in the treatment of ulcers of the skin.

7. Lithium

Lithium is present in very small amounts in human tissues—0.002–0.6 μg g^{-1} wet weight in most, higher in lymph nodes. It is without any known function at these levels. In amounts several thousand times this level it is used in the treatment of manic-depressive disorders in man. Many toxic effects can occur with overdose.

8. Rubidium

Rubidium is present in rather surprising amounts in human tissues, about 4–20 μg g^{-1} wet weight, with total body content estimated at 360 mg in an adult. This is a good deal more than many essential elements, yet no function has been attached! It may behave as a passive substance for K to some degree, without known consequence.

9. Silver

Silver exists in minute quantities in human tissues (higher in dental enamel). It has been assigned neither function nor toxicological significance. In experimental animal systems, however, Ag is a strong copper antagonist, and can induce Se-vitamin E deficiency. Man is unlikely to accumulate significant amounts, except when it is used therapeutically for long periods of time, as in Ag-containing nose-drops. It then is stored in excess especially in the skin, causing a grey pigmentation called argyria.

10. Strontium

Strontium is present in small amounts in most tissues, with more in bones and teeth. It is of interest primarily because of the implications of bone storage of

radioactive ^{90}Sr, a potential hazard of nuclear fission, and known animal carcinogen. Along with radioactive Cs, U, etc., geochemical concerns focus on the geographic locations of mining, processing, shipping, bomb testing, disposal sites, and potential soil and water contamination. This subject hardly bears review in this chapter.

11. Titanium

Highly abundant in the earth's crust, Ti apparently gains limited access to humans and the human food chain. Plant, animal and human tissues generally contain 0.1–5 μg g^{-1} wet weight (lungs sometimes containing much higher amounts). It has been assigned neither function nor special toxicity. There are no current geochemical implications to human health for Ti, Te, Zr or the other elements not mentioned in this chapter.

V. Special problems of health and environment

Two human health problems receiving extraordinary attention, for rather obvious reasons, are cardiovasdular disease and cancer. Much of the research now being conducted with respect to geochemistry and human health other than nutritional or toxicological research relate to these topics. They will be summarized briefly in a format considering all elements and their interactions.

1. Cardiovascular disease

Cardiovascular disease, including atherosclerosis, coronary artery disease and myocardial infarction, cardiac arrhythmia, hypertension and cerebrovascular accidents (strokes) account for half the deaths each year in the US. These disorders are believed to be multifactorial in aetiology. The factors include personality, life style, occupation, site of residence, psychological stress, diet, environment, etc. Of the environmental factors, drinking water is believed by many to contribute up to 20% of the "risk" associated with cardiovascular disease. Two recent publications summarize the research in this area (Calebresi et al., 1980; Harlan et al., 1981). Readers should refer to them for details, and for proper identification of innovators and critics of original publications. The following points are evident: (i) Epidemiologic research frequently demonstrates an inverse relationship between the hardness of water in many geographic regions and the prevalence of one or more types of cardiovascular disease. (ii) These correlations tend to diminish in strength when smaller and smaller geographic units are studied, pointing in part to the

need for studies of individuals. (iii) Interpretations include on the one hand, protection against cardiovascular disease by elements in hard water (Ca and especially Mg), or decreased amounts of elements in soft water which may be protective (especially Se); on the other hand, some workers postulate a relationship to the presence in soft water of greater amounts of toxic elements (Cd and especially Pb). (iv) Variations in correlations from many reports may relate to interactions between or balance between pairs of elements (e.g., Cu/Zn, Cd/Se, Ca/Cd). (v) Smoking, a known contributor to cardiovascular disease, may be a significant confounder (possibly even through direct contribution of toxic elements) as may alcohol intake (Shaper *et al.*, 1981). (vi) Animal models, including a well-developed Cd/hypertension model, are highly suggestive, but direct extrapolation to humans is problematic. (vii) Dietary elements from sources other than drinking water (especially sodium) may be critical. (viii) Groundwater composition is not necessarily similar to drinking water composition, neither of which are necessarily similar to actual consumption of elements in the liquid portion of the diet. (ix) Statistics are statistics, and not proof of causality. (x) Even given a cloak of believable respectability, the "water hypothesis" of cardiovascular disease aetiology does not constitute a sufficient mandate for public intervention measures, unless disorders other than cardiovascular are also taken into account. Given all the uncertainties, the potential relationship between geochemistry (and its manipulation!) and cardiovascular disease remains a stimulating and fascinating research area.

2. Cancer

Search for an environmental cause of human cancer had its formal beginning, it is often said in the recognition over 200 years ago that scrotal cancer among chimney-sweeps was caused by occupational exposure to soot. Many such examples have emerged from clinical observation and epidemiologic investigation since that time. Examples range from sunlight or X-ray induced skin cancer to asbestos-related lung cancer. The social and political demands of recent years to find the cure or prevention of (all) cancer via heavy investment of public funds have not produced the all-inclusive dramatic discoveries that were perhaps naively expected. Yet enormous progress has been made, and in some relatively simple ways. One of these is the documentation by laborious record-keeping that there are great geographic variations in the prevalence of different kinds of cancers. Geographic variation suggests among other things geochemical influence on carcinogenesis. Many critics hasten to point out that climatological, cultural and socioeconomic factors are of equal or concomitant variation. More detailed references

provide for further examination of the accumulated data (Searle, 1976; Kharasch, 1979; Sigel, 1980; Newell and Ellison, 1981).

A few generalizations are listed, in many ways analogous to the the generalizations concerning environmental geochemistry and cardiovascular disease: (i) Many elements, especially those in the "toxic" heavy metal group, are carcinogens in various circumstances in the laboratory, in animals, and some in man (Sigel, 1980). These are most often related to direct exposure to rather concentrated amounts, either experimentally or (in man) industrially. (ii) Many other elements may influence carcinogenesis in more indirect, but nevertheless significant fashion. Some may "antagonize" known carcinogens, perhaps as simply as by inhibiting absorption (Ca/Cd). Some may enhance excretion (Se/As). Some may enhance the detoxication of other organic carcinogens via such pathways as microsomal enzyme metabolism (Cu/benzpyrene). Others may alter immune surveillance mechanisms that protect against "foreign" cancer cells (for example, in Zn deficiency). (iii) Some elements catalyse biochemical systems which protect at a fundamental level common to the pathogenesis of many types of cellular alteration including carcinogenesis. For example, Se-glutathione peroxidase and Cu–Zn–Mn-superoxide dismutase may protect against free-radical accumulation and peroxide formation. (iv) Other elements may induce metal-binding proteins that trap potential metal carcinogens, for example, Zn, Cu, Cd, Hg "metallothioneins". (v) Still others might act through means as indirect as inhibiting fungal production of aflatoxins, which are suspected of causing human liver cancer. The possibilities are numerous, and provide a firm basis for continued investigation of geochemical influences on human cancer.

VI. Conclusions

It may seem to the reader that studies of geochemistry and health are impossibly complex, many arguments are unresolvable, and elemental interactions are overwhelming. For example, satisfying the daily requirements for trace elements in man (to prevent deficiency) may be quite different from satisfying requirements for the proper amount *and balance* of elements to prevent subtle toxicity, carcinogenesis, developmental defects or a host of long-term and therefore possibly "age-related" human ills. Unfortunately, the combinations and permutations are nearly endless, and there is the potential of preventing one disorder while predisposing to another! Yet from such seemingly impossible webs of often conflicting information (or perhaps independent of them) emerge periodically dramatic individual advances in knowledge. It was only a few decades ago that pellagra, a vitamin deficiency that hospitalized and killed thousands in the southeast USA, was believed

(upon reasonable epidemiological grounds) to be an infectious disease. It was only a few years ago that Zn deficiency in man was first recognized. It was only very recently that Se availability based on geochemical variations was found to be causally related to a frequently devastating cardiovascular disease, which is now preventable with Se supplementation. It may only be a few more months, or days, before some new "truth" of geochemistry and human health emerges probably to be rejected initially by those with opposing theories. It may indeed be a truth discovered serendipitiously. Only one thing is certain; there is much to learn.

References

Ackrill, P., Ralston, A. J., Day, J. P. and Hodge, K. C. (1980). *Lancet* **2**, 692–693.

Alfrey, A. C., LeGendre, G. R. and Kaehny, W. D. (1976). *New Eng. J. Med.* **294**, 184–186.

Anderson, C. E. (1977). *In* "Nutritional Support of Medical Practice" (Schneider, H. A., Anderson, C. E. and Coursin, D. B., eds), pp. 57–72. Harper & Row, Hagerstown, Maryland.

Axelson, O., Dahlgren, C., Jansson, D. and Rehnlung, S. O. (1978). *Br. J. Indus. Med.* **35**, 8–15.

Barton, R. Th. and Hogetveit, A. Ch. (1980). *Cancer* **45**, 3061–3064.

Bechet, P. E. (1930). *Arch. Derm. Syph.* **23**, 110–117.

Beck, J. C., Benson, D. F., Scheibel, A. B., Spar, J. E. and Rubenstein, L. Z. (1982). *Ann. Int. Med.* **97**, 231–241.

Becklake, M. R. (1979). *In* "Cecil-Textbook of Medicine" (Beeson, P. B., McDermott, W. and Wyngaarden, J. B., eds), pp. 983–1002. W. B. Saunders Co., Philadelphia.

Becklake, M. R. (1982). *New Eng. J. Med.* **306**, 1480–1482.

Beeson, K. G. (1978). *In* "Geochemistry and the Environment. Vol. III: Distribution of Trace Elements Related to the Occurrence of Certain Cancers, Cardiovascular Diseases and Urolithiasis", pp. 59–78. National Academy of Sciences, Washington, DC.

Benson, A. A. and Summons, R. E. (1981). *Science* **211**, 482–483.

Bergoglio, R. M. (1964). *Prensa Med. Argent.* **51**, 994–998.

Bond, G. H. and Hudgins, P. M. (1980). *Biochim. Biophys. Acta* **600**, 781–790.

Broad, W. J. (1981). *Science* **213**, 1341–1344.

Brown, A. C. and Crounse, R. G. (eds) (1980). "Hair, Trace Elements, and Human Illness". Praeger Publishers, New York.

Brun, R. (1979). *Contact Derm.* **5**, 43–45.

Burchfiel, J. L. Dulfy, F. H., Bartels, P. H. and Needleman, H. L. (1980). *In* "Low Lead Lead Exposure—the Clinical Implications of Current Research" (Needleman, H. L., ed.), pp. 75–89. Raven Press, New York.

Byrne, A. R. and Kosta, L. (1978). *Sci. Total Environ.* **10**, 17–30.

Calebresi, E. J., Moore, G. S., Tuthill, R. W. and Sieger, T. L. (eds) (1980). *J. Environ. Path. Toxicol.* **4** (2 and 3), 1–326.

Capel, I. D., Pinnock, M. H., Dorrell, H. M., Williams, D. C. and Grant, E. C. G. (1981). *Clin. Chem.* **27**, 879–881.

Cappon, C. J. and Smith, J. C. (1982). *J. Anal. Toxicol.* **6**, 10–21.

Carlisle, E. M. (1972). *Science* **178**, 619–621.

Caster, W. O. and Wang, M. (1981). *Sci. Total Environ.* **17**, 31–36.

Christensen, O. B., Moller, H., Andrasko, L. and Lagesson, V. (1979). *Contact Derm.* **5**, 312–316.

Craighead, J. E. and Mossman, B. T. (1982). *New Eng. J. Med.* **306**, 1446–1455.

Crapper, D. R., Krishan, S. S. and Dalton, A. J. (1973). *Science* **180**, 511–513.

Curran, G. L. and Burch, R. E. (1967). *In* "Trace Substances in Environmental Health", Vol. I (Hemphill, D. D., ed.), pp. 96–102. University of Missouri Press, Columbia, Missouri.

Degraeve, N. (1981). *Mutation Res.* **86**, 115–135.

Eichorn, G. L., Shin, Y. A., Clark, P., Rifkind, J., Pitha, J., Tarien, E., Rao, G., Karlik, S. J. and Crapper, D. R. (1979). *In* "Trace Metals in Health and Disease" (Kharasch, N., ed.), pp. 123–133. Raven Press, New York.
Elmes, P. (1980). *J. Geol. Soc. Lond.* **137**, 525–535.
Emmerson, B. T. (1970). *Ann. Int. Med.* **73**, 854–855.
Ericson, J. E., Shirahata, H. and Patterson, C. C. (1979). *New Eng. J. Med.* **300**, 946–951.
Fierz, V. (1965). *Dermatologica* **131**, 41–58.
Fitzgerald, F. T. (1978). *In* "Advances in Internal Medicine", vol. 23 ((Stollerman, G. H., ed.), pp. 137–157. Year Book Medical Publishers, Chicago.
Flessel, C. P., Furst, A. and Radding, S. B. (1980). *In* "Metal Ions in Biologic Systems, vol. 10, Carcinogenicity and Metal Ions" (Sigel, H., ed.). Marcel Dekker, New York.
Frank, A. L. (1980). *Environ. Health Persp.* **34**, 27–30.
Frost, D. V. (1978). *In* "Inorganic and Nutritional Aspects of Cancer" (Schrauzer, G. N., ed.), pp. 259–279. Plenum Press, New York.
Furst, A. (1971). *In* "Environmental Geochemistry in Health and Disease" (Cannon, H. L. and Hopps, H. C., eds), pp. 109–130. Memoir 123. The Geological Society of America, Inc., Boulder, Colorado.
Ganther, H. E. (1978). *Environ. Health Perspect.* **25**, 71–76.
Goodman, L. S. and Gilman, A. (1975). "The Pharmacologic Basis of Therapeutics", 5th edn. Macmillan Publishing Co., New York.
Graham, J. A., Miller, F. J., Daniels, M. J., Payne, E. A. and Gardner, D. E. (1978). *Environ. Res.* **16**, 77–87.
Harlan, W. R., Sharret, A. R., Weil, H., Turing, G. M., Borhani, N. O. and Resnekov, L. (1981). *Circulation* **63**, 242A–271A.
Hodge, K. C., Day, J. P., O'Hara, M., Ackrill, P. and Ralston, A. J. (1981). *Lancet* **2**, 802–803.
Hutchinson, J. (1888). *Trans. Pathol. Soc. Lond.* **39**, 352.
Kaaber, K., Veien, N. K. and Tjell, J. C. (1978). *Br. J. Dermatol.* **98**, 197–201.
Kaaber, K., Menne, T., Tjella, J. C. and Veien, N. (1979). *Contact Derm.* **5**, 221–228.
Kharasch, N. (ed.) (1979). "Trace Metals in Health and Disease". Raven Press, New York.
Kirschgessner, M. and Schnegg, A. (1980). *In* "Nickel in the Environment" (Nriagu, J. O., ed.). Wiley, New York.
Kirschgessner, M. and Reichlmayr-Lais, A. M. (1981). *Biol. Trace Elem. Res.* **3**, 279–285.
LaBella, F. S., Dular, R., Lemon, P., Vivian, S. and Queen, G. (1973). *Nature, Lond.* **245**, 330–332.
Langer, A. M. and Wolff, M. S. (1978). *In* "Inorganic and Nutritional Aspects of Cancer" (Schrauzer, G. N., ed.), pp. 29–55. Plenum Press, New York.
Lauwerys, R. (1979). *In* "The Chemistry, Biochemistry and Biology of Cadmium" (Webb, M., ed.), pp. 433–455. Elsevier/North Holland Biomedical Press, Amsterdam.
Lees, R. E. M. (1980). *Br. J. Indus. Med.* **37**, 253–246.
Lemen, R. A., Dement, J. M. and Wagoner, J. K. (1980). *Environ. Health Persp.* **34**, 1–11.
Mabuchi, K. A., Lilienfeld, A. and Snell, L. (1979). *Arch. Environ. Health* **34**, 312–319.
Magos, L. and Webb, M. (1980). *In* "CRC Critical Reviews in Toxicology", November, pp. 1–42.
Maines, M. D. and Kappas, A. (1977). *Clin. Pharmacol. Therap.* **22**, 780–790.
McDonald, J. C. and McDonald, A. D. (1977). *Prev. Med.* **6**, 426–446.
McNeely, M. D., Sunderman, F. W. Jr., Nechay, M. W. and Levine, H. (1971). *Clin. Chem.* **17**, 1123–1128.
Menne, T., Mikkelsen, H. I. and Solgaard, P. (1978). *Contact Derm.* **4**, 106–108.
Mertz, W. (1981). *Science* **213**, 1332–1338.
Miller, G. E., Grant, P. M., Kishore, R., Steinkruger, F. J., Rowland, F. S. and Guinn, V. P. (1972). *Science* **175**, 1121–1122.
Millette, J. R., Clark, P. J., Pansing, M. F. and Twyman, J. D. (1980). *Environ. Health Persp.* **34**, 13–25.
Morse, D. L., Harrington, J. M., Houseworth, B. S. and Landrigan, P. L. (1979). *Clin. Toxicol.* **14**, 389–399.
Needleman, H. L. (ed.) (1980). "Low Level Lead Exposure—the Clinical Implications of Current Research". Raven Press, New York.
Needleman, H. L., Gunnoe, C. E., Leviton, A., Reed, R., Peresie, H., Maher, C. and Barret, P. (1979). *New Eng. J. Med.* **300**, 689–695.

Newell, G. R. and Ellison, N. M. (eds) (1981). "Nutrition and Cancer: Etiology and Treatment". Progress in Cancer Research and Therapy, Vol. 17. Raven Press, New York.

Nielson, F. H. (1976). *In* "Trace Elements in Human Health and Disease", vol. II (Prasad, A. S., ed.), pp. 379–399. Academic Press, New York and London.

Nielson, F. H. and Sandstead, H. H. (1974). *Am. J. Clin. Nutr.* 27, 515–520.

Nielson, F. H., Givand, S. H. and Myron, D. R. (1975). *Fed. Proc.* 34, 923.

Nishigori, H., Alker, J. and Toft, D. (1980). *Arch. Biochem. Biophys.* 203, 600–604.

Ott, S. M., Maloney, N. A., Coburn, J. W., Alfrey, A. C. and Sherrard, D. J. *New Eng. J. Med.* 307, 709–713.

Parker, R. D. R., Sharma, R. P. and Miller, G. W. (1978). *In* "Trace Substances in Environmental Health", Vol. 12 (Hemphill, D. D., ed.). University of Missouri Press, Columbia, Missouri.

Parkinson, I. S., Ward, M. K., Feest, T. G., Fawcett, R. W. P. and Kerr, D. N. S. (1979). *Lancet* 1, 406–409.

Perl, D. P., Gajdusek, D. C., Garruto, R. M., Yanagihara, R. M. and Giggs, C. J., Jr. (1982). *Science* 217, 1053–1055.

Peterson, P. J. (1979). *Phil. Trans. R. Soc. Lond.* B228, 169–177.

Pihl, R. O., Drake, H. and Vrana, F. (1980). *In* "Hair, Trace Elements, and Human Illness" (Brown, A. C. and Crounse, R. G., eds), pp. 128–143. Praeger Publishers, New York.

Piomelli, S. (1980). *In* "Low Level Lead Exposure—the Clinical Implications of Current Research" (Needleman, H. L., ed.), pp. 67–74. Raven Press, New York.

Prasad, A. S. (1978a). *In* "Trace Elements and Iron in Human Metabolism" (Hemphill, D. D., ed.), pp. 203–206. Plenum Press, New York.

Prasad, A. S. (1978b). *In* "Trace Elements and Iron in Human Metabolism" (Hemphill, D. D., ed.), pp. 206–209. Plenum Press, New York.

Prasad, A. S. (1978c). *In* "Trace Elements and Iron in Human Metabolism" (Hemphill, D. D., ed.), pp. 349–362. Plenum Press, New York.

Reeves, A. L. (1978). *In* "Inorganic and Nutritional Aspects of Cancer" (Schrauzer, G. N., ed.), pp. 13–27. Plenum Press, New York.

Revis, N. W. and Zinsmeister, A. R. (1981). *Proc. Soc. Exp. Biol. Med.* 167, 254–260.

Sanderson, K. V. (1976). *In* "Cancer of the Skin—Biology, Diagnosis and Management", Vol. 1 (Andrade, R., Gumport, S. L., Popkin, G. L. and Reese, T. D., eds), pp. 473–491. W. B. Saunders, Philadelphia.

Schrauzer, G. N. (1978). *Adv. Exp. Med. Biol.* 91, 323–344.

Schrauzer, G. N. (1979). *In* "Trace Metals in Health and Disease" (Kharasch, N., ed.), pp. 251–261. Raven Press, New York.

Schroeder, H. A., Balassa, J. J. and Tipton, I. H. (1964). *J. Chronic Dis.* 17, 483–502.

Schwarz, K. and Milne, D. B. (1972). *Nature, Lond.* 239, 333–334.

Schwarz, K., Milne, D. B. and Vinyard, E. (1970). *Biochem. Biophys. Res. Commun.* 40, 22–29.

Searle, C. E. (ed.) (1976). "Chemical Carcinogens". ACS Monograph 173. American Chemical Society, Washington, DC.

Sebastien, P., Bignon, J. and Martin, M. (1982). *Science* 216, 1410–1513.

Shaikh, Z. A. (1982). *In* "Biological Roles of Metallothionein" (Foulkes, E. C., ed.), pp. 69–76. Elsevier/North Holland, New York.

Shaper, A. G., Pocock, S. J., Walker, M., Cohen, N. M., Wale, C. J. and Thomson, A. G. (1981). *Br. Med. J.* 283, 179–186.

Sigel, H. (1980). "Metal Ions in Biologic Systems: Vol. 10, Carcinogenicity and Metal Ions". Marcel Dekker, New York.

Singhal, R. L. and Thomas, J. A. (eds) (1980). "Lead Toxicity". Urban and Schwarzenberg Inc., Baltimore and Munich.

Spencer, H., Kramer, L., Osis, D., Wiatrowski, E., Norris, C. and Lender, M. (1980). *Ann. N.Y. Acad. Sci.* 355, 181–194.

Spruit, D., Bongaarts, P. J. M. and De Jongh, G. J. (1978). *Contact Derm.* 4, 350–358.

Stout, M. G. and Rawson, R. W. (1981). *In* "Nutrition and Cancer, Etiology and Treatment" (Newell, G. R. and Ellison, N. M., eds), pp. 243–272. Raven Press, New York.

Sunderman, F. W. Jr. (1965). *Am. J. Clin. Path.* 44, 182–188.

Tagnon, I., Blot, W. J., Stroube, R. B., Day, N. E., Morris, L. E., Peace, B. B. and Fraumeni, J. F. (1980). *Cancer Res.* 40, 3875–3879.

Tassinari, M. S. and Long, S. Y. (1982). *Teratology* **25**, 101–113.
Thatcher, R. W., Lester, M. L., McAlaster, R. and Horst, R. (1982). *Arch. Environ. Health* **37**, 159–166.
Thornton, I., John, S., Moorcraft, S. and Watt, J. (1980). "Trace Substances in Environmental Health", XIV, pp. 27–37. University of Missouri, Columbia, Missouri.
Tiffin, L. O. (1971). *Plant Physiol.* **48**, 273–277.
Tohyama, C. and Shaikh, Z. A. (1981). *Fundamental appl. Toxicol.* **1**, 1–7.
Tohyama, C., Shaikh, Z. A., Ellis, K. J. and Cohn, S. H. (1981a). *Toxicol.* **22**, 181–191.
Tohyama, C., Shaikh, Z. A., Nogawa, K., Kobayshi, E. and Honda, R. (1981b). *Toxicol.* **20**, 289–297.
Tseng, W. P., Chu, H. M., How, S. W., Fong, J. M., Lin, C. S. and Yeh, S. (1968). *J. Nat. Cancer Inst.* **40**, 453–463.
Underwood, E. J. (1977a). *In* "Trace Elements in Human and Animal Nutrition" (Hemphill, D. D., ed.), 4th edn, pp. 132–158. Academic Press, New York and London.
Underwood, E. J. (1977b). *In* "Trace Elements in Human and Animal Nutrition" (Hemphill, D. D., ed.), 4th edn, pp. 449–451. Academic Press, New York and London.
Underwood, E. J. (1977c). *In* "Trace Elements in Human and Animal Nutrition" (Hemphill, D. D., ed.), 4th edn, pp. 398–409. Academic Press, New York and London.
Underwood, E. J. (1977d). *In* "Trace Elements in Human and Animal Nutrition" (Hemphill, D. D., ed.), 4th edn, pp. 388–397. Academic Press, New York and London.
Underwood, E. J. (1977e). *In* "Trace Elements in Human and Animal Nutrition" (Hemphill, D. D., ed.), 4th edn, pp. 430–433. Academic Press, New York and London.
Underwood, E. J. (1977f). *In* "Trace Elements in Human and Animal Nutrition" (Hemphill, D. D., ed.), 4th edn, pp. 243–257. Academic Press, New York and London.
Underwood, E. J. (1979). *Phil. Trans. R. Soc. Lond.* **B288**, 5–14.
Valkovic, V. (1977). "Trace Elements in Human Hair". Garland STM Press, New York.
Valkovic, V. (1980). *Origins of Life* **10**, 301–305.
Wagner, S. L., Maliner, J. S., Morton, W. E. and Braman, R. S. (1979). *Arch. Derm.* **115**, 1205–1207.
Waldbott, G. L. (1978a). "Health Effects of Environmental Pollutants", 2nd edn, pp. 182–184. C. V. Mosby Co., St Louis, Mo.
Waldbott, G. L. (1978b). "Health Effects of Environmental Pollutants',, 2nd edn, pp. 160–171. C. V. Mosby Co., St. Louis, Mo.
Waldbott, G. L. (1978c). "Health Effects of Environmental Pollutants", 2nd edn, pp. 171–178. C. V. Mosby Co., St Louis, Mo.
Waldbott, G. L. (1978d). "Health Effects of Environmental Pollutants',, 2nd edn, pp. 150–159. C. V. Mosby Co., St Louis, Mo.
Walker, G. S., Aaron, J. E., Peacock, M., Robinson, P. J. A. and Davison, A. M. (1982). *Kidney Int.* **21**, 411–415.
Webb, M. (ed.) (1979a). "The Chemistry, Biochemistry and Biology of Cadmium". Elsevier/North Holland Biomedical Press, Amsterdam.
Webb, M. (1979b). *In* "The Chemistry, Biochemistry and Biology of Cadmium", pp. 195–283. Elsevier/North Holland Biomedical Press, Amsterdam.
Wixson, B. G. and Page, A. L. (Chairman and Vice-Chairman) (1980). Panel of the Trace Element Geochemistry of Coal Resource Development Related to Health, Subcommittee on the Geochemical Environment in Relation to Health and Disease. US National Committee of Geochemistry, National Research Council, National Academy Press, Washington, DC.
Wood, J. M., Fanchiang, Y.-T. and Craig, P. J. (1972). *In* "Trace Metals in Health and Disease" (Kharasch, N., ed.), pp. 43–53. Raven Press, New York.
Yeh, S. (1973). *Human Path.* **4**, 469–485.
Yeh, S., How, S. W. and Lin, C. S. (1968). *Cancer* **21**, 312–339.

11

Geomedicine in Scandinavia

J. LÅG

I. Introduction: explanation of the term "geomedicine"

Several terms combine names linking the earth sciences and medicine, including those of "geographic medicine" and "medical geography". A more comprehensive term is "geomedicine".

The expression "geomedicine" seems to have been introduced by Zeiss (1931) and has been discussed by a number of workers such as Rimpau (1934). But it has taken a long time for the subject to acquire its present status. One of the most important causes of this delay is its complex and interdisciplinary nature.

Different authors have used the term "geomedicine" in different ways. Opinions vary as to the connection between veterinary medicine, plant pathology, etc., and different environmental factors. My view is that the subject should include parts of veterinary medicine, exclude plant pathology (geophytomedicine), and take into account the common, outdoor environmental factors (Låg, 1978c). In this way it is possible to reach the following definition: Geomedicine is the science dealing with the influence of ordinary environmental factors on the geographical distribution of pathological and nutritional problems of human and animal health. According to this explanation the so-called internal environmental factors are not included. The influence of the indoor environment, for example, in factories and offices thus falls outside the scope of geomedicine, and comes within the area of occupational medicine.

Some subdivision of this comprehensive subject is desirable. A rough

APPLIED ENVIRONMENTAL GEOCHEMISTRY
ISBN 0-12-690640-8

systematization may be based on the classification of environmental factors: (i) climatic and (ii) earth factors. A more detailed specification can be made by the division of these two groups. An important part of the influence of the soil factors concerns their effects on vegetation. The transportation of elements from soil to plant and then to animal and man is of special interest. The expression edafo-geomedicine is suggested as a name for this field (Låg, 1972). When geomedical problems are related to the water supply, the term hydrogeomedicine may be used.

Of course, many cases will be difficult to specify in such a scheme. The climate, for instance, has a direct influence as well as an indirect one on the soils. Borderline cases will occur between geomedicine and other subjects: for example, the effects of radiation in the environment which may cause genetic changes with medical consequences; similarly the risk of infection can depend on temperature, and soil conditions may influence the occurrence of parasites, etc.

II. Historical aspects of Scandinavian geomedicine

For a very long time man has noticed that particular diseases appear in specific areas. Concepts of cause and effect may also be old, as even primitive people can have very well developed powers of observation. However, only after the detection of some fundamental natural laws of chemical, medical and nutritional character was the basis laid for the understanding of such problems.

Associated with the question of the history of this science, it is necessary to remember an old, disregarded Norwegian publication by Vogt (1888), which explains that the high frequency of osteomalaci in cattle in regions in southernmost parts of Norway relates to the very small amount of apatite in the bedrock. Even older are the detailed descriptions given by Oddur Eiriksson and by Benedikt Pjetursson of damage to the teeth of domestic animals resulting from the eruption of the Icelandic volcano Hekla in 1693 (Palsson et al., 1980). Of course, at that time it was not known that the reason was fluorosis.

Relationships between the fluorine deficiency and dental caries incidence have been carefully studied in Scandinavia since the last World War. Attention has been particularly centred around the need for fluoridization. Analyses of the F content of natural waters from different sources and their relationships to caries frequency have been reported from several districts (see, for example, Møller, 1965).

As a consequence of research results from other countries, it became clear

that cases of goitre caused by a deficiency of I occurred in some dry inland regions of Norway (see, for example, Løken, 1912). In the period between World War I and II there were many publications on this subject (Lunde, 1928; Sande, 1937; etc.). For a long time it was supposed that low dietary intake of fish and of fish products from the ocean was the main reason for the poor I supply. New investigations have shown that plant materials in the goitre districts had low I contents (see Chapter 9).

Nearly 100 years ago goitre was studied in Norway as a geomedical problem by Johannessen (Johannessen, 1889). He refused to accept the explanation that I deficiency was the cause of goitre. Like some authors in Central Europe at that time, he thought that the disease was associated with areas with certain types of bedrock geology.

The disease osteomalaci in cattle was, long ago, given a characteristic Norwegian name, "beinskjørhet". This may be translated as "fragile bones". An old publication mentions that this illness could be caused by pasturing in peatland and feeding with hay from peatland (Lindeqvist, 1856). Other agronomists have referred to the disease in a range of publications in the late 19th and early 20th centuries. The geologist, Vogt (1888), seems to be the first to see this illness in relation to the chemical composition of the bedrock. He was told by local people that at farms situated on a certain type of bedrock, cattle had to be given crushed bones or other matter rich in P in order to get rid of the difficulty. When he investigated the anorthosite rock in these affected areas, he found that it was extremely poor in apatite.

The vegetation in these regions is particularly sparse, as noticed by the geologist, Esmark (1823). The farmers in the district had given those pastures a particular name "harde beiter" or "severe pastures". Aanestad (1895) stated as an explanation that on these pastures the cattle are exposed to osteomalaci due to a deficiency of P in the vegetation. A common plant species in these pastures has the characteristic Latin name, *Narthecium ossifragum*.

Later Tuff (1922) discussed the problem of osteomalaci in detail. Ender (1942) has written about P deficiency causing so-called lick disease in inland regions. In Sweden the chemist, Svanberg (1932) clearly drew attention to the effects of P in animal husbandry.

In certain Norwegian districts deficiencies of Cu and Co in animal nutrition have been found (Engdal and Ulvesli, 1942; Ender, 1942, 1944, 1946; Ender and Tananger, 1946). In one such area a combination of Zn and Cu deficiency occurs (Dynna and Havre, 1963).

Thorough investigations have been carried out into the contents of Cu and Co in Swedish hay (Svanberg and Nydahl, 1941; Svanberg and Ekman, 1949). In Denmark, an association between Co deficiency in animal nutrition and the extent of podzolized soils has been presented by Bendixen (1951).

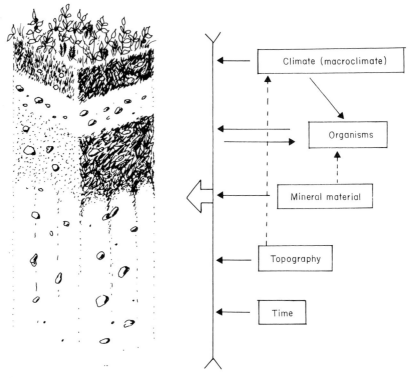

Fig. 11.1 Schematic presentation showing the influence of soil-forming factors.

III. Soil formation and circulation processes

In the course of soil formation the original properties of mineral material are more or less changed. For example, during the development of a podzol, which is a common soil group in Scandinavia, a comprehensive leaching of elements takes place from the upper layers of the soils.

Direct and indirect effects of the soil-forming factors are shown in Fig. 11.1. It is obvious that the qualities of the original soil material influences the soil profile. Where the bedrock has an extreme composition, the soils indicate this. As already mentioned above, soils and vegetation poor in P are found in regions of anorthosite bedrocks in Norway. Examples of the effects of rock material on soil development in Scandinavia include that of quartzite, which often favours podzolization, and of limestone, which leads to the formation of brown earths. The mechanical composition also has a strong effect on soil development. Soil texture is important both for affecting soil moisture

conditions and for influencing the solution and absorption of nutrients as well as of toxic elements in the soil.

The topography has an influence on the water regime. In areas with a broken topography, for example, smaller amounts of water percolate through the soil profile because much of the precipitation flows away as surface water.

The length of the period of soil formation influences the extent of the changes that take place in the original soil material. Most of Scandinavia was covered by ice during the last Quaternary glaciation. The period of soil formation for the largest land areas is of maximum of 10 000–15 000 years. In geological terms this is a relatively short period of time.

Climatic factors have an important effect on soil formation, and likewise have a large direct influence on plants and animals. Temperature and precipitation, for example, influence both the decomposition of soil organic matter and transport of elements within the soil. Precipitation water contains dissolved material that may influence the chemical qualities of the soils. Pollution from industry into the atmosphere may come down to the soil surface with precipitation. Such pollution may to an extent disturb the natural processes in the soil.

Living organisms are an important factor in the study of soil-forming processes, but they are also dependent on the nature of the soils themselves (see the arrows pointing in both directions in Fig. 11.1). The effects of the organisms on soils are many and varied. In this context the supply of plant residues from which humus is derived is especially important.

The nutrients and other materials that plants take up from the soil return with the litter when the plant dies. The roots are integrated with the soil. The plant remnants above ground fall to the soil surface and are, with time, incorporated into the soil. The nutrients may then again be taken up by the plants, and in this way the circulation processes between soil and plants continue.

This recirculation can be extended when animals or humans eat plant material and their refuse is returned to the soil. As a general statement, we can say that the soil is the natural recipient for all plant remnants.

IV. Geochemical and soil chemical maps

For a long time geochemistry has generally been supposed to be a theoretical subject with the main emphasis on the chemical composition of the globe. The term was introduced as early as 1838 (by C. F. Schönbein). Gradually, the distribution of the various elements was better understood. From 1911 till his death in 1947, the Norwegian geochemist, Goldschmidt, published important results from his investigations in this field (see, for example, Goldschmidt, 1954).

With increasing comprehension, there followed a greater possibility that geochemical knowledge could be applied to solve important practical problems. When searching for mineral ore in the bedrock, for example, it became obvious that an understanding of geochemical relationships contributed towards success.

Usually there are no clear borderlines between the various applications. This is especially valid for the relationships between geochemistry and soil science. Some problems have been studied in both these sciences, though from different points of view. Valuable contributions may be made both from the study of geochemistry and of soil science to solve identical problems. Often maps based on geochemistry and soil chemistry are useful material when starting to answer questions of an applied character. To ascertain the effects of pollution, for instance, it is necessary to be acquainted with the natural properties of the environment. A term that has recently come into use is ecotoxicology. This expression comprises harmful chemical effects on natural organisms in the environment. Here there is not only talk about damage caused by pollution but also harmful effects of nature's primary material. Maps based on soil chemistry and geochemistry are often of great help for estimating problems affecting plant production.

Maps of bedrock geology showing the distribution of various rocks of known chemical composition give some basic knowledge of geochemical parameters. Parallels can be drawn to Quaternary maps and soil maps.

However, special geochemical maps have also been compiled, using the analysis of stream sediments for purposes of ore prospecting; the Geological Survey of Norway has published maps showing the contents of a number of elements in such sediments over a large part of southeastern Norway. Similar analyses have been performed for other districts, but the maps are not yet completed.

Humus samples from forests in Nord-Trøndelag, Oppland, and Buskerud counties, collected in co-operation with the National Forest Survey, are the basic material for an extensive research activity that has given interesting soil chemical and geochemical results. It has been shown that salts from ocean water in particular interfere with the chemical composition of humus near the coast. Likewise, as for other well-known elements in ocean water, the content of Se decreases from the coast towards the interior of the country. Heavy metal distribution in this forest humus also shows interesting features. Great interest has been evoked in pollution from global air currents in Scandinavia, especially in relation to acid precipitation; attention has also been drawn to heavy metal supply (see, for example, Hvatum, 1971; Rühling and Tyler, 1973; Steinnes, 1980).

For agronomical purposes, many samples from cultivated soils have been analysed for pH and concentrations of easily soluble nutrients. Man's

interference with arable land by cultivation considerably changed its proper-
ties, but for the elements that are not added with cultivation, the original
composition of the soils is very important. There is a need for a greater sense of
urgency to complete geochemical and soil chemical maps for Scandinavia.
Analytical data from earlier investigations can be used in this connection, but
there is a demand for new samples of bedrock, water, soil and plant material.

A co-operative study has started between the geological surveys in Finland,
Norway and Sweden towards a large geochemical project for the northern
hemisphere (north of 66°). These investigations are to include analysis of water,
stream sediments, organic material in streams, stream mosses, common
terrestrial humus and morainic soil material.

To complete such geochemical and soil chemical maps will take a long time.
Many different institutions are needed to participate in the work. Which parts
of the land area will receive most attention will depend especially on the so-
called "users' interests". It seems that ecotoxicological and geomedical
problems are of great interest in addition to problems of geochemical
prospecting. In planning the future preparation of such maps, it is necessary to
have participation of scientists with a broad scientific and technical
background.

V. The chemical climate as a health factor

Rainwater was at one time regarded as almost as pure as distilled water.
Comparatively recently, after comprehensive investigations had been carried
out with modern analytical methods, it became clear that rain and snow can
contain considerable concentrations of soluble material. A research program
that started in Sweden and expanded to Norway and several other countries,
provided much data to determine the chemical composition of precipitation.
In particular, a comprehensive investigation was undertaken in connection
with the International Geophysical Year, 1957–1958.

Norway has a very large geographical variation both in amount and
composition of rain and snow. A precipitation of more than 3000 mm occurs at
some places just inland from the west coast, and 300 mm and even less in
narrow valleys at relatively short distances to the east. The variations in
chemical composition can be illustrated by the following examples. On
average in the years 1955–1962 the soil surface was supplied per m^2 with
25 742 mg Cl, 14 831 mg Na and 1734 mg Mg at Lista in southwestern
Norway; the corresponding figures for Vågåmo in the dry area of eastern
Norway were 135 mg Cl, 134 mg Na and 50 mg Mg (Låg, 1963).

The large chemical differences in the precipitation have influenced the soils
greatly. Figure 11.1 shows how we think the climate directly and indirectly

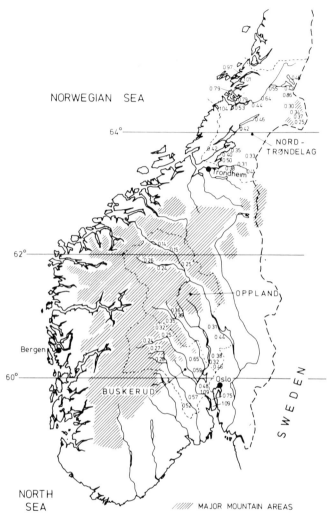

Fig. 11.2 Regional distribution of Se (ppm) in humus layers of Norwegian forest soils.

affects soil formation. Determination of exchangeable ions in the humus layer
of natural soil profiles showed a decrease of Na and Mg and a corresponding
increase of Ca from the coast inland (Låg, 1968). Analytical figures for I, Br and
Cl showed a tendency parallel to those of Na and Mg (Låg and Steinnes, 1976).
In addition, it was remarkable to find that the Se content also decreased away
from the coast (Fig. 11.2) from more than 1.0 to less than 0.3 ppm (Låg and
Steinnes, 1978).

The medical consequences of these soil chemical differences was an

interesting new question. Determination of I and Br in barley and wheat showed much higher contents in the samples from the coastal areas than in those from the inland regions (Låg, 1972, 1978b; Låg and Steinnes, 1977). It is well known that goitre has been comparatively common in districts in eastern Norway with a low precipitation, and usually it has been explained by a low consumption of fish rich in I. These new research results show, however, that the smallgrain grown in the inland regions also has a very low I content.

The element Se has lately received a lot of attention both in veterinary and human medicine. After demonstrating the geographical pattern of Se distribution in Norwegian soils, it is easy to understand that problems in animal husbandry due to Se deficiency are most likely to occur in dry inland districts. Muscular degeneration in lambs and calves, remedied by supplementation with Se compounds, has been known for some time (Mikkelsen and Hansen, 1967, 1968). In Finland, where, roughly speaking, the climate is continental, Se deficiency in animal husbandry has been counteracted over a longer period. As far as it is known, Finland was among the first countries in the world where the addition of Se to the concentrate feedstuffs was allowed. Comprehensive studies of Se in soils and plants have also been carried out in Denmark (Bisbjerg, 1972; Gissel-Nielsen, 1977).

Selenium plays an important part in essential biochemical processes. According to Goldschmidt (1954) the content of Se in the lithosphere is only 0.09 ppm. Around the world, scientists are attempting to determine the possible role of Se in relation to important human-medical problems, such as cancer and multiple sclerosis. Accounts of Scandinavian research in these fields were recently presented at a symposium in Oslo (Låg, 1980).

Considerable medical interest may also be aroused for other elements where distribution may be influenced by climate. The expression "climate" is usually meant to infer the most common physical factors such as temperature, wind, precipitation, air humidity, etc. However, we should also take into account the chemical variation of the climate. As shown, such climatic differences influence soil formation, the chemical composition of plants, and even the health of man and animals. In addition to the natural variations in the chemical climate, it is necessary to take into account pollution of the atmosphere by man.

VI. Natural trace element poisoning

We have to assume that man discovered poisonous effects on soils and plants a long time ago. However, a clear understanding of the causes could only be realized as basic knowledge in chemistry and related subjects was developed.

Many descriptions of poisoning are given in botanical and agronomical literature. Much attention has also been given to harmful effects on domestic

animals. As early as 1856, the serious illness "alkali disease" or "blind staggers" was described in horses in USA (Underwood, 1971). Later, it was proved that the cause of the disease was Se poisoning due to a very high Se content in soils and plants.

Another acute and serious problem in livestock is fluorosis resulting from volcanic eruptions. In Iceland, for instance, this toxicological problem has been very serious (Palsson et al., 1980).

Some small areas in Norway where soils contain extremely high concentrations of heavy metals are of interest when discussing natural poisoning with trace elements. Some years ago in Vardal, in the neighbourhood of the town Gjøvik, an area of approximately 100 m² almost without vegetation was discovered, where the Pb content of the surface soil varied between 1 and 11% (Låg et al., 1970). The source of the Pb in the soil was galena in a quartzite vein further up in the slope. Weathering had released the Pb, which had then moved downslope in groundwater. The content of the Pb in the soil surface had then been concentrated to a much higher level than that in the bedrock from which it had originated. From a geochemical point of view this process is very interesting. In Norway we have not found such a high soil Pb content as a result of pollution caused by man.

After the discovery of the poisoned soil in Vardal, similar phenomena were sought in other places. Patches of natural Pb-poisoning were then found in Snertingdal, Nord-Aurdal, Nordre Osen, at Galåa, and in Stabursdalen. In addition, a Cu poisoned area was found in Raitevarre in Finmark, and Ni poisoning in Rana, Nordland. Toxic effects of Zn in combination with other elements, such as Cd, are found in Sinklien and at Mosbergvik in Nordland. Due to weathering of sulphides, sulphuric acid can be formed and oxidation of a large quantity of sulphide may give considerable fall in pH. Examples of toxicity related to low pH have been found at Hjerkinn and at Gjersvik. At different sites the degree of poisoning of soils and of damage to vegetation varies (see, for example, Låg and Bølviken, 1974; Bølviken and Låg, 1977).

In all the areas mentioned above, moving water has brought the toxic material to the soil surface. The actual location of the poisoned spots is therefore connected to the hydrology of the landscape. In these areas, during most of the growing season, there is no excess water at the soil surface. However, in especially wet periods, such as the time of snow melt, moving groundwater will reach the soil surface at locations which are usually comparatively dry.

Various plants have different abilities to survive high concentrations of heavy metals. In the poisoned areas investigated up to the present time, the common species Vaccinium myrtillus and V. vitis-idaea are mostly completely lacking. Areas with moderate Pb poisoning have a characteristic vegetation of Deschampsia flexuosa. The Cu poisoned field has, in addition to Deschampsia

flexuosa, Juncus trifidus, Festuca ovina and *Viscaria alpina.* The three first-mentioned species are favourable as pasture. *Sphagnum* species appear to be very sensitive, and are not present where poisonous effects are heavy or moderate. Plant species that can tolerate a high concentration of heavy metals in the soil will themselves contain high concentrations of these elements when growing in poisoned areas. Considerable amounts of undesirable elements can in this way be brought into biological circulation.

As this type of heavy-metal poisoning is connected with percolation of water parallel to the soil surface, it will only develop in sloping terrains. With the exception of the locality in Nord-Aurdal, sulphide mineralizations have always been found in the area above the poisoned patches.

It has been known for a long time that many heavy metals form compounds of low solubility with humus. Lead and Cu are especially strongly fixed in this way. Concentrations of heavy metals in the surface layer of the soil can therefore be explained as a result of absorption where the water carrying the metals in solution reaches the soil surface. The processes leading to such heavy-metal poisoning have most probably evolved over the same time scale it has taken the soil profile to develop. In the localities described, the time could be said to be almost 10 000 years.

There are still many unsolved problems pertaining to this natural toxicity, owing among other things to the short durations of the investigations. In all probability such naturally poisoned areas exist in many places.

Explanations of natural poisoning may prove to be beneficial in evaluating pollution processes caused by man.

VII. Environmental pollution of a global character

Dispersion of radioactive by-products of nuclear fission into the atmosphere has created a considerable interest in global pollution problems. After the surface atomic explosions ceased, this environmental pollution decreased rapidly.

Polluting substances derived from industrial activities have been widely spread with the world air currents. Comprehensive analyses have been carried out into the transportation of sulphur and the effects of acid precipitation in Norway and Sweden (Overrein *et al.*, 1980). Fish deaths have occurred in fresh water over large areas due to acid precipitation.

Air currents that bring acid precipitation also transport other undesired substances. Organic micropollutants have been demonstrated in Norway, and some of these substances have possible carcinogen effects (Overrein *et al.*, 1980). The accumulation of some heavy metals in the surface soils in southern districts of Norway, when compared with northern areas, is linked with

transportation by air from industrialized countries (see, for example, Steinnes, 1980).

VIII. Environmental pollution from local sources

Industrial pollution has caused a rapid increase in the interest in toxicity problems pertaining to soils and plants. Changes and additions in textbooks printed in several editions gives some impression of the growing attention to this subject. Generally, the number of chapters dealing with toxicity problems have increased. Even if the expression geomedicine is not mentioned, many of the problems discussed are closely related to this subject.

Several examples may serve to illustrate the effects of pollution caused by man.

In relation to statements concerning fluorosis near the Icelandic volcanoes, it may be mentioned that similar problems exist near Al factories. In fact, animal husbandry is not possible in the vicinity of many Norwegian factories producing Al. Damage to wildlife, especially elk, has also been noticed (Holt, 1978).

At many mining sites, characteristic examples of toxic effects of metals on soils and plants are observed. In addition, watercourses are polluted. Freshwater fish are especially sensitive to many heavy metals. In addition water from sulphide deposits will often contain sulphuric acid.

The smelting and calcining of ores often leads to the emission of toxic material from chimneys and causes pollution of the surface soils in the neighbourhood.

At Røros Cu deposits in the central part of Norway, which have been mined for more than 300 years, more than 1000 ppm Cu was found in the humus layer of natural soil profiles at a distance of 1 km from a furnace.

In the vicinity of a furnace belonging to Kongsberg Sølvverk, a concentration of up to 13.6 ppm Hg was observed in the humus layer (Låg, 1976).

Modum Blåfargeverk, where activities ceased late in the 19th century, produced Co from an As bearing sulphide ore. The soils and the plants around the furnace now have an abnormally high As content. Long after the activity has ceased relatively large quantities of As are circulating between soils and plants. However, analyses of some samples of food plants from a local garden showed As contents which were not considered dangerous according to the tentative limit set by FAO/UNESCO (Låg, 1978a).

In Odda, western Norway, more than 2% Zn was found in the surface layer of the soils near a Zn factory. In addition, heavy pollution with Pb, Cd, Hg and, to some degree, Cu, was discovered. The content of Se and As in these soils was also higher than that found normally. Chemical analyses gave a basis for

caution against high dependency upon food plants grown in the neighbourhood of the factory (Låg, 1975).

A Ni factory in Kristiansand has caused severe soil pollution in the surrounding area. Here the humus layer of natural soils contained more than 1% nickel. Even at a distance of 1.5 km from the factory the concentration was as much as 0.17%. The concentration of Cu was also high, ranging from 0.05 to 0.69%. The soils were also contaminated with other elements.

Pollutants in the localities of Røros, Kongsberg, Modum, Odda and Kristiansand are carried to the soil surface by atmospheric dispersion, especially from the chimneys. However, there are other possible causes of pollution due to different types of industry; for example, slag and other waste products may cause toxicity.

Situated at a Ni factory at Evje is a sedimentary deposit of waste materials that up to the present time is only partially covered by vegetation. Plants in many places display signs of toxic effects. In practice, a huge slag heap is partially without vegetation. Corresponding slag heaps are found at other Ni works.

A large mound of water-sorted waste material from mining at Grua has remained without vegetation over a period of more than 50 years. This debris has a very high content of Zn, Cd and Pb, with one sample containing 2.47% Zn and 81 ppm Cd.

To move such waste materials to other areas can cause new harmful effects. An illustration of this was found in an oat field near an abandoned Ni works at Vaeleren, Ringerike. By chance, lumps of slag from the furnaces have been deposited in the field, resulting in patches of stunted, chlorotic oat plants.

Also, the influence of sulphuric acid from industry has been studied in Sweden by Johansson (1959) and in Norway by Haugbotn (1976).

IX. Examples of geomedical investigations in Scandinavia in modern times

1. Introduction

Rapid progress in analytical methodology has resulted in better chances of solving problems of a geomedical character. The discovery of important causal relationships in nutrition and pathology increases, of course, the possibilities of understanding geomedical relationships.

The term geomedicine has until recently been used only seldom in Scandinavia, where it was perhaps first introduced in 1972. In this section we are going to use the term geomedicine according to the definition in Section I.

From such a comprehensive subject, from which has arisen a wide range of publications, it is only possible to present a few examples. Primarily, it has served to highlight the effects on health related to a deficiency or an excess of one or more elements.

2. Iodine and Br in soils and cereals

A relationship between I deficiency and goitre has been recognized for a long time in certain districts in Norway.

Batt (1940) states that there is a fine balance between the presence or absence of goitre in humans residing all over the inland areas of Norway. Sande (1937) refers to the death of numbers of lambs from goitre in some herds in Alvdal, and says that the illness is a scourge to the sheep industry in some districts. Likewise, goitre is well known in horses and cattle. In the other Scandinavian countries goitre seems to be less frequent.

Intake of food and fodder rich in I has led to fewer cases of goitre in Norway. The addition of I to kitchen salt and the intermixture of herring meal or other fish meal in concentrates to domestic animals have been common remedies. It was long believed that goitre in the Norwegian inland was related to the low consumption of saltwater fish. Recent investigations, however, show, as mentioned, that soils and smallgrain in these districts are deficient in I. Bromine has a similar distribution pattern as that for I. So far, little is known about the importance of Br in nutrition. Consequently, in inland districts with low precipitation the food was often deficient in I, not only due to a minimal use of saltwater fish in the diet but also because the I content of plant products grown in these areas is extremely low.

3. Geographical variation in Se distribution and possible consequences

Further investigations with the content of trace elements in uncultivated soils in Norway showed that Se had a similar geographical distribution to I and Br (Låg and Steinnes, 1974, 1978). The Se content of humus layers of forest soils was particularly low in places with low precipitation and far from the ocean (Fig. 11.2).

At present there is a strong medical interest in Se. This element has an important role in metabolic processes. It may be said that it was a risk of "nature" to give such a rare element such important tasks.

Muscular degeneration in domestic animals has on some occasions been traced back to Se deficiency. As far as is known, Finland was among the first countries in the world where Se addition to the fodder was permitted.

In the other Scandinavian countries, scientists have recently been working on Se problems and have pointed out the possibilities of relationships between cancer and multiple sclerosis and Se deficiency. From the relatively large Scandinavian geomedical literature on Se, publications by Bisbjerg (1972), Gissel-Nielsen (1977), Sippola and Tares (1978), Schalin (1980) and Jonson and Pehrson (1980) are of particular significance.

Up to the present there have been no known cases of natural Se toxification in Scandinavia.

4. Fluorine deficiency and toxicity

Great interest has been shown in the influence of F supply in food on the dental health of humans. This came about as a result of the discovery that F addition in many cases decreases caries frequency. Such problems have been discussed in several Scandinavian papers (see, for example, Sellman et al., 1957; Scheinin et al., 1964; Møller, 1965).

However, there are also many examples of damage caused by excess fluorine. In Iceland it is well known that volcanic eruptions have resulted in fluorine toxification. There are detailed reports on damage to the teeth of domestic animals after the Heklas eruption in 1963 (Palsson et al., 1980). In modern times many investigations have been conducted into the effects of volcanic activities in the environment and its effects on livestock, and recommendations on how to avoid fluorosis have been proposed.

Fluorine toxicity in livestock is common in the vicinity of Al factories where chimneys discharge F compounds resulting in extremely high F contents in plant material. This has made animal husbandry impossible in close proximity to Al factories (Ender, 1969; Flatla, 1972). As well as problems connected with animal husbandry, it has been shown that F compounds may also cause damage to game (Holt, 1978).

5. A comprehensive Finnish investigation into mineral elements in food and animal feed

In 1974 an investigation began in Finland to consider the relationships between the chemical composition of cultivated soils and crops ("Mineral elements ...", 1978). In the following year a large-scale investigation was started on the content of inorganic elements in Finnish food (Koivistoinen, 1980). The publications arising from these two studies comprise a large and important source of data.

Among other things, it is concluded that Finnish plant products and Finnish diet is deficient in Se. It is pointed out, for example, that the Ca/Mg ratio is high. In this connection it is important to remember the situation in Norway. As mentioned above, in inland areas of Norway, with a comparable climate to that of Finland, the Se content of natural soils is low and the Ca/Mg ration high. In coastal districts with ample precipitation, soil Se and Mg contents are much higher.

These Finnish investigations also point towards the health consequences of trace elements such as F, Mn, Fe, Cu and Zn in natural food material. Furthermore, the question has arisen whether the treatment and processing of food may interfere with the contents of Cr, Ni, Co and Pb.

6. Toxic effects of heavy metals

Many sheep die in Norway each year owing to Cu poisoning, though the sources of the metal have not been discovered. The discovery of natural Cu-poisoned soils may be of help in clarifying the cause of some of these cases. Copper toxicity in domestic animals may also be related to an extremely low supply of Mo, giving rise to a specific chemical interaction.

Sometimes Pb toxicity has occurred in domestic animals that have licked Pb objects or paint with a high Pb content. Until now there have been no proven cases of Pb toxicity in domestic animals related to natural Pb-poisoned soils. But in an experiment with rabbits fed on hay of *Deschampsia flexuosa* taken from a poisoned area, it was shown that after 4 weeks there was an accumulation of Pb in the liver, kidneys and bones (Låg and Bølviken, 1974).

High Mn contents in fodder are suspected of giving rise to sickness in domestic animals (see, for example, Svanberg, 1933).

Poisoning has also occurred as a result of mining, when watercourses are easily contaminated, resulting in fish death. Several heavy metals have a strong toxic effect on fish. Also, investigations in connection with acid precipitation have shown that increasing Al concentrations in waters are often the cause of fish death (Overrein *et al.*, 1980).

7. Possible harmful effects of agricultural chemicals

In agriculture, large quantities of chemicals are applied in the course of fertilizer and lime application and as a result of plant protection. The purpose in using these materials is to increase crop production. But in certain cases damage may arise.

Pesticides are used to protect plants against insects, various fungal diseases, etc., and weeds. Such chemicals may, however, have undesirable consequences. Examples include that of seed treated with certain Hg compounds that may have a harmful effect on seed-consuming birds, and again that the use of DDT has had more serious consequences than originally expected. In the Scandinavian countries a more restrictive attitude has been developed towards the use of pesticides.

Some commercial fertilizers may contain harmful elements; for example, P fertilizer usually has a small, though significant, Cd content. The chemical composition of plants is influenced by fertilizing. Besides the fact that the concentration in plant tissue usually rises owing to the fertilizer element, one element may also reduce the content of another. The natural nutrient balance may be changed by artificial fertilizers, and fertilizing with one or more nutrients over a long period of time may exhaust other nutrients in the soil.

As an example of the interference of fertilizer application on nutrient balance with possible geomedical consequences, the effects of K on plant Mg content may be mentioned. Heavy dressings with K may result in a lower plant Mg content, and so-called grass tetany may be related to such conditions (Ødelien, 1960).

Liming influences plant composition both through the change of soil pH and the enrichment of Ca in the soil. The availability of many minor nutrients is decreased after liming. Molybdenum is an exception, and uptake of this element is increased after liming the soil.

X. Conclusions: organizations, activities and future investigations

In 1971 in Norway an attempt was made to include a geomedical project in the MAB (Man and the biosphere) program, but without success. The Norwegian Academy of Science and Letters arranged, in co-operation with the other Scandinavian scientific academies, a geomedical symposium in 1978 (Låg, 1980). In a Finnish meeting "Mineral Elements 80", in December 1980, many problems of geomedical interest were discussed.

To continue the work started by the Scandinavian scientific academies a small committee with members from the five Scandinavian countries has been nominated. The intention is to make a literature survey and to prepare another symposium.

In Scandinavia, there are considerable variations in the soil chemical composition owing to variations in both climate and geology. In addition to factors of physical climate, it is now evident that the chemical composition of precipitation has an important influence on soil chemical conditions. In addition to well-known knowledge of I deficiency in dry inland areas, it is now obvious that the distribution of many other essential elements is dependent on climate.

Selenium and Mg are examples of elements that have recently received much attention. The relative content of these two elements in the surface layer of uncultivated soils is larger in coastal districts with high precipitation than in dry inland districts. Both human and veterinary medicine is concerned with Se and Mg supplies in relation to important diseases.

Variations in the amounts of elements such as Cd and Li seem to have a relationship with geological variations. Until now geographical patterns of diseases in Scandinavia related to these elements have not been proved with certainty, but interesting scientific questions have been raised.

The geographical distribution of minor elements in soils and plants has been studied intensively. However, important questions in this connection are still unsolved. The relationship between the availability of these elements to plants

on one side and the base saturation of the soils on the other are important problems. Partly it is a question of the effects of different soil pH conditions and partly the direct influence of Ca.

Interactions between different elements and their availability to plants are important in many connections. The chemical composition of plants can be influenced to a considerable degree by antagonism and synergism.

As in plants, metabolic processes in animal and man are influenced by the ratios between different elements or compounds. Medical problems can thus originate from an imbalance between different ingredients in nutrition.

Comprehensive analysis of the chemical composition of soils and plants forms a useful basis for geomedical research. Probably in the years ahead more information will be compiled in the Scandinavian countries. Likewise, analyses of water from different sources will be continued.

With time we hope to manage to obtain a more detailed understanding of the composition of diets in Scandinavia.

Veterinary research into problems of toxicity and deficiency of a geomedical character will be continued. In human medicine, intensive studies will probably be continued to try and find out if particular illnesses such as multiple sclerosis and certain cases of anaemia are geomedical problems. There are further comprehensive research programs into the cancer and cardiovascular diseases. Work initiated to try to find if there is any geomedical causes will be continued on a larger scale.

References

The author thanks Professor Sam Norfeldt, Sweden, for his help in the literature survey.

Aanestad, S. (1895). *Tidsskr. Det norske Landbrug* **2**, 339.
Batt, F. (1940). *Norsk Veterinaer-Tidsskr.* **52**, 89–98.
Bendixen, H. C. (1951). *Nordisk Jordbrugsforskning* **33**, 634–639.
Bisbjerg, B. (1972). "Studies on Selenium in Plants and Soils". Risø Report No. 200. Roskilde.
Bølviken, B. and Låg, J. (1977). *Appl. Earth Sci.* **86B**, 173–180.
Dynna, O. and Havre, G. N. (1963). *Acta Vet. Scand.* **4**, 197–208.
Ender, F. (1942). *Norsk Veterinaer-Tidsskr.* **54**, 3–27, 78–127, 137–158.
Ender, F. (1944). *Norsk Veterinaer-Tidsskr.* **56**, 173–186.
Ender, F. (1946). *Norsk Veterinaer-Tidsskr.* **58**, 118–143.
Ender, F. (1969). "Air Pollution Proceedings", pp. 245–254. Wageningen.
Ender, F. and Tananger, I. W. (1946). *Norsk Veterinaer-Tidsskr.* **57**, 313–331, 353–405.
Engdal, O. T. and Ulvesli, O. (1942). *Meld. Norges Landbrukshøgsk.* **22**, 535–590.
Esmark, J. (1823). *Magazin Naturvidenskaberne* **1**, 205–215.
Flatla, J. L. (1972). "Festskrift til ... Knut Breirem ...", pp. 37–50. Gjøvik.
Gissel-Nielsen, G. (1977). "Control of Selenium in Plants". Risø Report No. 370, Roskilde.
Goldschmidt, V. M. (1954). "Geochemistry", 730 pp. Oxford University Press, Oxford.
Haugbotn, O. (1976). *Meld. Norges Landbrukshøgsk.* **55** (8), 118 pp.
Holt, G. (1978). *In* "Symposium om økotoksikologi", 6–7 novbr, 1978, pp. 91–94. NAVF, NFFR, NLVF, NTNF. Ås.
Hvatum, O. O. (1971). *Tekn. ukeblad* **118**, 27, 40.
Johannessen, A. (1889). "Studier over Mavens Fysiologi og Patologi, Tuberkulose og Strumaets

Aeriologi", 71 pp. Kristiania.

Johannsson, O. (1959). *Lantbrukshögsk. Ann.* **25**, 57–169.

Jönson, G. and Pehrson, B. (1980). *In* "Geomedical Aspects of Present and Future Research" (Låg, J., ed.), pp. 115–122. Universitetsforlaget, Oslo.

Koivistoinen, P. (ed.) (1980). *Acta Agr. Scand. Suppl.* **22**, 171 pp.

Lindeqvist, J. (1856). "Optegnelser under en Landbrugsreise gjennom det sydlige Norge i Sommeren 1855", 28 pp. Christiania.

Lunde, G. (1928). *Biochem. Zeitschr.* **193**, 94–104.

Løken, A. (1912). *Norsk Veterinaer-Tidsskr.* **24**, 177–187.

Låg, J. (1963). *Forskn. forsøk landbruket* **14**, 553–563.

Låg, J. (1968). *Acta Agric. Scand.* **18**, 148–152.

Låg, J. (1972). *Acta Agric. Scand.* **22**, 150–152.

Låg, J. (1975). *Ny Jord* **62**, 47–59.

Låg, J. (1976). *Ny Jord* **63**, 4–6.

Låg, J. (1978a). *Acta Agric. Scand.* **28**, 97–100.

Låg, J. (1978b). *In* "Eleventh Congress International Society of Soil Science", Vol. 1, pp. 227–228. Edmonton.

Låg, J. (1978c). *Norsk Veterinaer-Tidsskr.* **90**, 621–627.

Låg, J. (ed.) (1980). "Geomedical Aspects in Present and Future Research", 226 pp. Universitetsforlaget, Oslo.

Låg, J. and Bølviken, B. (1974). *Norges Geol. Unders.* **304**, 73–96.

Låg, J. and Steinnes, E. (1974). *Ambio* **3**, 237–238.

Låg, J. and Steinnes, E. (1976). *Geoderma* **16**, 317–325.

Låg, J. and Steinnes, E. (1977). *Acta Agric. Scand.* **27**, 265–268.

Låg, J. and Steinnes, E. (1978). *Geoderma* **20**, 3–14.

Låg, J., Hvatum, O. Ø. and Bølviken, B. (1970). *Norges Geol. Unders.* **266**, 141–159.

Mikkelsen, T. and Hansen, M. Aas (1967). *Nordisk Veterinaer Medicin* **19**, 393–410.

Mikkelsen, T. and Hansen, M. Aas (1968). *Nordisk Veterinaer Medicin* **20**, 402–419.

"Mineral Elements in Finnish Crops and Cultivated Soils" (1978). *Acta Agric. Scand. Suppl.* **20**, 113 pp.

Møller, I. J. (1965). "Dental Fluorose og Caries", 288 pp. Rhodos, Copenhagen.

Overrein, L. N., Seip, H. M. and Tollan, A. (1980). "Acid Precipitation—Effects on Forest and Fish", 175 pp. Final report of the SNSF-project 1972–1980, Oslo.

Palsson, P. A., Georgsson, G. and Petursson, G. (1980). *In* "Geomedical Aspects in Present and Future Research" (Låg, J., ed.), pp. 123–132. Universitetsforlaget, Oslo.

Rimpau, W. (1934). *Munch. med. Wochr.* **25**, 940–943.

Rühling, A. and Tyler, G. (1973). *Water, Air Soil Pollut.* **2**, 445–455.

Sande, E. (1937). *Norsk Landbruk* **3**, 144–145.

Schalin, G. (1980). *In* "Geomedical Aspects in Present and Future Research" (Låg, J., ed.), pp. 81–102. Universitetsforlaget, Oslo.

Scheinin, A., Kalijarvi, E., Harjola, O. and Heikkinen, K. (1964). *Acta Odont. Scand.* **22**, 229–254.

Sellman, S., Syrrist, A. and Gustafson, G. (1957). *Scand. J. Dental Res.* **65**, 61–93.

Sippola, J. and Tares, T. (1978). *Acta Agric. Scand. Suppl.* **20**, 11–25.

Steinnes, E. (1980). *In* "Geomedical Aspects in Present and Future Research" (Låg, J., ed.), pp. 217–222. Universitetsforlaget, Oslo.

Svanberg, O. (1932). *Kungl. Lantbr.-Ak. handl. och tidsskr.* **71**, 660–716.

Svanberg, O. (1933). *Lantbrukshögsk. Ann.* **1**, 209–250.

Svanberg, O. and Ekman, P. (1949). *Kungl. Lantbr. högsk. Ann.* **16**, 558–567.

Svanberg, O. and Nydahl, F. (1941). *Kungl. Lantbr.-Ak. Tidsskr.* **80**, 457–480.

Tuff, P. (1922). "Osteomalacie hos Storfe. Vol. 2. Nordiska Veterinärmötet i Stockholm 1921", pp. 405–431. Förhandlingar.

Underwood, E. J. (1971). "Trace Elements in Human and Animal Nutrition". Academic Press, New York and London.

Vogt, J. H. L. (1888). *Arch. Math. Naturvidenskab* **12**, 1–101.

Zeiss, H. (1931). *Münch. M. Wschr.* No. 5, 198 ff.

Ødelien, M. (1960). *Tidsskr. Det norske Landbruk* **67**, 353–371.

12

Assessment of Metal Pollution
in Soils

S. V. MATTIGOD and A. L. PAGE

I. Introduction

Soils are unconsolidated materials at the earth's surface, whose properties are
governed by the nature of the parent material, climate, landscape and biota all
acting through time. Soils are heterogeneous, open, dynamic systems that are
comprised of solid, liquid and gaseous phases. Soil systems continually
exchange matter and energy and thus reflect the physical, chemical and
biological environments in which they occur. The physical, chemical and
biological properties are related through a complex web of interactions and, as
such, any changes in a single property will cause varying degrees of changes
among all properties. Therefore, mass transfers through addition of elements
including metals to soil systems will not only change the chemical properties
but will also influence physical and biological properties.

The presence and/or additions of certain metals to soils at levels that would
have deleterious effects on organisms can be considered to constitute metal
pollution. This broad definition includes two categories of harmful effects. In
the first category, the concentrations of metals in soils may not affect the
growth of vegetation but would constitute a health threat to higher organisms
in the food chain that consume the vegetation. The second category would be
concentrations of metals in soils that would diminish the growth of vegetation
(phytotoxic levels). Soils serve as a medium through which groundwaters are
recharged and any constituent added to soil that may adversely affect the
beneficial use of groundwater also constitutes metal pollution. Therefore, the
term "metal pollution of soils" encompasses all categories of harmful effects.

APPLIED ENVIRONMENTAL GEOCHEMISTRY
ISBN 0-12-690640-8

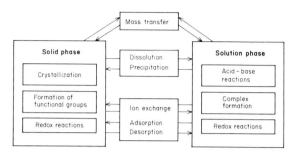

Fig. 12.1 Types of interactions within and between solid and solution phases in soil systems.

Metals that are initially present in soils are distributed between the solid, solution and gaseous phases. The gaseous forms of metals in soil air constitute a minor part of total metal that is present in a soil system. There are several types of chemical interactions that influence the partitioning of metals between solid and liquid phases (see Chapter 5). Metal complexation with various organic and inorganic ligands, oxidation–reduction reactions, ion exchange–adsorption reactions, and dissolution–precipitation of solid phases along with mass transfer continually dictate the quantities and concentrations of metals in each phase. These complex interactions are the principal controls on mobility and bioavailability of metals in soil systems. Figure 12.1 indicates the interrelationships between the various types of interactions.

Traditionally, assessment of metal pollution of soils has relied on measurements of total metal in soil systems, determination of solution concentrations, evaluation of the adsorbed and exchangeable parts of the total concentrations and metal concentrations obtained through the use of various selective extractants. These parameters have been used in deriving correlative and regressive relationships with mobility and bioavailability. Recent advances in computer modelling of metal equilibria (discussed in Chapter 5) have provided a useful adjunct tool to better and more conveniently assess the solution by considering the detailed speciation chemistry resulting from the interactions represented schematically in Fig. 12.1.

Generally, metals as a group, if present at elevated concentration in soils constitute a major potential problem of pollution, however, certain metalloids (B, As) and non-metals (Se) may also present a similar pollution threat if present at enhanced concentrations. Therefore, it is appropriate to include these three elements in this discussion that focuses mainly on pollution of soils by metallic elements.

This chapter, in addition to providing a brief survey of some anthropogenic inputs of metals into soils, will provide a few examples of computer modelling as applied to assessing metal pollution in soils.

Table 12.1 Metal contents of parent materials and soils*

Element	Basalt[a]	Soil[a]	Andesite[b]	Soil[b] (bauxite)
Al	6.00%	10.40%	9.37%	28.97%
Fe	8.00%	10.30%	5.76%	6.96%
Ti	1.95%	1.20%	1.09%	1.48%
Co	59	81	65	21
Cr	170	160	75	260
Mn	1200	1300	700	310
Ni	200	300	140	50
Sr	1200	36	720	~100

* All concentrations are in μg g^{-1} except as noted.
[a] Data from Navrot and Singer (1976).
[b] Data from Wolfenden (1965).

II. Sources and types of metal pollution

1. Metal concentrations under natural conditions

The metal contents of soils are the result of soil-forming factors acting through time. Among these, the principal factor that dictates the metal content of a soil is the composition of parent material. Several studies indicate the relationship that exists between the metal contents of parent materials and soils that develop during *in situ* weathering. Table 12.1 compares the metal concentrations of soils to those of the parent materials from which they formed. Weathering of basalt has occurred under humid Mediterranean climate, whereas andesite has been subjected to more intense weathering under tropical conditions. Elemental compositions (Table 12.1) indicate that, among major metals, Al, Fe and Ti remain at or near the site of weathering and thus are enriched in soils, whereas Sr shows depletion. Cobalt and Ni are slightly enriched in basaltic soil, but depleted in bauxitic soil. There is no change in Cr content of basaltic soil in contrast to significant enrichment in bauxitic soil.

Enrichment or depletion of metallic elements in soils can be examined within the framework of relative mobilities of metals under weathering conditions. Table 12.2 based on the work of Andrew-Jones (1968) lists the relative mobilities of certain metallic elements under differing electron and proton activity conditions. The metallic elements included in the table are either essential plant nutrients or metallic elements that can accumulate in plants and pose a hazard to consuming organisms and/or be phytotoxic.

Data presented in Table 12.2 show that alkali and alkaline earth elements have high mobility under all conditions in the weathering environment. These metals, therefore, would be depleted in soils relative to parent material. Iron,

Table 12.2 Relative mobilities of metals in the weathering environment (based on Andrew-Jones, 1968)

| | Weathering conditions | | | |
| | Electron activity | | Proton activity | |
Relative mobilities	Oxidizing	Reducing	Acid	Neutral to alkaline
High	Mo, V, U, Ca, Na, Mg, Sr, Zn	Ca, Na, Mg, Sr	V, U, Ca, Na, Mg, Sr, Zn, Co, Cu, Ni, Hg	Mo, Ca, Na, Mg, Sr
Medium	Ca, Co, Ni, Hg, Cd	—	Cd	Cd
Low	K, Pb	K, Fe, Mn	K, Pb, Fe, Mn	K, Pb, Fe, Mn
Very low to "immobile"	Fe, Mn, Al, Cr	Al, Cr, Mo, V, Zn, Co, Cu, Ni, Hg, Cd, Pb	Al, Cr	Al, Cr, Zn, Cu, Co, Ni, Hg

Mn, Al, Cr and Pb have low to very low mobilities and thus would be enriched in soils. Elements in the first transition metal series, V, Co, Ni, Cu and Zn, have varying mobilities that depend on particular weathering conditions. These metals have high mobilities under acid conditions and, due to formation of sparingly soluble metal sulphides, very low mobilities under reducing conditions. Therefore, transition metals in soils can either be enriched or depleted relative to parent material depending on the dominant factors that exist in the weathering environment.

Distribution of metals in soil profiles is controlled by pedogenic processes in conjunction with elemental cycling by plants. These processes generally bring about differences in metal concentrations in various soil horizons. A good example of heterogeneous metal distribution in a highly weathered soil profile from Rhodesia (Hawkes and Webb, 1962) is shown in Fig. 12.2. The oxisol profile shows that the upper part of the B horizon is enriched in Cu, Cr, V, Mn and Fe. Elemental cycling by vegetation can also bring about metal accumulation in upper parts of A horizons (Hawkes and Webb, 1962).

Typical ranges of metal concentrations found in soils are illustrated in Fig. 12.3. These data based on the compilation of Bowen (1979) exclude soils that are near ore bodies and those that have been contaminated which show wider ranges for the trace metals than major metallic elements. Potentially toxic

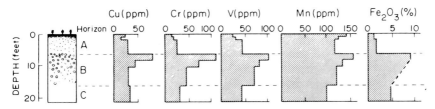

Fig. 12.2 Heterogeneous metal distribution in an oxisol from Rhodesia (after Hawkes and Webb, 1962).

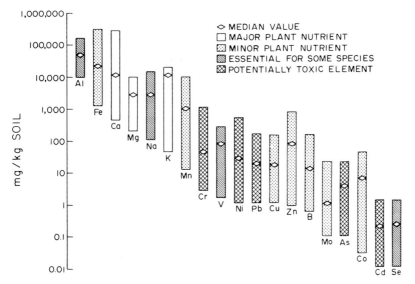

Fig. 12.3 Ranges and median values of metal concentrations found in uncontaminated soils (data from Bowen, 1979).

metals such as Cr, Ni and Cd have ranges that extend over orders of magnitude.

Soils under natural conditions may contain concentrations of certain metals at phytotoxic levels. Saline soils contain sufficient levels of soluble sulfate, bicarbonate, and chloride salts of Na, Ca and Mg to depress the growth of sensitive plants. Salinization of soils under natural conditions can be due to *in situ* weathering of parent materials, intrusion of saline waters and aeolian salt transport and accumulation. Natural occurrences of saline soils are common in arid and semi-arid regions throughout the world.

Elevated concentrations of many heavy metals can occur naturally in soils. Such occurrences of phytotoxic levels of heavy metals in soils constitute natural cases of metal pollution. High concentrations of heavy metals in soils

Table 12.3 Norwegian soils with presumed phytotoxic levels of lead and copper $(\mu g \ g^{-1})$*

Area	Cd	Cu	Ni	Pb	Zn
Snertingdal	0.9	15	12	24 500	44
Gala	0.7	6	9	6400	40
Skavern	0.9	126	37	97 000	416
Krokvann	1.8	260	48	10 400	860
Hjerkin	1.3	785	18	57	232
Karasjok	0.6	7400	32	18	36

* Concentrations in surface soils (2–5 cm) based on data from Låg and Bølviken (1974).

can be either due to parent materials that are ore bodies or due to secondary dispersion. Soils from Norway that are highly contaminated with heavy metals under natural conditions have been reported by Låg and Bølviken (1974) (see Chapter 11). These soils contain presumed phytotoxic levels of Pb and Cu. Table 12.3 lists the concentrations of Cd, Cu, Ni, Pb and Zn found in surface soils (2–5 cm) of six different regions in Norway. According to Låg and Bølviken (1974), various degrees of phytotoxicity were observed due to high concentrations of Pb in soils from Snertingdal, Gala, Skavern and Krokvann. Phytotoxicities due to abnormally high concentrations of copper were evident in soils from Hjerkin and Karasjok.

Levels of a non-metal, Se, in soils sufficiently high to produce forage unsafe for animal consumption occur in a number of regions throughout the world. Walsh *et al.* (1951) reported Se concentrations in forage of 150 to 500 $\mu g \ g^{-1}$ Se when grown on soils with Se concentrations which ranged from 30 to 324 $\mu g \ g^{-1}$. Livestock from the area were suffering from acute Se toxicity.

There are several naturally occurring radionuclides of metals (see Chapter 16). Enhanced presence of these radioactive metals in soils constitutes natural cases of metal pollution. The bulk of the natural radioactivity is attributable to ^{40}K and ^{87}Rb with detected radiation levels of 0.2–1200 and 20–560 becquerels kg^{-1} (Bq kg^{-1}) respectively (Bowen, 1979). Other radioactive metal species such as ^{210}Pb, ^{230}Th, ^{232}Th, ^{234}U and ^{238}U generally account for less than 1% of total activity. A soil sample from a B-horizon developing on granite has been reported to contain ^{230}Th, ^{210}Pb and ^{238}U at anomalous activities of 16 280, 6290 and 3330 Bq kg^{-1}, respectively (Megumi and Mamuro, 1977). Unusually high radioactivity of 25 920 Bq kg^{-1} in volcanic ash soils of Nine Island in the Pacific that is ninety times that of average activity (~ 290 Bq kg^{-1}) in soils has been reported by Marsden (1959). Elevated activities of radionuclides that constitute pollution of soils can be expected near ore bodies such as the Oklo reactor in Gabon. This natural extinct fission nuclear reactor was operative about 1.8 billion years ago from

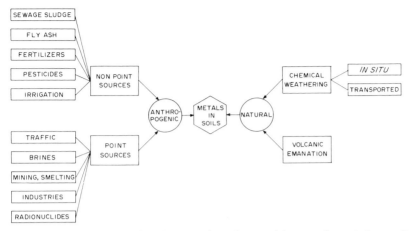

Fig. 12.4 Diverse sources of anthropogenic and natural inputs of metals into soils.

naturally enriched deposits of U. At present this reactor site contains fission products and actinides that have been enriched due to weathering (Bryant *et al.*, 1976).

2. Anthropogenic metal additions

Anthropogenic metal inputs due to industrial activities are a major source of metal pollution of soils. Unless strict emission control is implemented, industrial activities such as mining, smelting and refining can result in widespread dispersal of metals throughout the environment. Metal pollution of soils is a result of both deliberate as well as accidental inputs from human activities. Figure 12.4 schematically indicates various categories of anthropogenic metal inputs into soils. It is seen that those brought about by human activities are much more diverse and complex in comparison to natural metal pollution. The compositions, quantities and the modes of these inputs vary widely and thus influence the metal behaviour in affected soils. Anthropogenic metal inputs can be broadly classified as point or non-point sources. The point sources are those that are in the vicinity of metal-polluted soils and thus traceable as a source of pollution. The metal inputs into soils from both point and non-point sources can be widespread and can occur at considerable distances from the sources. Also, the metal inputs from non-point sources are due to deliberate application of wastes, fertilizers, pesticides, etc., whereas, metal inputs from point sources are usually unintentional.

Metal contents of wastes and other inputs can provide a clue to the magnitude of metal pollution that can be expected in recipient soils. Several sources that form major input sources of metals into soils are examined below.

Table 12.4 Range of metal concentrations ($\mu g\ g^{-1}$) in sewage sludge and soils

Metal	Sewage sludge[a]	Soils[b]
Cd	1–3410	0.01–2
Co	2–260	0.05–65
Cr	Trace–99 000	5–1500
Cu	52–17 000	2–250
Hg	0.6–56	0.01–0.5
Mn	32–9870	20–10 000
Mo	Trace–1000	0.1–40
Ni	2–8000	2–750
Pb	13–26 000	2–300
V	15–400	3–500
Zn	72–50 000	1–900
B	4–1000	2–270
As	1.1–230	0.1–40

[a] Berrow and Weber (1972), Berggren and Oden (1972), Blakeslee (1973), Miller *et al.* (1979), Torrey (1979), Chaney (1980).
[b] Bowen (1979).

(a) *Non-point sources*

(i) *Sewage sludge.* Sewage sludge is solid waste that results from treatment of urban and industrial waste waters. Disposal of sewage sludge on agricultural lands has been in practice on a limited scale for several decades. Such use has been encouraged due to the fertilizing and soil conditioning value of those materials. One of the potential problems of such sewage sludge disposal on land is the accumulation of toxic concentrations of heavy metals in soils. Typical ranges of concentrations of heavy metals that are encountered in sewage sludges are listed in Table 12.4. In comparison with ranges of metal concentrations in uncontaminated soils, sewage sludges may contain extremely high concentrations of various metals. Therefore, long-term application poses a problem of pollution.

Metal concentrations in sewage sludges are governed by two important factors, the nature and the intensity of industrial activity as well as the type of sewage treatment process employed. Detailed discussion of sources and types of metal contribution to sewage can be found in a report by Page (1974). Effects of various treatment procedures on metal concentrations in sewage sludges have been compiled by Torrey (1979).

Metal contents of sewage sludges have also been evaluated by organic acid or saturation extractions (Page, 1974). It has been noted that maximum amounts of metals extracted from sewage sludges are considerably greater than maximum amounts extracted from soils.

Based on sewage sludge applications at agronomic rates, metal uptake by higher plants from sewage sludge-treated soils and the chemistry of heavy metals, the metals in sewage sludges have been classified into low-hazard and serious-hazard categories (CAST, 1976). Manganese, Fe, Al, Cr, Pb and Hg are considered to be low-hazard metals. Cadmium, Cu, Mo, Ni and Zn are considered to be potentially deleterious metals.

(ii) *Fly ash.* It is estimated that the combustion of fossil fuels would mobilize quantities of various metals into the environment that are comparable to those originating from major sedimentary cycles (Bertine and Goldberg, 1971). Fly ash (also known as precipitator ash) usually amounts to 70% of the total ash residue produced in power plants. Barely 10% of the total ash produced in the US is being recycled (Brackett, 1973). Therefore, large quantities of fly ash have to be disposed of on land. Chemical and physical characteristics of fly ash are principal factors in determining the potential for metal pollution of soils that receive those wastes.

Ranges of metal concentrations that are found in fly ash in comparison with ranges of metal concentrations in soils are listed in Table 12.5.

Table 12.5 Range of metal concentrations ($\mu g\ g^{-1}$) in fly ash and soils

Metal	Fly ash[a]	Soils[b]
Al	1000–173 000	10 000–300 000
Fe	10 000–290 000	2000–550 000
Ca	1100–220 000	700–500 000
Mg	400–76 000	400–9000
Na	100–20 300	150–25 000
K	1500–35 000	80–37 000
Mn	58–3000	20–10 000
Cr	10–1000	5–1500
V	50–5000	3–500
Ni	6.3–4300	2–750
Pb	3.1–5000	2–300
Cu	14–2800	2–250
Zn	10–3500	1–900
Mo	7–160	0.1–40
Co	7–520	0.05–65
Cd	0.7–130	0.01–2
Se	0.2–134	0.01–2
B	10–618	2–270
As	2–6300	0.1–40

[a] Page *et al.* (1979).
[b] Bowen (1979).

It is observed that the maximum concentrations of heavy metals such as V, Ni, Pb, Cu, Zn, Mo, Co, Cd, metalloids, B and As, and non-metal Se encountered in fly ash significantly exceed the maximum concentrations of the same metals in uncontaminated soils. Therefore, potential for soil pollution from these elements exists when fly ash with high metal concentrations is disposed of on land.

Metal concentrations in fly ash show a size-dependent distribution. It has been noted that Cd, Cu, Mo, Pb and Zn tend to increase in concentration with decreasing particle size (Lee and Von Lehmden, 1973; Davison et al., 1974; Klein et al., 1975; Kaakinen et al., 1975; Natusch, 1975; Ondov et al., 1976). In addition, metals may also show a distinct density distribution. Recent analyses of a sample of size-density separated fly ash derived from combustion of subbituminous coal from Western US has shown that metals Al, K, Na and Hg tend to be concentrated in light density fractions, whereas Ca, Mg, Fe, Mn, Co, Cr, V and Zn tend to concentrate in heavier density fractions (Mattigod, unpublished data).

Metal speciation in fly ash has also been studied by several researchers (Simons and Jeffrey, 1960; Watt and Thorne, 1965; Brzakovic, 1970; Plank, 1974; Natusch et al., 1975; Mattigod, 1980). These studies indicate that Al is mainly in the form of mullite, Mg is present predominantly as MgO, Ca is present as CaO, anhydrite and calcium ferrites. Titanium is present as rutile, Zr as zircon, and Ba as barite. Iron is present as magnetite, haematite and calcium ferrites. Sodium and K may be associated with the glassy material (Mattigod, 1980). At present, there are no data regarding speciation of other metals that are present in minor quantities in fly ash.

Sodium, Ca, Mg and B are easily mobilized from fly ash–soil mixtures (Page et al., 1979). Substantial increases in soil salinity and alkalinity may occur when unweathered fly ash is disposed of on land (Mulford and Martens, 1971; Elseewi et al., 1978; Phung et al., 1978; Adriano et al., 1978; Page et al., 1979).

Elemental enrichment studies on plants grown on soils subjected to fly ash additions have shown high enrichment rates for Se, and significant accumulations of Mo, B, Ba and As (Adriano et al., 1980).

It is known that fly ash addition to soils can enhance the availability of essential plant nutrients such as Ca, Mg, Mo and B and also reduce soil acidity (Adriano et al., 1980). Despite these beneficial effects, disposal of fly ash on land in large quantities poses a potential for metal pollution of soils.

(iii) *Fertilizers.* Other potential sources of metal pollution of soils are the enormous quantities of chemical fertilizers and soil amendments that are added to arable soils and grasslands. It is known that fertilizers and other soil additives contain many trace metals in significant concentrations (Swaine, 1962). The presence of trace metals in fertilizers is dependent on the

Table 12.6 Range of concentrations (μg g^{-1}) of trace metals in fertilizers, limestones and soils*

Metal	Fertilizers				Limestone	Soils
	N	P	K	Mixed		
Cd	—	1–200	tr–0.1	—	tr–13	0.01–2
Co	tr–6	tr–13	—	tr–13	tr–130	0.05–65
Cr	tr–50	tr–1000	tr–1000	tr–900	tr–300	5–1500
Cu	tr–800	tr–3000	tr–3000	tr–800	tr–10 500	2–250
Mn	tr–3000	tr–2840	tr–10 000	tr–10 000	tr–9300	20–10 000
Mo	tr–1.7	<1–30	tr–100	tr–15	tr–85	0.1–40
Ni	tr–80	tr–300	tr–80	tr–800	tr–130	2–750
Pb	tr–800	tr–80	tr–50	tr–200	tr–200	2–300
V	tr–50	tr–3900	tr–50	tr–2100	tr–3000	3–500
Zn	tr–800	tr–2400	tr–50	0.4–2530	tr–700	1–900
As	tr–3000	tr–1490	tr–400	tr–1100	tr–20	0.1–40
B	tr–1360	tr–1000	tr–900	tr–4200	tr–6000	2–270
Se	15–36	0.8–25	<0.5	—	tr–14	0.1–2

* Boawn *et al.* (1954), Runnels and Schleicher (1956), Clark and Hill (1958), Swaine (1962) and Bowen (1979).

concentrations of these metals in source ores and also on the gains and losses that occur during the manufacturing process (Clark and Hill, 1958).

Ranges of trace metal concentrations found in nitrogen, phosphate, potassium, mixed fertilizers and limestone are listed in Table 12.6. Maximum concentrations of Cd, Cu, V, Zn, As, B and Se in some types of fertilizers clearly exceed the range of concentrations of these elements in soils. Therefore, accumulation of these elements can be expected in agricultural soils that are subjected to additions of chemical fertilizers. In particular, among non-nutrient heavy metals, Cd concentrations in phosphatic fertilizers exceed by orders of magnitude, the background levels found in soils. Therefore, several studies have focused on Cd accumulations in soils subjected to additions of phosphate fertilizers. Accumulations of this potentially toxic metal in plants grown on these soils have also been studied. Five- to twelve-fold increases in Cd content in the upper 10 cm of soil were recorded by Williams and David (1973, 1976). Recently, Mulla *et al.* (1980) reported a fourteen-fold enhancement of Cd in surface soils that had been subjected to heavy applications (1975 kg P ha^{-1} yr^{-1}) of triple superphosphate over a period of 36 years. Saturation extracts from these soils had Cd concentrations twice those found in untreated soils. Swiss chard grown on Cd-rich soils had approximately six times more Cd in tissues in comparison to plants growing on control soils (Mulla *et al.*, 1980).

Soil amendments such as metallurgical slags have very high concentrations of Co, Cr, Cu, Ni, Pb and Zn (Swaine, 1962). Use of these slags clearly poses a potential metal pollution problem.

Amendments such as limestone are widely used on agricultural soils. Concentrations of Cd, Co, Cu, Mo and V from limestones can exceed the background levels found in soils (Table 12.6). Enhancement of these metals can be expected in soils that are repeatedly amended with trace metal-rich limestones. At present, there appears to be scant data regarding metal pollution of soils from this source.

Fertilizers are also sources of additions of radionuclides of metals into soils. Potassium and phosphate fertilizers are known to contain radionuclides, ^{40}K, ^{238}U, ^{232}Th and ^{226}Ra. It is estimated that approximately 2.5×10^{13} Bq ^{226}Ra is added to soils every year through phosphate fertilizer additions.

Estimates of enhancement in radioactivity of soils can be made from annual rates of consumption of fertilizers. The current rate of world consumption of phosphate fertilizers is estimated at 26.5×10^6 metric tonnes yr^{-1} (Kurian, 1979). Assuming that the average radioactivity of phosphate fertilizers is the same as that of phosphate rock (5.27 Bq g^{-1}; Marsden, 1959) and that 90% of applied fertilizer remains in soils, a total of 1.3×10^{14} Bq of radioactivity is added to soils every year. Similarly, based on annual consumption of 23.06 $\times 10^6$ metric tonnes of potassium fertilizers, and that an average 30% of added K remains in plow depth after plant removal and leaching, 2.2×10^{14} Bq of residual radioactivity due to ^{40}K accumulates in soils. The average increase in radioactivity of arable soils through phosphate and K fertilizer additions can therefore be estimated at 1.6×10^{-4} Bq g^{-1}, within a plough depth of 15 cm (average bulk density 1.2 g cm^{-3}). Compared with the average natural radioactivity of soils (0.029 Bq g^{-1}; Marsden, 1959), addition of fertilizers enhances radioactivity by approximately 0.6% per year. Such enhancement in soil radioactivity is estimated to be orders of magnitude smaller than the enhancement through anthropogenic input of artificial radionuclides from nuclear fission (Bowen, 1979). However, estimates by Bowen (1979) indicated that soils in Britain receive more radioactivity per year through fertilizer additions than from fallout of fission products.

(iv) *Pesticides*. Inorganic pesticides are also a source of metal contamination of soils, as they are mainly derivatives of Cu, Hg, Pb, Mn and Zn. Repeated applications of these pesticides could lead to metal enhancement and pollution of soils. Soils in apple orchards with Cu concentrations exceeding 1500 ppm have been reported (Hirst et al., 1961). Surface soils in old vineyards subjected to Cu pesticide applications contained Cu concentrations up to 845 ppm (Delas et al., 1960). Mercury concentrations exceeding 2 ppm have been reported in wheat-growing soils (Sand et al., 1971). Soils in orchards subjected

to Pb arsenical sprays were reported to contain Pb concentrations ranging from 87.5 to 405 ppm (Jones and Hatch, 1945). These authors reported that eight different plant species grown for three years on Pb contaminated soils contained enhanced Pb levels in tissues. Reported Pb enhancement ratios for these plants were 1.2 for tops, 1.6 for edible parts and 3.1 for roots.

At present, inputs of inorganic pesticides into the soil environment are small and continuing to decrease (Bowen, 1979). However, no ameliorative means are available at present to reduce metal concentrations in soils that have been contaminated.

(v) *Irrigation.* Irrigation of arid and semi-arid soils poses a potential hazard of salinization. Inadequate drainage, dissolved constituents in irrigation waters, and weathering of soil minerals all contribute towards salinization of arid and semi-arid zone soils that are brought under irrigation. Various salts of metals such as Na, Ca and Mg accumulate in high concentrations in saline soils. This type of metal pollution, induces reduction in plant growth and yield through three different mechanisms. Reduced water availability to plants through osmotic effects, uptake and accumulation of toxic levels of certain metals and non-metals in plants, and nutrient imbalances are recognized to be the major detrimental effects of salinization.

The metals in saline soils are likely to exist as carbonate, bicarbonate, hydroxycarbonates, chlorides, sulphates, nitrates and occasionally iodates (Doner and Lynn, 1977). Metal pollution through irrigation is one of the aspects of secondary salinization that is considered a major problem in many parts of the world. Ameliorative methods are available to reduce salinity problems which are based mainly on improved drainage and leaching of excess salts.

(b) Point sources

(i) *Traffic.* It is widely recognized that soils adjacent to highways have enhanced Pb concentrations. Emission of Pb compounds by vehicles that use fuels with Pb additives is the source of such contamination. There are innumerable studies listed by Nriagu (1978) that indicate that Pb concentrations of soils near highways are high and decline exponentially as a function of distance from the highways. Lead content of urban soils is reported to range from 25 to 2985 μg g^{-1} (Ward et al., 1974; Nriagu, 1978). However, concentrations as high as 8000 μg g^{-1} have been measured (Bashirova, 1966). Meteorological factors, vegetation, topography and traffic intensity are major factors that influence Pb concentrations in roadside soils. Accumulations of Pb in urban soils over a period of 40 years have been reported by Page and Ganje (1970). This study indicated that no Pb accumulations were detected

where traffic density was 80 vehicles per square mile, whereas Pb concentrations in surface (2.5 cm) soils were enhanced by a factor of two or three where traffic density exceeded 580 vehicles per square mile.

Several studies listed by Nriagu (1978) indicate that Pb accumulations occur mainly in the top 10 cm layer of soils and that Pb in these soils resides in immobile forms. This is confirmed by a study (Olson and Skogerboe, 1975) that reported frequent occurrences of anglesite ($PbSO_4$) as the major Pb component in Pb contaminated roadside soils. Minor components such as PbO and lanarkite (Pb_2OSO_4) were also identified in these soils.

Other modes of transportation such as trains and aircraft may also contribute towards Pb contamination of soils. However, the extent of Pb contamination from these sources has not been clearly assessed (Nriagu, 1978).

Contamination of roadside soils by Cd, Ni and Zn due to automobile traffic has been reported by Lagerwerff and Specht (1970). Presence of Zn and Cd in motor oils and tyres was suggested as a source.

(ii) *Geothermal brines.* Owing to high concentrations of dissolved metals, geothermal brines are potential sources of metal contamination of soils. After recovering heat for power generation, the brines are either reinjected into wells or disposed of in holding ponds. Accidental spills and leakage from these holding ponds can bring about metal contamination of surrounding soils. One of the world's known geothermal fields is located in the Imperial Valley, California, in the USA. The environmental impact that includes potential metal contamination of soils due to the development of this geothermal source is being studied extensively (Phelps and Anspaugh, 1976). In the affected areas in this region, metal contamination of soils could have adverse impact on agriculture. Ranges of metal concentrations typically encountered in geothermal brines of this area are listed in Table 12.7. Some of the world's most concentrated brines occur in this area (Ellis, 1979). These brines are mainly chloride brines of Na and Ca. Some of these metal-rich brines are ore-forming fluids (White, 1968) that contain very high concentrations of Fe, Mn, Pb, Zn, Ba and B. Contamination with brines can be expected to increase soil salinity and concentrations of heavy metals in surrounding soils. Geothermal brines that contain high concentrations of B pose additional hazards due to the phytotoxic nature of this element.

(iii) *Mining and smelting.* It is estimated that the current rates of mining equal or exceed natural rates of cycling for a number of metals (Bowen, 1979). For heavy metals such as Cd, Cr, Cu, Hg, Mn, Pb and Zn the rates of mobilization from mining are estimated to exceed by a factor of ten or more the rates of mobilization from natural cycling. One of the consequences of such human activity is pollution or prospects of contamination of proximate soils. Detailed

Table 12.7 Metal concentrations in geothermal brines from Imperial Valley, California*

Metal	Range (μg g^{-1})
Na	610–58 440
K	70–23 800
Ca	9–40 000
Mg	<0.05–740
Ba	0.15–1100
Sr	2.10–448
Co	<0.0005–<0.01
Cd	<0.0005–2
Cu	<0.1–8
Fe	<0.1–2290
Mn	<0.05–1400
Ni	<0.1–4
Pb	<0.5–102
Zn	<0.01–600
B	4–498
As	0.025–12

* White (1968), Phelps and Anspaugh (1976) and Ellis (1979).

discussion regarding metal contamination from mining and smelting is provided in Chapter 13.

Geochemical reconnaissance surveys are useful in identifying mineralized regions as well as regions of soil contamination (Webb et al., 1978). Detailed surveys in the UK have revealed the extent of metal contamination of soils due to mining activity (Colburn et al., 1975; Colburn and Thornton, 1978). Agricultural soils in the Tamar mining area in England are known to contain up to 2000 μg g^{-1} Cu and 2500 μg g^{-1} As (Colburn et al., 1975). Contamination of soils in England with Pb in concentrations ranging from several hundred to several thousand μg g^{-1} with peak values up to 1% have been reported in Derbyshire (Colburn and Thornton, 1978), in the Tamar Valley (Colburn et al., 1975) and in Wales (Alloway and Davies, 1971).

Metal concentrations in soils from Shipham, UK, that have been contaminated by mining activity are compared with baseline level of metals found in surrounding soils (Table 12.8). These soils developing on dolomitic conglomerate show enhanced concentrations of several heavy metals. One sample of contaminated top soil showed a 30-fold increase in Mo, a 20-fold increase in Ba and a 4-fold increase in Pb over background levels. Generally, metal contamination through mining activity is confined to the top 15 cm of soils. A useful index to assess such contamination is the relative topsoil

Table 12.8 Metal concentrations* in soils affected by mining activity

Metal	Contaminated[a] Top soil 0–15 cm	Subsoil 15–30 cm	Proximate soil[a] Top soil 0–15 cm
Ca	7.09%	9.31%	0.36%
Mg	1.78%	2.56%	0.41%
K	1.61%	2.42%	2.11%
Fe	6.67%	3.57%	5.80%
Zn	6.02%	4.47%	0.67%
Al	1.51%	1.56%	2.99%
Na	521	581	2320
Ba	4960	2900	750
Mn	2655	2305	5935
Cu	68	43	42
Cd	578	423	29
Pb	8100	7230	1825
Mo	30	9	trace

* Concentrations in $\mu g\ g^{-1}$, except where indicated.
[a] Wrington Series from Shipham, UK. Proximate soil contains baseline metal levels.

enhancement (RTE), a ratio of total metal concentrations in top soil (0–15 cm) to that found in subsoil (15–45 cm) (Colburn and Thornton, 1978). RTE for a Shipham soil sample ranged from 1.1 for Pb to 3.3 for Mo. The RTEs for Pb in contaminated soils in the UK are known to range from 1.2 to 4 (Colburn and Thornton, 1978).

There is extensive documentation of metal contamination of soils near smelting operations (Canney, 1959; Marten and Hammond, 1966; Goodman and Roberts, 1971; Bolter et al., 1972; Burkitt et al., 1972; Lagerwerff et al., 1972; Little and Martin, 1972; Miesch and Huffman, 1972; Buchauer, 1973; Hutchinson and Whitby, 1973; Roberts et al., 1974; Beavington, 1975; Cartwirght et al., 1976; Temple et al., 1977; Ragaini et al., 1977; Munshower, 1977; Kabata-Pendias and Gondek, 1978).

Enhanced levels of Pb, Zn, Cu, Cd, Ni, As and Se are reported to occur in soils in the vicinity of smelters. Reported data on maximum total and extractable metal concentrations that have been encountered in surface soils in the proximity of smelters have been tabulated (Table 12.9). Surface soils near a Zn smelter are known to contain 50 000–80 000 $\mu g\ g^{-1}$ Zn, 900–1500 $\mu g\ g^{-1}$ Cd, 600–1200 $\mu g\ g^{-1}$ Cu and 200–1100 $\mu g\ g^{-1}$ Pb (Buchauer, 1973). Higher concentrations were reported for a few locations near this smelter that may have been contaminated by ore concentrates. Lead concentration as high as 49 000 $\mu g\ g^{-1}$ in surface soils near a secondary Pb smelter that emits

approximately 15 000 kg of Pb per year has been recorded by Roberts *et al.* (1974). Surface soils (0–5 cm) with Pb concentration of 6.2% and As concentration of 2000 μg g^{-1} are known to occur near the same two secondary Pb smelters in Canada (Temple *et al.*, 1977). Copper–nickel smelting operations in Sudbury basin, Canada, are suspected of being the source of Cu and Ni contamination of nearby surface soils (Hutchinson and Whitby, 1973). These investigators report that concentrations of Ni, Cu and Co as high as 3309, 2071 and 154 μg g^{-1}, respectively, were detected in these soils. Soil contamination near a smelter complex near Kellogg, Idaho, was reported as early as 1959 (Canney, 1959). A more extensive recent survey of this area by Ragaini *et al.* (1977) indicated that the surface soils (0–2 cm) contained as high as 2.9% Zn, 7000 μg g^{-1} Pb, 140 μg g^{-1} Cd and 110 μg g^{-1} As. Generally, surface soils have higher metal concentrations than subsurface soils indicating that metals have very low mobility. However, a report by Canney (1959) indicated that Zn concentration in subsurface soils was higher than in surface soil.

Enhanced levels of extractable metals in soils near smelters are also common. Zinc concentrations as high as 1.6%, and Cd concentrations of 102 μg g^{-1} were extracted from surface soils near a smelter (Lagerwerff *et al.*, 1972). Nitric acid extractable metals in surface soils near a smelter in Helena Valley, Montana, occurred at concentrations as high as 6800 μg g^{-1} Pb, 160 μg g^{-1} Cd and 150 μg g^{-1} As (Miesch and Huffman, 1972). High concentrations of various metals that were extracted with acetic acid ,EDTA and water from several contaminated soils have been reported (Little and Martin, 1972; Burkitt *et al.*, 1972; Hutchinson and Whitby, 1973; Beavington, 1975; Cartwright *et al.*, 1976; Munshower, 1977; Kabata-Pendias and Gondek, 1978).

Also, several studies indicate the occurrence of enhanced metal concentrations in vegetation growing on soils adjacent to smelters (Hindawi and Neely, 1972; Hutchinson and Whitby, 1973; Buchauer, 1973; Roberts *et al.*, 1974; Beavington, 1975; Munshower, 1977; Temple *et al.*, 1977).

Many studies confirm that metal concentrations in soils decline exponentially with increasing distance from smelters. Factors that govern metal distribution and accumulation in soils around a smelter are proximity, wind direction and velocity, topography, vegetation, precipitation and the quantities of metal emissions.

There is a lack of data regarding the solid-phase speciation of metals in contaminated soils. However, the metal inputs into soils around smelters are likely to be in oxide forms (Lagerwerff *et al.*, 1972).

(iv) *Industries.* Urban soils are known to contain higher metal concentrations compared with rural soils (Klein, 1972; Linzon *et al.*, 1976; Temple *et al.*,

Table 12.9 Maximum metal concentrations in surface soils near smelters

Maximum concentrations (μg g^{-1})						Metal fraction	Sample depth (cm)	Location	Reference
Ni	Cu	Zn	Pb	Cd	As				
—	—	—	680	—	—	Dithizon in CHCl$_3$	0–2.5	Secondary Pb smelter Minnesota, USA	Marten and Hammond (1966)
234	214	543	263	26	—	0.5 N CH$_3$COOH	0–5	Cu–Zn–Pb smelter Swansea, UK	Goodman and Roberts (1971)
—	—	4170	22 740	—	—	Total	0–7.6	Pb smelter Missouri, USA	Bolter et al. (1972)
—	70	15 600	1600	102	—	1 N HCl	0–5	Pb–Zn–Cd–Cu smelter Galena, USA	Lagerwerff et al (1972)
—	—	—	—	95	—	HNO$_3$	0–16	Secondary smelter Vancouver, Canada	John et al. (1972)
—	—	>1000	>126	>6.5	—	2.5% CH$_3$COOH	0–5	Pb–Zn smelter Avonmouth, UK	Little and Martin (1972)
—	—	5000	600	32	—	HNO$_3$	0–5	Avonmouth, UK	Burkitt et al. (1972)
—	—	>200	6800	160	150	HNO$_3$	0–10	Pb–Zn smelters Helena, USA	Miesch and Huffman (1972)
—	1200	80 000	1100	1500	—	Total	Al horizon	Zn smelters Palmerton, USA	Buchauer (1973)
3309	2071	84	75	—	—	Total	Surface	Cu–Ni smelter Sudbury, Canada	Hutchinson and Whitby (1973)
142	59.5	1.4	—	—	—	Water	Surface	Sudbury, Canada	Hutchinson and Whitby (1973)
—	—	—	40 000	—	—	Total	0–2	Secondary Pb smelters Toronto, Canada	Roberts et al. (1974)
—	—	—	62 150	—	2000	Total	0–5	Toronto, Canada	Temple et al. (1977)

>1.1	>850	>230	>13	>2	—	0.5 N CH_3COOH 0.02 M EDTA	0–10	Cu smelter Wollongong, Australia	Beavington (1975)
—	—	2220	11	—	—	0.1 M EDTA	0–5	Pb smelter Port Pirie, Australia	Cartwright et al. (1976)
—	—	—	29	—	—	1 N HCl	0–3	Cu–Zn smelter Anaconda, USA	Munshower (1977)
—	29 000	7900	140	110	—	Total	0–2	Pb smelter Kellogg, USA	Ragaini et al. (1977)
855	90	390	1	—	—	Total	0–3	Cu smelter Glogow, Poland	Kabata-Pendias and Gondek (1978)
453	33	335	0.5	—	—	1 N HCl	0–3	Glogow, Poland	Kabata-Pendias and Gondek (1978)
14	13	0.6	0.09	—	—	Water	0–3	Glogow, Poland	Kabata-Pendias and Gondek (1978)

Table 12.10 Major industrial sources of potential metal inputs into soils (based on Dean *et al.*, 1972, and Klein and Russell, 1973)

Industry	Cd	Cr	Cu	Hg	Pb	Ni	Zn
Paper		×	×	×	×	×	×
Fertilizers	×	×	×	×	×	×	×
Chemicals	×	×		×	×		×
Petroleum refining	×	×	×		×	×	×
Metal works	×	×	×	×	×	×	×
Automobile, aircraft, plating and tinning	×	×	×	×		×	
Power plants	×	×	×	×		×	×
Textile and tanning		×					

1977). This, in part, reflects metal emissions from various industrial activities together with household sources, such as fossil fuel residues and bonfire ash. Table 12.10 indicates various industries that are potential sources of metal inputs into proximate soils.

Table 12.11 lists maximum concentrations of metals in surface soils near different types of industries. Enhanced concentrations of Cd, Cr, Cu, Hg, Ni and Zn in surface soils near a coal-fired power plant were reported by Klein and Russell (1973). Concentrations of Pb measuring 1600 μg g^{-1} and As as high as 113.6 μg g^{-1} have been reported in soils near another power plant by Temple *et al.* (1977). A comprehensive review regarding metal pollution of surface soils near coal-fired power plants has been provided by Elseewi *et al.* (1983).

Concentrations of V, Pb and Zn as high as 27.5, 30 and 144 μg g^{-1}, respectively, have been reported for surface soils near rock phosphate plants (Severson and Gough, 1977; Parker *et al.*, 1978). A case of Hg contamination of soils near a chlor-alkali plant has been recorded by Bull *et al.* (1977). Elevated levels of Pb and As have been measured in surface soils near various industrial facilities such as battery manufacturing, municipal incinerator, and sewage-treatment plants (Temple *et al.*, 1977). Vanadium concentrations as high as 56 μg g^{-1} were present in surface soils near a ferro-alloy chrome ore plant (Parker *et al.*, 1978).

Maximum Cu concentrations of 58.6 μg g^{-1} (HNO$_3$ extractable) were reported by Hemkes and Hartmans (1973) in urban surface soils under high-voltage power lines. The authors suggested that this anomaly is due to increased corrosion of power lines in an urban environment.

Metal contamination of soils near industrial facilities is not as widely documented as water contamination. However, available data clearly suggests that various industries are sources of metal enhancement in surrounding surface soils.

Table 12.11 Maximum metal concentrations in surface soils near industries

Industry	Sample depth (cm)	Metal fraction	Maximum concentration ($\mu g\ g^{-1}$)						Reference
			V	Cu	Hg	Pb	Zn	As	
Coal-fired power plant[a] Michigan, USA	0–2	H_2SO_4–$KMnO_4$ –4% $K_2S_2O_8$	—	4.6	0.0102	—	35	—	Klein and Russell (1973)
Coal-fired power plant Ontario, Canada	0–5	Total	—	—	—	1600	—	113.6	Temple et al. (1977)
Coal-fired power plant Nevada, USA	0–2	Water	—	0.04	—	—	0.14	—	Bradford et al. (1978)
Phosphate processing Idaho, USA	A horizon	Total	—	—	—	30	144	—	Severson and Gough (1976)
Phosphate processing Wyoming, USA	Surface	Total	27.5	—	—	—	—	—	Parker et al. (1978)
Chlor-alkali plant UK	0–2	Total	—	—	12.6	—	—	—	Bull et al. (1977)
Chrome alloy plant Utah, USA	Surface	Total	55.75	—	—	—	—	—	Parker et al. (1978)
Battery manufacturing Ontario, Canada	0–5	Total	—	—	—	20 750	—	27	Temple et al. (1977)
Sewage treatment Ontario, Canada	0–5	Total	—	—	—	2330	—	19.8	Temple et al. (1977)
Municipal incinerator Ontario, Canada	0–5	Total	—	—	—	2450	—	47.6	Temple et al. (1977)

[a] Also measured: Cd, 1.46 $\mu g\ g^{-1}$; Cr, 6.5 $\mu g\ g^{-1}$; Ni, 4.0 $\mu g\ g^{-1}$.

Table 12.12 Anthropogenic radionuclides of metals in soils (based on Haury and Schikarski, 1977, and Bowen, 1979)

Radionuclide	Half-life (yrs)	Amount released (Bq)[a]	In soil (Bq/kg) average (range)	Source[b]
^{241}Am	458	—	—	^{241}Pu decay
^{60}Co	5.1	7.77×10^{12}	—	P
^{134}Cs	2.1	1.09×10^{13}	—	P, R
^{137}Cs	33	1.20×10^{18}	63 (18–20)	P, R, W
^{55}Fe	2.9	1.40×10^{18}	—	W
^{54}Mn	0.82	?	7.4	W
^{63}Ni	92	?	—	W
^{238}Pu	86.4	3.2×10^{13}	(0.007–0.07)	W
^{239}Pu, ^{240}Pu	24 400, 6600	13×10^{15}	(0.05–1.4)	W
^{241}Pu	14.9	2.2×10^{17}	16	R, W
^{90}Sr	28	7.8×10^{17}	35 (20–25)	P, R, W
^{99}Tc	210 000	?	—	W

[a] Cumulative releases from weapon testing up to 1973; cumulative releases from power plants and reprocessing 1975–2000.
[b] P, Power plants; R, Fuel reprocessing; W, Weapons testing.

(v) *Radionuclides.* Several artificial radionuclides have been detected in soils. Many of these artificial radionuclides of metals have long half-lives and tend to accumulate and enhance the ionizing radiation from soils. Some of these radionuclides such as ^{226}Ra, ^{228}Ra, ^{210}Pb, ^{90}Sr and ^{127}Cs can be taken up by plants (Higgins and Burns, 1975). Artificial radionuclide addition to soils occurs through diverse sources. Major sources are nuclear weapons testing, nuclear reactors and allied industries. Several of these artificial radionuclides of metals, estimated cumulative releases from major sources and detected activity in soils are listed in Table 12.12. Significant releases of ^{137}Cs, ^{55}Fe, ^{241}Pu and ^{90}Sr into the environment are the results of testing of weapons. In particular, high activities of ^{137}Cs and ^{90}Cr in soils have been recorded. Estimated cumulative inputs of these radionuclides from fallout are 54 Bq ^{137}Cs and 37 Bq ^{90}Sr per square meter of soil (Knizhnikov and Barkhudarov, 1975). It is known that ^{137}Cs in soils is generally less mobile than ^{90}Sr (Russell, 1966; Ritchie *et al.*, 1974). Significant accumulation of long-life ^{239}Pu, ^{240}Pu and short-life ^{241}Pu in soils can also be noted. A decay product of ^{241}Pu, ^{241}Am is expected in time to accumulate in soils (Holm and Persson, 1977). Recent studies (Cleveland and Rees, 1981) indicated that tetravalent Pu can be mobile in soils as complexes of dissolved organics.

Coal-fired power plants can also be a source of radionuclide additions to soils. Fly ash contains ^{235}U, ^{238}U and ^{232}Th chain nuclides (McBride *et al.*, 1978). These authors estimated that up to 5.3×10^9 Bq radioactivity due to

these nuclides would be released per year from a 1000 MW coal-fired power plant. These estimates are based on 1% of the total ash being emitted through stacks. The average rate of release is likely to be 8% of the total ash (Van Hook, 1978) thus amounting to 4.2×10^{10} Bq of radioactivity released per year. The increase in radioactivity of soils in a 20 km radius around a 1000 MW coal-fired plant would be approximately 33 Bq m^{-2} yr^{-1}. This increase in soil radioactivity is similar in magnitude to that brought about by fertilizer additions (~ 25 Bq m^{-2} yr^{-1}), but significantly less than the activity added by nuclide fall-out from weapon testing (54 Bq ^{137}Cs and 37 Bq ^{90}Sr; Kinzhnikov and Barkhudarov, 1975).

Other minor sources of radionuclide additions to soils are cement manufacturing (3×10^{10} Bq yr^{-1} emission of ^{226}Ra; Moore et al., 1976), metal production, and other industries.

The extent of soil contamination by artificial radionuclides has been assessed mainly through estimates of emissions from sources rather than on direct soil measurements.

III. Assessment of metal pollution

1. Measurements of metal concentrations

Metal pollution of soils is assessed through measurements that include metal concentrations in soils solutions, on exchange and adsorption sites, in solid phases and the sum of metal concentrations in all phases of a soil system.

Various reagents that extract varying fractions of metals present in soils have been widely used purportedly to assess "availability" of these metals to plants and soil organisms. Total metal concentration is the most useful index to assess the degree of accumulation of metals in soils. Metal availability to plants is better reflected from soil solution composition. Because soils are dominated on the mass basis by the solid phases, sampling soil solutions under unsaturated conditions presents unique problems. To overcome this problem, aqueous extracts from soils at saturation have been routinely used as a measure of soil solution composition. There are at least two methods available for measuring soil solution composition under unsaturated conditions (Schuffelen et al., 1964; Hinkley, 1979). The latter study based on in situ sampling, indicated several orders of magnitude difference in metal concentration between soil solutions under unsaturated conditions and phreatic water. Conventionally, metal concentrations in soluble forms are determined on 0.45 μm filtrates. It is known, however, that colloidal iron hydroxides and oxyhydroxides (Stumm and Bilinski, 1973) and smectites can occur in particle sizes smaller than 0.1 μm. Therefore, measurements of metal concentrations in 0.45 μm filtrates may include an unknown fraction of solid phases as well as

metal in true solution. According to Stumm and Bilinski (1973), indications of supersaturation in many natural waters can be attributed mainly to the arbitrary definition of soluble constituents as being those in the 0.45 μm filterable fraction.

Metal pollution in soils can also be assessed on the basis of quantity and types of solid phases associated with each metal. Such characterization of solid phases of major metals can be easily accomplished. Solubility data on various solid phases can provide a reasonable basis for assessing solution metal concentrations. Characterization of solid phases of trace metals in soils is not as easily accomplished due to low concentrations and potentially diverse solid forms. Detailed discussion regarding trace metal solid forms in soils can be found in Chapter 5.

Various extractants have been used by several researchers to assess metal concentration in anthropogenic source materials, and in soils with and without metal enhancement. Extractants that are commonly used are acetic acid, hydrochloric acid, nitric acid, ethylenediaminetetra-acetic acid (EDTA), diethylenetriaminepenta-acetic acid (DPTA) and water.

There are several factors that influence the extractability of metals by these reagents. Some of the variables that influence extractability of metals from soils with DTPA are time and intensity of grinding samples, soil–solution ratio, speed and type of shaking, type of containers, degree of mixing and shaking and filtering periods (Soltanpour *et al.*, 1976). It is apparent that owing to lack of recognized standard extraction procedures, the results obtained by various researchers are not comparable. It appears that the only rationale behind these extraction methods is that the results provide an index to "bioavailability".

There is a growing awareness that knowledge about metal speciation in soils is a better means to assess the impact of metal pollution. Experimental schemes exist (see Chapter 5) that can provide reasonable estimates of metal speciation in aqueous phase. Techniques such as energy dispersive X-ray analysis (EDXA) and X-ray photoelectron spectroscopy (XPS) can provide useful information regarding metal speciation in solid phases. In addition, chemical equilibrium computer programs provide detailed predications of metal speciation in soils. A combination of both experimental and theoretical approaches to metal speciation in soils has the potential to provide a general and viable framework for assessing metal chemistry in soils.

A theoretical basis for computer simulation of metal speciation in soils is provided in detail in Chapter 5. A succinct description and several applications of this approach will be provided in the latter part of this chapter.

2. Effects on plants and soil organisms

Metal pollution of soils is also assessed by its impact on plants and soil organisms. This concept is based on the established fact that plant tissue

analyses is a reliable indicator of not only the nutrient status of the plant itself but also the nutrient availability from the soils (Smith, 1962; Hodgson et al., 1971). It is known that plants accumulate both essential and non-essential metals. This property is the basis for biogeochemical prospecting (Hawkes and Webb, 1962; Levinson, 1974) and also a means of assessing "bioavailability" of metallic elements from contaminated soils. The literature is replete with data on metal concentrations in plants growing on soils enriched with metals from various sources.

Metal concentrations in plant tissues are influenced by several plant, soil and environmental factors. Some of these are: metal species in soils, plant species and variety, stage of growth, season, temperature, light, and various types of metal interactions. Metal concentrations in different parts of a plant are also highly variable.

Comprehensive reviews regarding metal concentrations in plants growing on soils that were subjected to sewage sludge additions may be found in a report by Page (1974) and by CAST (1976). Similar reviews regarding metal uptake by plants growing on fly ash amended soils are provided by Adriano et al. (1980) and Elseewi et al. (1981). Studies of soil contamination from diverse sources generally include measurements of metal concentrations in plants growing on contaminated soils.

Correlation between extractable metal concentrations in soils and metal concentrations in plant tissues has been widely used as a predictive tool in assessing metal contamination. In view of the number of variables that affect such measurements, assessment can be specific only towards the site and plant species studied.

There exists a considerable body of knowledge regarding "bioavailability" and toxicity of metals to aquatic organisms. Similar studies on soil organisms are rather sparse. However, several studies regarding metal tolerances and toxicities of bacteria and lower plants do exist (Bowen, 1979) and the subject is reviewed in Chapter 7. Assessment of soil metal pollution through the use of soil organisms has limitations similar to those involving higher plants.

IV. Chemical modelling of metal speciation in soils

1. Basis for modelling

Knowledge of metal distribution between solid, solution and, in some cases, gaseous phases is essential for understanding the chemistry of metals in soil systems. Additional knowledge regarding metal speciation in each of the phases provides a more sophisticated approach to soil–metal chemistry. As discussed earlier, experimental techniques do provide some knowledge regarding speciation of metals in each phase. However, none of the current

experimental techniques provides detailed measurements of the multitude of probable metal species in soil solution. This limitation has spurred the development of computer modelling studies of metal speciation in soil systems. The basis for modelling is that the metal distribution between phases as well as speciation within each phase of a soil system can be predicted by simulating all categories of reactions (Fig. 12.1) that are likely to occur within the system. Details of such an approach and the chemical basis are to be found in Chapter 5.

Based on current knowledge regarding various types of reactions that are likely to occur in soil systems, we can formulate a set of requirements for chemical models. These criteria are essential in order to ensure that the results of chemical modelling at least qualitatively reflect major natural interactions and are not just exercises in numerical computation.

(a) Metal–inorganic ligand interactions

All potential metal–inorganic ligand interactions should be included in the model. Many models include only those interactions for which experimental stability constants are available and ignore those interactions for which constants are unavailable. Mattigod and Sposito (1979) discuss the problems inherent in this approach and suggest inclusion of estimated constants for such interactions. They also mention several methods to estimate stability constants.

(b) Metal–organic ligand interactions

It is recognized that metal interactions with soluble natural organics are a significant category of reactions in soil systems. Failure to address these interactions in chemical models would lead to invalid results. Currently, only a few chemical models are capable of simulating this important group in reactions in soils.

(c) Redox reactions

Electron activity controls several reactions in soil environments. A chemical model for soil systems should include electron activity as one of the variables with respect to redox reactions involving both metallic and non-metallic elements.

(d) Ion exchange and adsorption reactions

Soils are solid phase dominated systems; as such, ion exchange and adsorption reactions form a significant part of the solid–solution interactions.

Soils contain both constant potential and constant charge surfaces. Therefore, methods that describe exchange–adsorption phenomenon on both types of surfaces should be an integral part of any chemical model that purports to simulate the principal interactions in soil systems.

(e) Dissolution–precipitation reactions

Formation and dissolution of various amorphous and crystalline phases is another important category of reactions that should be simulated by chemical models. All potential reactions in this category should be considered (Mattigod et al., 1981) in order to simulate the partitioning of input metals between solid and solution phases. In addition, the models should be capable of simulating the formation of metastable solid phases in soil systems.

(f) Soil solution–gas phase interactions

Exchange of CO_2, N_2 and O_2 between soil solution and soil atmosphere has direct bearing on the carbonate, nitrate and redox chemistry of soils. Composition of soil atmosphere and its interaction with other soil phases is an important link in a chain of reactions that influence metal speciation. Therefore, a reasonable method to describe such interaction should be part of a comprehensive model.

(g) Other aspects

Another important aspect of chemical equilibrium modelling is the inclusion of a sufficient number of components to provide reliable simulations. The number of components that should be included depends on whether information regarding major or minor element speciation is required. A principal factor in the choice of components is that all components that are present in equal or greater concentration than the components of interest should be included.

There are several chemical equilibrium models being used by various groups of researchers. A comprehensive review of some of these models is available in Nordstrom et al. (1978). These models can be generally grouped into specific or general-purpose models based on the number of categories of interactions the models are capable of simulating. Specific-purpose models are capable of addressing only certain categories of interactions, such as speciation in solution phase and redox reactions. These programs generally possess data bases that are limited only to a certain group of metals and ligands. Therefore, such models can simulate only a restricted aspect of metal speciation in soil systems. In contrast, general-purpose programs contain

extensive data sets involving all major and trace metals and ligands and are capable of simulating all major categories of interactions. Many of these programs also include temperature as a variable and mass transfer calculations.

2. Description of a model: GEOCHEM

GEOCHEM is a multipurpose chemical equilibrium computer program that has been developed for soil systems. This program was derived from the REDEQL2 program that was created by McDuff and Morel (1974). A detailed description of GEOCHEM can be found in Chapter 5. Additional information regarding GEOCHEM can be obtained from Mattigod and Sposito (1979) and Sposito and Mattigod (1980). This program fulfills all the criteria for modelling that were enumerated in the previous section of this chapter. In addition to the capabilities that have been described in Chapter 5, the GEOCHEM program contains two unique features that were inherited from REDEQL2. One is that a set of solids can be selected with the constraints of Gibbs phase rule, so that formation of metastable solid phases can be simulated. This option allows one to take into account the widely ranging kinetics of mineral formation reactions in soil systems.

The second feature is the computation of a parameter known as interaction intensity, defined as:

$$\delta_{x,y} = \frac{\partial pX}{\partial pTOT\,Y}$$

where X = free ionic concentration of a component X; $pX = -\log X$; $TOT\,Y$ = total molar concentration of component Y; and $pTOT\,Y = -\log TOT\,Y$.

The partial derivative is applied with all other components except X and Y held at fixed concentrations. Interaction intensities computed for a multicomponent system indicate the principal pathways of interactions that exist in a system. Detailed discussion regarding interaction intensities is provided by Morel et al. (1973).

In essence, changes in free ionic concentration of a component can be predicted for a specified system that has been subjected to mass transfer of another component. If $\delta_{x,y} > 0$ and large, the free ionic concentration of X increases when the total amount of Y increases. Conversely, if $\delta_{x,y} < 0$ and large, the free ionic concentration of X decreases as a response to an increase in Y. When $\delta_{x,y} \approx 0$, there is no influence of component Y on the free ionic X component.

Consequences of mass transfer of a single component from a system on

changes in free ionic species of any other component can be better understood by studying a table of interaction intensities. This offers a more elegant and easier approach as compared with an alternate method of making many computations for a system, by changing in sequence, total concentration of each component and examining the changes in free ionic concentrations of all other species.

Therefore, computation of interaction intensities by GEOCHEM provides a useful means of evaluating the responses of soil systems that are continually subjected to mass transfer of various components.

3. Applications

(a) *Modelling anthropogenic inputs*

In recent years, an increasing number of studies have focused on modelling the impact of anthropogenic metal inputs into soil systems. Elemental speciation in soil systems subjected to inputs of sewage sludges (Mattigod and Sposito, 1979), geothermal brines (Sposito *et al.*, 1979), acid rain (Sposito *et al.*, 1980) and inorganic constituents from coal gasification (Ireland *et al.*, 1982) have been predicted by GEOCHEM. These modelling studies have provided valuable insights into the chemistry of speciation of metals in soil systems and a basis for predicting the behaviour of various elements in contaminated soils. In many cases, empirical observations have provided qualitative verification of predictions made by modelling studies.

A typical approach to chemical equilibrium modelling will be illustrated by the use of GEOCHEM to study the chemistry of soils affected by geothermal brines.

Accidental contamination of agricultural soils due to spillage or seepage of metal-rich geothermal brines is considered to be a potential problem in geothermal power development in the Imperial Valley of California, USA. Enhanced metal concentrations and increased salinity of soils as well as potential contamination of groundwater resources are some of the major problems that can develop in this region. Chemical equilibrium modelling studies for various scenarios involving brine contamination of soils in this region are contained in a report (Sposito *et al.*, 1979). The following example illustrates a situation in which soil solution has been contaminated by the intrusion of geothermal brine. Table 12.13 lists the chemical compositions of uncontaminated soil water and geothermal brine. The brine is presumed to be in equilibrium with solid phases that are predicted to form upon cooling to 25°C. The speciation of elements that may occur when the soil water contains 10% brine by weight was predicted using GEOCHEM. The results of the computations are summarized in Table 12.14. Five solid phases were predicted to precipitate from brine–soil water mixtures. The bulk of alkali cations were

Table 12.13 Chemical composition of geothermal brine and soil water

Element	Brine[a] ($-$log of total molar concentration)	Soil water[b]
Li	1.30	4.66
Na	-0.40	2.00
K	0.42	2.89
Mg	1.52	2.64
Ca	0.17	2.28
Sr	2.29	4.20
Ba	2.12	—
Mn	2.67	4.66
Fe	6.62	5.75
Ni	4.17	5.99
Cu	4.33	5.33
Zn	2.34	4.97
Pb	3.54	7.02
B	1.51	4.42
CO_3	—	2.40
NO_3	1.61	3.56
F	3.64	4.15
Si	3.67	—
PO_4	—	4.19
SO_4	6.78	2.12
Cl	-0.64	2.03
"Ful"	—	4.65

[a] Brine from Imperial Valley cooled to 25°C and in equilibrium with precipitated phases: $SiO_2 \cdot 2H_2O$, MnO_2, $Fe(OH)_3$, $BaSO_4$ and adsorption surfaces: amorphous silica, iron and manganese oxides.
[b] Soil water from Holtville soil series, Imperial Valley, California. "Ful" concentration computed from total soluble organic carbon. (Consult Chapter 5 for details regarding soluble organic model.)

predicted to be in free ionic form. In the case of alkaline earth cations except Ba, almost 30% of metals in solution are predicted to be in chloride complex forms. A part of Sr and all of Ba were predicted to be present as celestite ($SrSO_4$) and barite ($BaSO_4$), respectively. More diverse speciation was predicted for metals, Ni, Cu, Zn and Pb. Borate, carbonate and chloride complexes of these metals are likely to form to a significant degree. Up to 40% of the Pb could be immobilized as cerussite ($PbCO_3$). One of the palpable outcomes of these calculations is the behaviour of major cation components as compared with the behaviour of transition metal cations. In case of major cations, free ionic forms predominate, whereas complexed species are dominant among the transition metal cations.

The web of interactions that exists between various elements in this contaminated soil system is reflected by the table of interaction intensities

(Table 12.15). It is seen that there is a small influence of Na and Ca on the free ionic concentrations of Ni, Cu, Zn and Pb. It is observed that the major influence on increasing free concentrations of Ni, Cu and Zn would be due to increases in total concentrations of the respective metals. However, a small value of $\partial pPb^{2+}/\partial pTOTPb$ indicates that an increase in total concentrations of Pb would have negligible influence on free Pb^{2+} concentrations owing to precipitation of cerussite. The importance of borate and carbonate complexes of these metals in this system is reflected largely by high interaction intensities calculated for these ligands. Any increase in total concentrations of these ligands would produce a significant decrease in free ionic concentrations of these metals through complex formation reactions. Chloride as a ligand has significantly less influence, and SO_4 among all these ligands has the least effect on free metal concentrations.

Extended simulations that included ion exchange surfaces of the soil indicated that Cu, Zn and Pb concentrations in contaminated soil solution would be effectively attenuated. Approximately a third of the Ca in solution was also predicted to be on exchange sites. However, exchange reactions seemed not to significantly influence the solution concentrations of other cations such as Na, K, Li and Mg.

The conclusions drawn from this modelling study were that in this brine-contaminated soil system:

(i) The metals Na, K, Li and Mg would be present mainly in free ionic forms and are not likely to be adsorbed on exchange sites in the soil. Therefore, these metals and to some extent Ca also would be mobile within the contaminated soil.

(ii) Almost all of Ba, Mn, Fe and part of Sr and Pb added to the soil through brine intrusion under oxic conditions, would be immobilized in solid forms.

(iii) Cu, Zn and Pb in solution phase would be highly attenuated through adsorption reactions and this would restrict the mobility of these metals.

(iv) Borate and carbonate ligands are important as metal-complexing agents. Chloride, despite its high concentration, influences metal complexation to only a minor degree.

(v) High concentrations of B added to the soil from brine contamination remains in solution phase mainly as unchanged species and would be likely to be highly mobile within the soil system.

Results of a field study qualitatively confirmed these modelling predictions. Chemical composition of water draining through a soil that was apparently contaminated with brine seeping through a holding pond (Phelps and Anspaugh, 1976) indicated that concentrations of metals Li, Na, K, Mg and Ca

Table 12.14 Predicted elemental speciation in brine–soil water mixture[a]

Element	Total concentration (pM)	Species (% of total)[b]	
		Principal species	Minor species
Li	2.30	Li^+ (83.8), $LiCl^0$ (15.9)	—
Na	0.58	Na^+ (85.9), $NaCl^0$ (13.90)	$NaSO_4^-$ (1.0)
K	1.41	K^+ (90.8), KCl^0 (8.6)	KSO_4^- (0.5)
Mg	2.29	Mg^{2+} (72.2), $MgCl^+$ (25.5)	$MgSO_4^0$ (1.7), $MgHCO_3^+$ (0.3)
Ca	1.14	Ca^{2+} (67.7), $CaCl^+$ (29.4)	$CaSO_4^0$ (2.1), $CaHCO_3^+$ (0.4)
Sr	3.24	Sr^{2+} (52.1), $SrCl^+$ (28.5), $SrSO_4$ (solid) (17.0)	$SrSO_4^0$ (1.3), Sr–"Ful" (0.8)
Ba	3.12	$BaSO_4$ (solid) (100)	—
Mn	3.63	MnO_2 (solid) (100)	—
Fe	5.79	$Fe(CO_3)_3^{3-}$ (97.7)	$Fe(CO_3)_2^-$ (2.2)
Ni	5.12	$NiB(OH)_4^+$ (37.4), Ni^{2+} (32.5), $NiHCO_3^+$ (19.5), $NiCl_2^0$ (6.6)	$NiCl^+$ (1.5), $NiSO_4^0$ (1.0), $NiCO_3^0$ (0.7), $NiCl_3^-$ (0.5)
Cu	5.05	$CuB(OH)_4^+$ (46.8), $Cu[B(OH)_4]_2^0$ (28.8), $CuHCO_3^+$ (19.5)	Cu^{2+} (2.0), Cu–"Ful" (1.5), $CuCl^+$ (0.6), $CuCO_3^0$ (0.4)

		Principal species	Minor species
Zn	3.34	Zn^{2+} (52.4), $ZnB(OH)_4^+$ (24.0), $ZnHCO_3^+$ (15.9)	$ZnCl^+$ (3.7), $ZnSO_4^0$ (2.0), $ZnCl_2^0$ (1.7)
Pb	4.54	$PbCO_3$ (solid) (39.1), $PbCl^+$ (24.0), $PbHCO_3^+$ (13.2), $PbCl_2^0$ (7.1), Pb^{2+} (5.5)	$Pb[B(OH)_4]_2^0$ (3.9), $PbCl_3^-$ (2.4), $PbCO_3^0$ (2.0), $PbB(OH)_4^+$ (1.6), $PbCl_4^{2-}$ (1.0)
B	2.51	$H_3BO_3^0$ (95.5)	$ZnB(OH)_4^+$ (3.5), $CuB(OH)_4^0$ (0.3)
CO3	2.44	HCO_3^- (46.8), $H_2CO_3^0$ (33.8), $NaHCO_3^0$ (8.0), $CaHCO_3^+$ (7.5)	$ZnHCO_3^+$ (2.0), $KHCO_3^0$ (0.6), $MgHCO_3^+$ (0.5), $PbCO_3$ (solid) (0.3)
NO3	2.57	NO_3^- (90.4), $CaNO_3^+$ (5.7)	$NaNO_3^0$ (2.5), KNO_3^0 (1.0)
F	4.07	F^- (83.6), CaF^+ (10.5), MgF^+ (5.5)	—
Si	3.80	$Si(OH)_4^0$ (100)	—
PO4	4.24	$Ca_5(PO_4)_3(OH)$ (solid) (98.7)	$CaHPO_4^0$ (0.5), $H_2PO_4^-$ (0.4)
SO4	2.17	SO_4^{2-} (31.1), $NaSO_4^-$ (31.7), $CaSO_4$ (20.1), $BaSO_4$ (solid) (11.2)	KSO_4^- (2.6), $SrSO_4$ (solid) (1.4), $MgSO_4^0$ (1.3)
Cl	0.35	Cl^- (86.7), $NaCl^0$ (7.6)	$CaCl^+$ (4.4), KCl^0 (0.8), $MgCl^+$ (0.3)
"Ful"	4.70	H–"Ful" (49.0), Sr–"Ful" (24.0), "Ful" (12.0), Ca–"Ful" (9.8)	Na–"Ful" (3.8)

[a] Brine 10% by weight in mixture, computed ionic strength = 0.43, pH 6.29, pe = 12.0, computations by GEOCHEM included 419 soluble complex species and 73 possible solids.

[b] Species that constitute ≥5% of total concentration of each element are included under principal species. Species constituting between 0.3 and <5% of total concentration of each element are listed as minor species.

Table 12.15 Interaction intensities for the brine-soil water system*

X	TOTY Na	Mg	Ca	Ni	Cu	Zn	Pb	B	CO_3	SO_4	Cl
Ni	0.09	0	0.08	1.00	0	0.08	0.02	-1.79	-2.51	-0.02	-0.21
Cu	0.15	0	0.15	0	1.02	0.20	0.05	-4.60	-5.97	-0.01	-0.11
Zn	0.06	0	0.05	0	0	1.05	0.01	-1.17	-1.67	-0.02	-0.11
Pb	0.24	0.01	0.23	0	0.01	0.21	0.06	-4.31	-8.01	-0.01	-0.15

* Only selected parts from a table of interaction intensities ($\partial pX/\partial pTOTY$) predicted by GEOCHEM has been reproduced.

and the metalloid **B** were highly elevated in comparison with composition of waters draining through uncontaminated soils.

(b) *Soil–plant relationships*

It is generally recognized that metal ion availability and uptake by plants are influenced by several factors such as pH, ionic strength, redox potential, composition of solution, ionic valence and ion size (Frausto da Silva and Williams, 1976). Therefore, elemental speciation in soil solution is a major factor in controlling the availability and uptake of various essential and non-essential elements by plants.

Some of the recent work by Sposito and Bingham (1981) and Pavan (1981) has focused on relationships between metal uptake by plants and concomitant metal speciation in soil and nutrient solutions.

In one of the experiments, Sposito and Bingham (1981) studied uptake of Cd by sweet corn grown in soils that were subjected to known additions of $Cd(NO_3)_2$. Speciation of 10 metals and 13 ligands in saturation extracts of these soils was computed by GEOCHEM. The calculations included 344 soluble complexes involving interactions between various metals and ligands. The results showed (Fig. 12.5) that Cd uptake by sweet corn was highly

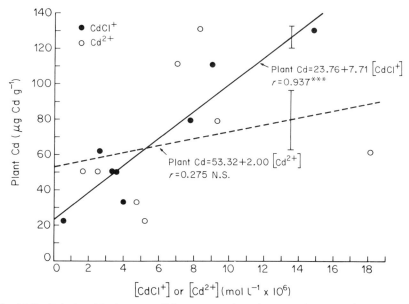

Fig. 12.5 Relationship between Cd concentrations in corn shoots and computed molar concentrations of Cd^{2+} or $CdCl^+$ species in saturation extracts (data from Sposito and Bingham, 1981).

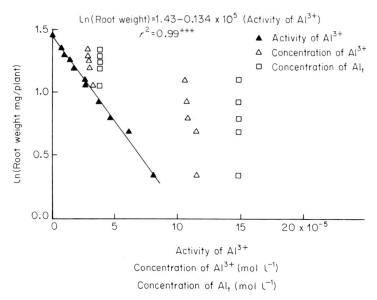

Fig. 12.6 Correlations between root weights of coffee plants and computed activities of Al^{3+} specie or concentrations of Al^{3+} specie or total Al concentrations in nutrient solutions (data from Pavan, 1981).

correlated with concentrations of $CdCl^+$ in soil solutions. No significant correlation was observed between Cd in plant tissue and Cd^{2+} concentrations in the saturation extracts of soils. The authors concluded that reduced charge on Cd through complex formation appeared to enhance Cd uptake by corn.

In a study involving Al toxicity on coffee plants, Pavan (1981) used GEOCHEM to compute metal speciation in nutrient solutions containing 9 metals and 6 ligands. The results indicated that the root growth in coffee plants was correlated significantly with the activity of Al^{3+} ion in solutions. Neither Al^{3+} concentrations nor total Al in solution showed any viable relationship with root growth (Fig. 12.6).

These examples clearly demonstrate the need to know the speciation of various metals in contaminated soils for a better assessment of their bioavailability.

Acknowledgements

This work was supported by the University of California, Water Resources Center, as part of Water Resources Project UCAL-WRC-W-585 and a grant from the Kearney Foundation. Excellent and efficient typing services of Ms Martha Stephans is gratefully acknowledged.

References

Adriano, D. C., Woodford, T. A. and Ciravolo, T. G. (1978). *J. Environ. Qual.* **7**, 416–421.

Adriano, D. C., Page, A. L., Elseewi, A. A., Chang, A. C. and Straughan, I. (1980). *J. Environ. Qual.* **9**, 333–344.

Alloway, B. J. and Davies, B. E. (1971). *Geoderma* **5**, 197–208.

Andrew-Jones, D. A. (1968). *Mineral Ind. Bull.* **11**, 1.

Bashirova, F. N. (1966). *Oklr. Prir. Urale, Ural. Felial Akad. Nauk SSSR* **5**, 789–792; *Chem. Abstr.*, 1967, **67**, 57062j.

Beavington, F. (1975). *Environ. Pollut.* **9**, 211–217.

Berggren, B. and Oden, S. (1972). Analysresultat, Rörande Tungmetaller och Klorerade Kolväten I Report of Inst. för markvetenskap Lantbrukshögskolan, 750 07, Uppsala, Sweden.

Berrow, M. L. and Webber, J. (1972). *J. Sci. Food Agric.* **23**, 93–100.

Bertine, K. K. and Goldberg, E. D. (1971). *Science* **173**, 233–235.

Blakslee, P. A. (1973). "Monitoring Considerations for Municipal Wastewater Effluent and Sludge Application to the Land". USEPA Workshop, Champaign, Illinois.

Boawn, L. C., Viets, F. G. and Crawford, C. L. (1954). *Soil Sci.* **78**, 1–8.

Bolter, E., Hamphill, D., Wixson, B., Butherus, D. and Chen, R. (1972). *In* "Trace Substances in Environmental Health, VI" (Hemphill, D. D., ed.), pp. 79–86. University of Missouri, Columbia.

Bowen, H. J. M. (1979). "Environmental Chemistry of the Elements". Academic Press, London and New York.

Brackett, C. E. (1973). Proceedings of 3rd International Ash Utilization Symposium, Pittsburg, Pennsylvania, pp. 12–18. US Bureau of Mines, Washington, DC.

Bradford, G. R., Page, A. L., Straughan, I. R. and Phung, H. T. (1978). *In* "Environmental Chemistry and Cycling Processes" (Adriano, D. C. and Brisbin, I. L., eds), pp. 383–393. Technical Information Center, US Department of Environment.

Bryant, E. A., Cowan, G. A., Daniels, W. R. and Maeck, W. J. (1976). *In* "Actinides in the Environment" (Friedman, A. M., ed.), pp. 89–102. American Chemical Society, Washington, DC.

Brzakovic, P. N. (1970). *In* "Ash Utilization", Proceedings of 2nd Ash Utilization Symposium, pp. 205–219. USDI IC. 8488.

Buchauer, M. J. (1973). *Environ. Sci. Technol.* **7**, 131–135.

Bull, K. R., Roberts, R. D., Inskip, M. J. and Goodman, G. T. (1977). *Environ. Pollut.* **12**, 135–140.

Burkitt, A., Lester, P. and Nickeless, G. (1972). *Nature, Lond.* **238**, 327–328.

Canney, F. C. (1959). *Min. Eng.* **11**, 205–210.

Cartwright, B., Merry, R. H. and Tiller, K. G. (1976). *Aust. J. Soil Res.* **15**, 69–81.

CAST (1976). "Application of Sewage Sludge to Cropland: Appraisal of Potential Hazards of the Heavy Metals to Plants and Animals". Report 64, Council for Ag. Sci. & Tech., Ames, Iowa.

Chaney, R. L. (1980). *In* "Sludge–Health Risks of Land Application" (Bitton, G., Damron, B. L., Edds, G. T. and Davidson, J. M., eds), pp. 59–83. Ann Arbor Science, Ann Arbor, Michigan.

Clark, L. J. and Hill, W. L. (1958). *J. Assoc. Official Ag. Chem.* **41**, 631–637.

Cleveland, J. M. and Rees, T. F. (1981). *Science* **212**, 1506–1509.

Colburn, P. and Thornton, T. (1978). *J. Soil Sci.* **29**, 513–526.

Colburn, P., Alloway, B. J. and Thornton, I. (1975). *Sci. Total Environ.* **4**, 359–363.

Davison, R. L., Natusch, D. I. S., Wallace, J. R. and Evans, C. A. (1974). *Environ. Sci. Technol.* **8**, 1107–1111.

Dean, J. G., Bosqui, F. L. and Lanouette, K. H. (1972). *Environ. Sci. Tech.* **6**, 519–522.

Delas, J., Delmas, J. and Demias, C. (1960). *Compt. Rend.* **250**, 3867–3870.

Doner, H. E. and Lynn, W. C. (1977). *In* "Minerals in Soil Environments" (Dinauer, R. C., ed.), pp. 75–96. SSSA, Madison, Wisconsin.

Ellis, A. J. (1979). *In* "Geochemistry of Hypothermal Ore Deposits" (Barnes, H. L., ed.), pp. 632–683. Wiley, New York.

Elseewi, A. A., Bingham, F. T. and Page, A. L. (1978). *In* "Environmental Chemistry and Cycling Processes" (Adriano, D. C. and Brisbin, J. L., eds), pp. 568–581. CONF 760429, USDC, Springfield, Virginia.

Elscewi, A. A., Grimm, S. R., Page, A. L. and Straughan, I. R. (1981a). *J. Pl. Nutr.* **3**, 409–427.
Elseewi, A. A., Page, A. L. and Straughan, I. R. (1983). *In* "Air Pollutants and Their Effects on the Terrestrial Ecosystem". Wiley, New York (in press).
Frausto da Silva, J. J. R. and Williams, R. J. P. (1976). *Structure Bonding* **29**, 67–121.
Goodman, G. T. and Roberts, T. M. (1971). *Nature, Lond.* **231**, 287–292.
Haurny, G. and Schikarski, W. (1977). *In* "Global Chemical Cycles and Their Alterations by Man" (Stumm, W., ed.), pp. 165–188. Dahlem Konf.
Hawkes, H. E. and Webb, J. S. (1962). "Geochemistry of Mineral Exploration". Harper and Row, New York.
Hemkes, O. J. and Hartmans, J. (1973). *In* "Trace Substances in Environmental Health, VII" (Hemphill, D. D., ed.), pp. 175–178. University of Missouri, Columbia.
Higgins, I. J. and Burns, R. G. (1975). "The Chemistry and Microbiology of Pollution", p. 248. Academic Press, London and New York.
Hindawi, I. J. and Neely, G. E. (1972). *In* "Helena Valley Montana, Area Environmental Pollution Study", pp. 81–94. USEPA Publ. AP-91.
Hinkley, T. (1979). *Nature, Lond.* **277**, 444–446.
Hirst, J. M., LeRiche, H. H. and Bascomb, C. L. (1961). *Plant Pathol.* **10**, 105–108.
Hodgson, J. F., Allaway, W. H. and Lockman, R. B. (1971). *In* "Environmental Geochemistry in Health and Disease" (Cannon, H. L. and Hopps, L. C., eds), pp. 57–72. GSA Mem. 123.
Holm, E. and Persson, B. R. R. (1976). "Transuranium Nuclides in the Environment", p. 435. IAEA, Vienna.
Hutchinson, T. C. and Whitby, L. M. (1973). *In* "Trace Substances in Environmental Health, IV" (Hemphill, D. D., ed.). University of Missouri, Columbia.
Ireland, R. R., McConachie, W. A., Stuermer, D. H., Wang, F. T. and Koszykowski, R. F. (1982). *In* "Atomic and Nuclear Methods in Fossil Energy Research" (Filby, R. H., ed.). Proc. Topical Conf. Am. Nuclear Soc., Am. Chem. Soc., Dec. 1980, Mayaguez, Puerto Rico. Plenum, New York.
John, M. K., Chuah, H. H. and Van Laerhoven, C. J. (1972). *Environ. Sci. Tech.* **6**, 555–557.
Jones, J. S. and Hatch, M. B. (1945). *Soil Sci.* **60**, 277–288.
Kaakinen, J. W., Jorden, R. M., Lawasani, M. H. and West, R. E. (1975). *Environ. Sci. Technol.* **9**, 863–869.
Kabata-Pendias, A. and Gondek, B. (1978). *In* "Trace Substances in Environmental Health, XII" (Hemphill, D. D., ed.), pp. 523–531. University of Missouri, Columbia.
Klein, D. H. (1972). *Environ. Sci. Tech.* **6**, 560–562.
Klein, D. H. and Russell, P. (1973). *Environ. Sci. Tech.* **7**, 357–358.
Klein, D. H., Andren, A. W., Carten, J. A., Emery, J. F., Feldman, C., Fulkerson, W., Lyon, W. S., Ogle, J. C., Talim, Y., Van Hook, R. I. and Bolton, N. (1975). *Environ. Sci. Technol.* **9**, 973–979.
Knizhnikov, V. A. and Barkhudarov, R. M. (1975). *Atom. Ener. Rev.* **13**, 171–214.
Kurian, G. T. (1979). "The Book of World Rankings", p. 430. Facts on File, NY.
Låg, J. and Bølviken, B. (1974). *Norges Geol. Under. Bull.* **23**, 304, 73–96.
Lagerwerff, J. V. and Specht, A. W. (1970). *Environ. Sci. Technol.* **4**, 583–586.
Lagerwerff, J. V., Brower, D. L. and Biorsdorf, G. T. (1972). *In* "Trace Substances in Environmental Health, VI" (Hemphill, D. D., ed.), pp. 71–78. University of Missouri, Columbia.
Lee, R. E. and Von Lehmden, D. J. (1973). *J. Air Poll. Cont. Assoc.* **23**, 853–857.
Levinson, A. A. (1974). "Introduction to Exploration Geochemistry". Applied Publishers Ltd, Calgary.
Linzon, S. N., Chai, B. L., Temple, P. J., Pearson, R. G. and Smith, M. L. (1976). *J. Air Poll. Control Assoc.* **26**, 650–654.
Little, P. and Martin, M. H. (1972). *Environ. Pollut.* **3**, 241–254.
Marsden, E. (1959). *Nature, Lond.* **183**, 924–925.
Marten, G. C. and Hammond, P. B. (1966). *Agron. J.* **58**, 553–554.
Mattigod, S. V. (1980). "Separation and Identification of Compounds in Fly Ash". Rept. Kearney Foundation of Soil Science.
Mattigod, S. V. and Sposito, G. (1979). *In* "Chemical Modeling in Aqueous Systems" (Jenne, E. A.,

ed.), pp. 837–856. ACS Symposium Series No. 93. American Chemical Society, Washington, DC.

Mattigod, S. V. *et al.* (1981). *In* "Chemistry in the Soil Environment" (Stelly, M., ed.), pp. 203–221. ASA Special Publication No. 40. Am. Soc. Agronomy, Soil Sci. Soc. Am., Madison.

McBride, J. P., Moore, R. E., Witherspoon, J. P. and Blanco, R. E. (1978). *Science* **202**, 1045–1050.

McDuff, R. E. and Morel, F. M. M. (1974). "Description and Use of Chemical Equilibrium Program REDEQL2". Tech. Rept. EQ-73-02. California Institute of Technology, Pasadena, California.

Megumi, K. and Mamuro, T. (1977). *J. Geophy. Res.* **82**, 353–356.

Miesch, A. T. and Huffman, C. (1972). *In* "Helena Valley, Montana Area Environmental Pollution Study", pp. 65–80. USEPA, Publ. AP-91.

Miller, R. H., Logan, T. J., White, R. K., Lynn Forster, D. and Stitzlein, J. N. (1979). "Ohio Guide for Land Application of Sewage Sludge". Res. Bull. 1079 (Rev.) OARDC. Wooster, Ohio.

Moore, H. E., Martell, E. A. and Poet, S. E. (1976). *Environ. Sci. Technol.* **10**, 586–591.

Morel, F. M. M., McDuff, R. E. and Morgan, J. J. (1973). *In* "Trace Metals and Metal-Organic Interactions in Natural Waters" (Singer, P. C., ed.), pp. 157–200. Ann Arbor Science, Ann Arbor, Michigan.

Mulford, F. R. and Martens, D. C. (1971). *Soil Sci. Soc. Am. Proc.* **35**, 296–300.

Mulla, D. J., Page, A. L. and Ganje, T. J. (1980). *J. Environ. Qual.* **9**, 408–412.

Munshower, F. F. (1977). *J. Environ. Qual.* **6**, 411–413.

Natusch, D. F. S., Bauer, C. F., Matusiewicz, H., Evans, C. A., Baker, J., Loh, A., Linton, R. W. and Hopke, P. K. (1975). *In* "Proceedings of International Conference on Heavy Metals in the Environment, Toronto, Canada", vol. II, Part 2, pp. 553–575. Univ. of Toronto, Toronto.

Navrot, J. and Singer, A. (1976). *Soil Sci.* **121**, 337.

Nordstrom *et al.* (1978). *In* "Chemical Modeling in Aqueous Systems" (Jenne, E. A., ed.), pp. 857–892. ACS Symposium Series No. 93. American Chemical Society, Washington, DC.

Nriagu, J. O. (1978). *In* "The Biogeochemistry of Lead in the Environment" (Nriagu, J. O., ed.), Part A, pp. 16–72. Elsevier/North-Holland Biomedical Press, Amsterdam.

Olson, K. W. and Skogerboe, R. K. (1975). *Environ. Sci. Tech.* **9**, 227–230.

Ondov, J. M., Ragaini, R. C., Heft, R. E., Fisher, G. L., Silberman, D. and Prentice, B. A. (1976). *In* "8th Mat. Res. Symp. Meth. and Standards for Env. Meas". Gaithersberg, Maryland.

Page, A. L. (1974). "Fate and Effects of Trace Elements in Sewage Sludge When Applied to Agricultural Lands—A Literature Review Study". US Environment Protection Agency.

Page, A. L. and Ganje, T. J. (1970). *Environ. Sci. Tech.* **4**, 140–142.

Page, A. L., Elseewi, A. A. and Straughan, I. R. (1979). *Res. Rev.* **71**, 83–120.

Parker, F. D. R., Sharma, R. P. and Miller, G. W. (1978). *In* "Trace Substances in Environmental Health, XII" (Hemphill, D. D., ed.), pp. 340–350. University of Missouri, Columbia.

Pavan, M. A. (1981). "Toxicity of Al(III) to Coffee (Coffea arabica L.) in Nutrient Solution Culture and in Oxisols and Ultisols Amended with $CaCO_3$, $MgCO_3$, and $CaSO_4 \cdot 2H_2O$". Ph.D. Dissertation, University of California, Riverside.

Phelps, P. L. and Anspaugh, L. R. (eds) (1976). "Imperial Valley Environmental Project Progress Report". Lawrence Livermore Lab. UCRL-50044-76-1.

Phung, H. T., Lund, L. J. and Page, A. L. (1978). *In* "Environmental Chemistry and Cycling Processes" (Adriano, D. C. and Brisbin, I. L., eds), pp. 504–515. CONF 760429, U.S.D.C. Springfield, Virginia.

Plank, C. O. (1974). "The Effect of Fly Ash Application of the Nutrient Supplying Capacity of Soils, Crop Yields, and Chemical Properties of Displaced Soil Solutions". Ph.D. Thesis. Virginia Polytech. & State Univ. University Microfilms, Ann Arbor.

Ragaini, R. C., Ralston, H. R. and Roberts, N. (1977). *Environ. Sci. Tech.* **11**, 773–781.

Ritchie, J. C., McHenry, J. R. and Gill, A. C. (1974). *Ecology* **55**, 887.

Roberts, T. M., Hutchinson, T. C., Paciga, J., Chattopathyay, A., Jervis, R. E., VanLoon, J. and Parkinson, D. K. (1974). *Science* **186**, 1120–1123.

Runnels, R. T. and Schleischer, J. A. (1956). "State Geological Survey of Kansas", Bulletin 119, Part 3, pp. 81–103.

Russell, R. S. (1966). "Radioactivity and Human Diet". Pergamon Press, Oxford.

Sand, P. F., Wiersma, G. B., Tai, H. and Stevens, L. J. (1971). *Pestic. Mont. J.* **5**, 32–33.
Schuffelen, A. C., Koenigs, F. F. R. and Bolt, G. H. (1964). "Proceedings of 8th International Congress on Soil Science, Bucharest, Romania", Vol. III, pp. 519–528. Academy of the Socialist Republic of Romania, Bucharest, Romania.
Severson, R. C. and Gough, L. P. (1976). *J. Environ. Qual.* **5**, 476–482.
Simons, H. S. and Jeffrey, J. W. (1960). *J. Appl. Chem.* **10**, 328–336.
Smith, P. F. (1962). *Ann. Rev. Pl. Phy.* **13**, 81–108.
Soltanpour, P. N., Khan, A. and Lindsay, W. L. (1976). *Comm. Soil Sci. Pl. Anal.* **7**, 797–821.
Sposito, G. and Bingham, F. T. (1981). *J. Pl. Nutr.* **3**, 35–49.
Sposito, G. and Mattigod, S. V. (1980). "GEOCHEM: A Computer Program for the Calculation of Chemical Equilibria in Soil Solutions and Other Natural Water Systems". Kearney Foundation of Soil Science, University of California, Riverside.
Sposito, G., Page, A. L. and Mattigod, S. V. (1979). "Trace Metal Speciation in Saline Waters Affected by Geothermal Brines". Kearney Foundation of Soil Science, University of California, Riverside.
Sposito, G., Page, A. L. and Frink, M. E. (1980). "Effects of Acid Precipitation on Soil Leachate Quality—Computer Calculations". Environmental Research Laboratory, US Environment Protection Agency, Corvallis.
Stumm, W. and Bilinski, H. (1973). *In* "Advances in Water Pollution Research", Proceedings of 6th Int. Conf. (Jenkins, S. H., ed.), pp. 39–52. Pergamon Press, Oxford.
Swaine, D. J. (1962). "The Trace-Element Content of Fertilizer". Commonwealth Agricultural Bureau, Farnham Royal, Bucks, England.
Temple, P. J., Linzon, S. N. and Chai, B. L. (1977). *Environ. Pollut.* **12**, 311–320.
Torrey, S. (1979). "Sludge Disposal by Land Spreading Techniques". Noyes Data Corp., New Jersey, USA.
Van Hook, R. I. (1978). "Potential Health and Environmental Effects of Trace Elements and Radionuclides from Increased Coal Utilization", p. 54. ORNL-5367, Oak Ridge National Laboratory.
Walsh, T., Gleming, G. A., O'Connor, R. and Sweeney, A. (1951). *Nature, Lond.* **168**, 881.
Ward, N. I., Brooks, R. R. and Reeves, R. D. (1974). *Environ. Pollut.* **6**, 149–158.
Watt, J. D. and Thorne, D. J. (1965). *J. Appl. Chem.* **15**, 585–594.
Webb, J. S., Thornton, I., Howarth, R. J., Thompson, M. and Lowenstein, P. L. (1978). "The Wolfson Geochemical Atlas of England and Wales". Oxford University Press, Oxford.
White, D. E. (1968). *Econ. Geol.* **63**, 301–335.
Williams, C. H. and David, D. J. (1973). *Aust. J. Soil Res.* **11**, 43–56.
Williams, C. H. and David, D. J. (1976). *Soil Sci.* **121** (2), 86–93.
Wolfenden, E. B. (1965). *Geochim. Cosmochim. Acta* **29**, 1051–1062.

13

Assessment of Metal Pollution in Rivers and Estuaries

ULRICH FÖRSTNER

I. Introduction

The introduction of waste products into rivers and estuaries, especially those in industrial and population centres of Europe, North America and Japan, has led to a significant increase in metal contamination. (A comparison of the consumption rates of heavy metals with the natural concentrations of the respective elements in rocks, soils and sediments, i.e., "the index of the relative pollution potential" (Förstner and Müller, 1973) or "the technophility index" (Nikiforova and Smirnova, 1975), indicates that particularly large man-made enrichments can be expected for Pb, Hg, Cd, Zn and Cu in the environment.) Many metals taking part in this process are toxic (see, for example, the compilation by Friberg *et al.*, 1979). In several instances the metal enrichment surpasses that of the natural environments many times over: the level of Hg, Cd and Zn in organisms are 10–100 times greater in polluted inland and coastal waters than those in less contaminated areas (Bryan, 1976). A similar increase above "normal" levels of these and other metals was established in water samples from polluted rivers such as the lower Rhine River (Förstner, 1981a,b)—even higher concentrations were observed in waters mining areas (see Chapter 14). Also, sediment samples taken from streams and marine coastal areas during the last centuries reveal an increase that is in many cases exponential (Salomons and De Groot, 1978).

On this basis, it is obvious that problems are going to arise for the coastal fishing industry and for the use of rivers as potable water supplies. Studies of mussels and fish from European and North American estuaries have indicated

APPLIED ENVIRONMENTAL GEOCHEMISTRY
ISBN 0-12-690640-8

a significant rise in Hg levels which can undoubtedly be attributed to excessive contamination, for example, from waste dumping, river-borne pollutants and atmospheric inputs (De Wolf, 1975; Krüger et al., 1975; Bourget and Cossa, 1976). Oyster rearing in rivers and estuaries is adversely affected by a strong increase of Cd, Hg and Zn (Thrower and Eustace, 1973; Thornton et al., 1975; Ayling, 1977). In several European population centres it is becoming increasingly difficult to apply conventional and economical procedures for providing drinking water supplies, such as bank filtration and artificial recharge, owing to, among others, the potential danger of metal contamination from surface waters (Kölle et al., 1971).

At the same time as the increase in metal concentrations, there has been an increase in the extent of polluted sediments and other materials through the closing of lagoons, the extension of harbour areas, the deepening of navigation channels and the channelling of rivers. Dredging activities result in large amounts of contaminated sediments (approximately 400 m³ per year in US inland and coastal waters), for which safe disposal areas on land or in the aquatic environment have to be found (Windom, 1976). Other problems caused by the presence of metals in dredged materials arise in the agricultural sector and in respect to the protection of the groundwater (Engler, 1980).

Methods of investigating the metal loads in the aquatic system differ according to the various aims of such investigations. They range from an inventory of metal concentrations in the various sampling media through the search for the origin of increased loads to the question of ecotoxicity of dissolved metals and/or the compatibility of metal-contaminated substances in the environment. These data are partially interpreted on the basis of standard values, for example, water quality criteria. Generally, however, complicated interrelations are found within the aquatic ecosystem, which are only partially researched.

Owing to the large quantity of data that have been produced on this subject in the last 10 years, it is necessary to concentrate on a few characteristic examples in this chapter. Detailed information, surveys and literature compilations are found in Hemphill (1967–83), Leland et al. (1974–78), Hutchinson (1975), Krenkel (1975), Nriagu (1978, 1979a, 1979b, 1980a, 1980b, 1980c), Förstner and Wittmann (1979), Bowen (1979), Perry (1979), Ernst (1981), Müller (1983), Salomons and Förstner (1983), and many other publications.

II. Pollution assessment in waters and sediments

1. Water

The most obvious medium in which to assess, monitor and control metal pollution is surface water, since data are then directly related to potentially

toxic effects in organisms. However, it has been established that in river waters there are strong fluctuations in trace metal concentrations that are attributable to many variables, such as daily and seasonal variations in water flow, surreptitious local discharges of effluent, changing pH and redox conditions, the input of treated secondary sewage, detergent levels and temperature.

Major difficulties arise from inadequate sampling, storage and analysis procedures. It has been argued that many of the earlier data on dissolved heavy metal contents in seawater are on the whole too high (Patterson and Settle, 1976); probably similar problems also exist in fresh and estuarine waters and "it is safe to assume that many of the natural water values quoted in the literature are high solely for reason of contamination during sampling and analysis" (Martin *et al.*, 1980).

An example of the distribution of metals in estuarine waters is given in Fig. 13.1. The concentration of Cd in the Bristol Channel is higher than the range of Cd values found in coastal waters of the Irish Sea; levels reach 4 μg l^{-1} (about 50 times greater than that of the open sea levels), and even higher in the eastern part of the Channel. The Cd is possibly entirely of industrial origin, entering

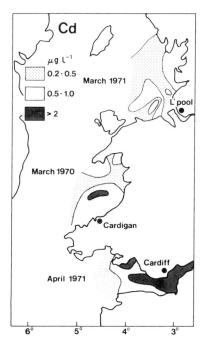

Fig. 13.1 Enrichment of Cd in water of the Irish Sea derived from industrial, domestic and mine waste effluents (from Abdullah *et al.*, 1972).

the Bristol Channel from the Avon and Severn Estuary. Runoff from mineralized zones and sites of former mining activity is the main source of trace metals in Cardigan Bay which is relatively free from industrial effluent and, because of a low population density, from domestic waste. This example shows that such measurement procedures can pin-point significant point sources of metal pollution as well as sources of a regional origin.

It should be noted that not only is the abundance of a particular metal constituent of importance, but also its availability in the form of solubilized species. Organic ligands, such as fulvic acid, NTA and EDTA, can inhibit the uptake of metals and thus may raise the toxic threshold (Andrew et al., 1976). For most heavy metals, such as Cu, it seems that free-ion activity is a good indicator of toxicity to phytoplankton (Jackson and Morgan, 1978), and probably to other organisms. On the other hand, organic complexing may enhance toxicity, as is demonstrated by the examples of mercury-alkyl compounds (Wood, 1974). The determination of specific single metal forms or associations is therefore important in such cases. A batch method for determining ion exchangeable trace metals in neutral waters has been described by Hart and Davies (1977).

2. Indicator organisms

Biomonitoring of metal pollution has been given ever-increasing attention owing to the ability of various marine and freshwater organisms to accumulate trace elements (Bryan, 1976). Phillips (1977) has proposed that the best studied indicator types to date are bivalve molluscs and macroalgae. Among the former group, "*Mytilus edulis* may be the most appropriate candidate for experimentation because of its extensively studied physiology, its worldwide distribution in temperate waters and the amount of accumulated knowledge concerning its uptake of metals and its metal content in various waters". The International Environmental Program Committee (IEPC) has endorsed the practical "Mussel Watch" program, which entails the analysis of specimens from some 100 open ocean and coastal sites worldwide (Goldberg, 1975, 1978). Metal accumulation by aquatic bryophytes from polluted mine streams was studied by Whithead and Brooks (1969), MacLean and Jones (1975) and Burton (1979). Since analysis of algae mainly reflects accumulations that occur during a limited period of growth, it would appear that they are potentially suitable indicators of localized, short-term pollution effects.

Analysis of microphytes has been proposed for monitoring heavy metals in freshwaters (Mayes and McIntosh, 1975). Williams and Coffee (1975) used a technique of packing organic material (commercial "dogfood") in perforated polythene bags for determining trace levels of radionuclides.

Table 13.1 Cadmium concentrations in water, seaweeds, limpets and dog whelks of four collecting stations on the southern side of Severn Estuary and Bristol Channel (after Butterworth et al., 1972)

Collecting station	Distance from Avonmouth	Seawater (μg Cd l^{-1})	Fucus (mg Cd kg^{-1})	Patella (mg Cd kg^{-1})	Thais (mg Cd kg^{-1})
Portishead	4 km	5.8	220	550	n.a.
Brean	25 km	2.0	50	200	425
Minehead	60 km	1.0	20	50	270
Lynmouth	80 km	0.5	30	50	65

Exemplary investigations performed by Butterworth et al. (1972) in the Severn Estuary are chosen here to demonstrate the effects of pollution on metal concentrations in aquatic organisms (Table 13.1). Above normal amounts of Cd in the water samples from this area are shown in Fig. 13.1; they are apparently transmitted to the living material inhabiting the shore—at relatively low levels in seaweed *Fucus* (producer), at higher levels in the limpet *Patella* (primary consumer) and greatest concentrations in the dog whelk *Thais* (secondary consumer of polluted organisms).

Although this type of metal amplification at higher trophic levels has not been generally confirmed for most metals (except for Hg, as reported by Prosi, in Förstner and Wittmann, 1979), it appears reasonable for sampling and subsequent analysis to investigate organisms that have especially high rates of metal enrichment.

3. Suspended matter and sediments

Aquatic solids are composed of a mixture of material inputs from different sources, including eroded rocks and soils, sewage and solid waste particles, atmospheric fallout and autochthonous formations in the aquatic system, for example inorganic precipitates, biogenic matter, adsorbates on particles from solution, complexed and colloidal matter. For the methological aspects, it is important to note that heavily contaminated river sediments sometimes contain up to 30% sewage particles and more (Hellmann, 1972).

Sediment analysis can be particularly useful in detecting pollution sources and in the selecting of critical sites for routine water sampling for contaminants that, on discharge to surface waters, do not remain solubilized but are rapidly adsorbed by particulate matter and may thus escape detection by water analyses. During periods of reduced flow rates, suspended material settles to the bed of the river, lake or sea, becoming partly incorporated into

the bottom sediment. With lateral distribution analyses (quality profiles), local sources of pollution can be determined and evaluated. Vertical sediment profiles (cores) also are useful, because they often uniquely preserve the historical sequence of pollution intensities, and at the same time enable a reasonable estimation of the background levels and the variations in input of a pollutant over an extended period of time (Förstner, 1976). The latter approach is particularly useful if the rate of sedimentation is known (for instance, from radiochemical dating with ^{137}Cs and ^{210}Pb; Krishnaswami and Lal, 1978).

New aspects of research into sediments relate to the fact that the sediments with their contaminants are in a constant interrelation with the liquid phases and organisms; this means that the sediments themselves represent another environmental contaminant. Important problem areas with regard to the presence of contaminated sediment in the environment are discussed in Salomons and Förstner (1980):

(i) the potential availability of the contaminants in the sediments for aquatic life;
(ii) the behaviour of contaminants in dredged material during and after disposal in dumping areas, mainly with respect to potential pollution of groundwater;
(iii) the uptake of contaminants by plants from polluted sediments on agricultural land.

To assess the environmental impact of contaminated sediments, information on total concentrations alone is not sufficient. Of particular interest is the pollutant fraction in the sediments that may take part in short-term biogeochemical processes. The two aims of sediment studies are primarily:

(i) the identification, monitoring and control of pollution sources;
(ii) the estimation of the possible effects of polluted sediments. These may vary in respect to sampling, preparation of samples and analytical procedures. The following section deals with both points, and includes characteristic examples.

III. Sediment studies

1. Sample preparation

(a) Sampling, processing and analysis

Sampling procedures for *source reconnaissance analysis* are described by Förstner and Salomons (1980). Surface bottom sediments are usually taken with a grab sampler of the Van Veen or Ekman–Birge type from a depth of

15–20 cm. Material of the upper, flakey, light brown, oxidized layer is generally dissimilar to the layers below it. It is suggested that the chiefly dark layers directly underneath (ca. 1–3 cm depth) are more representative of the pollution situation over the last few years, especially in river deposits exhibiting rapidly fluctuating sedimentation rates, and should be given priority for subsequent investigations. To complement this, surface sediment (current contamination) as well as a sample from deeper sections (10–20 cm depth) could be examined. In environments with a relatively uniform sedimentation, for example in lakes and in marine coastal basins, where the deposits are fine-grained and occur at a rate of 1 to 5 mm yr^{-1}, a more favourable procedure involves the taking of vertical profiles with a piston corer. A core profile of approximately 1 m covers a historical period of at least 200 years, and its development can be traced by virtue of the metal content in the individual layers. Suspended sediments are recovered by filtration, continuous-flow centrifugation or by sediment traps. In rivers, water discharge rates must be known and sampling frequently repeated.

Sediment collection and processing for selective extraction (see Section III.3(c)) and for total trace element analyses has been described in detail by Jenne *et al.* (1980), from which the following is extracted.

(i) *Suspended sediment.* If amounts of suspended sediment and associated trace elements are to be calculated, a representative suspended sediment sample must be taken by using a depth-integrating sampling procedure, for which any rubber parts of the sampling equipment are replaced by silicone ones, and exposed metal coated with a suitable plastic or replaced with Teflon (ASCE, 1969; USGS, 1972). A 0.1 µm membrane will normally separate the particulate and dissolved phases effectively enough to provide valid data for thermodynamic geochemical calculations, whereas the 0.45 µm membrane may not, mainly with respect to Al, Fe and Mn (Kennedy *et al.*, 1974). Metals such as Cu, Zn and Mn can be leached from filter membranes in sufficient quantities to contribute > 1 µg l^{-1} to the initial portion of the filtrate if the membranes are not adequately preleached (Zirino and Healy, 1971; Watling and Watling, 1975). A related problem that can arise during filtration is the loss of trace elements from solution due to sorption onto the filter membranes (Kennedy *et al.*, 1979). Filtration time can be reduced by using backflushing filters (Kennedy *et al.*, 1976).

(ii) *Bed sediments.* Fewer bed sediment samples than those of water or suspended sediments may be sufficient to obtain a reliable estimate of the trace metal concentration of a river cross-section. Samples from recently deposited bed sediment should be taken from 5 or more equidistant points across the stream and from a depth of approximately 1–2 cm. Anoxic sediments that

require different sample preservation techniques such as oxygen exclusion and freezing should be avoided. [This seems to contradict our earlier data (Förstner and Salomons, 1980) and will therefore remain controversial. However, one should consider that the later application of "selective" extraction procedures generally applied to (potential) dredged sediments—that is, to samples that are representative for the total deposit in a certain section of river, thereby including also deeper sediment layers.] If total analyses or strong acid digestion is planned, the sediment is dried at 60°C, crushed and stored; for mass calculation, reweighing after drying at 110°C may become necessary.

(iii) *Extraction of pore waters.* Interstitial waters are recovered from sediments by leaching, centrifugation or squeezing; oxidation must be prevented during these procedures. *In situ* methods are considered most promising, particularly for studies on the sediment–water interface. A technique described by Mayer (1976) consists of placing a dialysis bag with distilled water into the sediment and allowing equilibration to take place between the inserted and ambient water over a period of some 7–8 h at 25°C. Vessels covered by dialysis membranes can be inserted in close intervals (1 cm) for the analysis of concentration gradients near the sediment surface (Hesslein, 1976).

(iv) *Sediment digestion.* Except for direct measurements on solid matter, for example, by neutron activation analysis or X-ray fluorescence spectroscopy, it is necessary to bring the metals into solution for analysis. Complete digestion usually is performed with hydrofluoric acid (for dissolution of silicates) combined with perchloric acid, sulphuric acid or nitric acid. Numerous studies have shown that aqua regia (HNO_3–HCl, 1:3) or conc. nitric acid decomposition of sediments is sufficient for trace metal analysis. It has been suggested that for the present type of study, it is not necessary to obtain full digestion of all sediment components including detrital minerals, since the pollution effects usually are associated with the surface of the sediment particles including their inorganic and organic coatings. Simple HCl–HNO_3 (1:1) digestion has therefore been proposed for the determination of trace metals by atomic absorption spectroscopy (Anderson, 1974). Leaching techniques with dilute acids will be described in Section III.1(c).

(iv) *Analysis of metals.* A comparison of costs and characteristics of some commercially available trace analytical instrumental methods is given by Nürnberg (1979).

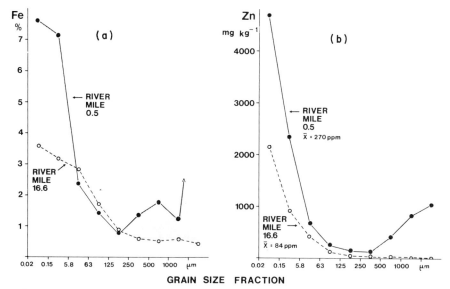

Fig. 13.2 Concentrations of (a) Fe and (b) Zn by particle size for sediments from two sampling stations (river mile 16.6 upstream, river mile 0.5 downstream urban area) of the Saddle River near Lodi, New Jersey (after data from Wilber and Hunter, 1979).

(b) *Grain size effects*

Two effects must be considered when sediment analyses are used for the identification of pollution sources. Firstly, under conditions of high water discharge erosion of the river bed takes place and generally leads to a lower degree of local contamination (Schleichert, 1975). (For brief periods during the initial stages of storm runoff there is often a significant increase in the metal concentration in solution, which can be explained as a flushing effect; Grimshaw *et al.*, 1976.)

Secondly (a fact often overlooked) it is imperative to base metal analyses, particularly those from river sediments, on a procedure that provides for particle size.

In examples from the Saddle River presented in Fig. 13.2, the grain size dependencies of heavy metals are compared between samples taken upstream and downstream of an urbanized area at Lodi (New Jersey). In the less contaminated material (for example, from river mile 16.6), a general decrease of metal concentrations is found with increasing particle diameter. In the polluted material there is a typical increase of metal concentrations in the clay and silt fractions; it is conceivable that the metal enrichment is due to organic matter not removed during sewage treatment processes. A characteristic feature of the polluted sediments (for example, from river mile 0.5) is the increase of metal concentrations (except for Mn) in the medium and coarse sand fractions, particularly significant for Pb, Cu, Ni, Cr, Cd and Zn (Fig. 13.2,

right), but also evident for Fe (Fig. 13.2, left). This is probably due to the input of coarse waste particles. Wilber and Hunter (1979) have argued that since the larger sediment fractions are least affected by scour and transport, they may best reflect the effect of urbanization on the distribution of heavy metals over an extended period of time at a given location.

Be that as it may, the fine sand fractions (approximately 20–200 μm) seem to be of particular interest, firstly because they comprise most of the total sediment, and secondly because they show the most obvious differences between individual metals: the concentrations of Fe, for example, are similar in both the strongly polluted and less-polluted sediments (Fig. 13.2, left), whereas the typical "anthropogenic" metals, Pb, Cr and Zn, are significantly enriched in these intermediate grain size fractions of the polluted material. Since, however, considerable variations are found for the individual metals even within this grain size range, a generally acceptable basis for comparison is not possible. [In addition, it should be noted that the mechanical fractionation will not accurately separate individual particles according to their size; the deposition of "coatings" (Fe–Mn oxyhydrates, carbonates and organic substances) in relatively inert (with respect to heavy metals) materials such as quartz grains is one of the major reasons for the still relatively high contents of trace metals in the medium-sized sediment fractions.]

Different methods for grain size corrections are compiled in Table 13.2 (after De Groot et al., 1976; Förstner and Wittmann, 1979; Förstner and Salomons, 1980). These methods will reduce (not eliminate) the effect of the fraction of the sediment that is largely chemically inert, including mostly the coarse-grained quartz, feldspar and carbonate minerals, and will increase the substances active in metal enrichment, such as hydrates, sulphides, amorphous and organic materials. In the assessment of metal pollution at a specific locality, the extrapolation techniques both for grain size and specific surface areas of the material require many (10–15) samples. In addition, the calculation of the regression line is a time-consuming and inaccurate procedure. It is often not possible to determine the regression line owing to the limited range in grain size or specific surface area of the sediment at a certain locality. The quartz correction method in some cases has to be extended to dilution effects caused by feldspar, carbonates and opaline silica (Salomons and Mook, 1977; Chester, 1978). Normalizing anthropogenic metal concentrations to the concents of "conservative" elements such as Al and K, thus on the percentage of clay minerals, has one major disadvantage in that it gives a ratio value instead of absolute concentration data. But it can be attempted to standardize the contents to a standard material (e.g., average shale), defining the enrichment factor, e.g. of element "i" in the sample as the concentration ratio of "i" to Al (C_i/C_{Al}) compared with the ratio in the standard material. The method based on the separation of grain size is advantageous because only few samples from a particular locality are needed. However, separation of the

Table 13.2 Reduction of grain size effects (from Förstner and Salomons, 1980)

Separation of grain size fractions	
204 μm	Thornton *et al.* (1975)
175 μm	Vernet and Thomas (1972)
63 μm	Allan (1971)
53 μm	Loring and Rantala (1977)
20 μm	Ackermann (1980)
	Jenne *et al.* (1980)
2 μm	Banat *et al.* (1972)
	Helmke *et al.* (1977)
Extrapolation from regression curves	
Specific surface area	Oliver (1973)
% < 63 μm	Smith *et al.* (1973)
% < 20 μm	Lichtfuß and Brümmer (1977)
% < 16 μm	De Groot *et al.* (1971)
Correction for "inert" minerals	
Metals in quartz-free sediment	Thomas (1972)
Carbonate/quartz-free sediment	Salomons and Mook (1977)
Comparison with "conservative" elements	
Ratio element X/Al	Bruland *et al.* (1974)
Sediment enrichment factor	Kemp *et al.* (1976)

fraction of less than 2 μm in settling tubes is time-consuming (the re-mobilization of metals, as has sometimes been suspected, is relatively low; Jenne *et al.*, 1980). The fractions less than 173 μm and 204 μm contain considerable percentages of large grains that are usually low in trace metals. Therefore, the fraction < 63 μm is recommended for the following reasons (Förstner and Salomons, 1980):

(i) trace metals have been found to be present mainly in clay–silt particles;
(ii) this fraction is most nearly equivalent to the material carried in suspension (the most important transport mode of sediments by far);
(iii) sieving does not alter metal concentrations, particularly when water of the same system is used;
(iv) numerous metal studies have already been performed on the < 63 μm fraction allowing better comparison of results.

However, Ackermann (1980) has effectively argued in favour of the application of the < 20 μm fraction from estuary sediments; he contends that better correlation with "conservative elements" such as Cs, Rb and Se, as well as a relatively high percentage of this fraction in these deposits can be attained.

(c) *Initial survey of the man-induced metal fraction*

The assessment of both sources and environmental effects of trace metals in particulate matter must predominantly consider the most mobile fraction of

these elements, which is that introduced by man's activities and bound to the sediment in sorbed, precipitated or co-precipitated (carbonates and hydrous Fe–Mn oxides) and organically complexed forms. Goldberg (1954) suggested that a large portion of the "hydrogenous" metal fraction in recent sediments can be dissolved by specific attack with dilute acids; a residue of relatively inertly bound metals from the natural rock and soil detritus ("residual fraction") can be found predominantly in the coarser grain sizes. The metal data thus obtained by acid extraction should compare favourably with data from the separation of the fine-grained fraction of sediments (see above).

Studies by Cross *et al.* (1970) on the distribution of Mn, Fe and Zn in sediments of the Newport River Estuary, North Carolina, and by Gross *et al.* (1971) on marine waste deposits of the New York Metropolitan Region were among the first to consider the *chemical fractionation* of non-detrital/residual bound metals in polluted sediments by extraction with 0.1 M and 1 M hydrochloric acid, respectively. In more recent studies other acids or acid concentrations have come into use for the general differentiation of metal species associated with hydrous oxides, carbonates, sulphides and surficially sorbed materials from the residual fraction, for example, 0.1 M nitric acid (Jones, 1973), 0.3 M hydrochloric acid (Malo, 1977), 0.5 M HCl (Agemian and Chau, 1976) and dilute (25%) acetic acid (Loring, 1975), as well as the chelators EDTA (ethylenediaminetetra-acetic acid) and DTPA (diethylenetriamine-penta-acetic acid) commonly used in soil research (Gambrell *et al.*, 1977). Procedures for assessing the potential availability of particle-associated trace metals will be given in Section III.3(c) under sequential chemical extraction.

A practical example of this type of study is the initial assessment of trace metal pollution in surface sediments from two Greek gulfs by Chester and Voutsinou (1981) illustrated for Cd in Fig. 13.3. The technique proposed by Chester and co-workers involved the leaching of the samples with cold 0.5 M hydrochloric acid and has been shown to "provide a rapid, inexpensive way of establishing the gross degree to which a sediment population has been subjected to trace metal pollution from the overlying waters". In this illustration it is evident that the highest non-residual concentrations of Cd (and Pb, Zn) are found in sediments around Salonika and the industrialized area of the northern Thermaikos gulf, in particular in the region of the outflow of the Axios River, which drains an industrialized catchment area.

2. Assessment of pollution sources and intensities

(a) *Background concentrations*

To determine the extent of pollution in an aquatic system by means of the heavy metal load in sediments, it is of primary importance to establish the

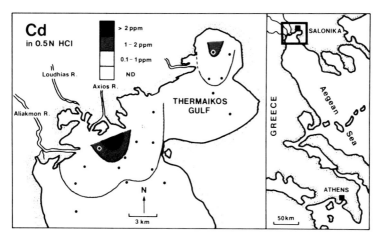

Fig. 13.3 The distribution of 0.5 M HCl extractable Cd in the surface sediments of the Gulf of Thermaikos (Greece) (from Chester and Voutsinou, 1981).

natural level of these substances, i.e., the "pre-civilization" level, and then subtract it from existing values for metal concentrations in order to derive the total enrichment caused by anthropogenic influence.

To obtain an ideal comparative basis for environmental studies the following criteria should be fulfilled, so as to achieve representative values for metal concentrations: many sediment samples must be analysed which correspond with recent deposits in their (i) grain size distribution, (ii) material composition and (iii) conditions of origin. A fourth criterion is that the samples must be uncontaminated by civilizational influences.

Several possibilities have been suggested to establish background values for trace metals (Förstner and Wittmann, 1979):

(i) average shale composition as a global standard value;
(ii) fossil aquatic sediments from defined environments as a standard, taking into account natural allochthonous and autochthonous factors and mechanisms as well as regional influences;
(iii) recent deposits in relatively unpolluted areas; and
(iv) short, dated sedimentary cores, which provide a historical record of events occurring in the watershed of a particular river or estuary. These would enable an estimation of both the background levels and the changes in input of an element over an extended period of time. Sedimentary core analysis involving simultaneous determination of younger and older deposits shows significant advantages over a consecutive measurement of pollutants on samples taken from the same locations at different times (Schoer and Förstner, 1980).

Table 13.3 Average concentrations (mg kg^{-1}) of metals in shales (Turekian and Wedepohl, 1961) and in fossil and recent freshwater sediments

Metal	Average "shale"	Fossil Rhine sediments[a]	Recent lake sediments mostly from remote areas[b]	
			Median	Range (90% of data)
Fe	47 700	32 350	43 400	11 500–67 300
Mn	850	960	760	100–1800
Zn	95	115	118	50–250
Cr	90	47	62	20–190
Ni	68	46	66	30–250
Cu	45	51	45	20–90
Pb	20	30	34	10–100
Co	19	16	16	4–40
Hg	0.4	0.2	0.35	0.15–1.50
Cd	0.3	0.3	0.40	0.10–1.50

[a] Arithmetic mean of 4 values (Förstner and Müller, 1974). Fraction <2 μm.
[b] Median of 87 values (Förstner, 1981b). Fraction <2 μm.

Table 13.3 gives a compilation of background concentrations for heavy metals evaluated using methods (i) to (iii). The data correspond relatively well except for Cr, which seems to be affected in the shale composition where a higher percentage of examples is influenced by basic rocks. For example, a strong enrichment of Co, Ni and Cr (by factors of ten or more) has been found in recent lake deposits of the ultra-basic ("Greenstone") belt around Kalgoorlie, Western Australia (Förstner, 1977b). Geothermal Hg "pollution" by fumarolic emanations was determined in river and lake sediments of New Zealand (Hoggins and Brooks, 1973; Weissberg and Zobel, 1973). Contamination by Zn and Mn of trout streams in the Great Smoky Mountains National Park resulting from exposed anakeesta formations was reported by Bacon and Maas (1979). In a summary of the Hg contents in rocks, soils and stream sediments of the USA, Pierce et al. (1972) point out that values greater than 1 mg kg^{-1} Hg, as found for example in the Coeur d'Alene district (Gott et al., 1969) and in the Taylor Mountains, Alaska (Clark et al., 1970), are considered worthy of further investigation as they possibly indicate Hg mineralization processes or surface contamination by mercury-bearing wastes. The study of sediment cores is especially suited for the differentiation of natural metal enrichment, for example, in zones of mineralization and where anthropogenic effects occur as a consequence of mining and smelting activities (Allan, 1974).

(b) *Accumulation in sediments*

Reviews on the concentration of heavy metals in fluviatile (Förstner and Müller, 1976) and coastal marine sediments (Förstner, 1979, 1980) have shown that particularly high rates of enrichment are usually found for the metals Hg, Cd, Pb, Zn, Cu and Cr. In Table 13.4 a compilation is given of examples for background and maximum metal concentrations in sediments from bays, estuaries and harbours. In some highly contaminated areas the rate of metal accumulation is 2000 to 3000 fold above natural values.

A quantitative measure of the metal pollution in aquatic sediments has been introduced by Müller (1979), which he calls the "index of geoaccumulation":

$$I_{geo} = \log_2 \frac{C_n}{1.5 \times B_n}$$

where C_n is the measured concentration of the element n in the pelitic sediment fraction ($< 2\,\mu m$) and B_n is the geochemical background value in fossil argillaceous sediment ("average shale", see Table 13.3); the factor 1.5 is used because of possible variations of the background data due to lithogenic effects. The Index of Geoaccumulation consists of six grades, whereby the highest grade 6 reflects a 100 fold enrichment above the background values ($2^6 = 64 \times 1.5$). In Table 13.5, two examples of heavily polluted river systems in the Federal Republic of Germany are presented. The index values of the upper Rhine (between Basel and Mannheim, before the waters of the Neckar and Main Rivers enter the Rhine) lie at a maximum of 3 for Cd and Pb. Cd reaches the highest grade 6 in the middle section of the river and in the lower Rhine (below the mouth of the Main River to the German/Dutch border), where pollution can be traced to influents from the Neckar River and from the Ruhr area. At this location the indices for Pb and Zn rise to 4, and those for Hg, Cu and Cr each increase by one unit.

In deposits in the Hamburg harbour area, which originate from the Elbe River, the index of Cd and Hg is 6, whereas Zn and Pb have a geoaccumulation index rating of 5. The example of Elbe River sediments near Stade (given by Müller, 1980) shows a clear decrease of metal contents in estuarine sediments which is chiefly the result of an increasing mixing of heavily contaminated fluviatile sediments with less contaminated marine sediments in the tidal area (Müller and Förstner, 1975). But even here the metal contents are so high that they could be detrimental to coastal fishing, as recent press reports on Elbe eel polluted by Hg have shown.

(c) *Statistical analysis*

(i) *Correlation coefficients.* Correlation coefficients (r) derived from linear regression analysis of possible element pairs can be used for closer verification

Table 13.4 Background and maximum metal concentrations (mg kg^{-1}) in sediments from bays, estuaries and harbour areas (from Förstner, 1980)

	Ag	Cd	Cr	Cu	Hg	Pb	Zn	Reference
Background values	(0.1)[a]	(0.3)[a]	68[b]	14[b]	(0.4)[a]	13[b]	70[b]	—
Narragansett Bay (Rhode Island)	3.3[c]	3.9[c]	155	190	—	140	250	Goldberg et al. (1977)
Port Philip Bay (Victoria/Australia)	—	9.9	—	85	—	183	278	Talbot et al. (1976)
Severn Estuary (UK)	—	4.7	—	—	—	200	590	Butterworth et al. (1972)
Solent (Southampton, UK)	—	4.2	—	—	5.6	—	800	Leatherland and Burton (1974)
Rio Tinto Estuary (Spain)	—	4.1	—	1400	—	1600	3100	Stenner and Nickless (1975)
Restonguet Estuary (UK)	7	12	1060	4500	—	1620	3000	Thornton et al. (1975)
New Bedford Harbor (Mass./USA)	40	76	3200	7500	3.8	560	2300	Stoffers et al. (1977)
Corpus Christi Bay (USA)	—	130	—	—	—	—	11 000	Holmes et al. (1974)
Derwent Estuary (Tasmania/Australia)	—	862 (1400)	258	1130 (10 100)	—	1000 (11 000)	10 000 (104 000)	Bloom and Ayling (1977)
Sörfjord (Norway)	190	850	—	12 000	—	30 500	118 000	Skei et al. (1972)

[a] Average shale (Turekian and Wedepohl, 1961).
[b] Lower section (60–80 cm) of Narragansett core.
[c] Eisler et al. (1977).

Table 13.5 Geoaccumulation indices for metals in sediments from Rhine River and Elbe River

I_{geo}	I_{geo}-class	Upper Rhine[a]	Lower Rhine[b]	Elbe (Hamburg)[c]	Elbe (Stade)[d]
>5	6		Cd	Cd, Hg	
4–5	5			Zn, Pb	
3–4	4		Pb, Zn	Cu	Cd
2–3	3	Cd, Pb	Hg		Hg, Zn, Pb
1–2	2	Zn, Hg	Cu	Cr	
0–1	1	Cu			Cu, Cr
<0	0	Cr			

[a] Basel–Mannheim.
[b] Mainz–Emmerich (Müller, 1979).
[c] <63 μm fraction (ARGE-Elbe, 1980).
[d] <2 μm (Müller, 1980).

of suspected major sources and inputs of metal pollutants. Investigations on sediments from 87 lakes situated in different climatic and lithogenic milieus by Förstner (1981b) showed a high degree of:

(i) positive correlation between the elements Fe, Cr, Ni, Co and Mn, and to a lesser degree Cu, indicating the influence of the lithology of the lake catchment;

(ii) strong positive correlation between the Sr contents and those of total carbonate, which is partly associated with allochthonous influences;

(iii) negative correlation between Fe and elevated contents of carbonate, Sr and organic carbon, suggesting a dilution effect by these components on Fe; and

(iv) positive correlation (99% significance) between the metals Zn, Pb, Cd and Hg, organic carbon, and to a lesser extent Cu, which indicates the effects of man's activities on the aquatic environment.

(ii) *Cluster analysis.* The correlation coefficient matrices can be expressed in a more synoptical, graphical manner by the method described by Davaud (1976), using a multivariate analysis algorithm. In this type of diagram the distance between two variables is a function of their degree of association. The chemical evolution of muds in Lake Morat (Davaud, 1977) in southwestern Switzerland showed characteristic differences between older and younger sediments which are due to natural processes such as sediment diagenesis, but also to anthropogenic influences such as eutrophication and excess loading of heavy metals.

The same method was used by Rapin (1980) to demonstrate the anthropogenic effects on the sediment from the Bay of Nice and Villefranche-sur-Mer

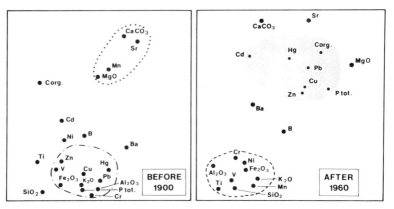

Fig. 13.4 Geochemical associations (degree of statistical linear dependence) in uncontaminated (before 1900) and polluted (after 1960) sediments of dated cores from Bays of Nice and Villefranche-sur-Mer (France) (after Rapin, 1980).

on the French Mediterranean coast. Figure 13.4 compares the correlation coefficient matrices "before 1900" and "after 1960" of chemical data from dated sedimentary cores. It is evident that in both graphs there is a clustering of the major components of clay minerals (Al, Fe, K, Si) and some trace elements such as Ni, V, Cr, Ti, as well as of carbonates and Sr. Pollutant elements such as Hg, Pb, Cd, Cu and Zn, and nutrients C_{org} and P_{total} in the post-1960 sediments show a characteristic shift from the Clay Pole to a new clustering at the upper right side of the diagram, resulting in the formation of a Pollutant Pole. However, whether this statistical association between C_{org} and heavy metals indicates a distinct organophility of the latter is questionable. In such polluted areas, contamination by heavy metals may simply coincide with the accumulation of organic substances as both derive from urban, industrial and agricultural waste effluents. To confirm the suspected chemical association between organic elements and trace metals, a sequential extraction method can be used (see Section III.3(c)).

(iii) *Principle-component analysis (multivariate statistics)*. Factor analysis reduces the numerous inter-element relationships among many variables to simple correlations. An example is given by Trefry (1977) for Mississippi Delta sediments (Table 13.6). The factor program used takes the initial correlation matrix, diagonalizes it and solves for simple values and for vectors that are linear subcombinations of the original variables; each vector (or factor) successively maximizes the indicated variance for each variable. The end result is a grouping of variables that are highly correlated. Sediment metal distribution indicated by a single factor (for example, Fe and Al in Table 13.6) is probably controlled by a single process; metals with more complicated

Table 13.6 Factor analysis for Mississippi Delta sediment data* (Trefry, 1977)

	Factor 1	Factor 2	Factor 3
Fe	0.96		
Al	0.92		
Mn		−0.50	0.61
Zn	0.77	0.55	
Pb	0.39	0.75	
Cu	0.51	0.68	
Co	0.69		
Ni	0.35	0.56	0.51
$CaCO_3$		−0.78	0.43
Sand	−0.93		
Silt	−0.56	0.70	
Clay	0.88	−0.40	
Eigenvalues	6.130	3.296	1.122
Relative % of total	47.2	25.4	8.6
Cumulative %	47.2	72.5	81.1

* Loadings <0.3 omitted.

factor patterns (for example, Mn and Ni in Table 13.6) may have a more complex distribution. For the interrelations of parameters of the Mississippi Delta sediment studied by Trefry (1977), three factors account for 80% of the sample variance (Table 13.6). Factor 1, with high loadings of Fe, Al and clay, characterizes the clay-rich, alumosilicate detritus of the Mississippi River and associated metals, such as Zn, Co and Cu. Factor 2, with negative loadings of Mn, $CaCO_3$ and clay, characterizes sediments that are very near the river mouth and polluted with Pb and perhaps Zn and have a greater predominance of heavy minerals (in the silt fraction) with associated metals (Ni, Zn and Cu). Factor 3 is associated with the Mn-rich zones found in the outer shelf and fan sediments with higher carbonate contents, indicating Ni and Mn re-mobilization. In summary, about 50% of the variance of these near-shore sediment-associated metal concentrations is due to an association of metals with alumosilicates; the remainder of the variance is caused by pollution, physical sorting of particles and post-depositional remobilization of metals (Trefry, 1977).

3. Estimation of environmental impact

As the metal components in solution are basically available to organisms, interest in the assessment of metal pollution in rivers and estuaries is

predominantly directed to those metals that are either already in solution or potentially can reach the dissolved phase. It has been shown, however, that a forecast of the latter based on knowledge of physicochemical equilibrium and stability conditions is unreliable, even for relatively simple systems. However, in the case of extraction and deposition of contaminated dredged materials, a rapid answer to such questions is often needed, and a number of methods have been developed that allow, albeit unsatisfactorily, the estimation of the transfer of metals in the sediment-water-biota systems.

(a) Sediment–water interrelations

Investigations undertaken by Aston and Thornton (1977) on stream sediments of both mineralized and unmineralized areas in Great Britain have shown that sediment analyses may provide a semiquantitative measure of the metal concentration of associated waters. The salient factors in their estimations are the degree of contrast and the assignment of threshold values. "Contrast" is defined as the highest anomalous concentration divided by the average background concentration (similar to "geoaccumulation index" given in Section III.2(b)). It was found that high-contrast values are readily identified for contaminated areas, and it is suggested that these data could be related to the highest desirable level (HDL) values for the particular trace element in water. In the case of Cd, the tentative threshold for metal in the sediment is reached at approximately 5–10 mg kg^{-1} Cd, based on the WHO drinking water standard; for Zn the value is approximately 2000 mg kg^{-1} Zn, for Cu 1000 mg kg^{-1} and for Pb 500 mg kg^{-1}, respectively. However, because of considerable variations in the physical and chemical environments of the catchment areas as well as of the aquatic systems proper, this approach can only be taken as a rough estimate, and has to be verified by detailed assessment of water analyses.

(b) Elutriate test

To estimate short-term chemical transformations, the interrelations between solid phases and water has been increasingly subjected to laboratory experimentation. The advantage of such experiments is that especially important parameters can be directly observed and particularly unfavourable conditions simulated.

The Army Corps of Engineers and the US Environmental Protection Agency have developed an elutriate test that is designed to detect any significant release of chemical contaminants in dredged material. This test involves the mixing of one volume of the dredged sediment with four volumes of the disposal site water for a 30-min shaking period. If the soluble chemical

constituent in the water exceeds 1.5 times the ambient concentration in the disposal site water, special conditions will govern the disposal of the dredged material (Lee and Plumb, 1974).

The oxygen state and solid–liquid ratios during the test procedures were shown to be the most important factors influencing the test results (Lee *et al.*, 1975). The elutriate test, meanwhile, has shown its usefulness in projecting the long-term release of certain contaminants from resettled dredged materials (Brannon *et al.*, 1980).

Experimental data have demonstrated that a release of trace metals such as Zn and Cd may occur at pH 5 under oxidizing conditions (Gambrell *et al.*, 1977). These acid-reducing conditions do not occur normally in open-water disposal, but if the sediment is placed in any upland containment area where oxidizing conditions may prevail for a year or more, and if the sediments are high in total sulphide, pH may reach an acidic stage, resulting in a significant release of some contaminants to the water-soluble phase (Burks and Engler, 1978). However, from such examples it became clear relatively early that the knowledge about the association of metals obtained from the elutriate test alone was insufficient to assess their potential solubility and availability.

(c) *Chemical extraction sequences*

Metals in interstitial water are the most mobile fraction of those in sediments and, consequently, the most available (Engler, 1980). Thus, special attempts have been made to measure this portion as well as to understand the mechanisms of their release into open water (Gieskes, 1975; Hoshika *et al.*, 1977; Adams *et al.*, 1980; Batley and Giles, 1980; Lee and Swartz, 1980).

In the solid phase, various chemical association forms must be differentiated, as they become available under varying environmental conditions. These include adsorption and cation exchange, carbonate phases, Mn and Fe oxyhydrate phases (reducible phases), and organic phases (including sulphidic phases, i.e., oxidizable phases). The detritally bound metal portions are generally not immediately available. Table 13.7 presents several chemical leaching reagents currently used for environmentally relevant metal investigations. It has been shown that better results are obtained by applying the individual reagents in an extraction sequence in which the "strength" of the extraction substance increases from the relatively easily extractable exchangeable cations to the less easily extractable metal components such as those in Fe hydroxides.

Based on such knowledge, Bruland *et al.* (1974) differentiated the oxidizable, reducible, and residual phases in polluted sediments near a sewer outfall in the County of Los Angeles. Studies by Gupta and Chen (1975) on sediment from the Los Angeles harbour and by Brannon *et al.* (1976) on contaminated

Table 13.7 Methods for extracting metals from major chemical phases in sediments
(examples) (after Salomons and Förstner, 1980)

Adsorption and cation exchange	
$BaCl_2$–triethanolamine pH 8.1	Jackson (1958)
$MgCl_2$	Gibbs (1973)
Ammonium acetate (pH 7)	Engler *et al.* (1974)
Carbonate phases	
CO_2 treatment of suspension	Patchineelam (1975)
Acidic cation exchanger	Deurer *et al.* (1978)
NaOAc–HOAc buffer (pH 5)	Tessier *et al.* (1979)
Reducible phases (in approximate order of release of iron)	
Acidified hydroxylamine ($+0.01$ M HNO_3)	Chao (1972)
Ammonium oxalate buffer	Schwertmann (1964)
Hydroxylamine–acetic acid	Chester and Hughes (1967)
Dithionite–citrate buffer	Holmgren (1967)
Organic phases (including sulphides)	
H_2O_2–NH_4OAc (pH 2.5)	Engler *et al.* (1974)
H_2O_2–HNO_3	Gupta and Chen (1975)
Organic solvents	Cooper and Harris (1974)
0.5 M NaOH	Rashid and King (1971)
0.1 M $NaOH/H_2SO_4$	Volkov and Fomina (1974)
Na hypochlorite–dithionite/citrate	Gibbs (1973)

harbour sediments from Lake Erie, Mobile Bay, Ala., and Bridgeport, Conn., were performed by applying sequential extraction techniques, to include the determination of the metal contents in interstitial water, and in ion-exchangeable, easily reducible, and moderately reducible, organic and residual sediment fractions.

Extraction schemes related to the above-mentioned ones have been used for the speciation of particulate metals in a small drainage area of the Haw River, North Carolina (Shuman *et al.*, 1978), in Lake Michigan (Fillipek and Owen, 1979), the Yamaska and Saint Fracois Rivers in Canada (Tessier *et al.*, 1979), the Rio Grande (Popp and Laquer, 1980), Tokyo Bay (Kitano *et al.*, 1980), in the upper Mississippi River (Eisenreich *et al.*, 1980), and in the highly polluted lower Rhine River (Förstner and Patchineelam, 1980).

A simplified scheme consisting of an extraction with 0.1 M hydroxyl-amine–HCl (pH 2) followed by an extraction with hydrogen peroxide (30%; pH 2.5)–ammonium acetate was used for the study of sediments from the Rhine, Meuse, Ems and Scheldt Rivers and from the North Sea by Salomons and De Groot (1978). This scheme, including an additional step for exchange-able cations, was used in the study of sediments from 18 river systems, including major rivers in France, the Magdalene, Orinoco, Zaire Rivers in

Table 13.8 Chemical extraction of selected trace metals in a sediment sample from the lower Rhine River (factor of enrichment is estimated) (data from W. Calmano and C. Schumann, Inst. f. Sedimentforschung Univ. Heidelberg, unpublished)

Sediment fraction	Fe %	Mn %	Zn %	Cr %	Cu %	Pb %	Cd %
Cation exchange[a]	0.1	8.5	10.3	0.1	2.7	1.5	26.7
Easily reducible[b]	2.0	32.4	35.4	0.4	0.2	0.6	42.3
Moderately reducible[c]	50.8	38.1	33.7	86.3	48.4	38.6	1.9
Organic fraction[d] 0.1	0.1	3.8	8.3	6.0	14.5	5.2	16.8
Detrital fraction[e]	47.1	17.2	12.7	7.1	34.2	54.1	12.3
Total (% or mg kg^{-1})	2.33%	583	921	338	202	118	9
Factor of enrichment	1	1	10	5	5	5	30

[a] Ammonium acetate, 1 M, 1:20 solid/solution ratio, 2 h treatment.
[b] 0.1 M hydroxylamine hydrochloride + 0.01 M HNO_3, 1:100, 24 h.
[c] 0.2 M ammonium oxalate + 0.2 M oxalic acid, 1:100, 24 h shaking.
[d] 30% H_2O_2 (90°C) + 1 M NH_4OAc, pH 2, 1:100, 24 h shaking.
[e] HF–$HClO_4$ digestion.

other continents, and in the Ottawa River of North America (Salomons and Förstner, 1980).

In Table 13.8, more recent data of an intercalibration sediment sample are displayed, which were obtained by the Federal Institute of Hydrology (FRG) (Ackermann et al., 1979) from the lower Rhine River in an extraction sequence comprising five steps. The relatively easily extractable associations, "cation exchange" and "easily reducible" (the latter also containing carbonate-associated portions), are high, especially those for Zn and Cd, whereas, under certain conditions, the more easily remobilizing organic association forms are considerable for Cu and Cd. These and other data show that the surplus of metal contaminants introduced into the aquatic system from man's activities (i.e., "factor of enrichment" in Table 13.8) usually exists in relatively unstable chemical associations and is, therefore, predominantly accessible for biological uptake. (The chief exception is Pb, which, in spite of a clear enrichment, occurs up to and more than 50% in the "detrital fraction". It is possible that, in this case, relatively resistant associations are involved, for example, Pb oxides, that are present in atmospheric fallout.

At present there are still considerable difficulties in presenting the results of extraction studies to show the expected effects in biological systems. Luoma and Jenne (1977a,b) have presented initial data on the effect of metal partitioning in different sediment components on metal availability to organisms. Using deposit-feeding clams on various types of sedimentary substrates, which were labelled with heavy metal nuclides (for example, ^{109}Cd), their studies indicated that the bioavailability of the heavy metals is

inversely related to the strength of metal–particulate associations in the sediments. Regression analyses were made for sediment fractions and metal concentrations in the related deposit-feeding bivalves (Luoma and Bryan, 1979), indicating, for example, that the uptake of Zn by *Macoma baltica* in San Francisco Bay is controlled by the competitive partitioning of Zn by extractable Fe and Mn forms in the substrate.

IV. Bioassays on dredging activities

Dredging activities may disperse sediments and create water problems owing to turbidity and pollutant release. These impacts can be indirect or direct, long-term or short-term (Windom, 1976).

Generally speaking, metal levels have been found to be fairly constant after an initial re-equilibration with the sediments. Even if some metals become more soluble under aerobic conditions, reoxidation generally seems to favour reprecipitation as soon as the sediments are dispersed (Windom, 1976). More serious problems may occur when dredged materials are deposited, especially onto agricultural areas. Although some components, for example, P, N and K, may be beneficial for plant growth, other elements, especially Cd, Cu and Zn, can be very harmful, and may even lead to metal enrichment in foodstuffs (see also Chapter 8).

The application of various bioassays to assess the potential pollution arising from dredging activities, as required by legislative mandate in the US, has been reviewed by Engler (1980):

(i) Liquid-phase bioassay. Algae and zooplankton were found to respond adequately and may be used to assess stimulation or toxicity. An estimation of mixing and dilution factors that are expected to occur on disposal must be included in the experimental design to simulate field conditions. The mortality of organisms, rather than sublethal considerations, has to be chosen as the indicator of potential environmental effects.

(ii) Solid-phase bioassay. The greatest potential for impact on benthic organisms generally lies with settleable or solid-phase material. When selecting organisms, one filter-feeding, one deposit-feeding and one burrowing species should be included (US EPA/CE, 1977). Mortality is chosen as the interpretative endpoint because of its clear environmental significance.

(iii) Bioaccumulation. Because of long-term effects of bioaccumulation and the short-term nature of the laboratory bioassays (10-day duration), field evaluation of bioaccumulation in site-specific aquatic organisms should be used wherever there has been a historic precedence of disposal at the site in question. A valid conclusion regarding bioaccumulation is based on statistically significant (95% confidence level) differences in the body burden of

specific constituents between organisms in the dump site and the same species living on uncontaminated sediments of similar sedimentologic characteristics.

Because of concern of possible synergism or antagonism, the liquid-phase bioassay was considered more stringent than the water-quality criterion (for example, Train, 1979) for any single parameter. The decision to issue permits is then based on an evaluation of the probable impact of the proposed activity on the public interest (USEPA, 1976). Other relevant factors considered include conservation, economics, aesthetics, fish and wildlife, flood damage prevention, land use, navigation, recreation, water supply, water quality, energy needs and safety, and in general the needs and welfare of the people (USACE, 1978; Engler, 1980).

References

Abdullah, M. I., Royle, L. G. and Morris, A. W. (1972). *Nature, Lond.* **235**, 158.
Ackermann, F. (1980). *Environ. Technol. Lett.* **1**, 518.
Ackermann, F., Bergmann, H. and Schleichert, U. (1979). *Z. Anal. Chem.* **296**, 270.
Adams, D. D., Darby, D. A. and Young, R. J. (1980). *In* "Contaminants and Sediments", Vol. 2 (Baker, R. A., ed.), p. 3. Ann Arbor Science, Ann Arbor, Michigan.
Agemian, H. and Chau, A. S. Y. (1976). *Analyst* **101**, 761.
Allan, R. J. (1971). *Can. Inst. Min. Met. Bull.* **64**, 43.
Allan, R. J. (1974). *Geol. Surv. Can.* **74-1/B**, 43.
American Society of Civil Engineers (1969). *J. Hydrol. Div., ASCE* **95** (HY5), 1477.
Anderson, J. (1974). *At. Absorpt. Newsl.* **13**, 31.
Andrew, R. W., Hodson, P. V. and Konasewich, D. E. (eds) (1976). "Toxicity to Biota of Metal Forms in Natural Water". International Joint Commission, Windsor, Ontario.
Arbeitsgemeinschaft "Reinhaltung der Elbe". (1980). "Heavy Metal Data from the Elbe River 1979/80". Wassergütestelle Elbe, Hamburg.
Aston, S. R. and Thornton, I. (1977). *Sci. Total Environ.* **7**, 247.
Ayling, G. M. (1977). *Water Res.* **8**, 729.
Bacon, J. R. and Maas, R. P. (1979). *J. Environ. Qual.* **8**, 538.
Banat, K., Förstner, U. and Müller, G. (1972). *Naturwiss.* **12**, 525.
Batley, G. E. and Giles, M. S. (1980). *In* "Contaminants and Sediments", Vol. 2 (Baker, R. A., ed.), p. 101. Ann Arbor Science, Ann Arbor, Michigan.
Bloom, H. and Ayling, G. M. (1977). *Environ. Geol.* **2**, 3.
Bourget, E. and Cossa, D. (1976). *Mar. Pollut. Bull.* **7**, 237.
Bowen, H. J. M. (1979). "Environmental Chemistry of the Elements". Academic Press, London and New York.
Brannon, J. M., Rose, J. R., Engler, R. M. and Smith, I. (1976). *In* "Chemistry of Marine Sediments" (Yen, T. F., ed.), p. 125. Ann Arbor Science, Ann Arbor, Michigan.
Brannon, J. M., Plumb, R. H. and Smith, I. (1980). *In* "Contaminants and Sediments", Vol. 2 (Baker, R. A., ed.), p. 221. Ann Arbor Science, Ann Arbor, Michigan.
Bruland, K. W., Bertine, K., Koide, M. and Goldberg, E. D. (1974). *Environ. Sci. Technol.* **8**, 425.
Bryan, G. W. (1976). *In* "Marine Pollution" (Johnston, R., ed.), p. 185. Academic Press, London and New York.
Burks, S. L. and Engler, R. M. (1978). "Water-Quality Impact of Aquatic Dredged Material Disposal". Rept. DS-78-4, US Army Eng. WES, Vicksburg, MS.
Burton, M. S. (1979). *Environ. Pollut.* **19**, 39.
Butterworth, J., Lester, P. and Nickless, G. (1972). *Mar. Pollut. Bull.* **3**, 72.

Chao, L. L. (1972). *Soil Sci. Soc. Am. Proc.* **36**, 764.

Chester, R. (1978). Comitato Nazionale Encrgia Nucleare, La Spezia, Italy, June 28, 1978.

Chester, R. and Voutsinou (1981). *Mar. Pollut. Bull.* **12**, 84.

Clark, A., Condon, W. A., Hoare, J. M. and Sorg, D. H. (1970). *U.S. Geol. Surv. Open-File Rept.*, No. 10.

Cooper, B. S. and Harris, R. C. (1974). *Mar. Pollut. Bull.* **5**, 24.

Cooper, –. and Harris, –. (1974). *Ref. to come*, ms. p. 674.

Cross, F. A., Duke, T. W. and Willis, J. N. (1970). *Chesapeake Sci.* **11**, 221.

Davaud, E. (1976). Dissertation University Geneva, Ecole de Physique No. 1745.

Davaud, E. (1977). *In* "Interactions between Sediments and Fresh Water" (Golterman, H. L., ed.), p. 378. Junk BV, Wageningen, Netherlands.

De Groot, A. J., De Goeij, J. J. M. and Zegers, C. (1971). *Geol. Mijnbouw* **50**, 393.

De Groot, A. J., Salomons, W. and Allersma, E. (1976). *In* "Estuarine Chemistry" (Burton, J. D. and Liss, P. S., eds). Academic Press, London and New York.

Deurer, R., Förstner, U. and Schmoll, G. (1978). *Geochim. Cosmochim. Acta* **42**, 425.

De Wolf, P. (1975). *Mar. Pollut. Bull.* **6**, 61.

Eisenreich, S. J., Hoffmann, M. R., Rastetter, D., Yost, E. and Maier, W. J. (1980). *In* "Particulates in Water" (Kavaunagh, M. C. and Leckie, J. O., eds), *Advances in Chemistry Ser. 189*, p. 135. American Chemical Society, Washington, DC.

Eisler, R., Lapan, R. L., Telek, G., Davey, E. W., Soper, A. E. and Barry, M. (1977). *Mar. Pollut. Bull.* **8**, 260.

Engler, R. M. (1980). *In* "Contaminants and Sediments", Vol. 1 (Baker, R. A., ed.), p. 143. Ann Arbor Science, Ann Arbor, Michigan.

Engler, R. M., Brannon, J. M., Rose, J. and Bigham, G. (1974). 168th Meeting of American Chemical Society, Atlantic City, NY.

Ernst, W. H. O. (ed.) (1981). Proceedings of the International Conference "Heavy Metals in the Environment", Amsterdam, Sept. 14–18, 1981. CEP Consultants, Edinburgh, UK.

Fillipek, L. H. and Owen, R. M. (1979). *Chem. Geol.* **26**, 105.

Förstner, U. (1976). *Naturwiss.* **63**, 465.

Förstner, U. (1977a). *In* "The Transport of Sediment-Associated Nutrients and Contaminants" (Shear, H. and Watson, A. E. P., eds), p. 219. IJC/PLUARG, Windsor, Ontario/Canada.

Förstner, U. (1977b). *Geol. Rundschau* **66**, 146.

Förstner, U. (1979). *In* "Origin and Distribution of the Elements" (Ahrens, L. H., ed.), p. 849. Pergamon Press, Oxford.

Förstner, U. (1980). *In* "Biogeochemistry and Chemistry of Estuaries" (Olausson, E. and Cato, I., eds), p. 310. Wiley, Chichester.

Förstner, U. (1981a). *In* "Handbook of Strata-Bound and Stratiform Ore Deposits", Vol. 9 (Wolf, K. H., ed.), p. 271. Elsevier, Amsterdam.

Förstner, U. (1981b). *In* "Handbook of Strata-Bound and Stratiform Ore Deposits", Vol. 9 (Wolf, K. H., ed.), p. 179. Elsevier, Amsterdam.

Förstner, U. and Müller, G. (1973). *Geoforum* **14**, 53.

Förstner, U. and Müller, G. (1974). "Schwermetalle in Flüssen und Seen als Ausdruck der Umweltverschmutzung". Springer, Berlin.

Förstner, U. and Müller, G. (1976). *Fortschr. Mineral.*, **53**, 271.

Förstner, U. and Patchineelam, S. R. (1980). *In* "Particulates in Water" (Kavaunagh, M. C. and Leckie, J. O., eds), *Advances in Chemistry Ser. 189*, p. 177. American Chemical Society, Washington, DC.

Förstner, U. and Salonons, W. (1980). *Environ Technol. Lett.*, **1**, 494.

Förstner, U. and Wittmann, G. (1979). "Metal Pollution in the Aquatic Environment". Springer-Verlag, Berlin

Friberg *et al.* (eds) (1979). "Handbook on the Toxicology of Metals". Elsevier/North-Holland, Amsterdam.

Gambrell, R. P., Khalid, R. A., Verloo, M. G. and Patrick, W. H. (1977). "Dredged Material Research Program". US Army Corps of Engineers, Rept. D-77-4, Vicksburg, MS.

Gibbs, R. J. (1973). *Science*, **180**, 71.

Gieskes, J. M. (1975). *Ann. Rev. Earth Planet. Sci.*, **3**, 433.

Goldberg, E. D. (1954). *J. Geol.*, **62**, 249.
Goldberg, E. D. (1975). *Mar. Pollut. Bull.*, **6**, 111.
Goldberg, E. D. (1978). *Environ. Conserv.*, **5**, 101.
Goldberg, E. D., Gamble, E., Griffin, J. J. and Koide, M. (1977). *Estuar. Coastal Mar. Sci.* **5**, 549.
Gott, G. B., Botbol, J. M., Billings, T. M. and Pierce, A. P. (1969). *U.S. Geol. Surv. Open-File Rept.*, No. 3.
Grimshaw, D. L., Lewin, J. and Fuge, R. (1976). *Environ. Pollut.* **11**, 1.
Gross, M. G., Black, J. A., Kalin, R. J., Schramel, J. R. and Smith, R. N. (1971). *Mar. Sci. Res. Cent., State Univ. N.Y.*, Tech. Rep. 8.
Gupta, S. K. and Chen, K. Y. (1975). *Environ. Lett.* **10**, 129.
Hart, B. T. and Davies, S. H. R. (1977). *Aust. J. Mar. Freshwater Res.* **28**, 397.
Hellmann, H. (1972). *Dtsch. Gewässerkundl. Mitt.* **16**, 131.
Helmke, P. A., Koons, R. D., Schomberg, P. J. and Iskandar, I. K. (1977). *Environ. Sci. Technol.* **11**, 984.
Hemphill, D. D. (ed.) (1967–1983). "Trace Substances in Environmental Health", Vol. 1–Vol. 17. University of Missouri, Columbia.
Hesslein, R. (1976). *Limnol. Oceanogr.* **21**, 912.
Hoggins, F. E. and Brooks, R. R. (1973). *N.Z. J. Mar. Freshwat. Res.* **7**, 125.
Holmes, C. W., Slade, E. A. and McLerran, C. J. (1974). *Environ. Sci. Technol.* **8**, 255.
Holmgren, G. S. (1967). *Soil Sci. Soc. Am. Proc.* **31**, 210.
Hoshika, A., Takimura, O. and Shiozawa, T. (1977). *J. Oceanogr. Soc. Japan* **33**, 161.
Hutchinson, T. C. (ed.) (1975). "Proceedings of the International Conference on Heavy Metals in the Environment", Vol. I and Vol. II, Part 1 and 2. Institute for Environmental Studies, University of Toronto, Canada.
Jackson, G. A. and Morgan, J. J. (1978). *Limnol. Oceanogr.* **23**, 268.
Jackson, M. L. (1958). "Soil Chemical Analysis". Prentice Hall, Englewood Cliffs, NJ.
Jenne, E. A., Kennedy, V. C., Burchard, J. M. and Ball, J. W. (1980). *In* "Contaminants and Sediments", Vol. 2 (Baker, R. A., ed.), p. 169. Ann Arbor Science, Ann Arbor, Michigan.
Jones, A. S. G. (1973). *Mar. Geol.* **14**, M1.
Kemp, A. L. W., Thomas, R. L., Dell, C. I. and Jaquet, J. M. (1976). *J. Fish. Res. Board Can.* **33**, 440.
Kennedy, V. C., Jones, B. F. and Zellweger, G. W. (1974). *Water Resour. Res.* **10**, 785.
Kennedy, V. C., Jenne, E. A. and Burchard, J. M. (1976). *U.S. Geol. Surv. Open-File Report* No. 126.
Kennedy, V. C., Zellweger, G. W. and Avanzino, R. J. (1979). *Water Resour. Res.* **15**, 687.
Kitano, Y., Sakata, M. and Matsumoto, E. (1980). *Geochim. Cosmochim. Acta* **44**, 1279.
Kölle, W., Dorth, K., Smiricz, G. and Sontheimer, H. (1971). *Vom Wasser* **38**, 183.
Krenkel, P. A. (ed.) (1975). "Heavy Metals in the Aquatic Environment". Pergamon Press, Oxford.
Krishnaswami, S. and Lal, D. (1978). "Lakes—Chemistry, Geology, Physics" (Lerman, A., ed.), p. 153. Springer, New York.
Krüger, K. E., Nieper, L. and Auslitz, H.-J. (1975). *Arch. Lebensmittel-hyg.* **26**, 201.
Leatherland, T. M. and Burton, J. D. (1974). *J. Mar. Biol. Assoc. U.K.* **54**, 457.
Lee, C. R., Engler, R. M. and Mahloch, J. L. (1975). US Army CE, DMRP, Misc. Paper D-76-5.
Lee, H. and Swartz, R. C. (1980). *In* "Contaminants and Sediments", Vol. 2 (Baker, R. A., ed.), p. 555. Ann Arbor Science, Ann Arbor, Michigan.
Lee, G. F. and Plumb, R. H. (1974). US Army CE/WES, DMRP, Contract Rept. D-74-1.
Leland, H. V. *et al.* (1974–1978). *J. Water Pollut. Control Fed.*, June editions, vols. **46–51**.
Lichtfuβ, R. and Brümmer, G. (1977). *Naturwiss.* **64**, 122.
Loring, D. H. (1975). *Can. J. Earth Sci.* **12**, 1219.
Loring, D. H. and Rantala, R. T. T. (1977). *Fish. Mar. Serv. Techn. Rept.* **700**, 58pp.
Luoma, S. N. and Bryan, G. W. (1979). *In* "Chemical Modelling in Aqueous Systems" (Jenne, E. A., ed.), p. 577. *Symposium Ser.* **93**, American Chemical Society, Washington, DC.
Luoma, S. N. and Jenne, E. A. (1977a). *In* "Trace Substances in Environmental Health", Vol. 10 (Hemphill, D. D., ed.), p. 343. University of Missouri Press, Columbia.
Luoma, S. N. and Jenne, E. A. (1977b). *In* "Biological Implications of Metals in the Environment" (Wildung, R. E. and Drucker, H., eds), p. 213. NTIS-CONF-750929, Springfield, Virginia.
MacLean, R. O. and Jones, A. K. (1975). *Freshwat. Biol.* **5**, 431.
Malo, B. A. (1977). *Environ. Sci. Technol.* **11**, 277.

Martin, J. H., Knauer, G. A. and Flegal, A. R. (1980). "Zinc in the Environment" (Nriagu, J. O., ed.), Part 1, p. 193. Wiley, New York.

Mayer, L. M. (1976). *Limnol. Oceanogr.* **21**, 909.

Mayes, R. and McIntosh, A. (1975). *In* "Trace Substances in Environmental Health" (Hemphill, D. D., ed.), Vol. 9, p. 157. University of Missouri Press, Columbia.

Müller, G. (1979). *Umschau* **79**, 778.

Müller, G. (1980). *Naturwiss.* **67**, 560.

Müller, G. (ed.) (1983). Proceedings of the International Conference "Heavy Metals in the Environment", Heidelberg/FRG, Sept. 6–9, 1983. CEP Consultants, Edinburgh, UK.

Müller, G. and Förstner, U. (1975). *Environ. Geol.* **1**, 33.

Nikiforova, E. M. and Smirnova, R. S. (1975). Abstracts of International Conference on Heavy Metal in the Environment, Toronto, *C-94.*

Nriagu, J. O. (ed.) (1978). "The Biogeochemistry of Lead in the Environment", Part A. Elsevier/North-Holland, Amsterdam.

Nriagu, J. O. (ed.) (1979a). "The Biogeochemistry of Mercury in the Environment". Elsevier/ North-Holland, Amsterdam.

Nriagu, J. O. (ed.) (1979b). "Copper in the Environment", Part 1. Wiley, New York.

Nriagu, J. O. (ed.) (1980a). "Zinc in the Environment", Part 1. Wiley, New York.

Nriagu, J. O. (ed.) (1980b). "Cadmium in the Environment", Part 1. Wiley, New York.

Nriagu, J. O. (ed.) (1980c). "Nickel in the Environment". Wiley, New York.

Nürnberg, H. W. (1979). *Sci. Total Environ.* **12**, 35.

Oliver, B. G. (1973). *Environ. Sci. Technol.* **7**, 135.

Patchineelam, S. R. (1975). Unpubl. Dissertation, University of Heidelberg.

Patterson, C. C. and Settle, D. M. (1976). *Nat. Bureau Stand. Publ.* **422**, 321.

Perry, R. (ed.) (1979). Proceedings of the International Conference "Management and Control of Heavy Metals in the Environment". CEP-Consultants, Edinburgh, UK.

Pierce, A. P., Botbol, J. M. and Learned, R. E. (1972). *U.S. Geol. Surv. Paper 713*, 14.

Phillips, D. J. H. (1977). *Environ. Pollut.* **13**, 281.

Popp, C. J. and Laquer, F. (1980). *Chemosphere* **9**, 89.

Rapin, F. (1980). Dissertation, University of Geneva (unpublished).

Rashid, M. A. and King, L. H. (1971). *Chem. Geol.* **7**, 37.

Salomons, W. and De Groot, A. J. (1978). *In* "Environmental Biogeochemistry", Vol. 1 (Krumbein, W. E., ed.), p. 149. Ann Arbor Science, Ann Arbor, Michigan.

Salomons, W. and Förstner, U. (1980). *Environ. Technol. Lett.* **1**, 506.

Salomons, W. and Förstner, U. (1983). "Metals in the Hydrocycle". Springer-Verlag, Berlin.

Salomons, W. and Mook, W. G. (1977). *Neth. J. Sea Res.* **11**, 119.

Schleichert, U. (1975). *Dtsch. Gewässerkundl. Mitt.* **19**, 150.

Schoer, J. and Förstner, U. (1980). *Dtsch. Gewässerkundl. Mitt.* **24**, 153.

Schwertmann, U. (1964). *Z. Pflanzenernähr. Düng. Bodenk.* **105**, 194.

Shuman, M. S., Haynie, C. L. and Smock, L. A. (1978). *Environ. Sci. Technol.* **12**, 1066.

Skei, J. M., Price, N. B., Calvert, S. E. and Holtedahl, H. (1972). *Water Air Soil Pollut.* **1**, 452.

Smith, J. D., Nicholson, R. A. and Moore, P. J. (1973). *Environ. Pollut.* **4**, 153.

Stenner, R. D. and Nickless, G. (1975). *Mar. Pollut. Bull.* **6**, 89.

Stoffers, P., Summerhayes, C., Förstner, U. and Patchineelam, S. R. (1977). *Environ. Sci. Technol.* **11**, 819.

Talbot, V. W., Magee, R. J. and Hussain, M. (1976). *Mar. Pollut. Bull.* **7**, 53.

Tessier, A., Campbell, P. G. C. and Bisson, M. (1979). *Anal. Chem.* **51**, 844.

Thomas, R. L. (1972). *Can. J. Earth Sci.* **9**, 636.

Thornton, I., Watling, H. and Darracott, A. (1975). *Sci. Total Environ.* **4**, 325.

Thrower, S. J. and Eustace, I. J. (1973). *Food Technol. Aust.* **25**, 546.

Train, R. E. (1979). "Water Quality Criteria". Castle House, Tunbridge Wells, England.

Trefry, J. H. (1977). Dissertation Texas A&M University, Dallas, 223 pp.

Turekian, K. K. and Wedepohl, K. H. (1961). *Bull. Geol. Soc. Am.* **72**, 175.

US Environmental Protection Agency (USEPA). (1976). "Quality Criteria for Water". USEPA 440/9-76-023, Washington, DC.

US Environmental Protection Agency/Corps of Engineers. (1977). "Ecological Evaluation of

Proposed Discharge of Dredged Material into Ocean Water". US Army Engineer Waterways Experiment Station, Corps of Engineers, Vicksburg, MS.

US Army Corps of Engineers. (1978). "Public Notice No. 9393". US Army Engineer District, New York.

US Geological Survey. (1972). "Geological Survey Research", p. 147. US Geol. Surv. Prof. Paper 800-A.

Vernet, J.-P. and Thomas, R. L. (1972). *Eclogae Geol. Helv.* **65**, 307.

Volkov, I. I. and Fomina, L. S. (1974). *In* "The Black Sea—Geology, Chemistry and Biology" (Degens, E. T. and Ross, D. A., eds), p. 45. *Am. Assoc. Petrol. Geol. Mem.* **20**, Tulsa/Oklahoma.

Watling, H. R. and Watling, H. J. (1975). *Water S.A.* **1**, 28.

Weissberg, B. G. and Zobel, M. G. (1973). *Bull. Environ. Contam. Toxicol.* **9**, 148.

Whitehead, N. E. and Brooks, R. R. (1969). *Bryologist* **72**, 501.

Wilber, W. G. and Hunter, J. V. (1979). *Water Resour. Bull* **15**, 790.

Windom, H. L. (1976). *CRC Critical Rev. Environ. Control* **5**, 91.

Williams, L. G. and Coffee, G. L. (1975). *J. Water Pollut. Control Fed.* **47**, 354.

Wood, J. M. (1974). *Science* **183**, 1049.

Zirino, A. and Healy, M. L. (1971). *Limnol. Oceanogr.* **16**, 773.

14

Heavy Metal Contamination from Base Metal Mining and Smelting: Implications for Man and His Environment

BRIAN E. DAVIES

I. Introduction

Man's history from his infancy as *Homo habilis* in ancient Africa to today's technological might is a record of his increasing expertise in extracting and using the earth's natural materials. The progression of civilizations is described in terms of metals—copper, bronze, iron—each more versatile than the other and each requiring greater skills in mining, smelting and fabrication. Mastery of metals has given western man his relative freedom from hunger, disease and discomfort, but in recent years it has become accepted that these same metals, some of which are toxic, are accumulating in the biosphere, perhaps to his detriment. Every time metals or their compounds are heated, pulverized or dissolved they become environmentally labile and may escape to follow natural biogeochemical pathways until they reach a sink such as sediments, soils or the biomass. The extent to which such releases occur depends on the efficiencies of the relevant industrial process. In the past industries were often grossly inefficient and massive emissions occurred, such as pollution from historic copper mining in the Israeli desert region, which has enabled archaeologists to find and reconstruct ancient workings. These ancient processes were small scale and their environmental effects were localized, although intense. Modern industries are circumscribed by stringent pollution control legislation and their emissions are small; however, the industries are large and their effects correspondingly widespread.

Much of the environmental damage that has occurred in the past in mining areas has been caused by SO_x gases released during smelting, and the escape of

APPLIED ENVIRONMENTAL GEOCHEMISTRY
ISBN 0-12-690640-8

organics from froth flotation is a modern problem. This chapter will, however, concentrate on "heavy metals", a term that is both convenient and imprecise: as used in this chapter it refers to metallic elements of density $\geqslant 6 \text{ g cm}^{-3}$. Some of these elements are essential for life processes and are therefore nutrient elements, whereas others have no known biological role. All of them are toxic at higher concentrations.

Heavy metals occur naturally and are always present in rocks, soils and organisms. Excepting Fe, their normal concentrations in rocks and soils are less than 0.1% and they are regarded as "trace elements". Industrial contamination causes an increase above natural, or "background", concentrations, but difficulties in interpreting data can arise since the background concentration is itself variable according to the nature of the local rock or depletion–concentration processes such as leaching or precipitation in soils. In this way, heavy metal investigations differ from studies into organic pollution or man-made radionucleides where simple detection is in itself an indicator of contamination. Statistical treatment of data or the recognition of characteristic spatial patterns can help in differentiating natural biogeochemical "anomalies" from anthropogenic "neoanomalies". The reader is referred to Sinclair (1980) and Davies (1980) for descriptions of these methods. The word "pollution" is emotive and commonly implies damaging ecological effects. In this chapter, "contamination" will be used to imply any increase in concentration above natural background due to industrial emissions, and pollution will describe situations where contamination is known to cause damage to organisms.

II. Heavy metals in rocks and ore minerals

The great bulk of the earth's crust is formed from igneous rocks, and a useful approximation is that the upper 16 km of the crust is 95% igneous (including metamorphic) and 5% sedimentary rocks. The sedimentary rocks are spread at the surface over the igneous basement and as much as 75% of surface exposures may be classified as sedimentary. Igneous rocks form by precipitation from a cooling rock melt or magma made up of molten silicates and entrapped gases, especially steam. A series of rocks results containing various silicate minerals characterized by decreasing Fe and Mg contents and increases in Si, Na and K. Trace elements occur in these minerals by occupying crystal lattice positions normally tenanted by the mineral's major constituents. A major criterion governing the possibility of substitution is that of ionic size (see Chapter 1): the incoming element should have an ionic radius close to that (within 14% is a rule of thumb) of the normal lattice constituent. Isomorphous replacement of Fe^{2+} (ionic radius = 0.83 Å) is possible by Ni^{2+} (0.78 Å) or

Co^{2+} (0.82 Å), and basic or ultra-basic rocks, where the mineral olivine is dominant, tend to have high concentrations of these trace elements; indeed, certain serpentines are usable as Ni ores since the metal can now be extracted economically from them. Conversely, the Fe-poor rocks, granite and rhyolite, may contain too little Co to maintain ruminants in good health after the element has passed from the weathering rock up the food chain. Cobalt deficiencies (induced vitamin B_{12} deficiencies) are widely recognized in sheep in granite areas.

Sedimentary rocks are common at the earth's surface and are formed following the physical and chemical breakdown of igneous rocks whose weathering products are transported by water or air to sedimentary basins. The processes and controls operating during this weathering cycle are complex (see Chapter 1), and detailed accounts have been provided by Mitchell (1964) and Krauskopf (1967). Certain sediments are naturally enriched in trace elements and are therefore significant in contamination studies, especially black shales. These are formed by deposition in stagnant marine basins and are dark coloured because they contain sulphide minerals and large quantities of organic matter; they grade into pure organic materials such as coal. Their composition has been reviewed by Gibson and Selvig (1944), Vine and Tourtelot (1970) and Chatterjee and Pooley (1977). They tend to be rich in Ag, As, Cr, Mo, Ni, Pb, V and Zn, and small outcrops can cause minor soil metal anomalies that may be mistaken for contamination neoanomalies. The widespread use of coal as a fuel makes it a potential source of environmental contamination.

Thus, the natural trace element composition of the environment is controlled in the first place by the geochemical nature and history of local rocks. Emissions from mining and smelting increment these background concentrations by releasing to biogeochemical pathways elements contained in metal ores. Strictly, an ore is any accumulation of a mineral in a quantity sufficient to be capable of economic extraction, but the greatest interest centres on the sulphide ore minerals. Metals react as electron-pair acceptors with electron-pair donors and both donors and acceptors may be classified as hard or soft (Pearson, 1967). Soft donors prefer to bind to soft acceptors, and heavy metals tend to be soft or intermediate in their acceptor quality and hence preferentially bond to the soft donors SH^-, S^{2-} and RS^-: in traditional geochemical terminology they are chalcophilic. The most common ore minerals are the sulphide ores, and heavy metals often exercise a toxic effect in plant and animal metabolism by reacting with sulphydryl groups.

The sulphide ore minerals occur as localized concentrations within the host rock from which they are liberated during mining. Sometimes the minerals formed contemporaneously with the host rock (syngenetic minerals), but in other formations the minerals were precipitated in existing rock faults from

Table 14.1 Common sulphide ores of selected heavy metals

Ore metal	Ore name	Chemical composition	Ore metal, %
Antimony	Stibnite	Sb_2S_3	72
Arsenic	Arsenopyrite	FeAsS	46
Bismuth	Bismuthinite	Bi_2S_3	81
Cobalt	Linnaeite	Co_3S_4	58
Copper	Bornite	Cu_5FeS_4	63
Copper	Chalcopyrite	$CuFeS_2$	35
Copper	Chalocite	Cu_2S	80
Copper	Covellite	CuS	66
Copper	Enargite	$Cu_3As_5S_4$	48
Copper	Tetrahedrite	$Cu_{12}Sb_4S_{13}$	52
Lead	Galena	PbS	88
Mercury	Cinnabar	HgS	86
Molybdenum	Molybdenite	MoS_2	60
Nickel	Millerite	NiS	65
	Pentlandite	$(Ni, Fe)_9S_8$	22
Zinc	Sphalerite	ZnS	67

moving hot solutions originating in a deeper, igneous emplacement (epigenetic minerals): Evans (1980) has provided a general account or ore geology. Some of the common base metal ore minerals are listed in Table 14.1. Isomorphous substitution can occur both for the metal and the sulphide anion in the crystal, and permissible substitutions may be predicted from chemical theory. Vaughan and Craig (1979) have written a comprehensive account of the mineral chemistry of metal sulphides. Theoretical predictions of ore crystal substitutions have a limited value in practice, since the minerals usually contain intergrowths or inclusions of other minerals. The minor elemental constituents of the ore minerals may have considerable economic importance; for example, galena can contain several percent Ag and the economic impetus for developing Pb mines in Tudor Britain was the argentiferous nature of the ores. Silver is still an important co-product of the Pb industry as is Cd in Zn mining since sphalerite often contains several percent Cd. The environmental importance of these guest elements lies in the fact that they are generally very toxic, ordinarily are present in rocks in only tiny traces, yet are readily released to the environment when ores are dressed and smelted. For example, the background content of Cd in most soils is less than 1 mg kg^{-1}, yet up to 1000 mg kg^{-1} have been found in soils in the English village of Shipham, which was a notable smithsonite (calamine) mining centre at the end of the 18th century (Davies and Ginnever, 1979; Thornton, 1979). During environmental investigations it is important to remember that the presence of

Table 14.2 Common trace constituents of three common sulphide ore minerals. Some frequently occur up to several percent of the host mineral where others are usually present in smaller concentrations (based on data in Fleischer, 1955, and El Shazly *et al.*, 1956)

Mineral	Common guest constituents > 1%	< 1%
Galena (Pbs)	Ag As Bi Sb Se	Cd Cu Fe Hg Mn Ni Sn Tl Zn
Sphalerite (ZnS)	Ag As Cd Cu Fe Hg In Mn Sb Sn	Ba Co Cr Ga Ge Mo Ni Tl V
Chalcopyrite (CuFeS₂)	Mn	Ag As Bi Cd Co Cr In Mo Pd Pb Se Sn Ti

one ore type presupposes the probable presence of other ores and their accompanying guest elements. The common minor constituents of several sulphide metal ores are listed in Table 14.2.

III. Mining and refining ores

When an ore body is exploited, the ores and gangue minerals are crushed, dissolved or leached and heated, so there is ample opportunity for materials to be lost to the environment. Sulphide ores are sometimes mined by open cast or open pit methods and sometimes by underground or shaft and adit mining. In Derbyshire, England, long trenches or "rakes" were excavated following the strike of the ore outcrops, and when further deepening of the rake became impractical, shafts were sunk to penetrate the lode. Historically, in Europe underground mining was the rule. At present in the USA the main Cu ores are porphyry deposits where the Cu minerals are uniformly deposited throughout a rock composed of other minerals (having an overall Cu content of 0.6–2%), and in the arid regions of the west and southwest they are mined by open pit techniques. In contrast, Pb and Zn ores are largely mined underground.

Open pit mining involves drilling, blasting, loading and transportation of metal-rich rock, and the consequent "fugitive" dusts may present a problem: clearly, the composition of the dust depends on the natures of the ore and host rock. Substantial amounts of solid waste result from both open pit and underground mining, the estimated average for 1972 being one tonne per tonne of ore mined (see Table 14.3). In the past, however, methods were more

Table 14.3 Waste produced from three hypothetical modern base metal mines (data adapted from Appendix 2 of Zuckerman *et al.*, 1972)

	Copper		Lead/zinc
	Open pit	Underground	Open pit
% ore recovered in mine	100	75	100
% ore recovered in treatment	85	90	85
Ratio waste rock to ore	2:1	0.1:1	0.9:1
		tonnes \times 10^6	
Total ore	60	98	10
Total waste rock	120	1	9
Total tailings	59	9	9

more inefficient, and interpretation of data in Jones (1922) for 19th-century mining in Wales suggests that from 15 to 38 tonnes of waste were produced during the concentration of 1 tonne of Pb ore. The "run of mine" ore is composed of the valuable ore minerals and the waste or gangue minerals that have to be separated, a process called ore dressing, mineral dressing or milling, which yields an ore concentrate and the waste, or tailings. The liberation of the ore from the host rock is accomplished first by a comminution or grinding stage followed by a separation. The oldest separation technology is gravity separation in water. Here, use is made of the fact that the ores typically have high densities (galena = 7.6 g cm^{-3}) compared with the host rock and gangue minerals (for example, calcite = 2.7 g cm^{-3}). In the traditional process, the fine-ground ore/rock mixture was placed in a compartmented box called a "jig". The compartments were separated by wire mesh and the vertical movement of water in the jig caused the heavy ore minerals to travel to the bottom leaving the waste behind. The middle compartment contained the "middlings", a mix of ore and rock which was then processed by "buddling" in which flowing water down a gently inclined surface swept away the lighter rock leaving behind the ore. The waste water from the jigs and buddles was highly charged both with metal solutes and sand and silt-sized ore particles. For most of the British mining period there were no regulations concerning the disposal of this effluent, and it was passed direct to local streams and rivers. As a result of public disquiet the Rivers Pollution Commissioners heard evidence in 1872 that lead mining in Wales was causing the death of stock and the failure of crops on floodplain land. They remarked (Frankland and Morton, 1874)

Table 14.4 Heavy metals in soils and sediments in west Wales in the 19th century (data recalculated from Frankland and Morton, 1874; the analytical method is unknown)

	Dry material, mg kg^{-1}	
	Pb	Zn
Field soil, Clarach Valley	11 800	8 200
Stream bank, Goginan mine	13 000	15 800
Rheidol river sediment: 1	220 000	4 600
Rheidol river sediment: 2	2 200	6 800
Dyfi river sediment	25 800	18 000

that lead mining was the one that caused the most serious pollution of rivers, and that mining was carried out in an extremely slovenly manner so that reckless waste of materials was permitted in many mines; perhaps 25% of the ore was lost at this stage. No waste water or river water data are available from that period but some soil and sediment analyses were made and are given in Table 14.4.

Gravity separation is still used, especially in tin mining, but has largely been replaced by froth flotation for Pb, Zn and Cu, which has permitted both the mining of low-grade and complex ores and the reworkings of tailings from gravity plants. Flotation was patented in 1906 and is a selective process allowing specific separations from mixed ores. It utilizes the differences in physicochemical surface properties of mineral particles when mixed as a pulp with various organic reagents through which air is bubbled. The ore particle is rendered hydrophobic by compounds called collectors, and so clings to an air bubble in the rising froth of the flotation cell. The most widely used collectors are organic acids, soaps, xanthates and dithiophosphates, and more than one collector is generally used. Froth stability is maintained by a "frother" which should possess negligible collector properties. Separation of ore mixtures is achieved by "activators" and "depressants". For example, the inclusion of $CuSO_4$ as an activator causes surficial Zn in the sphalerite mineral lattice to be replaced by Cu and hence renders sphalerite more reactive with xanthates, whereas the inclusion of cyanides (depressants) reduces the concentration of Cu^{2+} released from any Cu ores in a flotation mix. Solution pH is controlled by lime and other inorganic compounds. Some common flotation reagents are listed in Table 14.5, and Wills (1980) should be referred to for a full discussion of the technique. Release of these flotation chemicals to rivers may damage aquatic ecosystems (Jennett and Wixson, 1977), and their presence in tailings has limited the reuse of mine wastes in agriculture (Gregory et al., 1975). The efficiency of flotation combined with antipollution measures results in

Table 14.5 Some reagents used in froth flotation (Wills, 1981)

Name	Formula	Use
Sodium oleate	$CH_3(CH_2)_7(CH_2)_7COONa$	Collector
Sodium xanthate	$C_2H_5OCS_2Na$	Collector
α-Terpineol	$CH_3C_6H_8COH(CH_3)_2$	Frother
Cresol	$CH_3C_6H_4OH$	Frother
Methyl isobutyl carbinol	$(CH_3)_2(CH_2)_3OCH_3$	Frother
Cupric sulphate	$CuSO_4$	Activator
Sodium sulphide	Na_2S	Activator
Sodium cyanide	$NaCN$	Depressant
Lime	$Ca(OH)_2$	Regulator
Sulphuric acid	H_2SO_4	Regulator

Table 14.6 Surface water quality data for Missouri (mg l^{-1}). Stations 10 and 21 were control streams, 11 and 12 were discharge pipes from tailings ponds and 17 was an effluent pipe within a smelting complex (data derived from Jennett and Wixson, 1977)

Station		Pb	Zn	Cn	Cd
10	Max.	0.160	0.088	0.010	0.015
	Min.	<0.005	<0.010	<0.010	0.000
	Mean	0.015	0.14	0.010	0.008
21	Max.	0.180	0.103	0.010	0.025
	Min.	<0.005	<0.010	<0.010	<0.001
	Mean	0.025	0.024	0.010	0.010
11	Max.	0.058	0.170	0.010	0.031
	Min.	<0.005	<0.010	<0.010	0.004
	Mean	0.010	0.089	0.010	0.004
12	Max.	0.023	0.190	0.012	0.018
	Min.	<0.005	<0.010	<0.010	0.000
	Mean	0.009	0.083	0.010	0.007
17	Max.	14.8	16.5	0.330	5.50
	Min.	0.010	0.012	<0.010	0.004
	Mean	1.113	4.858	0.031	1.884

negligible heavy metal pollution of waterways in a modern mining area (Table 14.6).

After dewatering, the ore concentrates are roasted and smelted to yield the required metal. A complex of processes is used here, including thermal and chemical separations to extract other metallic constituents of the ore, such as Cd or Ag. For example, the metals recovered from Cu ore include Ag, As, Au, Mo, Ni, Pd, Pt, Re, Se, Te and W (MCP, 1979).

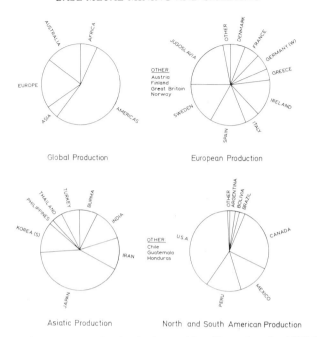

Global Production

European Production

Asiatic Production

North and South American Production

Fig. 14.1 Relative Pb ore production in the world and its regions for 1979 (ILZ, 1980). Summary figures (in millions of tonnes): Africa = 0.18; Americas = 1.3; Asia = 0.12; Europe = 0.5; Australia = 0.39.

The size of a mining or smelting industry cannot be related directly to any pollution hazard since countries differ in their emission-control regulations. Nevertheless, the bigger the industry, the greater is the likelihood that environmental contamination may be locally important, and older mining techniques were dirtier than modern ones. Figure 14.1 depicts world Pb production, and is therefore an approximate guide to localities where environmental contamination from mining might be expected.

IV. Environmental pathways

From the above brief description of the technological processes used in metal mining, it can be seen that there are numerous opportunities for heavy metals to be released to the environment. The metals and their compounds may be released as solutions, colloids or suspended particles in aqueous effluents, or as gases and aerosols or dusts from smelter stacks, ore stock piles and tailings or during transportation. Having been released, they follow normal geochemical and ecological pathways until they reach sinks such as sediments, soils or

biota. Mining operations as sources of contaminants are summarized in Fig. 14.2. Three general distribution processes are recognized, namely fluvial dispersal, atmospheric dispersal and gravitational dispersal.

1. Fluvial dispersal

Flowing water is the dominant agent in landscape evolution, and weathered and eroded rocks provide dissolved and suspended materials which rivers transport. Rivers are not simple chutes down which weathering products are carried out to sea. Rather, the suspended sediment load may be deposited on the valley floor as alluvium, which can weather to soil, and forms a floodplain, whose sediments are deposited or reconstructed by overbank sedimentation during flood inundation or by deposition within the river channel, which alters its shape by meander migration. The composition of the alluvial matrix is augmented by adsorption and precipitation of river solutes, and depositional basins become geochemically enriched. The consequent enhanced fertility of floodplain soils makes them agriculturally valuable.

Pollutants enter this slow and complex process of fluvial transport and may not only cause immediate damage to aquatic ecosystems but, by being retained in alluvial soils, can pose long-term agricultural problems. The long-term effects have been studied in the base metal mining areas of England and Wales, where the mining industry declined rapidly in the late 19th century and, until the Rivers Pollution Act of 1876, disposal of wastes was unregulated.

The river ecosystems in west Wales were very badly affected during the mining period, and their subsequent recovery was investigated by ecologists at Aberystwyth during the earlier decades of this century. A review of that early work has been provided by Newton (1944). The river Rheidol has fully recovered as have long stretches of the Ystwyth, despite its being considered in the 1930s as beyond redemption and suitable only for receiving mine effluents in the event of any resurgence of mining.

The drainage adits from many abandoned mines in Britain are still localized sources of river pollution. For example, at the Cwm Rheidol mine, near Aberystwyth, two adits discharge water into the nearby river Rheidol. The flow of this river is regulated as part of a hydroelectric power scheme which includes a fish ladder to permit salmon to by-pass the generating plant and so travel up-river and through the mine outfall. In 1961 a small treatment plant was installed to cleanse the adit drainage: typical analytical data for the two drainage streams were pH = 3.1 and 1.9 and metal contents 0.30 and 0.35 mg l^{-1} Pb, 28 and 188 mg l^{-1} Zn and 14.4 and 212 mg l^{-1} Fe. The treatment plant consists of four linked 30×40 ft concrete bays each containing 500 t of 3.7 cm limestone chippings. After completion, the pH of the

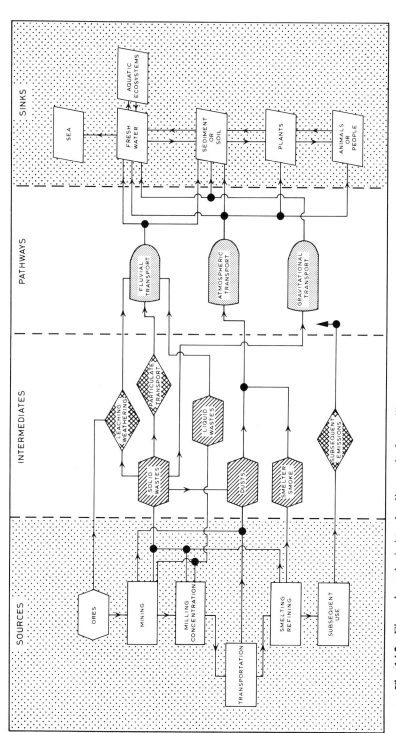

Fig. 14.2 Flow chart depicting the dispersal of metallic contaminants to the environment in mining and smelting areas.

outflow water was raised to 10.8 and metal contents reduced to 0.16 mg l^{-1} Pb and 0.2 mg l^{-1} Zn (Treharne, 1962). In 1969 the ore reserves of the mine were reassessed and, during the exploration, the plug to one adit was accidentally removed and polluted water flooded out, resulting in a significant fish kill in the main river. The new drainage conditions have overwhelmed the treatment plant capacity, and a spot test by this author in May, 1979, demonstrated that water flowing into the plant was of pH 4 and had metal contents of 1.9 mg l^{-1} Pb and 19 mg l^{-1} Zn, whereas that flowing out was of pH 5 with metal contents of 0.3 mg l^{-1} Pb and 29 mg l^{-1} Zn. The ores at this mine contain more pyrite than is usual in neighbouring mines, and pyrite is a common, but valueless, component of sulphide ores which accumulates in tailings. In a wet environment it oxidizes in a reaction that can be summarized:

$$4FeS_2 + 14H_2O + 15O_2 = 8H_2SO_4 + 4Fe(OH)_3$$

Consequently, the drainage from adits and tailings can be very acid, and stream beds become coated with ferric hydroxide ("ochre") slimes. At Cwm Rheidol the drainage waters are easily recognized by their red-brown beds. In Wales alone there are some 300 abandoned lead mines, and therefore the cost of treating every polluted adit drainage would be exorbitant. One of the challenges facing a modern mine manager is to arrange to leave the mine in a fail-safe condition when it is abandoned, and subsequent incursions into the workings should be made with great care.

The overall effect of abandoned mines on surface water quality in Wales has been reported by Abdullah and Royle (1972, 1975). They concluded that mineral deposits and mine wastes were the major sources of heavy metals in streams and rivers (see Table 14.7). Grimshaw et al. (1976) have also reported heavy metal values for Welsh rivers, and they estimated that the river Ystwyth yielded 72 t of dissolved Zn in each of two successive years. In North Wales, Elderfield et al. (1971) found that heavy metals originating from the Llanrwst mining district were the cause of problems in an oyster hatchery at the mouth of the river Conwy. Thornton (1974) has related poor water quality in the southwest of England to abandoned Cu–As mines.

Although modern mining is closely regulated, the large size of a mine or smelter implies the possibility of significant environmental effects, and local waters must be carefully monitored.

Algae and other aquatic plants display a remarkable affinity for heavy metals. Jennett and Wixson (1977) and Gale and Wixson (1979) have proposed that mine effluents may be treated effectively by encouraging the growth of such algae in tailings ponds and artificial stream meanders, since studies in the Missouri New Lead Belt have demonstrated an effective reduction in both dissolved heavy metals and suspended particulates by these plants.

During fluvial transport, solutes become complexed and also adsorbed on

Table 14.7 Pb and Zn (μg l^{-1}) in membrane-filtered surface waters in Wales for monthly samples September 1970 through September 1971; the influence of mining on water quality is evident (data abstracted from Abdullah and Royle, 1975)

Name	Pb		Zn	
	Range	Mean	Range	Mean
I Non-mineralized				
Rhiw (River)	0.3–4.1	1.2	4.1–32.7	12.9
Iaen (River)	0.4–5.5	1.2	3.6–48.3	14.0
Seiont (River)	0.5–5.5	1.8	4.9–31.9	12.7
Dysynni (River)	0.4–2.8	1.2	12.4–29.3	19.0
Talyllyn (Lake)	0.5–1.8	0.7	5.8–27.9	14.1
Padarn (Lake)	0.5–3.3	1.4	7.3–57.5	18.2
Cwellyn (Lake)	0.4–1.7	0.9	11.3–17.8	14.5
Overall	0.3–5.5	1.2	3.6–57.5	15.1
II Mineralized				
Twymyn (River) i	6.6–58.9	25.8	366–832	542
ii	1.4–17.0	5.7	163–456	307
iii	0.8–7.8	3.2	56–160	116
Rheidol (River) i	0.6–5.0	2.2	12.9–83	54
ii	0.6–10.1	2.2	18.7–204	124
iii	0.8–6.8	2.6	29–280	146
Ystwyth (River) i	0.8–30.7	8.5	20–384	241
ii	0.5–9.7	2.5	17–440	296
Overall	0.5–58.9	6.6	17–832	228

the suspended sediments. Ramamoorthy and Kushner (1975) found that filtered samples of Ottawa river water (in Canada) contained organic complexing agents that could bind heavy metals, and Andrew and Harriss (1975) concluded that a large part of the dissolved Hg in certain estuarine waters of the USA was associated with dissolved organic matter. Gardiner (1974) proposed that adsorption of Cd on to mud solids is likely to be of major importance in controlling the concentration of Cd in fresh water. Blanton et al. (1975) studied Hg in a former cinnabar (HgS) mining district of Texas and found that Hg was strongly bound to stream alluvia so that movement of Hg was controlled by sediment transport. Desorption of metals from sediments may also occur, and Jennett et al. (1980) have proposed that highly reducing conditions combined with very acid waters having a high complexing ability and subject to a high degree of mixing at the sediment–water interface will favour release; but more research is needed to establish how and when such release actually occurs. Sediments, therefore, are very effective sinks for metals during fluvial dispersal.

Incorporation of mine effluents into flood plain soils is conspicuous in the

river valleys of Britain. The old lead mining areas are clearly delimited by high stream sediment Pb contents in the Wolfson Geochemical Atlas of England and Wales (Webb *et al.*, 1978). Davies and Lewin (1974) and Lewin *et al.* (1977) have studied heavy metals in soils and sediments both in river valley cross-sections and in dated sediments in developing meandering loops. Three categories of metal values emerged: channel sediments dating to the period of maximum Pb production in the 19th century contained highest levels, flood loams contained intermediate levels, whereas valley slopes were affected only by up-slope spoil heaps. Data for a river cross-section are given in Table 14.8, and values for a dated meander loop in Table 14.9.

Exposed fluvial sediments weather to form soils, and Alloway and Davies (1971a) reported that alluvial soils in Welsh catchments affected by Pb mining

Table 14.8 Soil anlyses for a transect across the Ystwyth valley which was badly polluted in the 19th century: the metal values illustrate how floodplain soils were especially at risk (data adopted from Davies, 1976)

	Total metals (mg kg^{-1} dry soil)		
Sample description	Pb	Cu	Hg
Valley side: slope soil	240	15	0.14
Valley floor: liable to flooding	1507	36	0.96
Active channel sediment	1593	36	1.43
Valley floor: flood liable	821	31	1.36
Valley floor: flood liable	1422	30	1.34
Channel: active during mining	3423	45	1.78
Valley floor: flood liable	1024	37	0.46
Valley side: slope soil	104	17	0.08

Table 14.9 Soil data for dated sections of a developing meander loop in the Rheidol valley, Wales (Davies and Lewin, 1974). The ignition loss values demonstrate increasing soil maturity and, except for Zn, metal contents are lower in the younger sections

Age zone	pH	Ignition loss %	Mean metal content (mg kg^{-1} dry soil)			
			Pb	Zn	Cu	Cd
1845–1886	4.4	7.2	1500	485	72	2.3
1886–1904	4.7	4.6	1011	364	39	0.9
1904–1951	4.4	6.5	785	368	45	0.3
1951–1971	4.7	2.2	503	324	27	0.1
1972	4.8	1.4	368	243	23	0.1

Table 14.10 Data for soils in Cerdigion (west Wales) differentiated according to topography and location: local base metal mines produced mainly Pb and Zn ores

	Range and mean (mg kg^{-1} dry soil)			
	Pb	Zn	Cu	Cd
Slope soils				
Mine area	33–1680 (270)	20–1900 (193)	5–25 (16)	0.6–2.1 (1.2)
Non-mining	17–57 (30)	35–157 (82)	3–15 (10)	0.6–2.0 (1.5)
Alluvial soils				
Mine area	90–2900 (1420)	95–800 (455)	17–42 (30)	—
Non-mining	24–56 (42)	80–171 (129)	14–31 (19)	—

were contaminated by heavy metals. The data in Table 14.10 illustrate how soils in west Wales differ in metal content according to topography and liability to contamination. Figure 14.3 is a flow model for the fluvial dispersal of mine wastes in Wales.

2. Atmospheric dispersal

When contaminants are released into the air, they are carried by the wind and eventually fall to the ground. The pattern of ground contamination depends on the nature of the emitting source, the size and density of the particle, changes in the size and composition of the particle during transport, and wind strength and direction. Particles of diameter < 1 μm are not significantly affected by gravity and wind turbulence, and the temperature of the smoke plume are important controls.

Sources can be conveniently grouped into three classes: continuous point sources, such as smelter stacks; area sources, such as dry tailings; and line sources, such as roads and railways along which ore concentrates are carried.

Ore smelting and refining has long been a notable cause of air pollution. It was common in Britain last century for the hearth to be placed at the foot of a hill, the stack on top of the hill and the two connected by a flue labyrinth in which oxides of Pb or As would settle, and therefore air pollution diminished and metal recovery was optimized. Direct damage to vegetation is usually due to the emission of sulphur gases. At Sudbury, Ontario, Gorham and Gordon (1960a,b) observed that vegetation was severely blighted within 3 km of the smelter and damage could be observed up to 8 km; strong sulphate accumulation was detected in soil within 1.6 km. At the Amax smelter, in Missouri, SO_2 and acid mist emissions were established as the cause of premature browning of nearby forest trees in 1970, and effective control

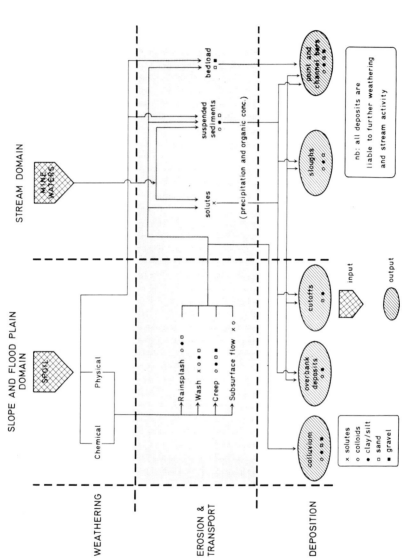

Fig. 14.3 Flow chart depicting the dispersal of mine wastes by fluvial activity in west Wales (reproduced by permission of J. Wiley & Sons Ltd).

measures were promptly introduced (Wixson, 1974). Monitoring stations around a modern smelter are usually now linked to a computer-based data acquisition system so that any significant rise in ambient SO_2 can immediately be reported and obviated. (At the Amax smelter, the sinter–acid plant is shut down whenever the ambient SO_2 at any station exceeds 0.25 ppm for more than 10 min.) Meteorological data are also regularly reported to smelters in order to anticipate adverse climatic conditions.

Accumulations of heavy metals around the stacks are not visible, but are serious in the long term because of the persistence of heavy metals in soils. The sites of old smelters are still readily identified by the residual contamination halo (Davies and Roberts, 1978) and, despite emission-control regulations, modern smelters have caused similar neoanomalies to form. The general conclusion that can be drawn from the published reports is that the ground pattern is usually an ellipse, with the major axis trending along the direction of the prevailing wind, and heavy metal contamination is most severe within approximately 3 km of the stack and then declines exponentially until background levels are reached within 10–15 km. For example, in the Missouri new lead mining area, Jennett et al. (1974) concluded that deposition rates from one of the smelters could be predicted by the equation:

$$Y = 8.76 \times 10^6 \times D^{-1.2704} \ (r = 0.995)$$

where Y is the rate of deposition of Pb as mg m^{-2} month^{-1} and D the radial distance from the stack. Similar distance–decay patterns have been reported by other authors (Little and Martin, 1972; Lagerwerff et al., 1973; Temple et al., 1977); Figure 14.4 depicts the pattern of Ni accumulation around a British refiner.

Area sources associated with the mines or smelters may also contribute significant quantities of "fugitive" dusts to the immediate environment. During dry weather unvegetated spoil may start to blow, and Davies and White (1981) have described how dust blow from a 19th-century waste heap in west Wales was a hazard to a small hamlet located near the tailings. Figure 14.5 shows the spoil blowing on a windy day, and Fig. 14.6 depicts the deposition of Pb around the tailings pile. Unless protected, ore concentrates, which contain some 70% Pb on a weight basis, may blow from stock piles at a smelter, and further blow may occur when these concentrates are transported from the mine to the smelter. Jennett et al. (1974) have commented that soil Pb concentrations may be increased for up to a hundred or more metres away from the road along which the ore is carried: such routes are line sources.

3. Gravitational transport

In older mining districts the waste debris was heaped wherever convenient, which was often high on a hillside above productive agricultural ground. The

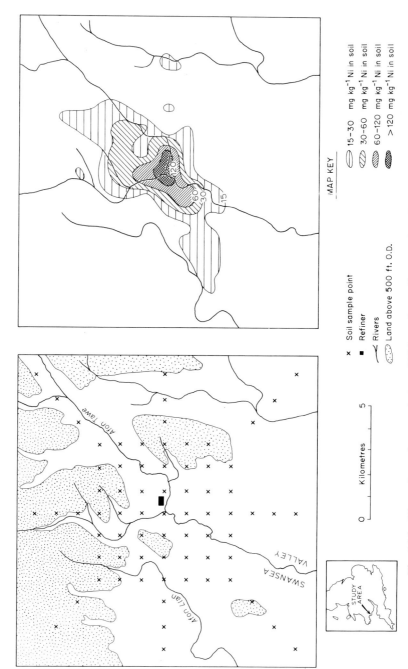

Fig. 14.4 The pattern of accumulation of Ni in surface soils around a refiner in South Wales.

MAP KEY

⬭ 15–30 mg kg⁻¹ Ni in soil
▨ 30–60 mg kg⁻¹ Ni in soil
▨ 60–120 mg kg⁻¹ Ni in soil
▨ >120 mg kg⁻¹ Ni in soil

× Soil sample point
■ Refiner
〰 Rivers
⬭ Land above 500 ft. O.D.

Fig. 14.5 Mine waste blowing on a windy day in the area shown in Fig. 14.6.

normal process of gravity-induced surface creep causes the debris to move downslope to form an extensive fan of contaminated land. In the Tamar valley area of Devon and Cornwall, Davies (1971) concluded that 31% of apparently productive slope soils were contaminated by heavy metals and in many cases this was due to the dispersal of dump material. The passage of water through the heaps will also cause dispersal, partly through removal of solutes in surface run off but also by surface wash of colloids and fines. Complex chemical changes occur inside waste heaps. Boorman and Watson (1976) identified two major zones in a sulphide ore tailings pile in Canada, namely, a surface oxidation zone and a deeper reduction zone. In the surface zone, 92% of the Zn had been lost, since ZnS readily oxidizes to $ZnSO_4$, whereas for Pb, insoluble anglesite ($PbSO_4$) formed and little Pb was removed. In dry weather, soluble metal salts may effloresce on the surface and then be blown away (Johnson *et al.*, 1978). Thus, toxic metals are removed from spoil heaps by several processes that are difficult to differentiate in the field; Table 14.11 exemplifies the distribution of soil Pb and Cd downhill from an old waste heap in Derbyshire.

V. Soils and biota as heavy metal sinks

Section IV has described how heavy metal compounds move from emitting sources along pathways that are conceptually distinct but operate simul-

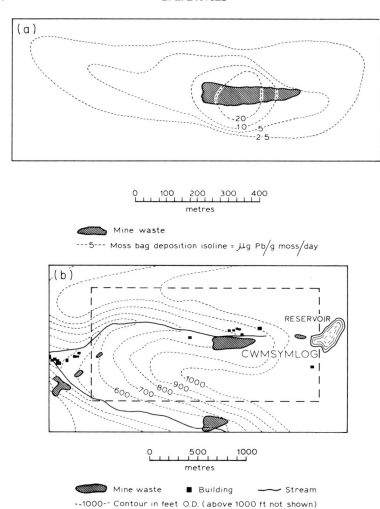

Fig. 14.6 Pattern of deposition of Pb from an area of mine wastes subject to wind blow in west Wales. Movement of dust was monitored by nylon mesh bags containing moss (*Sphagnum* spp.) and hung from posts around the railings area. (a) Mean annual Pb deposition isopleths. (b) Location map.

taneously. These metals continue to move until trapped in sediment, soil or biota.

Aquatic ecosystems are likely to be the first to be damaged from mining pollution. The earliest ecological studies were carried out in the Aberystwyth area where uncontrolled mining had rendered lifeless significant reaches of local rivers. This early work assumed that dissolved Pb was the prime toxic

Table 14.11 Heavy metal values for soils taken along a transect downslope from spoil associated with a rake in Derbyshire, England: accumulation of metals immediately above the field boundary wall is conspicuous and contamination is still evident 40 m below the wall

Relative distance (m)	Total metal (mg kg^{-1} dry soil)				Explanatory note
	Pb	Zn	Cu	Cd	
20	1380	1 334	24	18	Uphill of rake
0	4543	26 473	69	33?	Rake spoil
20	4389	11 164	60	15	Below rake
49	1957	2 363	34	33	Below rake
60	2034	167	32	27	Below rake
73	2372	2 891	56	34	Below rake
74	—	—	—	—	Drystone wall
94	887	1 073	36	17	Below wall
114	1025	821	27	12	Below wall

agent, and Carpenter (1926) concluded that trout were killed in polluted rivers by suffocation since Pb formed a colloidal precipitate on the fish grills. In later studies Jones (1940) commented that dissolved Zn was probably just as serious a hazard as Pb, but that the absence of certain soft-bodied fauna could be accounted for by the scouring action of mine refuse on the river bed. He also noted that certain insect species appeared to be tolerant of dissolved Zn, and metal tolerance has since been noted by other authors. McLean and Jones (1975) found that filamentous green algae (*Hormidium* spp.) and certain bryophytes in the river Ystwyth were metal tolerant. Burton and Peterson (1979) also worked in the Ystwyth and also concluded that several bryophytes were metal tolerant and might be used in monitoring water pollution. Warren *et al.* (1971) have suggested that trout liver could be used as a prospecting tool. In the Missouri lead belt, dense gelatinous mats of algae form which trap fine sediments and concentrate metals, but during high discharge periods they may break loose and float downstream (Jennett *et al.* 1974); it has already been noted that these algae have been suggested as a way of cleansing mine waste water. However, in that Missouri area, and in contrast with west Wales, Jennett and Wixson (1977) have reported that dissolved heavy metals do not present a significant biological hazard, except possibly Zn (cf. Table 14.6), as a consequence of high water pH and hardness combined with effective pollution control processes: game fish can be observed in tailings ponds. But the relationship between metals in fish and in water is not necessarily direct. In Ullswater, in the English Lake District mining field, aquatic macrophytes accumulate heavy metals, but contents correlate better

with sediments rather than with water, and water plants play an important role in cycling Pb from sediments to trout (Welsh and Denny, 1976).

The earlier discussion of fluvial transport has shown how sediments can accumulate heavy metals in contaminated catchments and those sediments may become the parent material for soils. Heavy metals can also enter soils directly from mining activities.

In uncontaminated soils, Cu, Hg and Pb are usually enriched in surface horizons (Butler, 1954; Archer, 1963; Fleming and Ryan, 1964; Mitchell, 1964; McKeague and Kloosterman, 1974), but the distribution of other metals is more complex. Nickel and Cr often increase with depth from the surface irrespective of drainage class (Archer, 1963; Fleming and Ryan, 1964), but Zn sometimes accumulates in the surface (John, 1974; Mitchell, 1964) or can increase with depth (Stanton and Burger, 1966). Leaching rates for heavy metals appear to be low. Purves (1972) passed the equivalent of 40 m of rainfall through soil columns and found the levels of toxic metals were not substantially reduced. Frissel *et al.* (1974) found that less than 1% of added Hg was leached from soil and that most loss was by volatilization. Korte *et al.* (1976) detected measurable concentrations of Co, Cr, Cu, Ni and Zn in column leachates but not Cd or Pb. Both clay and the organic fractions are responsible for binding heavy metals. Le Riche and Weir (1963) found that mineral fractions in the soil contributed to the total trace element content in the order clay > silt > sand, but much of the Cu and Pb was bound in the humus and iron oxides. Hodgson *et al.* (1966) reported that 98.5–99.8% Cu in displaced soil solutions was organically complexed.

This low leachability of heavy metals together with their tendency to accumulate in the organic-rich surface horizons has a special relevance in contaminated areas, where the metals tend to be deposited direct on the soil surface in large amounts. In the Missouri new lead belt, Bolter *et al.* (1975) have observed that only in heavily contaminated sites was there any significant penetration of metals below 5–8 cm. Data for a typical Missouri soil profile located in reafforested land 500 m NNW of a modern Pb smelter are given in Table 14.12 and demonstrate the effects of accumulation of Pb over about 6 years. These values may be compared with those for a profile (Table 14.13) from Devon, England. This profile was located near a Pb mine that was abandoned in 1876 and within the sphere of influence of a smelter that ceased in 1896. Both profiles clearly exemplify the tendency for heavy metals to remain in the surface layers, and even in the older profile there is little evidence of Pb penetration below 30 cm despite a high rainfall (1000 mm), occasional ploughing, constant earthworm activity (the land was under grass) and a century of leaching. It seems that once soils have become contaminated they are likely to remain in that condition and will be depleted in Pb and other metals only by profile renewal through normal erosion rather than leaching:

Table 14.12 Heavy metal data for a profile located 500 m NNW from a modern smelter in the Missouri new lead belt. Samples were taken in 1975 and the smelter commenced working in 1969 (data adapted from Bolter, 1977)

Depth (cm)	Metal concentration (mg kg^{-1} dry soil)			
	Pb	Zn	Cu	Cd
0–5	774	56	24	4.5
10–15	43	28	6	1.5
20–25	22	26	6	2.1
30–35	29	31	6	1.5
40–45	43	40	10	2.0
50–55	28	54	14	3.0
60–65	25	50	14	2.5

Table 14.13 Heavy metal data for a profile near a lead mine abandoned in 1876 and some 2 km from a lead smelter active during the period 1820–1896 in Devon, England

Depth (cm)	Metal concentration (mg kg^{-1} dry soil)			
	Pb	Zn	Cu	Cd
0–10	318	142	57	0.9
10–20	93	74	43	0.4
20–30	98	80	20	0.6
30–40	53	90	15	0.5
40–50	39	106	38	0.5
50–60	36	114	42	0.6
60 +	42	85	21	0.6

there is ample evidence in pedological literature that in geomorphologically stable sites soils can be 5000–6000 years old.

The pattern of soil contamination that can arise from mining is illustrated in Fig. 14.7 and shows the distribution of mines and smelters in north-east Wales. The Pb and Cd isopleth maps illustrate how a geochemical landscape can evolve from the activities of smelting and mining.

Earthworms play a major part in mixing soil and maintaining a good crumb structure, and they are also an important food source for many birds and small mammals. Several authors (Van Hook, 1974; Ireland, 1979; Hartenstein et al., 1980) have reported that heavy metals may accumulate in earthworms and Cd can be concentrated from the soil: the data in Table 14.14 exemplify this. This would seem to be an important route through which toxic metals might reach wildlife. Furthermore, those reclamation schemes that depend on a shallow

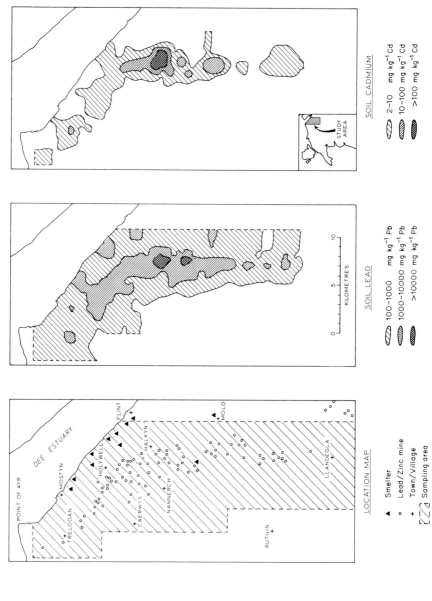

Fig. 14.7 Cadmium and Pb soil concentration patterns in a Pb mining area in North Wales.

Table 14.14 Mean metal contents in soil (S, total metal content) and earthworm (W, *Lumbricus rubellus* (Hoffmeister)). Pb is variable, but the high content in Cwmystwyth is noteworthy and Cd is concentrated in worm tissue (data abstracted from Ireland, 1979)

	Metal as mg kg^{-1} dry weight					
	Pb		Zn		Cd	
	S	W	S	W	S	W
Cwmystwyth	1314	3592	138	739	2	15
Borth	629	9	992	676	4	4
Dolgellau	42	28	100	416	4	25

layer of clean soil being lain over a contaminated substrate appear to ignore the mixing activities of worms.

VI. The soil–plant system

1. Reclamation of tailings areas

Grossly polluted land may be quite devoid of plant life, and special treatment measures are needed to restore it for amenity, agricultural or horticultural use. The tailings from mining present a special problem here, since they may have concentrations of heavy metals that are toxic to plants; analytical data for selected spoil heaps are given in Table 14.15. Furthermore, their other chemical and physical properties are likely to be unsuitable, for example, the angle of repose of heaps may be so steep that there is continuous erosion and collapse. The particle size may be such that not enough water is retained to supply plants during dry periods, or the material may be so fine that the tailings area is always waterlogged. Usually there is a lack of the essential nutrients, and the first stages of revegetation take place in animal droppings; in Wales, gorse (*Ulex* spp.) is commonly an early colonizer since it is drought resistant and a nitrogen fixer. These problems are common to many kinds of industrial waste, but metal mine tailings are also often toxic. Hewitt (1948) worked with sugar beet seedlings in sand culture and proposed a general order of toxicity: $Ni > Co \gg Zn > Cu > CrO_4 > Cr = Mn = Pb$. Although different plants have different sensitivities to metals, it is generally true that Ni is highly toxic and Zn is likely to be the limiting factor in the colonization of Pb–Zn waste.

One approach to land reclamation is simply to cover the waste with comparatively innocuous materials, such as colliery spoil, cultivate in cheap

Table 14.15 Analytical data to show the variability of composition of metal mine spoil (mg kg^{-1}) (data for Zimbabwe were taken from Wild and Wiltshire, 1971, and for the USA from Kramer, 1976)

	Pb	Zn	Cu
Zimbabwe			
Banket, Gwanda	200	50	40
Reliance, Umtali	1000	900	1200
Falcon, Umvuma	20	100	10 000
Wales			
Cwm Ystwyth, Dyfed	5500	1140	87
Cwm Symlog, Dyfed	14 350	641	424
Minera, Clwyd	2650	29 248	52
England			
Wheal Franco, Devon	197	98	2790
Drakewalls, Cornwall	63	59	209
New Great Consols, Cornwall	824	880	5260
USA			
Elvins, Mo.	5320	2740	113

organic materials, such as sewage sludge or composted urban rubbish, fertilize and then sow with commercial seed mixtures. Where such procedures are not economic, recourse may be had to plants that have developed a tolerance to heavy metals. Bradshaw (1971) has listed tolerant species that are recognized in Britain, and accounts of their use are given in Chadwick and Bradshaw (1980) and in Hilton (1976). The latter reference is a comprehensive account of the first integrated attempt at reclaiming badly contaminated land, namely the Lower Swansea Valley in Wales, which was a major smelting complex last century.

2. Soil analysis and metal uptake prediction

In most cases, however, contaminated land supports plant growth and the problem of its use becomes one of assessing whether crops are absorbing trace elements at a level likely to constitute a hazard to animals and man. This problem is best investigated by growing one or more test crops in the suspect soil, in either pots or field trials, and then analysing the plant material to establish its metal content. Bioassays are, however, costly in both time and money and usually more expeditious procedures are adopted, in which the soil is analysed chemically for "available" elements and plant uptake thereby predicted.

The traditional objectives of soil testing are to classify soils for the purpose of fertilizer application and hence to predict the probability of obtaining a profitable response to fertilizer use. Last century it was believed that plant roots exude sap organic acids which attack soil minerals and render soluble the nutrient elements. B. Dyer in 1894 concluded that the average acidity of sap was equivalent to 1% citric acid, and he suggested that citric acid solutions could be used to extract soils to assess their plant nutrient status. Although the theory was wrong, the technique proved relatively successful and dilute acetic or citric acids are still used as all-purpose extractants. Other dilute acids and solutions of various salts, singly and in combination and adjusted to different pH values, have found favour with individual workers for specific soils in specific localities, but none is universally applicable. In the last 20 years attempts have been made to assess the K supplying power of soils by estimating the energy of replacement of adsorbed K, and the radioisotope ^{32}P has been added to soil in pots when its subsequent partitioning between soil and plant permits the assessment of available P in soil. But only very recently have there been new ideas in micro-nutrient analysis (Sposito, 1981, and this volume), and there is still a general reliance on simple extracting solutions that have been found, entirely empirically, to be useful in identifying deficient soils. In Great Britain, the state agricultural advisory service used disodium EDTA (see Table 14.17), usually at a concentration of 0.05 M and adjusted to pH 7, to identify Cu-deficient soils: values <1.6 mg l^{-1} Cu indicate deficiencies whereas values >4.0 mg l^{-1} Cu indicate a soil well stocked with Cu (Thornton and Webb, 1980). Knezek and Ellis (1980) have reviewed soil test methods in the USA where DTPA (Table 14.17) extractable levels of <0.5 mg kg^{-1} Zn and <0.2 mg kg^{-1} Cu indicate deficiency.

In recent years, extraction techniques have been used to try to identify soils where heavy metals are so high as to yield crops of suspect quality. Inherent in this approach is the belief that it is possible to correlate soil and plant metal contents. Such work is still in its infancy, and an extractant that appears suitable for one metal in one locality may not be effective for the same metal in a different locality or for other metals. This is exemplified in Table 14.16 which contains correlation coefficients derived from growing radish (*Raphanus sativus L.*) as a test crop in two metal mining areas of Great Britain (B. E. Davies and J. M. Lear, unpublished data).

These same extractants may also be used to fractionate metals in soils (e.g., McLaren and Crawford, 1973; Luoma and Jenne, 1976) since they may be present in many chemical forms. Metal speciation in soils is only poorly understood even for the essential plant micronutrients, but our knowledge in this area is improving. Lindsay (1979) has given an account of speciation in the soil solution for several metals and has developed the necessary equilibrium equations to predict stable species according to soil reaction and redox

Table 14.16 Correlation coefficients for heavy metals in radish bulb and the same metals in soil (40 sites) as analysed by different extractants to demonstrate that no single extractant satisfactorily predicts uptake of all metals (B. E. Davies and J. M. Lear, unpublished data)

Soil fraction	Pb	Zn	Cu	Cd
Total	0.743	0.283	0.373	0.700
EDTA	0.408	0.146	0.317	0.854
CH_3COOH	0.662	0.458	0.134	0.773
NH_4NO_3	0.737	0.864	—	0.316

potential. Sposito (1981, and this volume) has developed a computer program to predict which metal species and complexes are likely to be present in water and soil solutions.

The soil solution is believed to be the immediate source of metals for plants, and it may be derived by centrifugation, expression under fluid pressure or through the use of saturation extracts. Soil solution constituents may also be extracted from soil by water or by 0.01 M $CaCl_2$. The soil solution is in equilibrium with other soil compartments. Ions may be held on charged surfaces (clays, oxides, humus), by adsorption forces and may be displaced from these sites by simple salt solutions, such as 1 M NH_4NO_3 at pH 7. In this way the "exchangeable" ions are measured. Of course, such an extraction procedure also measures soil solution constituents, and samples of a given soil must be extracted separately using several procedures in order to characterize each compartment. As well as non-specifically sorbed metals, another compartment comprises specifically sorbed ions, for example, precipitates. Soil humus plays an important part in retaining metals for release to plants and it holds the elements both by adsorption on dissociated carboxylic and phenolic groups and by complex formation, including chelates, and plants may be able to access these sites directly through decomplexation. The use of chelating agents as soil extractants has grown since Viro (1955) first suggested using EDTA for Cu and Zn. Since most agricultural soils are freely drained, chemical reactions are dominantly controlled by oxidizing conditions; for example, Fe(II) rapidly converts to Fe(III) and precipitates as $Fe(OH)_3$, which then ages to FeOOH or Fe_2O_3. Iron and Mn oxides scavenge heavy metals, especially Mo which may be extracted with acid ammonium oxalate solutions, sometimes in the presence of ultraviolet irradiation. Table 14.17 lists some soil extractants together with the fractions they are thought to dissolve: these fractions are not, of course, exclusive, and a reagent that extracts metals at a given level of solubility necessarily also extracts those that are more soluble.

Table 14.17 Some soil extractants commonly used both to fractionate trace elements in soil and to predict plant availability. The table indicates which soil fraction that extractant is supposed to access

Soil fraction	Commonly used extractants
Soil solution	H_2O; 0.01 M $CaCl_2$
Exchangeable ions	M NH_4NO_3; 0.1 M NH_4Cl; 0.2 M $MgSO_4$; 0.5 M CH_3COONH_4
Specifically sorbed ions	0.1 M HNO_3; 0.1 M HCl; 0.5 M CH_3COOH
Organic complexes	0.05 M EDTA (NH_4 or Na salt) 0.05 M EDDAH; 0.005 M DTPA/0.1 M TEA/0.005 M $CaCl_2$, pH = 7.3
Oxide bound	1 M CH_3COONH_4/0.002 M $C_6H_5(OH)_2$ (for Mn); 0.2 M $(COO)_2(NH_4)_2$/0.15 M $(COOH)_2$ pH = 3.3 (for Mo)
Total	HF; $HNO_3/HClO_4$; HNO_3/HCl

EDTA = Ethylenediametetra-acetic acid; EDDAH = Ethylenediaminedi-o-hydrophenyl-acetic acid; DTPA = Diethylenetriaminepenta-acetic acid; TEA = Triethanolamine.

3. Heavy metals in herbage and vegetables

Although it is not possible to predict metal uptake by plants with certainty from soil analytical data, high soil metal values generally do imply enhanced plant absorption. However, there are differences between metals. Most authors agree that the availability of Pb to pasture plants is low, and relatively large differences in soil contents result in only small increases in plant contents. Marten and Hammond (1966) grew bromegrass on Pb-contaminated soils in a glasshouse and found no significant increase in Pb uptake for soils of Pb contents from 12–95 ppm but did at 680 ppm. Tunney et al. (1972) added mine concentrates to soil and reported that the Pb content of ryegrass related significantly to soil levels but availability was low. Thornton (1980) has reported similar results for herbage collected from contaminated fields in Britain and has noted that soil Cu is also characterized by low availability: it is a common finding by agronomists that it is difficult to increase the Cu content of grasses. Nonetheless, locally, uptake by grasses of soil Pb may be important, and the appearance of metal toxicity symptoms will not necessarily assist in identifying problem areas, since they may not occur even in grasses with high heavy metal contents (Alloway and Davies, 1971b). The Pb content of grasses also varies seasonally, being highest in winter, and this can be important for cattle where mild winters permit an extended grazing season (Mitchell and Reith, 1966).

Experimental data such as those reported here generally relate to washed samples. In the field, herbage is grazed dirty, and the metal content of leaf surface dust may be very significant where it consists of rain splash from contaminated soil or fallout from a smelter. The ingestion of this material may expose the grazing animal to an excess metal intake or to an induced imbalance of essential elements (Suttle *et al.*, 1975). The importance of soil ingestion is described in detail in Chapter 8. Merry and Tiller (1978) have studied contamination of pastures around a Pb–Zn smelter in a semi-arid locality in Australia and ascribed the Pb content of the herbage largely to dust, the Cd content to root absorption; the herbage Zn was the result of both processes.

In recent years more attention has been paid to the uptake of heavy metals by vegetables, although the contributions made to community diets by locally grown vegetables has not been established. Modern Pb mines have often been developed in remote rural areas; for instance, those in the Missouri new lead belt are located in dense forest land. But older mining areas stimulated the growth of towns and villages which have often continued to flourish after mining has stopped. In such areas industrially contaminated land can be bought cheaply for housing development, and abandoned miners' cottages are attractive as second (holiday) homes or as primary residences for city workers willing to commute.

Warren (1972) reported that trace element contents of vegetables are far greater than generally recognized when derived from industrial and mining areas. Davies and Roberts (1975) grew radish in gardens in the metal contaminated area depicted in Fig. 14.7 and reported accumulations of Pb such that the British legal limit for Pb in food for sale was exceeded (1 mg kg^{-1} wet weight). Subsequently, Davies and White (1981) reported the results from growing several vegetables in gardens contaminated by past metal mining in England and Wales. Lead tended to accumulate in the roots of carrots, onions, Brussels sprouts and lettuce and was not readily translocated to edible leaves. Nonetheless, lettuce leaves did accumulate sufficient Pb to present a potential problem for health, as did the Pb levels in carrot and onion. In the case of Cd, the root acted as a translocation barrier in onion and Brussels sprouts, but not in carrot or lettuce where it accumulated in the leaves. Figure 14.8 illustrates this differential translocation of metals by vegetables.

Wild, perennial plants also absorb heavy metals from the soil. Sheppard and Funk (1975) analysed tree trunk cores from Ponderosa Pine growing on the banks of the Spokane River (Idaho, USA) which flows through the Coeur d'Alene mining area and found that trace element data were in rough agreement with local lake sediment core data and with the history of ore production. This use of long-growing perennials as monitors of the environment has led to the identification of ore bodies through biogeochemical prospecting.

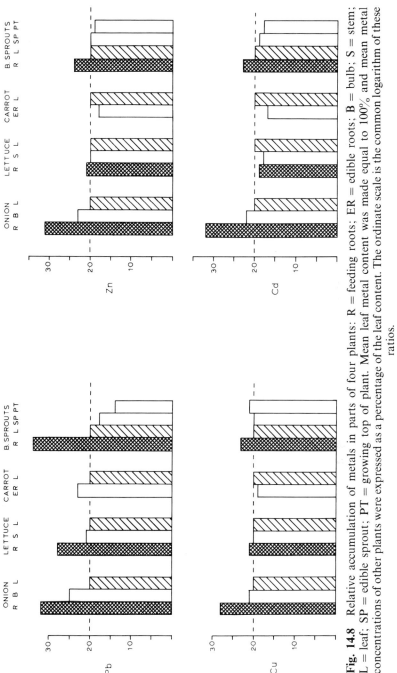

Fig. 14.8 Relative accumulation of metals in parts of four plants: R = feeding roots; ER = edible roots; B = bulb; S = stem; L = leaf; SP = edible sprout; PT = growing top of plant. Mean leaf metal content was made equal to 100% and mean metal concentrations of other plants were expressed as a percentage of the leaf content. The ordinate scale is the common logarithm of these ratios.

In earliest times the ores exploited were those that occurred near the surface and were probably discovered by chance. Such ore bodies enhance the trace element content of superjacent soils and the plants growing on them. When the resulting soil metal contents are very high, specific metal tolerant floral associations may be recognized, or metal toxicity symptoms (leaf chlorosis or necrosis) may be discerned in non-tolerant ecotypes together with changes in the colour or shape of petals. Brooks (1972) has described botanical methods of prospecting in detail, and historical accounts make it clear that early miners used such evidence in searching for ores. Even where there is no visible effect of metal stress on plants, elevated trace element contents can be identified and geochemical anomalies recognized. The ore body may not be identified through one of the principal metals but through an associated minor constituent possessing greater environmental mobility. These elements have been described as pathfinder elements by Warren (1980), who has provided a comprehensive account of biogeochemical prospecting, and the reader is also referred to Brooks (1972), Rose et al. (1980) and Sinclair (1980) for further information. The environment in mineralized areas may be adversely affected even before the ores are exploited; Låg et al. (1970) have described an area in Norway where mineralization has caused boil Pb levels to be so high (4.7% Pb) that little grows in some localities.

VII. Metal mining and human health

Workers in the mining and smelting industries are most immediately at risk from the release of metals to the environment. The dangers posed by Pb mining have long been recognized and Pb poisoning has several local names in England and Wales, for example, belland (Derbyshire), y belen (Wales) and mindering (Somerset). In his account of Pb poisoning in Derbyshire, Willies (1974) has traced the origin of several British Acts of Parliament concerned with worker or environmental protection to Pb poisoning in mines and potteries. Heavy metals often exert their toxic effects through their strong affinities to —S and —SH groups. The toxicology ot Pb is particularly well documented, especially its interference in the haem synthesis pathway and body Pb burdens may be estimated by determining the activity of the enzyme aminolaevulinic acid dehydrase (ALA-D), which is rate-limiting for the system (Lee, 1981). The monitoring of blood Pb is now routine in the mining industry as is the checking of atmospheric Pb which is limited to 0.15 mg m^{-3} in both Britain and the USA. Waldron (1980) has reviewed the implications of environmental Pb for human health including occupational exposure. The effects of exposure to Cd have been documented by Fassett (1980), Co by Kipling (1980) and Mn by Mena (1980). Much of the epidemiological data

showing the relationship between atmospheric Ni and lung or nasal cancer was derived from studies at a smelter near Swansea, Wales (Sevin, 1980).

People living within the sphere of influence of mines and smelters may also be affected by the industrial operations. One of the best documented episodes derives from Japan and concerns a condition now known generally as "Itai-Itai" disease (see Chapter 10). In 1955 an unusual disease was reported from a small village lying in the flood plain of the Jintsu River in Toyama Prefecture. The chief symptoms were severe pains in the bones of the legs and back together with skeletal deformities. The disease was confined to elderly women who had borne many children and many patients were bed-ridden. After investigation nutritional deficiencies such as those of vitamin D or Ca or P were largely discounted as principal causes and attention focused on heavy metals.

Upstream of the affected area is the Kamioka zinc mine which produced a million tons Zn and over 4000 tons Cd between 1874 and 1960, and during processing it has been estimated that 21.2 tons Cd were lost annually to the river. Upstream of the mine the river contained no detectable dissolved Cd whereas downstream up to 0.009 mg 1^{-1} Cd were detected. Similarly, in the non-filtered, non-settled water 5.7 and 3.8 mg 1^{-1} Cd were found upstream and 363 and 382 mg 1^{-1} Cd downstream (Yamagata, 1978). Kobayashi (1978) has reported that the mean Cd content of soil in paddy fields in the affected area was 6 mg kg^{-1} Cd, whereas rice contained 125 mg kg^{-1} Cd compared with 30 mg kg^{-1} Cd from a nearby control area : river water was used both for cooking and drinking. These investigations pointed to an abnormally high intake of Cd and this metal is held by some to be the cause of the disease. However, its aetiology is complex and an alternative vitamin deficiency cause has been proposed by others: recent accounts of Itai-Itai have been given by Tsuchiya (1978) and Nomiyama (1980). Certainly, much higher soil Cd levels have been reported elsewhere without being associated with Itai-Itai : in the Somerset village of Shipham, garden soils contain 2.0–97.9 mg kg^{-1} Cd (Davies and Ginnever, 1979), but there is no clear evidence for any significant health effect in the villagers that can be ascribed to environmental Cd.

Consumption of water from mines or mineralized strata can lead to health problems. Wyllie (1937) described As poisoning in a family in Ontario, Canada, who drew their water from a deep well that penetrated an aquifer in contact with arsenopyrite beds. Borgono and Greiber (1972) ascribed cutaneous lesions in residents of Antofagasta, Chile, to the high As content of drinking water derived from the local river in whose catchment there are As-rich Cu deposits. High blood Pb levels have been reported in adults and children living near smelters (e.g., DOE, 1974) and in children living in Derbyshire where the soil is heavily contaminated by Pb from past mining (Barltrop et al., 1975, and Barltrop, 1976).

Table 14.18 Summary data (mean \pm standard error) to exemplify the association between soils contaminated by Pb and enhanced caries prevalence (data abstracted from Anderson and Davies, 1980)

	Soil Pb (mg kg^{-1})	Dental caries DMF score
Wales		
Contaminated valley	1420 \pm 201	6.32 \pm 0.79
Control valley	42 \pm 2.4	4.68 \pm 0.63
England		
Bere Alston Pb area	216 \pm 18	7.72 \pm 1.16
Tamar Valley control	42 \pm 5.1	5.0 \pm 0.59

In recent years more attention has been paid to the possibility that local geochemical anomalies or contamination neoanomalies might affect community health especially for diseases such as cancers or multiple sclerosis, and the relationship between environmental I and endemic goitre is well known. Several surveys have shown that stomach cancer is unusually prevalent in parts of Wales and the north of England (Legon, 1951; Howe, 1960, 1963, 1979) and high rates have been associated with unusual accumulations of trace elements in soils and plants (Stocks and Davies, 1960, 1964). Soil Pb has been linked with multiple sclerosis (Campbell et al., 1947; Gould and Warren, 1980). But no firm evidence has been adduced to substantiate the supposed link between these diseases and the geochemical environment. Good geographical associations have been established between the prevalence of human dental decay and trace elements in food and water. The beneficial role played by F^- in preventing caries is well known (Murray, 1976) and a similar beneficial effect has been established for Mo (Jenkins, 1967; Anderson, 1969). In contrast, Se has been associated with increased caries prevalence (Hadjimarkos, 1969). Barmes et al. (1970) proposed that Pb might be linked with caries, and Anderson and Davies and co-workers have found significant associations between Pb contamination of soil and vegetables in old mining areas and increased caries prevalence in children (Anderson et al., 1976, 1979; Anderson and Davies, 1980); the data in Table 14.18 illustrate their findings.

VIII. Conclusions

Civilization would collapse if denied the use of base metals and their compounds and, although a case can be made out for supposing that recycling metals could significantly reduce the need for new supplies, it must be accepted that man will mine and smelt as long as there are ores to do so. In the past,

mines and smelters were primitive and their manner of working largely unregulated so that gross but localized emissions of toxic metals and their compounds to the environment were commonplace. Modern mining is very much less damaging to the environment but emissions do still occur. This chapter has attempted an overview of the impact of the industry on man and his habitat: many years of investigational work lie ahead. Minimizing industrial emissions and learning how to manage contaminated environments are scientific and technological challenges for the years ahead.

Acknowledgements

The cooperation of Dr B. G. Wixson and his staff and the use of the facilities in the Department of Civil Engineering of the University of Missouri at Rolla, Missouri, USA, are gratefully acknowledged: most of this chapter was written while the author was a Visiting Professor at UMR.

References

Abdullah, M. I. and Royle, L. G. (1972). *Nature, Lond.* **238**, 329–330.

Abdullah, M. I. and Royle, L. G. (1975). *In* "Proceedings of 7th British Coarse Fish Conference, Liverpool", pp. 20–32.

Alloway, B. J. and Davies, B. E. (1971a). *Geoderma* **5**, 197–207.

Alloway, B. J. and Davies, B. E. (1971b). *J. Agric. Sci. (Camb.)* **76**, 321–333.

Anderson, R. J. (1969). *Caries Res.* **3**, 75–87.

Anderson, R. J. and Davies, B. E. (1980). *J. Geol. Soc., London* **137**, 547–559.

Anderson, R. J., Davies, B. E. and James, P. M. C. (1976). *Br. Dental J.* **141**, 311–334.

Anderson, R. J., Davies, B. E., Nunn, J. H. and James, P. M. C. (1979). *Br. Dental J.* **147**, 159–161.

Andrew, A. W. and Harriss, R. C. (1975). *Geochim. Cosmochim Acta* **39**, 1253–1257.

Archer, F. C. (1963). *J. Soil Sci.* **14**, 144–148.

Barltrop, D. (1976). *Archiv. Higijenu Rada Toksikologiju* **26**, 81–96.

Barltrop, D., Strehlow, C. D., Thornton, I. and Webb, J. S. (1975). *Postgraduate Medical J.* **51**, 801–804.

Barmes, D. E., Adkins, B. L. and Schamschula, R. G. (1970). *Bull. Wld. Health Org.* **43**, 769–784.

Blanton, C. J., Desforges, C. E., Newland, L. W. and Ehlmann, A. J. (1975). *Trace Subst. Environ. Health* **9**, 139–148.

Bolter, E. (1977). *In* "The Missouri Lead Study" (Wixson, B. G., ed.), pp. 95–108. Final Progress Report, University of Missouri, Rolla.

Bolter, E., Butz, T. and Arseneau, J. F. (1975). *Trace Subst. Environ. Health* **9**, 107–112.

Boorman, R. S. and Watson, D. M. (1976). *CIM Bulletin (Can.)* **69**, 86–96.

Borgono, J. M. and Greiber, R. (1972). *In* "Trace Substances in Environmental Health", vol. V (Hemphill, D. D., ed.), pp. 13–24. University of Missouri, Columbia.

Bradshaw, A. D. (1971). *Trans. Bot. Soc. Edinburgh* **41**, 71–84.

Brooks, R. R. (1972). "Geobotany and Biogeochemistry in Mineral Exploration", 290pp. Harper and Row, New York.

Burton, M. A. S. and Peterson, P. J. (1979). *Environ. Pollut.* **19**, 39–46.

Butler, J. R. (1954). *J. Soil Sci.* **5**, 156–166.

Campbell, A. M. G., Daniel, P., Porter, R. J., Ritchie, Russel W. and Smith, H. V. (1947). *Brain* **70**, 50–58.

Carpenter, K. E. (1926). *Ann. Appl. Biol.* **13**, 395–399.

Chadwick, M. J. and Bradshaw, A. D. (1980). "The Restoration of Land", 317pp. Blackwell, Oxford.

Chatterjee, P. K. and Pooley, F. D. (1977). *Proc. Austral. Inst. Min. Metall.* No. 263, 19–30.

Davies, B. E. (1971). *Oikos* **22**, 366–372.

Davies, B. E. (1976). *Geoderma* **16**, 183–192.

Davies, B. E. (1980). *In* "Applied Soil Trace Elements" (Davies, B. E., ed.), 482pp. Wiley, Chichester.

Davies, B. E. and Ginnever, R. C. (1979). *J. Agric. Sci. (Camb.)* **93**, 753–756.

Davies, B. E. and Lewin, J. (1974). *Environ. Pollut.* **6**, 49–57.

Davies, B. E. and Roberts, L. J. (1975). *Sci. Total Environ.* **4**, 249–261.

Davies, B. E. and Roberts, L. J. (1978). *Water Air Soil Pollut.* **9**, 507–518.

Davies, B. E. and White, H. M. (1981). *Sci. Total Environ.* **20**, 57–74.

CUEP/DOE. (1974). "Lead in the Environment and Its Significance to Man". Pollution Paper No. 2, HMSO.

Elderfield, H., Thornton, I. and Webb, J. S. (1971). *Mar. Pollut. Bull.* **2**, 44–47.

El Shazly, E. M., Webb, J. S. and Williams, D. (1956). *Trans. Inst. Min. Metall.* **66**, 241–271.

Evans, A. M. (1980). "An Introduction to Ore Geology", 231pp. Blackwell Scientific Publicatiohs, Oxford.

Fassett, D. W. (1980). *In* "Metals in the Environment" (Waldron, H. A., ed.), 333pp. Academic Press, London and New York.

Fleischer, M. (1955). *Econ. Geol.* **50**, 970–1024.

Fleming, G. A. and Ryan, P. (1964). *In* "Transactions of 8th International Congress on Soil Science", vol. 4, pp. 297–308.

Frankland, E. and Morton, J. C. (1874). "Fifth Report on the Rivers Pollution Commissioners". HMSO, London.

Frissel, M. J., Poelstra, P. and Van der Klugt, N. (1974). *Ref. to come.*

Gale, N. L. and Wixson, B. G. (1979). *Dev. Ind. Microb.* **20**, 259–273.

Gardner, J. (1974). *Water Res.* **8**, 157–164.

Gibson, F. H. and Selvig, W. A. (1944). "Rare and Uncommon Elements in Coal". US Department of the Interior, Bureau of Mines, Tech. Paper 669.

Gorham, E. and Gordon, A. G. (1960a). *Can. J. Bot.* **38**, 307–312.

Gorham, E. and Gordon, A. G. (1960b). *Can. J. Bot.* **38**, 477–487.

Gould, C. E. and Warren, H. V. (1980). *Sci. Total Environ.* **15**, 261–268.

Gregory, N., Flindall, R. and Ford, T. D. (1975). *In* "Lead Mining in the Peak District" (Ford, T. D. and Rieuwerts, J. H., eds), 136pp. Peak Joint Planning Board, Bakewell.

Grimshaw, D. L., Lewin, J. and Fuge, R. (1976). *Environ. Pollut.* **11**, 1–7.

Hadjimarkos, D. M. (1969). *Caries Res.* **3**, 14–22.

Hartenstein, R., Neuhauser, E. C. and Collier, J. (1980). *J. Environ. Qual.* **9**, 23–26.

Hewitt, E. J. (1948). *Nature, Lond.* **161**, 489–490.

Hilton, K. J. (ed.) (1976). "The Lower Swansea Valley Project", 329pp. Longmans, London.

Hodgson, J. F., Lindsay, W. L. and Trierweiler, J. F. (1966). *Soil Sci. Soc. Am. Proc.* **30**, 723–726.

Howe, G. M. (1960). "The Geographical Distribution of Cancer Mortality in Wales", pp. 199–214. Institute of British Geographers, Transactions and Papers, No. 28.

Howe, G. M. (1963). "National Atlas of Disease Mortality in the United Kingdom". Thomas Nelson, London.

Howe, G. M. (1979). *Geog. J.* **145** (3), 401–415.

ILZ. (1980). "Lead and Zinc Statistics", vol. 20.

Ireland, M. P. (1979). *Environ. Pollut.* **19**, 201–206.

Jenkins, G. N. (1967). *Br. Dental J.* **121**, 435–444.

Jennett, J. C. and Wixson, B. G. (1977). *In* "The Missouri Lead Study" (Wixson, B. G., ed.), pp. 179–399. Final Progress Report, University of Missouri, Rolla.

Jennett, J. C., Bolter, E., Gale, N., Tranter, W. and Hardie, M. (1974). *In* "Minerals and the Environment". IMM, London.

Jennett, J. C., Effler, S. W. and Wixson, B. G. (1980). *In* "Contaminants and Sediments", vol. I (Baker, R. A., ed.). Ann Arbor Science, Ann Arbor, Michigan.

John, M. K. (1974). *Can. J. Soil Sci.* **54**, 125–132.
Johnson, M., Roberts, D. and Firth, N. (1978). *Sci. Total Environ.* **10**, 61–78.
Jones, J. R. E. (1940). *Ann. Appl. Biol.* **27**, 368–378.
Jones, O. T. (1922). "Lead and Zinc. The Mining District of North Cardiganshire and West Montgomeryshire", p. 20. Mem. Geol. Survey; Min. Resources.
Kipling, M. D. (1980). *In* "Metals in the Environment" (Waldron, H. A., ed.), 333pp. Academic Press, London and New York.
Knezek, B. D. and Ellis, B. G. (1980). *In* "Applied Soil Trace Elements" (Davies, B. E., ed.), 482pp. Wiley, Chichester.
Kobayashi, J. (1978). *In* "Toxicity of Heavy Metals in the Environment" (Oehme, F. W., ed.), pp. 199–260. Marcel Dekker, New York.
Korte, N. E., Skopp, J., Fuller, W. H., Niebla, E. E. and Alesh, B. A. (1976). *Soil Sci.* **11**, 350–359.
Kramer, R. L. (1976). Unpublished M.S. (Civ. Eng.) Thesis. University of Missouri, Rolla.
Krauskopf, Konrad B. (1967). "Introduction of Geochemistry". McGraw-Hill, New York.
Låg, J. Hvatum, O. O. and Bølviken, B. (1970. *Jordundersokelsens Saertrykk* **159**, 141–159.
Lagerwerff, J. V., Browee, D. L. and Biersdorf, G. T. (1973). *In* "Trace Substances in Environmental Health" (Hemphill, D. D., ed.), pp. 71–78. University of Missouri, Columbia.
Lee, W. R. (1981). *J. R. Coll. Physicians, London* **15**, 48–54.
Legon, C. D. (1951). *Br. J. Cancer* **5**, 175–179.
Lewin, J., Davies, B. E. and Wolfenden, P. J. (1977). *In* "River Channel Changes" (Gregory, K. J., ed.). Wiley, Chichester.
Lindsay, W. L. (1979). "Chemical Equilibria in Soils", 449pp. Wiley, New York.
Le Riche, H. H. and Weir, A. H. (1963). *J. Soil Sci.* **14**, 225–235.
Little, P. and Martin, M. H. (1972). *Environ. Pollut.* **3**, 241–254.
Luoma, S. N. and Jenne, E. A. (1976). *Trace Subst. in Environ. Health* **10**, 343–351.
McKeague, J. A. and Kloosterman, B. (1974). *Can. J. Soil Sci.* **54**, 503–507.
McLaren, R. G. and Crawford, D. V. (1973). *J. Soil Sci.* **24**, 172–181.
McLean, R. O. and Jones, A. K. (1975). *Freshwater Biol.* **5**, 431–444.
Marten, G. C. and Hammond, P. B. (1966). *Agronomy J.* **58**, 553–554.
MCP. (1979). "Copper: Mineral Commodity Profile", 20pp. US Department of the Interior, US Bureau Mines, Attsburgh, Pa.
Mena, I. (1980). *In* "Metals in the Environment" (Waldron, H. A., ed.), 333pp. Academic Press, London and New York.
Merry, R. H. and Tiller, K. G. (1978). *Aust. J. Exp. Agric. Animal Husb.* **18**, 89–96.
Mitchell, R. L. (1964). *In* "Chemistry of the Soil" (Bear, F. E., ed.), 515pp. Van Nostrand Reinhold, New York.
Mitchell, R. L. and Reith, J. W. S. (1966). *J. Sci. Food Agric.* **17**, 437–440.
Murray, J. J. (1976). "Fluorides in Caries Prevention". John Wright, Bristol.
Newton, L. (1944). *Ann. Appl. Biol.* **31**, 1–11.
Nomiyama, K. (1980). *Sci. Total Environ.* **14**, 199–232.
Pearson, R. G. (1967). *Chem. Brit.* **3**, 103–107.
Purves, D. (1972). *Environ. Pollut.* **3**, 17–24.
Ramamoorthy, S. and Kushner, D. J. (1975). *Nature, Lond.* **256**, 399–401.
Rose, A. W., Hawkes, H. E. and Webb, J. S. (1979). "Geochemistry in Mineral Exploration", 657pp. Academic Press, London and New York.
Sevin, I. F. (1980). *In* "Metals in the Environment" (Waldron, H. A., ed.), 333pp. Academic Press, London and New York.
Sheppard, J. C. and Funk, W. H. (1975). *Idaho Environ. Sci. Technol.* **9**, 638–642.
Sinclair, A. J. (1980). *In* "Applied Soil Trace Elements" (Davies, B. E., ed.), 482pp. Wiley, Chichester.
Sposito, G. (1981). *Environ. Sci. Technol.* **15**, 396–403.
Stanton, D. A. and Burger, R. du T. (1966). *S. Afr. J. Agric. Sci.* **9**, 809–822.
Stocks, P. and Davies, R. I. (1960). *Br. J. Cancer* **14**, 8–22.
Stocks, P. and Davies, R. I. (1964). *Brit. J. Cancer* **18**, 14–24.
Suttle, N. F., Alloway, B. J. and Thornton, I. (1975). *J. Agric. Sci. (Camb.)* **84**, 249–254.
Temple, P. J., Linzon, S. N. and Chai, B. L. (1977). *Environ. Pollut.* **12**, 311–320.

Thornton, I. (1974). *In* "Minerals and the Environment". IMM, London.

Thornton, I. (1979). *Chem. Brit.* **15**, 223.

Thornton, I. (1980). *In* "Inorganic Pollution and Agriculture", 324pp. Ref. Book 326, MAFF, HMSO, London.

Thornton, I. and Webb, J. S. (1980). *In* "Applied Soil Trace Elements" (Davies, B. E., ed.), 482pp. Wiley, Chichester.

Treharne, W. D. (1962). *Water Waste Treatment* **8**, 610–613.

Tsuchiya, K. (1978). "Cadmium Studies in Japan: a Review", 376pp. Elsevier, Amsterdam.

Tunney, H., Fleming, G. A., O'Sullivan, A. N. and Molloy, J. P. (1972). *Irish J. Agric. Res.* **11**, 85–92.

Van Hook, R. I. (1974). *Environ. Contamin. Toxicol.* **12**, 509–511.

Vaughan, D. J. and Craig, J. R. (1979). "Mineral Chemistry of Metal Sulphides". Cambridge University Press, Cambridge.

Vine, J. D. and Tourtelot, E. B. (1970). *Econ. Geol.* **65**, 253–272.

Viro, P. J. (1955). *Soil Sci.* **79**, 459–465.

Waldron, H. A. (1980). *In* "Metals in the Environment" (Waldron, H. A., ed.), 333pp. Academic Press, London and New York.

Warren, H. V. (1972). *J. R. Coll. Gen. Practit.* **22**, 56–60.

Warren, H. V. (1980). *In* "Applied Soil Trace Elements" (Davies, B. E., ed.), 482pp. Wiley, Chichester.

Warren, H. V., Devavault, R. E., Fletcher, K. and Peterson, G. R. (1971). *CIM* Special Volume No. 11, 444–450.

Webb, J. C., Thornton, I., Howarth, R. J., Thompson, M. and Lowenstein, P. (1978). "The Wolfson Geochemical Atlas of England and Wales". Clarendon Press, Oxford.

Welsh, P. and Denny, P. (1976). *Trace Subst. Environ. Health* **10**, 217–223.

Wild, H. and Wiltshire, G. H. (1971). *Chamber Mines J.* **13**, 26–30.

Wyllie, J. (1937). *Can. Public Health J.* **28**, 128–135.

Willies, L. (1974). *Bull. Peak Dist. Mines. Hist. Soc.* **5** (5), 302–311.

Wills, B. A. (1980). "Mineral Processing Technology", 2nd edn, 525pp. Pergamon Press, Oxford.

Wixson, B. G. (1974). *In* "Minerals and the Environment". IMMM, London.

Yamagata, N. (ed.) (1978). *In* "Cadmium Studies in Japan: a Review" (Tsuchiya, K., ed.), 376pp. Elsevier, Amsterdam.

Zuckerman, Lord, Arbuthnot, Viscount, Kidson, C., Nicholson, E. M., Warner, Sir Frederick and Longland, Sir Jack. (1972). "Report of the Mining Commission". HMSO, London.

15

Health Implications of Coal Development

BETSY T. KAGEY and BOBBY G. WIXSON

I. Introduction

Coal, extracted from the geologic remains of old lake beds and swamps historically known for contributing to the major revolution in the working of iron and other ores, is once again being resurrected to its role as a major fuel source owing to economical, political and geographical energy constraints presently imposed by problems in the marketing of oil. During the mid-18th and through the 19th centuries, coal was king and many wonderous things were attributed to its power. In the USA, coal surpassed wood as a major fuel source in the 1800s and furnished some 70% of the nation's energy by 1925 (National Geographic Magazine, 1981).

Without coal and its by-products, the tremendous advancements in the iron process would have been impossible. Jeffery (1925) discussed this impact from the age of coal commenting that those nations without coal were at a disadvantage in the strength for existence, since iron works and the processing of other ores were fundamental to national well-being. However, history has also recorded that coal used for fuel during this time was not without many environmental and health problems and contributed to smoke, soot, SO_2, and the release of trace elements. These airborne dangers were further coupled with a high accident and death rate associated with the underground mining of coal; as a result, cheaper and cleaner oil and gas dethroned "king coal" as a major energy source in the late 1940s.

Today, the world is again entering into another age in which energy supplies are unable to cope with increasing demands and oil has become more limited and expensive. A current special report on energy has projected that US energy demands will increase from 78 quads (78 quadrillion British thermal units) in 1980 to 108 quads by the year 2000 (National Geographic Magazine,

APPLIED ENVIRONMENTAL GEOCHEMISTRY
ISBN 0-12-690640-8

1981). This same report projected a 28.2% increase in coal utilization, so that coal would furnish 34.3% of the total energy needs and represent the nation's primary energy source by 2000. Coal is found throughout the world, but the US, the Soviet Union and China possess nearly two-thirds of all the known coal reserves.

According to Ezra (1978), coal is the largest reserve for the world's major source of energy and the brightest hope for the future if exploited now. A report by the World Coal Study (1980) stressed one major conclusion that "coal will have to supply between one-half and two-thirds of the additional energy needed by the world" and that "to achieve this goal, world coal production will have to increase 2.5 to 3 times, and the world trade in steam coal will have to grow 10 to 15 times above the 1979 levels". This study described coal as the bridge to future energy systems while stressing world coal prospects, environmental problems, resources, reserves and production, technologies, investments and energy projections.

II. Coal, trace elements and health

Coal has special problems associated with different parts of the mining, cleaning, transportation, utilization and waste disposal cycle. These problems were studied in a report on "The Trace Element Geochemistry of Coal Resource Development Related to Environmental Quality and Health" by a panel of the US National Research Council (1980a). This report classified potentially hazardous elements in coal resource development by five categories of: (i) greatest concern; (ii) moderate concern; (iii) minor concern; (iv) radioactive elements; and (v) concern but with negligible concentrations, in coal and coal residues. Besides the troublesome gaseous compounds of C, N and S, the elements of greatest concern were listed as As, B, Cd, Pb, Hg, Mo and Se. The report summarized the current state of knowledge of this subject and presented recommendations for additional data gathering and research on the trace element geochemistry associated with coal resource development.

A "Report on Health and Environmental Effects of Increased Coal Utilization (1980)" was made by a special committee to study this important aspect of the US National Energy Plan. The basic findings were that it was safe to proceed with the increased utilization of coal provided that environmental and safety policies adhered to Federal and State air, water and solid waste regulations. The potential release of trace elements to the environment was one of the six major areas of concern identified.

The environmental and health risks associated with an intensified use of coal has been studied by many groups, and the two-volume report by Braunstein et al. (1981) is a valuable resource document for understanding

some of the possible consequences of increased coal utilization. The report on "Health Effects of Fossil-Fuel Combustion Products: Needed Research" was published by the National Research Council (1980b) with recommendations for needed research in epidemiology, experiments on human subjects, studies on experimental animals, trace elements, transformation and transport of pollutants, analysis and monitoring, and mutagenesis.

III. Health effects of pollutants from coal

Many studies are directed toward understanding problems and developing possible solutions to the increased utilization of coal and, as such, function to mutually draw geochemists and epidemiologists together for research on trace elements and health.

Possible impacts on health are studied through epidemiology, and adverse human health effects associated with the proposed increase in coal utilization represents a compilation of acute, chronic and subclinical effects. Data pertaining to specific exposure variables such as sulphur oxides, trace elements, or organic compounds are derived, in part, from the study of the particular element and/or compound in question and its related toxicity. In the study of health effects of any pollutant, three major types of designs are used:

(i) Toxicological (animal studies). Toxicological studies represent laboratory experiments of animals, cells and biochemical systems in which toxic doses, causal pathways and mechanisms of response are established. Testing a compound for carcinogenicity is current acceptable laboratory practice. However, extrapolating dose–response curves to humans is a major drawback of this design.

(ii) Clinical (experimental studies). In clinical studies, persons with the disease or experimental subjects are studied in very controlled, precise experiments where levels of exposure of a specific pollutant are controlled. Information on long-term exposure is usually unobtainable from this design. Ethical questions pertaining to experimentation on humans are ever-present and place limitations on each study.

(iii) Epidemiological (population-based studies). Epidemiology studies the health and health indices of communities (groups of persons with similar characteristics) in which natural long-term, low-dose exposures are estimated. The major drawbacks of these studies are the inability to quantify exposure, to control for confounding variables and to produce strong cause–effect relationships at low exposure levels.

Each design offers a specific set of results which in themselves may be

conclusive, but each set is subject to the limitations of the specific study design. These limitations lead to the utilization of the results from all three sources of information in determining causal relationships. Unfortunately, not all of the constituents in coal that are posed as having adverse health effects have been subjected to such rigorous study, and care must be taken in extrapolating cause and effect relationships from scanty data. In addition, interactive effects both among the coal constituents and with other pollutants, for the most part, are only postulated at this point in time. Studies of the health effects of specific pollutants have been published, but few take into account the fact that none of these pollutants exist alone and their effects on health do not occur one at a time. One or two interactive effects that have been studied are thought to only represent the tip of the iceberg.

A better understanding of the major pollutants associated with coal and how they affect human health will enable one to understand the complexity of this topic.

IV. Coal utilization

In order to combine the geochemical and epidemiological approach to health implications of coal development, a simplified diagram illustrating the pathway for coal extraction, cleaning and preparation, transportation, combustion, or conversion and disposal of end products is illustrated in Fig. 15.1. Each step of this pathway will be examined from beginning to end as to

		COAL SOURCE	
PHASE	I	EXTRACTION	Surface Underground Auger
	II	CLEANING AND PREPARATION	Washing and crushing
	III	TRANSPORTATION	Railroad Truck Slurry pipeline Barge Conveyor
	IV	COMBUSTION	
	V	CONVERSION	
	VI	DISPOSAL OF	Fly ash residues

Fig. 15.1 Illustration of different phases pertinent to trace elements and health aspects of coal utilization.

possible release or mobilization of pertinent trace elements associated with primary exposures that may contribute to possible health impacts.

V. Extraction

Phase I of coal resource development is concerned with the extraction of coal by surface, underground or auger methods. The redistribution of trace elements may occur through drainage water in surface mining, and by subsidence, groundwater movement or acid mine drainage from underground or auger methods. Reclamation (especially for surface or strip mining) and revegetation may also contribute to trace element redistribution.

The actual mining of coal has been associated with many fatal accidents throughout history. By 1930, accidents in underground coal mines (2063 fatalities, 1.87 deaths per million employee-hours) were the major hazard associated with this occupation (Council on Environmental Quality, 1979). Now, owing to changes in the US work force, equipment, safety standards and reporting systems, there are approximately 100 deaths annually due to accidents in underground mines (0.36 deaths per million employee-hours). These data from the US Dept. of Labor, Mine Safety and Health Administration (Table 15.1) indicate that deaths and non-fatal accidents for both underground as well as surface mines are still of present concern. Data are also shown for accidents related to the mechanical cleaning of coal. An increase in coal production during the next 20 years may also increase accidents. Accidents are thought to be beyond human control. However, with good maintenance of equipment, the worksite and the workforce, some of these statistics may hopefully be decreased over time.

Another major health concern within the occupational setting of underground coal mines is that of Coal Worker's Pneumoconiosis (CWP), better

Table 15.1 Number of injuries and frequency rates per million employee-hours for coal in the US, 1977 (Council on Environmental Quality, 1979)

	Fatal		Non-fatal		Total disabling	
	No.	Rate	No.	Rate	No.	Rate
Underground	100	0.43	11 724	50.86	11 824	51.29
Surface	29	0.24	2277	18.93	2306	19.17
Independent surface and yard	1	0.15	126	18.57	127	18.72
Mechanical cleaning	9	0.27	862	26.13	871	26.41
Total	139	0.36	14 989	38.37	15 128	38.73

known as Black Lung Disease. Pneumoconiosis is a general term that represents deposition and retention of airborne dust particles in the lungs without regard to specific lung pathology. Some of the dusts that are responsible for such chronic obstructive lung diseases are silica, coal, Fe, asbestos, talc and cotton dust. Biological responses to dust vary with the size of the particles (< 5 μm are considered most hazardous), shape, density, chemical composition, concentration of dust and length of exposure. In addition, other factors that have been found in influence response are past history of infections (especially tuberculosis) and concurrent pulmonary disease.

In the study of CWP, specific etiologic agents within the dust as well as in the host have been incriminated. They are the Si content of the coal, tuberculosis, other infections, a rheumatoid factor as well as the total dust content of the lung. In essence, CWP has been shown to be related to numerous agents and may either be due to a single agent or some combination thereof (Wagner, 1972).

CWP, as all pneumoconiosis, is a chronic debilitating disease which develops over a long period of time. Persons with CWP experience difficulty in breathing. In the more advanced cases, CWP victims find it extremely difficult to do the simplest of tasks because of their shortness of breath. In addition, the heart overcompensates for the lung's inefficiency and some persons with CWP have been known to die of cardiac arrest.

The control of respirable dust within the mine is accomplished by: (i) inhibiting the formation of the dust; (ii) inhibiting the dispersion of the dust; and (iii) ventilating the face either by exhausting the dust from the point of generation or by diluting the dust with large volumes of air (Morse, 1972).

Epidemiologic studies of the mining industry have identified specific diseases that are related to exposure at the worksite. These findings represent long-term, high-dose exposures. In the recent Occupational Mortality Decennial Supplement (1981) data for England and Wales provided indirect methods of discovering resultant adverse health effects associated with the mining of coal both above ground and underground. When these experiences were compared with the general population, certain excesses appear (Table 15.2). Accidents, as discussed earlier, are of major importance when discussing the health of underground workers; deaths due to respiratory diseases, CWP as well as tuberculosis, circulatory diseases and cerebrovascular disease (stroke) were all found to be greater in the mining population. With respect to cancer mortality, stomach cancer and pancreatic cancer appear to be in excess when compared with the general population.

Consistency of findings with regard to past mortality studies strengthens existing correlations. In the US, coal miners showed elevated rates of stomach cancer, and when compared with non-coal counties in Utah this risk increased to an 8-fold difference (Enterline, 1972). Mention was made that all homes of

Table 15.2 Excess of specific disease mortality in coal miners by worksite as compared with the general population of England and Wales for men aged 15–64 years, 1970–1972 (Occupational Mortality Decennial Supplement, 1978)

Disease category	Worksite	
	Underground	Above ground
Accidents	×	
Respiratory disease	×	×
Tuberculosis	×	
Circulatory disease	×	×
Cerebrovascular disease		×
All neoplasms		
Stomach cancer	×	×
Pancreatic cancer	×	
All causes	×	×

the gastric cancer patients in the coal county were heated with coal and in some, coal was used for cooking, emphasizing the difficulty in separating occupational exposure from environmental. Rockette (1977) could only reproduce these findings in men over the age of 80 years. Klauber and Lyon (1978) found no relationship between miners and excess stomach cancer. The validity of the relationship between coal mining and stomach cancer due to the strong indirect relation between social class and this particular disease has been questioned (Freudenthal *et al.*, 1975). However, while controlling for the effects of social class, Cregan *et al.* (1974) still found an excess risk for miners.

Strip or surface mining of coal presents a different occupational setting. Dust exposures are considerably less and, as shown earlier, there are fewer accidents. However, other occupational exposures, such as extremes in heat and cold and noise are also considered hazardous to the workers of this particular portion of the industry.

Current interest with respect to coal mining underground is aimed at the use of diesel-powered machinery. The introduction of diesel into the mines has been said to increase production as well as safety. However, the questions of related health effects, especially in regard to cancer risks and chronic disease risks, are far from being answered, owing to the lack of long-term studies. Pollutants found to be present from diesel fuels are polynuclear aromatics (PNAs are known carcinogens), nitrogen oxides (pulmonary irritants), an increase in noise, as well as aldehydes, CO, CO_2, SO_2 and H_2SO_4. Moreover, there is the possible interaction of all these underground emissions with the dust that is generated during the actual process of mining.

VI. Cleaning and preparation

Phase II of the health aspects of coal utilization is concerned with the cleaning and preparation of coal.

Almost one-half of all the coal mined in the US is cleaned, leading to a redistribution of Cd, Cr, Cu, Fe, Hg, Ni, Pb, Zn, As, Mn, Se, Co, Ni and Zn (National Research Council, 1980a). Unfortunately, cleaning coal does not eliminate elements but just separates them from the organics. What cleaning does accomplish is to reduce S and concentrate possible toxic and/or harmful trace elements (especially Mn, Co, Ni and Zn) to facilitate meeting environmental standards. By removing these elements from the coal, the further combustion of coal will be less toxic with respect to the areas being served. However, the disposal of by-products from the cleaning process and how that might affect health is unknown.

Elements of greatest concern (As, Pb, Zn, Mo, Cd and Se) are, in part, removed during the washing of coal. This coal cleaning wastewater, as well as the runoff from coal piles, may affect local water quality if not treated properly.

Again, it becomes an exercise of separating out each component contained in the water and relating each to separate adverse health outcomes. Dust generated by thermal drying or crushing of coal may present respiratory problems similar to those generated within the coal mines, but on a much smaller scale. Heat drying of coal is now being replaced with mechanical dewatering methods, which use less energy and avoid dust problems.

VII. Transportation

Phase III of the coal utilization pathway is concerned with the different methods of transporting the coal to the consumer.

Coal transported by railroad or truck poses various possible health problems. Accidents involving workers and pedestrians are of major concern. It is estimated that approximately 100 deaths yr^{-1} result from the transportation of coal by rail (Lave, 1977). Dust is minimized during transportation by setting or treating the coal. However, dusts generated by the loading and unloading of coal may cause respiratory irritation. Noise and coal dust coming in contact with the skin are two other areas of concern. Although a loss in hearing is not considered to be life-threatening, it is related to an increase in accidents as well as a change in a person's quality of life.

The transportation of coal slurries through pipeline utilizes large amounts of water (approximately one ton of water for each ton of coal transported), which poses environmental problems in water quality similar to those discussed in Section VI. In the event of an accidental spill or leakage from this

transport system, local water quality may be affected by the short-term concentrated effluents, such as: pyritic materials, As, Pb, Zn, Mg, Ga and Se leaching into the local water tables. Dewatering of the slurry and processing of the waste water can be accomplished at the receiving point with conventional technology.

The potential effects of pollution by accidental spills are much less for coal than for oil or liquified natural gas. Coal storage piles must also be managed so as to control dust, blowage, leaching and spontaneous combustion.

The public health impacts of trace elements mobilized during various methods of transportation are not well known, and more research is needed in this area.

VIII. Combustion

Phase IV of the coal utilization pathway is concerned with trace elements related during combustion.

According to Falk and Jurgelski (1979), any assessment of health effects from coal combustion requires definition and quantification of the source and transport of emissions as well as background on the population at risk, including dietary, occupational history and smoking habits.

Air pollution from coal-fired plants includes: dust, SO_x, NO_x, total suspended particles (TSP), O_3, CO_2, Hg, Se, F, S, B, Cr, V, radionuclides and polynuclear aromatics (PNA). Pulmonary irritants among this list include dust, SO_x, NO_x, TSP, O_3 and CO_2. The degree of respiratory irritation is dependent upon the particle size characteristic, the concentration and the host's current health status. Particles equal to or less than 5 μm in size are considered to be the most hazardous since they tend to get into the lungs and remain there. Chemical and electrical properties of the dust are also important when considering adverse health effects. Lead is readily soluble in body fluids and does not remain in the lungs, thus creating no lung pathology. Persons with existing chronic obstructive lung disease, such as emphysema or chronic bronchitis, are more susceptible to the adverse effects of air pollutants.

Sulphur dioxide has been used as one of the major indices of air pollution and studied for its effect on human health. The major physiologic response to SO_2 is one of increased airway resistance. When inhaled, SO_2 increases the acidity of the respiratory tissue by forming H_2SO_4. The degree of irritation is dependent upon atmospheric concentrations and particle size. Particles greater than 1 μm in diameter produce severe coughing and at 3 ppm, SO_2 produces a sulphur odour which is detectable. In the US, worksite levels of SO_2 are restricted to 5 ppm. However, persons with emphysema or chronic bronchitis are more susceptible to the irritating effects of SO_2. In addition,

cigarette smokers react to SO_2 concentrations in the air more than non-smokers, and it is thought that the combined effect of SO_2 and cigarette smoking increases the risk of developing emphysema. TSP and SO_2 have been found to exert their greatest effect on the very young, the very old and the infirm. Both have also been linked to an increased incidence of lower respiratory tract infection (Goldstein, 1979). Other adverse health effects associated with SO_2 include impairment and irritation of the eyes, throat and lungs. These effects are said to be reversible when exposure ceases. The interaction of SO_2 with other pollutants (such as Fe, Mn and V) may act as catalysts in increasing airway resistance (Waldbott, 1978).

The chemical transformation of SO_2 and other air pollutants are dependent upon meteorologic and pollutant variables of humidity, temperature, sunlight, oxidants and metal concentration. However, even without exact knowledge of these compounds, it is a well-established fact that during periods of an extended atmospheric inversion with high exposure there is an increase in mortality.

NO_2 is the most prevalent nitrogenous compound directly emitted into ambient air from fossil fuel (Dreisback, 1971). Other sources of airborne NO_2 include automobile exhaust and indoor gas stoves. Exposure to NO_2 produces increased airway resistance owing to its corrosive effect on the mucous lining of the lung. In the presence of water (or body fluid), NO_2 forms nitric and nitrous acid. Persons exposed to NO_2 have been found to be more susceptible to infection because NO_2 impairs the ability of the lungs to clear inhaled infectious organisms (Waldbott, 1978). Asthmatics, when exposed to NO_2, suffer broncoconstriction, and in persons with pre-existing cardiorespiratory disease, NO_2 exacerbates their condition. In addition, nitrosamines (known carcinogens) do not naturally occur in coal, but it is hypothesized that they may be formed during combustion (Goldstein, 1979).

Inorganic carcinogens such as As, Be, Cd, Cr, Co, Ni, Se and U exist in coal, but most will be removed by electrostatic precipitation. However, As, Cd and Se may escape from the precipitator and reach residents in the surrounding area.

Fly ash particles (see Chapter 12) may contain Se, Be, Pb, Cd, As, Ni, Zn, Se, Te, Sb and V, all of which have possible toxicologic significance. Fly ash is of respirable size and deposits in the lungs. It has been postulated that the trace elements on the surface areas of fly ash could catalyse the conversion of SO_2 to sulphates and sulphites.

Photochemical oxidants may also be formed in plumes from coal-fired plants and related health effects of O_3 include eye and lung irritation.

Benzo(a)pyrene (BaP) is used as an index for the class of compounds (known as polynuclear aromatics) since its concentration in air is correlated with other hydrocarbons and SO_2. Under experimental conditions BaP is carcinogenic,

and SO_2 plus BaP were found to be co-carcinogenic in the development of lung cancer. BaP is not one of the more resistant hydrocarbons, and is destroyed after 24 h exposure to light and air. When exposed to an oxidant atmosphere, many other PNAs are also destroyed (Falk and Jurgelski, 1979). However, PNAs do not readily decompose in soil.

1. Selected airborne trace elements

Certain trace elements mobilized into the atmosphere during the coal-combustion process are of concern as to possible health impacts. Some of the better-known elements include the following.

(a) *Nickel*

The Ni content of coal is approximately 0.04 lb ton^{-1} in the eastern US and the major source of atmospheric Ni is from the combustion of fossil fuels. Atmospheric Ni concentrations increase during the winter months, depending upon time and location; urban residents may inhale anywhere from 2 to 14 μg day^{-1} Ni. The health effects associated with exposure to Ni have been found primarily at the worksite through epidemiologic and/or experimental studies. These adverse effects include: dermatitis, respiratory cancer, nasal cancer and the inhibition of spermatogenesis. Nickel carbonyl is a known carcinogen and the question of latent effects associated with environmental exposure to this compound is of interest (Sunderman, 1971). However, during coal combustion nickel carbonyl is thought to decompose and thus does not present a possible hazard at this stage of coal utilization. Other studies on this trace element in relation to health and disease have indicated that Ni is retained largely in the ash when coal is burned (Nielsen *et al.*, 1977).

(b) *Fluorine*

There have been only a few instances of health effects in man attributed to airborne F for persons living near a fluorine-emitting industry. However, the response was non-specific. Fluorine is an element much like a double-edged sword. At the low end of the spectrum it is a preventive measure in combating dental caries and at the opposite end, is considered toxic. The levels found in the air due to the combustion of coal are presently not considered a health risk (Vostal *et al.*, 1971).

(c) *Selenium*

The average Se content of coal in the US is approximately 2.76 ppm. As with F, Se appears to be both an essential and a toxic trace element, depending upon

concentration. At the atmospheric concentrations, Se does not appear to present any risk to human health (Gunn *et al.*, 1976). However, it has been estimated that the amount of Se entering the atmosphere from the burning of fossil fuels is approximately 6 times larger than that derived from mined ores (Oldfield *et al.*, 1974). Since Se deficiencies in livestock are common throughout many parts of the world, airborne Se may be beneficial rather than considered as a hazardous environmental pollutant.

(d) *Arsenic*

In Czechoslovakia, there is a particular coal-fired plant burning "brown coal" which is high in As. Despite the use of electrostatic precipitators, it has been estimated that approximately 0.5 ton day^{-1} As in the form of As_2O_3 is emitted from this plant (Bencko and Symon, 1977). Air, water and soil samples in the surrounding community were shown to have increased levels of As and the children in this community had increased levels of As in their hair. Further study of the area showed that these children were experiencing audiometric problems. This was first noticed by the local voice teachers in the schools who complained about the lack of singing ability in some of their pupils (Bencko *et al.*, 1977). In turn, this prompted a study of 10-year-old children who live near this plant, which showed a greater number of hearing impairments in the exposed children than in the non-exposed controls. These findings were consistent with past clinical studies relating As poisoning to deafness. These data are part of a group known as subacute effects of particular pollutants. These effects, measured in the midst of all of the other pollutants emitted by this source are not, as of yet, causal. However, they do point up the difficulty in studying health effects associated with coal usage and how some researchers are combining clinical findings and local experience with existing knowledge of trace elements.

(e) *Lead*

The amount of Pb emitted to the atmosphere from coal combustion is dependent upon such factors as its concentration in the coal, type of boiler configuration, properties of the element and the effectiveness of the control devices. If not carefully controlled, Pb may predominate in small particles emitted from high-temperature combustion sources (Braunstein *et al.*, 1981). However, most data indicate that Pb is retained within the sluice and precipitation ash with only a small amount (7%) being discharged with the flue gas (Natural Research Council, 1980a). Threshold limit values for lead are set at 0.15 mg m^{-3} to prevent cumulative poison, brain damage or convulsions.

(handwritten marginalia: "highly volatile")

(f) *Mercury*

Another concern with coal combustion is the amount of Hg present in some coal feed stock. Because of its potential to become easily volatized, some 98% of the total Hg mass entering the combustion stream from coal is lost to the atmosphere in the flue gas (Natural Research Council, 1980a). However, most studies have indicated that the amounts of Hg deposited on soils near coal-burning operations do not become critical over the projected life of the operation.

The health impacts of Hg have been studied extensively and intake by inhalation is of concern only when contact with elevated vapor concentrations occur regularly. Threshold limit values have been set at 0.01–0.1 mg m^{-3} to prevent effects such as nephritis, gastrointestinal tract disturbances, nerve damage and depression of cellular enzymatic mechanisms (Braunstein *et al.*, 1981).

(g) *Cadmium*

(handwritten marginalia: "highly volatile w/flyash")

Cadmium is another trace element considered to be of concern since it is quite toxic to most biological systems above a critical level. Coals throughout the world vary in Cd concentration which may present problems in combustion. For example, some Australian coals contain sufficient Cd as to be of concern to possible users in Japan and Asia (Swaine, 1977). Cadmium is highly volatile and research has indicated that it would be retained by the fly ash in the small-sized, respirable fraction ($< 5 \mu$m) of a particle with an increase in concentration with decreasing particle size (Braunstein *et al.*, 1981). Possible health impacts are associated with respiratory irritation, disease or cancer.

IX. Conversion

Phase V of the coal utilization cycle focuses on the conversion of coal to other types of liquid or gaseous energy products. Coal liquefaction plants are closed systems, and, unless there are leaks within the process, there should not be any adverse occupational health problems during operation. However, when the system is shut-down for cleaning, coal liquefaction materials may present a problem. These materials contain potentially hazardous and biologically active substances, many of which have not been characterized as to composition or health effects (Van Hook, 1979). It is believed that these materials will contain products similar to those that arise in a coke oven and coal-tar process, which have been associated with high cancer risk (scrotal cancer, facial epithelioma and other skin cancers in workers) (Freudenthal *et al.*, 1971). Potential leaks within the closed system include: SO_2, SO_2 reaction

products (sulphates and sulphides), CO, NO, NO_2, fly ash, unburned hydrocarbons, polynucleararomatic amines (PNA) including BaP and aldehydes (Falk and Jurgelski, 1979). Sulphur dioxide has been found to be a cocarcinogen when combined with BaP. The list includes many compounds that are known respiratory irritants and carcinogens.

Other potential occupational hazards associated with the liquefaction process are high temperature, pressure and flammable materials that present potential fire and explosion dangers causing thermal and chemical burns as well as severe respiratory irritation.

β-Naphthalylamine and benzidine are formed during the production of coal, gas and coke. In occupational studies, these compounds have been found to increase the risk of stomach cancer, pancreatic cancer and kidney cancer in workers (Freudenthal et al., 1975). Other cancers found to be related to occupational exposure to the products or distillation of bituminous coal include skin, lungs, urinary organs, larynx, nasal sinuses, kidneys, bladder, stomach, intestines, pancreas and blood-forming organs. The exact agent for most of these is still unknown and "it is estimated that no more than 40% of the organic compounds formed during coal use have been characterized and, of these, only a small number have been tested for carcinogenicity". "In general, in the absence of medical data, it was assumed that compounds with boiling points in excess of 250°C should be handled with caution" (Freudenthal et al., 1975). These include polycyclic hydrocarbons, methylated derivatives of polycyclic hydrocarbons and nitrogen (heterocyclic compounds).

To date, these closed systems discussed have been bench-scale and pilot plant operations, therefore, health effects associated with their large-scale or long-term use are unknown. If care is taken to protect the worker from exposure to these boiling organics as well as controlling leaks within the system, adverse health consequences should be minimized.

Airborne compounds found within the coal-conversion processes include: benzene, toluene, xylene and BaP (Van Hook, 1979). Most of these have been measured at levels below current existing standards and others are not as yet regulated as to exposure within the occupational setting. Other possible contaminants within this process include: gaseous S, hydrocarbon emissions, trace elements, other organics, ash, char and water contaminants (Talky, 1978).

Water effluents from a coal gasification plant, before treatment, will contain: suspended solids, phenols, thiocyanates, cyanides, ammonia, dissolved solids, sulphur compounds, trace elements, tar and oil (Reznek, 1977). Once these have been removed from the water, the only health hazards present are in the form of solid wastes. Direct emissions of contaminated water is minimized by recycling or the use of wastewater treatment. But the leachates from treatment ponds may also present a more difficult pollution problem.

Therefore, conventional disposal techniques for liquid or solid wastes from coal conversion plants may not be possible because of the high probability that the material might contain toxic, mutagenic and carcinogenic compounds (Council on Environmental Quality, 1979).

As new coal-conversion technologies are developed to make gases and liquids from coal, they will have to control or dispose of the waste products in the same environmentally acceptable way as coal-combustion plants. Emphasis needs to be concentrated on controlling the production or release of potential carcinogens and possible toxic materials in the waste (World Coal Study, 1980).

X. Disposal of end products

The final pathway of the coal utilization cycle is concerned with the recycling or ultimate disposal of the end products generated during combustion or conversion. According to a National Research Council study (1980a), "the disposal of solid wastes resulting from the increased use of coal will probably cause the greatest health hazards because of the chances for ground or surface water pollution unless new research leads to better controls".

Factors affecting both bottom and fly ash characteristics are: the source of the coal; the method of firing; the ash-fusion temperature; and the efficiency of the equipment for collecting fly ash. Generally, both bottom ash and fly ash are disposed of as a water slurry in settling ponds or trucked directly and dumped into strip-mining pits. The pH of these settling ponds may range from 3.3 to 12; half of the effluents are alkaline. This range is dependent upon the SO_3 and alkaline metal oxides in the ash and the buffering capacity of the water. Trace metals are more soluble in acidic solutions, and problems similar to acid mine drainage may occur as a result of the process of ash disposal. In addition, rainfall, particle size, underlying geology and drainage patterns all add to the varying characteristics of each specific disposal site.

The health effects associated with disposal are primarily concerned with the ash disposal's possible influence on drinking water supplies. Increases in heavy metals and interaction between these increases and existing local water supply constituents are as yet unknown, but research has indicated that in some areas drinking water may be affected (Kagey et al., 1980). Fly ash may also yield leachates under certain conditions that contain trace elements (As, B, V, Cd, Cr, Mn) which are not acceptable by water-quality standards. Sulphur and its by-products are not particularly toxic as a solid waste. The U that exists in coal is mostly concentrated in the bottom ash during combustion and is firmly bound in the glossy ash and released only in very long-term reactions (National Research Council, 1980a). Other heavy metals and radioactive Th

and U in coal ash and sludge are deleterious to health, and their possible access into local water supplied through leaching must be controlled.

XI. Conclusions

Coal resource development has some unique aspects associated with trace elements and health. Most accidents or fatalities reported for the industry are associated with the underground mining of coal. The cleaning and preparation of coal requires adequate treatment of any effluents associated with the process.

Table 15.3 Summary of source, primary exposure and possible health impacts for health implications of coal development

Source	Primary exposure	Possible health impacts
Mining		
Underground	Dust, noise, diesel exhaust (PNAs, CO, CO_2, SO_2, H_2SO_4)	Coal worker's pneumoconiosis, hearing loss, cancer (stomach, pancreas), all respiratory irritation
Surface	Acid mine drainage Heavy metals (Pb, Cd, As) increase in pH	? Cancer ? Cardiovascular disease, subclinical effects
Cleaning and preparation	Dust, trace elements (Cd, Cr, Cu, Fe, Hg, Ni, Pb, Zn, As, Mn, Se), SO_2, organics	Cancer (respiratory, nasal) dermatitis, respiratory irritation, inhibition of spermatogenesis, enzyme inhibition
Transportation	Dust, water, contamination (metals and organics)	Respiratory irritation Cancer
Combustion		
Air emissions	SO_2, NO_2, TSP, O_3, CO, Ni, B, Se, Cu, As, Pb, Fe, Hg, Cr, V, PNAs	Respiratory irritation, chronic disease, cancer, decreased resistance to infection, hearing loss
Fly ash	As, B, Vr, Cd, Cr, Mn and Se, particulates	Respiratory irritation/ disease, cancer
Residue	Organics	
Conversion	Benzene, toluene, etc.,	Cancer (i.e. leukaemia)
Disposal	Radionuclides Organics Trace elements (i.e., Cd, Hg	Cancer, subclinical CNS disorders

Transportation of coal may be accomplished with existing systems and with localized minor environmental impacts in the case of accidental spills or discharges. The combustion of coal is concerned with the effective control of gaseous compounds of S, N and C as well as trace elements such as Ni, F, Se, As, Pb, Hg and Cd.

Coal conversion into liquid or gaseous products are not large-scale operations at present, so historical data are lacking on long-term geochemical or health effects. However, effluent control should meet similar criteria to that required for combustion.

The disposal of coal waste products (fly ash, etc.) represents a potential problem for effective control technology to prevent leaching into ground or surface water supplies.

During coal resource development, different sources are associated with primary exposure and possible health impacts. These sources and impacts are summarized in Table 15.3. The possible health implications associated with coal utilization may be effectively reduced and controlled through adherence to National or State regulations developed for the protection of the environment and human health.

Improved cooperative efforts between geochemists and epidemiologists are needed for studies on areas of mutual interest. Information gained would be beneficial in assisting with the projected increase in coal utilization for energy needs with good environmental and health protection.

Acknowledgements

The authors would like to acknowledge the support given by the US Environmental Protection Agency grant EPA–R–807133 010, "Health Impacts of Altered Geochemistry Associated with Mine Drainage from Western Interior Coals".

References

Bencko, V. and Symon, K. (1977). *Environ. Res.* **13**, 378–355.
Bencko, V., Symon, K., Chladek, V. and Pihrt, J. (1977). *Environ. Res.* **13**, 386–395.
Braunstein, H. M., Copenhaver, E. D. and Pfunder, H. A. (eds) (1981). "Environmental, Health and Control Aspects of Coal Conversion. An Information Overview". Ann Arbor Science, Ann Arbor, Michigan.
Council on Environmental Quality. (1979). "Environmental Quality, 1979", 10th Annual Report. Washington, DC.
Cregan, E. T., Hoover, R. N. and Fraumeni, J. F. (1974). *Arch. Environ. Health* **29**, 28–30.
Dreisback, R. H. (1971). "Handbook of Poisoning", 7th ed. Lange Medical Publications, Los Altos, California.
Enterline, P. F. (1972). *Am. J. Public Health* **54**, 758–768.

Ezra, D. (1978). "Coal and Energy". Wiley, New York.

Falk, H. L. and Jurgelski, W., Jr. (1979). *Environ. Health Perspectives* **33**, 203–226.

Freudenthal, R. I., Lutz, G. A. and Mitchell, R. I. (1975). "Carcinogenic Potential of Coal and Coal Conversion Products". Battelle Energy Program Report, Columbia, Ohio.

Goldstein, D. B. (1979). *Environ. Health Perspectives* **33**, 191–202.

Gunn, S. A. (Chairman). (1976). *In* "Medical and Biological Effects of Atmospheric Pollutants". National Academy of Sciences, Washington, DC.

Jeffrey, E. C. (1925). "Coal and Civilization". Macmillan, New York.

Kagey, B. T., Wixson, B. G. and Gale, N. L. (1980). *J. Geol. Soc. Lond.* **137**, 565–570.

Klauber, M. R. and Lyon, T. L. (1978). *Cancer* **41**, 2355–2358.

Lave, L. (1977). "Coal as an Energy Source: Conflict and Concensus 1977", 8pp. National Academy of Sciences, Washington, DC.

Morse, K. M. (1972). *Ann. N.Y. Acad. Sci.* **200**, 401–404.

National Geographic Magazine. (1981). "Energy, A National Geographic Special Report", February. Washington, DC.

National Research Council. (1980a). "Trace-Element Geochemistry of Coal Resource Development Related to Environmental Quality and Health" (Panel of the Trace-Element Geochemistry of Coal Resource Development Related to Health, Wixson, B. G., Chairman). National Academy Press, Washington, DC.

National Research Council. (1980b). "Health Effects of Fossil-Fuel Combustion Products: Needed Research" (Committee on Research Needs on the Health Effects of Fossil-Fuel Combustion Products). National Academy Press, Washington, DC.

Nielson, F. H. *et al.* (1977). *In* "Geochemistry and the Environment", vol. II. National Academy Press, Washington, DC.

Occupational Mortality Decennial Supplement. (1978). "1970–1972, England and Wales", Series DS No. 1. Office of Population Census and Surveys, London.

Oldfield, J. A. (Chairman). (1974). *In* "Geochemistry and the Environment", vol. I, pp. 57–63. National Academy of Sciences, Washington, DC.

Report on Health and Environmental Effects of Increased Coal Utilization. (1980). *Environ. Health Perspectives* **36**, 135–154.

Reznek, S. (1977). *In* "Coal as an Energy Source", pp. 34–38. National Academy of Sciences, Washington, DC.

Rockette, H. (1977). "Mortality Among Coal Miners Covered by UMWA Health and Retirement Funds", pp. 77–155. National Institute of Occupational Safety and Health, US Department of Health, Education and Welfare, Morgantown, West Virginia.

Sunderman, W. F. (Chairman). (1971). *In* "Medical and Biological Effects of Environmental Pollutants". National Academy of Sciences, Washington, DC.

Swaine, D. J. (1977). *In* "Proceedings of the Eleventh Annual Conference on Trace Substances in Environmental Health" (Hemphill, D. D., ed.), pp. 107–116. University of Missouri, Columbia.

Talty, J. T. (1972). *Environ. Sci. Technol.* **12**, 890–894.

Van Hook, R. I. (1979). *Environ. Health Perspectives* **12**, 890–894.

Vostal, J. J. (Chairman). (1971). *In* "Medical and Biological Effects of Atmospheric Pollutants". National Academy of Sciences, Washington, DC.

Wagner, J. C. (1972). *Ann. N.Y. Acad. Sci.* **200**, 401–404.

Waldbott, G. L. (1978). "Health Effects of Environmental Pollutants", 88pp. C. W. Mosby Co., St Louis, Missouri.

World Coal Study. (1980). "Coal-Bridge to the Future" (Wilson, C. L., ed.). Ballinger Publishing Co., Cambridge, Mass.

16

Natural Radioactivity in the Environment

S. H. U. BOWIE and JANE A. PLANT

I. Introduction

Uranium, Th and K are the main elements contributing to natural terrestrial radioactivity. All three are lithophile and are concentrated preferentially in acid igneous rocks compared with intermediate, basic and ultrabasic varieties. Uranium occurs in crustal rock at an average level of about 2.5 ppm. It has two primary isotopes, ^{238}U and ^{235}U, which occur at the present time in the proportion 99.3% ^{238}U/0.7% ^{235}U. The environmental significance of ^{235}U is small although this is the fissile isotope which forms the basis of nuclear energy production. The specific activity of ^{238}U in natural systems is approximately 20 times that of ^{235}U. It also has a greater number of decay products (Table 16.1), several of which are long-lived, and it is more radiotoxic.

Thorium has only one isotope, ^{232}Th, but it is approximately four times more abundant than U in crustal rocks. It has a relatively simple decay series (Table 16.2), although its specific toxicity both in air and water is many times that of U and even exceeds that of ^{239}Pu.

Potassium levels in crustal rocks average about 2.5%, but of the three naturally occurring isotopes, ^{39}K, ^{40}K and ^{41}K, only ^{40}K is radioactive. The respective isotopic abundances are 93.08, 0.012 and 6.9%. Potassium-40 decays by β emission to ^{40}Ca and to ^{40}Ar by electron capture.

II. Radioelements in rocks

1. Uranium

Uranium is an essential constituent in about 100 minerals. Of these, the most important ore minerals are uraninite, UO_2, and the less well-crystallized

APPLIED ENVIRONMENTAL GEOCHEMISTRY
ISBN 0-12-690640-8

Table 16.1 ^{238}U decay series

Isotope	Half-life	Principal decay modes
^{238}U	4.5×10^9 yr	α, γ
^{234}Th	24.1 day	β, γ
^{234}Pa	6.75 h	β, γ
^{234}U	2.48×10^5 yr	α, γ
^{230}Th	8.0×10^4 yr	α, γ
^{226}Ra	1622 yr	α, γ
^{222}Rn	3.82 day	α
^{218}Po	3.05 min	α
^{214}Pb	26.8 min	β
^{214}Bi	19.7 min	α, β, γ
^{214}Po	1.6×10^{-4} s	α
^{210}Pb	22.0 yr	β, γ
^{210}Bi	5.01 day	β
^{210}Po	138.4 day	α
^{206}Pb	Stable	

Table 16.2 ^{232}Th decay series

Isotope	Half-life	Principal decay modes
^{232}Th	1.41×10^{10} yr	α
^{228}Ra	6.7 yr	β
^{228}Ac	6.13 h	β, γ
^{228}Th	1.91 yr	α
^{224}Ra	3.64 day	α
^{220}Rn	55.3 s	α
^{216}Po	0.145 s	α
^{212}Pb	10.64 h	β, γ
^{212}Bi	60.6 min	α, β
^{212}Po	3.04×10^{-7} s	α
^{208}Tl	3.10 min	β, γ
^{208}Pb	Stable	

variant, pitchblende, coffinite $U(SiO_4)_{1-x}(OH)_{4x}$, brannerite (U, Y, Ca, Fe, Th)$_3$Ti$_5$O$_{16}$, davidite (Fe, Ce, U) (Ti, Fe)$_3$(O, OH)$_7$, uranothorite (Th, U)SiO$_4$ and uranothorianite (Th, U)O$_2$.

Uranium has four oxidation states, the most important of which are U^{4+} and U^{6+}. Uranium of valency 4 forms solid solutions with elements such as tetravalent Ce, Zr and Th, for example, in the accessory minerals cerianite, zircon and uranothorianite. Such minerals are highly resistant to weathering

and usually occur intact in stream sediments and alluvial deposits. However, some minerals, particularly silicates, niobates–tantalates and phosphates containing rare earths or Zr together with U and Th, lose their crystallinity as a result of internal radiation and become metamict. The atomic disordering that occurs in minerals such as thorite, monazite, brannerite and zircon is particularly important, as in extreme cases the glassy mineral formed is chemically reactive and may become altered or hydrated.

With the more soluble forms of U minerals, for example uraninite or pitchblende and coffinite, U^{4+} ions are readily oxidized to uranyl (UO_2^{++}) ions. UO_3 is amphoteric; forming soluble uranyl salts with acids, and with bases forming insoluble uranates. The uranyl ion occurs in the secondary uranium phases such as autunite $Ca(UO_2)_2(PO_4)_2 \cdot 12H_2O$, torbernite $Cu(UO_2)_2(PO_4)_2 \cdot 12H_2O$ and carnotite $K_2(UO_2)_2(VO_4)_2 \cdot nH_2O$.

In igneous rocks, U occurs mainly in accessory minerals, but some is loosely held along grain boundaries and in defects in crystal lattices. In arenaceous sediments, U levels are usually less than 1 ppm because of the relative ease with which U can be leached from interstitial U or from pitchblende and coffinite in an oxidizing environment. However, when such sediments are derived from an igneous rock source containing abundant U and Th-resistate minerals, abnormal concentrations of both elements may occur. In extreme cases where some form of segregation has taken place, as in the case of placer deposits, U and Th values may be high enough to be of economic significance. Uranium leached from any rock under oxidizing conditions is readily precipitated in a reducing environment such as occurs in sandstones rich in organic matter or in Fe sulphides. Uranium grades in such deposits are commonly between 0.05 and 0.2% U. In finer-grained sediments, for example shales formed in anoxic basins, U is commonly concentrated in organic matter (mainly sapropel) to levels of 30 to 60 ppm U. The Upper Cambrian shales of southern Sweden, which were deposited under strongly reducing conditions in a shallow epicontinental sea, contain up to 350 ppm U in deposits containing about 1 mt U.

Phosphatic sediments, like shales, derived their U from sea water through the ability of U to form phosphate complexes, such as $(UO_2HPO_4)_2^{2-}$, in water of relatively high pH. Most phosphorite deposits contain between 10 and 60 ppm U, but some are enriched to 2500 ppm or more. Vast tonnages at grades of over 100 ppm U occur in a belt of phosphorites extending from Morocco through Algeria, Tunisia and into Egypt. Similar deposits occur in Florida, and it is from these that U is sometimes recovered as a by-product in the manufacture of phosphoric acid.

Lignites formed under reducing conditions are also enriched in U. They show much greater variations in U content than shales or phosphorites with some containing only a few ppm U, whereas others have contents of up to 1%

U. Such levels are only exceeded in the case of vein deposits, which commonly contain between 0.07 and 2% U, and in pegmatites, which are usually of relatively small tonnage.

From the environmental point of view, U is of greater significance than either Th or K, first, because it contributes more radioactivity weight for weight than the other two elements and, secondly, because hexavalent U is extremely mobile under oxidizing conditions, especially in acid or carbonate-rich waters. Uranium is also mobile as colloidal particles or as organic complexes. Under reducing conditions, however, it is strongly sorbed by organic substances and Fe sulphides. Its mobility or stability depending on Eh/pH conditions is of special importance to the distribution of radioelements in the environment.

Because of the use of U for nuclear power generation, an understanding of its distribution in the earth's crust, and of the processes controlling its mobilization, are fundamental to problems connected with nuclear energy production and waste disposal.

Excluding concentrations of U and Th that constitute economic deposits, the U and Th contents of rocks can vary by factors of as much as 60 000 to 10 000, respectively. Examples of U contents of different rock types are given in Table 16.3.

Table 16.3 Uranium contents and typical ranges in different rock types (ppm)

Rock type	Mean	Range
Igneous		
Mafic	0.8	0.1–3.5
Diorite and quartz diorite	2.5	0.5–12
Silicic	4.0	1.0–22
Alkaline intrusive		0.04–20
Sedimentary		
Shale	3.0	1–15
Black shale		3–1250
Sandstone	1.5	0.5–4
Orthoquartzite	0.5	0.2–0.6
Carbonate	1.6	0.1–10
Phosphorite		50–2500
Lignite		10–2500

2. Thorium

Thorium occurs mainly in accessory minerals, the most important of which are monazite $(Ce, La, Nd, Th)PO_4$, thorite $ThSiO_4$, uranothorite $(U, Th)SiO_4$ and brannerite.

Thorium has only one oxidation state, Th^{4+}. Thorium forms solid solutions with elements such as U, Ce and Zr. For example, in uranothorianite, thorite and davidite. All Th minerals are relatively insoluble and thus economic concentrations in placer deposite are quite common. Concentrations in acid igneous rocks mainly of thorite and monazite in vein and pegmatite deposits are also sufficient on occasions for Th to be recovered economically.

Secondary Th minerals are rare though in Th silicates in particular $(OH)_4$ substitutes for (SiO_4). For example, thorite $ThSiO_4$ becomes thorogummite $Th(SiO_4)_{1-x}(OH)_{4x}$, which is isostructural with the primary U silicate, coffinite.

3. Potassium

Unlike U and Th, K is a major element in rock-forming minerals occurring mainly in aluminosilicates such as the K feldspars and micas. Typical contents of K_2O in granitic rocks range from about 0.5% in sodic leucogranites to over 8% in potassic leucogranites. Potassic rhyolites and syenites also contain 8% or more K_2O. Sedimentary rocks usually contain between 0.3 and 2.7% K_2O.

III. Radioelements in soil and water

What is equally, or more, important when compared with the U and Th contents of rocks is the distribution of these elements and their daughter products in soil, water and air.

Locally derived soils usually reflect the U content of the underlying rocks. However, they may also be depleted or enriched in U, depending on oxidation–reduction conditions and on the pH of circulating waters. In some circumstances, where humic organic matter accumulates and water migration through the medium is maintained, U can be enriched by a factor of 10 000 from water containing average amounts of the element. Examples of uraniferous peat bogs of regional extent occur in Scandinavia and the USSR—one of the richest known being those of northern Sweden which contains up to 3.1% U on a dry basis (Armands, 1967).

Uranium that goes into solution can migrate over long distances and can be concentrated both in surface and groundwater. Such concentration is enhanced by the ability of U to form complexes such as $UO_2(CO_3)_3^{4-}$, $UO_2(CO)_2^{2-}$ and $UO_2(HPO_4)_2^{2-}$, which are most stable in solutions where the pH is greater than 7.5. Depending on particular conditions that affect the rate of weathering, considerable amounts of U can be concentrated in groundwater derived from rocks containing normal U concentrations.

Weathering and leaching of U tends to result in separation of the parent material from its daughter products. This results mainly from their differing chemical properties and half-lives. The physiologically important daughter ^{226}Ra is not nearly so mobile in surface oxidizing conditions as U, and only occurs on average at a level of 9×10^{-7} ppm in rocks and 8×10^{-7} ppm (1 pci g^{-1}) in soils. However, over areas enriched in U, appreciable Ra can go into solution and migrate over some kilometres distance from its source before being absorbed, for example, on Fe and Mg oxides or onto clay minerals. Radium may also be co-precipitated with Ba, Ca or Mg. The fixation of Ra by whatever means has an important bearing on its immediate daughter, ^{222}Rn, which is a gas. Radon has a half-life of 3.825 days and is thus never found far away from ^{226}Ra. Its movement is mainly by diffusion through porous rock or by dissolution in ground or surface waters. Movement also takes place along faults and fissures; and in some deep faults with associated thermal springs, dissolved Rn escapes to atmosphere with pressure release. At the Badgastein Spa in Austria, springs are estimated to discharge some 200 mCi day^{-1} Rn. Brines in particular carry considerable amounts of Ra and Rn owing to Ra complexing with the chloride ion. Such waters are commonly associated with oil- and gas-bearing basins.

Average contents of U in soils range from 1 to 5 ppm. Radium contents vary between 0.1 and 2.0 pCi g^{-1}. Thorium-230 being a relatively immobile radionuclide, is sometimes concentrated in soils from which the more mobile parent ^{238}U has been leached.

Uranium contents of groundwater vary markedly depending mainly on the bedrock type and on proximity to U deposits as well as to the composition of the water. Generally, levels of more than 4 ppb U are considered to be anomalous. However, in arid continental conditions contents of several hundred ppb U have been recorded, and in the vicinity of U deposits these may be 2000 ppm U or more. Uranium contents in low-temperature groundwaters are given in Table 16.4.

Radium in water is usually less than 1 pCi l^{-1}, but stream waters may contain 5–10 pCi l^{-1} and spring and well waters tens to hundreds of thousands pCi l^{-1}; the highest recorded level being 709,800 pCi l^{-1} (Smith *et al.*, 1961).

Radon levels, as would be expected, generally relate to those of Ra. Usually concentrations are a few pCi l^{-1}. Wells and springs are often enriched to several thousand pCi l^{-1}, with a highest recorded figure of 152 000 pCi l^{-1}.

Thorium has a very low mobility, which is reflected in its concentration in resistate minerals. Soils generally contain around the crustal abundance of 10 ppm Th, while surface waters contain 0.005–0.1 ppb Th.

Potassium, which is a principal plant nutrient along with N and P, is not considered here in any detail. Levels of the radioisotope ^{40}K are about 3 ppm

Table 16.4 Uranium content in ppb in low temperature groundwater (data from Scott and Baker, 1962)

Terrain	Mean	Range
Igneous		
Silicic	4.5	0–32
Basic/Intermediate	0.9	0–9.2
Sedimentary		
Sandstone and conglomerate (including mineralization)	26.2	0–2100
Non-mineralized	2.2	
Siltstone and shale	10.6	0–69
Carbonates	2.0	0–33
Sand and gravel	2.5	0–74
Metamorphics	4.4	0–37

in crustal rocks, 1.3 ppm in sedimentary rocks and about 0.3 ppm in surface and underground waters.

IV. Environmental aspects of radionuclides

Radiotoxicity levels are usually assessed in relation to dose rates of ionizing radiation. In nature, these stem from cosmic and terrestrial sources as well as from body radiation. The cosmic component of radiation varies with altitude and latitude, being greater at high altitudes than at sea-level and greater at the poles than at the equator. There is no significant change, however, so far as the UK is concerned, though persons living in the south of England receive a somewhat lower dost than those in northern Scotland. Human body radiation can be considered as being constant, so that variation in dose rate is due essentially to changes in terrestrial radioactivity.

All terrestrial materials emit ionizing radiations. These are the well-known α, β and γ emissions of the two U decay series, the Th decay series and the β, γ emissions of ^{40}K. The ^{238}U series of radionuclides will be used as an example, although the ^{232}Th series may be equally important because of its greater specific toxicity and abundance in nature. α particles are the least penetrating of the emissions. They scarcely reach the surface, whereas β radiation is essentially adsorbed by 0.5 cm of rocks or soil and γ radiation by 0.5 m. Nevertheless, marked differences in dose rates occur at surface and in the lower levels of the atmosphere over different rock types. Soil is also radioactive, with levels usually lower than those of the underlying rocks. Granites, for example, have higher contents of U, Th and K than more basic rocks and over granitic

rocks radiation levels can be increased by a factor of 10 or more above average.

Granites, however, are by no means the most radioactive of rocks as would appear to be the case by frequent references to Aberdeenshire and southwest England. Some shales contain ten or more times more U than highly radioactive granites, and acid volcanics covering large areas can have equivalent U and Th contents to granite.

The U contents of different rock types in the UK are currently being studied, and early observations will be used to illustrate the resulting variation in radiation levels that can be expected to be found. Regional geochemical data for U are now available from stream sediment samples for much of the northern Highlands and Islands of Scotland, and considerable variations in levels have been identified (Fig. 16.1, Table 16.5).

Very low levels of 0.5 to 1 ppm in stream sediments occur over most of the Lewisian complex of the western mainland of Scotland and over Tertiary basic and ultrabasic rocks. Moine and Dalradian rocks with contained intrusive complexes, with the exception of such late discordant granites as Cairngorm and Etive, have contents near average crustal abundances. The Ben Loyal syenite is abnormally radioactive, showing 10–35 ppm U in stream sediments; and parts of the Cairngorm granite range from 4 to 30 ppm U.

Some of the highest concentrations of U in the UK are associated with the grey lacustrine facies sediments of the Middle Old Red Sandstone of Caithness and Orkney (Fig. 16.2). In Orkney, for example, radiation levels on rock surface have a mean value of 15 μR h^{-1}, but several thin phosphatic horizons reach 150–300 μR h^{-1} with U contents over 1000 ppm U and locally levels greater than 300 μR h^{-1} are recorded (Michie and Cooper, 1979).

Intermediate levels of radiation (10–12 μR h^{-1}) are common over much of southern Scotland, central Wales and southwest England. As might be expected from the stream-sediment data, exceptionally low levels of 6–7 μR h^{-1} characterize the Lewisian granulite-facies metamorphic rocks of northwestern Scotland. Other rocks exhibiting low activity are igneous varieties of basic or ultrabasic composition, limestones and chalk, all of which have levels of 6–7 μR h^{-1}. The Moine metamorphic rocks of Scotland average 8–9 μR h^{-1} as do the Old Red Sandstone facies of the Midland Valley and Jurassic sediments. Higher radiation is common over shales and volcanic rocks of the Ordovician, usually between 13 and 14 μR h^{-1}, and similar levels are the rule over the Middle Old Red Sandstone flags of Caithness.

Large-area anomalous activity occurs mainly over relatively highly evolved K-rich granites such as Cairngorm and Etive in Scotland where activity is greater than 15 μR h^{-1}. Similar radiation levels occur over Shap and Skiddaw in the Lake District and the southwest of England granite bosses.

More restricted, but appreciably higher, radioactivity is associated with sedimentary rocks such as phosphatic limestones of lower Carboniferous age,

0.00
3.00
3.00
5.00
5.00
9.00
9.00
18.00
18.00
1000.00

5000 8700 12400 16100 19800 23500 27200 30900 34600 38300 42000

Fig. 16.1 Distributions of uranium in Northern Scotland based on stream sediment samples.

Table 16.5 Estimated range of U concentrations in stream water and sediment over northern Scotland (Plant *et al.*, 1982)

Region	Water (ppb)	Stream sediment (ppm)
Yesnaby–Stromness district, Orkney	2–13	1–2
Helmsdale granite	1–14 (48)*	12–56 (150)*
Ben Loyal (syenite)	1–48	10–35 (156)*
Cairngorm granite	1–8 (23)*	4–30 (120)*
Older forceful Caledonian granites	1	2–8
Strath Halladale granite complex	1	4–10
Moine migmatite complexes	1	1–4
Basic and intermediate complexes	1	1–4
Moine psammite and semipelite	1	2–8
Lewisian complex	1	1–3
Middle Old Red Sandstone of Orkney and Caithness		
Basal conglomerate breccia	1–2	2–4
Red facies	1–3	2–4
Grey facies	1–11	2–4

* Maximum values in parentheses.

black shales and marine shale bands in the Coal Measures. Even more local are anomalous areas associated with U mineralization where activity is as much as 50 times that recorded over the Lewisian metamorphic facies. Examples are those of Orkney, Caithness, Dalbeattie and numerous occurrences of U both within the southwest England granites and in their metamorphic aureoles.

V. Special conditions

Radon escapes to atmosphere over the earth's crust and is dissipated. However, it can collect in the atmosphere under inversion conditions and invalidate the measurements made on the daughter product ^{214}Bi when using γ-spectrometric methods of detecting U occurrences from aircraft. Radon is a heavy gas (9.73 g l^{-1} at NTP) and tends to concentrate in confined spaces, for example, in mine workings and inside houses. Furthermore, the decay products of radon, namely, ^{218}Po, ^{214}Pb, ^{214}Bi, ^{214}Po, ^{210}Pb, ^{210}Bi and ^{210}Po are solids that become attached to aerosols and can readily be inhaled and fixed on the lungs. The α-emitting nuclides ^{218}Po, ^{214}Po and ^{210}Po are considered to be most damaging to health.

It is well documented that poorly ventilated underground workings,

including some for metals other than U, are likely to contain more than the permissible levels of Rn currently set at 100 pCi l^{-1}. The risks associated with exposure to Rn are now well understood and can be controlled by good mine ventilation and the testing of Rn levels in the workings by continuous monitoring. Concern has been expressed about Rn build-up in houses constructed of granite. There is no doubt this should be investigated, but it is unlikely that any long-term elevation of levels would occur in inhabited dwellings. Radon escape from normal granites is comparatively low, as the Ra content is of the order of 0.1–2 pCi g^{-1} and escape of the ^{222}Rn daughter takes place from only a thin veneer of the exposed surface. Even when crushed, the emanation efficiency of granite is only about 10%.

A building material that has a greater potential risk than granite is that prepared from uraniferous shales which contain more than 100 times the U content of the richest granites. The use of such substances combined with low ventilation conditions induced by a high degree of thermal insulation could be a cause for serious concern and should be investigated further. Recent investigations in the USA (Fleischer, 1981) indicate, in the sealing of homes and the incorporation of Rn-emitting sand or rock as a heat-storage material, Rn has increased in some energy-efficient homes to more than 100 pCi l^{-1} of air.

1. Ingested radionuclides

In previous sections, attention has been given to doses from terrestrial and cosmic sources that reach the whole body. Also, inhalation of Rn has been discussed. However, this is only part of the story. Radionuclides belonging to the four main decay series are present in the atmosphere, in food and in potable water. These can be inhaled or ingested and so constitute internal irradiation. Potassium-40, which occurs in all cereals, fruits and vegetables, is the main radionuclide ingested. The longer-lived decay products of Rn, namely, ^{210}Pb, ^{210}Bi and ^{210}Po are prevalent in the atmosphere and likely to be inhaled.

2. Radionuclide pollution

The regional geochemical survey of the UK currently being carried out by the Institute of Geological Sciences provides baseline data from which any increased levels of radioactivity can be assessed. In the regions of northern Scotland already covered, no contamination arising from industrial sources has been noted. In some areas of afforestation and intensive agriculture increased levels of U can be attributed to the use of phosphate fertilizer (Michie

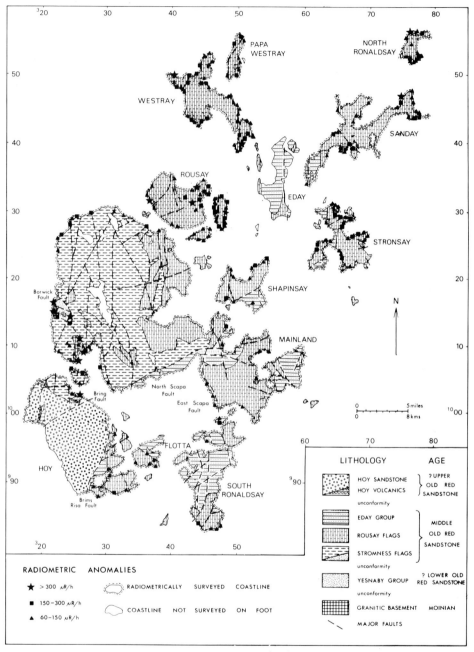

Fig. 16.2 Distribution of the main anomalies discovered on Orkney. (From Michie and Cooper, 1979.)

and Cooper, 1978). This is not surprising, particularly in instances where pulverised rock phosphate is used, since this can contain 100–200 ppm U.

3. Radionuclides and health

There is no evidence relating differences in natural levels of radiation with disease in the UK. Neither is there any valid evidence of cause and effect between the intake of naturally occurring radionuclides and disease. This may be because few epidemiological studies have yet been carried out linking radiation or ingested radionuclides with health. This is a complex matter dependent more on the biological availability of radionuclides than their total concentration. Evidence in the UK and elsewhere is that U in water may not be directly related to the concentration of U in rock or soil, but rather to waters of high pH, high conductivity and high concentration of dissolved carbonate. For example, in Caithness and Orkney and parts of the Permo-Triassic basins of England, U is present as soluble carbonate or phosphate complexes. Other complexes of U known in water are hydroxide, fluoride, sulphate and possibly silicate and the important organic complexes which are particularly important in regions of soft acid water.

Accessory minerals in igneous rocks may contain more than 75% of the total U and Th present, but this is tightly bound and unlikely to be liberated. Certain mineral species, however, lose their crystalline structure mainly through α-particle bombardment and become metamict. Such minerals are relatively reactive chemically and soluble in groundwater.

Uranium, Th and K from rock, soil and water is taken up by plants and may even be accumulated by certain species. This is most important in arid or semi-

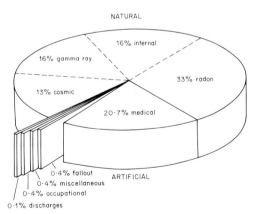

Fig. 16.3 Average annual dose to the population of the UK. (From National Radiological Protection Board, 1981.)

arid terrain where roots may penetrate 20 m or more and take up radio-nuclides. If the ingestion of radioactive material is considered a hazard, epidemiological studies linking the U and Th contents of plants with health would seem worthwhile. Biogeochemical surveys already carried out in the USA, Australia, Canada and elsewhere in the search for U deposits could well form the basis of such research.

Natural radiation contributes a total of almost 80% (Fig. 16.3) (National Radiological Protection Board, 1981) of the average annual dose to the population of the UK.Research into the significance of variation in natural levels would therefore seem relevant in assessing the importance of small increases, currently assessed as 0.1%, due to discharges to the environment by the nuclear power industry.

Acknowledgement

The contribution to this chapter by J. A. Plant is published with the permission of the Director of the Institute of Geological Sciences.

References

Armands, G. (1967). *In* "Geochemical Prospecting in Fennoscandia" (Kyalheim, A., ed.), pp. 127–154. Interscience, New York.

Fleischer, R. L. (1981). *Phys. Today* August.

National Radiological Protection Board. (1981). "Living with Radiation", 2nd edn. HMSO, London.

Michie, U. McL. and Cooper, D. C. (1979). *Rep. Inst. Geol. Sci.* No. 78/16.

Plant, J. A., Ostle, D. and Miller, J. (1982). *Rep. Inst. Geol. Sci.* No. 83/1, pp. 32–39.

Scott, R. C. and Barker, F. B. (1962). "Data on Uranium and Radium in Groundwater in the United States", p. 115. US Geological Survey, Professional Paper No. 426.

Smith, B. M. *et al.* (1961). *J. Am. Water Wks. Assn.* **53**, 75.

Index

495